WHEN ART MAKES NEWS

WHEN ART MAKES NEWS

WRITING CULTURE AND IDENTITY
IN IMPERIAL RUSSIA

KATIA DIANINA

NIU PRESS

DEKALB, IL

© 2013 by Northern Illinois University Press

Published by the Northern Illinois University Press, DeKalb, Illinois 60115

Manufactured in the United States using acid-free paper

All Rights Reserved

Design by Shaun Allshouse

Library of Congress Cataloging-in-Publication Data

Dianina, Katia.

When art makes news : writing culture and identity in imperial Russia / Katia Dianina.

pages : illustrations ; cm

Includes bibliographical references and index.

ISBN 978-0-87580-460 6 (cloth) — ISBN 978-1-60909-075-3 (e-book)

1. Nationalism and art—Russia—History—19th century. 2. Nationalism in art. 3. Art and society—Russia—History—19th century. 4. Art, Russian—19th century—History and criticism. 5. Russia—Civilization—1801–1917. 6. Museums—Russia—History—19th century. I. Title.

N6987.D53 2013

701'.03094709034—dc23

2012048217

To my Family—and the Firebird

CONTENTS

LIST OF IMAGES

ACKNOWLEDGMENTS

This volume grew out of my obsession with Russian museums. The years I spent researching, writing, and editing were ones of discovery—both scholarly and personal—but they were also a time in which this book on public discourse itself matured through dialogue with others: authors, colleagues, mentors, and friends. I was privileged to enjoy the guidance and support of many people and institutions; today I would like to thank those who offered me inspiration and critical insights, encouragement and recognition, words of wisdom and lessons in style: Susan Bean, Rosalind Polly Blakesley, Joseph Bradley, David Brandenberger, Jeffrey Brooks, Patricia Chaput, Christopher Ely, Caryl Emerson, Donald Fanger, Amy Farranto, David C. Fisher, Alison Hilton, Barbara E. Johnson, Janet Kennedy, Nathaniel Knight, Marcus C. Levitt, Louise McReynolds, Anne Odom, Wendy Salmond, Andreas Schönle, Richard Stites, Elizabeth Syrkin, William Mills Todd, III, and Richard Wortman. I gratefully acknowledge funding from an ACLS/SSRC/NEH International and Area Studies Fellowship, as well as a Faculty Travel Grant in International Studies and a Research Support Grant in the Arts, Humanities, and Social Sciences from the University of Virginia.

Parts of this volume appeared earlier in journal articles: "The Feuilleton: An Everyday Guide to Public Culture in the Age of the Great Reforms," *Slavic and East European Journal* 47, no. 2 (2003); "The Firebird of the National Imaginary: The Myth of Russian Culture and Its Discontents," *The Journal of European Studies* 42, no. 3 (2012); and "Museum and Message: Writing Public Culture in Imperial Russia," *Slavic and East European Journal* 56, no. 2 (2012). Revised versions of these publications are used here with permission.

A Note on Translation and Transliteration

This study on popular perception of art relies heavily on ephemeral journalistic writing, much of which has never been translated. The stylistic peculiarity of the originals was purposefully preserved in order to accurately represent the volatile spirit of this evolving art criticism for the general reader. Unless otherwise noted, all translations are mine. I have primarily followed the Library of Congress transliteration system. For the sake of readability, Russian names ending in –ii have been changed to –y (Belinsky, Danilevsky); customary practice was observed in rendering names well known in English (Benois, Gogol). Bibliographical references adhere more strictly to the standard Library of Congress system.

WHEN ART MAKES NEWS

INTRODUCTION
The Talk of the Nation

"**A**gain culture? Yes, culture again. I don't know anything else that can save our country from ruin," wrote Maxim Gorky in 1918.[1] Culture as salvation and pride, faith and beauty—the tradition of investing culture with special meaning has deep roots in Russia. It has survived the revolutions and wars of the twentieth century and remains one of the few constants of identity that the imperial, Soviet, and post-Soviet periods share. Culture is Russia's secular religion: major national upheavals and everyday hardship notwithstanding, Russians' devotion to culture has persisted through time. Boris Pil'niak expressed it brilliantly: "I love Russian culture, Russian history—no matter how absurd—its originality, its awkwardness, its stovebenches (*lezhanki*) (you know, those with glazed tiles), its blind alleys; I love our Mussorgskian excess (*musorgsovshchina*)."[2] His passionate rhetoric is contagious: when dealing with a subject more appropriate for veneration than critical study, the audience understandably takes part in this emotionally charged discourse. The much-loved Russian canon includes Pushkin and Gogol, Dostoevsky and Tolstoy, Ostrovsky and Chekhov, Repin and Vasnetsov, the Hermitage and the Tretiakov Gallery, classical music and balalaika concerts, Tchaikovsky and Mussorgsky, folk songs and fairy tales, the Ballets Russes and the Mariinsky Theater, icons and matreshka dolls, the Firebird and Fabergé. The list, inherently incomplete, goes on. How do individual works and institutions of art cohere into a long-standing tradition? When and how does culture become a marker of national affiliation?

A number of good surveys of Russian culture already exist, and several new studies on painting, architecture, and folk art in particular have recently appeared as well.[3] For the most part, this book is not about literature or the history of the arts. Nor is it concerned with the familiar attribute of this culture— Russian Orthodoxy—a time-honored institution largely bypassed by debates

on the emergent secular tradition during the imperial period. Instead, *When Art Makes News* focuses on art as a public event, describing and evaluating the complex impact the visual arts had on society and considering the origins of the Russian cult of culture. It seems that in a country where the writer is a "second government" and "the museum is more than simply a museum," culture has always been the talk of the nation—in salons, conference halls, or around kitchen tables.[4] Many of its classical elements, however, date back only as far as the second half of the nineteenth century, a time that produced the core of images and texts currently associated with Russian heritage. This volume is about *how* this national tradition was written.

When Art Makes News takes us back to the 1860s, when the visual arts—including painting, architecture, sculpture, and theater design—joined literature in the ongoing project of constructing Russian cultural identity.[5] The era of the Great Reforms, known for initiating radical changes in every aspect of the country's life, also precipitated the rise of modern Russian culture. Until the middle of the nineteenth century, Russia had lacked the very basic prerequisites for a public culture: a civil society and a mass-circulation press. The Great Reforms (1860–1874) gave Russia the foundation for a modern nation with a free peasantry, independent courts, and an elected local administration (*zemstvo*).[6] Already at the beginning of his reign, Alexander II closed the Supreme Censorship Committee, lifted the ban on foreign travel, and abolished high fees for passports. In 1865, new "temporary rules" further eased the government's control of the press, revoking preliminary censorship of daily newspapers and the majority of journals. These liberal changes expanded the public space for the articulation and dissemination of national ideas.

The advancement of the visual arts, which took place in this favorable context, was especially conspicuous due to the public character of exhibitions, their pronounced national inflection, and the sheer volume of creative output. During several decades between the emancipation of the serfs and the turn of the century, a remarkable transformation took place: no longer an exclusive privilege of the initiated, art became a familiar marker of national belonging. Two phenomena were responsible for this massive growth in cultural production: the public exhibition and the mass-circulation newspaper. Museums and exhibitions delivered art in a variety of forms and genres to urban audiences in the capital cities, while popular newspapers and journals supplied extensive commentary, which made these cultural events accessible to the general public across the country.

The second half of the nineteenth century was Russia's museum age.

Fragments of cultural identity were collected at that time in contemporary museums, which gathered all things native: art, history, applied science, ethnography, folk arts and crafts, and military history. Between 1851 and 1900, many institutions of visual display opened their doors to the public: the Imperial Hermitage, the Tretiakov Gallery, the Historical Museum, the Polytechnical Museum, the Russian Museum, and the Historical Military Museum, among others.

The national turn in the arts introduced distinctly Russian themes and styles into a visual culture that appealed to the general public: the realist canvases of the Itinerants, the rustic gingerbread designs of exhibition pavilions, and the exotic multicolored architecture in the style of pre-Petrine Muscovy. It also drew attention to the capital of old Russia, Moscow, associated for many with a traditional vernacular unadulterated by Western civilization. It was during the museum age that many paintings, monuments, and whole buildings attained a special status as symbolic expressions of nationality. Yet the power of these images depended on popular writing, which helped "translate" symbolic representations into readily accessible messages. The printed word, I argue, was the main vehicle through which institutions of culture in tsarist Russia reached broader audiences.

It was also around midcentury that aesthetics entered the spotlight of public debates. Literature "laid the foundation for publicity and public opinion" in the first half of the century, as the legendary critic Vissarion Belinsky and many after him observed. During the 1860s, the visual arts, too, began to contribute to the "civic duty" of fashioning an "imagined community."[7] Culture became the talk of the nation when artists and critics actively engaged in the production and dissemination of Russian art, and when, in the wake of the liberating reforms and increasing literacy, the general public matured to welcome it. The new discursive opportunities that the daily press provided encouraged open discussions of art-related topics; these were less suspected of subversive intent than many other contemporary issues. One author explained the prominent place that art and art criticism came to occupy in society during those turbulent decades: "Due to the circumstances, the question of art and the polemics about it have been pushed to the forefront lately, or better put, recently the sphere of art has been almost the only one in which those who write could express their thoughts and opinions with greater freedom."[8] Experts and novices, professionals and amateurs, Russians talked about culture because they could discuss it freely. The amount of writing in the popular press devoted to cultural affairs of all kinds

at this time is astonishing: alongside the familiar book reviews, there was an explosion of public discourse on theater, the circus, art exhibitions, museums, libraries, monuments, cancan dancing, and other novelties. This was in striking contrast to the earlier half of the century, when both the number of cultural offerings and their refraction in the press were rather limited. In a country where culture had thus far been described mostly in terms of its lack, and where the term itself barely existed in the age of the great national poet Alexander Pushkin, the conspicuous eruption of public activity in the 1860s was an affirmative statement.

Why did Russians come to care about culture so much? This book considers the story the visual arts can tell us about the process of gathering, framing, and interpreting culture for the general public. At the center of this study is the development of a shared discourse on cultural self-representation as it was articulated by visual displays and popular journalism. The exhibition hall and the newspaper page were two new public spaces engendered by the Great Reforms where discourses on art and nationality intersected. This dialogue, uniquely preserved in contemporary periodicals, allows us to document several pivotal encounters between art and society—at local and international exhibitions, in museums and public squares, in the pages of newspapers and journals—and evaluate their resonance in Russian civil society. Art-inspired writing, which fed on contemporary cultural nationalism, helped convert local events into building blocks of identity. Commentary in the mass-circulation press was crucial because newspaper columns not only reflected cultural happenings, but gave them meaning for the community at large. The visual arts became broadly available both as a source of pride and as a subject of wide-ranging controversy via popular writing.

Russian culture thrived on debate. While most cultural events took place in urban centers, especially St. Petersburg and Moscow, the daily press disseminated their messages throughout the Russian-speaking empire. Museums and exhibitions became available for the majority of literate Russians in the form of printed commentary, supplied by specialists on the one hand, and a cohort of often anonymous journalists on the other, with sporadic contributions by men and women of letters (Fedor Dostoevsky, Mikhail Saltykov-Shchedrin, Dmitry Grigorovich, Vladimir Korolenko, Vsevolod Garshin, Evgenia Tur), as well as many ordinary readers. These were not impartial reviews: contributors offered strong partisan opinions, argued with organizers and with each other, and imposed their definitions and agendas. Nor were these exchanges always agreeable. Art provoked

heated debates, sparked now by a single painting, like Nikolai Ge's *The Last Supper*, now by a museum, now by the fate of Russian aesthetics as a whole, as demonstrated by the bitter exchange between the nationalist critic Vladimir Stasov and the *World of Art* impresario Sergei Diaghilev near the century's end. With each new opinion, a fresh layer of meaning was added to a piece of art or to an institution, as it traveled from newspaper, to journal, to another newspaper and back.

Among the contested topics were the Russian school of art (whether it existed or not, and if yes, since when) and the national style in architecture (which version of it was authentic and which spurious). Contemporaries also debated whether Russian art was original or derivative, whether the Russian exhibits at world's fairs were adequate, and whether Russia had a distinct identity overall. In retrospect, answering these open-ended questions definitively would seem impossible. But what mattered most at the time was the conversation itself, not the answers. Konstantin Bestuzhev-Riumin, professor of history at St. Petersburg University, summarized the benefits of Russian museums in the liberal daily *The Voice* (*Golos*) as follows: museums "stimulated much talk and spread knowledge all over Russia; and what is more important, they temporarily excited discussion."[9] It was out of these discussions that the idea of a shared culture was born. In a paradox that is at the core of this monograph, rather than reflecting material culture, popular writing was a culture-building event in itself.

The contemporary newspaper was the principal forum for this dialogue between art and society, providing what Benedict Anderson calls "a new grammar of representation," essential for envisioning a national community.[10] Mass-circulation newspapers of the 1850s–1890s offer us a unique opportunity to glean insight into the larger practice of culture-building via writing. In the pages of popular dailies, such as *The Voice*, *The New Time* (*Novoe vremia*), *The St. Petersburg Sheet* (*Peterburgskii listok*), *The Stock Market News* (*Birzhevye vedomosti*), *Moscow News* (*Moskovskie vedomosti*), and *The St. Petersburg News* (*Sankt-Peterburgskie vedomosti*), among others, Russian cultural heritage was coauthored by journalists, artists, critics, and the reading public. While these sources may not provide comprehensive documentation or a conclusive resolution to the question of what that culture was, they do illuminate the process by which the Russian public *imagined* that shared cultural experience and by which those imaginings were manufactured, disseminated, and consumed.

The shift from the factual to the representational register uncovers a thick

and uneven slice of contemporary public life, where the extremes—Russia and the West, the nation and the empire, the icon and the axe—coexisted in so many versions. Driven by the same oppositions that shaped much of Russian history, public discourse constantly shifted focus and location, moving between St. Petersburg and Moscow, Talashkino and Paris, architecture and stage design, etc. The newspaper was a special site of culture that provided a meeting place for these opposites. But culture thus gathered in periodicals was short-lived, like newspapers themselves, and this volatility distinguished art as discourse from the literary canon or the permanent museum display. Culture as discourse was an inherently incomplete and messy project, something that people actually *disagreed* about—not a solid monument, but a bricolage of contested opinions.

The reader-friendly column, the feuilleton, was particularly well-suited to engage a broad readership in this ongoing exchange. A topical piece open to sundry content, the feuilleton rarely contained a disinterested discussion of art, instead inflecting aesthetics with the burning issues of the day. It was this plenteous, opinionated writing that ultimately transformed institutions for the display of material objects into carriers of identity and converted art into a mobilizing factor in society. If it seems that every literate Russian in the country cared about monuments and museums, this is because the visual arts were routinely inscribed into current public debates on national self-representation. Similarly, it was the topicality of these debates that imparted a distinctly Russian flavor to institutions that were originally European. Regular refraction of the visual arts in the contemporary press helped shape the aesthetic sensibility of often poorly educated general audiences; it also promoted national consciousness and shaped a community out of the participating public. In the words of one journalist, "Our general reading public (*srednee chitaiushchee obshchestvo*), its views and ideas, its weaknesses and contradictions, are reflected, as in a mirror, in the most widespread and popular daily editions."[11] Culture thus reflected in the mirror of public opinion represented the culture of the nation.

There was little harmony in this image, however. While exhibitions and museums proper take care of physical objects, the discourse constructed around them deals with the portrayal of these objective realities in light of current ideologies, popular opinion, and personal preferences. The professionalization and canonization of the visual arts advanced rapidly in the second half of the nineteenth century. But before any books on Russian art were available, the key agents of this discourse were everyday critics of culture of

every persuasion—all those who, regardless of their qualifications, circulated their opinions in the newly liberated popular press and weighed in on issues of aesthetics and politics. Taking art beyond the museum walls and rereading its history based on accounts in the contemporary press also gives credit to transient writing, which ignited much of the public discussion, and its many authors, who were the unofficial architects of Russian identity. And here we encounter another paradox: instead of pride and celebration, we find controversy and the outright rejection of culture by prominent founding fathers, such as Dostoevsky and Tolstoy.

By focusing on the public and the literate "middle," this volume questions a familiar assumption that culture in the notoriously unfree tsarist Russia was built primarily from the top down. The mass-circulation press empowered literate Russians to participate in far-reaching debates and partake in a shared experience. Not many expressed their opinions as powerfully as Gorky and Pil'niak, but generations of Russians before and after them cared about culture just as deeply. In the pages of the popular press, such icons of Russia's secular tradition as Ilya Repin's *Barge Haulers on the Volga* (*Burlaki na Volge*) or Viktor Vasnetsov's *Epic Heroes* (*Bogatyri*) became part of their daily lives, even if they never attended an exhibition or a museum.

This culture-making scenario was by no means unique to Russia. Recent scholarship has problematized the nation as a "work of art" in a number of comparative contexts.[12] With France predictably in the vanguard, other European countries, most notably Great Britain and Germany, experienced the kind of acceleration in the spheres of visual display and the popular press that has become known in Russian scholarship as the "museum boom" and the "newspaper boom."[13] This volume does not argue that Russia's relation to culture was somehow superior to other nations; compared to other countries, with their own national mythologies and cults of culture, the Russian scenario did not differ radically. What makes the awakening of public artistic discourse in Russia an instructive object of study is that against the background of aggravating social circumstances—censorship, serfdom, autocracy—this powerful burst of cultural activity in the 1860s, performed in the name of national awareness, was particularly remarkable. And so much more noticeable was the irony that a cult of high culture took root in a largely uneducated country.

The scope of this study covers the gamut of writing devoted to the visual arts, from professional to recreational, published in Russian-language periodical editions between 1851 and the turn of the century. Many of the

opinions under review here were published anonymously; authors often used pseudonyms as well. Since both attributed and unidentified writings fed into the ongoing controversy, issues of agency cannot always be decided with certainty. It is useful to remember, however, that the discourse in question did not belong to any one person or even an entire articulate group; it was the property of the reading public. In the spirit of my sources, I treat the ephemeral feuilletons and the canonical classics as equal contributors to what constituted the culture of the day. Juxtaposed with these lesser-known columns, such familiar texts as Dostoevsky's *Notes from Underground* (*Zapiski iz podpol'ia*), Alexander Ostrovsky's *The Snow Maiden* (*Snegurochka*), and Nikolai Leskov's *Lefty* (*Levsha*) reveal surprising connections and new insights.

Part I is an outline of the theoretical underpinnings of the Russian obsession with culture. In the opening chapter I review the historical background and elaborate on a conceptual framework for the analysis of art as discourse. Rather than taking the greatness or unique nature of Russian culture for granted, I problematize the term and explore the genesis of this cultural mythology. The discussion that follows demonstrates the multiplicity of meanings that coexisted in the popular contemporary press, where instead of glory, we find perpetual crisis. Culture as discourse turned out to be a highly dissonant affair. In this context, I examine several principal controversies, including the eruption of debates in 1876, 1888, and at the turn of the century, which document both the richness of possibilities and the incongruities in what passed for "culture" in the second half of the nineteenth century.

In Chapter 2 our focus turns to the international exhibitions that provided a major impetus to Russian debates on cultural identity. Although physically located outside of Russia, these European venues profoundly influenced the way Russians came to view their culture. It is for this reason that the history of public debates on Russian art begins in Europe. These high-profile European encounters also brought to the fore the vulnerable issue of cultural borrowings, challenging Russians to define themselves in distinct terms. Russian critics and creative writers used international exhibitions as an opportunity to debate what constituted Russian distinction and how it should be represented. Between the first world's fair in London in 1851 and the last exhibition of the century in 1900 in Paris, the two events framing this volume, the idea of national culture and its constitutive elements evolved from miniature experiments in the folk-inspired Russian style to an entire Berendeevka exhibition pavilion, designed to look like a peasant *izba*. Two of the earlier world's fairs are examined in more detail in this chapter: the

first is the Great Exhibition of 1851, followed by its less prominent successor in 1862, both of which took place in London with Russia's participation. Despite Russia's unremarkable self-representation at both, several major developments resulted from the diverse commentary in the press, as critics articulated the importance of the Russian style and the Russian school of art.

In Chapter 3 we return to Russia to examine the background against which the rise of public culture took place on the ground. The discussion here prioritizes three aspects that were central to this process in imperial society: nation-building, the museum age, and the newspaper boom. My main focus is the parallel growth of public museums and popular periodical editions and their contribution to debates on national distinction. Intensifying national movements in Europe and on Russian peripheries urged educated Russians to seek solutions to the predicament of cultural identity. Contemporary exhibitions and the popular press provided some of these answers; the discussion of the museum age that follows, however, foregrounds the questions themselves and the many controversies that the emerging institutions occasioned. While the numbers of visitors to museums and exhibitions grew substantially in the second half of the nineteenth century, the majority of literate Russians participated in these nationwide conversations on the most basic level: by reading daily newspapers, circulation of which increased dramatically in the wake of the Great Reforms. I conclude by demonstrating how the reader-friendly column, the feuilleton, made art accessible to the general public across the country.

The four thematic chapters of Part II are devoted to various forms of the visual arts and the attendant public debates. First I explore the interaction between art and authority in imperial society based on the example of three prominent institutions: the Millennium Monument, the Hermitage Museum, and the Academy of Fine Arts. The borrowed forms practiced in these three state-sponsored establishments served as a reminder that modern cultural tradition in Russia rested on solid Western European foundations, rendering any claims to the uniqueness of that tradition highly ironic. Russia's Millennium, celebrated widely in 1862, occasioned an extensive controversy over Russian history and heritage. The monument in Novgorod, an official artwork sponsored by the state, provoked a variety of responses in society, ranging from laudatory to highly critical. These reactions illustrate how art as public discourse worked in practice. When viewed through the perspective of the diverse contemporary texts about them, the Imperial Hermitage and the Academy of Fine Arts—a world-famous museum and a venerable

school of art—appear in a surprising light, as rather questionable anchors of identity. If anything, they figured in the popular imagination as sites for the negotiation of power between state and society.

The following chapter deals largely with painting, tracing the evolution of the tradition that became known as the "Russian school of art" and that figured in contemporary debates as an auspicious response to charges of imitation, which plagued Russian art displays in international and local exhibitions alike. The national realism of the group of artists known as the Itinerants (*peredvizhniki*) best represents the revolutionary aesthetics of the era; having revolted against the stifling neotraditionalism of the Academy in 1863, Russian painters turned to the "ugly" reality of their everyday surroundings and represented it in all its shocking detail. These paintings were highly unusual for contemporaries and scandalized society. Focusing on the way two famous collections, the Tretiakov Gallery and the Russian Museum, were represented in the periodical editions of the day, I demonstrate that art was present in society not only as a collection of actual masterpieces, but also as a network of conflicting opinions and debates, which dealt with many topical issues of the day besides fine pictures.

In Chapter 6 our attention shifts to several architectural representations of national identity, including Russian pavilions designed for international exhibitions abroad and the Historical Museum in Moscow. The representation of Russian history was topical in the second half of the nineteenth century, as was the question of the proper style in which to render these representations. Moscow figures prominently in this discussion as the main site for the proliferation of the Russian style and, increasingly, as the cultural center of Russia. The Historical Museum, posited by contemporaries as the symbol of Russian cultural distinction, was especially a magnet for extensive debates. One welcome outcome of the museum boom in Moscow was the articulate presence of the general public, which journalists often celebrated more than institutions of culture proper.

The late-nineteenth-century cult of antiquity led to the most ardent reinvention of objects and texts from the national past. In the last chapter I address the smaller-scale forms of the national revival, such as peasant handicrafts, souvenirs, stage designs, and interior decorations, as tokens of cultural identity. Artists' colonies in Abramtsevo and Talashkino served as islands of antiquity in the midst of an industrializing Russia. Via exhibitions, sales, and performances, as well as the plentiful commentary in the press that accompanied each of these public events, these special centers

for the preservation and restoration of Russian antiquity reached broader audiences. This version of the reinvented tradition also proliferated thanks to stylized works of fiction, such as Ostrovsky's spring tale *The Snow Maiden* and Leskov's famous *skaz* narrative *Lefty*. The success that the Russian Department enjoyed at the 1900 international exhibition in Paris was prepared by these practices.

One would expect a happy ending to the story of Russia's decades-long quest for viable expressions of national distinction. Instead, while Russian self-representation in the fairy-tale style was well received by many, contrarian critics of all stripes challenged its very authenticity and kept the controversy going. Yet I argue that even when the image or writing in question was a harsh criticism or a merciless caricature, it still contributed *positively* to the special reputation that Russian culture enjoys to this day. This creative tension between discourse and counter-discourse was necessary in itself, for in the process, the Russian general public became an articulate presence in society, and conversations about its culture turned into a national tradition.

PART I

THE PREDICAMENT OF RUSSIAN CULTURE

NATIONAL CULTURE

A Conceptual Reading

Nothing can be more vague, than the term itself; nothing
more apt to lead us astray, than the application of it to
whole nations and ages.

—J. G. Herder[1]

What is culture?... Culture is like accent, it is a measure of distance:
social, geographical and political. No one has an accent at home.
The entire idea of accent, like culture, has meaning only when
confronted with others who 'speak' differently.

—J. Bradburne[2]

Today, culture is everything and everywhere. As a result of the cultural turn in academia in the 1980s and 1990s, hundreds of definitions and dozens of approaches to the concept have become available. Indeed, we face a veritable "cacophony" of discourses on culture.[3] James Clifford famously announced twenty years ago that "culture is a deeply compromised concept that I cannot yet do without."[4] Still, this well-worn term continues to inspire many books, academic and popular, big and small, on culture in general and on Russian culture in particular. With critical perspectives ranging from historical to mythological, so much has been written about this elusive essence called Russianness over time that one scholar recently even cautioned against an excess of culture in academia.[5]

There are several reasons for this lasting interest, sparked lately by the advent of Russian cultural studies. Culture is in the eye of the beholder: new generations, disciplines, and schools of thought produce new readings. Culture is always a process. The story of Russian culture is continuously revised and rewritten from various perspectives. As I argue, the grand notion of Russian national culture was actually born out of fierce controversy, and debates *between* several of its versions remain central to articulations of identity today. Which version speaks to us depends on many national, institutional, generational, and personal variables. Another reason is the state of intermittent crisis in cultural identity: the "problem of culture."[6] It is at a time of crisis, which heightens the experience of uncertainty and doubt, that national identity becomes an issue. In Russia, according to the religious philosopher Nikolai Berdyaev, it was in the second half of the nineteenth century that "the problem of the value of culture" was first posed.[7]

Before turning to this academic subject rife with controversy, several disclaimers are in order. While I emphasize the diversity of opinions, I do not treat culture in the broad anthropological sense of a "complex whole," nor according to the dictionary definition of a "complex of distinctive attainments, beliefs, and traditions"—the sense in which James Billington, for instance, uses the term.[8] Nor do I consider culture strictly from the perspective of history, art history, or cultural studies, even though many of my "texts" are indeed museums and paintings. The reconstruction of every detail is not my goal; several recent studies have already accomplished this task.[9] The purpose of this chapter is to record the volatile spirit of contemporary debates on culture. My main source is the printed page, albeit not of novels, but of newspapers and journals, and my approach is that of a historically grounded textual and cultural analysis. Rather than studying works of art or literature per se, taken alone or as a group, I focus on the public discourse that created a national culture out of them. When art makes the news, it becomes a part of national culture.

Despite the popular appeal of the art-inspired writing under review, the scope of culture in this study differs from "mass culture," conventionally understood, although there are a few inevitable overlaps.[10] In my model, basic literacy figures as the common denominator for a variety of groups that came to constitute the public, as it allows broad audiences—who may not otherwise be partial to museums and paintings—to share a print-based experience. If print culture "had little impact on the majority of the population" in the prereform-era society, as Richard Stites argues, in the second

half of the century public discourse became the key mover of culture not only in its own right, but as a propagator of the arts as well.[11] Without duplicating the tremendous amount of work that went into previously published volumes, I examine the Russian tradition of *writing* public culture.[12] As an umbrella term, I adopt what Jeffrey Brooks offers in reference to literary production in imperial Russia: "a national culture based on the printed word," or "national culture" for short.[13]

To judge by the periodical press of the era, the writing of a shared culture in imperial society was uneven and fickle. Commentary in the mass-circulation press was crucial because newspaper columns not only reflected cultural happenings, but also fashioned their meaning for the community at large. In the pages of contemporary periodical editions, we discover, for instance, that neither the world-famous Hermitage nor the renowned Russian Museum played a major role in advancing national culture; by contrast, the controversial Historical Museum and the initially private Tretiakov Gallery did. As I demonstrate below, it is not so much an institution or a work of art per se, but its resonance in society that fosters a nationwide conversation. Between the lines of the casual feuilletons that survive on the crumbling, yellowed pages of popular dailies, we glean insight into the components of culture long since forgotten.

To judge by nineteenth-century periodicals, the Russian tradition of locating a positive identity in culture was highly contested at its origins, with some prominent authors taking a definitive stance *against* culture. Modern public life in Russia evolved out of controversy between pro- and anticultural positions. This helps explain Berdyaev's keen, if paradoxical, statement, which succinctly summarizes the Russian predicament: "the Russian idea is not an idea of culture."[14] I nevertheless contend that this negative take on culture, having generated many heated debates, contributed to a positive mythology that surrounds the Russian tradition today. In the course of public debates of the day, culture became a "household word" and a familiar marker of identity.

In this chapter I begin by surveying some of the available studies and proceed to conceptualize the idea of culture as it formed in Russia in the course of the nineteenth century. I continue by outlining an interdisciplinary paradigm that helps account for the many incompatible versions of culture that concurrently existed. Select episodes from the history of the debates that follow demonstrate the dynamics of culture writing in imperial society; by looking in depth at a few moments during which the controversy heightened,

I prioritize close reading of those contemporary texts rather than pursuing an exhaustive chronological treatment of all events. In conclusion, I draw attention to what contemporaries identified as a crisis of culture near the century's end when pronouncements to this effect sounded on all sides. This perceived crisis, however, only reinforced the Russian tradition of talking about culture, a tradition that has endured to this day.

What's in a Term

Ever since Russian culture was popularized in the West between 1885 and 1920 in the form of translations, international exhibitions, and Ballets Russes performances, numerous attempts have been made to describe and understand Russia through its cultural expressions. Virginia Woolf's short essay "The Russian Point of View" is one of the better-known efforts to capture the spirit of the profoundly alien literature that enjoyed unprecedented fame at the time. Subsequent surveys resulted in the collection of what I call the "big books" of Russian culture—well-known and well-loved studies, which several generations of English-speaking students and scholars have relied upon: *The Icon and the Axe: An Interpretive History of Russian Culture*, by James Billington (1966); *Land of the Firebird: The Beauty of Old Russia*, by Suzanne Massie (1980); *Between Heaven and Hell: The Story of a Thousand Years of Artistic Life in Russia*, by Bruce Lincoln (1998); *Russia Under Western Eyes: From the Bronze Horseman to the Lenin Mausoleum*, by Martin Malia (1999); and *Natasha's Dance: A Cultural History of Russia*, by Orlando Figes (2002). Obvious differences in approaches and publication dates notwithstanding, the titles of all these volumes draw effectively on pairs of opposites, beautiful metaphors, and memorable images. In one way or another, they all address underlying assumptions about Russian culture, summarized well by Figes: "We expect the Russians to be 'Russian'—their art easily distinguished by its use of folk motifs, by onion domes, the sound of bells, and full of 'Russian soul.'"[15]

Russian culture as an exotic firebird, a beautiful peasant dance, a sanguine textbook, or a coffee table gift edition—the attempts to comprehensively gather and represent culture invariably result in mythic constructs. Such images of one unified national tradition are agreeable due to their finality, but they rely on inflexible assumptions: the overarching pair of binaries, "us vs. them," and the effacement of boundaries between groups within

a nation.[16] They represent an attempt to overcome the differences between "cultures" in the plural within a society at large. By contrast, the multiple versions highlighted below emphasize the fragmentary and the incomplete, drawing attention to the uneven process of culture-building.

Crossing national and disciplinary divides, we discover a plurality of cultures between mass and elite, visual and literary, private and public. Each has its own story to tell. The meaning ascribed to culture can only be contextual: it always depends on where and when this meaning is being articulated. According to Stuart Hall, "We all write and speak from a particular place and time, from a history and a culture which is specific."[17] The dialogue between the many stories and versions preserved in the contemporary periodical press offers a key to understanding how the public in the nineteenth century participated in shaping Russian national culture. It can also help explain how today we, too, are making—and not only consuming—culture on a daily basis.

As the nineteenth century progressed, the Russian public increasingly visited museums and exhibitions, attended operas and concerts, subscribed to journals and newspapers. For many, these activities were new, and satirical publications of the 1860s, like the weekly journals with caricatures *The Spark* (*Iskra*) and *Alarm Clock* (*Budil'nik*), did not tire of ridiculing aspiring museumgoers whose judgment regarding art was clearly misguided. Literacy was on the rise and so was general education in late imperial Russia; still, the popular press was often considered the main vehicle for delivering education to the public at large. With vehement debates surrounding most artistic production in the pages of mass-circulation newspapers, there was more discord than unity. The conversation itself, however, was the common denominator for these islands of difference comprising Russian culture: reading the popular press united the Russian public into a body of opinion.

Newspapers eagerly commented on all cultural events. More often than not, the newly literate Russian public perceived different forms of cultural expression, be they museums, monuments, or paintings, not only as independent works of art and architecture, but as news: *the way they were represented on the printed page*. To judge by any issue of a popular daily, such as *The Voice*, the self-nominated leader of public opinion in the 1860s, or *The New Time*, which assumed this populist role in the following decades—and contrary to the perceived notion that free expression of any kind was largely nonexistent—public culture flourished in imperial Russia. I borrow the description with which Leo Tolstoy opens his controversial treatise *What is Art?*:

Take up any one of our ordinary newspapers, and you will find a part devoted to the theatre and music. In almost every number you will find a description of some art exhibition, or of some particular picture, and you will always find reviews of new works of art that have appeared, of volumes of poems, of short stories, or of novels.

Promptly, and in detail, as soon as it has occurred, an account is published of how such and such an actress or actor played this or that role in such and such a drama, comedy, or opera; and of the merits of the performance, as well as of the contents of the new drama, comedy, or opera, with its defects and merits. With as much care and detail, or even more, we are told how such and such an artist has sung a certain piece, or has played it on the piano or violin, and what were the merits and defects of the piece and of the performance. In every large town there is sure to be at least one, if not more than one, exhibition of new pictures, the merits and defects of which are discussed in the utmost detail by critics and connoisseurs.

New novels and poems, in separate volumes or in the magazines, appear almost every day, and the newspapers consider it their duty to give their readers detailed accounts of these artistic productions.[18]

Tolstoy accurately captures the composite image of a publicly available, contemporary culture that was the talk of the nation. Some celebrated it; others, Tolstoy among them, detested it.

For Tolstoy, culture is problematic; it is an artificial construct and a "shared diversion" (*obshchee otvlechenie*), qualified at best as "so called culture." Far from being a common national experience, culture, in the narrow sense of the arts (architecture, sculpture, painting, music, poetry), was accessible only to the "cultured crowd" (*kul'turnaia tolpa*), which Tolstoy identifies as "people of the upper classes." According to the writer, there are two kinds of culture and two kinds of art: "the people's art and the masters' art," a division that dates back to the westernizing tsar Peter the Great, when art shared by an entire people disappeared. But the binary that Tolstoy diagnosed was just one among many.[19] Class, faith, gender, location—these and other divisions continued to split the idea of "national culture" in the writings of early twentieth-century thinkers as well; they undermined the myth of a homogeneous, uninterrupted tradition. Next to Tolstoy's "so-called culture," we find many other versions, ranging from the national revival based on the celebration of peasant art to Sergei Diaghilev's exquisitely high art of the Ballets Russes. Short of resorting to mythology, how can we accommodate and account for all these irreconcilable possibilities?

An Interdisciplinary Paradigm for the Study of Russian Culture

A variety of conceptual frameworks contributed to my interpretation of Russian culture, including "imagined community" (Anderson), "invented tradition" (Hobsbawm and Ranger), "public sphere" (Habermas), "cultural capital" (Bourdieu), "semiotic mechanism" (Lotman), "webs of significance" (Geertz), art and society (Sternin), institutions of literature (Todd), dialogue of cultures (Bakhtin), "cultural poetics" (New Historicism), and the "lyric principle" (Likhachev).[20] Strong arguments have been made both in favor of and against these individual theories and methods; without prioritizing one or another, I outline my model in the form of the five position statements below.

1. *Russian culture as we know it today is a selective invented tradition of the late nineteenth century.* In Russia, as in much of Europe, the nineteenth century was a period of culture-gathering during which many collections of songs and tales, both real and imagined, appeared, and when the museum was firmly established as a public institution. Not that a unique native culture did not exist in Russia before this, as some extreme Westernizers argued at the time; what was invented was a "historic continuity" of modern culture with the ancient past, for where "the old ways are alive, traditions need be neither revived nor invented," as Hobsbawm and Ranger have famously argued.[21] In the second half of the nineteenth century, traditions were "mass-produced" all over Europe, as "nationalism became a substitute for social cohesion through a national church, a royal family or other cohesive traditions, or collective group self-presentations." Between 1870 and 1914, old rituals were reinvented to offset the erratic experience of modernity, and the new "idiom of public symbolic discourse"—ceremonies and celebrations, parades, statues, monuments, exhibition pavilions, museums, and stylized buildings—reached its peak in Europe.[22] To take one Russian example, the neonational style in the arts that came to define "traditional" Moscow at the end of the nineteenth century, much as it was inspired by centuries of history and folk motifs, was a modern stylization. Endorsed by the public and the state, this retrospective Russian style soon controlled the architecture of churches, private residences, public institutions, and everything from dinner menus to court attire and theater sets. In distinct contrast to the Europeanized cultural production of the preceding era, the national vernacular in the arts that developed in late nineteenth century was emphatically anti-European.

Russian culture as a modern tradition arose in the late 1860s and by the century's end became one of the main categories through which to measure and express identity. Common culture was by definition impossible until

the majority of the population was formally liberated with the abolition of serfdom in 1861; eased censorship laws then allowed the public sphere to expand. During the remarkable decades following the Great Reforms, a national affiliation based on a shared culture became the new creed for the evolving middle class, which lacked other obvious forms of cohesion. To be sure, institutions of culture that gave rise to reinvented traditions were gathered around the capital cities. The eighteenth-century revolution in the visual arts, for instance, was concentrated in imperial St. Petersburg; the center of its reversal—the national turn in the arts of the second half of the nineteenth century—was in the old Russian capital, Moscow. But these public events discursively reached across the nation in the form of commentary and debates; in such a way, the majority of the literate Russian-speaking population experienced common culture.

Near the end of the imperial period, national culture effectively became Russia's new secular religion. Brooks explains: "Among the changes that took place in late nineteenth- and early twentieth-century Russian cultural life was a shift in attitudes toward traditional symbols of Russian nationality, the tsar and the church. A new patriotism developed among the educated from the time of the critic Belinsky, and allegiance was directed less toward church and state than to Russian culture, in particular the literature of the golden age, the Russian classics."[23] Lower costs and special editions prepared for a mass audience helped make classic literature available to wider reading circles. Not only literature, but also music and architecture, painting and sculpture, as well as folk arts and crafts, came to symbolize identity for many Russians. The term *natsional'naia kul'tura* became a common expression in the Russian language at that time.

2. National culture is both a system of symbolic representations and a lived experience. Culture is simultaneously a synchronic collection of texts and the evolving practice of interpreting them. Yuri Lotman helpfully uses the analogy of the museum display to illustrate this double temporality of culture:

> As an example of a single world looked at synchronically, imagine a museum hall where exhibits from different periods are on display, along with inscriptions in known and unknown languages, and instructions for decoding them; besides there are the explanations composed by the museum staff, plans for tours and rules for the behaviour of the visitors. Imagine also in this hall tour-leaders and the visitors and imagine all this as a single mechanism (which *in a certain sense* it is). This is an image of the semiosphere. Then we

have to remember that all elements of the semiosphere are in dynamic, not static, correlations whose terms are constantly changing.[24]

On the one hand, we have a permanent museum or monument; on the other, an ever-shifting public discourse, best represented by a daily newspaper, obsolete the next day. Not only do these two seemingly incompatible aspects of culture coexist, but they inform each other as well; there is an ongoing dialogue between them, which assumes different forms under different historical circumstances. There is also a lasting conflict: lived experience threatens to undermine the image of national culture as finite and noncontroversial. Tellingly, the word and the concept entered the Russian public sphere in the late 1880s in the form of a public debate.

As a system of representation, with its designated heroes and ideals, culture is a necessary imaginary, as Lotman argues, for "culture requires unity."[25] It posits an ideal, a longing for a national form, a nostalgia for quintessentially Russian origins that can be identified and preserved, and a desire to unite a society, divided since Peter the Great's cultural revolution. National monuments and celebrations—the commemoration of the Russian state's Millennium in 1862 in Novgorod, the unveiling of the Pushkin monument in Moscow in 1880, the celebration of Karl Bruillov's centennial in 1899 in St. Petersburg—demonstrate most obviously the use of culture as a means for the reconciliation of antagonistic opinions. At the same time, there is nothing natural about culture. Culture, writes Bourdieu, is "artificial and artificially acquired": "culture is not what one is but what one has, or rather, what one has become."[26] In other words, culture is a learned behavior, and education is its main conduit. To partake in a national culture, one must first learn its language, as well as its numerous dialects.

Studying culture as lived experience means working with the entire range of cultural expressions from high to low. Rather than dividing elite and popular manifestations of culture, I prioritize the *translation* of the high culture of the visual arts into the broadly accessible printed word and the dialogue between art and society, all of which increasingly took place in the periodical press. In the course of this ongoing dialogue, both folk and elite expressions of culture became part of the shared practice, often in the form of book or exhibition reviews published in newspapers and journals. Common culture is located at the intersection of discourses: neither exclusively classical nor mass, it is that broad layer between the balalaika and the ballet with which most literate Russians could identify. The Rus-

sian culture-debating public was born out of these wide-ranging discussions in the press.

3. *National culture is a kaleidoscope of shifting perspectives.* Part of the difficulty with defining culture is that it is always in motion, always selective and partial. The whole idea of a timeless national culture is an abstraction and a convention, "a way of imposing an imaginary coherence on the experience of dispersal and fragmentation," writes Stuart Hall.[27] Multiple versions of culture exist that at certain times and in certain places encapsulated what "national" meant to certain groups of people. In the case of Russia, as Figes points out, the country is "too complex, too socially divided, too politically diverse, too ill-defined geographically, and perhaps too big for a single culture to be passed off as the national heritage." "[T]here is no *quintessential* national culture, only mythic images of it," like Natasha's peasant dance in Tolstoy's *War and Peace*. Still, we wish to capture the whole and to reconcile differences. Figes, for instance, locates the national essence in the "Russian temperament, a set of native customs and beliefs, something visceral, emotional, instinctive, passed on down the generations, which has helped to shape the personality and bind together the community."[28] This elusive essence, however, may well be part of the same mythology.

Let us consider the number of styles and approaches that, at one time or another, critics have claimed to represent the spirit of a uniquely Russian tradition in the arts: the critical realism of the Itinerants; the Russian landscapes of "this meager nature"; church architecture in the neo-Russian style; the national vernacular in applied arts; the pseudo-Russian architecture of exhibition pavilions; traditional and revived folk arts. The "materials" favored by various makers of culture varied radically, too. For instance, the ideologist of Pan-Slavism Nikolai Danilevsky, one of the earliest explicit advocates of national culture, built his canon exclusively out of the classics. The national revival, associated with the arts and crafts movement, prioritized utilitarian objects created by the peasantry, which then came to represent the souvenir identity of Russia at the 1900 Exposition Universelle in Paris and beyond. Still another version could be found in the exotic flavor of the Ballets Russes. Along with monuments and texts that make up a culture, we inherit a multitude of critical responses, for works of art do not go down in history quietly. Culture as discourse is akin to the Bakhtinian dialogue in that it is always in the making: "There is neither a first nor a last word and there are no limits to the dialogic context (it extends into the boundless past and the boundless future). Even *past* meanings, that is, those born in the

dialogue of past centuries, can never be stable (finalized, ended once and for all)—they will always change (be renewed) in the process of subsequent, future development of the dialogue."[29]

4. *National culture is a discursive construct.* I take the idea of national culture to be primarily a network of discursive positions.[30] Traditionally, culture has been described in terms of binary oppositions. Vladimir Paperny's reading of the Soviet cultural experience as alternation between two paradigms, the future-oriented, dynamic Culture 1 and the monumental Culture 2 oriented toward the past, is one fascinating example.[31] In the imperial period, public exchange was informed by pairs of binaries that have defined modern history: Russia and the West, Moscow and St. Petersburg, center and periphery, the city and the country. The opposites, however, also met on a regular basis in the newspaper columns: in feuilletonists' chatter, in polemical exchanges, in heated debates. This broad middle slice of culture between the extremes was informed not only by the oppositions per se but by the conversation *between* them.

Perhaps the entire predicament of culture needs to be recast from what culture *is* to how different groups and generations *talk* about culture. Culture is a form of communication—an ongoing many-voiced dialogue between persons, groups, and institutions.[32] The shared experience of attending exhibitions and reading newspapers connected members of this imagined community, as did the fierce controversy that unfolded in the pages of the press. For that reason, even static symbols remain active and alive, as different discursive positions claim them to represent their cause.

5. *National culture is a public culture.* Clifford Geertz writes: "Culture is public because meaning is."[33] In Russian imperial society, the visual arts that attracted the broad participation of educated citizens composed a portion of the public sphere. This was not the classical "*liberal* model of the bourgeois public sphere," nor was it a purely "literary" one.[34] More often than not, discussions in Russian society took place not in physical locations, such as coffee shops and clubs, but in the virtual public space of the printed word. Debates over the meaning of an individual painting or the design of the entire Historical Museum that unfolded in the pages of the popular press were some of the most eloquent manifestations of the public sphere.

Culture is part and parcel of the society that creates it; it is never "just culture." No aspect of cultural production, including individual talent, institutional support, and education can take place in abstraction from institutions of power. Art and politics have always been intertwined in Russia,

and many Russian emperors were noteworthy collectors, starting with Peter the Great, who founded the first Russian museum, the Kunstkamera, and ending with Nicholas II, who temporarily sponsored the production of Diaghilev's subversive the *World of Art* journal. Richard Wortman explores this "top down" paradigm of the Russian cultural tradition in depth in his *Scenarios of Power*.[35] Aside from this interaction between art and authority, other scenarios were available as well.

Taking for granted the pantheon of authors, artists, and heroes that conventionally serve to represent the Russian national tradition, my account gives priority to other agents of culture whose roles were less glorious and in fact often invisible: merchant patrons, industrialist collectors, adventurous entrepreneurs, art experts, professional journalists, anonymous authors, and amateur critics of every persuasion. It also allows us to shift our focus from a hierarchy of discourses to their parallel existence. Art critics like Stasov and Alexandre Benois, publishers of popular dailies like Andrei Kraevsky and Alexei Suvorin, and a host of anonymous journalists contributed to public culture by sharing their opinions in the press. The newly literate population participated through reading and writing popular columns and letters to the editor.

In sum, there is no such thing as "national culture" in the singular; instead, there is a plurality of discourses on identity, formal and informal, professional and amateur, that are in a constant state of flux, even when they are styled as traditional and permanent. The predicament of Russian culture stems from its mutability: ongoing revisions and reversals compose a national cultural experience. This frustrates our expectations and undermines familiar assumptions, for any effort to construct a well-ordered narrative results in inevitable simplification and further myth-making. Likewise, any neat classification of the numerous participants, many of whom wrote anonymously at the time, would be forced: the instability and the experimental usage of the term throughout the nineteenth century, which I discuss below, testifies to the experience of culture by contemporaries as largely a chaos of opinions and a "zone of contestation."[36]

The Evolution of Cultural Discourse

What did national culture mean in practical terms in imperial society? How did people experience culture? Russian national culture was a bela-

bored idea. Berdyaev defined the extreme fragmentation of the post-Petrine cultural tradition in the following terms: "There was no integrated form of culture in the imperial Russia of Peter. A highly composite and much-graduated state of affairs took shape; Russians lived, as it were, in different centuries."[37] The thoroughly westernized educated classes actually had to *learn* how to be Russian, which they did largely through literature and art.[38] This learning was complicated by the ongoing controversy that surrounded the idea of culture until the end of the century, where this study leaves off.

The genealogy of the concept *kul'tura* in the Russian language is a fascinating story. The present discussion is not a history of the term; highlighted below are just several episodes during which public debates flared up, as they did in 1876, 1888, and at the turn of the century. In the course of these debates, an important transformation took place as culture ceased to be the property of a narrow group of intellectuals and became a part of the public sphere. Scholars disagree on the exact date when the word *kul'tura*, initially a German borrowing, entered the Russian language, but there is a general consensus that it was not widely used prior to the 1880s.[39] Before the term was broadly accepted, its close synonyms, "enlightenment" and "education" (*prosveshchenie* and *obrazovannost'*), were commonly used instead. Although the word was recorded in a lexicon as early as 1837— which may suggest a certain regularity in its usage—in practice, culture existed in the Russian public sphere not as a definition but as a topic of debate.[40] Accordingly, in one of its first appearances outside reference sources in 1853, the word was proclaimed superfluous, a "mistake," and an "unjustified borrowing."[41] Few Russian authors used the word, and those who did, like Dostoevsky and Saltykov-Shchedrin, interpreted culture in a derisive and overwhelmingly negative sense. Such a provocative trend was not left uncontested, and many columns were subsequently given over to the Russian culture wars.

One of the strands in the debates on culture—the one that has attracted the most attention from scholars—is the distinction between "culture" and "civilization." This "conversation" has been going on in society on and off since the late 1860s. The wide range of contradictory definitions that circulated at that time indicates the experimental nature of these debates and the novelty of the concepts the public was trying to master.[42] Contemporaries treated culture concurrently in the broadest of anthropological and the narrowest of artistic senses; it was understood as at once a synonym and an antonym of civilization. There were no impartial contributors to these

debates: the Russian culture wars became a battleground for strong opinions issued by various public institutions and individual persons.

That the meaning of the word oscillated widely was not unusual. Raymond Williams, for instance, points to the alteration in meaning that took place in nineteenth-century Britain from "culture *of* something" to "*culture* as such, a thing in itself," culture as "an abstraction and an absolute." The category of "art" evolved in parallel with "culture" after 1800, and the two have remained intimately connected from that point on.[43] In the Russian language, however, culture remained a neologism decades after it was first registered in dictionaries. In the late 1870s, Saltykov-Shchedrin still referred to it in the novel *The Sanctuary of Mon Repos* (*Ubezhishche Monrepo,* 1878–79) as one of the expressions that is "not yet accepted, newly minted."[44]

In the following decades, "culture" became one of the main themes in Russian social thought. As a perennial *problem*, however, it had been in existence since the early nineteenth century. In 1827, the Romantic poet and philosopher Dmitry Venevitinov, founder and leader of the Society of Wisdom Lovers (*liubomudry*), framed the dilemma of Russian culture in terms of its obvious shortage of originality:

> The enlightenment of all independent peoples developed from their so-called native origins: their artistic creations, even when reaching a certain degree of perfection and consequently joining the world repository of intellectual achievements, did not lose their distinctive character. Russia has received everything from outside, thus this sense of imitativeness … and a total lack of any freedom or genuine activity (*deiatel'nost'*).[45]

The dilemma can be roughly summarized as follows: can a culture based on foreign models adequately express a unique national character? Venevitinov, for one, answered this question in the negative, arguing that a native culture cannot be built with borrowed forms. Petr Chaadaev's notorious "First Philosophical Letter" outraged society in 1836 when it was published in Russian translation in *The Telescope* (*Teleskop*) because the author specifically denied Russia an independent cultural history. Chaadaev categorically declared that Russia lacked an original culture, for everything about it was imitative, derivative, and imported.[46]

Systematic engagement with the dilemma of Russian cultural heritage began with polemics between Slavophiles and Westernizers. Early Slavophiles (Ivan Kireevsky, Alexei Khomiakov) were among the first to raise the demand

for a national culture ("*samobytnaia russkaia obrazovannost'*," as Kireevsky referred to it in Russian).[47] This is when *samobytnyi* (original, native) came to be regarded as an attribute of the utmost distinction. To be sure, the Slavophiles' cultural nationalism was part of the Romantic agenda, except that the only "culture" Russia had known was that of Europe.[48] If in Europe "culture and nationality are one, for the former developed out of the latter," as Kireevsky observed in 1832, in the Russian scenario, native could only mean uneducated. The problem of Russian culture consisted in that "national" and "culture" were antithetical notions: if culture was about enlightenment and education, the national was associated with the vast majority of the population, which was illiterate.[49] In a similar spirit, Khomiakov drew a sharp distinction between the "illiterate Rus'" (*neuchenaia Rus'*) and the "learned Russia" (*uchenaia Rossiia*), which resulted in conflict between national life and foreign culture, between originality and imitation.[50] National culture, in other words, was a contradiction in terms: from the very beginning, the idea of culture in Russia was associated with foreign, not native, origins.

How to fashion a national culture when "national" means distinctly *un*cultured? In the course of the Romantic quest for lost national traditions, contemporaries alternately located cultural identity in the Orthodox church, the peasant commune, the folk ornament, the Russian style of architecture, and realist painting. As often as not, these purposeful discoveries of the national self in culture were discursive constructs as much as they were material manifestations of the Russian vernacular. This discourse, launched early in the century, continued throughout the imperial period at a variable pace.

One loud eruption in the ongoing battle of opinions took place in 1876 when an extensive public dialogue on cultural identity unfolded in the press. Dostoevsky and contemporary author and critic Vasily Avseenko were among those who took part in the exchange.[51] Culture and its made-up derivatives (*kul'turnyi, kul'turit', okul'turivshiisia, dokul'turit'sia*) compose the main theme in the April 1876 issue of Dostoevsky's *Diary of a Writer*. Culture is essentially a curse word here; in response to Avseenko, Dostoevsky writes explicitly against the educated society that had been "depraved by culture." More specifically, the culture under attack refers to the westernized upbringing of the Russian educated elite—the so-called "cultured people" ("*kul'turnye liudi*"):

> They tell us straight that the common people (*narod*) have no truth whatsoever
> and that the truth can only be found in culture, which the upper layer of the
> cultured people preserves. To be entirely conscientious, I will take this dear

European culture of ours in the highest possible sense, and not merely in the sense of carriages and lackeys, precisely in the sense that we, compared to the common people, have developed spiritually and morally, we have been humanized and civilized and thus, to our credit, now differ from the common people entirely. Having made such an unbiased declaration, I will ask myself directly the following question: "Are we indeed so preciously good and so unmistakably cultured that we should toss the common people's culture to the side and bow down to our own culture? And finally, what precisely did we bring to the common people from Europe?"

The shorter version of the same sentiment explicitly equates "us" with Europe, education, and culture, and "them" with the passive, uneducated Russian majority.[52] As an alternative to this culture of appearance, which Dostoevsky disdainfully likens to vaudeville, the writer puts forth the culture of the people (*narodnaia kul'tura*) and its proponents, the Slavophiles. The Slavophiles benefited from European culture as much as the "cultured people" did, but without losing touch with their roots.[53] This entry in *Diary of a Writer* was part of the larger public debate on culture. Among those who contributed to it were Nikolai Mikhailovsky, editor of the thick literary and political journal *Notes of the Fatherland* (*Otechestvennye zapiski*), the popular writer Petr Boborykin, the publicist Pavel Gaideburov, and the authors V. M. and P. Ch., who wrote for a variety of periodical editions, including one of the oldest dailies, founded by Peter the Great himself, *The St. Petersburg News*, and a short-lived weekly newspaper *Rumor* (*Molva*).[54]

That same year, Saltykov-Shchedrin wrote a brilliant satire—an unfinished work called "The Cultured People" (*Kul'turnye liudi*), the first installment of which was published in early 1876 in *Notes of the Fatherland*. At the center of the published fragment is the cultured character Prokop—"one of the most impressive representatives of Russian cultured men, who only yesterday discovered that they have a culture." This type satirized by Saltykov-Shchedrin is about the general public; his "cultured" are the bureaucracy, the provincials, and all those who are eager to receive ready-made opinions and fashionable statements, especially of a foreign origin. Prokop, for instance, defines his affiliation with cultured society as follows: "I am a man of culture because I served in the cavalry. And also because I currently order my clothes at Charmer's. And also because on Saturdays, I dine at the English club."[55] Not unlike Dostoevsky's allusion to vaudeville, culture is a sheer caricature here that results in the special kind of ennui (*kul'turnaia toska*) endured by

Prokop and others like him. These excerpts from debates in 1876 demonstrate that not only did culture mean different things for different contributors, but also that a negative take on the subject predominated. Nevertheless, even while they rejected it, the authors of this growing volume of texts were building culture with their writing.

A major debate unfolded in 1888 in response to *Russia and Europe* (*Rossiia i Evropa*), a remarkable contemporary effort to systematically outline a culture by the naturalist and ideologue of Pan-Slavism, Nikolai Danilevsky. Initially, Danilevsky's treatise appeared in 1869 in the Slavophile journal *Dawn* (*Zaria*), numbering 700 subscribers, but it was barely noticed until almost twenty years later, when *Russia and Europe* became entangled in an extended controversy. The book came out as a separate edition in 1871 and was reissued in 1888. During the many conversations between thinkers, critics, and journalists, talk about culture in general, and Danilevsky's volume in particular, came to occupy a sizable place in the public sphere of imperial Russia. If it took over a dozen years for the 1200 copies of an earlier edition to sell out, it took the 1888 edition only a few months.

A flurry of discursive activity surrounding the reissue of *Russia and Europe* in 1888—in which the philosophers Vladimir Solovyov, Konstantin Leontiev, and Nikolai Strakhov, the professors of history at St. Petersburg University Konstantin Bestuzhev-Riumin and Nikolai Kareev, as well as many anonymous journalists, participated—was as much about Danilevsky's theory as about the conundrum of Russian culture in general. In the pages of the popular press, Danilevsky's single sizable volume was refracted as so many often contradictory opinions, which were broadly and readily available to the general public. Depending on who was writing, when and where, Danilevsky's ideas invited many interpretations.[56]

Danilevsky's theory of cultural-historical types hinges upon the premise that culture cannot be anything but national: "culture ... does not even deserve to be called culture if it is not original" (*kul'tura ... i imeni etogo ne zasluzhivaet, esli ne samobytna*).[57] Patriot of an original national culture that he was, Danilevsky nevertheless acknowledges that no such culture existed in Russia in 1869; overall, in comparison with the Greek and European "great cultural types," the Slavs' contribution to the sciences and the arts had been "rather unremarkable" (*ves'ma neznachitel'no*). All that Russia did have at the time was the "modest rudiments" of a new culture (*skromnye zadatki novoi kul'tury, novoi tsivilizatsii*). This was not due to the Slavs' inherent inability to engage in "purely cultural affairs," however: Danilevsky points

to historical reasons that prevented the Slavs from excelling in the field of culture. Nevertheless, he predicts a brilliant future. Since the rudiments of natural ability and talent, "which are necessary for the glamorous performance in the area of sciences and the arts," are sufficiently present in the Slavic cultural type, there is no reason to be disconcerted with the absence of actual cultural attainment; with more favorable conditions, rudimental buds will develop into "luxurious flowers and fruit."[58]

To prove that Russian culture has brilliant potential, Danilevsky offers a modest canon comprising the Russian classics: the writers Gogol, Pushkin, and Tolstoy; the artist Ivanov; the sculptor Pimenov; and the composer Glinka. The colossal success of Tolstoy's *War and Peace* in particular, he argues, proves that "we are essentially better than we seem. Let them find a comparable work in any European literatures!"[59] That the Slavic civilization had not yet yielded any luscious fruit was due largely to what Danilevsky calls "mock-Europeanism" (*evropeinichanie*). Mock-Europeanism is Russia's disease, the onset of which Danilevsky dates to Peter the Great, whose reforms impeded "genuine cultural development" and led to a radical transformation as "the Russian people split into two layers." Danilevsky explains: "The lower layer remained Russian, while the upper became European—so European as to be indistinguishable from Europe." The epithet "Russian" came to be associated exclusively with things that are good only for the common folk, for instance, "the poor Russian mare (*russkaia loshadenka*), the Russian sheep, the Russian chicken, Russian cuisine, the Russian song, the Russian fairy tale, Russian clothes." Thus everything that is "particularly Russian national" appeared to be deficient, "especially if one looks at it from a foreign point of view," and there was no other perspective available to those who derived all their education from foreign sources.[60]

If Danilevsky and his supporters believed optimistically that, once cured from the disease of mock-Europeanism, Russian society would regain its national confidence, his opponents openly ridiculed such faith in "Russia's great cultural originality" (*velikaia kul'turnaia samobytnost' Rossii*). One of the main provocateurs in the 1888 debates, which erupted after years of silence surrounding the first two publications of Danilevsky's work, was the philosopher Vladimir Solovyov. His article "Russia and Europe" (*Rossiia i Evropa*), published in 1888 in the liberal thick journal *The Messenger of Europe* (*Vestnik Evropy*), refutes both the modest rudiments and the expected luxurious fruit of Russian national culture: "Our contemporary reality does not offer any positive foundation for a new original culture." Solovyov de-

nies not so much the national distinctiveness of Russian culture as its radical difference and complete separation from the European tradition, the point upon which Danilevsky's position rested. Russian culture, far from being a separate and distinct historical type, is only a part of European culture for Solovyov, just as the Russian novel, despite its irrefutable distinctiveness, is part of the tradition initiated by Balzac and Thackeray. Developing his point further, Solovyov declares: "Just as Russian imaginative literature, with all its originality, is one of the European literatures, so too is Russia itself, with all its peculiarities, one of the European nations." For even if one were to grant Russia the rudiments of originality, the absent progress in the arts only proves that Russian national culture is a figment of Danilevsky's patriotic imagination. After all, the golden epoch of Russian culture (from Pushkin's *Eugene Onegin* to Tolstoy's *Anna Karenina*) was followed by a perceived decline, as Solovyov sees it, and the Russia of the second half of the nineteenth century had no masters to equal Danilevsky's original canon of Pushkin, Gogol, Tolstoy, Glinka, and Ivanov. In architecture and sculpture, as Solovyov points out in a footnote, Russia produced nothing whatsoever of distinction: the old Russian churches were built by foreign architects, and the single extraordinary monument—the Bronze Horseman in St. Petersburg—was likewise created by a foreigner.[61] Solovyov concludes that, since culture is at the very core of the Slavic question and since the original religious, artistic, intellectual, and political life in Russia did not evolve fast enough to compete with Europe, Russia should step aside and exercise national self-abnegation (*natsional'noe samootrechenie*), which is how it got its state and culture in the first place. For as long as Russia insists on national egoism, "it will remain powerless to produce anything great or even simply important."[62]

Solovyov's "Russia and Europe" inevitably stirred the public; an extended debate ensued during which writing turned into a culture-making pursuit. One of the ideologists of the soil (*pochvennik*), the philosopher Nikolai Strakhov, defended the idea of Slavic distinction in his article "Our Culture and World-Wide Unity" (*Nasha kul'tura i vsemirnoe edinstvo*), which appeared in the June 1888 issue of *The Russian Messenger* (*Russkii vestnik*), an influential conservative monthly founded by Mikhail Katkov, who also published the leading rightist newspaper *Moscow News*. Strakhov's position was summarized in Solovyov's acerbic repartee as a "sermon on national self-conceit" (*propoved' natsional'nogo samodovol'stva*): "*Let us be ourselves*—this is ultimately all that we need in his opinion. 'Let us be ourselves,' that is, let us

not think about any kind of substantial, fundamental improvement of our life, about any high ideals, *we are fine as is.*" Solovyov went on to mock Strakhov's rhetoric of humble beginnings and future opportunities: "All that we have is embryonic and rudimentary; all is in a preliminary, undefined form; all is pregnant with future promise, but is vague and chaotic in the present."[63]

As the exchange continued, the discourse pro and contra national culture grew denser. Ample cross-referencing, as well as direct and approximate quotations, allowed participants and readers to follow the dialogue closely. Without having read the whole dialogue, not to mention Danilevsky's sizable volume, readers could tune in to an overview of the debate and follow its developments. Sundry opinions peppered the popular press while Solovyov settled scores with his opponents. Writing for the popular nationalist daily *The New Time*, edited by prominent journalist and entrepreneur Suvorin, one anonymous author, who styled himself as "an ordinary reader" (*obyknovennyi chitatel'*), underscored the necessity to give space to national aspects of the Russian mind, a mind schooled by Western Europe for too long, and to encourage its "striving for independent national culture" (*stremlenie k samobytnoi kul'ture*). While agreeing with Solovyov that "without 'culture' and sciences it is hard to be a genuinely useful member of mankind," he categorically objected to obtaining that culture at the cost of the "mental slavery of Russian society."[64] Such broadly accessible writing served as a conduit of knowledge about the state of Russian culture for the reading majority. These anonymous authors fully share the credit for keeping the talk of culture topical with experts on the question like Strakhov and Solovyov.

The big debate on culture eventually ebbed out only to return again, at different times, during the many cultural revolutions of the twentieth century. Danilevsky's ideas, for one, enjoyed an enthusiastic revival among members of the Eurasian movement. In the course of the nineteenth century, the idea of national culture made phenomenal progress from "no culture," to experimental definitions, to the mainstream popular press, and to Tolstoyan "so-called" banal culture. But even as talk of Russian culture was everywhere, there was still no agreement as to what that culture was, or whether it was even necessary.

A Crisis of Culture

Toward the end of the imperial period, the discontent expressed by many nineteenth-century thinkers grew into an articulated crisis. The atmosphere

of the early twentieth century was conducive to reflections on the ways of culture. Anton Chekhov dramatized his vision of culture's decline brilliantly in *The Seagull*. The symbolist author Andrey Bely wrote an essay poignantly titled "The Problem of Culture" (*Problema kul'tury*). Among other contributors to contemporary debates on cultural identity were such thinkers as Viacheslav Ivanov, Berdyaev, Mikhail Gershenzon, and Lev Shestov.[65] Turn-of-the-century debates oscillated between two extremes: the "end of culture" and the "cult of culture." Invariably, the "middle and middling forms" (*sredinnye i usrednennye formy*) came under attack from both sides.[66] National culture as an expression of *collective* identity lost currency at the end of the imperial period, when it was assailed on all fronts by such dissimilar thinkers as Berdyaev and Lenin.

Berdyaev argued that in Russia, where national consciousness had been defined by apocalyptic and nihilistic trends, culture was rejected as an intermediate and moderate solution. For him, culture is an aristocratic construct opposed to bourgeois civilization. Berdyaev writes, "The highest elevations of culture belong to the past, and not to our bourgeois democratic age, which is, more than anything, interested in the leveling process."[67] At exactly the opposite end of the spectrum, the leader of the Socialist Revolution Vladimir Lenin unfolded a campaign in 1913 against national culture based on his theory of class struggle. National culture may have been a viable agenda 125 years ago, writes Lenin, but not in the present, when the nation is split into bourgeoisie and proletariat. "In *every* national culture there are, however undeveloped, *elements* of democratic and socialist culture, because in *every* culture, there is a mass of workers.... But in *every* nation there is also a bourgeois culture ... which exists, at that, not only as 'parts' (*elementy*), but as the *dominant* culture. This 'national culture' *is* on the whole a culture of landlords, priests, and bourgeoisie."[68] From the perspective of Marxist theory, as much as from that of religious philosophy, the notions "national" and "culture" simply did not belong together.

Around the turn of the century, new sepulchral imagery began to dominate the discourse and the motif of a "rescue from culture" resounded in contemporary debates. Contrary to previous efforts to collect and display artifacts, Russian thinkers now challenged culture to transcend the material world of institutions and to turn into a life-creating force. In essays by Bely, who wrote extensively on the "ways of culture" (*puti kul'tury*), culture is emphatically spiritual and individualistic. According to him, only a life of creativity can overcome the death of culture, which Bely represents as

a mausoleum of museum relics where one can play the "grand piano of culture": touch the keys and pleasant sounds emerge—Rafael, Leonardo, Wagner.[69]

More fundamentally, the utopian philosopher Nikolai Fedorov announced that "the goal of life must be the salvation from culture."[70] For Fedorov, culture, as well as institutions that gather, organize, and display it, is antithetical to life. Hence he takes the museum—the quintessential such institution and a stronghold of identity—and deconstructs it as a false and mechanical manifestation of life. Fedorov's ideal museum does not preserve fragments of the material heritage; it rather functions as a laboratory for the resurrection of dead forefathers, recycling the past into a life-creating energy.[71] Perhaps the most explicit argument against modern secular culture belongs to the Russian Orthodox theologian Pavel Florensky, who frames it as only a poor substitute for God: "We got very used to believing in culture instead of God." He continues: "Modern man needs Christian culture; not theatrical props, but a serious culture, culture according to Christ, a genuine culture."[72] The religious cult offered one of the turn-of-the-century solutions to the crisis of modern culture.[73] The recourse to traditional and reinvented Russian mythology, which enjoyed an enthusiastic revival near the century's end, was another possibility to resolve this perceived crisis.

We can go on and on, as contemporaries did, on a quest for a lasting resolution to Russian debates on culture. The modernist turn in the arts and the avant-garde aesthetics, which aimed to toss the classics overboard "off the ship of modernity," remain outside the scope of the present volume, as do many other subsequent developments as well. Time and again, each utterance in support of a national culture invited resistance, so when Fedorov appealed for salvation *from* culture, Nikolai Roerich declared that culture *was* the salvation.[74] The debates that flared up in the final third of the nineteenth century have never been settled, and this is why culture remained the talk of the nation until it was streamlined post-1917 to serve Marxist ideology and then squeezed into a tight formula of "national in form and socialist in content" during the Stalinist era.[75] Yet even when the counter-discourse receded underground, it did not disappear: what was hidden from view for some was a vital expression of cultural identity for others. During the post-Soviet period, those turn-of-the-century conversations returned. The titles by Danilevsky, Solovyov, Berdyaev, and many other thinkers who wrote on Russian cultural identity a century ago but stayed out of print for decades

during the Soviet era, have been reissued. The perpetual controversy has continued to pull culture in different directions, keeping cultural identity at the center of public life.

What is special about Russian culture is neither the Russian soul nor the Russian style; the uniqueness of both has been repeatedly contested. Culture is an invented tradition and a practice of constantly revising that tradition, of losing and finding it, of writing and rewriting. National culture exists as discourse *and* counter-discourse. The Russian pride and paradox is that Culture (emphatically high with a capital "C") has come to serve as a *popular* marker of identity in a country with a barely literate population. Via open debates in the press, the Russian general public learned how to *talk* culture and made a national tradition of it.

Before the onset of the turn-of-the-century crisis, the idea of national culture flourished in Russia. The chapters that follow focus on this period of gathering and debating culture in the second half of the nineteenth century, when famous museums, monuments, and styles emerged, along with the fierce controversies that accompanied every single effort to build and articulate the national idiom in the arts. Framing the fifty years of conscious culture-building in imperial Russia are two international exhibitions that showcased Russian achievements and deficiencies: the first world's fair in London, which took place in 1851, and the culminating event of the century, the 1900 Exposition Universelle in Paris.

LAUNCHING THE DISCOURSE

International Exhibitions and Russian Texts

The Great Exhibition of the Works of Industry of All Nations opened in London's Hyde Park on May 1, 1851. It was housed in the magnificent Crystal Palace, as *Punch* magazine cleverly dubbed the enormous palatial greenhouse designed for the occasion by Joseph Paxton (*image 1*). During the five and a half months of its tenure, more than six million people visited the Crystal Palace where exhibitors from thirty-two nations, including Russia, displayed their wares.[1] The extensive railway networks and cheap organized excursions, such as those by Thomas Cook, allowed provincials of all estates to travel to London for the occasion. Some 60,000 foreigners (with an estimated 854 Russians among their ranks) visited England during the Great Exhibition season as well.[2] There is extensive literature devoted to this major event of the Victorian era; I will focus exclusively on representations of the exhibition facilities and the variety of art objects displayed within, as well as the wide-ranging controversy they occasioned in Russia.[3] Russians wrote a lot about the international marvel of the Crystal Palace. Why did the world's fair in London attract so much attention in the tsar's domain?

The story of Russian culture-building begins with an international exhibition for a reason. The second half of the nineteenth century was a time when exhibitions and critical assessment of them proliferated all over Europe.[4] Although none of the world's fairs took place in Russia, they challenged educated Russian subjects to think about themselves in distinctive terms and to represent those imaginings in a national style that was recognizably their own. The Great Exhibition in London was about Russian cultural identity, too. Special commemorations and displays as opportunities to style identity were not per se new; lavish coronation albums, to take one prominent example, served well to represent the coun-

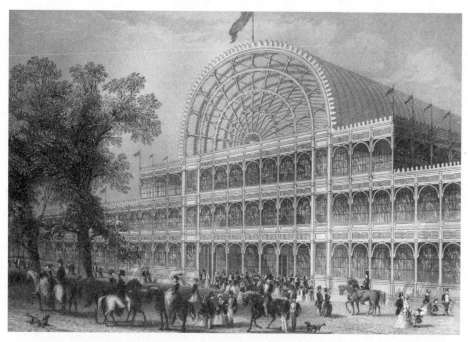

1. The Crystal Palace (North Transept), the Great Exhibition in London, design by Joseph Paxton (1851). *Tallis's History and Description of the Crystal Palace, and the Exhibition of the World's Industry in 1851*, vol. 3 (London, 1852)

try in unique terms, both locally and abroad.[5] But these richly illustrated editions with limited print runs were not intended for the general public, nor did they trigger much conversation, let alone debate, in society; nor were they meant to. The first international exhibition, on the other hand, afforded unprecedented publicity to Russia. That this publicity turned out to be largely negative only precipitated civic engagement at home. The Crystal Palace may have diagnosed a crisis of Russian culture, but it also urged solutions. Two important discoveries date back to the era of early international exhibitions. In 1851 in London, a unique Russian style, as embodied in a widely celebrated decorative sculpture by the silversmith Ignaty Sazikov, provided a clue to Russian success at world's fairs and was instrumental in fashioning cultural identity for international display. A second discovery took place during the International Exhibition of 1862, when Russian critics announced the birth of a peculiarly Russian school of art, even as foreign observers mercilessly criticized Russian paintings for being imitative.

"The Great Exhibition and the Little One"

"For Russians in the middle of the nineteenth century, the Crystal Palace was one of the most haunting and compelling of modern dreams," writes Marshall Berman. "The extraordinary psychic impact it had on Russians— and it plays a far more important role in Russian than in English literature and thought—springs from its role as a specter of modernization haunting a nation that was writhing ever more compulsively in the anguish of backwardness."[6] Whether we agree with Berman's striking imagery or not, it cannot be denied that some of the most remarkable literary treatments of the Crystal Palace were indeed conceived by Russian authors. In 1863, Nikolai Chernyshevsky published *What is to Be Done?*, which contained the famous dream of the Crystal Palace; the following year, Dostoevsky wrote *Notes from Underground*, a literary riposte to Chernyshevsky and his followers, where the dream turns into a nightmare. These famous narratives are deeply embedded in a public discourse that circulated widely within the periodical press of the time and that consisted of a variety of opinions, original and derivative, objective and false. The various readings and misreadings of this modern spectacle, authored by Russian writers, critics, and feuilletonists, fanned a controversy that became a major cultural event in the evolving Russian public sphere.

Let us first consider the resonance that the Crystal Palace occasioned in Britain. We will see that the coverage in the Russian press both fed on foreign reviews and deviated from them sharply. In Britain, several elements shaped the Crystal Palace as a discursive construct. One current of the debates was defined by the pair of opposites: civilization vs. barbarism. In a *Household Words* sketch devoted to the 1851 event, "The Great Exhibition and the Little One," Charles Dickens sarcastically contrasted two kinds of displays: the first recognized "the progress of humanity, step by step, towards a social condition," when "a more refined and fixed condition of happiness" would be achieved in greater nations; the second, the so-called "little one," referred to those less advantageous departments at the world's fair that represented "odd, barbarous, or eccentric" nations untouched by "this law of human progression." Dickens sketched the latter position as follows: "There may be—for a free will, and a perverse one, too, appear to be allowed by Providence to nations as well as individuals—there may be an odd, barbarous, or eccentric nation, here and there, upon the face of the globe, who may see fit to exercise its free will, in the negative form of will-not, and who may seclude itself from the rest of the world, resolved not to move on with

it." Unlike the Great Exhibition, the little does not move "in a right direction towards some superior condition of society"; it stands still. Dickens used Great Britain to illustrate the first kind of display, and China, the second.[7] To judge by representations in the contemporary British press, the Russian empire belonged to the "lesser" nations as well.

Another line of controversy followed the culture vs. commerce opposition. The Crystal Palace was both a fancy museum and a trade fair, and from the very beginning, it elicited contradictory responses from contemporaries. On the one hand, the Crystal Palace was all about the glitter of so many wonderful things. Among others, Charlotte Brontë found this display exhilarating: "The brightest colours blaze on all sides; and ware [sic] of all kinds, from diamonds to spinning jennies and printing presses, are there to be seen. It was very fine, gorgeous, animated, bewildering."[8] On the other, critics of the exhibition saw "the phantasmagoria of capitalist culture" behind all this wonder. As Walter Benjamin famously summarized this second category of responses, "World exhibitions are the sites of pilgrimages to the commodity fetish."[9] The contemporary John Ruskin ridiculed the new commercialization of taste that Paxton's greenhouse exemplified: "in the centre of the 19th century, we suppose ourselves to have invented a new style of architecture, when we have magnified a conservatory!"[10] And another visitor to the Crystal Palace, William Morris, was appalled by the very banality of the whole show.[11]

Likewise troublesome was the clash between the idea of universal brotherhood that the world's fair represented and the explicitly nationalist agendas of individual departments within. Underscoring the ideology of one big family behind the Great Exhibition, one religious tract described it in terms of a peaceful "gathering of the people" and the great "poet's dream."[12] The popular press in Britain as well as in Russia, however, did not hesitate to mock these ideals. The conservative publicist and religious thinker Alexander Sturdza, for example, questioned the moral value of what he referred to as "some sort of soulless brotherhood."[13] Faddei Bulgarin, the notorious editor of *The Northern Bee (Severnaia pchela)*, too, categorically dismissed the "brotherly love" of the exhibition:

> The benefits of local exhibitions of art, manufacture or agriculture are obvious enough: exhibitions incite competition among artists, manufacturers, and landowners; competition and effort, in turn, lead to improvements in all sorts of production. This is an axiom, and it is from this point of view that we should look at the current Universal Exhibition in London. But all the

fantastic dreams about the Exhibition that supposedly command brotherly love among people and sow the seeds of peace in everyone's heart, etc.—all this is nothing but poetry, which is as foreign to commercial and industrial soil as lemons and oranges are alien to Lapland. Brotherly love of thy neighbor belongs to the Holy Scripture and not to the London Exhibition.[14]

Indeed, the universal exposition turned out to be about national and local issues for many. Victorians used it to define themselves as a nation.[15] The representations of the world that the organizers put on display spoke of their power to secure Britain's central position within it: "the exhibition layout essentially balkanized the rest of the world, projecting a kind of geopolitical map of a world half occupied by England, half occupied by a collection of principalities vying for the leftover space."[16] Both greater and lesser nations defined themselves at the international forum precisely *against* other participant "brothers." Some Russian journalists, for instance, scoffed at the whole notion of a world's fair and argued that Russia should promote its local fairs instead. Thus Bulgarin announced that Russia's main power lay not in London, but in Nizhnii Novgorod, where Russia's largest trade fair was located.[17] This is just one example among many illustrating how the International Exhibition in London served essentially as a stimulus for debates on vital issues at home, rather than as a subject of interest in its own right. The ongoing tension between the extremes—the national and the universal, the aesthetic and the commercial, the material and the verbal—is responsible for much of the peculiar resonance that the Crystal Palace elicited in Russia.

The Great Exhibition closed in October 1851. Several years later, the Crystal Palace building was moved from London's Hyde Park to the suburb Sydenham Hill, where it remained until it was destroyed by a fire in 1936. The enlarged and relocated permanent structure at Sydenham accommodated a variety of exhibits related to history and art, including ten so-called "fine arts courts." A decade after the first world's fair, a different exhibition pavilion of unfortunate design was erected in London for the 1862 International Exhibition. It is necessary to underscore the following facts for the present discussion of the three exhibition facilities and their representations: there were two Crystal Palaces (the original one in Hyde Park and the modified one at Sydenham) and two international exhibitions in London that took place in 1851 and 1862, the second of which was housed in a new hideous building named by contemporaries the "wretched shed," while the relocated Crystal Palace continued to welcome visitors at Sydenham.

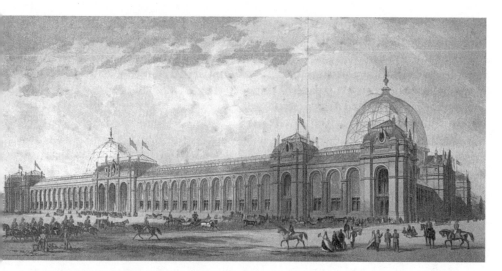

2. The exhibition pavilion for the 1862 World's Fair in London, design by Captain Francis Fowke. *Illustrated London News*, 24 May 1862

The International Exhibition of 1862 went down in history as an aesthetic and financial failure, although it was conceived as bigger and better than its 1851 predecessor. Where the Crystal Palace had inspired poetry, the new building for the exhibition, designed by Captain Francis Fowke of the Royal Engineers, provoked spite. It consisted of the main façade and two adjoining wings, decorated by enormous crystal domes (*image 2*).[18] Contemporaries' response to this architectural design was overwhelmingly negative, and two years after it had been erected as a permanent exhibition facility, the building was razed to the ground. Below is a summary of representative reviews of it in the British press:

> The structure had the advantage of being large; otherwise it was not well received. The *Art Journal* called it a "wretched shed" and a "national disgrace"; *Fraser's* termed the "monstrous piles" an "architectural fungus"; *Illustrated London News* thought it "would be absurd" to call it architecture…. *Quarterly Review* called it an "ignorant, presumptuous, tasteless, extravagant failure."[19]

Quarterly Review further elaborated on the unfortunate design: "There was something *uncanny* about the whole building, with its permanent and its nonpermanent portions; and its hideousness was of that genuine stamp which appeals as forcibly to the instincts of the million as to the science of

the expert.... The only thing which out of sheer charity was sought for, but could not be found, was something to praise."[20] In short, the 1862 successor to the first Great Exhibition was only a lesser imitation of the original.

Unlike elsewhere in Europe, the 1862 International Exhibition had more impact in Russia than the first Great one. A tremendous volume of texts about it appeared in a variety of periodical editions, and the Russian press deserves full credit for turning the unsuccessful world's fair into a major public event within the Russian empire. For instance, *The Northern Bee*, a flourishing daily, which enjoyed the rare privilege of publishing political news, serialized letters from London, advertised a new guidebook for Russian travelers, and printed a large map of the exhibition.[21] *The Russian Arts Bulletin* (*Russkii khudozhest-vennyi listok*), an illustrated almanac issued by artist Vasily Timm, published a reproduction of the ill-conceived exhibition building by Captain Fowke.[22] Following the lead of their colleagues abroad, Russian journalists delighted in criticizing this wretched "shed or stable" masquerading as a temple of the arts.[23] But where the British press played on the contrast between the two London exhibitions, in Russian accounts, a strange superimposition of 1862 onto 1851 took place, resulting in the paradox that was the Russian Crystal Palace. Stasov, for example, insisted that 1862 was the first time that Russia had participated in an international fair, disregarding the 1851 exhibition altogether.[24] Stasov also announced that the 1862 world's fair "was more important for Russians than for any other peoples and countries."[25] His reason for this assertion was the discovery of the Russian school of art, the subject of this chapter's last section.

The critic Vladimir Stasov (1824–1906) made many arbitrary statements.[26] He is often cited in this volume not because he was an exclusive authority on a particular topic, be it international exhibitions or local art shows, but because he was one of the key movers of the public discourse on the arts and an indefatigable participant in contemporary debates on culture and identity. A prolific critic, Stasov wrote on the arts in many separate fields and genres. Aside from international exhibitions, he discoursed authoritatively on painting, national architecture, music, and folk ornamentation. His opinion on the history of Russian *byliny* was as forceful as his commentary on the recent trends in the visual arts and music. Overall, his output is estimated at over seven hundred articles published in fifty periodicals over the course of some fifty years. His motto, "realism and nationality," ran as a leitmotif through much of his writing, and he made a career out of promoting this aesthetic. He even styled himself as a national artifact of sorts,

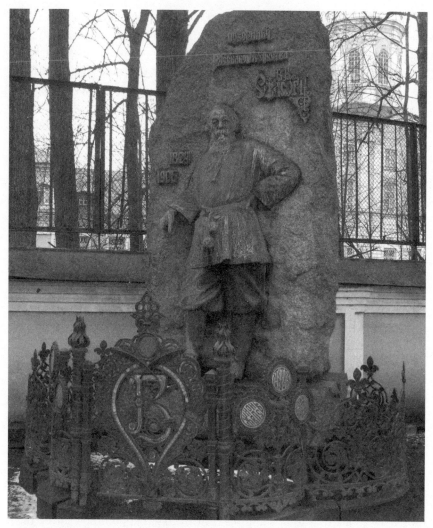

3. Gravestone of Vladimir Stasov, sculptor I. Ia. Gintsburg, architect I. P. Ropet (1908). The Necropolis of Artists, Alexander Nevsky Monastery in St. Petersburg

wearing a red peasant blouse and a long beard, and it was this image that contemporaries preserved for posterity (*image 3*). Although Stasov did not have formal training in art history, he was the head of the Art Department at the Public Library in St. Petersburg, where he served for over 30 years and offered consultations to many authors and artists. He also frequented concerts, hosted musicians and artists at his home, and gave lectures on music.

Most of all, he was a public intellectual of his time, not only because he voiced his opinions openly, but because his words resonated loudly and sparked discussion in society. "A person can only write well if he is in flames," he is known to have said.[27] But it was specifically in dialogue with others that his voice attained the quality of a "trombone," as contemporaries nicknamed the feisty critic. One could call him a scandalmonger, too, for Stasov savored controversy. Author and critic Dmitry Filosofov, for instance, reminisced that Stasov actually enjoyed reading denunciations in the press and then formulating elaborate rebuttals to his offenders.[28] Stasov's polemics with other critics on account of Russian painting is discussed further in Chapters 3 and 4. His strong opinions issued in conjunction with international exhibitions, as we shall see below, contributed significantly to the controversy that the early world's fairs occasioned in the Russian public sphere.

Writing the Crystal Palace: Russian Readings and Misreadings

In Russia, the Crystal Palace as a discursive event quickly acquired a fame independent from the World's Fair. It was associated with several important ideas: the Crystal Palace was about a crisis of self-representation that was diagnosed in London; about a modernity that was happening elsewhere; about the spectral St. Petersburg and the great literary tradition that it engendered; about distinction and inferiority; about aspirations and anguish. Most importantly, due to the intensity and urgency of these debates, the British Crystal Palace turned into a public event in Russia as well. So much was written about this international phenomenon that it became an inseparable part of nineteenth-century Russian culture. The literary battle between the versions of the Crystal Palace that Chernyshevsky and Dostoevsky authored was part of a long-standing controversy that commenced in 1851 and lasted, with interruptions, for over a decade. The varying degrees of refraction that the British exhibition pavilion suffered under the pen of Russian writers, journalists, memoirists, and occasional authors suggests that the Russian idea of the Crystal Palace fed on errors and misreadings as much as on factual reportage. Many journalists, even when stationed in the British capital, practiced a method of writing popularly known as "news gathering through the grapevine" ("*soobshchenie po slukham*"), which often involved little more than reading other newspapers or simply making news up.[29] Moreover, "correspondents" customarily delivered their material in the

form of newspaper feuilletons, which freely mixed objective facts with the subjective chatter of its opinionated columnists.

The written word was the main vehicle by which the Crystal Palace arrived in Russia circa 1851. Unlike the thousands of Britons who traveled to London on excursion trains, the majority of educated Russians participated only vicariously, without leaving the comfort of their armchairs. Russian newspapers and journals covered the first world's fair extensively: three popular newspapers in the capital cities, *The St. Petersburg News, Moscow News*, and *The Northern Bee*, published regular updates on the exhibition's progress, as well as all the auxiliary information necessary for potential and virtual travelers.

Some of the earlier writings devoted to the Crystal Palace were in the genre of travel narratives; a sense of wonder predominates in these stories. Russians who were able to travel to London in 1851 spared no words to describe the marvelous impression that the Crystal Palace produced on them. Professor Modest Kittary of Kazan' called the palace "the best work of art that the English displayed at the universal exhibition."[30] In almost identical terms, Baron Fel'kerzam defined the palace as a remarkable masterpiece: "We like it, we are astounded by its colossal yet harmonious proportions, its lightness and levity, strength and simplicity, utility and beauty...."[31] Georg Min, whose "Letters from London" were serialized in *Moscow News*, compared the Crystal Palace to "something magical from a distant childhood, some fairy tale from *A Thousand and One Nights*."[32] The Slavophile Alexander Koshelev, who was in London in August 1851, likewise framed his impressions of the Crystal Palace in the familiar terms of fairy tales and wonder:

> The exterior of this building dazzles you with its immensity, simplicity and elegance. You look but you cannot fathom what you see. There have been enormous buildings before, but this one exceeds all the rest previously known, not only in its dimensions but in its simplicity and the uniformity of its lines and materials—its extraordinary appearance is particularly striking.—Is it not a dream that I see? Is it not a fairy tale that I'm reading?[33]

Many other "fairy tales" of the Crystal Palace were available in Russia that summer as well, especially to subscribers of *Moscow News*, where two sets of "Letters from London" were serialized between June and September 1851.[34]

The Crystal Palace became a fixture of the Russian imagination. Slavophile philosopher and theologian Alexei Khomiakov, who himself did not travel to London, could write, for instance: "Yes, I would also like to take a

look at this wonderful building of crystal and iron, to see how effortless-
ly the pipelike pillars (*trubchatye stolby*) rise, how bravely the glass arches
curve, how the light plays off that unusual crystal, translucent for the rays of
the sun, but opaque for the human eye." There was a "certain poetic charm"
to the Crystal Palace, one it communicated to the entire Great Exhibition.
By extension, the host country of such an exalted world's fair also assumed
the features of a wonderland in Khomiakov's writing. "Please imitate such a
land!" he appeals to his Russian readership. Just as the English take pride in
all things English, so too should Russians stop shying away from everything
Russian.[35] Koshelev similarly concludes his travel account with a rhetori-
cal move akin to Khomiakov's, returning his readers' attention to Russia, to
"our own land," which he entreats them to study and embrace (*srodnit'sia*).[36]
This shift from the marvel of the Crystal Palace to the celebration of its host
nation and then to an urgent appeal to transfer the experience to Russia
was repeated over and over again. In his coverage of the exhibition, Bul-
garin likewise celebrated English patriotism and recommended that Russians
emulate such noble national sentiments as the "love of one's own nest, that is,
one's motherland, or home, or estate" and the "love of one's own nationality"
(*liubov' k svoei narodnosti*).[37] On the other hand, several other commentators
defended Russia, arguing that Russian civilization was no different than its
European counterparts, and that the only reason that Russia lagged behind
in the development of its industry was the absence of a native bourgeoisie.[38]

Another round of publications appeared when the private Crystal Palace
Company bought the original building and moved it to the London suburb
Sydenham. The Crystal Palace at Sydenham became an exhibition and en-
tertainment facility for the general public, housing ethnographic displays,
copies of antique statues, reproductions of ancient dwellings, "fine arts
courts," including the popular Egyptian and Greek installations, models of
prehistoric animals, a waxwork Court of the Kings and Queens of England, a
portrait gallery, and a giant concert hall. In 1854, Chernyshevsky published
a review article about the reopened Crystal Palace in *Notes of the Fatherland*.
The author drew information from fifteen different newspapers and jour-
nals from France, Britain, and Germany.[39] Like some of the earlier Russian
writing devoted to the subject, Chernyshevsky calls the reassembled Crystal
Palace "a wonderful building," "a wondrous palace," "something unbeliev-
ably splendid, elegant, dazzling," etc. More importantly, the Crystal Palace in
Sydenham became a museum of the arts with "a serious and useful purpose":
the edification of all those who did not have the necessary education to read

scholarly monographs in all their detail. According to Chernyshevsky, the Crystal Palace attracted an average of two million people annually.[40]

Extensive reportage like Chernyshevsky's helped secure the Crystal Palace a prominent place in Russian public culture, including attempts to replicate it in St. Petersburg. In 1860, for instance, architect G. A. Bosse proposed a miniature model of the Crystal Palace to house a permanent exhibition of flowers in the city center.[41] Although this particular project was never realized, the Crystal Palace continued to circulate in the public sphere as a figment and a rhetorical construct for years to come.

The Russian public's interest in questions of identity and representation peaked in the wake of London's 1862 International Exhibition. The Crystal Palace, which by this time was permanently established at Sydenham, was undergoing a discursive revival as well. In the 1860s and early 1870s, next to travel accounts, reviews, and feuilletons, several fictional and polemical narratives appeared that fed on newspaper reportage and, in some cases, personal impressions, among them Chernyshevsky's *What Is to Be Done?*, Lev Paniutin's "The New Year," polemical writings by Nikolai Vagner and Stasov, and Dostoevsky's paradoxical versions of the Crystal Palace in "Winter Notes on Summer Impressions" and *Notes from Underground*. Based on these and other readings and misreadings, we find many Crystal Palaces circulating in the Russian public space: a British phenomenon of material culture translated into a plurality of Russian written texts, where fantastic and realistic interpretations coexisted. A Russian public discourse advanced by the British spectacle was something that the popular daily *Son of the Fatherland* (*Syn otechestva*) had in common with Dostoevsky's thick journals *Time* (*Vremia*) and *Epoch* (*Epokha*), which published "Winter Notes" and *Notes*, and with the radical journal *Contemporary* (*Sovremennik*), where *What Is to Be Done?* first appeared.

Chernyshevsky created a fictional representation of the Crystal Palace in Vera Pavlovna's famous fourth dream in *What Is to Be Done?*[42] Dream and wonder, let us recall, were the predominant Russian responses to the Crystal Palace in 1851, too. At the culminating moment of the narrative, Vera Pavlovna observes a palatial greenhouse that accommodates citizens of the future who lead "healthy and very elegant" lives. She considers: "But this building—what on earth is it? What style of architecture? There's nothing at all like it now. No, there is one building that hints at it—the palace at Sydenham: cast iron and crystal, crystal and cast iron—nothing else."[43] This is a dream of Russian modernity, a "lyrical expression of the potentialities of an industrial age," as Berman has observed.[44] The dream proceeds through

different stages of women's history, which Vera Pavlovna's elder sister unveils in front of her. Each stage opens with a new scene and a new setting: first Vera Pavlovna sees the realm of the fertility goddess Astarte, set against a background of lofty mountains and nomads' tents; the next scene takes her to Athens, with its magnificent temples and public buildings, where Aphrodite rules; then comes the age of Christendom, with its knights and castles, where Chastity resides. Compositionally, the progress of Vera Pavlovna's dream is reminiscent of the permanent exhibition in the Crystal Palace at Sydenham, with its historical courts and fine arts departments.

Paniutin's "The New Year" (*Novyi god*) is another utopian vision of the Crystal Palace dream turned into reality. Paniutin, a famed feuilletonist who wrote under the pseudonym Nil Admirari, worked for the newspaper *The Voice*. "The New Year," although nominally a work of fiction, is a topical, loose narrative, which reads like a newspaper column. The narrator imagines himself celebrating New Year's eve in the company of Schiller, Goethe, Longfellow, and other great poets whom he has invited off his bookshelf. The company makes merry as they sing hymns of joy. Then the narrator meets a spiritualist, who predicts many wonderful things for the coming year, including the advent of a railway network more extensive than in England and the arrival of a new "Palace of Industry" in the center of St. Petersburg. This "fantastic crystal building," explicitly modeled after the one in Sydenham, was to be the "eighth wonder" of the world. The whole of Russia would benefit from such an institution: some 200,000 visitors were to come every day to see its rich museums, the exhibition of the Economics Society, and its chemistry lab. "As a whole, this single center will fortuitously gather everything that is necessary for the edification and entertainment of such an inquisitive and talented population as that of St. Petersburg." Before this dream dissolves into another somber awakening, the narrator envisions that foreign guests would come to Petersburg specifically to see "the treasures of our industry exhibited in this wondrous castle."[45]

The utopian versions of the Crystal Palace that Chernyshevsky and Paniutin presented served to compensate for the inferior impression that Russia had produced on the international scene during the two exhibitions in London. The Crystal Palace seemed to provide a magical solution: if only Russia were to have a Crystal Palace, then the country would gain all that it was lacking: progress, industry, education, democracy. Indeed, upon seeing the imagined crystal edifice in the center of St. Petersburg, Paniutin's narrator exclaims: "But it's England! A perfect England!"

Different aspects of the Crystal Palace continued to be discussed in the Russian press long after both London exhibitions were over.[46] For instance, professor of zoology and children's author Nikolai Vagner lauded this architectural marvel as a citadel of elementary public education in Britain in his essay "'The Little People' of London at Sydenham's 'Crystal Palace.'"[47] For the art critic Stasov, the Crystal Palace meant a universal survey museum encased in the most original architecture:

> An enormous greenhouse, an enormous glass dome (*futliar*), with which some gigantic hand has covered the products of human creativity tugged and lugged here from all over; the dome under which the most gigantic, the most magnificent Hyde-Park trees, captured within the exhibition palace, were standing freely; the dome lit throughout by the miserly English sun, from above and from the sides; the dome which left no corner unlit and which let shine all the colors and forms, all the creations of fantasy, luxury, and utility that filled the palace.[48]

Stasov praised the new institution in Sydenham for gathering samples of art from around the globe and arranging architectural fragments from some of the most famous buildings amidst the fountains and greenery. In the Crystal Palace, Stasov saw the ideal of a national museum open to all realized successfully. He recognized the value of such a useful institution, absent in Russia at the time, and during the 1860s and 1870s, the critic actively promoted both Russian national art and a public museum to house it.

A dream, a school, a museum—these are some of the connotations that the Crystal Palace enjoyed in Russia. Most of them were positive: unlike the Russian department within, the palace itself, whether as a marvel of modern architecture or as a symbol of progress, did not face sharp criticism in Russia. There were some notable exceptions, however.

As an extreme example of counter-discourse, let us consider two narratives by Dostoevsky, "Winter Notes on Summer Impressions" (1863) and *Notes from Underground* (1864). There is a tradition of reading Dostoevsky's *Notes from Underground* in dialogue with Chernyshevsky's *What Is to Be Done?* where the Crystal Palace stands surrounded by a "stone wall" of materialist, utilitarian thinking. Among others, N. F. Bel'chikov, B. P. Koz'min, V. A. Tunimanov, Joseph Frank, Efraim Sicher, and Marshall Berman have written about this literary debate.[49] According to some of these interpretations, *Notes from Underground* and *What Is to Be Done?* dramatize two visions of

modernization for Russia: "modernization as *adventure* and modernization as *routine*."[50] Frank demonstrates that *Notes from Underground* is a "satirical parody" on *What Is to Be Done?* operating on a number of levels, including the conflict between the social romantics of the 1840s and the "new people" (*novye liudi*) of the 1860s. Buckle's *History of Civilization in England*, which became available in Russian translation in 1863 and was immediately popular with the radicals, was a textbook for these new people and their dreams.[51] In his writings, Dostoevsky attacked both Chernyshevsky and Buckle. His debate with Buckle was played out on an intertextual level as well, when the editor Dostoevsky placed a selection from *History of Civilization* in the same issue of *Time*, where he began publishing his "Winter Notes."[52]

Let us consider a different intertextual connection and examine Dostoevsky's work, the style of which Nabokov has disparagingly labeled as a "journalistic excursion," against the numerous accounts of the international exhibitions in the popular press.[53] As we know, Dostoevsky was an avid reader of mass-circulation newspapers like *The Voice*, which he never tired of criticizing. Jeffrey Auerbach supposed, as Berman did before him, that "Dostoevsky's characterization of the Crystal Palace is so anomalous that one wonders if he ever even saw it."[54] It may very well be that he did not, as I suggest below. Nor was it necessary to *see* the Crystal Palace in order to write about it, considering the number of printed texts in circulation in the Russian press for over a decade. Moreover, when the Great Exhibition took place in 1851, Dostoevsky was in Siberian exile; in 1862, he traveled to Europe for the first time and visited London during London's second world's fair. The question should be phrased differently: *which* exhibition facility was Dostoevsky writing about?

We find no description of the Crystal Palace in "Winter Notes," written by Dostoevsky following his trip to Europe in 1862 in the form of a travel narrative. Instead, the object of the narrator's vitriol is the International Exhibition of 1862, housed in the "wretched shed" in the center of London, which Dostoevsky did avowedly see:

> Yes, the Exposition is striking. You feel the terrible force that united here all these countless people coming from all over the world into one fold; you become aware of an enormous idea; you feel that something significant has been achieved here, some victory or triumph.... You look at these hundreds of thousands, these millions of people, humbly streaming here from all corners of the globe, people who have come with one single thought, quietly,

stubbornly and silently crowding into this colossal palace, and you sense that here something definitive has taken place, taken place and been completed. It's like some Biblical scene, something about Babylon.[55]

The narrator introduces the metaphor of an anthill to describe a larger social order, which, despite rationality, is devoid of higher meaning or a shared language. According to him, the exhibition is all about "the necessity to at least somehow get on together, at least somehow form a commune and get settled in one anthill."[56] Dostoevsky's anthill, which returns in *Notes*, is a classic image in Russian literature. It was also part of the common discourse in the press of the 1860s. *Son of the Fatherland*, for instance, published the following excerpt, cribbed from *The Economist* on the day the exhibition opened on May 1, 1862: "Visiting the palace of industry now is more like visiting an anthill rather than an exhibition.... It is curious to see ants from all over the world, speaking every possible different language, but doing the same thing, in the same fashion, in the same anthill."[57] Writing about a different facility—the Crystal Palace in Sydenham—Stasov, too, compared the "hundreds of thousands" of people scattered across the garden's greenery to a stirring, multicolored anthill.[58]

"Winter Notes," subtitled "a feuilleton for the whole summer," reads like a typical freewheeling column devoted to sightseeing, exhibitions, theater performances, and other cultural impressions gathered in a big city or on a grand European tour. But the narrator of "Winter Notes" is a bad traveler, as he concedes: "In my travels abroad I hated to follow the guidebook, to see things on order (*po zakazu*), to fulfill my traveler's duty, and thus I overlooked in some places such things that it's a shame to say." Could it be that Dostoevsky, an inexperienced traveler in Europe for the first time, actually overlooked Paxton's palace, which required a side trip by rail from the city to Sydenham, and took the "definitive" palace with two crystal domes in the center of London for *the* Crystal Palace? When the feuilletonist of "Winter Notes" enumerates the attractions of London that he has observed, he goes in quick succession through "the poisoned Thames," Whitechapel, and then "the City with its millions and world trade, the Crystal Palace, the international exhibition."[59] The distance between suburban Sydenham and the exhibition in London's center was far greater than this description allows. Nor did Dostoevsky spend much time in London, where his days, as scholars claim, were "filled with personal communication with Herzen."[60]

The "Crystal Palace" in *Notes from Underground* resembles Paxton's original as little as the "very well-ordered and spacious" establishment where Raskolnikov goes to read newspaper accounts of his crime.[61] In *Crime and Punishment*, the name Crystal Palace ironically graces a common tavern; in *Notes from Underground*, the marvel of modernity is called "a chicken coop" and tenement building. The Underground Man refuses to accept this chicken coop for a palace: "I won't accept as the crown of my desires a large building with tenements for poor tenants to be rented for a thousand years and, just in case, with the name of the dentist Wagenheim on the sign."[62] A gigantic chicken coop is a bizarre mixed metaphor, which has surprised many. In the context of the contemporary periodical press, this chicken coop of gigantic dimensions would seem to belong to the same group of facilities for domestic animals as the "sheds" and "stables" that peppered the press during the 1862 International Exhibition. Gigantic or colossal was a common attribute that journalists used to describe Fowke's massive palace. Dostoevsky, too, rendered his London impressions in superlative terms: he depicted the exhibition as "a colossal palace" and "a colossal decoration," and a mass of drunken Londoners on Saturday night impressed him as a "colossal and bright" vision.[63]

The Underground Man declines to participate in the construction of this colossal collective dream: "And, as long as I'm still alive and feel desire— may my arm wither away before it contributes even one little brick to that building!" Here is another paradox: how do bricks fit into a crystal palace, described in Vera Pavlovna's euphoric dream as "cast iron and crystal, crystal and cast iron—nothing else"? Berman noticed the unusual "heaviness" of Dostoevsky's literary architecture: "Readers who try to visualize the Crystal Palace on the basis of Dostoevsky's language are apt to imagine an immense Ozymandian slab, bearing men down with its heaviness—a heaviness both physical and metaphysical...."[64] In contrast to the glass and iron of Paxton's Crystal Palace, bricks were used as the primary building material for the 1862 exhibition site, and all the commentators, as if in chorus, disapproved of the choice. All that was "crystal" about the new exhibition palace were the two glass domes, defined by the British press in the following unflattering terms: "colossal dish covers," bigger than St. Paul's Cathedral, "as useless as unsightly."[65] The Russian press dismissed the domes altogether while elaborating on the basic metaphor of the "shed." In his letters from London, which were published in *The Northern Bee*, journalist Vasily Poletika expanded on the usual "shed," labeling the building more precisely, "a brick

shed" (*kirpichnyi sarai*).[66] It is to this "brick shed," at which many were sticking out their tongues in the summer of 1862, that the Underground Man refuses to contribute a single little brick.

Whether Dostoevsky's misreading was intentional or not, his version of the Crystal Palace stands for the Russian dream gone wrong—in literature, at international exhibitions, and in the popular press. His narrators personify Russia's wounded self-esteem. It is likely that Dostoevsky visited the Russian department while in London in 1862, possibly in the company of Alexander Herzen.[67] If so, the anguish of his narrator-feuilletonist in "Winter Notes" makes sense. In a "flash of wounded patriotism," he reacts to the technological marvel of the new Köln bridge with an excuse typical of those Russians who apologized for their department in the press: "Damn it ... we invented the samovar too."[68] Dostoevsky's critique of modernity pivoted on the Russian question, which the international exhibitions brought to public attention: what was better, the progress of Western civilization or the national tradition, the bridge or the samovar? And, aside from the samovar, what did this national tradition consist of?

The Discovery of the Russian Style, circa 1851

The Great Exhibition of 1851 was covered extensively by journalists across the world. Aside from the novelty of the experience, the capacity of the popular press to shape and disseminate opinion was responsible for the proliferation of writing devoted to the first world's fair in a variety of forms and genres. In Great Britain, technological developments in publishing in the 1830s and the growth of railway networks eased the production and distribution of the periodical press, while the general growth of literacy increased its consumption. In Russia, such a revolution in publishing, qualified retrospectively as the "newspaper boom," became possible only in the 1860s.

In 1851, the British press did not write much about the Russian department, despite the many awards that the Russian exhibitors received. The tone of what it did write was set by *The Times*, which attracted an extensive readership, especially from the middle class. One contemporary described this newspaper's reputation for manufacturing ready opinion in the following unambiguous terms: "*The Times* averred that the Great Exhibition was a Great Thing; and the world believed it."[69] In the Russian department, journalists commended "the superb malachite ornaments of untold value from

the property of Count Demidoff, the beauty of which cannot be exaggerated." At the same time they drew attention to their expensive cost of production: "It is almost with a pang of sorrow that we see the time and labour which countries less busy and occupied than ours can bestow upon the slow and laborious operation of putting together in artistic form the scattered and diversified fragments of mineral wealth as illustrated in these specimens of malachite manufactures."[70] *The Art-Journal Catalogue* likewise pointed to the cost of Russian fanciful objects: "The Russian contributions to the Crystal Palace evince a large amount of costly splendour combined with quaint and characteristic design, showing much fancy in the Art-manufacturers who have been engaged in their fabrication."[71]

The overall portrait of Russia that the foreign press outlined was that of a "widely extended empire," rich in raw materials and precious jewels but short of ingenuity, originality, and democracy.[72] Art and politics converged in the foreign portrayals of Russia, and Russophobia on the eve of the Crimean War informed these judgments, despite the professed spirit of peaceful competition. The most ornate exhibits (jewelry, diamonds, gold, silver) were also the most incriminating for a regime that had been routinely described as "paralyzing" and "prohibitive."[73] The comprehensive guidebook *Tallis's History and Description of the Crystal Palace* defined the aesthetics of the Russian department as boasting "a certain air of grandeur and rude luxury."[74]

In the context of an international exhibition, every object on display, be it of art, technology, or agriculture, acquires a symbolic quality. In 1851, several items in the Russian department were designated as carriers of identity and style: two bronze candelabra of enormous size from the Moscow manufacturer Krumbiugel'; malachite doors, vases, chairs, and tables from the mines of the Princes Demidov; jasper vases; porcelain vases; a silver centerpiece and numerous silver cups and statuettes from the workshop of Moscow silversmith Sazikov; and a casket of ebony, decorated with fruit made of semiprecious stones. The fruits were apparently so true to life that the Prince of Wales was recorded as saying that he should really like to eat them. The Russian emperor himself had contributed the last item, deemed by *The Times* as "worthy in every respect [of] the magnificence of the Autocrat." The newspaper spared no epithets to describe this wondrous artifact and its "marvelous fidelity": "This is really one of the chief wonders of the Exhibition, and far surpasses anything of the kind that we have seen. An immense cluster of grapes is typified by amethysts, bunches of cherries and

currants by carnelians, and leaves by jasper, beautifully shaded. Then, there are pears of agate, and plums of onyx....”[75] At the same time, contemporaries in England asked, what kind of Russia was this department representing, made up “entirely of articles for those whose wealth enables them to set no limit to the indulgence of their tastes”?[76] The Russian traveler Koshelev echoed this concern, pointing out with disappointment that there was not a single samovar in the Russian department. Overall, Russia appeared rich in objects of luxury and poor in objects of practical use (*pol'za*). Koshelev was also keen to notice the overall absence of genuine “Russianness” in the Crystal Palace: “Altogether, in the department of luxury we shined, but we showed nothing of our real everyday life, as if ashamed of it.”[77]

Sazikov's silver centerpiece, representing a wounded Dmitry Donskoy, was the most talked-about Russian item in the Crystal Palace (*image 4*). It received a Council Medal, the highest award at the Exhibition, given “for novelty and beauty of design, as well as for excellence of workmanship.”[78] *Reports by the Juries* described its ingenuity in laudable terms:

> The talent of M. Sazikoff is ... especially displayed in a large center-piece representing a fir-tree, at the foot of which the Grand Duke Dmitry Donskoy, sitting wounded, is learning from his soldiers that he has gained the victory. The composition of this group is excellent: the chasing possesses great fulness [sic], and is, at the same time, most carefully executed: the figures, fine in composition and superior in execution, possess a great degree of originality, and are arranged in a natural manner; and the character as well as the merit displayed in this group place it above anything hitherto produced in this description of manufacture.[79]

Aside from the prizewinning centerpiece, other items by the same artist were likewise touted as objects “which reflected great credit upon the taste of the old Russian capital.”[80] English publisher John Tallis was generous with praise, too: “There are other smaller fancy subjects distributed in various parts of the glass case, such as a goblet, representing a Cossack woman; another, with a Finnish hunter; a third, with a milk-woman; and a paper-press, ornamented with a group of a dancing-bear with peasants, all characteristic and capitally executed.” *The Illustrated Exhibitor* likewise thought that these figurines showed “no little humour and taste” and reproduced their illustrations.[81] Sazikov's work rarely enticed criticism, albeit *The Art-Journal Catalogue* observed that even the best of Sazikov's silver cups called to mind “the

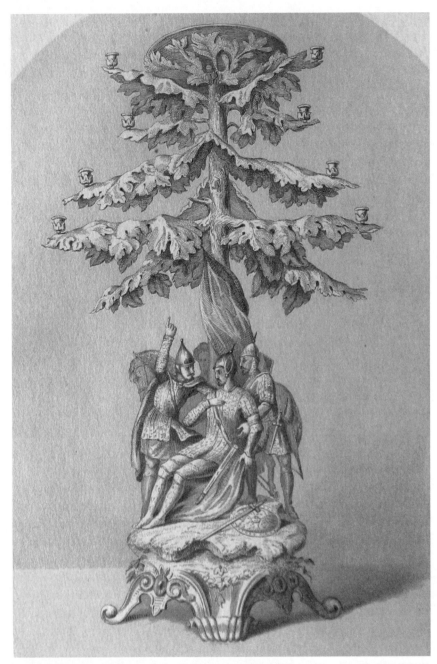

4. Ignaty Sazikov's silver centerpiece with the Grand Duke Dmitry Donskoy. *Tallis's History and Description of the Crystal Palace, and the Exhibition of the World's Industry in 1851*, vol. 2 (London, 1852)

German works of the fifteenth century, to which they are nearly allied."[82] The Russian press, for the most part, echoed the European appreciation for Sazikov's accomplishments: "Until now, all silver works made in Russia imitated foreign models; in the works of Mr. Sazikov, the ideas, drawings, models, and their execution arise from the intellect and labor of Russians."[83] The Moscow silversmith enjoyed continuous success at nineteenth-century world's fairs. Later in the century, Sazikov's national style would serve as a prototype for Fabergé's sculptural groups.[84] In a sense, Sazikov laid a foundation for the export version of vernacular culture, one that would triumph at the 1900 International Exhibition in Paris.

The traditional Russian style was "discovered" simultaneously in Britain and in Russia; the international competition in London provided the necessary context for this discovery to be made. L. M. Samoilov and A. A. Sherer, the Ministry of Finance's envoys at the Exhibition who participated in the arrangement and promotion of the Russian department, authored an extensive review, concurrently published in the two leading newspapers, *The St. Petersburg News* and *Moscow News*, in July 1851. The same material also appeared as part of their official report in *The Commercial Newspaper* and *The Journal of Manufacture and Trade*.[85] As might be expected, Samoilov and Sherer's semiofficial evaluation of the Russian department was full of patriotic enthusiasm: "The feeling of our superiority, our championship is confirmed by the public's constant attention; throngs of people kept rushing in to see our malachites, jaspers, mosaics, bronzes, porcelain, silver, and diamonds."[86] Writing from London a few months later, Georg Min arrived at a nearly identical conclusion: "Overall, Russia presented itself at the universal competition with honor (*dostoinym obrazom*), and in many regards surprised the representatives of the European nations that visited the Crystal Palace with its unexpected excellence."[87]

In 1851, contemporaries were only beginning to identify what composed a unique style in the realm of art manufacture. Prior to its departure for London, the silverwork that Sazikov prepared for the exhibition had attracted favorable attention when it was displayed in a shop of Russian manufactured goods in St. Petersburg. A feuilletonist from *The St. Petersburg News* urged the newspaper's readership to visit the shop and appreciate these specimens of "original Russian taste" before they proceeded to London. He introduced Sazikov's centerpiece as an extreme rarity in the manufacturing business: it was a "purely Russian" article, inspired by old Russian artwork and history. The figure of Dmitry Donskoy, a celebrated Muscovite warrior, was well-

chosen for the occasion. Sazikov's unique talent consisted in blending new forms with traditional craftsmanship, which resulted in the production of objects that were "extraordinarily distinctive and national" in their character. Every piece bore the "seal of nationality" (*pechat' natsional'nosti*), something that separated Sazikov's work from that of his peers. Other Russian manufacturers, the journalist generalized, "do not dare to comprehend that a good work of art, which reproduces objects familiar and dear, skillfully designed and executed, will always find much more understanding with the Russian public than imitations that are absolutely foreign to our lives."[88] The next feuilleton placed in *The St. Petersburg News* profiled the malachite ornaments from the Demidovs' factory, also displayed in St. Petersburg on the eve of the Great Exhibition. Like Sazikov's silverwork, Demidovs' malachite pieces were introduced as genuine Russian works.[89]

But firsthand accounts were rare in 1851. Most of the "Russian" writing about the exhibition (with the notable exception of a few sources authored by Russian travelers), was borrowed from the foreign press, and the journalists openly admitted it. The feuilletonist for *The St. Petersburg News* revealed, for example, that for his accounts of the Great Exhibition, he selected for his readership the best news from "thousands" of foreign journals.[90] Bulgarin, for his part, derived all the news he deemed necessary from French feuilletonists.[91] Not infrequently, Russians learned about the Russian display in London from the *Daily News*, *Morning Post* and *Indépendance Belge*. It was as if Russia was looking at herself in the mirror of the foreign press.

Consequently, the same artifacts that the foreign press selected to describe the Russian department appeared throughout Russian newspapers as well: the silver and bronze candelabra, malachite doors, and jasper vases served as an advertisement of sorts for the department. As the most conspicuous and popular Russian objects in the Crystal Palace, they came to embody the idea of Russia "for show." And although the originality of the silver centerpiece and malachite mantelpiece was questioned at times by international judges, in the pages of Russian newspapers, these objects were described as material manifestations of a Russian tradition. Sazikov's name soon became synonymous with "Russian style": where the international jury praised craftsmanship, in the pages of the Russian newspaper *Moscow News*, Sazikov's work was qualified as an expression of "national taste, national form and style." It seems that in 1851, between official reports and popular feuilletons, contemporaries found in Sazikov's work a satisfactory answer to the challenge of national self-identification. And yet

the public discourse on Russian national style that spread precipitously after 1851 was also the beginning of a controversy. Koshelev, for one, considered Sazikov's artwork "heavy and artificial"; thus voices of dissent contested the discovery, even as many continued to celebrate this newly found idiom of national self-expression.[92]

The Russian School of Art at the International Exhibition, 1862

Eleven years after the 1851 Exhibition, Russia readied itself for another world's fair in London. The two crucial events in Russian history that had occurred between 1851 and 1862, the Crimean War and the emancipation of the serfs, informed the tone of the written commentary on the 1862 world's fair.[93] The journalist L. de-R. conveyed the feeling of a participatory zeal that defined the reform-era years and reflected on the arts as well: "For Russians, this exhibition is a purely public affair; out of support for the exhibition, out of love for their country, any evasion, due to ill will or laziness. etc., already composes a kind of civic sin."[94] Six hundred fifty-eight exhibitors were apparently enlisted to participate, as one contemporary account reported.[95] This time, the Russian commission adopted a conscious strategy of representing its country in distinctly national terms.[96] Russian reportage from the 1862 world's fair likewise took a national turn.

Although more Russians were able to journey to London in 1862 than in 1851 due to the lifted ban on foreign travel and reduced passport fees, for a majority, reading remained their main form of travel. Correspondents and columnists were instrumental in articulating opinion because, as one anonymous commentator explained, "in the mass of our reading public there is still so much childish respect for everything printed, so much sweet faith in the printed word."[97] Next to feuilletonists, art critics and writers also published their thoughts in the mass-circulation press.

Despite a conscious effort to correct the mistakes of 1851, the exhibits' deficiency in national character and the general inadequacy of the display remained pressing concerns for the majority of commentators. *The Northern Bee*'s Second London Correspondent observed, for instance, that all the particularly precious objects that Russia had put on display in the main aisle had turned out to have as little "Russian nationality" about them as the French displays.[98] What then distinguished the Russian department? The Second London Correspondent answered as follows: "Earlier, Russian visitors had

a hard time finding what they call *our* things. No task can be easier now. *Your* things are where all the boards are, arranged in the most inconvenient and dangerous manner for the visitors."[99] The only distinguishing feature of the Russian department, it would seem, was a sense of chaos in which even genuinely unusual things got lost. A lack of labels in English, which the Second London Correspondent was rightfully concerned about, did not help the display either.[100]

More thoughtful commentators tried to look beyond the surface. Poletika, for instance, found the Russian department generally acceptable; what was *not* acceptable was precisely the Russians' inability to *display* objects to their advantage. Thus Pavel Obukhov's celebrated cannon, instead of being showcased like the famous Koh-i-Noor diamond, was shoved under a table; an exquisite brocade was cut into tiny pieces and placed awkwardly in a dark cupboard. It was the "appearance" (*naruzhnost'*) of the Russian department more than its content that was shabby, insisted Poletika. Had the manufacturers sent more items and had the organizers displayed them more decorously, the Russian department would have attracted more positive commentary in the press.[101] Stasov, too, wrote with exasperation that, like barbarians who do not know the value of their riches, the Russians had left the most interesting artifacts, including the "famous" cannon, lying about on the floor. What a difference from the conscious pride with which the English took care to arrange their department![102] As it was, the Russian department appeared "strange": its overall progress, as many critics observed, was "neither better nor worse" than in 1851. But the principal gain derived from the 1862 exhibition was the discovery of the Russian school of art. Although Russian art was for the most part disregarded in London, the exhibition commentators at home took up the subject with a renewed sense of hope.

National art had become a measure of identity in London. "The best Art is that which best represents the mind of the race, and we may read ourselves as a nation in the independence and vigorous individuality of our artists." In this way British critic and poet Francis Turner Palgrave proudly set out to celebrate the English school of painting at the International Exhibition of 1862.[103] The author of the official *Handbook to the Fine Art Collections* did not have much to say about the foreign exhibitions of art and nothing at all about the Russian display. For Russians, however, this silence was pregnant with an overdue opportunity to debate the meaning—and the very existence—of a new phenomenon called "the Russian school of art." Stasov compared Russia's debut on the international artistic scene to a young lady's

first ball: a much-expected opportunity to impress society with her beauty and dignity. But the Russian lady that appeared in London looked more like a poor "birdie with broken wings and twisted legs."[104]

The organizers of the 1862 International Exhibition recognized the rich potential of art to confer status upon the national departments. Unlike industry and science, the fine arts at the exhibition did not attract big crowds, but they did stimulate considerable commentary on the role of art in framing a national profile.[105] "Of all the displays at the 1862 exhibition, the fine arts galleries most blatantly reinforced nationalism," writes Thomas Prasch. "The arrangements lent themselves to the display of national schools of art."[106] Art was no longer merely about aesthetics; it had become a battleground for politically charged opinions.

The International Exhibition of 1862 was pivotal for Russian art. As Stasov wrote in this regard, "For many other nations, the current exhibition has been of far less significance than for us. They have museums for their national art, they have books and essays about it." Russians, however, had neither a national museum, nor a school of art to call their own at the time. "It required such an extraordinary occasion as an international exhibition," the critic continued, for Russians to "lazily" begin conceiving of their creativity in terms of a national school.[107] The periodical press emphasized the importance of this display "in front of everyone" (pered vsemi), for what was at stake was more than just the prestige of individual artists—it was the fate of the entire Russian tradition in painting.[108] How should Russians introduce their art to Europe? How could they persuade critics of their art's originality (samobytnost')? Which works of art should travel to London for this purpose? How to adequately display "the pride and glory of national art"? These are some of the questions that journalists brought to the attention of the reading public both during and after the exhibition.[109] These questions were legitimate; as one writer accurately surmised, foreigners did not know Russian art at all; even if they had chanced to visit the Hermitage, they would have seen mostly European art. Thus drawing on their understanding of Russia as a barbaric country, foreigners "assumed us to be barbarians in the matter of art as well." The International Exhibition offered a unique opportunity to correct this assumption.[110]

And yet the organizers of the Russian department failed to select a representative collection. The philologist Fedor Buslaev thought, for instance, that Russia could have improved its chances at the world's fair by sending some celebrated works, such as Karl Briullov's *The Last Day of Pompeii* (*Poslednii*

den' Pompei).[111] Stasov was disappointed that the Millennium Monument was not represented at the exhibition, even in the form of a small model: "why hide and conceal precisely what is destined to testify about our own age for all the centuries in the future (*vsem budushchim stoletiiam*)?"[112] Stasov also criticized Russian private collectors who refused to contribute to this national project, recording their typical reaction: "I shall never send a single picture from my collection to the exhibition! ... Let the English first rebuild our Sevastopol!" As with manufactured goods, in the sphere of fine arts, the Russian public refused to join forces in what should have been a collective task of representing its homeland abroad. In the end, Russia dispatched to London fewer than fifty paintings, almost no sculptures, and nothing in the way of architecture.[113]

Despite the unfavorable reviews that predictably followed, the domestic periodical press used the London exhibition to stimulate popular interest in Russian art and to launch debates on related topics. In the wake of the International Exhibition, the monthly art album that specialized in reproductions of Russian paintings, *Northern Lights* (*Severnoe siianie*), published a historical overview of Russian art over the past century.[114] Two years later, in celebration of the Academy of Fine Arts' centenary, journalists and art critics would resume this project of historicizing Russian art in full force. The London exhibition challenged the Russian public to think specifically about Russian fine arts, a novel occupation in itself, since there was no tradition of reading and writing about art in Russia, as the author and art historian Dmitry Grigorovich observed in 1863.[115] International exhibitions made this lack only more visible. At the same time, individual authors and journalists contributed steadily to what would evolve by the century's end into a public discourse on the Russian arts.[116]

If acquainting the Russian reading public with the history of its own art was one strategy that the press used to stir up national feeling, another consisted in reprinting scathing reviews of Russian art from the foreign press. The verdict that foreign observers passed on Russian paintings can be summarized in one word: imitative. Such was the opinion of the London *Times*, and the Russian weekly newspaper published by Katkov *The Contemporary Chronicle* (*Sovremennaia letopis'*) repeated the claim in its pages.[117] The *Art-Journal* evaluation was not much different:

> Russia became at length an emporium of imported Arts and manufactures; and thus she adopted and copied in her new capital of St. Petersburg the

civilisation [sic] and even the architecture and painting of modern Europe.

The result is now before us in the picture galleries of the International Exhibition. As might have been anticipated, for originality we find imitation, and instead of the unity of a national and historic style, we have a discord, in which all the schools of Europe take common part.

The Art-Journal concluded on the "hopeful" note that a genuine Russian art "from out her midst must yet arise"—art that would be "consonant to her zone, her people, and her faith."[118] The hope that *The Times* saw in the Russian department was similarly rooted in characteristically Russian subjects. Thus the reviewer praised Alexei Venetsianov's *A Peasant-Girl Receiving the Holy Communion* as one of the earliest and best paintings representing real Russian life. Nikolai Sverchkov's *A Village Wedding-Train*, depicting a merry bride flying across a frozen lake in a heavy sleigh (*kibitka*), and Valery Iakobi's *The Lemon-Seller*, also received praise as original works of art. This was in contrast to academic-style canvases, such as Fedor Bruni's *Jesus Christ at Gethsemane*, or Timofei Neff's *La Cucumella nelle Grotte*, which appeared as "alien plants cultivated for the pleasure of persons from high society and at their expense, like flowers and fruit in hothouses."[119]

Among Russian critics of the exhibition, opinions differed greatly. Some assumed a defensive position, arguing that a unique national school of art really did exist in Russia, despite all evidence to the contrary.[120] Others denied any individuality to Russian art at all. Grigorovich, for instance, wrote: "The Russian school still does not have an original (*samobytnyi*) character of its own; it imitates now Italy, now France, now Belgium."[121] Buslaev referred to the Russian school of art only in combination with the qualifier "so-called."[122] In a more categorical manner, the Second London Correspondent declared that Russian art was so indistinct that he had to confirm whether he had actually visited the Russian department.[123] In response to this provocation, *The St. Petersburg Times* published an angry letter that exposed the special correspondent's absolute incompetence in judging art: if he could not distinguish Russian paintings from European engravings, how could he be qualified to question the existence of an independent school of art in Russia?[124]

But some of the most provocative statements in this public debate belonged to Stasov, a semiprofessional art critic whose writing in various organs of the periodical press would heavily influence the development of Russian art during the next several decades. "What kind of *our* art is it

in which everything is *foreign*?" asks Stasov. "At the universal exhibition it was not our art that made an impression, but our readiness to obediently echo any and all." "Endless imitation" was the only tradition that Russian art could claim as its own. In line with some of the more sanguine reviews in the foreign press, Stasov placed his hope on those among the recent paintings that addressed specifically Russian life and history. Russian artists should begin "painting from nature," to depict familiar, everyday Russian life. "Nationality" (*natsional'nost'*) was the only respectable road for Russian art: "it is high time for national consciousness to awaken and for us to begin doing things that are uniquely our own."[125] The paradox of Russian art was that it *had* to be "antinational" in order to exist in the first place, as Buslaev argued. Prior to the middle of the century, art remained essentially the prerogative of the privileged, thoroughly westernized classes, making its "enslavement to foreign influence stronger and more irresistible." The Academy likewise enforced a classical canon in the representation of biblical scenes, in Buslaev's opinion, leaving no room for any "national" elements.[126]

Authentic national art, the art of the "*new* Russian school," as Stasov referred to it, was not visible until the middle of the century. "No matter how painful and impossible it may seem, we must admit that real Russian art in post-Petrine Russia in fact appeared only around the 1850s."[127] The new Russian style in manufacture, first "discovered" at the Great Exhibition of 1851, and the new Russian school of art, born discursively in the wake of its 1862 successor, both belonged to a qualitatively new period of culture. This was the "national" (*natsional'nyi*) period in Russian art, which critics described using two key terms: "realism" and "nationality."[128]

ART AND SOCIETY

Gathering Culture, Writing Identity

Museums, monuments, exhibitions, and other public events provide rich material for the construction of cultural identity. During the nineteenth-century culture wars, museums came into focus as the quintessential institutions for the collection, preservation, and display of the national heritage. New exhibition facilities in imperial Russia were major accomplishments in their own right, but even before they emerged in situ, they existed discursively in the pages of newspapers, journals, and catalogues as well as in lecture halls and university auditoriums. Most importantly, they catalyzed conversations and debates: the museum became a discourse-generating institution. Whether expressly devoted to a recent display at the Academy of Fine Arts or to Russia's participation in the latest world's fair, newspaper reportage on cultural activities tended to transcend the realm of aesthetics and shift toward the many "complicated questions" of the day stirred by the Great Reforms. If the actual landmarks, such as the Historical Museum and the Russian Museum, did not materialize until close to the end of the century, public discourse on the visual arts made them consistently present in society from the early 1860s on. This is when visual culture became a matter of national concern.

The argument in this chapter follows several lines of inquiry. It starts with a discussion of the Russian national movement, in the course of which the question of cultural identity became paramount. Institutions of culture acquired an added value as markers of identity in this context. I proceed to outline the basic contours of the Russian museum age that followed in the footsteps of similar developments in Europe and that gave rise to such key institutions as the Tretiakov Gallery, the Historical Museum, and the Russian Museum. The discussion then turns to the popular press of the era; periodical

editions made all these new exhibitions and museums available to the general reader via an ever-growing number of reviews and sundry opinions. The peculiarity of the Russian scenario consisted in that the museum boom and the newspaper boom overlapped. In the second half of the nineteenth century, the novel phenomenon of public museum culture turned into daily news thanks to the explosion of writing in mass-circulation newspapers. Next I discuss a common feature of the periodical press that made the visual arts accessible to the reading majority: the newspaper feuilleton. This column was central to translating the less familiar language of the visual arts (painting, architecture, sculpture) for the literate. The last section of this chapter, "Russian Art as Controversy," explores different—and often disagreeable—forms of writing that contributed to a shared discourse in imperial society.

Defining Russia Culturally: The National Question and Its Representations

> The national question in Russia is not the question of existence,
> but of a *dignified existence.*
> —V. Solovyov[1]

The age of the Great Reforms heralded a new epoch of national self-consciousness, a certain "turn to nationality" (*povorot k natsional'nosti*), in the words of the Slavophile historian Ivan Beliaev. In January 1862, Beliaev argued in Ivan Aksakov's weekly newspaper *Day* (*Den'*) that Russian national consciousness (*soznanie narodnosti*), in gestation since Catherine II's coronation in 1762, had finally started to turn to conscious action.[2] Shortly thereafter, *Communal Word* (*Mirskoe slovo*), a bimonthly newspaper for the people, similarly announced the arrival of a new era of self-awareness (*samosoznanie*).[3] This national turn manifested itself in a number of forums; in the discussion that follows, I focus on expressions of cultural identity in the visual arts and in popular print. During the revolutionary 1860s, Russian society was contesting such familiar notions as Russian history, people, and statehood. The question of the day was, to quote historian Nikolai Kostomarov, "What are we (*chto my takoe*)?"[4]

The Great Reforms were one strategy aimed at answering this question. Cultural nationalism on popular and official levels was another. Culture was central to the nation-building processes in the age of modernity. "In modern societies the necessity of complex communication elevates the impor-

tance of 'culture', the manner in which people communicate in the broadest sense."[5] This was especially the case in tsarist Russia, where, for the duration of the nineteenth century and arguably beyond, culture remained the only outlet for the expression of national sentiments. Institutions of culture, such as museums, turned into nation-forming instruments when they became part of the "discourse of the nation," defined by Ronald Grigor Suny as the "cluster of ideas and understandings that have come to surround the signifier 'nation' in modern times."[6]

The crisis of self-representation that Russia suffered at the first international exhibition in 1851 was augmented by its defeat in the Crimean War (1853–56). The Crimean fiasco revealed that even Russia's traditional image as a competitive military power was no longer sustainable:

> If its army was so weak, then on what other basis could Russia claim to be a European great power? The question became even more urgent and difficult to answer over the next twenty years, as it became apparent that the successful players in the European balance of power were nation-states with strong industrial bases. Russia, as a multinational empire with a backward economy, was doubly vulnerable.[7]

It is worth emphasizing that Russia was not a national state of Russians; politically, it had been and remained a multinational dynastic empire. In fact, Geoffrey Hosking posits that in Russia, "the building of an empire impeded the formation of a nation."[8] The representation of the nation, however, was taking place on a daily basis in the press, where an *imagined* national community was fashioned and publicized. In the imperial period, it was mainly in the sphere of culture that the Russian idea—meaning essentially "an idealized self-image of the nation, the *acceptable* part of the national culture; the heritage, true or imaginary, of which the nation is proud, which is to be emulated"—took shape.[9]

The question of Russian national identity has been thoroughly researched by several prominent scholars.[10] What follows is a brief outline of the Russian nation-building scenario, which provides a necessary context for the discussion on artistic representations of identity and their interpretations by various social groups. Russian national consciousness emerged among the elite in the eighteenth century first as a reaction to increased Western influences in post-Petrine Russia, then as a response to the ideas of Enlightenment and Romanticism. Typical for this early stage in the national movement was the educated

minority's increased interest in Russian language, folklore, history, and literature. During the Patriotic War of 1812, ethnic nationalism briefly joined forces with imperial patriotism, only to part ways during the next decade in the aftermath of the Decembrists' uprising of 1825. In 1833, national identity became part of the official ideology, "autocracy, Orthodoxy, nationality (*narodnost'*)," as authored by Nicholas I's minister of education, Sergei Uvarov.[11] This formal tribute to the modern idea of the nation came under attack by the early Westernizers and Slavophiles; their differences notwithstanding, the intelligentsia of the 1840s considered ways to integrate the Russian peasantry into the nation and to abolish serfdom.[12] Belinsky was among the first to open the public discourse, when in 1841, he contrasted two Russian terms used to express the idea of the nation: *narodnost'* (a native Russian word, the one used in Uvarov's doctrine) and *natsional'nost'* (a borrowed French term). Belinsky called attention to the wide gap separating these two notions: the people (*narod*), according to him, implies the lower strata of the state, whereas nation (*natsiia*) represents a sum total of all layers of society.[13]

A major impetus for awakening a Russian national movement arose from external stimuli, in the absence of which the question of nationality tended to be obscured by more urgent social and political concerns. As Hans Rogger noted, "In order not to feel inferior before the products and representatives of European culture, articulate Russians were forced to develop for themselves a national self in which they could take pride and with which they could identify."[14] To affirm its own uniqueness, Russian culture posited itself explicitly against other traditions, as we have observed in the context of international exhibitions. In the West, the revolution of 1848, which became known as the Springtime of the Peoples, aroused national movements among the Czechs, Croats, Romanians, Slovenes, and Ukrainians. The national unification of Italy followed in 1861; Hungary became virtually independent as a result of the Austro-Hungarian Compromise of 1867; in 1871, the German nation-building project was finally completed with the establishment of the Second German Reich.[15] Closer to home, the Polish insurrection of 1863 shook the foundations of the Russian empire and escalated the Russian national movement.[16] The inception of jingoism (*kvasnoi patriotizm*), a period of self-adoration and self-praise in Russian society, dates to this time period as well. In short, nineteenth-century national movements worked like a "mine" planted into the bedrock of the multinational Russian empire.[17]

If in the 1840s intellectuals were "thinking nations into existence," as

Suny describes the spirit of Romantic nationalism, by the 1860s, national consciousness found its way into broader social circles.[18] Within the expanded ranks of civil society, debates on the nationality question grew in scope and importance. The system of cultural communication expanded rapidly in reform-era Russia with the appearance of *raznochintsy*, the non-noble intelligentsia. Growing literacy among new sectors of the population made something approaching a nationwide discussion possible for the general public, including government employees, women, merchants, clerks, *kustari*, servants, workers, peasants, and artisans.[19] The turning point in the history of the Russian national movement, as contemporaries saw it, was the emancipation of the serfs in 1861. Russian publicist and critic Nikolai Shelgunov pointed out that this pivotal event signaled the end of the "Romantic period" in Russian thought. According to Vladimir Sollogub, the author known for his society tales, prior to 1861, there was no such thing as the Russian people, but only a "big herd" of slaves. In his novel *Demons*, Dostoevsky likewise dates the period when society began talking about nationality and "public opinion" to the years immediately following 1861.[20] Yet it was also from the early 1860s on that increasing revolutionary activity began overshadowing other social developments and impeded the already chaotic course of Russia's nationalization. The Russian predicament, according to Martin Malia, consisted in that "a society barely emerging from serfdom, and with no legal political activity, lived after 1861 under the threat of a permanent revolutionary movement."[21] Consequently, the culturally oriented stage of the nation-building scenario remained central in Russia. In the realm of culture, different groups in Russian civil society—from the populists (*narodniki*) and liberal democrats, to the extreme nationalists and Pan-Slavists—authored versions of cultural identity in a common pursuit of a usable national self-definition.[22]

Not that Russian national identity was nonexistent prior to the turbulent 1860s; Russianness was in fact omnipresent, but it was "invisible." It was a "zero-value," a norm against which other people within the empire were defined.[23] Monuments, museums, and exhibitions, as well as material objects that they displayed, helped represent the abstract fatherland and make it evident.[24] In private collections, these images were available only to a select few; with the advent of the public exposition, they became accessible, at least in theory, to much broader audiences. Public displays made the idea of the nation visible, as a work of art and as a community of the museumgoing public.

The Museum Age in Russia

Museums are one of the most powerful means to
attain national consciousness.
—*The Voice*[25]

The period between 1851 and 1900 was Russia's museum age, which saw the unprecedented growth of public exhibitions and shaped, to a great extent, the world of Russian museums as we know it today. The museum age became possible in reform-era Russia in the context of the rising circulation of texts and images, improved education and literacy levels, and the popularization and secularization of culture. The gathering and interpretation of national heritage was the main project of the Russian museum age, with far-reaching results. One such result was the success that the Russian Department enjoyed during the world's fairs in Paris (1900) and Glasgow (1901). The museum age also laid the groundwork for the triumphant reception of Diaghilev's Russian Seasons in Europe.

Museums through a Historical Perspective

By definition, a museum age is a Pan-European phenomenon typically associated with the opening of royal collections to the public and the subsequent establishment of national institutions.[26] In Western Europe, the modern museum evolved at the end of the eighteenth century. Among the first royal collections to open to the public were the art museums of Dresden (1760s) and Munich (1779). In 1789, the Medici collection followed suit, as did the imperial museum in Vienna three years later. In 1793, the Louvre was established as a national gallery; in 1808, the Rijksmuseum; and the next year, the Museo del Prado. Somewhat later, in 1838, the National Gallery in London opened its doors to visitors; the national museum of Bavarian art, Bayerisches Nationalmuseum, was founded in 1854.[27] By the middle of the nineteenth century, the modern museum had become a familiar "fixture of a well-furnished state" in its double capacity as an institution of culture and a symbol of nationhood.[28] Among the royal galleries, the Imperial Hermitage in 1865 was the last major European collection to admit the general public.

The history of Russian museums begins with the first public institution, a chamber of curiosities called the Kunstkamera, founded in 1719 by Peter the Great, who was intent on transplanting his fascination with European

cabinets of wonder onto Russian soil. Although the first Muscovite collections of rarities can be traced to the end of the sixteenth century, it was with the establishment of the Kunstkamera as a public museum that private royal possessions became accessible to the public for the first time. The Kunstkamera museum was explicitly modeled on European collections of rarities and curiosities. During his first stay in Amsterdam in 1697, Peter visited the well-known museum of Jacob de Wilde, celebrated for its antique coins, pagan idols, ancient statues, and gems. Peter's acquisitions of Dutch collections such as the remarkable specimens prepared by Frederik Ruysch, a pioneer in anatomical preservation, and Albert Seba's assortment of bottled animals, fish, snakes and insects were followed by the tsar's famed edict of February 13, 1718, decreeing that everything antique and unique—living or dead, animal or mineral, natural or artificial—should be gathered for display in the Kunstkamera. Archaeological expeditions delivered ancient coins, manuscripts, and relics of extinct belief systems to the Kunstkamera, but the collection of curious items also embraced such abominations as eight-legged and two-mouthed lambs, deformed calves, Siamese twins, and two-headed babies preserved in formalin. Moreover, the first Russian public museum employed young men with various deformities who served in the Kunstkamera during the first decades of its existence and were exhibited to visitors, along with the more traditional stuffed, boxed, and bottled samples. Peter, not known for his squeamishness, would shock guests while giving tours of the museum by shaking hands with his pet monster Foma Ignatiev.[29] Not only genuinely "found" objects and people, but also relics of the grotesque imagination, found their way into Peter the Great's Kunstkamera. In the catalogue of items delivered to the museum from the provinces in 1725, for instance, we encounter such implausible entries as "a baby with a fish-tail" or "two dogs born to a sixty-year-old maiden."[30] Peter's cultural initiative, modeled on European chambers of curiosities, was received by a handful of Russian visitors with reservation, however, despite refreshments and other incentives offered on behalf of the tsar. While nominally accessible to visitors, the Kunstkamera remained an island, indeed a curiosity, of a foreign civilization in Russia throughout the eighteenth century.[31]

In 1764, Russian empress Catherine the Great founded the Hermitage Museum with the goal of establishing a collection in Russia that would rival the older and more prestigious museums of Western Europe. In some two decades after she seized power, she had gathered a massive repository of several thousand paintings of European masters, routinely described by

contemporaries in superlative terms.[32] Johann Gottlieb Georgi, a German geographer and professor of chemistry, for instance, portrayed the collection in 1794 as "one of the most advantageous (*preimushchestvenneishii*) galleries of Europe, in view of its ever so graceful (*naiiziashchneishii*) works by glorious masters from all schools, its exquisitely beautiful and rare precious paintings, and in view of their being so very numerous as well."[33] The museum depicted the Russian cultural scene very favorably; however, by displaying foreign rather than Russian art, Catherine's fabulous collection represented Russia not as it was, but as it was envisioned by its enlightened empress: this was Russia as part of Europe, sharing in the latter's cultural capital.

It was not until the middle of the nineteenth century that public museums became not just a curiosity, but an established fact of Russian culture. The origins of the Russian museum age can be traced back to London, where in 1851 the first international exhibition, housed in the marvelous Crystal Palace, took place, and where Russia's disappointing self-representation attracted much attention. That the Russian museum age should begin in Britain is symptomatic of the overall orientation of the Russian quest for viable self-identification. Ever since Peter the Great thrust open a window onto Europe, the Western point of view has been invariably present in discourses on Russian cultural identity. The 1851 "face-to-face" encounter with Europe in the Crystal Palace, where Russians were challenged to devise a distinct style of self-representation, provided an external stimulus to the process of secular culture-building underway in Russia.

The reform-era museum boom that ensued capitalized on a new type of display: the public exhibition.[34] In the earlier part of the century, only a few institutions of visual culture functioned regularly, even in the capital city of St. Petersburg: the Kunstkamera had virtually dissolved by 1836; the Hermitage remained officially closed to the general public until midcentury; the Rumiantsev Museum led a miserable existence in the city until it eventually moved to Moscow; and the Academy of Fine Arts opened its doors to visitors only once every three years during its infrequent exhibitions. Limited access prevented several private collections from contributing significantly to the art scene, among them Alexander Stroganov's picture gallery, which solely admitted connoisseurs and Academy students, and Nikolai Iusupov's collection of European art, which remained closed to the public until the October Revolution of 1917.[35] In 1860, for instance, all that St. Petersburg had to offer in the sphere of secular public culture was the small permanent exhibition of the Society for the Advancement of Artists, a public library,

and a botanical garden.[36] Access to museums and exhibitions was likewise a major concern. As one journalist writing for *The St. Petersburg News* observed in 1849: "In Petersburg, we have a few private galleries and cabinets of rarities, but they are accessible only to a narrow circle of a select few, and the public has heard about them only from rumors."[37] Ten years later, the same newspaper published a more urgent appeal for readily available galleries, museums, libraries, and botanical and zoological gardens: "Where one interested in such institutions must ask for entrance tickets five times, where only certain days of certain months are designated for public admission, and where visitors must even comply with a certain dress code, such institutions cannot be considered national and can only function as ornamental decorations of a city or a state, as objects of useless luxury." Compared to Paris and London, the author openly lamented, St. Petersburg lagged far behind.[38]

Against this sparse cultural background, the eruption of public activity that took place in the following decades was extraordinary. New exhibitions and galleries opened in quick succession: in 1858, the Kremlin Armory offered limited access to the public; in 1859, the Museum of Agriculture opened in St. Petersburg; beginning in 1860, the Academy of Fine Arts organized regular annual exhibitions; in the next three years, the private art gallery of the Moscow merchant Vasily Kokorev and the Kushelev picture gallery in the Russian capital became accessible to the general public as well. The Moscow Public and Rumiantsev Museum (*Moskovskii publichnyi i Rumiantsevskii muzeum*), the first public museum to be designated as such, opened in 1862; that same year, Russia participated in the second world's fair in London. Moscow's Ethnographic Exhibition took place in 1867; five years later, the Polytechnical Exhibition opened, and the Historical Museum was founded, both in Moscow. These institutions, along with the Tretiakov Gallery, the Museum of Decorative and Applied Arts, the Russian Museum, and the Suvorov Museum, were among the major achievements of the museum age. By the end of the century, 45 new museums of general interest had appeared throughout the Russian empire. Overall, 80 different museums were founded in the 1870s–90s (many in the provinces), while the number of exhibitions organized between 1843 and 1887 is estimated at 580.[39]

Numbers in themselves may be impressive, but what made the museum age truly remarkable in Russia was the public's enthusiastic response to this novel phenomenon. The Moscow museum boom was conspicuous above all. Moscow's cultural renaissance began in 1862 with the transfer of the Rumiantsev Museum from St. Petersburg, following which a number of educational and

recreational institutions sprang up in quick succession in the old capital. The museum scene in Moscow previously paled in comparison with St. Petersburg. For instance, in 1843, the city's patriot Khomiakov wrote emphatically: "Moscow is so far removed from any artistic movement, so poor in works of art."[40] The change in Moscow's cultural landscape in the 1860s was so radical that one witness described it succinctly as "museum mania" (*muzeomaniia*), defined as an unruly passion that drove the city to establish more and more museums.[41] Another Muscovite thought that Moscow's wonderful museums warranted a new proverb, which he publicized in *The St. Petersburg News*: "There is no place like home, except for a museum." Other daily editions in the northern capital provided regular updates on the state of Moscow's public culture, which was becoming increasingly relevant to the country as a whole. A growing network of institutions of culture spread from Moscow to the provinces as well.[42]

The museum age was one positive landmark on Russia's uncertain road to modernity. Many features contributed to the conspicuous explosion of museum culture in the last third of the nineteenth century, including the growing professionalization of the art world and the expansion of the art market in imperial Russia. Among others, the promotion of art criticism into the mainstream of public debates took place, as well as the advancement of basic education in aesthetics. Public museums played an important role in the perceived transfer of Russian cultural capital from St. Petersburg to Moscow and the general shift of cultural initiative from the state to society. Voluntary associations became an active force in organizing and popularizing institutions of visual display.[43] Society's engagement in the arts likewise manifested itself in a new system of patronage advanced by the wealthy members of the third estate, to which we owe great museums like the Tretiakov Gallery and Abramtsevo.[44] Reading and writing about these new sites of culture was a form of participation, too. Without a written accompaniment to the material objects on display, museums would never be able to reach a broader public. Popular discourse both precipitated and followed institutions of visual display, interpreting them for the general reader. In the following section I look closely at the writing that took place beyond the museum walls.

Museums and Texts

Museums serve to preserve a collective memory, display artifacts, fashion a national image, and provide a forum for education and debate.[45] The tradi-

tional role of the museum is that of a defense mechanism of culture.[46] Conceptually, the museum has also come to serve as an "institution of power" that articulates identity and promotes "attachment to the state and nation."[47] Cultural representations on display are tied to politics; as Benedict Anderson suggests, "museums, and the museumizing imagination, are both profoundly political."[48] Art and citizenship meet in the modern exhibition space, for along with artwork, the museum puts on display the very spirit of a national culture.[49]

Historically, the Louvre was one of the first institutions to serve the purpose of cultural unification when in 1793 this former royal palace became a public museum, "dedicated to transforming collected material goods into a collective spirit of citizenship that culturally reified the new nation."[50] This transformation affected both the nature of the exhibition space and the profile of its visitors. Unlike the exclusive princely collections of the premodern era, the public museum, as it began evolving in eighteenth-century Europe, offered a common space, theoretically open to all.[51] As a public collection, the Louvre gained the symbolic power to formulate the idea of the nation for the populace at large. The museum was also critical for forming the museumgoer, as Sharon J. Macdonald explains: "This was a moment for 'culturing' the public: for bringing 'culture', in the sense of 'high culture', to the masses and, more importantly, for attempting to constitute a public. That is, it was also a symbolic attempt to generate a 'public'—a self-identifying collectivity in which members would have equal rights, a sense of loyalty to one another, and freedom from previous tyrannies and exclusions."[52] In this scenario, the museum figures as both a power-wielding and a public-making institution.

Other critics have challenged this special authority of the museum and questioned the faithfulness of symbolic representations within. Like the avant-garde artists before them, some modern scholars have pronounced the museum a failure, a "discredited institution" unable to represent "anything coherent at all." Jim McGuigan practically equates representation in museums with "bias." Eugenio Donato argues that "representation within the concept of the museum is intrinsically impossible. The museum can only display objects metonymically at least twice removed from that which they are originally supposed to represent or signify."[53] Earlier critics of culture were likewise skeptical about the museum. Writing in 1937, Walter Benjamin criticized the public museum—a space where we "see the past in its splendid festive gown and rarely encounter it in its most shabby working clothes"—for its fragmentary and discriminatory representation of history.[54] The museum is a profoundly dialectical institution: on the one hand,

it rescues the past, and on the other, it rewrites that past. In a similar fashion, Theodor Adorno famously compared the museum with the mausoleum as "the bearer of a death symbolism."[55] As we have seen, this association with death, stasis, and the end of culture was common for Russian thinkers around turn of the century as well.

An instrument of power on the one hand, and a biased and discredited institution on the other—these irreconcilable opposites (and the range of meanings between them) point to the centrality of representational practices at work in the public museum. Representation is a "partial truth" pervaded by "literary procedures"; it is always a compromise, a construct, a fiction.[56] In James Clifford's opinion, "[t]he *making* of meaning in museum classification and display is mystified as adequate *representation*."[57] More than merely reflecting a social reality, representation creates and manages it within specific contexts.[58] The making of cultural identity that takes place in the public museum is not a "pure" representation either. Stuart Hall notes: "Precisely because identities are constructed within, not outside, discourse, we need to understand them as produced in specific historical and institutional sites within specific discursive formations and practices, by specific enunciative strategies."[59]

While exhibitions and museums proper see to material objects, the discourse constructed around them deals with the representation of these objective realities in light of national ideologies and public opinion. Distanced from the objects they represent in time and space, these rhetorical constructs are highly malleable, hence the constant fluctuation in meaning of otherwise "permanent" institutions of culture: while the building and content of museums may often go untouched for generations, the role that they play in society modulates over time. Texts are key to assessing this role.

A museum display depends on narratives—stories told by labels, guidebooks, tourists, or reporters. The written text accompanying a display of material objects functions as a translator, or a guide, someone who bridges the distance between artifact and viewer. In the late nineteenth century, the importance of writing was already appreciated by American ichthyologist and museum administrator George Brown Goode, who authored a famous dictum that radically reversed the priority of things and texts in the museum: "*An efficient educational museum may be described as a collection of instructive labels, each illustrated by a well-selected specimen.*"[60] This assertion literally converts the museum as a collection of material objects into a written text. Recently, exposition as writing has become a familiar trope

in cultural criticism. Mieke Bal, for instance, argues that the language of the museum belongs in the tradition of the nineteenth-century novel. Both the realist novel and the museum are text-based encyclopedic projects that digest the multiplicity of experience into a synchronous linear narrative. For Bal, the museum is essentially a discourse.[61] But the agent of museum discourse is not only "the museum" (as an institution, a public space, or a temple of art); it is the public exchange around it (lectures, guidebooks, tours, reviews, advertisement) that endows it with a "voice."

Writing helped connect generations of Russian speakers across the country with national treasures. All forms of writing inspired by the culture of display were "participants" in this identity-building project. In the pages of newspapers in particular, stories about museums reached broad audiences; popular periodicals also offered necessary guidance and even ready-made opinions for a general readership that was otherwise lacking in museum-going experience.[62] If the goal of the public museum is to make national riches available to all, the newspaper helps frame the museum's contents in popular terms, and thus renders it more accessible for the novices. Within the new set of social relations implied by public display, the museum came to both serve the national community and, at the same time, to *mold* it by rendering the visitor a participating citizen.[63]

The discussions of various public expositions in the popular press are indicative of this participatory spirit. In September 1861, for instance, the daily military, political, and literary newspaper *The Russian Veteran* (*Russkii invalid*) published a lengthy article outlining the many benefits of this new medium.[64] Another article, titled "The Importance and Use of Exhibitions" (*Vazhnost' i pol'za vystavok*), appeared the following year. Here exhibitions were described as the best and the most convenient means for familiarizing society with the products of different branches of the nation's economy.[65] In the pages of newspapers, public exhibitions were becoming valuable and familiar institutions of visual culture, the property of common knowledge and popular curiosity. As one journalist expressed it, "After politics, exhibitions play the most important role these days."[66]

The one aspect that journalists were often eager to underscore was the inherent Russianness of many of these displays. To what extent were museums and exhibitions that sprang up in the second half of the nineteenth century in fact uniquely Russian, as many contemporaries claimed? Historically, the museum age in Russia was certainly a part of a broader European movement. On the level of discourse, however, the momentous encounter

between art and society during the era of the Great Reforms conveyed a lasting aura of national distinction that surrounds Russian museums to this day. What distinguished the Russian scenario was not so much the museums as their message.

National Collections

Contemporary museums helped assemble Russian cultural identity by displaying all things native: art, history, applied science, ethnography, folk arts and crafts, and military history. Museums were only the most obvious sites for this undertaking. The mid-nineteenth-century national turn in the arts affected the entire field of cultural production. Culture-building was taking place everywhere: in concert halls and on stage, in libraries and schools, in textbooks and collections of legends and songs. Two novel developments—the distinctly national orientation of cultural offerings and their explicitly public nature—were the common denominators of otherwise discrete forms and genres. Let us briefly consider a larger context of the museum age.

The predicament faced by the defenders of the Russian national tradition was to collect sufficient evidence of that tradition's very existence. Many editions of folk songs and tales, as well as established galleries, museums, and collections could provide such evidence. Paradoxically, the most obvious manifestation of Russian distinction in the arts—the traditional icon—was not on the radar of contemporaries, for it was not until the turn of the century that the icon's status changed from a religious artifact to a work of art. Only in the early twentieth century, when cleaned and restored icons found their way to museums and exhibitions, did this manifestation of a brilliant national heritage suddenly become apparent to the general public. The present discussion of secular culture does not dwell on the religious dimension for this reason. Meanwhile, during the second half of the nineteenth century, new expressions of cultural identity, deemed uniquely Russian, appeared as well: social realism in painting, the neo-Russian style in architecture, the revival of folk arts and crafts, the Ballets Russes—no matter how different these trends were, they all shared the epithet "national." At the same time, the counter-discourse did not tire of undermining these claims to originality, fueling broad-ranging debates in printed texts and public spaces.

Initial culture-gathering efforts date back to the earlier decades of the nineteenth century, when scholars and amateurs alike began collecting folk-

lore in the spirit of Romantic nationalism. Ethnographer Petr Kireevsky had already gathered one of the first major collections of folk songs in the 1830s. During the reform-era years, a plethora of titles related to folklore appeared in quick succession. The first edition of *Russian Folk Legends* (*Narodnye russkie legendy*) compiled by Alexander Afanas'ev, came out in 1859; eight volumes of his *Russian Folk Tales* (*Narodnye russkie skazki*) were published between 1855 and 1863. In 1861–62, *Proverbs of the Russian People* (*Poslovitsy russkogo naroda*), collected by Vladimir Dal', the author of the well-known Russian language dictionary, appeared. The publication of traditional *Songs* (*Pesni*), gathered by Pavel Rybnikov, dates to the same time period as well (1861–67). Later in the century, arts and crafts specialists at Abramtsevo and the visionaries of the Ballets Russes would draw on these collections in order to successfully represent Russian heritage at exhibitions and performances both at home and abroad.

Traditional *byliny*, oral Russian epic poems, also saw a most enthusiastic revival. While the first collection of *byliny* by Kirsha Danilov dates back to the middle of the eighteenth century, it was the rediscovery in the 1860s of this presumably obsolete form still flourishing in northern Russia that resulted in a flurry of publications. Among many others, *Onizhskie Byliny Recorded by A. F. Gil'ferding in the Summer of 1871* (*Onizhskie byliny, zapisannye A. F. Gil'ferdingom letom 1871 goda*) appeared in 1873. In 1894, a scholarly compilation of *Russian Byliny in Old and New Recordings* (*Russkie byliny staroi i novoi zapisi*) came out. The systematic search for *byliny* continued until World War I and was regularly accompanied by critical responses to these newly discovered primary sources.[67] Aside from fairy tales and *byliny*, a variety of other forms of folklore was anthologized as well: lyric songs, riddles, laments, etc.[68]

Folk motifs became part of "high" culture via print editions, stage productions, and exhibition venues. It was in this spirit that traditional peasant handicrafts entered the Russian public sphere as collectibles and desirable commodities in the last third of the nineteenth century. In art music as well, folk elements contributed to what critics identified and celebrated as a special "Russianness." Mikhail Glinka was the first to employ folk themes in his compositions, in particular in his patriotic opera *A Life for the Tsar* (1836) and an orchestral piece based entirely on folk music, *Kamarinskaya* (1848). In the second half of the nineteenth century, the Russian national tradition found full articulation in the works of "The Mighty Handful" (*moguchaia kuchka*), as Stasov nicknamed the Balakirev Circle's composers.[69]

Much as the newly articulated national tradition was celebrated, it did not go uncontested. Scholars have recently emphasized the degree to which the whole idea of a "New Russian Musical School" was essentially invented by contemporary critics, especially the indefatigable Stasov. Next to Stasov, arguably the main architect of musical nationalism, were his many opponents. The Russian tradition in music was created in the dialogue between the national camp, represented by the Balakirev Circle and Stasov, and a cosmopolitan group, which included the Russian Musical Society and Anton Rubinstein. Precisely what should compose the proverbial Russianness in music was the subject of vehement debates as frequently as the question of which musical camp rendered it more truthfully.[70] As one contemporary critic put it, "Journals of every persuasion served as conduits of sundry opinions in society and increased the number of followers (*priverzhentsy*) of musical 'ideas' beyond the concert hall and the theater stage."[71] The mechanism for the production of meaning was essentially the same as with works of literature and the visual arts, and depended less on authors and artists than on their critics. Recent studies by Richard Taruskin, Caryl Emerson, Francis Maes, and Marina Frolova-Walker helpfully identify the plurality of musical trends and invented traditions that coexisted in the imperial Russian public sphere.[72]

In theater, the rise of the national tradition is often associated with the realist drama of Ostrovsky, a phenomenon analogous to that of the Itinerants, with a similar focus on the mundane and the unsightly. Ivan Goncharov, for instance, explicitly credited the playwright with the creation of "our own Russian, national theater" (*svoi russkii, natsional'nyi teatr*).[73] Public theater was also a culture-building project in that it served to train neophytes. As Ostrovsky himself framed it, the acculturation of the new, inexperienced spectator (*svezhii zritel'*), whom he compared to a wild tree (*dichok*), begins precisely in the theater, during powerful, accessible performances.[74] Between the new national drama of Ostrovsky and the traditional popular theater, such as the Petrushka puppet shows, as well as their later adaptations into the high art of the Ballets Russes, the national theme in theater evolved in the second half of the nineteenth century into many forms and genres.[75] In Chapter 7 this fascination with folk motifs on stage is further discussed using the example of Ostrovsky's beautiful but eccentric production, *The Snow Maiden* (1873).

In short, society wanted to see evidence of a unique national tradition in various artistic forms and welcomed it readily, accepting or rejecting the

nominations made by critics and following their debates with zeal. Whether the subject was painting, music, literature, or theater, critics judged all arts based on the presence or absence of national characteristics, which were reassigned on a regular basis in the pages of the contemporary press. Nationality was obviously not the only standard by which cultural achievements were measured; critical perspectives informed by many other social issues alternately harmonized with and challenged the trajectory of discussions on cultural identity.

Representations of national culture gathered by the end of the century in books and periodical editions offered some answers, however provisional and incomplete, to the basic question of Russian identity. The resultant collection—modern national culture—was a compilation of rediscovered and invented traditions, arranged as if for a changing display subject to many shifts in curatorial tastes and ideological priorities. While the remainder of this manuscript deals with the *process* of writing culture, here I would like to highlight some of the results.

The canonical version of Russian national culture took shape by the end of the imperial period.[76] The articulate pantheon of founding figures that had evolved by then included the national poet Pushkin, the composer Glinka, the painter Briullov, the playwright Ostrovsky as the founder of the Russian theater, and the musician Andreev, who was credited as the "father of the balalaika" not for inventing the instrument but for making balalaika concerts a popular diversion in the 1880s. Now and then, alternate father figures were suggested in the course of public deliberations, including, among others, the artists Fedotov, Vasnetsov, and members of the Itinerants, the sculptor of the Millennium Monument Mikhail Mikeshin, and the self-nominated architect Vladimir Shervud, who designed the Historical Museum.[77]

Prior to critics proclaiming a crisis of national culture in the early twentieth century, several publications came out synthesizing the many aspects of the Russian tradition. *Russia at the End of the Nineteenth Century* (*Rossiia v kontse XIX veka*), prepared by Vladimir Kovalevsky and originally published in French in conjunction with the 1900 International Exhibition in Paris, is a noteworthy example of "autoethnography"; it was soon reprinted in Russian translation.[78] The survey of the visual arts by Benois, published as part of the volume, explicitly prioritizes nationality as the defining impetus in much of nineteenth-century cultural production.[79] Perhaps the best-known effort to articulate and survey the entire tradition, including its various material

and spiritual manifestations, is the three-volume *Outlines of Russian Culture* (*Ocherki po istorii russkoi kul'tury*) by Pavel Miliukov, historian and founder of the Constitutional Democratic party, which contained everything from geography and climate to religion and education. But before fragments of national culture were gathered in anthologies and permanent museums or rubricated in indexes, for much of the nineteenth century, the national tradition was dispersed among various periodical editions.[80] The following sections consider the daily press and focus on the widely read column, the feuilleton, which popularized Russian national culture even before it was articulated as such.

The Newspaper Boom of the 1860s

The age of the newspaper deserves special consideration, not only because the mass-circulation press changed the profile of the Russian public, but also because popular print editions helped create that public in the first place. This readership was no longer exclusively "polite society," which determined taste and opinion in the time of Pushkin and Gogol, and which William Mills Todd III has analyzed brilliantly.[81] Nor was it exclusively the intelligentsia that Belinsky had cultivated since the 1840s. The general public that appeared on the scene in the 1860s read newspapers voraciously and readily responded to topics of interest. The daily newspaper and especially the reader-friendly column, the feuilleton, precipitated the development of public culture in imperial Russia considerably.

During the era of the Great Reforms, the number of Russian-language newspapers increased almost fivefold.[82] The number of daily general-interest newspapers grew even faster. If prior to 1855 only three dailies were available anywhere in the empire, by 1870, Russia published 38 newspapers, more than half of which were concentrated in the capital cities of St. Petersburg and Moscow.[83] The prereform era was ruled by the so-called "thick journals" (*tolstye zhurnaly*)—monthly editions several hundred pages long, with sections given over to prose, poetry, reviews, social criticism, political news, as well as cultural happenings and everyday miscellanea. During the "glorious period of Russian civic consciousness" (*slavnyi period russkoi obshchestvennosti*), as historian of Russian journalism and censorship Mikhail Lemke described the new era that followed, the popular dailies superseded the venerable thick journals.[84] Minister of the Interior Petr Valuev officially

recognized the onset of the age of the newspaper as early as 1863, when he acknowledged that the newspaper dominated that year's periodical output.[85] Consequently, if the thick journal had been the primary medium of public opinion in the earlier part of the century, restricted for the most part to the intellectual elite, with the rise of the daily press in the 1860s, the public discourse in its more egalitarian form shifted to the newspaper, which came to serve as a barometer of civic awareness.[86] According to another contemporary, the newspaper became a pulpit from which the preacher-editor could guide the reading public on a daily basis.[87] Such guidance was apparently welcome, as the newspapers' readership increased proportionally to the number of publications available on the market. What made news such a desirable commodity?

Following the Crimean defeat in 1855, Russian society, "awakened as if from a lethargic sleep," recalls Shelgunov. In the years 1856–58, the explosion of the press was particularly prominent, with periodical editions of all kinds reaching an unprecedented 250.[88] "That after Sevastopol everyone woke up, everyone began thinking, everyone became possessed of a critical spirit, is the key to the enigma of the 1860s. *Everyone*—this is the secret of that time and the secret of the reforms' success."[89] For a country with a largely illiterate population, "everyone" is certainly a rhetorical overstatement, but one expressive of the precipitous rise of a public spirit that accompanied the reforms.[90] The newspaper, along with the novel, "provided the technical means for 're-presenting' the *kind* of imagined community that is the nation" and fostered a spirit of national renewal.[91] One journalist described the newly awakened Russian society as being "galvanized with a participatory zeal, eager to seek and find good results."[92] A large portion of the newspaper readership of the 1860s resided in urban centers, especially in St. Petersburg and Moscow, where literacy rates reached, in Hosking's estimation, 55–60 percent and 40 percent, respectively.[93] Against the background of urbanization, new technology, improved communication networks, and an increased life tempo, news delivered in monthly installments by thick journals was no longer adequate. The new reader, while less demanding of style and substance, required prompt and accessible information.

The newspaper satisfied this demand; it also reflected the interests of the new readership in its pages. Beginning with the first Russian periodical, *The News* (*Vedomosti*), which Peter the Great launched in 1702, the evolution of the daily press was closely linked to the emergence of a civic consciousness. To a great degree, the Russian public was another product of Peter's

reforms.[94] While during its first 25 years *The News* was the sole periodical publication in Russia, with a modest print run ranging from 30 to 4,000 copies, it did not sell out. Until the early nineteenth century, only two proto-newspapers were published in the Russian empire: *The St. Petersburg News* and *Moscow News*. Even the Russian word for newspaper, *gazeta*, did not exist yet; it appeared for the first time in 1809 in the title page of *The Northern Post, or The New St. Petersburg Newspaper* (*Severnaia pochta, ili Novaia Sankt-Peterburgskaia gazeta*).[95] Underlying the newspaper boom of the 1860s was a radically new type of journalism, made possible by innovative reporting and major socioeconomic changes.[96] With improved print technology and loosened censorship rules, it became possible to report the news without much delay. "The newspaper is closer to life than the journal," one feuilletonist announced.[97] Professional newspaper correspondents supplied reports from different parts of Russia and Europe in a regular and systematic fashion. The first special newspaper correspondent was dispatched to London in 1851 to cover the Great Exhibition. The founding of the Russian Telegraph Agency in 1866 further expedited the transmission of information.[98]

The 1865 Temporary Regulations did away with preliminary censorship for periodicals published in St. Petersburg and Moscow.[99] For the daily newspapers, this change was consequential. Effie Ambler explains:

> Contemporaneity, the essential characteristic of a daily newspaper, had been unobtainable under Nicholas I, when all printed material had to be submitted for censorship approval well in advance of publication and certain official periodicals enjoyed a monopoly on foreign and military news.... Following issuance of the Temporary Regulations of 1865, serious daily newspapers in the two capitals had to deliver copies to the censor no earlier than the hour at which the paper was placed in the mails for subscribers.[100]

The same regulation permitted the sale of individual issues on the street, helping establish the most direct route between the newspaper and the reader.[101] Street sales and private advertising strengthened the newspaper's position as a relatively independent organ of the press. As a result, argues Louise McReynolds, the newspaper publishers succeeded in establishing "a voice independent of that of the government."[102]

In 1863, this "voice" found embodiment in Kraevsky's appropriately titled newspaper *The Voice* (1863–84), the first independent, privately owned daily in Russia. Until then, Bulgarin's semiofficial *The Northern Bee* (1825–64)

alone represented a gray category between the official and the private press, the so-called *ofitsioz*, an organ "ostensibly independent but secretly backed by the government to unofficially present an official point of view."[103] *The Northern Bee* claimed to speak for the general reading public, and indeed it was read widely.[104] It was the only newspaper to enjoy the privilege of publishing political news, so that even those who disapproved of its "physiognomy" continued to read it.[105] But first and foremost, *The Northern Bee* made for light, entertaining reading. It engaged the reader in dialogue, to which the occasional rubric "Correspondence" ("*Korrespondentsiia*"), a prototype of a "Letters to the Editor" column, bears witness. In this respect, *The Northern Bee* can be seen as an initiator of public discussion, however limited and contrived. But the obvious limitations of *The Northern Bee* did not go unnoticed by contemporaries. The following assertion appeared in 1831 in Nikolai Polevoi's bimonthly journal *The Moscow Telegraph* (*Moskovskii telegraf*): "Without any doubt, *The Northern Bee* occupies the first place among all Russian newspapers.... As a source of information, *The Northern Bee* deserves the full gratitude of the public; but as an organ of opinions—it is shy, inattentive to its readers, and often entirely silent!"[106]

During the era of the Great Reforms, commercial publications increasingly became popular and profitable. *The Voice* pioneered this new journalistic trend in 1863. A decade later, the Russo-Turkish War of 1877–78 propelled Russian journalism into "the golden age of the newspaper press."[107] General-interest newspapers such as *The Voice* and *The New Time*, with their broad coverage of politics, economy, literature, etc., had essentially subsumed the functions of other media by the end of the century, replacing both the thick journal and the novel for many Russian readers.[108] A clear correlation between major political upheavals and the rise of public consciousness becomes apparent from the circulation data for popular newspapers. For instance, with the beginning of the Crimean War, the number of subscribers to *The Northern Bee* increased to ten thousand, while during the Polish uprising in 1863, the circulation of Katkov's nationalistic *Moscow News* skyrocketed to twelve thousand.[109]

That the daily press came to play a vital role in society is obvious from a number of contemporary articles devoted to the subject. In 1861, *The Russian War Veteran* published a feuilleton titled "An Ideal Petersburg Newspaper," in which the author contemplates the advantages of newspapers over journals. This "ideal" newspaper was merely a figment of the feuilletonist's imagination, however; at that time, one could only hypothesize what a pop-

ular newspaper would look like.[110] But already four years later, the urban newspaper *The Petersburg Sheet* (*Peterburgskii listok*) ran an extensive reportage on the nine daily periodicals available in the capital city: there were seven Russian-language editions, one newspaper in French, *Journal de St.-Petersbourg*, and one in German, *Petersburger Zeitung*.[111] Among the Russian-language dailies, each had its own individual character and a specific audience, but each also shared the common features of a mass-circulating press, such as emphasis on facticity and particular details, focus on the general public, and prioritization of themes connected with the national question.[112] New genres and rubrics appeared to accommodate these new themes. The lead article (*rukovodiashchaia*) was one unique feature of the daily press that evolved in the 1860s. Another was the newspaper feuilleton, which soon became the main forum for a dialogue between newspaper and reader. Cables from abroad helped diversify content and ultimately contributed to the newspaper's unique telegraphic style, while commercial advertising, aside from securing financial independence, introduced typographical variety to its text.[113]

In December 1900, as if summarizing the trend, the journalist and publisher Fedor Bulgakov wrote:

> Newspapers are now being read more than anything. The reading of newspapers has become a necessity, and one cannot deny that they quickly and often conscientiously disseminate information, albeit in a rather fragmentary fashion. This reading offers something of interest and directs one to further reading on a daily basis. Having barely risen from our morning slumber, we cannot get by without being instantly taken around Europe, Asia, Africa, and America. Not only that, but we also wish that newspapers would disseminate and defend precisely our opinions (which usually means the prejudices intimated to us by others). One can only wish that our readers would look at their favorite newspaper critically and that they do not grow content with it to such an extent as to be incapable of enjoying other reading.[114]

The growing number of newspapers catered to the increasingly diverse reading public. With the proliferation of the daily press, it became possible for the Russian readership to encounter a plurality of discourses on nationality as well. Wortman writes: "The atmosphere of relative freedom after the emancipation permitted the expression of contesting views of what the nation represented." The liberal newspaper *The Voice*, for instance, envisioned

Russia as a modern nation-state; the Slavophile *Day* sought the origins of the nation in the peasantry; *The Russian World* (*Russkii mir*) offered a Pan-Slavist image of Russia as the leader of Slavdom.[115] Different local political groupings claimed to speak for the entire nation.[116] Various organs of the periodical press, many of which had an obvious affiliation with this or that particular camp, gave voice to all these concurrent versions of identity. Mutability and volatility of discourse were perhaps the only constants in this kaleidoscope of shifting positions and perspectives.

St. Petersburg's favorite newspaper in the 1860s was clearly *The Voice*. The journalist of *The Petersburg Sheet* defined the daily's winning position in 1865 as follows: "More than others, *The Voice* gratifies the sundry tastes of those who read newspapers and seek in them news in all areas of the political and social life of our fatherland, as well as among foreign states and peoples."[117] Another contemporary pronounced *The Voice* "the leading organ of Russian public opinion."[118] Scholars, too, have described it in superlative terms as "the most accomplished specimen of the bourgeois-liberal newspaper."[119] The newspaper represented itself as an organ that "was created by the reforms and always served the reforms," as longtime *Voice* contributor Vladimir Mikhnevich put it. At a time of great social upheaval, *The Voice* responded to the need of educated Russians to posit questions and search for answers.[120] The newspaper's ever increasing number of subscribers speaks for itself: if in 1865 *The Voice* had a circulation of about 5,000, in 1870 this number increased to 11,000, and by 1877 it reached 23,000.[121] The key to such phenomenal success was twofold: the proverbially "commercial soul" of its editor Kraevsky, who made an industry out of literature, and the arrival of a new type of reader.[122]

The growing general readership of the popular daily was drawn predominantly from the so-called middle estate. While not a strictly defined class in the European sense, the middle estate made itself increasingly visible in Russian society when the daily press provided it with a forum for shared culture.[123] The general reader (*srednii chitatel'*) was a relatively new social phenomenon in the 1860s, which the newspapers competed to accommodate. *The Northern Bee* was the first to cultivate this readership, catering, as it did, to the interests of the lower ranks of the bureaucracy, servants, and merchants.[124] *The Voice*'s predilection for this middle estate readership was obvious to contemporaries. According to one journalist, the newspaper was "an exact image of the present-day middle, primarily bureaucratic, Russian society."[125] Similarly, the newspaper *Son of the Fatherland*, with a circulation

of 20,000, imagined its readership as belonging to the same social type.[126] Interestingly, newspapers assumed their readers to be only partially educated; aside from other benefits, the daily press provided an opportunity to expand one's learning.[127] This detailed description of the general public appeared in the pages of yet another daily, *The Northern Post*, in 1863:

> The number of readers has increased ... to such a degree that not only in the libraries, but literally at every turn you meet some kind of a newspaper. Whenever free, every shop-keeper and every salesman reaches for a newspaper. In the meat shop and even on the street one always encounters newspaper pages; some literate person (*kakoi-nibud' gramotei*) would sit down somewhere on a bench with a newspaper, and a group of listeners gathers around. Some can barely sound it out (*s trudom razbiraet tekst po skladam*), but still read on, and read out loud. Due to this, political news is popularized remarkably fast and readers' opinions are successfully totaled.[128]

The new reader called for a new writer. If journalism had traditionally been the prerogative of intellectuals, the mass-circulation press was "staffed by people unencumbered by the intellectual tradition."[129] Popular dailies like *The Voice* occupied a middle position between the thick journal and the so-called "newspapers for the people" (*narodnye gazety*), purposely simplified for literate peasants and craftsmen. These unassuming editions, unlike the general-interest dailies, typically talked down to the reader, which was not conducive to their popularity in social circles beyond their intended audiences.[130]

To sustain an open dialogue between newspaper and reader, *The Voice's* editor Kraevsky invited subscribers from the provinces to submit pertinent information about their hometowns and villages for publication. Moreover, he presented the newspaper as a caring companion: to accommodate a readership from all walks of life, the newspaper even permitted the subscribers to pay in installments. Kraevsky emphasized the importance of "the active initiative of the public itself" for attaining a civic spirit. Inciting this civic activism was the self-proclaimed role of *The Voice*, which "broadened the base of what constituted 'the public' by inviting more and different Russians to coalesce into a body of opinion."[131] Contemporaries recognized this body of opinion to be a construct of sorts (which it always inevitably is). The judgmental journalist S., for instance, qualified *The Voice* as the bearer of "ready-made opinions suitable for people of the middle estate": "*The Voice's* readers can feel unencumbered by the need to reason independently; the

newspaper can think and speculate for them."[132] As one of the purveyors of public opinion, *The Voice* indeed reflected a middling image of the general reading public in mid-nineteenth-century Russia.[133]

In its self-proclaimed task to form and articulate public opinion, *The Voice* positioned itself between society and the state in a space known as civil society, or, to use Jürgen Habermas's term, the "public sphere."[134] The spirit of the Great Reforms demanded that "the 'public' be brought into contact with their 'government' if the nation was to follow the course of the West after the Crimean defeat."[135] *The Voice* responded by declaring "a new epoch—an epoch of mutual action from above and from below."[136] If traditionally little dialogue between the official and private spheres was possible in Russia, Kraevsky's liberal politics of moderation helped foster a precarious balance of sorts between them.[137] In an era of civic awakening, *The Voice*, claiming to speak for the middle estate, echoed the rhythm of a rapidly expanding public realm. More Russians wanted to take part in the debate over their nation's affairs, and more newspapers provided the forums for such open discussions. The editor of *The St. Petersburg News* Valentin Korsh captured this general sentiment in an advertisement for his own publication: "The Russian newspaper should first of all address Russian issues and interests."[138]

In the early 1840s, Belinsky wrote: "Russian literature laid the foundation for our publicity and public opinion."[139] While literature certainly continued to do so in the next generation, the daily newspaper was increasingly assuming the leading role in carrying out this "civic duty." When Kraevsky first advertised *The Voice* in 1862, he was explicit about the instrumental role of journalism in society: "Our news media functions as virtually the only public organ of opinion in the country and the only means of representing the public interest."[140] In like fashion, *Son of the Fatherland* promoted its new guise as a daily paper by promising its readers that it would "help in the formation of public opinion."[141] Some scholars believe that this tendency was common to all "liberal-bourgeois" newspapers, which were in the vanguard of the daily press in the 1860s.[142] But what did public opinion mean? And who was the public? These questions were not new; Gogol had asked earlier in the century who the Russian public was. This issue preoccupied Belinsky as well, who offered a provisional answer—the intelligentsia, a public that is "a single living personality, historically developed, with a certain direction, taste, and view of things."[143]

In 1859, Slavophile journalist and ideologue Konstantin Aksakov defined the cultured "public" as the exact opposite of the common people:

"Our public speaks French, while the *narod* speaks Russian. Our public wears German clothes, while the *narod* wears Russian; the public follows Parisian fashion, while the *narod*—its own Russian tradition."[144] Aksakov explicitly criticized the westernizing tendencies that separated the educated public from the common people. Vladimir Dal' likewise defined the public as comprising "society, except for the rabble, the common people" (*obshchestvo, krome cherni, prostogo naroda*).[145] Literacy is the marker in this opposition: the reading middle estate *is* part of the public, whereas the illiterate *narod* is not. Education and not class was the main prerequisite to be admitted into the public sphere. In other words, the commoners (with the exception, perhaps, of an estimated 6 percent of literate peasants) were rhetorically excluded from the cultural public, which was central to the process of nation-building.[146]

That public opinion is always part fiction, marketed by "a dealer in public opinion" also known as the publisher, has been convincingly demonstrated in the work of Habermas, among others.[147] But long before him, nineteenth-century journalists were fully aware of its simulated nature. When in 1826 Bulgarin for the first time introduced the idea of "common opinion" (*obshchee mnenie*)—the voice of the majority that leads the crowd and manipulates the public's behavior—he did it in a secret report to the state.[148] By the 1860s, however, public opinion had ceased to be a state secret, when many voices of Russian society poured out onto the pages of the daily press in competition for an audience. As Danilevsky declared, "newspapers that have a genuine social importance are, in a sense, midwives of public opinion; they help it to emerge into the world."[149] The journalist S. offered a different personification to represent the public opinion in which the newspaper *Voice*, for instance, trafficked. "Of necessity public opinion should dress in the civil servant's uniform in order to debate without fear those numerous issues which ought to be discussed and decided in respective offices and committees."[150] The public opinion of *The Voice*, in other words, reflected the opinion of its own reading public, mostly the petty bureaucracy and merchantry. Its competitors cultivated their own audiences as well: presumably, there were as many "public opinions" as there were reading publics.[151] What united this plurality of publics was precisely the fact that they were *reading*. One feuilletonist, in fact, casually equated "public" (*publika*) with "readers" (*chitateli*).[152]

In the context of the newspaper boom, it became possible to deliver art as news on a regular basis. Between the first and the last quarters of the nineteenth century, the publicity of artistic life grew in proportion to exhi-

bitions, publications, and readers. Welcoming this change, the art historian Petr Gnedich, who signed his art feuilletons for the daily *The New Time* with the pseudonym Old John, wrote in 1900: "Letters that I receive are dear to me not so much as an expression of sympathy to my opinions, but rather as an indication of increased sensitivity (*otzyvchivost'*) to questions of art not only among artists, but among the public in general."[153] Popular newspapers like *The Voice* and *The New Time* helped create this newly educated public by giving it a voice and an opinion.

The Feuilleton, or Russian Culture "Lite"

"The feuilleton is a good thing," wrote writer and critic Alexander Druzhinin in a monthly installment for *The Contemporary* serialized under the title "Letters from an Out-of-Town Subscriber" (*Pis'ma inogorodnego podpischika*). "Had our century invented nothing else besides the feuilleton, it would still not be considered a useless age." What made the feuilleton special, in Druzhinin's opinion, was the very simplicity of its form and the great diversity of its content. The feuilleton was an unaffected form of writing, which required "neither plot nor deep feelings nor tortured originality (*vystradannaia original'nost'*)," to invoke Druzhinin's peculiar allusion to fictional literature. Instead of a unified narrative, the feuilleton offered a random collection of fragments on topics ranging from theater, to art exhibitions and popular spectacles.[154]

Ksenofont Polevoi, one of Druzhinin's older contemporaries who wrote for the newspaper *The St. Petersburg News*, defined the feuilleton as "a collection of city news, spiced up with cute little jokes."[155] The column offered a slice of urban culture, which included "everything: theater reviews, novellas, anecdotes, the chatter of drawing rooms—a true medley of all sorts of things, a table laid with every kind of glittering trinket."[156] Although the popular feuilleton played on familiar pairs of opposites, such as Moscow vs. St. Petersburg, it did not divide readers; this all-encompassing form accommodated a variety of tastes and materials and ultimately made a shared cultural experience available to all literate audiences.

The nineteenth-century feuilleton was an urban phenomenon, related to the proliferation of the popular press and the expansion of the public sphere in the modern metropolis. The traditional story is that the feuilleton was "born" one fine morning in Paris on January 28, 1800, when the editor of

Journal des Débats inserted an extra sheet (Fr. *feuilleton*) into the paper as it went to the press.[157] Still a novelty in Russia in 1820 when the foreign term *feuilleton* was first introduced to readers (in its original French spelling), the orthographically Russified word was granted new "citizenship" in the pages of *The Northern Bee* during the mid-1820s. This early version of the Russian feuilleton has been customarily compared to the journalistic rubric "Miscellany" (*Smes'*) in that it contained similar sensational, often translated fare (anecdotes, gossip, trial accounts, etc.), and was likewise devoid of cohesion and narrative unity.[158] The feuilletons of *The Northern Bee*, most of which were penned by Bulgarin himself, were typical in this respect, with each successive paragraph advancing a fresh theme or introducing a new fad without much thoroughgoing analysis.[159] In its selection and representation of material, Bulgarin's paper drew upon the tradition of volatile journalism, as practiced chiefly in France. One critic described the French press of the 1830s–1840s as follows: "Avid for gain, the editors of the big newspapers have not wanted to demand that their feuilletonists write criticism founded on conviction and on truth. Their convictions have too often changed."[160] In the context of commercialized print culture, literature, too, threatened to turn toward the feuilleton format, as Walter Benjamin pointed out.[161]

Despite the obvious similarities, the feuilleton evolved in Russia quite differently from its French antecedent. Korsh described on occasion how the Russian feuilleton was supposed to distinguish itself from other European varieties: while the French feuilleton was light and the German, by contrast, was heavy (*polnovesnyi*), and while no feuilletons existed in England at all, the Russian version of this popular column combined both topical daily reportage and more refined works of imaginative literature.[162] The Russian feuilleton, especially in its newspaper variety, would retain this mixed character throughout the nineteenth century, unlike its French counterpart, for instance, which later became a form of serialized fiction.[163]

A regular column, positioned at the bottom of the page below the "cut-off" line separating the main body of the newspaper's text from auxiliary information, the feuilleton was a protean feature: articles of a literary, polemical, or scientific nature, as well as stories, sketches, travel accounts, local reportage, novels, poetry, etc.—all of these diverse forms of writing could be published as feuilletons (with or without explicit designation).[164] Sunday reviews of the cultural life of St. Petersburg—a familiar potpourri of urban events and anecdotes—especially enjoyed popularity.[165] But the geography of the feuilleton was not restricted to Russia's capital city, about which, indeed, many

occasional features were written. Rather, the feuilleton provided access to all facets of urban public culture, both in Russia and abroad, to the common reader. Feuilletons in *The Voice* included the following regular features: "Everyday Life," "Moscow Life," "Parisian Review," "Foreign Chronicle," "From All Points," "The Artistic Chronicle," "Theatrical Notes," and "Conversations about Music." Other categories encompassed bibliography and journalism, the arts and sciences, fiction, ethnography and travel, biography, society news, jubilee celebrations, obituaries, polemics, gossip, and other miscellaneous fare.[166] Apart from these recurring topics, a great number of feuilletons were published in reference to particular events in the cultural sphere under a separate heading. In 1867, for instance, *The Voice* ran a "mini-series" titled "The Ethnographic Exhibition in Moscow," familiarizing readers all over the country with this show and the public debates it precipitated.

Both newspapers and journals published feuilletons; as a form of writing, the feuilleton spans the "high culture" of the thick journals and the "middle-brow" culture of the popular daily press. In the pages of thick journals, however, the minor genre of the feuilleton attained a "higher" literary status. Beginning with the second half of the 1830s, as Donald Fanger qualifies this general tendency, "[f]rom the lowest level of transient journalism ... the feuilleton was aspiring, in the hands of at least some writers, to greater dignity as a literary form. By the middle forties, some of the most talented and serious of the younger writers were practicing it, among them Sollogub, Grigoriev, Grigorovich, Pleshcheyev, Panayev, Turgenev, and Goncharov."[167] Many acclaimed Russian writers, at one time or another, wrote feuilletons, which have been anthologized and studied in some detail.[168] Here, however, I am more concerned with the other version of the genre, the popular newspaper feuilleton, or the "lower" form, often deemed unworthy of critical attention.

While literary themes and polemical fare increasingly dominated the thick journal feuilleton, those found in *The Northern Bee* and *The Voice* tended to skirt politics and polemics, retaining a largely informative, casual character. Of course, not all newspaper feuilletons belonged to what Soviet scholar Evgenia Zhurbina qualifies as a "middle-brow, pedestrian genre" (*meshchanskii, obyvatel'skii zhanr*); Nekrasov and Dostoevsky, for instance, published feuilletons in *Literary Gazette* (*Literaturnaia gazeta*) and *The St. Petersburg News*, respectively.[169] But as a rule, the newspaper feuilleton was a form of undemanding reading geared toward a general readership.[170] Frequent updates on contemporaneous happenings, customarily published on Sundays, helped attract readers to the newspaper column and made it

a timely (if not always reliable) source of information. The feuilleton was an infinitely reproducible form of writing, capable of holding the reader's attention from one issue to the next.[171]

The year 1847, when *The St. Petersburg News* introduced the feuilleton rubric "Petersburg Chronicle" (*Peterburgskaia letopis'*) as a regular feature, is considered a landmark in the history of the Russian feuilleton. One contemporary described this weekly review as "a light article about public life and its everyday interests." Among others, Dostoevsky was invited to contribute to the new column.[172] A decade later, the author would write in his "Petersburg Visions in Verse and Prose": "In our age the feuilleton—is ... almost the main thing."[173]

When by the early 1860s, the feuilleton had developed into an indispensable attribute of the periodical press, so had its author, the feuilletonist. From a random collage of city news and personal observations, the feuilleton had evolved into a forum for journalistic polemics. The feuilletonist, too, metamorphosed from an amusing "chatterer" to a social critic and almost a protagonist of his own creations.[174] The profession of the feuilletonist became a special honor, as one of the column's better known practitioners, Boborykin, observed in his memoirs.[175] It was also a major responsibility, as another feuilletonist remarked near the end of the century: "How scary it is to be a publicist (*publitsist*). The point is that your voice—a regular human voice, with its own merits and flaws—after going through a printing press, is suddenly strengthened tenfold, a hundredfold, even a thousandfold."[176]

Historically a mere supplement, the feuilleton evolved into a distinct, if problematic, form of writing. Summarizing its development during the first half of the nineteenth century, Gary Saul Morson writes:

> Originally a journalistic miscellany in which disconnected items of news of the city's cultural life were presented, the feuilleton gradually became tied together by the loose and whimsical transitions of a digressive persona wandering from topic to topic—and sometimes, in the conventional role of flâneur, from place to place as well. The genre's subject matter was characteristically broad—so broad, indeed, that the problematic unity of the feuilleton became a theme for both feuilletonists and their critics (who sometimes attacked feuilletons in feuilletons).[177]

In "feuilletons about feuilletons," a peculiarly self-referential category of journalistic writing, the familiar character of the feuilletonist and all the

"secrets" of his trade were unveiled and often parodied. At the same time, the nineteenth-century feuilletonist—not unlike a modern-day columnist— was viewed as key to the newspaper's success; its print run and subscription rates depended largely on the feuilleton and feuilletonists. "Through the use of feuilletonists, editors emphasized the mien of the newspaper-as-companion," writes McReynolds.[178] Druzhinin dramatized the socially viable role of the feuilleton in his highly ironic "A Dramatic Feuilleton about the Feuilleton and the Feuilletonists" (1855). In the course of this staged conversation between the editor of one St. Petersburg newspaper and the feuilletonist Ch-r-k-zh-i-v (Druzhinin's pseudonym), it becomes clear that the fate of the editor—and of his publication—depended entirely on the feuilletonist's talents. The editor was willing to pay any price to employ the savvy Ch-r-k-zh-i-v as a regular contributor and thereby overtake the competition.[179]

A decade before, Belinsky, too, observed that the feuilletonist was "one of the most characteristic phenomena of St. Petersburg."[180] With the publication of "The Petersburg Feuilletonist," a sketch by Ivan Panaev, which was included in Nekrasov's *A Physiology of St. Petersburg* (1845), these journalists even emerged as a conspicuous "type."[181] In a customarily journalistic style, Panaev outlined a collective portrait of the St. Petersburg feuilletonist as a corrupt character of middling talent, in whom contemporaries could easily recognize such literary businessmen as Bulgarin and Vasily Mezhevich, among others.[182] Panaev exposed commerce and competition as genuine sources of inspiration behind the feuilletonists' "literary" productions. Commercialization of the mass-circulation press was further emphasized in Panaev's later piece, "The Literary Manufacturer of St. Petersburg" (1857), a title that refers to another notorious literary entrepreneur, the editor of the daily *Golos* Kraevsky.[183] Collectively, Panaev represented all these Russian journalists as latter-day versions of Triapichkin, the proverbial character from Gogol's *The Inspector General*.

The calendar dictated what material was to be published in any given newspaper issue.[184] Feuilletons provided up-to-date information on cultural novelties in the Russian capital; they also offered vicarious admission to sundry spectacles in urban centers from Moscow to Paris. In the form of the feuilleton, even the International Exhibition in London could travel to the Russian reader, as it did in 1851 and 1862. Accordingly, one author defined the journalist's role as follows: "A publicist is first and foremost a chronicler, impartially recording those facts which pass by him at any given minute."[185] But the feuilleton was more than just factual reportage. "Against the background of ordinary, regular

newspaper material, the feuilleton is perceived as extra-ordinary, extra-regular material, as a supplement to the main part of the newspaper."[186] And yet the very conditions for the feuilleton's existence were inherently journalistic. To a great degree, its reputation depended on the larger context of the newspaper in which it was printed: the "destiny" of the feuilleton mirrored the newspaper's fortune.[187]

The feuilleton is a newspaper rubric and a minor literary form.[188] In their groundbreaking work on feuilletons, the Formalists emphasize precisely the hybrid character of the genre and its double allegiance to both journalism and literature.[189] Viktor Shklovsky, for instance, defines the modern feuilleton as "something in between (*nechto srednee*), an article of practical character, which delineates facts, and what one conventionally would call a work of imaginative literature (*khudozhestvennoe proizvedenie*)." More than anything else, the feuilleton is "a particular method (means) of processing facts."[190] Recently, Morson qualified this "boundary genre" as an ad hoc form open to the flux of time that tends toward playfulness and parody.[191]

In the feuilleton, literature turns to extra-literary categories, to facts of everyday life, to history, to civic culture, etc.[192] Situated between fact and fiction, the feuilleton bridges the categories of the material and the literary; it translates everyday cultural events into texts. Written with a sense of humor and with a certain degree of authority, such "light" texts serve to advertise and popularize events in the public sphere. In the mid-nineteenth century, the feuilleton was the singular form of writing which could immediately transmit contemporary civic culture to the literate population at large, reaching beyond the cultural centers of St. Petersburg and Moscow, where the highest concentration of public spectacles was found. Informative, topical, and accessible to wide circles of the reading public, the feuilleton was a kind of popular, everyday guide to culture and a forum for public opinion in imperial Russia.

The author of this popular feature, the feuilletonist, positioned himself as a friendly companion to the reader. Thus the feuilletonist V. P., who in 1851 covered the Great Exhibition in London for *The St. Petersburg News*, announced by way of a preface to his reportage that he intended to talk to the reader without any pretensions, as friends might chat after dinner "*entre la poire et le fromage*."[193] It was the highly personalized voice of the narrator that separated the feuilleton from other journalistic material and captivated the general reader. Nominally a form of reportage grounded in facts, the feuilleton did not aspire toward objectivity in the presentation of its material. On the contrary, the language of the feuilleton was typically "colored" by

puns, witticisms, and quasi-literary metaphors of all sorts. Druzhinin, one of the recognized connoisseurs of this kind of writing, advised: "Happy is the purveyor of feuilletons if there is but a little store of poetry and pleasant memories in his soul with which to cast a bright light upon all the subjects about which he wishes to talk."[194] Although most feuilletons, particularly in the newspapers, were published anonymously, the personality of the author, with his or her individual literary background and ideological perspective, was blended into the potpourri of the narrative to such an extent that it made this inherently journalistic form of writing border on fiction.

The broadly appealing language of the feuilleton saw other applications as well. In a different kind of literary endeavor, the journalist Mikhnevich came up with an entire dictionary of contemporary public culture written in this style titled *Our Friends: A Feuilleton Dictionary of Contemporaries* (*Nashi znakomye: Fel'etonnyi slovar' sovremennikov*). It comprised 1,000 entries devoted to well-known public figures, many feuilletonists among them. Introducing this original production, Mikhnevich emphasized that his task was to bring together all remarkable contemporaries in the public eye and to represent them to the reader in an appropriately light, humorous tone. Thus next to the historian Bestuzhev-Riumin and the statesman Valuev, we find the dentist Wagenheim, the son of the once famous Wagenheim whose name Dostoevsky imagined adorning the Russian Crystal Palace in *Notes from Underground*. In a series of miniature feuilletons, this dictionary replicated the kind of effort that went into the production of the popular newspaper column on a daily basis.[195]

Public opinion about the visual arts was also informed by the feuilleton, which served as an exhibition space of sorts within the newspaper. From the annual show at the Academy of Fine Arts, to a trained flea exhibit in St. Petersburg's glass-roofed shopping arcade, the Passage, the newspaper feuilleton regularly profiled public exhibitions of all kinds. Sensational novelties fared particularly well. Among the most widely advertised events were the following sights of St. Petersburg's urban culture: public exhibitions of giants, dwarves, and Egyptian mummies in the Passage; music concerts in Pavlovsk; can-can balls all over the city; and spectacular shows by international celebrities—the tightrope virtuoso Blondin, "the rubber man," O. Prescott, and the bearded woman Julia Pastrana—all of whom made their spectacular appearance in the Russian capital in the 1860s.[196] There is an excellent parody of the newspaper feuilleton in *Crime and Punishment*, where Dostoevsky mentions another set of "celebrities" of the St. Petersburg entertainment scene—Izler, Bartola, and Massimo:

The tea and the old newspapers appeared. Raskolnikov sat down and began to search through them. 'Izler...Izler...Azteks...Azteks...Izler...Bartola...Massimo...Azteks...Izler...Pah, where the devil...? Ah, here are the news items: Woman Falls Downstairs...Vodka Causes Workman's Death...Fire on the Sands...Fire in Peterburgsky Quarter...Another Fire in Peterburgsky Quarter...Another Fire in Peterburgsky Quarter...Izler...Izler...Izler... Izler... Massimo... Ah, here...'[197]

The frequency with which the name of Ivan Izler, the contemporary king of the entertainment industry, is reiterated helps us imagine the kind of redundant and trivial material that usually composed the sensational column. Dostoevsky's parody imitates not only the typical subject matter of the feuilleton, but its very mode of representation as well.

Feuilletons capitalized on the "exhibition mania" that evolved in the wake of the Great Exhibition of 1851. Journalists from across Europe, including the first Russian foreign correspondents, went searching for both realistic and fantastic displays. The following excerpt from the British press demonstrates this penchant for the sensational and extraordinary, which European and Russian journalists shared:

[W]e have exhibitions of nearly all possible and impossible things under the sun—exhibitions of pigs, of paintings, of performing fleas, of parrots, ... of steam engines, and of babies. We have national and international gatherings, local, vocal, and rural shows. The list seems all but complete; yet, as there is nothing more fertile than the imagination of exhibiting mankind, fresh addenda continue to drop in every day.[198]

The juxtaposition of pigs and paintings in this account reveals journalists' indiscriminant enthusiasm for every kind of a public show.

In Russia, the St. Petersburg Passage was a magnet for just such shows. One exhibition that received extensive coverage in newspapers was memorialized in Dostoevsky's satire on the popular press of the day, *The Crocodile: An Extraordinary Event, or What Came to Pass in the Passage* (Krokodil: Neobyknovennoe sobytie ili passazh v Passazhe, 1865).[199] Among many other displays in the Passage that only regular feuilletonists cared to cover were a pair of giants and a troupe of trained fleas from Germany. A feuilleton devoted to the latter dwells on this miniature circus of eight skilled fleas driving a little cart and riding on a carousel. The reader also learns about the performing fleas' tragic history: during the sea voyage from Germany all

but eight perished. The owner laments the loss and the impracticality of recruiting more performers locally, as Russian fleas have proven to be "rather dense (*kak-to neponiatlivy*)."[200] The line between fact and fiction is proverbially blurred in this typical Sunday feuilleton. Yet there is something enticing about such writing, something that attracts the reader's attention, despite the obvious banality of the subject matter and the poverty of its literary means. What is the pleasure derived from these texts? For a start, the popular shows under review are presented as sensational novelties of interest to the general consumer seeking entertainment in the city. The feuilletonist sustains the reader's interest by communicating a haphazard mix of information in the form of a narrative. More importantly, he dramatizes contemporary exhibitions: in a conversational, easily accessible style, the feuilletonist ends up writing a story, complete with detailed descriptions, well-defined characters, and extensive dialogue. It is often unclear what the author had actually seen and what was imagined for the sake of holding the reader's attention. What is more, the feuilletonist styles his narrative in terms familiar to the newspaper's readers and thereby invites them to identify with the visitors to the Passage. Perhaps the most attractive feature of the Sunday feuilleton was that readers were actually reading about themselves in the newspaper column!

Indeed, these stories about the ephemeral shows in the St. Petersburg Passage were entertaining and popular. Yet later the same column would undertake reviews of various art exhibition venues, as if equating the trained flea performance and paintings as subjects equally worthy of public attention. In the feuilleton, the freak show and the art show, the low and the high, met in the middle that was the evolving Russian public culture. Some feuilletonists aspired to provide a basic aesthetic education to the general reader as well. The familiar tone of the feuilletonists was particularly effective in reaching out to audiences not trained in art appreciation. To what extent the feuilletonists actually educated their readers is debatable since many of their contributions attracted severe criticism from professional critics. But this did not diminish the appeal of popular columns. What the newspaper feuilleton did accomplish in nineteenth-century Russia was to invite participation, inspire debate, and articulate public opinion. The lasting benefit of this topical writing was that it shaped a modern community of newspaper-reading and museumgoing citizens. And this was another reason why public discourse on the arts enjoyed popularity in imperial Russia, even when the edifying promise of museums was compromised by the poor education of the majority of readers and writers.

Russian Art as Controversy

Contemporaries appreciated the role printed commentary played in delivering literature and the arts to the public. In 1870, for instance, Shelgunov argued that Russian literature owed much of its success to its critics:

> All our artists would wander off along various paths, because it is only the critic-journalists who show them the way. Who guided our novelists— Turgenev, Dostoevsky, Goncharov, Pisemsky, and all the other writers of more recent years? They were guided by Belinsky, Dobrolyubov, Pisarev. Novelists merely collect the firewood and stoke the engine of life, but the critic-journalist is the driver.[201]

The visual arts likewise depended on what passed for art criticism in reform-era Russia. More often than not this writing appeared in the form of feuilletons, authored by well-known authors, critics, columnists, and amateurs; some pieces were signed, while others were published anonymously.

To examine this evolving public discourse in action let us consider one art event closely. The annual exhibition at the Academy of Fine Arts in 1863 caused a sensation. Two paintings in particular attracted everybody's attention. One was Nikolai Ge's *The Last Supper* (*Tainaia vecheria*); the other Vasily Pukirev's *The Unequal Marriage* (*Neravnyi brak*). There was something about these works of art that galvanized educated society: literally every periodical had something to say about *The Last Supper*; every second one had an opinion about *The Unequal Marriage*. To judge by public debates that exploded around these works, art had become a matter of national interest and mobilized the civic ethos of society.

Among the better-known opinions of that exhibition are those of famous writers, Dostoevsky and Saltykov-Shchedrin, but theirs are only a select few amidst many others. For instance, art critic and museum curator Andrei Somov, writing for *The St. Petersburg News*, praised *The Last Supper*, which depicts a biblical scene, as a unique production of the Russian school, free of any extraneous influence (*image 5*).[202] The feuilletonist of *The Northern Post* commended Ge as a "thinking" (*mysliashchii*) artist; the authors N. A. and A. A., both of *The St. Petersburg News*, and the journalist P. P. writing for *The Contemporary Bulletin* (*Sovremennyi listok*), all celebrated the unprecedented realism and absence of theatricality in the work. P. P. wrote emphatically: "The main thing that strikes one about this new work is life—life in full swing (*b'iushchaia zhivym kliuchom*), life in the faces, in the immediate milieu (*v*

samoi obstanovke), and in all the smallest details. In front of us are people, in the highest and most complete meaning of the word." In the image of Ge's Christ, these journalists celebrated a "God-Man."[203] In contrast, Dostoevsky thought that the realism in this religious painting was excessive. Writing in 1873, when the painting was exhibited on the eve of its departure for the international exhibition in Vienna, the writer dismissed it as a genre painting, executed in a style utterly inappropriate for a religious subject. In his pursuit of realism, the artist had reduced it to "a regular quarrel of fairly regular people." Dostoevsky found Ge's version of Christ unacceptable; by situating Christ in an everyday context, the artist produced a lie.[204] Stasov, too, thought that Ge's Christ was a lie: "an elegiac melancholic" (*elegicheskii melankholik*), as he phrased it.[205] Another journalist likewise believed that the artist erred in taking liberties with the biblical text and in reading "between the lines" too freely.[206] Censor Alexander Nikitenko recorded his discontent with the painting in his

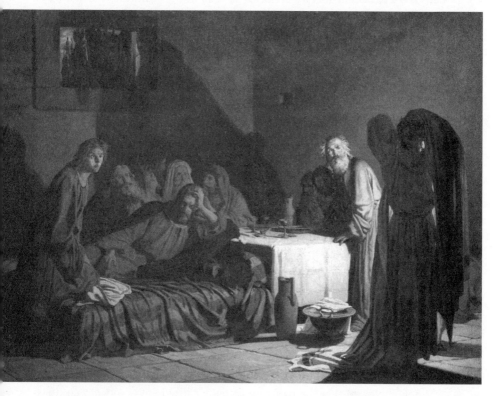

5. Nikolai Ge, *The Last Supper* (1863)

memoirs: the painting, a fine expression of "crude materialism," produced an unpleasant impression, mainly because the artist represented Christ as if he were a "robust young fellow saddened by some failure" (*v vide zdorovogo parnia, kruchiniashchegosia o kakoi-to neudache*).[207]

While some authors criticized the secular character of the painting, others, like Saltykov-Shchedrin, saluted it:

> Ge's painting represents an entirely new phenomenon for us precisely because it absolutely lacks any kind of clichéd devices or saccharine-bureaucratic effects and because the artist had an absolutely clear attitude toward the event that he was depicting. And such is the power of artistic truth that this absence of effects not only does not diminish the meaning of the event itself but, on the contrary, intensifies it and reveals the event in all its somber moral significance (*pouchitel'nost'*), in all its amazing beauty.

Saltykov-Shchedrin was no art critic and candidly admitted that his was a lay opinion: "I'm not a connoisseur of art; just the opposite, in this regard I consider myself to belong entirely to the crowd."[208] The author styled his review as an expression of that crowd's opinion, which was a common practice among critics at the time.

In the case of Pukirev's *The Unequal Marriage*, there was still less consensus among critics as to the painting's true meaning. This was the first genre painting of a large scale to represent a familiar and touching subject: a young bride, tears in her eyes, standing next to a decrepit general (*image 6*). The issue at hand was hardly a uniquely Russian phenomenon; yet contemporaries read it precisely as a representation of Russian social ills. Stasov defined it as "one of the most important, and at the same time, most tragic paintings of the Russian school." The plot of the painting was not complicated, and yet artists had never undertaken it before, claimed Stasov, apparently being "too busy with Greek heroes and Christian martyrs." Stasov's verdict was unquestionably positive: "All of Russian society immediately seized upon (*skhvatilos'*) this painting and fell deeply in love with it."[209] But where Stasov saw a national tragedy, other critics observed an absence of drama. Somov, for instance, thought that the painting was "anecdotal"; the journalist I., writing for *The Russian War Veteran*, found it unmotivated, while N. Dmitriev saw it as simply unpleasant.[210] Some critics, in fact, tried to help the artist correct his painting's shortcomings. Mikhail Fedorov, for example, believed that the painting actually caused envy, and not compas-

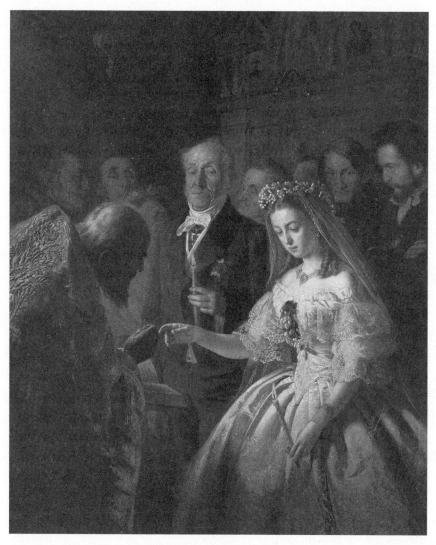

6. Vasily Pukirev, *The Unequal Marriage* (1862)

sion, because many young destitute women willingly chose such an unequal
but materially advantageous marriage. To improve Pukirev's work, he sug-
gested that the artist should represent a young man in place of the old gen-
eral "for complete effect."[211] If this particular interpretation appears prepos-
terous, it was hardly unique. One summary of the reviews dedicated to the
1863 exhibition even classified the opinions according to the temperament

of their authors: emotional feuilletonists, "thinking with their hearts," tend to sympathize with the plight of the unfortunate bride as she sets out on a difficult and sorrowful path in life, whereas the skeptical ones imagine her swift reconciliation with a future full of gala balls, receptions, and possible paramours.[212] The inconsistency between the professional (or even simply sensible) point of view of some of the critics and the freewheeling chatter of the majority of the feuilletonists who dabbled in art discourse on occasion is apparent. But this did not change the fact that throughout the exhibition period and beyond, *The Unequal Marriage* remained a distinct presence in society. Repin, in fact, reminisced that it had ruined the life (*isportila krov'*) of more than one old general, and apparently Kostomarov had even changed his intentions to marry a younger woman after seeing the painting.[213]

All this writing about the controversial *Last Supper* and *Unequal Marriage* endowed each artwork with the aura of a masterpiece; following a clamorous reception at home, both paintings were slated to travel to the International Exhibition in Paris in 1867. Tellingly, it was public opinion and not the Academy that nominated these works, as had been the case with earlier international fairs.[214]

After the first unsuccessful international display in 1862, art had become a prominent element in the formation of Russia's self-image at world's fairs and local exhibitions alike. Even if we call into question the inherent "Russianness" of Ge's and Pukirev's paintings (which was a discursive construct anyway), the overall national ethos in art remained strong during the reform era. The underlying question of national identity, which was a regular part of cultural criticism as practiced in the feuilleton, always rendered these deliberations on disinterested art topical. Art was also deemed national because an ever increasing number of educated Russians of different classes and genders cared about it. From the standpoint of the contemporary popular press, the emergent artistic discourse of the 1860s was all about nationality; nationality was present even in its absence.[215]

In sharp contrast to the international exhibition of 1862, when some reviewers found it difficult to even recognize the art that was Russian, the display in Paris in 1867 was a success precisely due to Ge and Pukirev, along with Perov and half a dozen others who represented the new national direction of Russian art. One review specifically emphasized that paintings traveling to the world's fair in Paris would be able to uphold Russia's "national honor."[216] Stasov rejoiced—finally, the Russian department of the exhibition possessed a distinct national character: "this time we won't fall flat on our

faces" (*na nyneshnii raz my ne udarim litsom v griaz'*).[217] The triumph of Russian art, abetted by Stasov's jubilant reviews, continued at the 1870 Exhibition of Russian Manufacture and Industry in St. Petersburg and at international exhibitions in London (1872) and Vienna (1873).[218] The appearance of Russian art in London in 1872 was striking, according to Stasov: "After prolonged intermissions, lazy stretching (*potiagivanii*) and delays, Russian art is suddenly *present* at the international exhibition, and how present!"[219] This victory of Russian art was largely rhetorical, however. The art itself was still "a tender flower," as one critic imagined it, but at least it was in caring hands.[220] Yet this evolving plant of national art did not exist in a vacuum, nor was it cultivated in a greenhouse of Western culture capable of producing only exotic simulacra. On the contrary, art and life were intertwined as closely as never before. What changed was that now Russians *needed* art—if not for its aesthetic pleasure then for its power to represent. Stasov in fact declared in early 1869 that Russian society "needed contemporary artists' paintings as much as it needed the novels, stories, dramas, and comedies of contemporary writers. In each of these works of art it encountered the same truth and faithfulness to real life as in literature; contemporaries deemed art precious for that alone."[221]

Writing about art mattered precisely because it was *not* about disinterested aesthetics alone. Art—as literature before it—allowed one to speak relatively freely in imperial Russia. This explosion of discourse also meant that a basic grammar of art appreciation had become available to society at large. In the preceding decades, journalists routinely represented the public as lacking education and taste, wandering through exhibition halls "with some sort of touching expression of bewilderment on their faces as they try to catch the eye of someone who could explain what is going on." The exhibitiongoing public, only recently described as "blind" and "ignorant," seemed to have grown in its competence to judge if not art itself then at least the writing about it.[222]

The rise of popular art criticism in the 1860s was fueled by specialized and general-interest publications in the preceding decades.[223] Already in 1814, the poet Konstantin Batiushkov recognized the importance of the written word for the promotion of the visual arts in his virtual excursion to the Academy, "A Stroll to the Academy of Fine Arts."[224] In the next few decades, the journals *The Moscow Telegraph*, *The Telescope*, and the *Library for Reading (Biblioteka dlia chteniia)* included essays centered around the arts on a regular basis. Although the first periodical to be exclusively devoted

to art, the *Journal of Fine Arts* (*Zhurnal iziashchnykh iskusstv*), lasted only a few years, the overall number of publications in which the evolving artistic discourse found an outlet increased steadily.[225] Around midcentury, *Russian Arts Bulletin* (1851–62) and *The Chronicle of Light* (*Svetopis'*) appeared, both of which featured engravings of recent works by Russian artists.

Among earlier efforts to popularize painting, an illustrated almanac, *Pictures of Russian Art* (*Kartiny russkoi zhivopisi*), published in 1846 by the art critic and writer Nestor Kukol'nik, deserves mention. This edition featured a dozen engravings of Russian paintings interlaced with selections of poetry, prose, and even an attempt at art criticism, namely two articles by Kukol'nik himself. As Kukol'nik explains in the first article, the idea for his almanac grew out of a resolve to "save" works of Russian art "scattered all across the empire" from oblivion. To "save" meant to reproduce in engravings, to discuss in print, and to make available to the reading public. Mere reproduction by itself was insufficient, however; as Kukol'nik clarifies, the "publication of pictures alone, without text somehow related to their content, would not be, perhaps, of special interest to the reading public."[226] Apparently, in order to judge art, the Russian reading public, still a neophyte in the field of art appreciation, required a certain amount of literary guidance that the publisher of *Pictures of Russian Art* provided. At a time when art criticism was still a rarity and when artists were only beginning to establish themselves professionally, the opinion of every critic seemed to matter. Not many of these critics were well positioned to write about art, so that a decade after Kukol'nik's publication, the journalist N. Kh. observed sarcastically: "Opinions on art are rare nowadays, thus even a feuilleton in *Son of the Fatherland* is important."[227]

In the decades that followed, however, the voices of serious critics began to sound next to the feuilletonists' idle banter. As the professional discourse on the arts strengthened in the second half of the nineteenth century, criticism as chatter no longer sufficed, much as it had helped disseminate art in the previous decades. With increasing frequency, professional critics attempted to distance themselves from their competitors, the feuilletonists, whose pedestrian opinions increasingly cluttered the public sphere. When Nikolai Ramazanov's fragmentary history of Russian art was published in 1863, it was praised as a serious and systematic endeavor against the background of freewheeling feuilletons, penned by people who routinely wrote about urban gossip and only once a year, during the Academy's exhibitions, miraculously turned into connoisseurs of fine art.[228] Yet the feuilletonists'

contributions were well received precisely because of the paucity of other literature on the topic. The first more or less comprehensive history of Russian art that emphasized its originality (*samobytnost'*) and viability did not come out until 1879, a translation from the French treatise *L'art russe* by Viollet-le-Duc.[229] The first survey in the original Russian—by Alexandre Benois—would be published only at the turn of the century.[230]

In the middle of the 1860s, the campaign against middling criticism reached a momentum when, bending under the barrage of condescending attacks, the cocky feuilletonists turned self-conscious, apologizing a priori for the shallow level of discourse that they, "ordinary mortals," had been delivering to their readership.[231] One feuilletonist in particular openly admitted to the incompetence of his brethren, just as he declared that the artists themselves should help with matters of taste: "Why do they call upon us, who are barely familiar and sometimes, more frequently, in fact, not at all familiar with the fine arts, in order to write about them? Why don't they write themselves, or teach us how to look at art and to judge it?"[232] Artists, in turn, claimed that, far from being useful, much of the writing in the popular press actually harmed art. For example, artist Grigory Miasoedov even reflected on the damage that popular discourse caused in the capital cities by comparing its effect unfavorably to the unmediated impressions of the provincial public.[233]

Mediating the professional and the popular aspects of art criticism was Vladimir Stasov, a key figure in many public debates on art and identity. Not only was Stasov a self-appointed arbiter of taste, but he policed discourse with unflagging enthusiasm. Although his own forceful opinions were not infrequently wrong, he was absolutely intolerant of the many dilettantes whose inane writing both enraged the critic and encouraged him to write more. Discussing the 1867 exhibition at the Academy of Fine Arts in predominantly laudable terms, Stasov chided *The Voice* for its needless and ignorant critique of an otherwise successful display and expressed hope that talent and common sense would be able to withstand the philippic of the uninitiated.[234] On another occasion, he launched a fierce attack on so-called art critics in the pages of *The St. Petersburg News*: "A new spirit of our native art is in the air, and one needs to be a Russian art critic, that is a feuilletonist (for we have no other art critics) in order not to see and not to feel this new spirit, and instead to complain lazily and boringly every year during the Academy's exhibition about the scanty number of paintings and the decline of art." Motivated by anything *but* the love of art, the feuilletonists were per-

forming a dubious service to the Russian public, Stasov claimed.[235] Time and again, Stasov pointed to a paradox underlying contemporary art criticism: despite the heavy volume of writing devoted to art, newspapers were only marginally helpful in elevating the public's taste; the quality of art feuilletons was such that they could only support the most superficial of interests.

At the same time, Stasov advocated a brand of art criticism calculated to resonate with a general readership; his signature fiery style, with its heavy emotional appeal and reliance on the more familiar literary conventions, invariably stirred up a public response. Stasov prided himself on providing a nonspecialized criticism and argued for its advantage over seasoned but slow responses from professionals associated with the Academy:

> One may be a specialist a thousand times over and nevertheless not have the gift of criticism. One may, on the contrary, be gifted in criticism and in no way be a specialist in the matter selected and critiqued. It is enough to be a specialist in critique: that is all that is needed.... Imagine what would happen were everyone to be forced to restrict themselves to specialists in a given business, if no one dared to object, if any dissent, any free thought of the non-specialist mind must be crushed?[236]

During the several decades that Stasov's voice dominated the public discourse, the roles of art, artists, and critics in society changed radically. Art no longer catered to the disinterested pleasure of a select few; its subjects were now drawn from real rather than imagined life, and matters of taste were no longer dictated by the elite Academy. Populist art criticism proliferated at the time when aesthetic judgment became the property of the educated public, allowing any "thinking person who could judge content that is the phenomena of life" to assume the position of an expert, as radical critic Dmitry Pisarev wrote unapologetically.[237] This context helps explain the prioritization of content over form in the writings of Stasov and others and the deluge of lay opinions on art that permeated the press in the 1860s: any "thinking" person could claim (as indeed many journalists did) to be an art critic.

Despite the magnitude of his contribution, the "aesthetic nationalism" that Stasov heralded as the underlying principle behind contemporary Russian art was not the critic's private creation. It was a discursive field informed by a multitude of frequently contradictory viewpoints, including those of his rivals which had but one thing in common: the mode in which they were printed

and circulated. Nor was the esteemed critic alone in his quest for a better quality of discourse on art. Among others, N. Nabokov wrote in defense of thoroughness and ethics in art reportage, qualities that were apparently in short supply among many feuilletonists.[238] Along with his detractors—first the unskilled feuilletonists, then a rising generation of the "decadents," with Sergei Diaghilev at their head—Stasov kept Russian art at the center of a wide-ranging controversy for the rest of the century. More often than not, the subject of such writing, the fine arts, was well-nigh incidental: what mattered was the creation of a *lingua franca* in a country that until recently had been strictly divided by literacy and rank. Instructive in this regard is a sketch by Gleb Uspensky, in which the viewing of a painting (supposedly, Nikolai Iaroshenko's *The Student* [*Kursistka*]) leads interlocutors to debate urgent contemporary issues, such as the division of labor and family life. The painting itself disappears from the essay after the first few pages, as if it were merely a pretext for the discussion of vital social concerns.[239]

Yet the road to professional discourse was paved with more difficulties than readily meet the eye. In 1885, Stasov still complained that art criticism in Russia "has managed to restrain, confuse and mislead many, many people."[240] Artist Alexander Kiselev, an active participant of Itinerant exhibitions and later a professor at the Academy of Fine Arts, wrote as late as 1893: "Primarily, art reviews are written here either by unsuccessful artists, or by untalented literary laymen. As a fortunate exception, we could only cite the rare articles on art by Garshin, Korolenko and Kramskoy, or, if you will, by Grigorovich, Matushinsky and others who have never been, except for the last, professional reviewers, but who have written their articles sporadically, as a sideline."[241] Even then such contributions were rare in a field dominated by newspaper reviewers who could be called critics if only "by some strange mistake."[242] Kiselev continues: "Our artists, of course, know the merits of these judges and blithely go forward, not paying any attention to this yelping. But the poor public, or better still, that small portion of it which cannot do without mentors and needs to refer to the authoritative instructions of the press for their opinions and tastes, ends up confused and disoriented. Who should they listen to?"[243]

To judge by Stasov's and Kiselev's remarks, it may seem that no progress was made in Russian art criticism during the fifty years surveyed here. But then the same Stasov published in 1882–83 his seminal "Twenty-Five Years of Russian Art," one of the first systematic attempts to describe the development of all the visual arts in Russia—painting, sculpture, and

architecture—that appeared in installments in *The Messenger of Europe*. That the same critic could simultaneously reinforce and undermine attempts at art criticism reminds us that its contours changed with each new utterance. This antagonism, however, and the many errors, purposeful or not, actually helped enliven the public discourse and promote the arts in imperial Russian society.

In the end, the controversy over art criticism produced several long-lasting results. One positive outcome was an evolving common language of aesthetics, albeit still porous and naïve, that comprised a stock of familiar material amassed in the course of several exhibition seasons. This emergent *lingua franca* became familiar enough for Saltykov-Shchedrin to make a parody on it. Describing Ge's notorious *The Last Supper*, the satirist exclaims, in imitation of the writing in the popular press: "Look, I'd say, how conscientiously such-and-such a nose is conceived! How artfully such-and-such a crease is traced! How cunningly the light is calculated!"[244] Another result related to what critics perceived as the development of taste. In 1872, the art critic Apollon Matushinsky, contributor to *The Voice* and *The Russian Messenger*, considered this welcome phenomenon at length:

> It is without a doubt a pleasing fact that in our public, the taste for works of art evolves more and more with every day. In recent times, art exhibitions in general have been more eagerly attended; buyers have appeared for the paintings. Good pieces do not last long—they sell, you might say, like hot cakes.... Journalism is also incomparably more interested in art than it was previously: several years ago, only a few thick journals allocated space in their pages to an overview of art exhibitions. Now there is almost no newspaper, no matter how tiny, that does not publish such reports. True, the judgment of our press about art is still frequently distinguished by its surprising naïveté, and even at times, its total ignorance of the matter, from which an awful cacophony ensues, but this is not the point. Regardless, this means that articles about art are being read, that there is an obvious demand for them, and that the public must be interested in them. Finally the provinces, until recently completely impartial to all that is going on in the sphere of art, have also begun to show a taste for the artistic.... Together all of this speaks eloquently of a newly emergent need in society—the need to satisfy an aesthetic feeling, which has always been a true sign of the rising level of general education in the country.[245]

Matushinsky is right on target in his analysis of the public discourse surrounding the arts, as he underscores its usefulness even in consideration of authors' general ignorance. In a familiar rhetorical move, the critic concludes with the main beneficiaries of this variegated writing on art-related topics: the Russian general public.

The proliferation of specialized journals in the 1870s–90s, such as *The Bee* (*Pchela*, 1875-78), *The Arts Journal* (*Khudozhestvennyi zhurnal*, 1881– 87), *The Herald of Fine Arts* (*Vestnik iziashchnykh iskusstv*, 1883–90), *Artist* (*Artist*, 1889–95), and the *World of Art* (*Mir iskusstva*, 1899–1904), helped elevate art discourse to a more professional level.[246] Next to popular dailies and the illustrated weekly *The Cornfield* (*Niva*), more serious critical writing appeared in art journals, which Habermas called "instruments of institutionalized art criticism," and which made discussion, the medium through which the public appropriates art, available to educated society.[247] Yet again the controversy around art did not diminish with the professionalization of art criticism; the tradition of debate continued in vivid exchanges between the specialists in the pages of the elegant art journals and their unceremonious opponents—the poorly trained feuilletonists.

Historical studies and surveys that appeared in the last quarter of the century, challenging and soon replacing the fragmentary writing of the popular press, also helped anchor the discourse and canonize the Russian tradition. Among the serious contributions that appeared around the turn of the century were *The History of Art* by Gnedich (*Istoriia iskusstv*, 1897), Benois's *History of Painting in the Nineteenth Century: Russian Painting* (*Istorii zhivopisi v XIX veke. Russkaia zhivopis'*, 1901–2), Novitsky's *History of Russian Art Beginning from Ancient Times* (*Istoriia russkogo iskusstva s drevneishikh vremen*, 1903), and A. Uspensky's *Sketches of the History of Russian Art* (*Ocherki po istorii russkogo iskusstva*, 1910). Six volumes of Igor Grabar's monumental *History of Russian Art* (*Istoriia russkogo iskusstva*, 1909–13), which comprised contributions by leading art historians, can be considered the crowning achievement in this effort to document and systematize the national tradition in the visual arts. Over a hundred years of art criticism, beginning with the first publication of its kind in 1793, *Meditations on the Free Arts* (*Rassuzhdeniia o svobodnykh khudozhestvakh*) by the Academy's vice-president Chekalevsky, resulted in a substantial bibliography.[248]

Russian art criticism came of age around the turn of the twentieth century, when substantial endeavors like Stasov's were no longer isolated cases. Devoted critics Sergei Makovsky, Nikolai Vrangel, Benois, Grabar, and many

others joined and then superseded the pioneer of art criticism in the list of those who authored the history of Russian art in books and articles. Makovsky's collection of essays, poignantly titled *Pages of Art Criticism*, is a landmark edition that both summarizes and critiques the Russian tradition. The critic indicated from the very beginning that his book was intended for "the uninitiated." Justifying his decision to reprint previously published essays, he emphasized that at the present time, the "big public" needed accessible information about Russian art more than ever, hence his focus on the nexus of artists, exhibitions, and the public. Makovsky specifically addresses the cultural environment (*kul'turnaia sreda*), in which the Russian public grew to recognize and appreciate its own artists. His concluding remarks are disparaging, nevertheless: "There is talent and a desire to work in Russia, but for cultural creation one needs a cultured social environment (*kul'turnaia obshchestvennaia atmosfera*), which remains absent."[249] Instead, he argues, the interaction between society and art is limited to just a couple of days following an exhibition's opening when a few paintings with an "interesting plot" receive hasty coverage and poor reproduction in the press. The Russian general public had yet to see the light (*prozret'*): in order to appreciate art one needs to develop a "culture of the eye" (*kul'tura glaza*), that is, the ability to look and perceive art; until then, the "mystery of beholding beauty" (*tainstvo sozertsaniia krasoty*) would remain inaccessible to such an indifferent public.

Like many before and after him, Makovsky dwelt on the "national question" and its implications for the development of an independent Russian tradition in the arts. He refers to "the surprisingly raw state" of Russia's "national-cultural consciousness" (*udivitel'naia nezrelost' nashego natsional'no-kul'turnogo samosoznaniia*). Thus the critic concedes that in terms of the "depth of national clairvoyance," there is still no Pushkin or Glinka or Rimsky-Korsakov among Russian artists. Considering the origins of Russian cultural tradition, Makovsky invokes an analogy of a plant with aerial roots (*rastenie s vozdushnymi korniami*), which draws its strength and nourishment from many different well springs. As to his solution to the predicament of Russian culture, Makovsky encapsulates it in the grotesque image of a national idea with wings: if Peter the Great was a callous surgeon who had amputated the diseased legs of the ailing nation, that nation without legs could grow wings and learn to fly. Russia's wings, according to Makovsky, are the hybrid cultural idea that links Russia and the West and that both venerates native origins and aims toward a common European

future. Had Russian culture not been split between westernizing and Slavo-phile tendencies, this "bewinged nationalism" (*okrylennyi natsionalizm*) would soar high.[250]

Not unlike Stasov's ambivalent position vis-à-vis critical commentary, the paradox of Makovsky's edition consists in the following: on the one hand, his collected articles support the institutionalization of Russian art criticism, yet on the other, his equivocal conclusions undermine the very possibility of anything resembling a canon; there is both the excess of culture and the crisis of culture here. Makovsky himself admitted that he had to revise his essays for the publication because "during the last ten years, views on paint-ing have changed radically"; his own efforts to describe the state of Russian art, not unlike those of his predecessors, represent only a part of the turbu-lent process of culture writing.

PART II
DISCURSIVE PRACTICES

INSTITUTIONS AND DEBATES
Negotiating Art and Power

During the second half of the nineteenth century, the visual arts were increasingly recruited in the service of the nation-building project via the press. We have observed that many institutions of culture in imperial Russia were modeled on Western European prototypes. Moreover, they were typically sponsored by the state; art has never been disinterested in imperial society. The tsar's unlimited authority notwithstanding, eruptions of public discourse in the wake of the liberating reforms provided new opportunities to negotiate the relationship between state institutions and creative artists, as well as the viewing and reading publics. At that time, museums and monuments came to serve as a visual pretext for broad public debates on issues of culture and representation. Educated Russians increasingly discussed and then challenged Western borrowings, questioning the very status quo of venerable institutions and the art produced within their walls.

In this chapter I analyze three instances of this emergent dialogue between art and power, following the way a monument, a museum, and a school of art were represented in the press. The history of the Millennium Monument, the Hermitage, and the Academy of Fine Arts is well known; there is no shortage of guidebooks or exhibition catalogues devoted to these famous sites of culture. A rather different picture emerges, however, when we attempt to reconstruct their meaning in contemporary society not as institutions but as discursive constructs. All three can be considered textbook examples of art being subservient to the state. In the case of the Millennium Monument, the emperor oversaw the design of the entire sculpture and the selection of individual figures for the composition. The imperial Hermitage, founded by Catherine the Great, enjoyed the patronage of the Romanovs from the very beginning. Members of the imperial family were appointed to preside over the Academy of Fine Arts as well. The resonance these cultural

monuments and institutions found in society could not be more different, however, ranging from vigorous to tame to nonexistent. Issues of borrowed forms and foreign foundations for a national cultural tradition were among the hottest topics that contemporaries discussed in the press.

The millennial celebrations became the center of national attention in 1862, the same year that Russia was "defeated" at the International Exhibition in London and a year after the emancipation was announced. A grandiose monument to 1,000 years of Russian history was erected in the ancient center of culture Novgorod. This sculptural representation became a familiar reference point, as the public was asking questions and challenging answers, only some of which were about the monument proper. Open for debate were not only the issues of who was chosen to represent Russia and why, but also how: the monument's foreign concept and its suitability to the Russian soil provoked an explosion of writing. This early expression of public discourse on the arts was so much more conspicuous because it took place when the reforms were only beginning to be implemented.

The world-famous Hermitage, by contrast, provoked little interest among Russian audiences and, despite its prominent position, remained largely invisible to the public until the end of the century. The discussion below considers the peculiar status of this museum in imperial society: the press wrote very little about this superior collection of European art, which offered free access to the general public in 1865. The museum's location next to the Winter Palace, its "foreign" art, and the rise of national realist aesthetics were among factors that excluded this institution from many contemporary debates.

The Academy of Fine Arts was the stronghold of artistic education in imperial Russia, and its role in Russian society is hard to overestimate. Unlike the Hermitage, it was present in the Russian public sphere, albeit always as a contested site of culture and a web of conflicting opinions. Beginning with the middle of the nineteenth century, the Academy's reputation was increasingly made beyond its walls. The multiple stories about the Academy that were available in the press shed new light on the interaction between official institutions and public discourse in the Russian empire.

The Millennium Monument, 1862

The Millennium Monument, described by contemporaries as "the principal" and the "most complete" memorial in Russia, represents one of the ear-

lier efforts to encapsulate Russian culture in one space (*image 7*).[1] Its unveiling was also one of the most adamantly disputed public events of the era, as the pantheon of national heroes that the monument represented turned out to be a highly controversial issue. Like museums, monuments are important "public sites of memory" that conserve history and fashion a national mythology.[2] To judge by the press, the Russian public followed the monument's progress with great interest over the course of its design and construction. Between the novel conception of the monument and its controversial implementation, there was a lot to talk about.

The celebration of Russia's Millennium in 1862 resonated widely in the country. "It has finally come to pass (*svershilos'*).... [T]he monument was unveiled, and Russia celebrated its millennium with all the triumph and grandeur befitting such a great day," wrote a correspondent for *Son of the*

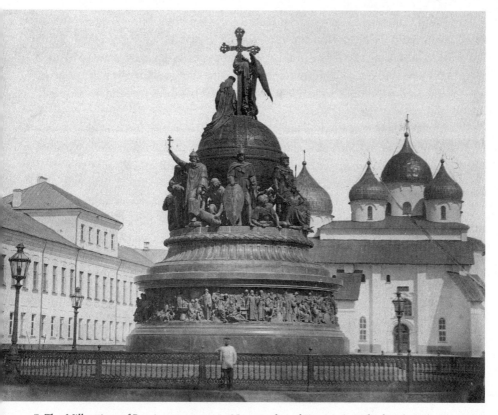

7. The *Millennium of Russia* monument in Novgorod, sculptor M. O. Mikeshin (1862)

Fatherland, reflecting the collective spirit of the festivities that took place on September 8, 1862, in Novgorod. "How much we've lived through! How much we've accomplished!... The greatness of this people can be felt throughout their entire history, with all their power and might vividly apparent."[3] To judge by the majority of newspapers, Russia rejoiced during the commemoration of a thousand years of its history: a great number of people set out on a pilgrimage to the center of the festivities in ancient Novgorod; still greater numbers participated vicariously via the popular press, which delivered the news to the capital city and beyond.[4] The coverage of this major public event, however, depended on periodical editions and their intended audiences, as well as individual contributors to what soon grew into a dense public discourse.

The Millennium was an important historical event; it was also a magnificent show. Olga Maiorova points out that a certain theatricality underlay the "grandiose performance" in support of Alexander II's model of autocracy.[5] Indeed, official and semiofficial records of the festivities represented not so much reality as a wishful image of Russia under the new government; this blurred the contrast between imperial and oppositional narratives of history. After all, the idea of the millennial festivities originated with the government, and the emperor personally supervised the design of the monument:

> The Millennium Monument in Novgorod was intended to celebrate the political and cultural progress of Russia under the rule of its monarchs since the ninth century. But Alexander and government officials also conceived it as meaning something larger, as commemorating the Russian nation as well as the monarchy. The history of the monument reveals an impulse for a representation of the elusive term *nation* that would encompass groups outside the state and suggest the unity of monarchy and people. But as the state remained central to Alexander's conception of nationality, the monument emerged as a representation, above all, of the ambiguity of the concept of nation in his scenario.[6]

Next to this top-down "scenario of power," several other narratives circulated concurrently in Russian society.

Aside from the physical commemorative composition in Novgorod, discursive monuments were built all over Russia in the pages of periodical editions. Conversations about the monument centered on topical issues: history, identity, representation, and the Russian public. One prominent leitmotif

was the emancipation of the serfs, which had been recently announced but was not yet implemented in full. Another was the monument to the tsar-liberator, "not wrought by hands," that "the *narod* had long ago erected in their hearts," as the newspapers described it in Pushkinian terms, disregarding the irony. Still another was the scholarly debate on the origins of the Russian state, which turned into a major public forum. The monument also raised the important question of representation: who should represent Russia and in what form? The gathering of elements of culture in a single memorial caused controversy: the relationship between form, adapted from Western European tradition, and content, drawn from Russian history, was as much a subject for debate as the highly selective process of canon-building and the politics of inclusion and exclusion that informed it. The upsurge of public spirit was phenomenal; Lemke compared the commemoration to "a gala procession of Russian public forces."[7]

The elaborate composition of the monument, designed by the young artist Mikhail Mikeshin, winner of a national competition, contains 129 historical and symbolic figures, arranged in three tiers reflecting social and political hierarchy. The overall shape of the monument has traditionally been compared either to a bell (a symbol of the people's voice) or to "Monomakh's cap" (*shapka Monomakha*, a symbol of the Russian monarchy).[8] Formally, however, it is the clear top-down structure of the monument that suggests its intended meaning. A personification of Russian Orthodox Faith occupies the top tier of the monument. Standing on her knees, with her head piously bent, is a woman (an allegorical figure representing Russia) who is receiving an ornate cross from an angel. These two figures rest upon an orb, a customary symbol of the autocracy; distributed around this sphere are statues of seventeen prominent statesmen, grouped to depict six pivotal moments in Russian history. The key characters at this middle level include the legendary founder of Rus', Riurik; Prince Vladimir, who adopted Christianity; Dmitry Donskoy, who liberated the country from the Tatar-Mongol yoke; Ivan III, who unified the Muscovite state; the young tsar Mikhail, who founded the Romanov dynasty; and Peter the Great, who founded the Russian empire. The lowest tier of the monument displays four large groups of historical characters: enlighteners (*prosvetiteli*), statesmen, military heroes, and writers and artists. The latter group consists of sixteen figures: the great scientist and poet Lomonosov; the architect Kokorinov; the playwright Fonvizin; the actor Volkov; the historian Karamzin; the writers Derzhavin, Krylov, Zhukovsky, Gnedich, Griboedov, Pushkin, Lermontov, and Gogol; the

painter Briullov; the composers Glinka and Bortniansky (*image 8*). Here we can clearly discern several layers and compartments of culture: this single segment at the bottom devoted to the arts represents artistic culture in its narrow sense, while the monument as a whole stands for culture in its broadest meaning.

The multitiered monument, with its many complicated meanings and numerous figures of varying sizes and significance, perplexed contemporaries, who were unsure how to read this unfamiliar allegory. *The Northern Post*, the official organ of the press whose sole responsibility was, in the sardonic words of a competitor, "to prove whatever the government deemed necessary," provided the "correct" interpretation of the monument's hierarchical structure.[9] The semiofficial *The Northern Bee* reprinted it verbatim, and versions of this description were repeated in other printed sources as well:

> The top part consists of two bronze figures, which designate Orthodox faith as the principal element in the life of the Russian people. Here one can see an angel holding a cross with one hand and in front of him a genuflecting woman who personifies Russia. A sphere, allegorically representing the orb of the Great Power (*derzhava*), serves as a pedestal to these figures. The following inscription girds the orb: "To the millennium of the Russian state that came to pass during the prosperous reign of Emperor Alexander II, 1862."[10]

Following the explanation of the central allegorical composition, newspapers proceeded to outline the six historical epochs positioned around the orb, concluding with descriptions of the 106 "great persons of the Russian land" at the base of the monument. The narrative structure of the monument invited the viewer to read the entire history of the Russian state in this one sculptural representation. One modern scholar, in fact, called it "an encyclopedia of Russian history," an explicit analogy to Belinsky's famous definition of Pushkin's novel in verse, *Eugene Onegin*.[11]

As an image and a text, the monument circulated broadly in the pages of the periodical press, reaching different groups of society in various parts of the country. This allowed the monument to become public property several years before the official millennial celebration took place in Novgorod. In 1859, a competition for the monument's design was publicly announced in newspapers. Later that same year, Stasov charged the winner, Mikeshin, in print with presenting a false image of Russia.[12] Mikeshin, in turn, countered these accusations in a "letter to the editor," published in the feuilleton sec-

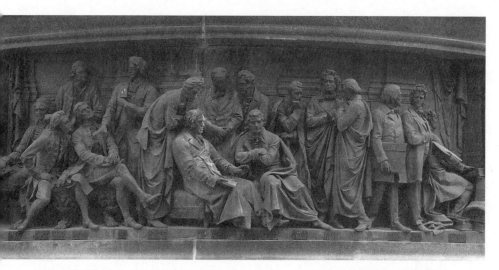

8. Sculptural group representing writers, artists, and musicians, The *Millennium of Russia* monument, fragment (1862). Photo by Dar Veter

tion of *The St. Petersburg News*, claiming that public opinion was on his side.[13] Stasov then wrote again, adamantly refuting the design's originality and nationality.[14] This altercation is just one instance of a vigorous public discourse that grew around the Millennium Monument even before the monument itself existed in material form.[15]

The selection of the historical figures to be included in the bas-relief turned out to be a particularly contentious issue. Heated debates originated in the narrow circle of specialists who gathered at Mikeshin's workshop to draft the master list of Russian national heroes. Among the prominent historians and authors whom the artist invited for consultation were Kostomarov, Ivan Turgenev, and Taras Shevchenko. The draft was completed in August 1860 and, with some amendments, ratified soon after.[16] The print media of the time evidences the fluidity of this canon under construction. One guidebook to the monument, for instance, published a mere three months prior to the Millennium holiday (the censor's permit is dated April 27, 1862), included biographical sketches of the poet Shevchenko and the actor Ivan Dmitrievsky. When the monument was unveiled, however, neither Shevchenko nor Dmitrievsky was represented.[17] Nicholas I, initially excluded from the assembly of national heroes, was added to the composition at the last moment, and newspapers reported on this addition only one month prior to

the monument's unveiling. The demonstratively excluded Ivan IV (Ivan the Terrible) and Pavel I were never "rehabilitated."[18]

The monument became a public site of culture where art and authority met and where imperial and national discourses clashed. The embodiment of national consciousness that the monument was meant to represent was achieved at the cost of effacing potentially compromising elements from it. Shevchenko's expulsion from the monument is one good example. A Ukrainian bard, writer, and artist, Shevchenko was a distinct presence in the public sphere until he had been sent into exile for his participation in what the government deemed the subversive activities of the Brotherhood of Saints Cyril and Methodius; upon his return to St. Petersburg in 1858, Russian society welcomed him warmly as a martyr.[19] Shevchenko then actively participated in shaping the monument's composition in Mikeshin's studio until his death in 1861. Later in this chapter, I discuss his pursuits at the Academy of Fine Arts as well. Still, he was deemed too polarizing a figure to be included. A year after the millennial celebrations, this rhetoric of national culture-building translated into the politics of Russification in the suppression of the Polish Uprising of 1863 and the ban on Ukrainian-language publications.[20]

From Mikeshin's workshop, the discussion of which events and people should represent the pride of the Russian nation poured out into the popular press. Journalists and scholars alike participated in these debates. In the opinion of the *Son of the Fatherland*'s feuilletonist, for instance, such a remarkable episode in Russian history as the war of 1812, whose "most energetic participant was the *narod* itself," should also have been represented in the monument. Similarly, the feuilletonist noticed a lamentable gap in the representation of Russian authors, where the figures of Vissarion Belinsky, Timofei Granovsky, and Gavrila Derzhavin should have been situated.[21] Even the addition of Gogol, whom Mikeshin adamantly defended, was not uncontroversial. Another journalist regretted the absence of the painter Alexander Ivanov amidst the already modest number of writers and artists and contested the inclusion of the architect Alexander Kokorinov.[22] The most extensive list of critical suggestions belonged to the philologist Buslaev, who viewed the whole selection process as utterly strange and arbitrary. "What kind of *heroic deed* is it to *found* a theater in Russia in the middle of the eighteenth century when it had long ago been established, renewed, and modified in the West?" With this rhetorical question Buslaev assails the figure of "some Volkov" (*nekto Volkov*), the founder of Russian theater. According to Buslaev, "some Kokorinov" (*nekii Kokorinov*) should not have

been commemorated either, whereas Andrei Rublev and Simon Ushakov, the old masters of icon-painting, should have. And if some "translator of verse" (*stikhotvornyi perevodchik*) Zhukovsky must be represented, so too must Derzhavin.[23] An appeal for Derzhavin's case was in fact "approved," and *The Northern Post* officially informed the public about this adjustment to the monument.[24]

One popular brochure, issued in 1862, was particularly critical of the facets of Russian culture that the monument represented. The author found missing, among several others, the following national heroes: the self-taught inventor Kulibin, the poet Kol'tsov, the architects Rastrelli, Bazhenov, and Voronikhin, and the painter Levitsky, who became known to Europeans during the latest International Exhibition in London.[25] The author also most strongly objected to "some sort of chlamys" (*khlamida*) that the sculptor draped Gogol in, referring to a fluid cloak that looked like a Roman toga. This innocuous detail was a convention of classical representation, but clothes borrowed from Roman antiquity sent a strange message about the image of a national culture. The Academy's Conference Secretary Fedor L'vov called the entire composition an incoherent "mass of bronze."[26] Stasov accused the monument of French melodrama and compared it to a whimsical vignette, or a jumbled charade.[27] This stream of counter-discourse, represented by Stasov, Buslaev, and L'vov, undermined the monument as too intentional and pretentious. To listen to them, the memorial to one thousand years of Russian history was an aesthetic disaster.

As a whole, contemporaries found the iconography of the monument to be confusing. Representing the nation in the shape of a woman was a novelty in Russia, and Mikeshin's "allegory of the female form," while familiar in Europe, puzzled some Russian critics and offended others.[28] Stasov, who deemed the monument a "pathetic imitation" of European art, named the Bavarian statue in Munich specifically as the prototype for the Russian monument. That Mikeshin dressed the top female figure representing Russia in a national costume also seemed to provoke more than convince. Dissonance between form and content was precisely Stasov's main point of contention. A foreign form imposed on national content resulted in an eclectic allegory, impenetrable to the common people. Stasov compared it to an "idle trinket" (*prazdnaia igrushka*) in the rococo style: "What is so good, what is so smart in all these riddles, allegories, and mysterious abstractions? If you do not tell the viewer about them ahead of time, he won't be able to figure them out by himself. And even if he guesses right, what's the use? 'Idle, idle toy!'—he will

first say, as he is walking and looking at the monument from all sides. 'And a toy with little artistic merit (*malokhudozhestvennaia igrushka*)!'—he would then add, having studied it more intently."[29] Buslaev likewise observed that the incomprehensible monument, with its ornate symbolism and complicated allegories, would not fulfill its intended function as "a book for the illiterate" (*kniga dlia bezgramotnykh*).[30]

For a work of art whose creation was personally supervised by the emperor, the plurality of publicly available opinions is striking. Discourse and counter-discourse coexisted in the public space created around the monument. The press did not make the final decisions on inclusions and exclusions, but it allowed for subversive statements to be made available alongside the official interpretation published in *The Northern Post*. Commenting on the variety of public responses to the monument, V. Ch. from *Son of the Fatherland* even attempted to classify all existing opinions, dividing them into separate categories. In conclusion, V. Ch. exclaims:

> But let me repeat, it would be totally impossible to hear out, let alone express on paper, the whole mass of opinions, judgments, objections, and explanations, which I chanced to hear today in the crowd of spectators, now tearing the monument apart detail by detail, now criticizing it in its entirety.... But all these diverse opinions agreed on one thing, namely that the emancipation of the peasantry from slavery should have been the seventh epoch represented on the monument, next to the other six that encircle the orb.... Let me repeat again, there is no counting of all those opinions and judgments![3]

This talk of the nation continued in other forums as well. One of the publications issued in conjunction with the Millennium, despite its didactic content, bore the friendly title *The Conversation* (*Beseda*), as if inviting others to listen in and participate in the discussion. In the monument itself, some characters, notably writers and artists, were represented as being engaged in casual conversation as well.

Maiorova observes that the placement of writers and artists in the national representation indicated that a new idiom for the dialogue between the state and society was being shaped. The public's participation in debates over the monument's composition was a tribute to a growing public sphere where counter-discourse could be, however provisionally, accommodated.[32] In this way, the Russian public engaged in the making of culture, justifying, at least in some sense, the monument's official designation

as national (*narodnyi*).[33] The monument's "nationality," however, was repeatedly questioned by its critics.

Panaev, for instance, observed before the millennial festivities took place in Novgorod: "In Mr. Mikeshin's monument we can see various famous persons from our history, but we cannot see either Russia or the Russian people."[34] In the categorical judgment of Stasov, this "monument to the people" represented neither the character nor the history of Russia in its fancy European design, just as it visibly lacked statues depicting the Russian people (*russkii narod*).[35] The *narod*, in whose name it was ostensibly created, was the monument's blind spot. Ivan Aksakov similarly underscored the exclusion of the common folk in his critique of the "Western jubilee sentimentality" surrounding the Millennium.[36] Buslaev developed this critique to a much greater extent in the pages of the moderate liberal newspaper *Our Time* (*Nashe vremia*):

> [T]his monumental work of art, in its historical and national content, does not come close to representing what the Russian people now understand to be their history and nationality.... *Nationality* issues define the main currents of contemporary life. In their name, wars are declared, policies enacted, and millions of enserfed laborers emancipated.... In order to be a true representation of this epoch, the monument to the Russian millennium ought to have fulfilled these contemporary demands of nationality, all the more so because it is a monument of history and of the people.[37]

In other words, the monument fell short of expressing the "national consciousness" (*natsional'noe soznanie*) of all of Russia; instead, it commemorated the millennium of the Russian state. Two decades later, Stasov would emphasize again the monument's "complete lack of nationality" (*polnaia nenarodnost'*).[38]

Considering all these divisive opinions, how could the monument function as a unifying presence in society? The press delivered both negative and positive statements, factual as well as false. Next to the monument's harshest critics, other authors represented the monument as a means to coalesce individual Russian citizens into an imagined community of a nation. One journalist wrote on the day of the festivities, for instance, "the entire Russian nation came together into one whole, no longer divided by anything, and moving toward the one great goal of progress."[39] Ar. Eval'd of *The St. Petersburg News* also underscored the "all-national" spirit of the holiday in

September 1862. Moreover, he provided a typical conversation of ordinary passengers traveling to Novgorod by train to illustrate his point:

—Where are you going?
—To Novgorod.
—To the unveiling of the monument?
—Yes.
—So, what's this monument like?
—Don't know, haven't seen it yet.
—When is the unveiling?
—The eighth of September.

And this, or something like this, you hear not in one, but in two, three, or four different corners of any train car. If you go into a different carriage, the story is exactly the same there. The name Novgorod is on everybody's lips, it follows every step and every conversation, so that you constantly find yourself caught in the crossfire of the words "Novgorod," "the monument," "the millennium," etc.[40]

The image of such spontaneous conversations is particularly effective in creating the impression that on the eve of the Millennium, the whole country participated in a common experience woven around Russia's heritage. A web of debates and opinions, this public discourse simultaneously reflected and fashioned the jubilant spirit of the nation.

The monument became a part of the nation-building scenario in another way, too, as reporters depicted all Russian citizens, regardless of rank, as "participant observers" in the millennial celebrations. An extended dramatization of one such scene, in which a tipsy soldier and a stately general freely engage in a dialogue near the Millennium Monument, was included in a Novgorod dispatch for *The St. Petersburg News*. In the middle of his otherwise fairly solemn reportage, the narrator introduces a group of drunken soldiers who debate the identity of the main historical figures, while surveying the monument closely. To dispel his companions' doubts, one brave soldier addresses their question directly to a general, grabbing the latter's elbow:

—Pardon me, your honor, that is your Excellency, he said wavering and taking off his hat: allow me to ask, is that not tsar Mikhail Fedorovich?

I confess, I did not expect the general to like such frivolity; I thought he

would rebuke my tipsy historian or, at least, leave his question unanswered. But the old general did not even try to free his elbow from the soldier's arm, nodded to him, and having looked up at the sculptural group in question, said calmly,

—Yes, it is Mikhail Fedorovich.[41]

Simplistic as they may appear, reports of such extemporaneous exchanges accomplished several things. By effacing divisions between classes, these representations helped create an impression of national unity.[42] They also made the monument readable for those who had difficulty deciphering Mikeshin's allegories. Moreover, writing compensated for the critical absence of such categories as the common people. By including soldiers and peasants in their reportage, journalists "corrected" the monument and represented the people as equal participants in the millennial celebrations. Contrary to critical opinions voiced by Buslaev and Stasov, other authors imagined even poorly educated people relating to the monument with ease.[43]

Intertwined with the theme of nationality was the leitmotif of "February 19th," as the press familiarly referred to the recent emancipation of the serfs. The feuilletonist of *Son of the Fatherland*, for instance, represented "liberation" (*osvobozhdenie*) as the common denominator in all the key epochs of Russian history, thus recasting the history of Russia as a continuous story of a freedom-loving state.[44] Another optimistic feuilletonist represented February 19th as the direct precursor to the revival of the Slavs: "Russia's millennium! Russia's millennium! The bell has rung! This is not the funeral dirge of the dying state; it is a call for the Slavic tribes to be reborn into a new life, the harbinger of which we celebrated on February 19th!"[45] The emancipation decree had laid a sound foundation for the new millennium, as the press represented it, affording a prominent place to the reigning tsar Alexander II.[46] Both forward- and backward-looking narratives regarded Alexander as one of the main heroes of the festivities, orchestrated according to a principle that Richard Wortman calls "the scenario of love": "The dedication ceremony of the statue was a moving performance of the tsar's scenario, confirming the bond of affection he felt for the estates of the empire."[47] Indeed, one contemporary journalist drew on precisely this alliance of the people, the tsar, and the Millennium as he projected the popular memory of the ceremony into a distant future:

[C]rowds of peasants line the banks of the river Volkhov in order to catch a glimpse of the One who decreed February 19th. Tomorrow they will take a

look at the monument and then disperse to their villages, leaving everywhere behind them bits of news about what they've seen and heard. And for a very long time afterward, memories of the all-Russian millennial celebration will be passed on from family to family, from generation to generation, among friends and around the dinner table.[48]

Writing from the perspective of the people's future memory of the past, V. Ch. went well beyond mere reportage in his representation of the national holiday. Crowds of commoners composed the necessary background for every scene of the great theatrical performance that took place in Novgorod, as they did, for instance, in several *lubki* issued for the occasion. The *narod* was not granted a speaking part in that show, the very meaning of which depended on the common people's silent presence.[49] But the rhetorical construction of the *narod* in the press made its imagined collective voice audible.

Not every participant in the nationwide debates accepted this agreeable scenario. Next to positive constructs of a nation liberated and united by emancipation, appeared an open mockery of celebratory discourse, as exemplified by Grigory Eliseev's article in *The Whistle* (*Svistok*), "862-1862, or Russia's Millennium." In this piece, Eliseev cast doubt on Russia's "unbelievable achievements on the way to progress and civilization" by revisiting the accursed questions that the monument was supposed to have laid to rest. "Should we move forward or backward?"; "How should we move forward—with our primers (*bukvar'*) or without?"[50] Under the pressure of so many question marks, the projected continuous narrative splintered again into so many fragments.

At the time of the Millennium celebrations, Russia's past was a topic that preoccupied broad circles of society, from scholars who delivered public lectures, to feuilletonists who reported on those events. Russians' "obsession with history" was by no means new; what was original in the 1860s, however, was the opportunity to discuss and debate national heritage in public and in print. According to the historian Pavlov, history also mattered because knowledge of the past leads to national self-understanding (*samoponimanie*).[51] The press construed a thousand years of history as an important milestone for the Russian people, "a monument to their past and a pledge for their future" (*pamiatnik svoemu proshedshemu i zalog budushchemu*), in the words of the second correspondent for *Son of the Fatherland*.[52] A different correspondent for the same periodical added later that anniversaries were "convenient moments" to review the past and evaluate it without prejudice.

Real and metaphorical monuments invited the Russian public to historicize a thousand years of national experience.

A number of contentious issues in Russian historiography (whether the Varangians landed in 852 or 862; whether they made their entry peacefully or by force, etc.) were vigorously discussed in anticipation of the Millennium celebration. One event that attracted a lot of public attention was an open dispute on the origins of the Russian state between Mikhail Pogodin, a historian from Moscow, and the "beloved professor" of St. Petersburg University Kostomarov.[53] At the core of this scholarly "duel," which took place on March 19, 1860, in the overcrowded Great Hall of St. Petersburg University, was the ethnic identity of the first princes of Rus': were they Norman Varangians (Pogodin's position) or ancient Lithuanians (Kostomarov's argument)?[54] Although the scholarly details of the argument turned out to be "dry" (at least in Chernyshevsky's opinion), all of St. Petersburg was abuzz over this display of "scholarly literary fireworks."[55] What distinguished this event, which turned arcane scholarship into a public performance, was its broad publicity. The "duel" was generously and enthusiastically covered in the press; the censor Nikitenko, who dismissed it as "merely a spectacle" (*prosto zrelishche*), was in the minority.[56]

Pogodin opened the evening with an emphatic statement to the effect that Russian society was finally mature enough to conduct public debates.[57] That history and identity had become the subject of public discourse was also a sign of society's progress. As the senator and satirical writer Kastor Lebedev commented, the burning questions of the day reflected even ancient history: "The times are not the same as they used to be in the 1830s and vital basics (*zhiznennye nachala*) of journalism rub off even onto questions dealing with events of the ninth century." The participants closed the debate on Russia's contested origins with a conciliatory salutation, "Long live our Russia, no matter whence she has come from! (*da zdravstvuet nasha Rus', otkuda by ona ne prishla!*)," greeted favorably by the audience and the press.[58] Many other scholarly debates and public lectures that soon followed continued to broadcast the millennial themes of heritage and identity across the country.[59]

Representations of the Millennium circulated in society in a variety of forms and meanings. The newspaper was only the most easily accessible medium. Publishers issued scores of books, brochures, pamphlets, illustrations, and guides, aimed at a variety of educated and semieducated audiences. Two commemorative publications appeared in conjunction with the millennial festivities: *Historical Poster on Russia's Millennium* (*Istoricheskaia*

karta-tablitsa tysiacheletiia Rossii), an illustrated overview of Russian history, and *An Ethnographic Description of the Peoples of Russia* (*Etnograficheskoe opisanie narodov Rossii*), a guide to the ethnic composition of the Russian empire.[60] Another guide, *Bibliographic Sketches of Those Represented on the Monument to the Russian Millennium* (*Biograficheskie ocherki lits, izobrazhennykh na pamiatnike tysiacheletiia Rossii, vozdvignutom v g. Novgorode 1862 g.*) by N. Otto and I. Kupriianov, enjoyed considerable popularity as well. The official calendar for 1862, *Mesiatseslov*, published an article by historian Platon Pavlov titled "The Russian Millennium: A Brief Sketch of the History of the Fatherland" (*"Tysiacheletie Rossii: Kratkii ocherk otechestvennoi istorii"*). Appended to it was a lithograph of the Millennium Monument that allowed many far and wide to visualize the memorial months before it was formally unveiled.[61] A commemorative bronze medal was struck to mark the September celebrations as well.[62]

The monument was also reproduced in contemporary *lubki*, lithographs, and photographs, several of which *The Northern Bee* feuilletonist reviewed soon after the festivities.[63] The feuilletonist of *Son of the Fatherland*, in turn, even suggested that the Millennium Monument should be reproduced in "hundreds of thousands" of miniature models so that people could imagine the past and the future of their Motherland "in every corner and quarter of Russia."[64] It was this endless reproducibility of the monument that rendered it a genuinely national object, its many versions disseminated in different visual and verbal forms among the Russian population. Despite its remote location and obscure iconography, the monument enjoyed a continued presence in Russian society. In this sense, the monument defied its harshest critics, who predicted that it was doomed to oblivion. Stasov encapsulated this critical spirit as follows: "This monument has been standing in its place for twenty years now. But why is it here? Who needs it? Does anybody even see it in its corner in Novgorod?"[65] Nevertheless, discourse kept the monument alive, albeit in the form of many dissonant narratives.

The Imperial Hermitage

The Imperial Hermitage was last among the major royal galleries in Europe to open its doors to the public in 1852. Free entrance to the museum was instituted even later, in 1865. While the idea of an institution of art for the public was both appealing and urgent in Russia, the Hermitage joined

the nation-building project with reluctance. This contrast with the Millennium Monument is telling. To judge by the contemporary periodical press, the Hermitage was then virtually invisible to the public. This invisibility is all the more striking today because the Hermitage is now arguably Russia's main museum. In the age of cultural nationalism, however, the Hermitage could offer little to patriots of Russian art either in terms of artwork or conversation. There was a small collection of Russian paintings in the museum starting in 1825, but it was uneven, random, and dominated by neoclassical subjects such as Briullov's *The Last Day of Pompeii* and Bruni's *The Brazen Serpent* (*Mednyi zmii*). Grigorovich was keen to observe that for those interested in Russian art, any church or private collection could offer more and better material than the two rooms of the Hermitage.[66] Overall, very little attention was paid to developing the Hermitage's Russian collection until 1897, when it was removed from exhibition altogether to become part of the Russian Museum. The museum's glory was and remains its superior collection of Western European art.

For its first one hundred years, the Hermitage museum, contiguous with the official residence of the Russian tsars in the Winter Palace, was a strange institution. The museum's origin dates to 1764, when Catherine the Great bought her first major collection from the Berlin dealer Johann Gotzkowski. In the following two decades, the Russian empress accumulated an impressive collection of Western art that could rival the older and more prestigious museums in Europe. Aside from Western European painting, Catherine's "enlightenment project" comprised engravings, natural curiosities, and an impressive collection of 10,000 cut gemstones. The museum originated as a small pavilion named "the hermit's abode," but it soon became the site for the so-called Hermitage assemblies, consisting of games, theater performances, and sumptuous banquets. In this scenario, paintings essentially provided a background for Catherine's Hermitage theatrics; her art gallery, located next door to the Hermitage Theater, became another stage for the exhibition of Russia's cultural capital. The Hermitage thus served as a showcase of enlightenment that advantageously represented Russia to foreign visitors.

During the first half of the nineteenth century, the Hermitage began to gradually metamorphose from an exclusive private collection to a public museum. Since the museum was essentially an extension of the Winter Palace, access to its riches before the 1850s was limited to a select few, including art-lovers of the noble estate, foreigners, and the students of the Academy of Fine Arts, and this only when the imperial family was away. When the court

was at the Winter Palace, only court society and special foreign dignitaries could gain access to the collection.[67] One foreign visitor, the German traveler Johann Georg Kohl, observed on this account: "The visiters [sic] to the Hermitage are not very numerous, because strangers as well as foreigners must obtain special tickets, which, it is true, are granted without difficulty; yet this little obstacle is sufficient to keep a great number of persons away.... There are in Petersburg many highly cultivated families who have never yet visited the Hermitage."[68] In 1826, for instance, only 600 tickets were printed. Since the Hermitage belonged to the Ministry of the Imperial Court's domain, contemporary city guides listed the museum under imperial palaces, not institutions of culture.[69]

The Gallery of 1812, which opened in December 1826 to display 332 portraits of military leaders who had distinguished themselves in the war with Napoleon, was one of the few pockets of public culture within the Romanovs' official residence that attracted the attention of contemporaries, like Alexander Pushkin, who described the Gallery in his poem "The General" (1835). Another important public event was the exhibition of Karl Briullov's famous painting *The Last Day of Pompeii* (1830–33) (*image 9*). The painting arrived at the Hermitage on the wings of European fame in August 1834 as a gift to Nicholas I, who accepted it graciously and summoned Briullov from Italy to assume a professorship at the Academy of Fine Arts. Many wrote about this special occasion, including Pushkin, Lermontov, Baratynsky, Zhukovsky, and Herzen. Nikolai Gogol recorded his impressions of the painting in an essay published as part of his *Arabesques* in 1835.[70] All these written accounts provided useful commentary on Briullov's painting, but this work of art still remained largely unfamiliar to the public. One anecdote that surfaced in 1899 in conjunction with Briullov's jubilee helps underscore the scarcity and poor quality of the means for disseminating art in the earlier half of the nineteenth century. Prior to the arrival of *The Last Day of Pompeii* to St. Petersburg, several reproductions circulated in society that were not copies but variations based on verbal descriptions of the painting. Even when the painting was displayed in St. Petersburg, it still remained a "fairy tale" in Moscow, and apparently the artist himself visited a panorama based on his painting, which had very little to do with the original.[71]

Following isolated instances of public display within the Winter Palace, Nicholas I commissioned a German specialist in museum architecture, Leo von Klenze, to build a separate building for the collection. On February 5, 1852, after ten years of construction, the New Hermitage, a neoclassical edi-

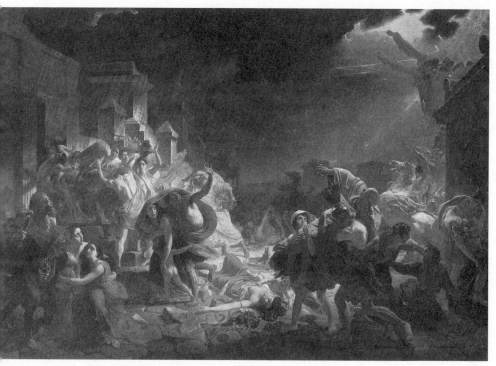

9. Karl Briullov, *The Last Day of Pompeii* (1830–33)

fice decorated with a Greek-style portico and the granite caryatids *Atlantes*, received its first visitors—guests of honor invited to an elaborate fete in the Catherinian tradition, which the emperor hosted to mark the occasion.

The opening of the public art gallery was a pivotal moment in the history of Russian culture. Still, the museum did not convert into a modern institution overnight. For its first decade, the New Hermitage was a public museum in name alone: "One visited the emperor, not the museum," as Germain Bazin laconically observed.[72] According to the 1853 set of visitors' "rules," formal dress—a black frock coat or a uniform—was a necessary attribute for the museumgoing public (with the exception of artists who came to work in the museum), and tickets were required of all visitors. One of the first guidebooks to the public museum described the situation succinctly: "In the previous century, the Hermitage functioned as a retreat for the imperial family and *coincidentally* as a museum. In our times, its character remains the same."[73]

As in the days of Catherine the Great, the ruling family continued to define taste in the public museum as well. The collection of the New Hermitage

was organized around Nicholas's erratic aesthetics and the sheer arbitrariness of his regal judgment. The artist Bruni recorded the following exchange with the sovereign, which took place as they sorted paintings in the Hermitage storage rooms:

—This is Flemish!
—Your Majesty, but it seems to me…
—No, you, Bruni, better not argue. Flemish it is.[74]

Nicholas likewise distinguished himself by auctioning off over a thousand paintings from the collection because he deemed them inferior. Despite these acts of "epidemic barbarism," as noteworthy art historian Baron Nikolai Vrangel qualified the sovereign's taste, the opening of the Hermitage as a public museum during his reign was no small achievement.

In the 1850s, the Hermitage still did not have all the necessary attributes of a modern museum: a complete inventory, catalogues, guidebooks, reproductions, art criticism, and unrestricted access. It was not until the early 1860s, when the director of the Berlin Museum Art Gallery, G. F. Waagen, was invited to modernize Russia's main museum that the Hermitage's collection was systematized and its full catalogue put together. A new set of "rules" adopted in 1863 eased the dress code, allowing social groups that lacked the requisite frock coats and uniforms access to the museum.[75]

In early 1864, the popular newspaper *The Voice* captured the spirit of these institutional changes, necessitated by the cultural and social renaissance of the 1860s, in the following summary:

> Recently, significant changes have been taking place in the Hermitage, the necessity of which has been felt for a long time. Thus, those wishing to visit the gallery and museum now do not encounter the same restrictions, which prevented many, perhaps, from such visits: now it is no longer absolutely necessary to wear a frock coat, for instance, etc. But these are trifles; most importantly the new reforms consist in the strict system, which had been applied to the Hermitage's multifaceted departments, and in the chronological order in which the precious artworks stored there have been classified.[76]

The newspaper mentioned another innovation as well: the museum had established the position of "director," appointing Stepan Gedeonov to occupy the post in 1863. This seeming formality introduced more than just

a new title; as Geraldine Norman has suggested, it marked a whole new stage in the history of the museum: "From the 1850s onwards, the molding of the museum's character slipped out of the hands of the imperial family and into those of professional administrators." It was Gedeonov who, during the reign of Alexander II, bought for the Hermitage such masterpieces as Leonardo da Vinci's *Litta Madonna* and Raphael's *Madonna Connestabile*, as well as an invaluable selection of antiquities from the Campana collection.[77] Under the director's initiative, the system of entrance tickets was altogether abolished in 1866. The number of visitors increased dramatically, reaching an estimated 50,000 a year in the 1880s, and continued to grow steadily in the following decades. During the last years of the Romanovs' reign, the Hermitage attracted close to 180,000 visitors per annum.[78]

With the conversion of the Hermitage into a public institution, a process that entailed the establishment of a professional administration, systematization of the collection, and unrestricted access to the public, the monarchs began to distance themselves from the museum. Yet despite these popularizing reforms, which swept the museum in the second half of the nineteenth century, Russian society hesitated to embrace the Hermitage's outstanding collection of Western European art as its own. The increasing number of visitors notwithstanding, lukewarm reviews of the Hermitage as a public facility culturally remote from Russia continued to punctuate the press throughout the optimistic 1860s and beyond. One journalist reported that there was something disingenuous about the Hermitage; another claimed that hardly anybody ever went to this major museum at all.[79] Worse, by the turn of the century, this temple of the arts in Russia was routinely described in sepulchral terms. Stasov, for example, compared it to a "gloomy well," while Sergei Makovsky described it as "a cemetery of art."[80] Alexandre Benois, who spent a lot of time copying in the Hermitage in the 1890s, recalled in his memoirs that "overall, the Hermitage stood empty (*pustoval*) during those years."[81] A seemingly legitimate source of national pride, the Hermitage was nonetheless never a popular museum for the duration of the nineteenth century. One modern scholar captured the essence of this conundrum perfectly: "One gets the impression that nineteenth-century Russian society passed by the Hermitage treasures, having deferentially taken off its hat in recognition of their absolute and well-deserved value, but for some reason its genuine interest was never really kindled."[82] Several reasons can be offered to explain the Hermitage's paradoxical position in the Russian public sphere.

In the first place, before the middle of the nineteenth century, the Hermitage was the exclusive domain of the Romanovs and their occasional guests. Afterward, the reserved tickets and formal attire required of all visitors circumscribed the general public's access to the Hermitage and delayed the museum's entrance into the burgeoning public sphere. Even after 1861, when the majority of the Russian population was liberated, the Hermitage did not become a favorite destination for the poorly educated masses. It seems that despite their physical proximity, European works of art remained out of reach for those museumgoers who did not know *how* to reach them.

Indeed, physical access accounts for art's broader availability to the public only in part. In an intriguing study, Pierre Bourdieu and Alain Darbel have demonstrated that artistic taste, an entirely "natural" phenomenon at first glance, is, in fact, a "cultivated pleasure"; far from offering an egalitarian art forum for all, the true function of museums is rather "to reinforce for some the feeling of belonging and for others the feeling of exclusion."[83] The Russian Hermitage functioned precisely as such an institution of exclusion even during the liberal 1860s.

If potential museumgoers needed a basic education in aesthetics (hitherto taken for granted by the Hermitage owners and their elite guests), the museum itself needed publicity. It was not enough to unlock the doors that guarded the national treasures and to make the works of art generally available to the public; for the institution to succeed, the support of Russian society was essential. Already in the late 1850s, Alexander II had commissioned a series of watercolors representing the Winter Palace and the Hermitage that recorded for posterity every detail of the imperial museum; soon thereafter, a series of catalogues and travel guides was issued to help increasing numbers of visitors, unencumbered by an education in aesthetics, navigate through the museum's vast galleries. Writing about the Hermitage in guidebooks, travel narratives, art journals, and the popular press helped bridge the gap between art and society. These publications, along with the administrative changes of the 1860s, slowly began to improve the museum's public image. A connection between the growing ranks of museumgoers and the accelerated production of literature about the museum in the 1860s is apparent; the 1880s and 1890s saw another such increase, and in the early decades of the twentieth century, newspapers were also drawn into this distribution network to meet the growing demand for information about the museum and its treasures.

Between 1859 and 1865, four guidebooks came out in quick succession, all aimed at the general visitor.[84] Among them was *A Stroll through the Hermit-*

age (*Progulka po Ermitazhu*) by Grigorovich, who framed his description of the museum in terms central to the spirit of the 1860s: national pride and popular education. The author's writing clearly intended to stir up patriotic sentiments in the general audience: "Not only does the Hermitage, with all the treasures contained therein, give rise to the feeling of national pride in everyone who comes to visit it—it also influences the development of taste and thus imperceptibly enlightens the visitor." Grigorovich wishfully represented the museum as a popular destination: "The importance of the Hermitage for Russia is proven by the fact that even though it has been inaccessible to most until now, and even though no strong interest in art has been noticed in our society, the Hermitage nevertheless enjoys great popularity in our fatherland. Just say the word 'Hermitage!' in any corner of Russia—everyone has already heard of it. Even those who have never been to Petersburg inquire about it."[85]

Grigorovich's guidebook was one of the first conscious efforts to redeem the Imperial Hermitage for Russian society. The important work of publicizing the museum's collections continued in the following decades in the pages of new art journals like *The Herald of Fine Arts* and the *World of Art*; photographic reproductions of the museum's masterpieces helped advertise the Hermitage for broader audiences as well.[86] Russian artists, for whom the Hermitage had served as a workshop and a school since its inception, soon joined forces in publicizing it. In the artistic community of the 1880s, the museum attained prestige at the hands of the famous painters Ilya Repin and Vasily Surikov, among others, who took the lead in reestablishing a positive reputation for the Hermitage after years of disregard.[87]

Perhaps the main reason behind the Hermitage's loose connection to the Russian public lies in the fact that its conversion to a public museum coincided with the rise of Russian national aesthetics, which I discuss in greater detail in the following chapter. The attention of Russian society in the 1860s was drawn to the new Russian school of art. The public demanded Russian paintings, of which the Imperial Hermitage, renowned for its collection of European masterpieces, possessed remarkably few. A lack of general education in the field of Western European art, combined with an increased interest in all things Russian, led the press to simply bypass the Hermitage, leaving it at the margins of the nation-building project.

At the turn of the century, the Hermitage continued to support the alternative model of cultural identity first advanced in the cosmopolitan age of Catherine the Great, which anchored national pride in a world-class collection of non-Russian art. Some critics, in fact, argued that the museum

remained "frozen" in the age of Catherine the Great.[88] When near the century's end Benois proclaimed the Hermitage to be "the main museum of the Russian state," the era of acute debates on nationality in the arts was largely over.[89] The image of this museum in the Russian public sphere depended heavily on whether those writing about it considered art from a national or a cosmopolitan perspective: this dialogue between discourse and counter-discourse continued until the end of the imperial period. During the second half of the nineteenth century, when issues of national identity dominated artistic discourse, the Russian public did not actively engage with this world-famous collection of non-Russian art. In a sense, there was nothing to argue about, hence the paucity of popular writing on the subject in the press.

Narratives of the Academy of Fine Arts

Amidst the sweeping reforms in all spheres of public life, the Imperial Academy of Fine Arts turned one hundred years old in 1864. The centennial became a momentous occasion to reflect upon the history of this institution and its role in Russian society. Two important dates stand out in the early history of the Academy. In 1758, during the reign of Elizabeth, the Imperial Academy of the Three Most Noble Arts—Painting, Sculpture, and Architecture—was founded by the statesman and patron Ivan Shuvalov. In 1764, Catherine II furnished it with its Statutes, Title, and Privileges.[90] Within a decade, a new building befitting a temple of the arts was designed by the architects Vallin de la Mothe and Kokorinov.[91]

But the inscription "for the free arts" that graced the Academy's stately building only partially reflected the actual state of artistic affairs in Russia. Elizabeth Valkenier writes that "the Academy has been, by and large, the mainstay not of free but of official art." The history of the institution had, in fact, been directly connected with the changing tastes and whims of the ruling monarchs. Catherine's initiative in the realm of the fine arts, for instance, was of critical importance for the development of the artistic scene in Russia: an avid collector, she not only outfitted the Hermitage with some of the best specimens of Western European painting, but took care to promote Russian art within the Academy's walls as well. Already in the first months of her reign, Catherine the Great visited classes at the Academy and inquired about the students' progress. Nicholas I, another self-styled connoisseur of the fine arts, did not spare any expense, either on the expansion

of the Hermitage or on artists' trips to Italy. At the same time, in 1829, he placed the St. Petersburg Academy under the jurisdiction of the Ministry of the Imperial Court and, in 1843, decreed that only members of the imperial family could be appointed to preside over it.[92] Under Nicholas's punitive regime, Valkenier summarizes, "the Academy was transformed into an instrument that molded artists into servitors of the state, subordinated art to the needs and tastes of the Court, and controlled artistic life throughout the country."[93] By midcentury, the Academy was a noticeably unfree institution.[94] Under these circumstances, the channels of communication between art and society, which the Academy presumed to uphold, were limited to triennial exhibitions and occasional reviews.[95] Judging by the periodical press of the time, the three key attributes that contemporaries used to describe the Academy's role in society were, in fact, all negative: the Academy was exclusive, formalistic, and antinational.

In 1839, the newspaper *The St. Petersburg News* published rules that were to be observed by visitors to the Academy during the two weeks that it was open to the public for the latest triennial exhibition. Complicating the public's access to the art was the condition that all visitors had to wear "decent attire" and that their behavior was to be strictly regulated (the rules even prescribed the specific route that the public was to follow through the galleries).[96] An important change came in the 1850s, when, to the public's delight, the Academy began holding annual exhibitions, described by one contemporary as "although poorer, at least more frequent."[97] But even then, the inertia of previous decades was hard to overcome, and the huge building on Vasil'evsky Island, "with its dark corridors, with its cold studios and big halls, which all together compose the Russian Academy of Fine Arts," remained "consigned to oblivion."[98] Russian art continued to be a "stranger" to the broader public, never leaving the walls of the Academy, a "majestic but gloomy building, which looks more like a coffin for art than its seed-plot.... Only once a year is the Academy's serene slumber disturbed, namely at the time of the annual exhibition, when the public was admitted to the two or three clean rooms of the sad building...."[99] The artist Lev Zhemchuzhnikov, who left the Academy in 1852, chose the same imagery of death and decay to describe the Academy of the 1840s and early 1850s: "It emitted mustiness, conventionality, and a lack of life."[100] As one amateur critic commented on the fundamental disconnect between art and the public, "our Academy of Fine Arts remains by itself and our society by itself" (*nasha Akademiia khudozhestv ostaetsia sama po sebe, a obshchestvo—samo po sebe*).[101]

The Academy's estrangement from society manifested itself not only in the sepulchral ambience of the building, but in the old-fashioned forms of art that it propagated as well. This Russian institution was typical for its time: the training that it offered to artists was similar to that of other European schools. By the midcentury, however, the neoclassical formalism that came to dominate the artistic canon in the 1830s now stifled the creative initiative of new generations of artists. At a time when society "demanded *national* art*," as Zhemchuzhnikov wrote in the Ukrainian monthly *The Foundation* (*Osnova*), old forms befitting topics from ancient history and classic mythology ceased to be viable.[102] Commenting elsewhere on the archaic demands of the St. Petersburg Academy, Zhemchuzhnikov criticized the "murderous scrupulousness" and the ubiquity of old-fashioned themes—"the same Ajaxes, Achilleses, Herculeses, and Andromedas" that every European academy had "chewed over and over again."[103] Such a rejection of neoclassicism stood in striking contrast to the aesthetic values of previous decades. Stories about the Academy that appeared in the contemporary press help demonstrate how Russian art and aesthetics evolved from the age of Catherine the Great to the time of Stasov, and how the Russian public learned to appreciate the newly found national tradition as indeed their own. As one of the few such institutions in Russia at a time when neither the Tretiakov Gallery nor the Russian Museum was open to the public yet, the Academy became the battleground of opinions on nationality in art.

Although separate appeals for nationality in art had sounded on occasion as early as the 1820s, it was not until the era of the Great Reforms that they found resonance in society at large. In 1817, Russian author and collector Pavel Svin'in wrote, for instance:

> It is highly desirable that the Academy should engage Russian artists to depict the glory of their own Fatherland. This rule is the best means of animating for posterity the great characters and events of our national history.... Nothing could teach Russians to respect what is their own so much as the strong impact of art upon the heart. The painter and the sculptor—no less than the historian and the poet—could be a vital organ of patriotism.[104]

The idea of art as an "organ of patriotism" found temporary embodiment in Svin'in's private museum of Russian painting. The first institution of its kind, it numbered eighty paintings by eighteenth- and nineteenth-century masters by 1829, among them Briullov, Bruni, Kiprensky, and Venetsianov.

Unfortunately, this attempt to gather Russian art terminated in 1834, when Svin'in had to sell his museum at auction.[105] In the absence of a Russian art gallery, the Slavophile thinker Khomiakov warned in the 1840s against the "great temptation" of ready foreign forms and expressed hope for the Russian fine arts. Khomiakov emphasized the organic connection between the nation and its artistic potential and outlined the artistic future of Russia. He argued that the Russian people were still evolving, and so too was their art, which would blossom in time of its own accord: "we can see in our painting only a hint of artistic talent, a guarantee of a beautiful future, but we cannot [yet] see Russian art."[106]

In the 1860s, however, Stasov announced a "new epoch" in the history of fine arts in Russia.[107] If prior to the 1840s Russia was not even considered a subject worthy of representation, two decades later, critics began demanding that the Academy should begin producing specifically Russian paintings.[108] Many journalists of the time observed that the Russian public, which had until recently been indifferent to art, was now showing increasing interest in the kind of art that "reflected its life and its truth," art that was familiar and therefore understandable. As one commentator phrased it, "Already contemporary society approaches art differently and expects to encounter in their artists' paintings a *Russian* mind-set and a *Russian* talent; it expects to find in their paintings not phantoms but reality, not dry phrasemaking but the truth."[109] Public interest in art was so well pronounced that reviewers of the Academy's exhibitions wrote about the crowds of visitors almost as much as they did about the paintings. One writer, for example, opened his review of the 1863 Academy's exhibition with the following panegyric: "The exhibition is always crowded, always packed with throngs of visitors.... Good luck! Let our public be more and more interested in works of art. So much the better for the public, so much the better for art."[110]

In the wake of the reforms, the Academy, much like the rest of society, shook off its heavy slumber.[111] Formerly an exclusive school of formal training, where even the academic museum and library had been off-limits to anybody except their curator, now "the Academy became the property of artists and art lovers and stopped being an isolated world unbeknownst to anyone, covered with mildew and decades worth of dust," as L'vov reminisced. When the public gained access to Russian art, the atmosphere of the annual exhibitions changed as well: "one could feel that society wished to advance this artistic institution further."[112] But the main change was not about the Academy proper: the "antinational" institution maintained its

highly selective status for many years to come. It continued to control the progress of Russian art (or rather arrested it, as some thought) and decided what to include in annual displays and what to send abroad to international exhibitions. However, it could no longer contain the controversy that such decisions generated. Discourse on the arts departed from the Academy and became the property of public debate.

Literary Paintings

Genre painting, the representation of scenes from everyday life, was one of the earliest subjects of controversy. Genre seemed to satisfy the aesthetic needs of the newly awakened, socially aware public. Stasov, for one, famously declared in 1862: "The entire future of our artistic school is in present-day *genres* and *genre painters*."[113] Landscape likewise stirred the public's attention because it strove to represent things that were uniquely Russian, that reflected the truth of quotidian life.[114] Christopher Ely argues that in the last third of the century, the Russian landscape, with its fields and forests, churches and peasants, became an all-inclusive genre that helped convey an image of Russia common to all. "By the final decades of the nineteenth century, the humble native landscape had become a mark of national distinctiveness and a point of pride throughout Russian culture."[115]

Genre painting began attracting ever greater crowds of visitors in the late 1840s. Describing the effect of some of the genre scenes exhibited at the Academy in 1850, one reviewer commended the "poetic riches hidden in the most unpretentious daily life," and declared that "the artistically beautiful does not require either togas or loud names or the bright azure of the skies."[116] By the 1860s, the volume of optimistic commentary on the Russian genre increased significantly. According to a contemporary observer: "Every year, more and more genre paintings appear at the exhibitions, and we should admit, this is quite pleasant to us, ordinary visitors.... Everyday life and everyday interests are somehow closer to the majority, one somehow sympathizes more with people of one's own kind, rather than with different people and different times."[117] The veteran genre painter Repin reminisced about the pure joy of the recognition that everyday-life scenes evoked in Russian society: "At the Academy's exhibitions of the 1860s, these pictures were a festive occasion of a kind. The Russian public rejoiced in them like children. They emanated freshness, newness, and, most importantly, a strik-

ingly real truth and poetry of genuine Russian life."[118] Another commentator also cheered what was perceived as the inherent familiarity of genre painting to the public: "We are not Greeks or Romans—we, ordinary little people, prefer life that is actual, real, that is close to us; we more readily sympathize with ordinary people than with heroes; our hearts lie closer to the drama of everyday life than to drama drawn from history, and genre and landscape are dearer to us than the canvases of 'historical painting.'"[119] The simplicity of the rhetoric in this excerpt is intentional: a familiar tone and an uncomplicated vocabulary helped reach the uninitiated and disseminate information about the fine arts via the popular press.

Next to Bruni's *Death of Camilla, Sister of the Horatii* and Briullov's *The Last Day of Pompeii*, genre paintings by Pavel Fedotov, representing prosaic Russian merchants, and Vasily Perov's depictions of drunken Orthodox clergy, looked very familiar indeed. At the same time, the genre's radical departure from more conventional neoclassical subjects and methods scandalized society. The new subject matter and the novel artistic method, which consisted in the scrupulous, painstaking reproduction of everyday reality in its most minute details, basically meant, as one critic phrased it, that "what the viewers could see in everyday life has gained the right to exist in art as well."[120] A. I. Mikhailov elaborated on this revolution in imagery: "Unprecedented personages have appeared in paintings. As a category of representation, the nobility and aristocracy have almost entirely disappeared. The peasantry, petty bourgeoisie, urban *raznochintsy*, intelligentsia, etc., have become the real heroes of this new art."[121] Another consequence of this fascination with the genre, as Diaghilev observed in retrospect, was that when art was used as "a mirror of everyday life," it turned painting "into an illustration, into a journalistic chronicle of life." It is this utilitarian take on the arts, celebrated by many critics in the 1860s, that the *World of Art* would challenge near the end of the century.[122]

In the meantime, genre painting enjoyed unprecedented success first and foremost because it was accessible to the large portion of the public not familiar with the Academic idiom. As Bourdieu persuasively argues, paintings that reproduce reality faithfully are more likely to be appreciated by the general public: "One of the reasons why the less educated beholders in our societies are so strongly inclined to demand a realistic representation is that, being devoid of specific categories of perception, they cannot apply any other code to works of scholarly culture than that which enables them to apprehend as meaningful objects of their everyday environment."[123] But

even realistic depictions of familiar scenes needed explanation for those not accustomed to "reading" works of art. Iakov Minchenkov, a landscape artist and curator of exhibitions, recalls hearing the following anecdote from Ivan Shishkin, an artist famous for his true-to-life pine forest landscapes:

> [H]e finished a large sketch of pine woods, which rendered nature with punctilious exactitude. It would seem that everything in the picture should be clear—tree trunks, pine needles, and a reflecting brook. But then a peasant woman came up, considered the painting at length, and sighed. Shishkin asks, "So, do you like it?" The woman replies, "Yes, couldn't be any better!" "And what is represented here?" The woman looks closely and determines: "Must be the Lord's coffin." Shishkin is surprised with her answer, and she adds: "I didn't guess right? Wait, I'll send my son Vasiutka, he's literate—he'll guess right away."[124]

Such a response from a visually illiterate peasant helps explain why popular writing on topics devoted to art proliferated: whether they were competent to judge art or not, the feuilletonists responded readily to the public's demand for commentary and attempted to translate the language of images into more familiar words.

This evolving discourse on the arts drew extensively on literature. As critics have demonstrated, commonplace subjects entered the realm of the visual arts in the footsteps of Belinsky and the Natural School. Nineteenth-century literature and art were intertwined rather closely, to which numerous fictional portraits of creative artists, as well as literary interpretations of actual paintings, offer fair testimony.[125] Art depended on writing, thus the "literariness" (*literaturnost'*) found in the works of many Russian artists of the period. For realist artists, in particular, "literary painting" (*literaturnaia zhivopis'*) became a recognizable trademark.[126] Likewise, contemporary litterateurs often worked with visual images—in reviews of art exhibitions, guidebooks, and fiction—"translating" them into literary terms. In the works of Batiushkov, Svin'in, Gogol, Shevchenko, Goncharov, Khvoshchinskaia, and Dostoevsky, among many others, the fine arts found a connection to a broader public outside of the capital cities where most art exhibitions took place.

The genre painter Fedotov, known in art history as a "Russian Hogarth," and touted by Stasov as "the first glimmer of our new direction in art," was an important transitional figure not only in that his work was situated "at a crucial juncture between Romanticism and Realism," but also in that he used both the visual and the verbal media to reach Russian society.[127] Fedo-

tov's three best known works, *The Fresh Cavalier* (*Svezhii kavaler*, 1846), *The Fastidious Bride* (*Razborchivaia nevesta*, 1847), and *The Major's Courtship* (*Svatovstvo maiora*, 1848) had a major impact at the Academy exhibition in 1848. For a start, Fedotov chose lowly, topical subjects drawn from the daily life of the middle estate, which he represented in meticulous detail. The artist took pride in the everyday material in his art: "My most important work is on the streets and in strange houses. I study life."[128] Not only did Fedotov represent life as it was, but he introduced his work with a loud gesture, "in a genuinely petty bourgeois fashion" (*istinno po-meshchanski*).[129] At the Academy exhibition, Fedotov presented his painting *The Major's Courtship* with an accompanying comic poem, which detailed the history of the major's military service, his "poor circumstances," and his crafty plans toward their improvement by virtue of a strategic marriage (*image 10*).[130]

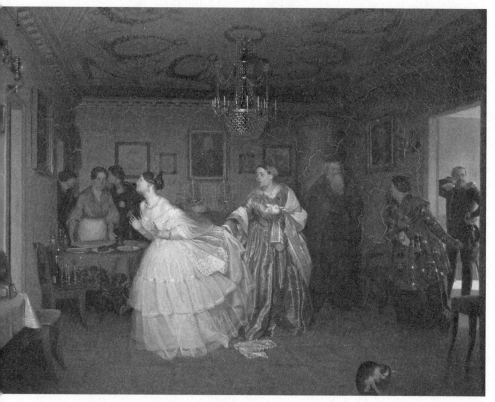

10. Pavel Fedotov, *The Major's Courtship* (1848)

The poem, subtitled "A Preface to the Painting," is written in the first person from the point of view of the major who decides to propose to the daughter of the well-to-do bearded merchant Kul'kov. Although the daughter is neither beautiful nor clever, "a caricature of a bride," the major reasons that by the age of forty, all women look alike. After all, as he casually alludes to Pushkin, "the poet, too, made peace with the crowd and forgot about inspiration." He then sends his servant Sidor to the matchmaker and instructs him to fabricate a story about his anticipated inheritance, imminent promotion, and his nightly appellation to the bride, which he repeats five times: "O Kul'kova! O my angel! Friend!" The poem ends with the servant leaving on his marriage-making errand. The painting suggests that the deal will be a success: the self-assured attitude of the major twirling his moustache, the quietly pleased expression on the merchant's face, the feigned bashfulness of the bride, the exaggerated concern of the mother, the maid's cunning eyes, the servants' conspicuous gossip in the background, the table set with champagne glasses, and even the nonchalantly indifferent cat in the foreground. If the painting may look like a good-humored parody, the accompanying poem, which Fedotov read out loud at the exhibition, was a biting satire. Aside from being ostentatious, Fedotov's oral presentation was apparently so offensive, especially to the officers whom the artist mercilessly parodied, that the censor immediately prohibited the poem's publication, although it continued to circulate in manuscript form.[131]

The Major's Courtship evoked an impression so powerful that it earned the artist, who did not have formal training, the title of Academician in 1848 and instant public recognition. Poet Apollon Maikov wrote: "The reason for the nearly universal rapture that Fedotov's paintings induced consists, for the most part, in the content that he borrowed from Russian everyday life and from a sphere more or less familiar to us."[132] Fedotov's genre paintings were also light and anecdotal, akin to newspaper feuilletons; unlike ponderous historical canvases, they appealed to the public of the middle estate, who recognized themselves in this topical art. Stasov, in fact, described Fedotov's method of painting as "a feuilleton type of illustration of everyday life."[133]

The written word was a necessary and effective mode of disseminating the visual arts in the middle of the century, as Fedotov's *Major's Courtship* demonstrates. The genre's closeness to narrative made paintings readable. Like works of fiction, paintings with stories from everyday life encoded in them were open to interpretation, giving an opportunity for critics and

viewers to create their own meanings. The periodical press also took care to solicit and publicize literary narratives to accompany paintings. In such a fashion, the writer Gleb Uspensky was entreated to compose the story supposedly lying *behind* Adrian Volkov's painting *The Interrupted Betrothal* (*Prervannoe obruchenie*, 1860) (*image 11*). The monthly art album *Northern Lights*, dedicated exclusively to Russian art, commissioned the piece to be placed next to a reproduction of the painting. In his story of passion and betrayal, called "Scandal: An Ordinary Story" ("*Skandal. Obyknovennaia istoriia*," 1865), Uspensky dramatized the painting in many lively details familiar to the general reader.

Uspensky's cast of characters includes a young woman, Avdot'ia Chaikina; a government clerk, Gavrilov, who promised to marry her, but instead has disappeared and left her with a child; and a merchant named Kuz'ma

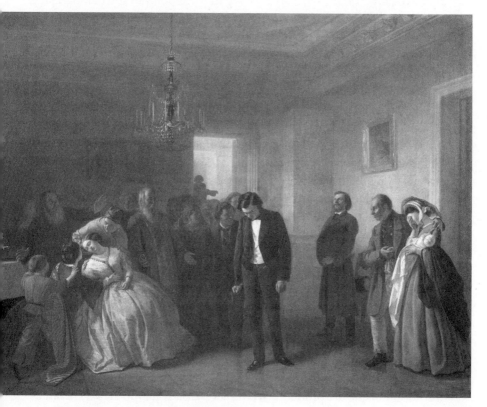

11. Adrian Volkov, *The Interrupted Betrothal* (1860)

Kochetov, who helps Avdot'ia find Gavrilov and break his imminent engagement to another woman whom the merchant himself fancies. In the moving scene depicted in the painting, the betrothal is broken: the bride faints, her father fumes, the merchant gloats, and Gavrilov, overcome with shame, stands frozen in the middle of the room. Uspensky's narrative does not stop here, however. Anticipating the reader's curiosity as to the future fate of the characters, the narrator offers a positive resolution to the scandal represented on canvas: Gavrilov repents and marries poor Avdot'ia, while the merchant gets engaged to the clerk's former fiancée.[134] The story helped frame the painting for the broad public by providing it with a history and even a happy ending.

Literary paintings introduced new subjects in art that previously had been rarely available to Russian audiences. The gradual democratization of art and discourse was underway in the second half of the nineteenth century. Already in the 1840s, art had begun to respond to the demographic and institutional changes in Russian society, and, in the wake of the Great Reforms, this tendency crystallized in the work of the Russian realist artists—the Itinerants (this artistic movement is discussed in more detail in the following chapter). Unlike the previous generation of the Academy-trained artists, most of this new cohort came from the lower middle class, while Repin was the son of a peasant.[135] Women also increasingly played a significant role in both making and writing about art. From the early 1860s on, more and more talented women artists, among them Bem, Vrangel, and Mikhal'tseva, figure in the reviews of the Academy's exhibitions.[136] In 1871, the Academy finally formally acknowledged the contributions of women, welcoming their creative activity and promising all possible support in an official statement.[137] But overall, by the time the Itinerants began exhibiting their art in the early 1870s, the Academy's role in the formation of Russian artists was on the wane. An authoritative institution for the encouragement of the fine arts in the earlier part of the century, its importance now paled in comparison with the popular success that the Itinerant exhibitions enjoyed. After twenty-five years of annual displays, the Academy's exhibitions again became triennial in 1876.[138] In writing, too, the Academy often figured as a superfluous and even antinational institution.

This image of the Academy, however, was a reflection of authors' priorities and persuasions more than an accurate representation of the state of the institution or the art produced within its walls. True, this new generation of artists challenged the venerable Academy, but it was largely the written

commentary that was responsible for representing it as outdated and antinational. Evgeny Steiner recently demonstrated that the Academy in fact did not discourage the national themes and that even the rebellious realist artists continued to exhibit within its walls. Nor was it *always* conservative and punitive, as many contemporary critics would have us believe.[139] Moreover, artists who were feted by critics for the Russianness of their scenes drew on Academy resources, receiving recognition and the titles of Professor and Academician, as we have seen with the example of Fedotov. Critics like Stasov did more to create this institution's negative reputation in society than either the democratically minded artists or the Academy's supposedly unsympathetic professors and directors.

THE RUSSIAN ART WORLD IN THE NEWS

Painting and Controversy

The rise of popular realist trends in reform-era Russia brought about innovative collecting and exhibiting practices. The two museums profiled below demonstrate this major shift in taste. The Tretiakov Gallery and the Russian Museum are both preeminent collections of Russian art, yet in the nineteenth century, they were present in the public sphere as antinomies. Although both museums nominally fulfilled society's demand for national art, only one of them—the Tretiakov Gallery—invited the extensive discussion and debates in the press that held the public's interest for decades. Their standing in society depended largely on the degree to which cultural nationalism dominated the discourse at a given time.

With the ascent of the Russian school of art, critics drew all attention to paintings by contemporary local artists. By the 1870s, the center of the Russian art world shifted toward the Itinerant exhibitions and the Tretiakov Gallery in Moscow, which acquired most of the realist canvases. The Tretiakov Gallery was a frequent subject in the press, attracting the commentary not only of experts, but also of dozens of amateur feuilletonists whose writing helped popularize Russian art. It may seem strange that the state-sponsored Russian Museum, which opened in St. Petersburg in 1898, should pale in comparison to its counterpart in Moscow. The national gallery in St. Petersburg possessed an impressive assortment of Russian original art; nevertheless, the response it elicited was largely indifference or else formal praise. This neglect had a significant impact on the Russian Museum's reputation.

"Realism and Nationality": The Rise of a Russian Realist Aesthetics

This art is, so to speak, a discovery to the modern critic; indeed
it is scarcely understood in Russia itself.
—M. Darcel[1]

The new epoch of realism in the visual arts began in the aftermath of the Crimean War, which, in Stasov's figurative language, "removed the gravestone under which Russia had been buried alive" and liberated the creative potential of the country. The war further revealed the poor state of Russian art. The disinterested art of the nobility turned out to be powerless to deal with contemporary reality, since "all it could do is paint angels and saints in the Italian academic style." Yet already in the late 1850s, new content and a new, critical mood were conspicuously present in the work of younger Russian artists; they presented not classical mythology or biblical allegory, as the Academy of Fine Arts had taught them, but the very prose of everyday Russian life. In the hands of this new "breed" of artists, Russian art underwent a radical metamorphosis. Stasov dates this revolution in taste to 1855, the year that Alexander II ascended the throne; it was during the twenty-five years that coincided with his comparatively liberal rule that Russian art grew into its maturity.[2] The movement that encapsulates the new aesthetics of realism during this remarkable quarter of a century is the Itinerants, formally known as The Association of Traveling Art Exhibitions (*Tovarishchestvo peredvizhnykh khudozhestvennykh vystavok*), who became a prominent presence in society following their first well-received exhibition in 1871.

The notion of a Russian school of painting had long attracted the attention of critics. The poet Batiushkov, let us recall, had commended art for stirring patriotic sentiments early in the century.[3] Several decades later, Khomiakov likewise declared that "all art should be and cannot not be (*ne mozhet ne byt'*) national," which for him primarily meant that art should be in touch with the common people.[4] Elsewhere, Khomiakov drew a comparison between other European schools of art and what he perceived to be the nonexistent Russian tradition: "A Fleming, upon entering his national gallery, recognizes himself in it. He feels that the magic artworks of Rubens and Rembrandt ... live and breathe in his very soul, his inner life." A German feels the same looking at his Holbein and Dürer, as does an Italian contemplating his Michelangelo and Raphael. "But what do the Russian soul and Russian painting have in common?... Will the Russian soul recognize itself

[in Russian art]?"[5] Near the end of the century, the collector Pavel Delarov articulated this problem fittingly: "Painting in Russia did not grow in the soil of free national labor, but in the soil of the Academy, willed into being by the Highest authority."[6]

Still, as late as 1849 (the year of Belinsky's death), the Academy contested society's rising demand for national content: "not nationality but grace is the goal of art; one should strive for grace, and the national will appear of its own accord" (*natsional'noe ne est' tsel' iskusstva, a iziashchnoe: k semu poslednemu dolzhno stremit'sia, a natsional'noe iavitsia samo soboiu*).[7] Boborykin, too, recalled that in the 1850s, the Academy still "reigned."[8] By the 1860s, however, the national idea had grown so widespread that some of the Academy's medalists even refused their hard-won privilege to travel and study abroad, preferring instead to stay and work in their homeland. "Artists wanted nothing else but Russia," writes Mikhailov about this new tendency, "and if they were sent abroad, they escaped, as Perov first did."[9] Miasoedov, one of the leaders of the Itinerants, in fact declared that Russians had no need to travel abroad because Italian art, with all its "Raphaels," was "dead," and the best samples of foreign art could be found much closer in the Imperial Hermitage anyway.[10] Stasov, too, insisted that Russian artists discontinue the "pernicious" practice of studying in Europe and pay closer attention to subjects at home instead.[11] If in previous decades the purpose of Russian art had still been open for discussion, the idea that it was first of all "deeply national," as Kramskoy articulated it, was generally accepted by Russians and foreigners alike by the early 1880s.[12] Thus, one esteemed foreign observer, the French novelist Theophile Gautier, chose specifically national terms in which to record his impressions of Russian art: "all their work is impregnated with a vigorous nationality.... In the catalogue of a recent great exposition ... where there were more than a thousand pictures, scarcely one hundred dealt with aught else than the landscapes, customs, and history of Russia." According to Gautier, this "vigorous nationality" of Russian art amounted to no less than a revolution in Russian aesthetics, which "shut closed the window that Peter the Great had opened onto the West" and brought art "back to its national originals."[13]

Russian themes and styles were only one manifestation of nationality in art; the other consisted in the accessibility of art to the members of society at large. Several circumstances accompanied this important metamorphosis of Russian painting from an academic discipline to a popular art form, including the dissemination of discourse on art in the press and the

circulation of artworks around the country by The Association of Travel-ing Art Exhibitions.

Stasov was the first to formulate some of the tenets of the reform-era aesthetic nationalism, which he saw as an extension of a similar tendency in literature. In his analysis, the new realist painting was beginning to catch up with the "artistic nationality" of Griboedov, Pushkin, and Gogol. In ar-chitecture, too, the new aesthetics of realism was marked by a more "sin-cere" national content in comparison with the officially prescribed pseudo-Russian architecture, as exemplified in the church designs of court architect Konstantin Thon that had decorated the reign of Nicholas I. Stasov was particularly keen on separating the formal nationality that dominated the art scene in the 1830s and 1840s, a nationality that was "utterly official, arti-ficial, forced, and superficial," from the "genuine nationality and realism that emerged not out of fashion, but out of the real necessity of the artists and the public" in the late 1850s and early 1860s.[14]

In a decade defined by unprecedented political changes, the role that aes-thetics played in Russian society was no less remarkable. Charles A. Moser argues, in fact, that "[ae]sthetic questions were at the forefront of Russian intellectual life during the fifteen years or so following the conclusion of the Crimean War and Alexander II's accession to the throne."[15] As demonstrated in Chapter 3, in the absence of professional critics and academic studies of art history, nearly every journalist and feuilletonist wrote on the subject, and the art column became a regular feature of the periodical press. Before guidebooks and specialized periodicals appeared, public discourse, volumi-nous but uneven, sustained society's interest in the visual arts. Some authors, however, attempted to formulate aesthetics befitting contemporary Russian reality. Among better known contributions, aside from Stasov's plenteous commentary, are Chernyshevsky's notorious Master's thesis, *The Aesthetic Relations of Art to Reality* (1855), Dmitry Pisarev's radical anti-aesthetics, Nikolai Dobroliubov's and Dostoevsky's polemics, and Apollon Grigoriev's conservative aesthetics.

The aesthetics of the 1860s was a paradoxical phenomenon, however: the most common attributes associated with it were "ugliness" and "dirt." Theodor Adorno has written persuasively on the legitimacy and even pri-macy of the ugly in modern art, which gives presence to unpalatable social phenomena that were previously treated as taboo.[16] In the Russian context, contemporary artists and radical critics, too, celebrated the fact that the in-flow of everyday material into art pushed the boundaries of the beautiful

to new limits. "If Briullov, Ivanov, and Kiprensky marked the culmination of the Western idealist tradition in Russia, Fedotov, Tropinin, Venetsianov, and their colleagues were the beginning of a new esthetic, which was often vulgar, unconventional, and even iconoclastic."[17] There was also something decidedly "antipoetic" about this new tendency in the arts.[18] Indeed, critics often found beauty to be absent, but they readily identified an implicit subversive agenda as an integral part of this new art. For a long time, open political demands on art and artists had only been voiced from abroad, as exemplified by Alexander Herzen and Nikolai Ogarev's *Free Russian Press*. The artists themselves, however, were not interested in political action; rather, their artworks became an arena in which critics' ideologically charged opinions were put to the test.[19]

Celebrated by some and criticized by numerous others, this shift in taste became the property of open debate in the early 1860s.[20] The artist and sculptor Nikolai Ramazanov, writing under the pseudonym "The Artist," was earnestly outraged with the vulgar populism of recent art:

> It is much more frightening to think about our art when the moral slime and the scum of the everyday life, in all their disgust, are cherished by our latest generation of artists and serve as the object of their love and delight. Since such scenarios in painting are incomparably more familiar, accessible, and entertaining for the majority of the public than the *Iliad*, the *Odyssey*, and history, it is understandable that thousands applaud this *living reality*; and the young artists, encouraged by this easy success, race in search of subjects, each one spicier than the other and dirtier than the next.[21]

At its core, the conflict at hand was one of high style versus popular taste. Elegant taste, it seems, was something in need of protection from the art of the everyday. In an earlier article, the same author solemnly defended the fine arts against what he called the "banality" of flea markets, street scenes, and scenes from the back rooms of taverns.[22] His criticism did not sound in a vacuum; in fact, in both cases he was responding to an anonymous opponent who also wrote for *The Contemporary Chronicle* (*Sovremennaia letopis'*) but who was strongly in favor of the new Russian genre painting.

Other voices soon joined the debate on both sides. In their vast majority, these were the voices of amateur critics; professional art criticism, while not entirely absent, was still evolving in the late 1860s, spurred, in part, by the largely intuitive writing of the feuilletonists.[23] In his review of

the Academy's annual exhibition in 1863, N. Dmitriev, for instance, lamented the painful feelings that the show had impressed upon him. "There is something unaesthetic that you take out from the temple of the arts. It is unpleasant to visualize the many corpses and the many sufferers, the bulging eyes of a madman looking at you crazily, etc. Art should, it seems, calm the spirit, comfort and purify it, if indeed it is troubled, but not disturb it!"[24] If, for Dmitriev, such a disturbance of the spirit was unpleasant, for Stasov and his ilk, on the contrary, to stir—in fact, to scandalize—society was precisely *the* function of the new art. Whereas the sole goal of the old academic tradition had been to celebrate the ideal of beauty, to seek it out and to reproduce it, the new realist art caused a scandal precisely by refraining from doing so, by throwing overboard the Academy's affected styles and subjects.

Prominent scholars have analyzed in insightful detail mid-nineteenth-century aesthetic debates, especially in reference to the literary production of the era.[25] The most influential treatise in turning aesthetics, as it was known at the time, upside down was Chernyshevsky's Master's thesis, *The Aesthetic Relations of Art to Reality* (1855). In his famous definition of the beautiful, "beauty is life," Chernyshevsky effectively situates aesthetics *outside* the realm of art within reality itself, a reality unlimited by decorum and consisting of all the "phenomena of real life that are of interest to man." Many contemporaries welcomed the main principle of Chernyshevsky's realist aesthetics; Stasov, for one, echoed it as follows: "the superior authority for art is neither the school nor the museum, but life itself."[26] What is more, Chernyshevsky argued that living reality was higher than art: "it must be admitted that our art has been unable to this day to create anything like an orange or an apple, let alone the luxurious fruit of tropical lands." Radical as it was, Chernyshevsky's aesthetics did not mean to "degrade" art, but rather to remind audiences of its proper function. According to this principle, predicated on instruction and judgment, the purpose of art is to reproduce reality, in all its multifaceted manifestations, to pronounce a judgment on it, and to explain its meaning and morality.[27] The application of utilitarian aesthetics to visual art in the 1860s was, in a sense, a continuation of the earlier Pushkinists versus Gogolians controversy in literature, which flared up in 1856–57 between Druzhinin, the proponent of the "pure art" theory, and Chernyshevsky, who ardently defended Belinsky and Gogol. Belinsky had written in 1847 that any work of literature, even if it were completely devoid of artistic qualities, was useful, as long as its content was true to life.[28]

Belinsky also famously declared when emphasizing the civic duty of aesthetics: "Art must serve mankind, not mankind art."[29]

Yet Chernyshevsky's utilitarian realism was tame in comparison with the sweeping anti-aesthetics of Pisarev, who not only welcomed Chernyshevsky's thesis, but actually went so far as to call for the total elimination of useless aesthetics. Pisarev took the radical position to the extreme: in his review of Chernyshevsky's treatise, poignantly titled "The Destruction of Aesthetics," he effectively dissolved the very subject of aesthetics into a matter of "physiology and hygiene."[30]

At the other end of the spectrum were "the esthetic critics," as Moser calls Dostoevsky, Apollon Grigoriev, and Nikolai Solovyov, among others. For Dostoevsky, art and beauty were absolute categories, independent of their use value or ideological orientation.

> Art is as much a necessity for man as eating and drinking. The need for beauty and creation embodying it is inseparable from man and without it man would perhaps have refused to live in the world. Man craves it, finds and accepts beauty *without any conditions* just because it is beauty and worships it with veneration without asking what it is useful for or what one can buy with it.[31]

Even after Dostoevsky conceded that art should respond to reality (and thereby fulfill a socially useful function), artistry and aesthetic value remained primary for him.[32] Moreover, he believed that the moral core of art ought never to be compromised.[33]

Dostoevsky openly criticized utilitarianism in art. Writing about the paintings that the Academy displayed in 1861, Dostoevsky singled out one, Valery Iakobi's *Convicts at a Halting Point* (*Prival arestantov*, 1861). According to the writer, the painting consisted of a series of snapshots of equally ugly subjects, which failed to satisfy because, for all of the artist's realism, he had neglected to represent real people. As a result, the painting was all about melodrama and "effect." (Dostoevsky was understandably sensitive to the subject considering his personal experience with penal servitude.) Nevertheless, Iakobi's painting strongly affected the exhibition's visitors; Dostoevsky himself noted that it transfixed people from all walks of life, and the Academy awarded Iakobi the prestigious First Gold Medal.[34] Here, as was the case in his critique of *What Is to Be Done?*, Dostoevsky's aesthetic judgment stood against the public's taste. Nevertheless, the aesthetics of ugliness caught on. Not until the turn of the century would it encounter a serious

challenge in the face of Diaghilev, who would famously denounce Cherny-shevsky as a barbarian.[35]

While the majority of the participants in the 1860s artistic controversy were concerned with literature, Stasov was among the first to apply the new aesthetics to the visual arts. The year 1863 marked the public "appearance" (explosion is more like it) of this new trend in Russian art when, on the eve of the Academy's centennial anniversary, fourteen contenders for the Gold Medal under the leadership of Ivan Kramskoy refused to participate in a competition to paint a subject from Old Norse mythology, "The Festival of the Gods in Valhalla." Instead, they walked out of the Academy and set up a workshop of their own, a working commune called the St. Petersburg Artel of Artists. The explosion of critical discourse in the press that followed the initial silence surrounding the 1863 anti-Academy rebellion was remark-able. Stasov would later recall that in the beginning, it was next to impos-sible to publish anything about the artists' exodus. His own article, which eventually appeared in the *Library for Reading* after a series of rejections, was the solitary exception to the rule.[36] A little over a decade later, the con-troversy over new realist art reverberated throughout the country.

If prior to this turning point in Russian art history all artists were like "one big factory of clichés, producing Italian women at fountains and pseu-dohistorical subjects," the post-1863 generation turned to subjects as diverse (and often as unattractive) as Russian life itself.[37] Valkenier summarizes:

> In the esthetic debate about the artistic merits of the realistically painted scenes from domestic and public life, conservative opinion bemoaned the disappearance of eternally beautiful forms and objects to the 'photographic' rendition of streets or taverns with all their 'trivial' and 'ugly' details. The liberals applauded these paintings of the real Russian world, long dealt with by Russian writers.[38]

Even if the theoretical side of the controversy had essentially drawn to a close by 1868, as Moser has suggested, the practical manifestations of the aesthetics of ugliness in literature and the arts continued to spread during the following decades.[39] It culminated in the works of the Artel artists and later the Itinerants, who broke away from what contemporary critics per-ceived as the stifling tradition of the Academy and instead went the way of Russian realist literature.[40]

Critical perception of this tendency is key to the discussion that follows,

for the iconoclastic artists themselves, as Steiner argues, "never acted un-compromisingly for the sake of their aesthetic ideals against the establish-ment." Nor were the authorities "unambiguously oppressive and dictatorial regarding either subject matter or exhibitional policy."[41] Nor were the Rus-sian artists unique in their effort to separate from official institutions; the Artists Federation of the Paris Commune (Fédération des Artistes), for in-stance, was established in the same year as the Artel and similarly pursued independence. Rather, the professional artists of the Russian realist school were motivated by the market as much as by aesthetic considerations and did not view themselves as the principled revolutionaries Stasov and many others considered them to be.

Although the Artel, which emerged in 1863 in St. Petersburg, and the Itinerants group, founded in 1870 by Moscow artists, were two independent movements, contemporary critics tended to see them as part of a continu-ous progression within Russian national realism.[42] The artist connecting the two groups who played an important role in the organization of both, Ivan Kramskoy, was outspoken about the position of the Russian school of art, and his pronouncements became the property of public discourse via populist writing that surrounded the artists' exhibitionary activity. In 1864, Kramskoy announced:

> The Russian [artist] should finally stand on his own feet in art. It's time to throw away those foreign diapers—thank God, we've grown a beard already but we are still walking in an Italian toddler's harness. It's time to think about the creation of our own Russian school, about our own national art! ... Our art dwells in slavery to the Academy, which is itself a slave of Western art. Our task now—the task of Russian artists—is to get free of this slavery.[43]

It was largely due to Kramskoy's strong statements, as well as the unprece-dented nature of the revolt at the Academy and Stasov's retrospective specu-lations, that the year 1863 went down in history as a turning point in Rus-sian aesthetics. Artists, however, worked on national topics before and after this notorious secession.

With the professionalization of the arts, the market economy replaced the state monopoly as the arbiter of taste. No longer servitors of the state, professional artists began responding directly to consumers, and art exhibi-tions turned into commercial venues.[44] The press emphatically represented the public as the arbiter on matters of style and opinion: "Art became a com-

modity produced for the market," as one critic aptly remarked.[45] In the words of another commentator, "The painting's content depends less on the artist than on the public. The artist does what the public wants, what it likes."[46] We can see this scenario depicted in Pukirev's topical work, *A Painter's Studio* (*V masterskoi khudozhnika*, 1865), where two merchants, the representatives of this new public, are shown discussing the value of a painting they are considering for purchase. Although the Academy had also been charging entrance fees since 1859 (something that caused an outburst of protests in the press allegedly on behalf of an easily discouraged public), for the Itinerants, ticket sales constituted a reliable source of income, amounting to 25,000 rubles in the 1880s. The sale of paintings provided another such source, reaching 95,000 rubles at the peak of The Association's success. The artists relied on sales, which spoke to both their success with the public and their independent financial security as well.[47] The financial considerations of The Association of Traveling Art Exhibitions were reflected in its foundational Statutes, according to which Itinerant exhibitions were to facilitate the sale of art, in addition to conveying it to the provinces and cultivating a taste for art in society overall.

Among the new subjects in art deemed uniquely Russian were peasants' poverty, the corruption of the clergy, destitute prisoners, destructive war, the inhuman labor of the masses, death and grief. This shift in aesthetics toward abrasive social realism amounted to no less than "a quantum jump from Fedotov's satirical treatment of various classes and their foibles to an exposé of institutions that oppressed the people."[48] Vasily Perov's *Easter Procession in the Country* (*Sel'skii krestnyi khod na paskhe*, 1861), for instance, touched upon the untouchable: in the image of a drunken priest, the artist hazarded to criticize organized religion and made a travesty of the whole Easter ritual. Perov's *Accompanying the Deceased* (*Provody pokoinika*, 1865), which Stasov considered to be one of the artist's best paintings, was equally damning. Stasov wrote at length about this work of art, comparing it to Nekrasov's poetry and celebrating the artist's exceptional ability to distill the hardship of the everyday lives of peasants into a touching picture of a burial. But the "terrible, harsh tragedy" of the painting consisted not so much in the burial itself, but in the fact that what it represented "happened every day in thousands of places all over Russia." This picture, much like Perov's other masterpiece *Troika* (1866), depicting three hungry apprentices struggling to pull a vat of water in freezing weather, allowed art to assume "all the grandeur of its designated role: it drew life, it 'explained' it, and 'judged' it."[49] In other words,

Perov's was the kind of "ugly" yet "useful" aesthetics that Chernyshevsky and Pisarev advocated: his art exposed and indicted. *Troika* and *Accompanying the Deceased* were successfully displayed at the International Exhibition in Paris in 1867.[50] Many of Perov's contemporaries were likewise bringing life, in all its ugly manifestations, into their art. Among these disturbing artworks were Iakobi's *Convicts at a Halting Point*, Konstantin Filippov's *In Besieged Sevastopol* (*V osazhdennom Sevastopole*, 1862), Firs Zhuravlev's *A Creditor Itemizing the Widow's Property* (*Kreditor opisyvaet imushchestvo vdovy*, 1862), Alexei Korzukhin's *Funeral Meal at the Cemetery* (*Pominki na kladbishche*, 1865), and Miasoedov's *Zemstvo at Lunch* (*Zemstvo obedaet*, 1872).[51]

Ilya Repin, who joined the Itinerants in 1878, created what Stasov thought was "certainly the first painting of the entire Russian school": *Barge Haulers on the Volga* (1870–73) (*image 12*). In Repin's group portrait of a team of barge haulers, half-human wretches engaged in inhuman labor, Russian critical realism reached its zenith. The painting was first shown at the Academy's exhibition of 1873 and immediately became famous. As Stasov claimed, the symbolic value of Repin's *Barge Haulers* was as important for the generation of the 1870s as Briullov's *The Last Day of Pompeii* had been for the previous one.[52]

Dostoevsky saw Repin's painting as part of the Russian collection intended for the International Exhibition in Vienna. Under the title "Apropos of the Exhibition" (*Po povodu vystavki*), the writer published a review of this art show in *Diary of a Writer*. Invariably conscious of the international context in which Russia would be viewed at the exhibition, and the role of Russian art in representing his country abroad with dignity, Dostoevsky sets out in this essay to underscore the peculiar nationality of Russian art. Dostoevsky specifically considers genre painting, the art form best suited to express Russian nationality, even though it may be the form least comprehensible to foreigners. The writer emphasizes the fundamental untranslatability of genuinely national works of art (such as those by Pushkin, Gogol, and "even" Turgenev) into the Western European idiom: "everything that is characteristic, everything that is ours, predominantly national (and thus everything that is genuinely artistic), in my opinion, is unrecognizable to Europe." In anticipation of the famous leitmotif of the Pushkin speech, Dostoevsky queries in 1873: "But genre, our genre—what could they possibly understand of it?"[53] Genre is, Dostoevsky continues, "the art of representing contemporary, current reality, which the artist has *experienced* personally and has seen with his own eyes."[54] Incidentally, Dostoevsky's opponent on

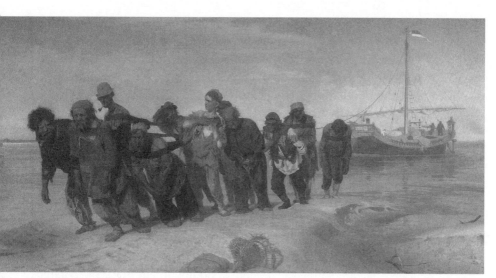

12. Ilya Repin, *Barge Haulers on the Volga* (1870–73)

many other counts, Stasov, did not think that Repin would "translate" either: "Repin drew with his brush something so horrible, something so appalling," that foreigners would not be able to fully appreciate the "crushing blow" (*gromovoi udar*) that this painting caused in Russian society.[55]

The new cohort of realist artists found representation in fictional narratives, too. Vsevolod Garshin's short story "The Artists" (1879) is programmatic in its dramatization of some key issues of the aesthetics of ugliness. The narrative comprises two competing story lines, one of a landscape painter with the speaking name Dedov, who stands for traditional academic training, and the other of the genre artist Riabinin, whose choice of subject matter identifies him as a realist. Instead of pursuing an Academy-sponsored trip abroad, Riabinin chooses to place his talent in the service of society, uncovering and exposing its ugly truths. Riabinin personified the new idea of the artist as a hero whose role is, in the words of one critic, to "serve life and become one of the prime movers in the development of social consciousness."[56]

Garshin represents the two traditions coexisting in dialogue and in conflict. By the end of the story, each artist produces a masterpiece, and each is praised by critics and the public. Dedov finishes his calm *Morning in May*, wins the Academy's gold medal, and, with the exclamation *Vivat Academia!* travels abroad to continue his training. Riabinin, on the other hand, chooses

"a strange and wild subject" to represent: a cauldron worker, dressed in "disgusting rags," his hair unkempt, his face flushed and filthy, crouching in the dark corner of a cauldron and "suffocating from exhaustion." A powerful, "terrible" work that even his opponent recognized as a masterpiece, Riabinin created more than simply a painting: he depicted the "ripened disease" of Russia.[57]

Garshin's fictional painting reminded contemporaries of an actual masterpiece, Nikolai Iaroshenko's *The Stoker* (*Kochegar*, 1878), a well-known representation of Russian social ills, which had, in fact, inspired Garshin.[58] The aesthetic disgust that the academically minded Dedov experienced at the sight of Riabinin's cauldron worker was an emotion not unfamiliar to the viewers of Iaroshenko's *The Stoker* and many other similarly disturbing works of art. "What kind of poetry is there in filth? ... this whole *muzhik* phase in art is pure ugliness. Who needs these infamous 'Boat Haulers' of Repin's? They are painted marvelously, no doubt; but that's all. Where is beauty, harmony, aesthetic quality (*iziashchnoe*)? Isn't it for the reproduction of beauty in nature that art exists?"[59] But the new generation of Russian artists, as we have seen, chose the ugly truth and made it into a public statement.

Yet how could all these *ugly* images of Russia—Iaroshenko's, Perov's, Repin's—contribute to the formation of a *positive* Russian identity? First of all, the everyday reality that the genre painters represented was a specifically Russian reality, which viewers recognized as such, and which established an instant connection between different members of the audience and the artists. Second, the social groups engaged in this community-building through art were diverse: even before the Itinerants' works set out to tour around the country, the periodical press had circulated and debated their work. In consideration of the rather lenient restrictions regulating what could be said about *art* (in striking contrast to other, more vulnerable subjects), a great number of amateur critics freely expressed their opinions in the press. While their analyses frequently lacked sophistication—and at times, even basic common sense—they did give voice to a rapidly growing albeit still amorphous body of Russian citizens from the middle estate. As we have previously observed, just as the deeper meaning of Fedotov's playful *The Major's Courtship* was to be found in the literary text accompanying it, writing, on the whole, often did more to promote a national consciousness in art than did the art itself.

In this regard, it is inconsequential whether or not such "genuinely" Russian artists as Fedotov and Repin were influenced by Western European art

(as Gray and Valkenier convincingly argue they were).[60] To judge by Russian society's response to these artworks, they were celebrated as uniquely, decidedly Russian. With the profession of art criticism only recently on the ascent, art "critics" were likely unaware of all the nuances of influence and adaptation. They were quite possibly wrong about the artists' innate "Russianness," but their opinions did circulate widely in the public sphere and thus played a major role in defining national culture. The distinctly Russian national spirit that purportedly resided in the paintings of the Russian realist school was their creation; it was a discursive formation located *outside* the canvas, in newspapers and journals, where public artistic discourse, led first of all by Stasov, and supported by many amateur and professional critics alike, was taking place.

Art in Motion: The Itinerant Exhibitions and the Tretiakov Gallery of Art

The Association of Traveling Art Exhibitions was more a public statement than an art movement or a trend. When the first Itinerant exhibition opened in St. Petersburg in November 1871, and then continued to Moscow, Kiev, and Khar'kov, Russian national art finally traveled across the country in material form, as well as in discourse. The first Itinerant show was an immediate and indubitable success, despite the relatively small collection of paintings that were displayed (in contrast to the usual 350–400 items at the Academy's exhibitions).[61] Amidst their number were such masterpieces as Perov's *Hunters at Rest* and *Fishermen*; Ge's *Peter I Questions Tsarevich Alexis in Peterhof* and a portrait of Turgenev; Alexei Savrasov's *The Rooks Have Come* and *Forest Road*; as well as works by Kramskoy, Illarion Prianishnikov, Miasoedov, Alexei Bogoliubov, and Shishkin. A whopping 11,515 people visited the exhibition during the month that it was open in St. Petersburg; another 10,440 saw the show in Moscow.[62] With these first successful exhibitions, the Itinerants had effectively become what Valkenier has described as "an alternate artistic center" to the Academy.[63]

Curiously, the Itinerant exhibitions, much as they helped define Russian national art, were not Russian at their origin. The initiator of the movement, Miasoedov, studied the practice of touring exhibitions in Germany and Belgium during his residence abroad in the 1860s; he and Ge were also interested in a British attempt to organize traveling art shows.[64] There was a precursor on the home front as well: an exhibition in Nizhnii Novgorod organized

by Kramskoy in 1865.[65] Still, the first Itinerant exhibition, broadly covered by the press and attended by thousands of visitors, was an unprecedented occasion: "It was the *debut* (*vykhod v svet*) of the *first* voluntary creative society in Russia."[66] Contemporaries especially praised the public character of this endeavor. Stasov, for one, reacted with joyous disbelief: who would have thought that Russian artists "should suddenly abandon their artistic haunts and want to plunge into the ocean of real life"?[67]

Among the unique features of Russian realist art, two are central for the present discussion: its dissemination and its consumption. Prior to 1871, even major provincial towns became acquainted with Russian painting only second hand via reviews in the press and occasional engravings, the quality of which left much to be desired in an age that preceded photo-mechanical reproduction.[68] With the Itinerant exhibitions reaching the provinces, the audience of potential aesthetic judges and the volume of discourse grew markedly. Before the end of the century, annual Itinerant exhibitions brought art to Moscow, Kiev, Kharkov, Odessa, Tula, Tambov, Iaroslavl', Kursk, Elizavetgrad, Poltava, Kazan', Saratov, Vilna, and Warsaw.[69] "Russians in the provinces were among the most enthusiastic supporters of the traveling exhibits," writes Valkenier. She hurries to qualify, however, that the Association's exhibitions

> were neither intended for nor ever reached the Russian peasantry and the working class. Unlike the populists of the 1870s, the Peredvizhniki did not go to the rural areas where 80 percent of the population lived in poverty and squalor; they never "soiled their hands" in actual contact with the rural masses. But they did introduce art to the provinces—to the educated provincial elite, to be more exact.[70]

The circulation of art in society reached the previously disengaged middle: the traveling exhibitions were aimed at the same general public that followed the evolution of Russian art in the press.

The system of art patronage changed as well when private citizens began to replace the Academy as arbiters of taste. At the time, artist Miasoedov wrote: "The amateur replaced the patron—not a platonic amateur, always ready to lend an enlightened piece of advice, but the amateur-buyer, the amateur-collector, fond of everything national and absolutely unencumbered by the cult of form or style, who for the most part appreciates the living essence (*zhivoe nachalo*) in art."[71] The social group that influenced the artistic

climate in the 1870s strongly consisted of the merchantry and the indus-
trial entrepreneurs. Wealthy Moscow merchants were the main sponsors of
the Russian style in architecture and were major supporters of the Russian
school in painting as well. Gray writes extensively about this new patronage
based in Moscow:

> The nascent patronage of the upwardly mobile merchants and industrialists
> led to numerous new collections. Most importantly, the absence of a
> heritage of assumptions on taste rendered the new patrons more receptive
> to novel artistic developments and deviations from the traditional, classical
> aesthetic. In line with the increasing patriotism and growing self-awareness
> characteristic of the time, and anxious to differentiate their own, developing
> patronage from that of the aristocracy, the new, burgher collectors began to
> eschew the foreign art market in favour of the art of their own country. Ideas
> of nationhood also engendered proposals for national collections.[72]

Unlike the Imperial Hermitage or the Academy of Fine Arts, the private
galleries of Muscovites Vasily Kokorev, Fedor Prianishnikov, Kozma Sol-
datenkov, and Gerasim Khliudov, among others, specialized in art by living
Russian artists. While the Hermitage jealously guarded its national trea-
sures with what many contemporaries perceived as draconian rules, many
art galleries in Moscow offered free access to all. The Kokorev Gallery, for
instance, was open "without any formalities for the educated public and all
those thirsting for education."[73] So ardent was the collecting activity of the
Moscow patrons in the 1860s and 1870s that in 1881 Stasov wrote with vexa-
tion: "Everything important that the new Russian school has created is in
Moscow." St. Petersburg, by contrast, did not have a single Russian gallery,
whether private or public.[74] The Moscow merchantry did a lot to promote
the national tendency in the visual arts. As Stites observes, the merchants,
whose cultural taste tended toward the visual and theatrical (*lubok*, icons,
folk fairs), served as "vital agents in 'nationalizing' the arts of Russia."[75]

The most celebrated Moscow collection belonged to industrialist and pa-
tron of the arts Pavel Tretiakov. Tretiakov began collecting contemporary
Russian art in the 1850s and by the mid-1870s had an extensive private gal-
lery, which he opened to the public. He was particularly active at Itinerant
exhibitions; his massive purchases provided the continued support for art-
ists who considered him an extraordinary benefactor and friend.[76] The leg-
endary patron of Russian realist painting often made his acquisitions even

before the exhibitions opened to the public.[77] The public's reaction varied based on location, however. Thus Stasov observed that in Moscow, the new hub for national artworks, Russians responded to Tretiakov's patriotic project with unadulterated enthusiasm, whereas in St. Petersburg, the imperial capital, society looked upon it with poorly concealed envy:

> Mr. Tretiakov is one of the worst enemies (*zloi vrag*) of St. Petersburg because in the very first moment he buys everything worthy of note that ever appears here and carts it off to Moscow, to his excellent gallery of Russian art. At the same time, he is one of those people whose name the history of our art will never forget because he values and loves it like few others, and who in a few short years has put together, by merit of his enormous means, a gallery of new Russian painting and sculpture unlike any other anywhere including the Academy and the Hermitage.... Thus a private person has taken upon his shoulders what big public institutions will not do, and carries it out with passion, fervor, enthusiasm, and—what is most surprising—with meaning.[78]

Tretiakov also participated in the world's fairs in London, Paris, and Vienna, lending works that enabled Russian art to begin receiving international recognition. He was a patriotic collector: the idea around which he built his collection was the establishment of a museum of Russian art for the benefit of the Russian public. Initially, he opened it to a close circle of friends in 1874; then in 1881, the museum became accessible to all, receiving 8,000 visitors that year. By the early 1890s, the Tretiakov Gallery enjoyed such wide acclaim that contemporaries even coined a saying: to be in Moscow and to not visit the gallery was like missing the Pope in Rome. The admission to the museum was free, and the annual number of visitors reached 50,000 by the early 1890s.[79] Shortly before his death, Tretiakov bequeathed the museum to the city of Moscow, and in 1893 the Pavel and Sergei Tretiakov Municipal Gallery opened its doors to the public. A neo-Russian façade for the building, designed by Viktor Vasnetsov in 1900, completed the image of the gallery as a marker of Russian cultural identity.[80]

The Tretiakov Gallery commemorated the triumph of Russian culture. In painting, this Russian turn found expression in a variety of forms and genres other than the national realism of the Itinerants: Fedotov's ironic genre paintings, the fairy-tale stylizations of Vasnetsov, Kustodiev's larger-than-life Russian merchants, Riabushinsky's brightly colored old Muscovy, Nesterov's lyrical Russian Orthodox imagery. These were all prime examples

of a national distinction in art, one of the answers to the disconcerting in-
dictment of "endless imitation" with which foreign and local commentators
routinely assailed Russian artists.

In an age of cultural nationalism, the support of museumgoing and
newspaper-reading audiences was no less important than the private pa-
tronage of the likes of Tretiakov. Tretiakov's position was essentially that of
an important middleman, as Norman defines it. The collector succeeded in
bringing painting, traditionally considered a high form of art, to the Russian
general public, who greeted the new aesthetics of "realism and nationality"
with noticeable enthusiasm. Moreover, in the pages of the popular press,
Tretiakov himself turned into a national hero for providing this valuable
service to society. His name and his museum became inseparable from the
artists practicing realist aesthetics.

The collector's portrait by Repin is well known, as are a dozen portraits
of noteworthy contemporaries, commissioned to artists by Tretiakov (*image
13*). The portrait gallery of the makers of Russian culture—well-known writ-
ers, composers, architects—that Tretiakov began accumulating in the 1860s
is an important public statement. The status of creative artists had clearly
changed in the second half of the nineteenth century: like Tretiakov himself,
they became heroes of contemporary public life.

Tretiakov's Russian pantheon started with the acquisition in the 1860s of
several portraits by Briullov, including those of architects Monighetti and
Gornostaev and the poet Zhukovsky. He negotiated the acquisition of Bri-
ullov's portrait of Nestor Kukol'nik from his widow for many years, eventu-
ally acquiring it in 1877. In June 1862, Tretiakov commissioned from artist
Nikolai Nevrev the first portrait expressly for his collection, that of actor
Mikhail Shchepkin. By the late 1860s, such orders became regular. Thus,
Perov created for Tretiakov's Russian pantheon portraits of Dostoevsky,
Maikov, Turgenev, Dal', Pogodin, and Ostrovsky—the majority of which
were contracted in 1872. Kramskoy contributed portraits of Nekrasov,
Saltykov-Shchedrin, Tolstoy, Sergei Aksakov, and Goncharov.

Another cultural tendency reinforced the status of the artist as a public
hero, when several volumes devoted to individual artists were issued in the
last third of the nineteenth century. The art historian Nikolai Sobko pub-
lished several commemorative editions. Among the first was *A. A. Ivanov:
His Life and Correspondence, 1806–1858* (*A. A. Ivanov, ego zhizn' i perepiska,
1806–1858*). When Tretiakov read the volume shortly after it came out in
1880, he thought that the book should serve as a "New Testament" to artists

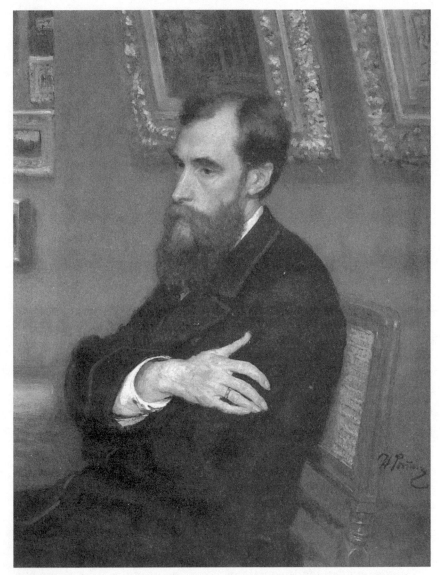

13. Ilya Repin, *Portrait of Pavel Mikhailovich Tretiakov, Founder of the Gallery* (1883)

and as an example for the general public.[81] *The Illustrated Catalogue of Paintings, Drawings, and Engravings of the Deceased I. N. Kramskoy, 1837–1887* (*Illiustrirovannyi katalog kartin, risunkov i graviur pokoinogo I. N. Kramskogo, 1837–1887*) came out in 1887, immediately after the artist's death. A volume

devoted to Perov followed suit in 1892.[82] Three volumes of the landmark *Dictionary of Russian Artists from Ancient Times until the Present* (*Slovar' russkikh khudozhnikov s drevneishikh vremen do nashikh dnei*), in which Sobko intended to gather all of the heroes of the Russian visual arts, but which remained unfinished, came out between 1893 and 1899.[83] The private correspondence of these artists also became available to the public, often before allowing a reasonable amount of time to pass. On one occasion, Tretiakov, who gave Stasov 177 of Kramskoy's letters for an article in *Messenger of Europe*, had to chastise the adamant critic for rushing to publicize this personal communication.[84]

Tretiakov is best known as a collector and founder of his museum, but he also participated in the creation of art and its critical evaluation. Repin, for instance, repainted the face of the central male figure in his *The Unexpected Return* (*Ne zhdali*, 1884–88) based on Tretiakov's suggestion and used as his model the writer Garshin, who was enjoying sensational success among the reading public at the time. The collector was also concerned about the interpretation of paintings by contemporaries. Thus, he wrote with apprehension about Vasnetsov's *After Prince Igor's Battle with the Polovtsy* (*Posle poboishcha Igoria Sviatoslavicha s polovtsami*, 1880) that "those who are less educated do not understand it; those better educated, say that it didn't turn out right (*ne vyshlo*)."[85]

Tretiakov followed the press coverage of the contemporary art scene closely and did not hesitate to correct erring authors.[86] For instance, responding to a publication by the editor of *The Arts Journal*, Nikolai Aleksandrov, who used the pseudonym Storonnii zritel', Tretiakov composed an angry letter where he recommended that the author verify his facts before making them public. In particular, Aleksandrov reported that Perov sold his art for next to nothing; in his response, Tretiakov, who in fact bought the artist's paintings, provided exact numbers and circumstances under which acquisitions were made.[87] On another occasion, a public confrontation took place between Tretiakov and his biggest supporter, the ideologue of national realism Stasov.

Stasov, who for decades had cheered relentlessly the entire collection as well as individual contributing artists, is no less a hero in the story of the Tretiakov Gallery than its famous founder. Stasov deserves a prominent place in the present discussion not because he distinguished himself as a proponent of good taste or oracle of truth (which is a proposition open to scholarly debate), but because he played a central role in the Russian public

sphere as a major agent of the Russian museum age.[88] In 1893, Stasov undertook a history of the Tretiakov Gallery in the pages of *Russian Antiquity* (*Russkaia starina*). Strangely, the critic begins it with an inflammatory statement, where he claims that the Gallery did not mean much to the Russian public, and that the museum had attracted no more than "two or three visitors." The rational for Stasov's odd statement was to lament the ostensible "neglect and apathy" that the public expressed toward this major venue for Russian art. Stasov thus launches an ardent defense of Tretiakov's undertaking, arguing that the name "The Municipal Gallery of Pavel and Sergei Tretiakov," as the museum was known when it opened to the general public in 1893, should be replaced with the "National Tretiakov Gallery," in light of its importance to the Russian people. The critic then compares holdings of Russian paintings in several museums to Tretiakov's: next to the Hermitage's "shameful" 75 paintings, the Tretiakov Gallery, built by a single person and numbering 1,276 works, was indeed a cause for national pride. Stasov spends the bulk of this lengthy publication savoring every detail from the history of the art gallery and the biography of its founder.[89]

This time, however, Stasov's zeal in promoting the Tretiakov Gallery misfired, as the publication led to a bitter public exchange with the museum's founder himself. Stasov's article, reprinted selectively in the newspaper *Moscow News*, provoked Tretiakov to respond to his supporter in the pages of the same newspaper. Tretiakov was outraged by Stasov's claims that the Gallery left the city and the public indifferent. On the contrary, the collector provided numbers of visitors for ten years between 1881, when 8,368 people came to the gallery, and 1890, when visitors numbered at 50,070. In a personal letter to Stasov, he added: "There was never any public indifference; there was rather harassment, indelicacy, carelessness, damage to the paintings, and even theft, but never indifference."[90]

A special album issued to commemorate the 25th anniversary of the Itinerant exhibitions in 1897 provided further details on numbers of visitors in various cities as well as other useful statistics on various aspects of the Itinerants' creative undertakings.[91] Aside from numbers of visitors, regularly reissued catalogues and routine reviews of the gallery provide evidence of a steady demand for Russian art among the public.[92] Contemporaries viewed the gallery as a "microcosm of new Russian painting" and a unique center for the study of the national school of art.[93] Tretiakov's taste in acquisitions became the gold standard by which critics and the public alike measured Russian art.

All this writing, positive and negative, accurate and not, maintained the public's interest in a subject that remained topical until the century's end. Another large round of publications took place following Tretiakov's death in December 1898, providing an opportunity for contemporaries to revisit the milestones in the life of the Gallery and its founder, and to review the history of Russian art that it had come to represent. An obituary in the *World of Art*, for instance, claimed: "No other nation in the world has a museum of its art that is so complete, so well systematized, and created with so much love." During the fifty years of his collecting activity, Tretiakov "single-handedly created in Russia a museum of Russian national art."[94]

Art for the Public? The Russian Museum of Alexander III

A national museum should be the common endeavor
of the entire nation.[95]
—D. Mikhailov

"We still do not have our national museum, and it's high time that we did," wrote Stasov in 1882. He took up this cause not merely because St. Petersburg remained the only major European capital to lack a national art gallery, but, more importantly, because the newly evolved Russian school of art, which the critic never tired of cheering, deserved an "honorable residence of its own" (*pochetnaia kvartira*). In his overview of the progress of Russian art, Stasov gave voice to an opinion shared by many: the Russian school of art merited both recognition from the general public and support from the state. A few random Russian paintings in the Hermitage could no longer adequately represent the achievements of the Russian school of art. Nor should collecting activity in Russia continue to depend on the artistic taste and financial support of a handful of noble "volunteers," like Tretiakov, Soldatenkov, and Prianishnikov; the state itself (*samo gosudarstvo*) should take the initiative and create a center for all works of national art.[96] Thus, Stasov impressed upon Russian society the necessity of a national art gallery in his seminal article "Twenty-Five Years of Russian Art."

The idea of a Russian national art gallery dates back to the early nineteenth century, and in the course of that century, it received a number of material and discursive incarnations. Among the first collections of national art were Pavel Svin'in's short-lived Russian Museum, praised by Stasov for its

patriotism, and the department of Russian painting created at the Imperial Hermitage in the 1820s.[97] The idea was partially implemented in the Rumiantsev Museum and Moscow Public Museum as well, but later in the century, the Hermitage's director, A. A. Vasil'chikov, again sounded the call for "an absolutely separate museum devoted to Russian art."[98] For much of this time, Tretiakov's art gallery remained a major *private* collection of Russian art. Only in 1893, when the "volunteer" Tretiakov gifted his museum to the city of Moscow, did the first public gallery devoted exclusively to Russian art come into being. Two years later, Russia's first ever *state* museum of national fine arts, the Russian Museum of Alexander III, known today as simply the Russian Museum, was founded in St. Petersburg; in 1898, it opened its doors to the public.[99]

As demonstrated earlier, the life of a museum in society can be effectively gauged by what is written about it in the contemporary press. In the discussion below, I examine a variety of written sources that document the reception of the Russian Museum in society at the turn of the twentieth century (guidebooks, catalogues, art journals, newspaper articles, memoirs, and official decrees). The volume of this writing is not vast; the most popular form of writing about art and culture in imperial Russia—the newspaper feuilleton—is largely absent. Other commentary in the popular press (reportage, an occasional review, brief notes) is likewise sparse—there exist just a handful of articles describing the opening ceremony attended by the tsar's family, members of the imperial court, and dignitaries.[100] With all due emphasis on the tsar's presence, these accounts underscored the theatricality of an event where art essentially provided a background to ceremony. Benois, in fact, compared the museum's inauguration ritual to a theatrical performance.[101] Among available sources, guidebooks to the new museum predominate. Art journals presented another important venue in which to introduce the museum to the public. More often than not, however, articles published in the *World of Art* or *Art et industrie* (*Iskusstvo i khudozhestvennaia promyshlennost'*) used the museum instrumentally as a vehicle to advance their own views on art.

According to contemporary sources, the Russian Museum's main achievement consisted in the institutionalization of Russian art. As Stasov and others observed on numerous occasions, Russian art was still very young (Stasov estimated its "age" at twenty-five years old in the early 1880s) and not well known, either in Russia or abroad. What the emergence of the Russian Museum signaled was that the Russian school of art had reached a stage of

maturity, that it deserved a residence and a history of its own. The metaphor "home" or "roof," routinely used to describe the museum's place in the history of Russian art, is telling. One guide defined its role in society in the following lofty terms: "Russian painting did not have a native abode (*rodnoi priiut*), its own 'home,' where everybody interested in it and in its fate could familiarize themselves with it comprehensively." Cheering the museum's accomplishment, contemporaries used the occasion to congratulate Russian art on acquiring its long-coveted "sweet home" (*davno zhelannyi "rodnoi priiut"*); prior to that, scattered Russian paintings had been essentially inaccessible to the public in St. Petersburg, so that "nobody knew them."[102] Another commentator emphasized that, with the opening of the Russian Museum, the "big public" (*bol'shaia publika*) of St. Petersburg could now visit its "dear native" (*rodnoe*) art in its new home.[103]

Authors of contemporary guides to the museum also underscored the historical scope of the Russian national gallery, where the entire tradition of Russian art was to find a complete and systematic representation. Those who needed help making sense of the "huge mass of paintings" that composed the museum could avail themselves of two catalogues, readily available for purchase at the museum's entrance. Museum guides, too, like one by the historian and author Anatoly Polovtsov, aimed to deliver information in an "accessible form" (*v obshchedostupnoi forme*) in order to aid the museum's visitors in appreciating the art.[104] Baron Vrangel likewise authored a two-volume catalogue of the collection, with descriptions of all the objects to be found in the museum, ostensibly in response to visitors' demand for such an edition.[105]

The first decade of the twentieth century saw the emergence of guides like Olga Kulibina's *Explanation of Paintings Compiled for the People*, written specifically for commoners.[106] These books' intended readership was the "mass public" (*massa publiki*); they described and explained individual paintings, artists, and terms, as well as the phenomenon of the Russian school of art overall.[107] Admission to the museum was free, and in the first year of its existence, about 100,000 people paid it a visit. Reproductions of paintings from the museum in art journals and popular editions also aided in bringing the museum's collection to a wide audience.[108]

The idea of Russian art's canonization was reinforced in the plethora of guidebooks that strengthened the museum's reputation but failed to diversify the largely monologic discourse associated with this institution. Despite free access to the Russian Museum and the broad appeal of its works representing

the national school of art, the Russian public did not celebrate the arrival of this long-awaited institution. It was as if the museum remained enshrouded in a silence interrupted only occasionally by the harsh criticism issuing from the new generation of art connoisseurs, such as Stasov's nemesis, the young "decadent" Sergei Diaghilev.

What Diaghilev declared, with his characteristic flair for absolute statements, was that the newly opened museum played no role in Russian culture whatsoever.[109] He was largely right: if everything associated with Russia's other major collection of national art—Moscow's Tretiakov Gallery—found ample reflection in the contemporary press, there was so little written about the new museum in the capital that it seemed as if Russian society hardly noticed this major event. Aside from a few reports on the official ceremony that marked the museum's opening, this long-anticipated milestone in Russian cultural life aroused little interest in society. The silence of the press was especially puzzling since, for decades, Russian society had demanded precisely such a national museum and since, at long last, the government responded to those demands. Why did this long-awaited establishment fail to fulfill its designated role as a marker of cultural identity?

The reasons behind this low-key encounter between the museum and Russian society in 1898 include timing, location, a change in aesthetic taste, and the museum's official status as a "monument" to the tsar. But the main reason, I suggest, was that, from the first days of its existence, the museum was largely excluded from popular discourse.

Time and place played a big role in determining the Russian Museum's fate. The museum's location in Russia's capital, while strategically prudent, only further underscored just how misplaced this belated national project was: during the second half of the century, the center of Russian national art and the public discourse associated with it had moved to Moscow, while St. Petersburg witnessed a revival of the cosmopolitan tendencies in Russian culture as the turn of the century approached. As a result, the Russian National Museum felt out of place in the imperial capital. Indeed, the association of national culture with Moscow was so strong that one guidebook directly suggested that by founding the Russian Museum, Alexander III was restoring to St. Petersburg the status of the country's cultural center.[110]

The new museum was advertised in 1895 as an "indelible" milestone in the history of Russian culture. The sentiment expressed in a piece announcing the museum's foundation in *The New Time* is indicative of the hopes that the nation placed in the new institution: "Let us wish that Russian society

and the Russian people will always find the expected benefit (*pol'za*) from the foundation of the 'Russian Museum', and that this benefit should manifest itself in the successful growth of Russian culture (*russkoi kul'tury*) in general and the development of Russian art in particular."[111] But the promise that the museum held for society was undermined by the very context in which it had emerged. The new institution appeared in the wrong place and at the wrong time, against a background that was markedly different from the nationally oriented cultural situation of the 1860s–80s. While Russian society waited for this national art gallery, taste itself was changing: the Itinerants, who had contributed greatly to the glory of the Tretiakov Gallery and whose works essentially shaped the canon of what became known as Russian "national art," were falling out of fashion, even as the leaders of the once rebellious movement were becoming part of the establishment at the Academy of Fine Arts. By the time the Russian Museum opened its doors to the public, the Itinerants' main proponent, the now-aging Stasov, had ceded much of his authority to younger critics and had himself become a target of ridicule in the press. The year of the museum's opening coincided with the inception of the *World of Art* journal, which put itself in explicit opposition to Stasov's doctrine of "realism and nationality." In this same year Tretiakov died, further eclipsing the Russian Museum's grand debut.

Public discourse changed along with aesthetics: the new generation of artists purposefully separated art from the burning issues of the day and, in a sense, disengaged art from the public. Plot-driven canvases, no matter how Russian in their subject matter, could no longer satisfy those who touted aesthetics as a value in its own right. Put simply, a museum conceived as a special monument to Russian art at the turn of the century was no longer needed after the Russian school of art had been institutionalized in the Tretiakov Gallery, as well as in many printed editions.

The inevitable comparisons with the Tretiakov Gallery, felt by many as the main impetus for the formation of the Russian Museum in St. Petersburg, were not kind to the latter. Despite the fact that the Tretiakov Gallery obviously suffered from what Polovtsov called "chronological" one-sidedness, its popular Itinerant paintings, which animated Russian society in the 1860s–80s and which contemporaries came to associate with the very origins of the Russian school, endeared the Moscow art gallery to a broad public from various walks of life.[112] While the scope of the Russian Museum was clearly more ambitious, major gaps were noticed both by the museum's enthusiasts and its detractors.[113] According to conventional wisdom, the Tretiakov

Gallery had a "significant" advantage over the Russian Museum overall.[114] A modern expert outlined the difference as follows: one was national in spirit, the other was national in name; one expressed the popular tendency of the Great Reforms, while the other embodied the doctrine of official nationality.[115] Miasoedov also emphasized the inferior status of the Russian Museum. Crediting Tretiakov with indirectly founding the Russian school of art, the artist writes: "I don't know whether the idea of the Russian Museum would ever have matured in St. Petersburg had we not already had it in the Tretiakov Gallery."[116]

Much like the Hermitage before it, the Russian Museum was first and foremost associated with the imperial court and the tsar. Despite its designation as *national*, the new gallery of art was founded specifically as a "monument" to the monarch Alexander III. It was a state museum (*gosudarstvennyi*) decreed by the tsar, administered by the Court Ministry, and supervised by the president of the Academy of Fine Arts. As such, this conception of the museum was not unwarranted: the tsar indeed fashioned himself as a connoisseur and an ardent supporter of the "renaissance of national art" (*vozrozhdenie natsional'nogo iskusstva*).[117] The myth of the museum's origins emphasized the emperor's personal involvement in its founding. As one contemporary source recorded it: "Rumor has it that one of the paintings presently gracing the museum's wall, specifically Repin's *St. Nicholas*, gave the deceased sovereign the idea, which he articulated right there on the spot: to found an all-national Russian museum where all the best works of Russian art could be concentrated."[118]

The founding document that set up the principles and regulations for the museum's activities, "The Statute of the Russian Museum of Emperor Alexander III" (*Polozhenie o Russkom muzee Imperatora Aleksandra III*), opens with the statement, versions of which can be found in almost every contemporary written source: "The museum is founded in memory of the Unforgettable Patron of Russian art, the emperor Alexander III, having the purpose of bringing together everything related to His Person and the history of His Reign, and providing a clear idea of Russia's artistic and cultural condition."[119] The priority given to the person of Alexander III over the state of Russian culture in this official document translated into a semiformal, tsar-centered discourse that quickly grew around the institution of art founded in his memory. Thus K. Voensky opens his brochure on the Russian Museum with a series of exalted statements on the tsar's sacred place in Russian history. The author continues with the description of the tsar's Russian-

ness, his will, perseverance, and noble character, all of which allowed him to "demonstrate to Europe and the entire world the moral power and indestructibility of spiritual Russia" (*nravstvennaia moshch' i nesokrushimost' dukhovnoi Rossii*). He then proceeds to characterize Alexander's collecting activity and his noble aspiration to create a museum that would not only preserve native art, but also reflect all of Russian life in its diversity and disseminate the national idea. For Voensky, as well as many of his contemporaries, the noble project of building a national museum could not come to fruition based only on the means and initiatives of private persons; the government's participation was essential to its lasting success.[120]

This celebratory spirit resonated in other sources. Polovtsov's guide even gave Alexander III additional credit for creating the Russian Historical Museum as well, whereas the latter was actually conceived and founded by a voluntary association of private citizens.[121] An article published in the widely read "thin" journal *The Cornfield* focused on the opening ceremony and the dignitaries who were present, concluding with a triumphant announcement that the museum will remain forever "the living monument" to Emperor Alexander III.[122]

Formally, the museum was divided into three departments: the memorial devoted to Alexander III, the artistic, and the ethnographic. The memorial department, however, despite ardent endorsements by Polovtsov and others, was not realized until 1917, and the ethnographic section likewise stalled.[123] Of the three formal subdivisions, only the art gallery was opened to the public. It was as if in the absence of the designated department, the art gallery came to stand for the tsar's memorial, reinforcing the association of "art museum *qua* monument to the tsar" that the founding document encouraged.

The Russian Museum was a unique site in society where art and authority met: imperial patronage and public interest at least nominally came together in the museum to promote national cultural identity and foster patriotic spirit. The museum and the discourse around it succeeded quite well in building a monument to the tsar, but they failed noticeably in their attempt to represent the entire history of Russian art—a flaw that did not escape the attention of even those contemporaries who otherwise wholeheartedly endorsed the place.

Among the museum's supporters was Stasov, who jovially welcomed the creation of a state museum of national art: "Today we witness the realization of our long-standing hopes and common needs. Finally, our first National

Art Museum is being created. And this is a museum whose existence is solid and safe for all times because it is a state institution and not a private one. … [T]he Itinerants can now only rejoice and cheer and clap their hands, as they attend the establishment of the National Russian museum." Artists, however, did not always share Stasov's optimism. Miasoedov, for instance, compared the new museum to the beloved Tretiakov Gallery and declared that he was not overjoyed by the official state museum (*Kazennomu muzeiu ne raduius'*).[124] The Russian public, which not so long ago had celebrated Tretiakov's gallery, also kept a deferential distance from the new state museum. Not unlike the Imperial Hermitage, the Russian Museum remained largely invisible due to its near complete absence in the popular press.[125]

Formally, the foundation of the Russian Museum supplied conclusive evidence that the Russian school of art, the existence of which was routinely disputed in the course of the nineteenth century, was not merely a figment of Stasov's imagination. Voensky outlines the achievements of the Russian "national art" that the museum came to represent as follows:

> Having become genuinely national, Russian art has attained in the present century universal importance as well; Russian literature has attracted the attention of the whole educated world for a while now, and in recent years has become an object of imitation for foreigners. If our painting, our sculpture, have not until now won the rights of citizenship in Europe, one of the underlying reasons for that certainly lies in the absence of a national museum, which could represent Russian art in its entirety and unity (*v ego tselosti i edinstve*). One would think that now, with the establishment of the Museum of Emperor Alexander III, this institution will have the same high-cultural (*vysoko-kul'turnoe*) importance for Russia as the National Museum in Paris and the British Museum in London have for France and England.

The patriotic message that Voensky ultimately reads into the museum's mission seems to suggest that the Russian population was expected to take pride in the museum: within the walls of the national museum, the author postulates, "Russian youth" (*russkoe iunoshestvo*) will receive a genuinely patriotic education, "warmed by their love for Russia and the unforgettable Tsar-Peacemaker" (*nezabvennyi Tsar'-Mirotvorets*).[126]

Next to the celebratory patriotism of some printed sources, however, a fierce counter-discourse soon unfolded that gave voice to harsh criticism of the various things that the Russian Museum *lacked*. In sharp contrast to the

noble mission of the museum, which was meant to represent the entire history of the Russian school of art, its collection was found to be incomplete and eclectic. Critics observed that it seemed to be suspended at a stage of becoming: the bright prospects that several authors envisioned for the treasury of Russian national art remained largely unfulfilled. The prolific journalist, art critic, and prose writer Nikolai Breshko-Breshkovsky, for instance, noticed something impulsive and almost forced in the museum's origins: "But the Russian Museum appeared all of a sudden (*vdrug*), unlike the Tretiakov Gallery, which has been in the making for decades, and thus the selection of paintings in the museum has somewhat of a random character. And it couldn't be otherwise."[127] Indeed, the museum comprised artworks that arrived from a number of institutions and private collections: 80 paintings were transferred from the Hermitage, 21 came from the Winter Palace, and the rest from several summer palaces and the Academy of Fine Arts. Private collections, including those of Alexei Lobanov-Rostovsky and Maria Tenisheva, were added to the initial exposition as well.[128] All these separate collections did not quite coalesce into a comprehensive narrative of the history of Russian art; thus Lobanov-Rostovsky's collection was preserved as a separate entity within the museum's exposition for a number of years.[129] Further additions to the collection, mostly purchased sporadically at local exhibitions, likewise left much to be desired.[130] Despite the fact that the Russian Museum possessed a number of gigantic (*ispolinskii*) paintings, like Vasily Surikov's *Ermak's Conquest of Siberia* (*Pokorenie Sibiri Ermakom*, 1895) and Genrikh Semiradsky's *Frina at Poseidon's Festival in Elevsin* (*Frina na prazdnike Poseidona v Elevsine*, 1889), as well as a series of enormously popular ones, like Repin's *Sadko* (1876), the overall impression the exposition produced was one of deficiency rather than splendor, due to the great number of inferior paintings jumbled together with masterpieces. Accordingly, Benois argued that the random, cluttered display of paintings detracted from their intrinsic value rather than celebrating the obvious achievements of the Russian school of art.

In their vast majority, contemporaries shared the critic's opinion that this collection tended to impress the viewer as something "sundry and not very reassuring" (*vpechatlenie chego-to pestrogo i ne ochen' uteshitel'nogo*).[131] The art historian and painter Petr Neradovsky, the museum's first conscientious curator (*khranitel'*), similarly observed that everything in the museum was done willy-nilly (*koe-kak*), "with unforgivable negligence, just to get the visitors in sooner" (*lish' by skorei*).[132] Chronologically, while the early history

of Russian art, and especially its academic tradition, was represented fairly well, the Russian Museum possessed only a handful of the popular realist paintings from the 1860s and 1870s and almost nothing in terms of the most recent Russian art that would appeal to young connoisseurs like Benois and Diaghilev.[133]

In aggregate, this haphazard and incomplete collection presented a vision of the Russian school of art that was far from glorious; if anything, as some of the most audacious critics insisted, the new museum rendered a disservice to Russian national culture. Not until the arrival of Neradovsky as curator in 1909 did systematic work on collecting and displaying national treasures begin. Until then, this "province" of a museum (*zakholust'e*), staffed with exactly two employees, hardly justified its own existence.[134]

Diaghilev's *World of Art* was particularly ruthless in attacking the museum's collection. Dripping with irony and sarcasm, a review of Polovtsov's guidebook by the art historian and artist Alexander Rostislavov aimed to dismantle Polovtsov's monumental narrative. Rostislavov categorically refused to recommend the guide as a companion to the museumgoing public: "What sort of companion is it—somewhat blind, somewhat deaf (*slepovatyi, glukhovatyi*), and at that, falsely eulogizing with patriotic howling" all sorts of artistic trifles. By referring to major canvases by Bruni, Vereshchagin, Semiradsky, Makovsky, Novoskol'tsev, Litovchenko, and many others as trifles, Rostislavov called into question the historical breadth and depth of the collection that Polovtsov and others celebrated.[135] This review is but one of the utterances in the counter-discourse on the Russian Museum that unfolded in the pages of the *World of Art* and that ran against the formal, celebratory current in the guidebooks and official announcements. Diaghilev, in fact, insinuated that the museum's failure to adequately represent Russian art was due precisely to its status as an official, state-sponsored establishment.

Another note by the *World of Art*'s editorial board fueled a spiteful controversy between the journal and the esteemed Itinerant artist Repin, now a professor at the Academy, who had earlier agreed to collaborate with the new group.[136] What inflamed the debate, which ultimately led to Repin's decisive resignation from the journal, was a curt little article published amid other announcements and opinions at the end of one issue of the *World of Art*.

Every newly opened museum cannot but have some weak works, but one should take care that things that are shameful, that compromise national creativity, do not find a way into it. Such works, deprived even of any historical

importance, should be quickly and energetically withdrawn. In view of these considerations, the following canvases should be immediately removed from our National Museum.

What followed was a list of fifteen paintings by artists both famous and unknown, among them Aivazovsky, Pavel Pleshanov, Bronnikov, Flavitsky, K. Makovsky, Vereshchagin, and Trutovsky; the list was to be continued in the following issues (*prodolzhenie budet*). Another note in the same issue called works by Neff, Galkin, Rizzoni, and, again, Aivazovsky, which were among the most frequently copied in the Museum of the Emperor Alexander III, "artistic rubbish" (*khudozhestvennyi khlam*). "Why should the Museum exist if the worst and most banal (*poshlyi*) things, works that are perhaps there only by accident, enjoy the most success? One can see from this how carefully one should approach the selection of paintings. Not only do bad works of art get noticed, but on the contrary, they spread throughout Russia like a plague infecting the ignorant public."[137]

Repin responded to this provocation publicly in the pages of *The Cornfield*, attacking the newly founded artistic journal and the novel aesthetics that it propagated; his response was reprinted verbatim in the *World of Art*. This exchange took place in the pages of two very different publications: the most popular weekly journal for family reading in imperial Russia, *The Cornfield*, and the elite *World of Art*. Their intended reading publics could not have been more different. What made the conversation possible, however, was that each quoted, reprinted, or indirectly referred to the other. This allowed the readership of each publication to follow the entire exchange, albeit often in biased and truncated form. Defending his cohort in *The Cornfield*, the venerable artist assailed the *World of Art* contributors and collaborators as decadent amateurs. He was outraged that the editorial board dared to dictate to the museum which paintings to remove from the exposition, as if the museum were the board's subordinate (*podchinennyi*). Repin likewise objected to the *World of Art*'s arrogant position on questions of taste and the public's viewing preferences. The artist's main charge against the *World of Art*, however, was the latter's total lack of patriotic feeling: "Not a morsel of patriotism," the offended leading painter of the Russian school of art exclaimed. In conclusion, he addressed the young generation of artists and critics affiliated with the *World of Art* with this harsh indictment: "In your philosophizing about art you ignore what is Russian, you do not recognize the existence of the Russian school. You do not know anything about

it, strangers to Russia that you are" (*kak chuzhaki Rossii*).[138] In his retort, Diaghilev offered a long list of Russian artists' names whose works had been published in the *World of Art*. He also took care to separate Repin's name from the "rubbish" that the Russian Museum was supposed to eliminate.[139]

Two years later, Diaghilev resumed his vitriolic attack on the Russian Museum. In his long article "About Russian Museums," he pointed to the haphazard origins of the national gallery in St. Petersburg, representing it as one of "the most sorrowful examples" of unrealized potential in Russian culture. If the Tretiakov Gallery, limited by the taste and means of a private collector, could gather a grandiose collection of paintings narrowly focused on the 1860s–80s, a state museum ought to be able to represent the entire history of Russian art, from Peter the Great to the present. "The museum must also be, without fail, our history in its artistic representations." Yet the national gallery sorrowfully failed in this undertaking, turning into "the most boring bureaucratic museum" instead (*skuchneishii kazennyi muzei*). The critic was equally outraged by the museum's acquisition practices, especially its unwillingness to purchase Maliavin's painting *Laughter* (*Smekh*), representing Russian peasant women in red, that had recently received a gold medal at the international exhibition in Paris and that "all of Europe had talked about for the past year." Nor did the museum transfer from Peterhof Palace a set of Levitsky's famous *Smolny Institute Girls* (*Smolianki*) as planned. "One should beg, beg a thousand times, that pearls of Russian art become accessible to the Russian public and that they all become part of the Russian artistic depository in their entirety."[140] Precisely what constituted those "pearls" was, of course, the *World of Art*'s own vision of Russian culture (the group strongly favored eighteenth-century artists, as well as their own contemporaries, like Maliavin and Serov). The failure of the state museum to represent Russian art in its historical development was unforgivable to Diaghilev; the critic lamented that no one cared about Russian art, that no one loved it. The task of a national museum, according to Diaghilev, was to gather "genuine works of Russian art" and, having gathered them, to love them. Coming from Diaghilev, who harshly criticized the state museum for its "cold, callous formalism" (*kholodnaia cherstvaia formal'nost'*), this discourse of love strikes a note of sincere distress.

The controversy that Diaghilev and Repin acted out in the press was hardly about the Russian Museum proper. Essentially, Diaghilev challenged the kind of canonization that was taking place in this state-sponsored institution. His exchange with Repin served to deflect public discourse away

from the museum—as an object of national pride—and toward issues of inclusion and exclusion from the canon.

Diaghilev's aggressive vitriol and Repin's righteous indignation are the main highlights of an otherwise well-tempered discourse that, if anything, further disengaged the public from the museum. If a handful of public figures campaigned against the national museum, the mass press remained, for the most part, silent on the issue, essentially leaving the museum out of the public debate on art and identity. By all appearances, Russians somehow did not wish to take national pride in the new art gallery established in their name. It is not that the museum received no visitors—the numbers that scholars provide are actually strikingly high and comparable to those of the Tretiakov Gallery. The public did attend the Russian Museum, but the museum failed to capture the national imagination, for it could not "travel" beyond the capital city and reach the vast majority of the Russian population in the pages of popular periodical editions the way the Tretiakov Gallery had. Nor did it incite wide-ranging debates like those that had roused Russian society only several years before.

Formal and semiformal panegyrics on the one hand, and vicious attacks by the "decadents" on the other—these are the terms in which written sources of the time couched discussions surrounding the Russian Museum. The guidebooks to the Russian national gallery of art that appeared periodically are the only evidence of "communication" between the museum and society at large. Indeed, with the professionalization of art criticism, much of the writing about art moved from the mass-circulation press to guidebooks and specialized art journals, where aesthetics, only recently a subject of controversy in the writings of Chernyshevsky and Pisarev, found a welcoming home.

BUILT OUT OF WORDS

History and Stylization

The national realism of the Itinerants, who introduced a radically new subject matter to painting and drew the public's attention to previously taboo aspects of the Russian experience, was one manifestation of the ongoing quest for a unique identity in the visual arts. The proliferation of the so-called Russian style in architecture and the applied arts was another such expression of the Russian obsession with cultural heritage. Exhibitions and museums that emerged in Moscow in the last third of the century drew considerable public attention due to their special designs with folk overtones. The Russian style that arose in the first half of the nineteenth century became a public statement in Moscow in the early 1870s, when it triumphed in the architecture of the Historical Museum. This museum was a distinctive project that was never completed but nevertheless remained a magnet for lively debates for over a decade.

In the course of the controversy that surrounded the Historical Museum, Russian history became a no less contested territory than the Russian school of art. That history plays a major role in the formation of nations is by now axiomatic. Anthony Smith theorizes: "The 'rediscovery' or 'invention' of history is no longer a scholarly pastime; it is a matter of national honour and collective endeavour. Through the tracing of our history, 'we' discover (or 'rediscover') who we are, whence we came, when we emerged, who our ancestors were."[1] In nineteenth-century Russia, contemporaries repeatedly noted the connection between the study of the past and the development of a national consciousness. Already in 1867, Solovyov observed: "There are times in the life of each people when the demand for national consciousness becomes one of its principal spiritual needs. To all appearances, such a time, a time of maturity, has [finally] come for our people. The study of

national history and archaeology has acquired particular importance and attracted special support."[2] The public's interest in history spiked during the millennial celebrations and continued to increase during the many reform-era exhibitions in Moscow, culminating in the national project that was the Historical Museum. It was then that Bestuzhev-Riumin announced a strong connection between history and identity: "People who wish to be great should know their history."[3]

Moscow museums and exhibitions of the late nineteenth century manifestly document this quest for national history. They also contributed greatly to the changed status of the old Russian capital. As newspapers wrote more and more about Moscow museums and their distinctly national character, the old capital of Russia became the cultural center of the country, which since midcentury increasingly gravitated away from St. Petersburg. Not only did Moscow accommodate and advance individual institutions of culture, but in itself, with its numerous architectural landmarks in the Russian style, the city became a monument of that culture, too. The reinvented Russian style became the face of Moscow, of Russia, and of Russian pavilions at international exhibitions abroad.

Culture in the Russian Style

The term "Russian style" gained currency around midcentury when Sazikov's centerpiece made news in London. It refers to a distinct vernacular in the visual arts that drew upon the traditions of Russian folk culture.[4] This Russian style was mainly a compilation of late-nineteenth-century tastes and opinions, but for several decades, it served as a unique idiom for the articulation of the national idea in architecture, the applied arts, and interior decoration. In architecture, certain features are typically associated with this style (and its versions known as national, neo-Russian, and neonational styles): whimsical decoration; colorful composition; an ornate outline; a plurality of materials and building units; old national forms, such as the stepped gables of the seventeenth century, called *kokoshniki*, and the faceted tower *shatyor*.[5] The rich ornamentation found in pre-Petrine church architecture was particularly conspicuous in the new Russian design. As *the* model to emulate, the historian Ivan Zabelin nominated St. Basil's Cathedral in the Red Square, considering it Russia's most curious edifice, no less distinct than Germany's Köln Cathedral.[6] But the many repetitions of this

and other churches were all modern stylizations. Not infrequently taken to excess, decorative elements drawn from peasant embroidery and traditional woodcarvings produced such epithets as "ornamentality" (*uzorochnost'*) and the less flattering "gingerbread" and "cockerel" (*prianichnyi, petushinyi*) to describe this highly ornate style.[7]

In retrospect, Sergei Makovsky declared the Russian style to be a sheer fabrication:

> This notorious (*preslovutyi*) style is a patriotic figment. We have not created an independent architecture. All forms of old Russian buildings are borrowed from Byzantine art, from Norway, Italy, India.... Hence the whimsicality of its outlines, the garishness, festive ornamentality of the churches, the tent-roofed towers and terems of the seventeenth century: the mixture of styles, Byzantine, Roman, Gothic, Renaissance, and maybe Indian.... That's it.[8]

But before the nature of this largely invented phenomenon became apparent to the discerning eye of the professional critic in early twentieth century, the Russian style enjoyed considerable popularity in a variety of forms and forums—from Thon's official church architecture of the 1830s and 1840s, to the international exhibition pavilions of the 1870s, and to Vasnetsov's fairy-tale Hut on Chicken Legs of the 1880s.

Formally, the Russian style first manifested itself in architecture and interior design in the 1870s. In its most ostentatious variety, the new vernacular attracted attention early in that decade at the 1870 All-Russian Exhibition of Manufacture in St. Petersburg and the Polytechnical Exhibition of 1872 in Moscow. These two exhibitions were the first large-scale efforts to give secular buildings a pre-Petrine appearance. At the 1896 All-Russian Exhibition in Nizhnii Novgorod, not only the pavilions but their attendants too were dressed in national costumes.[9] With this dress-up component, the exhibition almost looked like an ethnographic display; there was also something theatrical in the deliberate Russianness and fairy-tale ornamentation applied to civic architecture. With these temporary exhibitions the new vernacular gained high visibility, instant recognition, and broad popular acclaim.

At the world's fairs, Russian pavilions were likewise well received. Instead of glass and iron, Russians used traditional wood in the architecture of their exhibition facilities; they decorated their museums with ornamental details found in old churches and traditional izbas. The main practitioners of this conspicuous new style were the architects Gornostaev, Gartman, Ropet, and

Monighetti.[10] In 1873, Monighetti introduced the Russian style to interna-
tional audiences with his "Imperial" Pavilion at the World's Fair in Vienna.
Ropet created a complex of wooden buildings for the Russian Department
at the International Exhibition in Paris in 1878, recognized by critics as "the
best and the most original architectural creation in the whole World Ex-
position" (*image 14*).[11] The Russian style triumphed internationally at the
Parisian World's Fair in 1900, where the main pavilion was stylized as an old
Kremlin, and the richly decorated "Russian Village" housed the exposition
of folk crafts.[12] It may seem that Russians chose to represent their identity
precisely in the exotic terms that foreign observers admired; popular opin-
ion at home, however, celebrated these ornate designs just as much.

What was the appeal of old-fashioned themes and forms in the age of
modernity? The discovery of a national neo-Romantic style was part of the
modern quest for identity. The Russian revival, in one form or another, was
consistently present in the visual arts during the last two thirds of the nine-
teenth century; by the century's end, it dominated the landscape of central

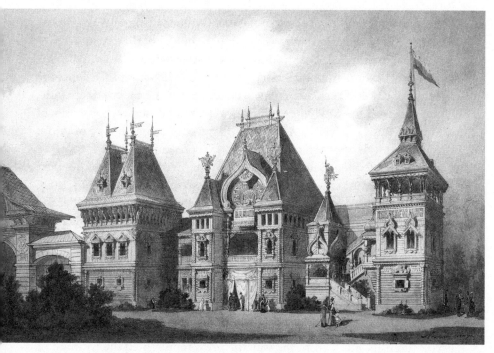

14. Russian Pavilion at the 1878 International Exhibition in Paris, design by I. Ropet

Moscow and defined the Russian presence at international exhibitions. The "ornamental" architecture of exhibition pavilions had become a material expression of the Russian longing for a national form in the arts. At home, too, museums had turned into temples of secular identity. The Russian style was indeed most frequently applied to museums' buildings and churches.

The imagery and the national sentiments that the vernacular tradition represented were broadly disseminated by exhibitions, reproductions, and popularizing commentary in the press. Although there was an undeniable element of theatricality in the national style, and although several other styles existed alongside it (the neoclassicism of St. Petersburg, for instance), it was this stylized neotraditionalism that society most readily recognized as *the* embodiment of the authentic Russian spirit. The style spread chronologically and geographically, in part because the aesthetics of the Moscow renaissance cut across class lines, with the merchantry, the nobility, professionals, the intelligentsia, and eventually the working class appropriating invented peasant traditions in the applied arts and architecture as their own. The influence of the national style spread beyond pure aesthetics as well. Russia's distinction, however, was achieved at the cost of the cultural Russification of the empire. A score of Russian Orthodox Churches in Warsaw dating to this time period serve as a painful reminder of this practice.[13]

Copious writing devoted to the national style helped disseminate this new trend beyond the old Russian capital and its environs, where the neotraditional edifices were concentrated. As the architect Nikolai Sultanov observed in 1881, "there appears a demand in society for works of art in the 'Russian style.'"[14] Alongside the recognition by public opinion, the national style was formally endorsed to represent Russia at the world's fairs; the Academy of Fine Arts likewise admitted that it was "the most significant revolution" in the history of Russian architecture.[15] In 1883, the newly invented tradition went on display in the imperial court at the Grand Duke Vladimir's gala ball; both Alexander III and Nicholas II famously sported personal attire designed according to the national style.[16] In the last quarter of the nineteenth century, the Russian style permeated every layer of culture. One encountered it daily not only in exhibition pavilions and museum halls, but in churches, public buildings, private residences, paintings, theater designs, applied arts, kustar workshops, book designs, costumed balls, interior décor, jewelry, dinner menus, everyday utensils, etc.[17] From the way the press represented the triumph of the newly rediscovered vernacular in the visual arts, it would seem that

Russians had finally found a style in which to fashion their identity, both in ceremonial displays and in everyday life. The revival of the pre-Petrine tradition was a rare instance when the state and society appeared to cooperate in their promotion of the Russian style as a unique expression of cultural identity. Richard Wortman demonstrates how this newly found tradition was endorsed and cultivated by those in power. What is more, the ubiquitous presence of the national idiom in society at large endowed it not only with authority, but with popular appeal as well. The strength and durability of this version of identity rested on this temporary alliance of high authority and the general public.

Moscow, the Seat of National Culture

A remarkable expansion of culture took place in Moscow during the 1860s and 1870s. Many persons, institutions, and voluntary associations contributed to the shift in Russian cultural history that rendered the old Russian capital as the seat of the reinvented tradition, leaving modern Western influences behind in cosmopolitan imperial St. Petersburg. Polenova reminisced about the contemporary spirit: "The overall national tendency of that time period drew one into the depths of Russia, further away from official, artificial St. Petersburg."[18]

Contemporaries agreed that the national revival of the last third of the nineteenth century was specifically a Moscow phenomenon, leading Mamontov to declare: "Unlike any other artistic centre, Moscow can still provide the artist with a lot of idiosyncratic, fresh, unpolluted material." Artists, too, found pride and endless inspiration in the old capital. Repin, for instance, rejoiced: "[Moscow] is so artistic and beautiful that I am now prepared to travel to the other end of the earth to see a comparable city.... I am almost beside myself with happiness at living in Moscow!" Vasnetsov recollected a similar sentiment that he experienced upon encountering the city: "when I arrived in Moscow I felt that I had come home, that there was nowhere else I wanted to go. The Kremlin and St. Basil's almost made me cry, so very national and unforgettable did it all strike my soul."[19]

Several milestones helped define the progress of national culture as it moved from St. Petersburg to Moscow: the transfer of the Rumiantsev Museum from the imperial capital in 1862; the Ethnographic Exhibition of 1867, the progenitor of another Moscow public museum, the Dashkov; the

Polytechnical Exhibition of 1872 and the two permanent institutions that it engendered: the Polytechnical and Historical Museums. Special circumstances attended the expansion of Moscow's cultural scene, including public initiative, broad access, and national thematics. Moscow's new institutions of culture were considered genuinely public, since the Rumiantsev, Ethnographic, Polytechnical, and Historical Museums all emerged as a result of initiatives on the part of private persons and voluntary associations. In the second half of the nineteenth century, individuals and societies played increasingly important roles in advancing the museum age in Moscow. Unlike St. Petersburg's Hermitage or the Academy of Fine Arts, the Moscow exhibitions and museums did not rely too strongly on state support.[20]

The Rumiantsev Museum

The museum age in Moscow began with the arrival of the Rumiantsev Museum, one of St. Petersburg's oldest cultural establishments. In May 1862, the same year that Russia's Millennium was celebrated across the country, the museum opened its doors to the public from its new location in Moscow. Barely noticed in either city in earlier decades, the thirty-year-old museum suddenly became a front-page item for the press, which touted it as no less than Russia's national museum.

The Rumiantsev Museum's famous collection of books served as the foundation for Moscow's main book depository of today, the Russian State Library (former *Leninka*). Otherwise, not much has survived of the original Rumiantsev Museum, as it fell into oblivion soon after it was disbanded in 1924. Only most recently, as part of post-Soviet national revival efforts, has the museum resurfaced in the Russian public sphere after one exhibition highlighted the cardinal role that this site of culture played in imperial Russia.[21] Indeed, the Rumiantsev Museum was once the talk of the nation.

The museum's origins date back to 1831, when it was formally established in St. Petersburg following the death of its founder, Count Nikolai Petrovich Rumiantsev. The collection consisted of rare books and manuscripts, as well as ethnographic and archaeological specimens. Once a week the museum admitted members of the public "of good background," although the library was open daily.[22] The library was the museum's major claim to fame: in pursuit of his keen interest in Russia's history, Count Rumiantsev had amassed more than 28,500 volumes and over 700 manuscripts and rare editions.[23]

During the three decades of its residence in St. Petersburg, however, the museum and the library languished in obscurity.[24] In 1842, a traveler to the Russian capital, J. G. Kohl, recorded the following unflattering impression:

> Of the private libraries opened to the public, the largest is that called the Rumantzow [sic] Museum, in a splendid edifice on the English Quay. It contains a great number of books in all departments of literature and human knowledge, classical and modern, Greek, Roman, German, and French, in history, natural history, and the belles lettres. How small is the interest produced by the capital here expended, I saw in my repeated visits, at which I was generally the only person. The attendant told me that there were many days when there was nobody whatever. From the strangers' [i.e., visitors'] book it appeared that during the first half of the month of April only six strangers had been there.[25]

Stasov's description of the museum was just as grim. The critic used the metaphor of a "forlorn shed" (*zabytyi ambar*), gloomy and cold, to describe the effect that the museum produced on its rare visitors.

If during its tenure in St. Petersburg the museum was habitually represented in terms of decay, upon its transfer to Moscow's Pashkov's House in 1862, this fruitless institution suddenly came into full bloom. The library enjoyed great success, with the number of books requested by patrons increasing exponentially from 2,500 in 1862 and 1863 to 20,000 in 1871.[26] During those years, the Rumiantsev Museum was open to the public four days a week for three to four hours. In 1862 alone 50,355 people passed through its galleries.

Why did this forlorn museum receive such an enthusiastic reception in Moscow? The contemporary press emphasized several factors. The Rumiantsev Museum arrived in Moscow during the same year that the millennial celebrations took place in Novgorod, and the organizers of the transfer emphasized this fortuitous link.[27] While St. Petersburg had such internationally recognized institutions of culture as the Hermitage, the Public Library, and the Academy of Fine Arts, Moscow lacked any educational establishments aside from the University prior to the advent of the Rumiantsev Museum. The press, which followed the museum's transfer very closely, repeatedly emphasized this fact. The museum was also special because of its status as a national institution. The Inspector of the Moscow Education District Isakov, who initiated the move, introduced the relocated museum expressly as an "*all-encompassing, national all-Russian* institution of enlightenment" (*natsional'noe vseob"emliushchee obshcherusskoe prosvetitel'noe uchrezhdenie*).

The Rumiantsev Museum was actually more than just one institution, as its formal name at the time—the Moscow Public Museum and Rumiantsev Museum—implies.[28] Housed next to it in the Pashkov House was another newly established collection based on Moscow University's holdings: the Moscow Public Museum. Colloquially, however, the composite institution was known simply as the Rumiantsev. The museum's art gallery likewise comprised several collections. The original picture gallery, which included Ivanov's famous *The Appearance of Christ to the People*, numbered 202 paintings, according to a contemporary catalogue.[29] In 1867, the bequest of Fedor Prianishnikov's collection of Russian paintings drew further attention to the Rumiantsev Museum. Described by one contemporary as a "pantheon of Russian art" (*panteon russkoi zhivopisi*) and by another as "one of a kind" (*edinstvennaia v svoem rode*), the Prianishnikov gallery contributed 132 excellent examples of the national school to the glory of the Rumiantsev Museum, including two famous paintings by Fedotov, *The Major's Courtship* and *The Fresh Cavalier*.[30] In the following decades, its fine arts department continued to grow, reaching an impressive number of 1,700 canvases by 1913.

Wide publicity accompanied the Rumiantsev Museum from the first days of its opening in Moscow. Even prior to that date, newspapers and journals represented the new public institution of culture as "the most significant phenomenon in Moscow's ongoing life."[31] One newspaper emphatically declared: "In the chronicles of our capital's public life, the day May 6, 1862, will be marked with good memories forever. From that day forward, the first Moscow public library and museum have made their presence felt."[32] *Son of the Fatherland* reprinted a lengthy article from *Moscow News*, sharing in the elation occasioned by the new museum.[33]

Aside from congratulating Muscovites on such an important acquisition, upbeat writing in the press familiarized the public with the new collections and explicated the museum's role in society. During the first days of the museum's opening, journalists observed a record number of visitors, with over two thousand people attending every day.[34] Commentators in both capital cities also highlighted the museum's educational potential, acknowledging the public's growing interest in Russian history. A voluntary association devoted to the study of Russian antiquity called "The Society for Ancient Russian Art" (*Obshchestvo Drevne-russkogo iskusstva*) was formed in Moscow concurrently with the museum.[35] In the meantime, the scholarly community of St. Petersburg mourned the loss of the Rumiantsev Museum. Stasov,

who publicly protested against the move, thought that the museum's depar-
ture was simply humiliating for the imperial capital.[36]

The Ethnographic Exhibition of 1867

The Ethnographic Exhibition opened in Moscow on April 23, 1867. Com-
mentators observed that it presented an extraordinary sight: as if in a kalei-
doscope, one could see all the diverse inhabitants of the vast empire in the
exhibition space of the Moscow Manège. Numerous mannequins, dressed in
colorful ethnic costumes and surrounded by characteristic regional artifacts,
enhanced the exhibition's appearance as a grand festival of the people.[37] The
Ethnographic Exhibition was an obvious success: 83,000 people visited the
Manège during the two months of the show's run, bringing in some 45,000
rubles in revenue.[38] Before long, a permanent collection—the Dashkov Eth-
nographic Museum—grew out of the 1867 Exhibition in Moscow.[39]

Among other things, the exhibition demonstrated that ethnography could
be used successfully as an "instrument for national self-identification."[40] As
Alexander Pypin observed, the study of ethnography leads to a better un-
derstanding of nationality.[41] The exhibition marked the transitional moment
between two distinct models of national identification: the imperial, official
nationalism associated with Nicholas I and the Russian ethnic nationalism
that dominated the reign of Alexander III.[42] Tension between the empire
and the nation was rife, but the organizers of the Ethnographic Exhibition
propitiously resolved it by means of a clever arrangement, which simultane-
ously recognized the broad diversity of the empire's many peoples and the
hierarchal primacy of Russians, whose exhibit was located prominently on
an elevated display platform.[43]

The Slav Congress that convened in conjunction with the Moscow Eth-
nographic Exhibition was in itself a "rather strange phenomenon," attended
by eighty-one delegates from Austro-Hungary, Serbia, Montenegro, Prus-
sia, and Saxony (representatives from Poland were conspicuously absent).[44]
The Congress achieved rather little, as specialists postulate, but it did stir up
latent discourse on Russia's special unifying mission in solving the Slavic
question.[45] Accordingly, Pogodin, Ivan Aksakov, and others proposed that
the Russian language assume the role of a Slavic *lingua franca*. Aksakov's
newspaper *Moscow* wrote ambitiously, for instance: "The Slavs are elect-
ing the Russian language as a means of their mutual rapprochement and

devoting themselves to learning it; booksellers in Western Slavic lands cannot stock enough (*ne nagotoviatsia*) Russian dictionaries and grammars.... What a glory to us, the Russians!"[46] The perennial Polish question, a sore in the public's eye since the most recent uprising in 1863, remained on the far periphery of this Slavic festival. On one rare occasion, Pogodin said with emphasis: "Let us all wish that the Poles, following the Gospel's prodigal son, come to their senses and return to the core of the Slavic family!"[47] The pro-Slavic press represented this "family" as something that was altogether natural; in the pages of the daily *Moscow* and the conservative weekly *The Russian* (*Russkii*), the carefully planned event came across as a "chance" (*sluchainyi*) encounter of the peoples that had happened of its own accord (*sam soboiu*).[48] The periodical press represented the entire population of Russia—irrespective of social standing—as participants in the festivities that accompanied the visiting Slavs when they toured the country in 1867. To judge by the press, the Ethnographic Exhibition and the Slav Congress were public events of national importance. In anticipation of the exhibition, newspapers published a broad appeal to their readership, soliciting readers' assistance and participation in mounting the display. Russian society was quick to respond with unexpected generosity.[49] *Moscow News*, for instance, regularly updated the list of incoming contributions.

Factually, the organization that stood behind the Ethnographic Exhibition was the voluntary association that played a crucial role in Moscow's public life during the age of the reforms: the Society of the Friends of Natural Science, Anthropology, and Ethnography (or OLEAE, in its Russian acronym). This society was founded in 1863 as an affiliate of Moscow University and soon engaged in vigorous public activity.[50] Anatoly Bogdanov, a young professor of zoology at Moscow University, was its recognized leader; a professor of geology, Grigory Shchurovsky, was appointed its president. The time and place of OLEAE's appearance are noteworthy: it grew out of the "spirit of rejuvenation that gripped all educated society in the early 1860s," as Ivan Kablukov notes in his commemoration of the voluntary association's fiftieth anniversary.[51] A product of the era of the Great Reforms, when the government allowed relatively independent organizations to take initiative in public outreach, OLEAE's self-proclaimed task was to popularize science and to democratize knowledge in Russia.[52] Public lectures, exhibitions, and museums were deemed particularly effective for this purpose. Aside from the Ethnographic Exhibition, OLEAE supported such major public events as the Moscow Slav Congress of 1867, the Polytechnical Exhibition of 1872,

the Polytechnical and Historical Museums, and the Anthropological Exhibition of 1878.[53]

Journalistic writing devoted to the Ethnographic Exhibition drew attention to this unique public event, but its overall evaluation was mixed.[54] Foreign sources were largely cynical, representing the exhibition as now a "political demonstration," now a "Potemkin village" of sorts.[55] Although Russian newspapers protested such impolitic views, the overall impression remained lukewarm.[56] For local critics, the ethnically Russian display in the center of the exhibition became a subject of contention. Most reviewers agreed that there was something unimpressive about this Russian installation. *Moscow News*, to take one extreme case, described the display as an expression of the "foul spirit" of "Russian self-degradation" (*russkoe samooplevanie*) and a bitter "satire of our fatherland."[57]

Nationally conscious contemporaries attempted to consolidate the public's response in their own writing. Thus, a month after the exhibition and the Slav Congress concluded, Aksakov wrote wishfully in a lead article: "We very much desire to have a singular opinion about the congress, namely our own."[58] Stasov earnestly defended the exhibition against journalistic naysayers. In the esteemed art critic's opinion, the Ethnographic Exhibition had been an important national event that should have elicited nothing but enthusiastic and proud commentary in the press. Analyzing the underlying reasons for the journalists' more ambiguous reactions, Stasov simply concluded that the press "did not understand anything in it." Where the journalists saw humdrum everydayness, Stasov saw authenticity, much more valuable in his opinion than the decorative theatricality that underlay the popular Western Slavic displays unanimously praised by the critics.[59]

Publicity helped the exhibition realize its main goal: the display of a "complete, vast Russia, with all its mixed character and diverse population," and the public's acquaintance with its fatherland (*znakomstvo s rodinoi*).[60] The president of OLEAE, Shchurovsky, emphasized this point: "An interest in studying Russia is a new phenomenon that our public has just discovered"; if previously Russians had been keen on studying Europe, now, for the first time, their attention had turned to Russia. In his mind, the Ethnographic Exhibition had succeeded in fostering a sense of self-awareness in its visitors and demonstrated that visual culture was an invaluable aid in nurturing an imagined community among the empire's citizens. "Indeed, exhibitions and museums are among the most powerful means for public education. Representing at first only the engaging side of the issue and

effortlessly satisfying [the public's] curiosity, exhibitions and museums are within everybody's grasp, accessible to all: they are as interesting to the specialist as to someone without education...."[61] Figuratively speaking, as one source did in retrospect, the ethnographic collections offered their visitors a course in the "study of the fatherland" (*kurs otechestvovedeniia*). Public lectures, delivered in conjunction with the forthcoming exhibition by distinguished specialists from Moscow University in 1866–67, assisted audiences in mastering this new subject.

The Moscow Museum and Exhibition Boom

The discourse incited by the Rumiantsev Museum and the Ethnographic Exhibition underscored a larger cultural shift from St. Petersburg to Moscow. Around the middle of the nineteenth century, contemporaries began representing Moscow as the center of Russian national culture, in distinct contrast to the imperial Petersburg that began to be increasingly associated with bureaucratic and foreign influence.

The press cheered the choice of the location for the Ethnographic Exhibition and the concurrent Slav Congress. The newspaper *Moscow*, for instance, promoted the city as "Russia's genuinely national capital."[62] It was not accidental that the newspaper, founded in the year of the exhibition, bore the city's name; during the two years of its brief but eventful life, it served as a daily advertisement for Moscow.[63] For Pogodin, too, Moscow was a kind of ideal mirror that could reflect the peace and harmony of Slavic brotherhood.[64]

A commemorative booklet, issued on the occasion of the fiftieth anniversary of the Moscow Public and Rumiantsev Museums, emphasized this newly found tradition of locating national culture and identity specifically in Moscow: "Our museums have a special meaning that only they possess. Within their walls, they concentrate the fruits of the Russian people's creativity over the course of their thousand-year history.... Situated in Moscow, the heart of Russia, with its relics and its Kremlin, they are Russian national institutions."[65]

Overall, writing in the popular press helped ground Russian history and art in the old Russian capital.[66] One lesser-known journalist, S. Maksimov, borrowed the metaphor of an exhibition to outline the city's cultural profile in *The Voice*: "Moscow itself, without any premeditation or artifice, is an everyday ethnographic exhibition, predominantly of the Great Russian tribes

from all the central provinces."[67] The ease with which contemporaries equated the city with the entire country highlights the symbolic role of Moscow as a national center that came to represent the whole of Russia in miniature.

Maksimov's metaphor is also characteristic of another change in Moscow's cityscape: Moscow became a museum city, a site both for epic-scale projects, like the Historical Museum, and selective private art galleries, including the collection of the Moscow industrialist Vasily Kokorev, which opened in 1862, and the picture gallery of Koz'ma Soldatenkov. The Kokorev Gallery accommodated a large hall for public lectures and literary readings, decorated in the likeness of a traditional peasant hut (*izba*) in the Russian style. Contemporary observers found the ostentatious Russianness of the Kokorev Gallery especially commendable.[68] In the same remarkable year for Moscow, 1862, Soldatenkov's museum was profiled in a new periodical edition, *The Picture Galleries of Europe* (*Kartinnye galerei Evropy*), established specifically in order to refine public taste. The journal was particularly keen on publicizing Russian art: even the lesser-known private galleries of the Muscovites Mosolov, Trofimovich, and the Golokhvastovs were described in its pages in scrupulous detail.[69] Another collection that attracted the public's attention in the 1860s was the Golitsyn Museum, which opened in 1865; it contained 132 paintings of various schools of art, a collection of curiosities, and a library.[70] It was open to the public three days a week, free of charge. The most distinguished museum of art in Moscow was clearly the Tretiakov Gallery, discussed in the preceding chapter.

Many of Moscow's new exhibitions and galleries in the 1860s and 1870s were organized systematically, following the scholarly approach pioneered in the Rumiantsev and Dashkov collections.[71] Not only did Moscow's exhibitions and museums contribute positively to the ongoing discourse on issues of identity, but they stimulated the development of a new scholarly subject in Russia: museum studies (*muzeevedenie*). By comparison—and in opposition to earlier tendencies—the press now represented the museum scene in St. Petersburg as much less vibrant. When the Kushelev Gallery, a generous bequest of Count Nikolai Kushelev-Bezborodko to the Academy of Fine Arts, opened to visitors in 1862, newspapers only briefly cheered the new arrival. The bulk of this renowned collection, however, comprised artworks of the "old" (i.e., European) school of art, hardly a subject of either popular interest or controversy.[72] Roughly the same could be said of Count Sergei Stroganov's private gallery, the oldest in St. Petersburg.[73] Still another collection of European art, belonging to Duke of Leuchtenberg,

remained closed to the public.[74] In other words, while there was no lack of art in St. Petersburg per se, its Western European holdings did not incite nearly as much discussion in an age of cultural nationalism as Moscow's Russian art depositories.

Contemporaries posited Moscow as the missing core of Russian cultural identity. Patriotic agitation in the wake of the 1863 Polish Uprising led to speculation over whether it might not be necessary to transfer the capital from St. Petersburg to Moscow. Dostoevsky, for one, as Panteleev reminisces, was a big advocate of this idea.[75] In the realm of visual culture, this overtly national turn found expression in the Russian themes and styles that came to dominate the art scene. The symbolism of Moscow as a new center of culture was transparent: located in the vicinity of the ancient Kremlin, the museums and exhibitions of the second half of the nineteenth century harked back to pre-Petrine Russia.[76] The proliferation of buildings in the Russian style helped Russify Moscow visually as well. Such prominent cultural institutions in the heart of the old city as the Polytechnical and Historical Museums, the City Duma, and the Upper and Middle Market Arcades, gave rise to a new foundational narrative, that of a genuine and pure Russian nation, strong in tradition and presumably free of foreign influence.[77] Unlike the classical and neoclassical tendencies, which were rooted in the cosmopolitan St. Petersburg, the late-nineteenth-century national style was closely linked to the Moscow cultural renaissance. By contrast, "the Westernizer St. Petersburg," in Sultanov's words, could boast few buildings in the Russian style, with the notable exception of the "Savior-on-the-Blood" Cathedral, which was more a disappointment than a delight to contemporaries.[78]

The museum boom in Moscow shaped the national definition of self not in terms of industrial progress but in terms of traditional folk culture, ostensibly liberated from two centuries of Western influence. Much as it was a newly devised tradition in many regards, the Russian style enjoyed instant recognition and lasting success due, in part, to its wide application in Moscow and in Russian pavilions at world's fairs. This was no longer the warped and uncertain modernity of underdevelopment associated with neoclassical St. Petersburg and its literary tradition, which for many signaled a crisis of identity. The romantic modernity à la Russe drew heavily on the aesthetics of pre-Petrine Muscovy. Its neotraditionalist designs were highly stylized and emphatically premodern, with an admixture of an undeniable element of self-exoticization. Yet both foreign and local observers lavished the national idiom with praise, for it delivered what Russia needed most in the

era of world's fairs: a distinct, secular identity that was experienced not as a void, but as a tangible presence. The semimythic, backward-looking Romantic style compensated for the native tradition lost to westernization and helped Russia overcome its modern crisis of identity.

Broader publicity and easier access to the collections in Moscow drew a more engaged public. Reviewers gave special attention to the viewing public in much of the writing devoted to the city's displays of history and art. Beginning with the Rumiantsev Museum, journalists regularly underscored the free admission to Moscow institutions of culture and the diverse audiences that they attracted. *The St. Petersburg News*, for instance, noted in 1862 that the Rumiantsev Museum was open to people "of all ranks, without exception": "Anybody, no matter what their attire, can wander freely in the beautiful rooms of the huge Pashkov house."[79] Another feuilletonist also emphasized that the entire city—"everybody literate and illiterate in Moscow"—visited the Rumiantsev Museum. Commoners (*prostye muzhichki*) presented a particularly remarkable sight in the halls of the new institution.[80] With this recurring emphasis on open access for all, reporters drew a sharp distinction between the museumgoing public in St. Petersburg and Moscow. One contemporary analyzed this difference in detail. Describing the visitors to the Rumiantsev Museum, the art critic Konstantin Varnek, writing for the *Russian Arts Bulletin* under the pseudonym K. V., observed great diversity: merchants and their wives, soldiers, peddlers, "and even peasants in their multifarious costumes." The reporter specifically notes that admission is free and that Muscovites—who show a predilection for "national attire" (*narodnyi kostium*)—keep to their traditions (*derzhatsia svoego, natsional'nogo*). In the St. Petersburg museums, by contrast, the author finds only uniforms and formality. According to Varnek, there was something disingenuous and fake about the Hermitage, where one was expected to parade about in "poorly pasted-on Western European peacock feathers" (*zapadno-evropeiskie prikleennye kleisterom pavlinie per'ia*).[81] Another journalist observed that hardly anybody ever went to major St. Petersburg museums: "Walk into the Hermitage or the Academy. Who is there? Two-three people, no more; however, thousands gather to watch the spectacles of Izler and Blondin."[82] The invocation of popular entertainers here suggests that the so-called "educated public" of St. Petersburg and its allegedly refined tastes could very well have been a sham. Some commentators even boldly asserted at the time that public life in Moscow was "better and happier" than in the bureaucratic,

"cultured" St. Petersburg.[83] Moscow's more democratic cultural scene of-
fered the space necessary for an evolving sense of national pride to develop
among the Russian public and added a positive note to the ongoing dis-
course on cultural identity.

Moscow's appreciative museumgoing public was something new and in-
deed worth writing about. But Moscow as a cultural capital was also a time-
specific construct dating to the exhibition boom in the city; it was a product
of a tradition that was reinvented daily in the pages of the periodical press
by famous writers, professional art critics, and anonymous columnists alike.
To judge by the numbers available to us, there was no shortage of visitors
in St. Petersburg museums, especially the Academy of Fine Arts and the
Russian Museum. However, the way contemporary journalists represented
these institutions produces the impression that all public life had moved
to Moscow. What the press effectively celebrated and what contributed to
the added value of Russian museums was precisely the public life that these
modern institutions of culture animated. The triumph of the museum age
was ultimately the triumph of the Russian public. In the course of the nine-
teenth century, the visitors to exhibitions and museums, as the periodical
press represented them, transformed from passive, bewildered observers to
agents of discourse, bound together by the rhetoric of cultural nationalism.
If, conventionally, the museum age came to an end at the turn of the century,
the traditions and ambiguities that it created remain at work in contempo-
rary Russia to this day.

"A Festival of Public Activity": The Birth of the Historical Museum, 1872–83

The Russian National Polytechnical Exhibition of Industry and the Arts
opened in Moscow in May 1872 and ran with great success throughout that
summer. Eighty-eight different pavilions were built for the occasion on the
Kremlin grounds, housing exhibits that belonged to twenty-six different
departments. During that summer 750,000 people visited the exhibition,
an impressive figure for a city whose population in 1872 was estimated at
400,000.[84]

Like the Ethnographic Exhibition five years earlier, the Polytechnical Ex-
hibition was sponsored by the voluntary society OLEAE. It was OLEAE's
decision to host a national exhibition and use it as a basis for an applied
science museum. The exhibition's location in central Moscow served as a

governmental endorsement: "By sharing space in and around the Kremlin customarily reserved for state or religious ceremonies," Joseph Bradley concludes, "the government conferred a degree of legitimacy on the projects of nongovernmental associations."[85]

The effects of this temporary exhibition were far-reaching not only in that it engendered the permanent Historical Museum, which became a major presence in public life, but because it also highlighted the initiative of voluntary associations and private persons in imperial Russia, helped shape the tastes and values of the Russian middle estate, and encouraged a sense of national self-awareness within the general public. In the sphere of education, deemed by organizers to be the show's primary focus, the exhibition demonstrated the usefulness of its displays in general learning. The newspaper *Grammarian* (*Gramotei*), aimed at the broad readership still in need of schooling, made concerted efforts to explicate not only the exhibition proper but all the unfamiliar terminology associated with it as well (museum, exhibition, polytechnical, etc.).[86] Organizers also used public lectures, which proved to be effective during the Ethnographic Exhibition five years before, as the means to further their educational goals. Newspapers broadly advertised twelve lectures on Peter the Great and his importance for the Russian people given by the famous historian Sergei Solovyov in April and May 1872. These free history lessons attracted, according to one newspaper, "the most numerous public from various classes of Moscow society."[87]

The Polytechnical Exhibition was not the first of its kind, but in style and spirit, it differed greatly from its two immediate predecessors, which had taken place in St. Petersburg in 1861 and 1870.[88] The 1861 Exhibition of Manufacture in St. Petersburg, not unlike the Great Exhibition in London a decade earlier, gave rise to much speculation. Despite the change of scene, the descriptions in the press were strangely familiar: again, Russian manufacturers put on display mostly objects of luxury, including Sazikov's famous silver centerpiece representing Dmitry Donskoy, and few things of common use.[89] Only in one respect was the St. Petersburg Exhibition of 1861 successful: it encouraged society to talk about Russian industry. Varnek, in fact, exhorted his readers to participate in the public discourse. "Go ahead, talk it over, argue, write, publish," he urged; this discussion could only help uncover the reasons for the not-so-remarkable condition of Russian industry.[90] The 1870 Exhibition in St. Petersburg, by comparison, showed some improvement, although it too failed to become a "spectacle" that would attract "tens of thousands" to the capital.[91] One feuilletonist reflected on the

exhibition's unfulfilled mission by profiling the "wilted" and disinterested public in St. Petersburg who came to see the show out of formulaic, banal patriotism.[92] Once again, the exhibition worked like a crooked mirror in which society saw a disagreeable image of itself.

The Polytechnical Exhibition in Moscow hoped to correct the distortions in the Russian self-image. As one corrective, the organizers included Russian history in the exhibition's repertoire, thereby adding a particular national coloration to the whole project. This historical dimension provided a welcome opportunity to display not only Russian industry and technology (both still dubious objects of national pride), but Russian military glory as well. Three departments—those given over to history, the Navy, and the defense of Sevastopol—included relics from a distant national past. The Sevastopol Department, established by General Zelenyi, archaeologist Count Uvarov, and Colonel Chepelevsky, is of particular interest for the present inquiry, as it was among this exhibit's organizers that the idea of a permanent Historical Museum originated in 1871.[93]

The Sevastopol display recast the memory of the recent Crimean defeat from the perspective of Russian heroism.[94] One could find there the portraits and personal belongings of Russian military leaders, model ships and weaponry, paintings, maps, battlefield plans, and even a whole mobile hospital. This commemorative patriotic display was amplified by a collection of archaeological finds from Kherson, an ancient site in the vicinity of Sevastopol, which testified to a millennium of Russian history in the region.[95] The juxtaposition of Sevastopol with ancient Kherson reinforced the old tradition of Russian military glory, just as it helped deflect the viewer's attention from the far less glorious results of the military campaign of 1853–56 proper.

The positioning of the Sevastopol department next to a historical display filled with Peter the Great's paraphernalia offered another reassuring context. The celebration of Peter the Great and his numerous conquests provided a solid background against which to reframe the memory of Sevastopol. The figure of Peter himself—the quintessential Russian "historical hero"—loomed large at the Polytechnical Exhibition of 1872, timed to coincide with the bicentennial celebration of the first emperor's birth.[96] The remembrance of the great Peter occasioned an upsurge of national feeling; the Minister of War, Miliutin, for instance, observed that the festivities stirred and briefly awakened patriotic feelings in society. The press helped to disseminate broadly such noble sentiments, both in Moscow and elsewhere in the empire. Peter's

personal belongings and his military conquests in particular became objects of popular pride. The newspapers eagerly traced the progress of Peter's old sailboat (*botik*), affectionately known as the "grandfather of the Russian Navy," from St. Petersburg to Moscow and cheered its installation at the exhibition's Navy Pavilion. They celebrated the Historical Department of the exhibition—essentially a memorial to Peter—as a "great temple" (*khramina*), to use one correspondent's description.[97] Peter's portraits, his bed, his medals, and the first edition of *The Russian News* (*Russkie vedomosti*)—all these and many other objects were put on display.[98] No detail large or small escaped the journalists' scrutiny: the press reviewed all existing monuments to Peter, published a feature about popular entertainment in his day, discussed his contribution to Russian public life, surveyed the history of St. Petersburg, Peter's most inspired creation, etc.[99] For the duration of the festivities in the spring of 1872, even the eternal competitors St. Petersburg and Moscow seemed to have partially reconciled. This celebration of Peter in Moscow gave added prestige to the old Russian capital. As one correspondent observed, "Peter I appealed to Russia to take the initiative and now Moscow celebrates his bicentennial with such a festival of public activity that he would be sure to greet it with a kind word."[100]

In this historically rich context, the Moscow Polytechnical Exhibition appeared as a "living monument" to Peter the Great, a uniquely Russian tribute that arose out of patriotic feelings, according to one journalist. Developing this felicitous metaphor further, the same author observed that the exhibition possessed a distinctly "Russian national character." "Following the history of this wonderful exhibition, we cannot but exclaim with Pushkin: 'This is the Russian spirit; it smells of Russia here' (*zdes' Russkii dukh, zdes' Rus'iu pakhnet*)!"[101] Peter's imperial ambitions notwithstanding, the Polytechnical Exposition had clearly taken a Russian turn. It was a sweeping culture-building project, similar to the Ethnographic Exhibition and the Millennium Monument several years earlier. Each of these major public events drew on a different model, however. The Millennium Monument was based on a top-down, official model of nationalism, reflected in its very shape. The Ethnographic Exhibition drew on ethnic nationalism in its representation of the ethnic diversity of the Russian empire, with Russians being allocated a superior position and status. The Polytechnical Exposition prioritized national history by drawing attention to a pantheon of Russian historical heroes gathered from different times and epochs. The recourse to the distant, almost mythical past of Kherson and the more recent era of

Peter the Great seemed to impart an aura of grandeur to all of Russian history. The message, as we have seen, is often found not in the objects laid out for display, but in the context (material, verbal, historical) that vests them with meaning. Under the aegis of Peter the Great, the Crimea, too, was subsumed into a long-standing Russian tradition of military glory. Aside from ensuring imperial patronage for the exhibition, Peter's colossal figure helped reframe official history and forge a spirit of Russian patriotism that both St. Petersburg and Moscow could share.

Russian national character could not be missed in the distinct architecture of the exhibition either. For the first time, the Russian style was used as the organizing principle of an exhibition. (To be more precise, this new architectural style had been first applied at the Exhibition of Manufacture in St. Petersburg two years earlier, but at that time the press virtually passed over it in silence.) The chief architect of the exhibition, Dmitry Chichagov, maintained this original style throughout—in the specially designed pavilions as well as in the theater and restaurants. Mostly made of wood and decorated with traditional carved ornamentation, the exhibitions' many buildings in their totality produced the impression of a gingerbread village borrowed from some familiar fairy tale.[102] The Moscow Polytechnical display also invited an analogy to a Russian city in miniature.[103] The Historical Pavilion, containing Peter the Great's memorabilia, attracted more attention than others. Contemporaries noted that Viktor Gartman's architectural design was the "most original" (preoriginal'nyi): this semicircular temporary structure, with a likeness of a Russian church in its center, was executed in a style that, in the following decades, would take over the center of Moscow.[104]

Amidst the wooden Russian architecture, one building distinguished itself by a radically different design that was, at the same time, strangely familiar. The Navy Pavilion, designed by the architect Ippolit Monighetti, was made entirely out of glass and iron; its resemblance to the British Crystal Palace was striking. Even English reviewers admitted that the Russians had finally displayed a fair copy of that international wonder.[105] The Navy Pavilion was among the most popular attractions with crowds of visitors wishing to see Peter's "botik" and the full-size merchant ship. The building itself, however, received significantly less attention. Russian newspapers hardly marveled at this symbol of modernity despite the Crystal Palace's fame. Why? In brief, because the public did not seek a copy of a European sensation, but Russia's own original, represented at the Polytechnical Exhibition by traditionalist structures designed by the pioneer of national-style architecture, Gartman.

Russian-style architecture was one distinguishing feature of the Polytechnical Exhibition; its broad press coverage was another.[106] Many newspapers wrote about it, but one of them deserves special mention. The daily newspaper *The Herald of the Moscow Polytechnical Exhibition* (*Vestnik Moskovskoi Politekhnicheskoi vystavki*) was founded by editor and publisher S. P. Iakovlev specifically for the purpose of covering the exhibition. In its composition, the newspaper represented the whole microcosm that was the Polytechnical Exhibition. Beginning from May 1, 1872, *The Herald* published daily updates on the exhibition's progress and detailed accounts of its various departments. The newspaper provided an overview of industrial exhibitions abroad and translated accounts of the Moscow show from the foreign press; it likewise printed numerous advertisements and occasional works of fiction. Outlining the newspaper's "program," however, the editor emphasized that aside from being a "true and complete reflection of everything that is to take place at the Exhibition," in order to be a genuinely comprehensive guide to visitors, the daily should also contain official announcements, foreign telegrams, court records, stock exchange news, correspondence from provinces, descriptions of tourist attractions, and feuilletons about Moscow public life (*fel'eton moskovskoi obshchestvennoi zhizni*).[107] Letters to the editor indicate that the public welcomed such a publication—a forum to exchange opinions about an exhibition that was indeed turning into an event of national importance.

A major transformation took place in 1872 with the launch of Iakovlev's edition: if in the preceding decade, writing about a display was often relegated to feuilletons at the bottom of the newspaper page, an entire newspaper was now devoted to a single exhibition. Within this printed microcosm of the Polytechnical Exhibition, "The Exhibition Feuilleton" (*Vystavochnyi fel'eton*), a series of sketches by a journalist who signed his creations as "Dip-the-Quill" (*Obmokni*), occupied but a modest place.[108] Serious discussion about the exhibition's different departments, their educational value and national meaning appeared in the more "prestigious" upper segments of the newspaper. The newspaper also included other features on Russian themes, which framed this main event in Moscow's public life accordingly. Moscow emerged in the pages of this newspaper as a setting for Russian history and art; it also emerged as a source of inspiration for creative writing. One fictional narrative, "Moscow in 1882," written in the tradition of Chernyshevsky's utopian *What Is to Be Done?*, albeit with a strong Russian flavor, represented the city as an ideal social space filled with people's theaters and

popular museums—institutions of public culture and education that the Polytechnical Exhibition had inspired.[109]

The National Museum

The *idea* of a national museum was not new but, for much of the nineteenth century, the Russian national museum existed only as a figment. The first concerted attempts to establish a public institution for the visual display of national identity were undertaken early in the nineteenth century. In 1817, under the title "A Proposal for the Establishment of a Russian National Museum," the journal *Son of the Fatherland* (*Syn otechestva*) published an article by the Prussian scholar Friedrich von Adelung, who urged the founding of a new kind of encyclopedic institution, a national museum (*natsional'nyi muzei*) that "will allow the immeasurably vast and extraordinarily diverse Russian state to be viewed with ease."[110] Two other plans for a national museum appeared in the 1820s, those of Burckhard von Wichmann and Pavel Svin'in. But all these intellectual undertakings remained unrealized at the time. A similar fate befell the proposal for a Museum of Aesthetics (*Esteticheskii muzei*) in the 1830s. Plans for ethnographic and historical museums associated with the founding of the Imperial Russian Geographic Society in 1845 were likewise left solely on paper. The public museum became another national dream that, like the Crystal Palace, captured the imagination of society at large: contemporaries yearned for such a comprehensive institution of Russian culture. Pogodin rendered this sentiment as follows: "How many gems of all sorts are scattered all over Russia, where they idle without any use or benefit!... Only when all of these items are stored together would one be able to write the history of art in Russia."[111]

In the year of Russia's Millennium, the idea of a comprehensive museum representing all spheres of Russian life and knowledge again became topical.[112] When the Rumiantsev Museum reopened in Moscow, it seemed to answer the needs of society. But it was not long before critics noticed that the Rumiantsev Museum, comprised of different divisions and departments, began producing the impression of a "crowded and tight, complicated" facility; at best, it could be designated as "only an embryo of the National Museum."[113]

The museum boom of the 1860s engendered many new institutions of culture: exhibitions and museums devoted to agriculture, ethnography, applied science, and ancient art. But a main, truly Russian museum was still

nonexistent. "We have many museums of applied science and specialized research (*mnogo u nas muzeev i prikladnykh, i spetsial'no-nauchnykh*)," wrote Bestuzhev-Riumin in *The Voice*, "but where is our national, all-Russian historical museum?"[114] (In Chapter 5 we saw that a decade later, Stasov also would lament, as if echoing Bestuzhev-Riumin, the nonexistence of a national art gallery.[115]) Finally, in 1872, the Historical Museum, called at the time the Russian National Museum (*Russkii natsional'nyi muzei*), named after the crown prince (future Alexander III), was endowed on the basis of the historical collections assembled by the Polytechnical Exhibition (*image 15*).

From the beginning, the museum was conceived of as precisely a national (*natsional'nyi*) institution, with its physical address on Red Square, flanked by the Kremlin and St. Basil's Cathedral, and the ethnic ring of the word "Russian" (*russkii*) in its original name. Although after 1881 it was officially known as the Imperial Russian Historical Museum (*Imperatorskii Rossiiskii istoricheskii muzei*), contemporaries used the two names, Historical and National, interchangeably.[116] In my discussion of the contemporary debates that unfolded around the museum, I follow this practice as well. Interestingly, at earlier stages, the organizers envisioned this museum as one devoted to the Russian military; the idea then metamorphosed into "a temple to Russian glory" (*khram russkoi slavy*), and only later—a museum of Russian history.[117] After the Crimean War, epic history replaced military power as a feasible anchor for national pride.

The new museum's special power consisted in the fact that it offered an "illustrated history" of the major epochs of the Russian state to its visitors and acquainted them with their heritage in accessible, memorable terms. The museum's organizers acknowledged the importance of visual imagery for the study of Russian history: scholarly knowledge is not very accessible, nor does it compose "a complete picture—only a picture, only a visual representation, can leave an indelible impression and have a moral influence." Painting and the theater stage, according to the new museum's visionaries, were the best educators for the masses.[118] The Historical Museum reinforced the power of visual aids, popularized by the preceding exhibitions.[119]

The press tasked the National Museum with cultivating in its visitors pride and respect for the country and "laying a foundation for national consciousness."[120] Terms for the study of the fatherland—*otechestvovedenie* or *otchiznovedenie*—that had first gained popularity a decade earlier, again peppered newspaper columns devoted to the new museum of history.[121] Bestuzhev-Riumin, for instance, appealed to his fellow citizens in the pages

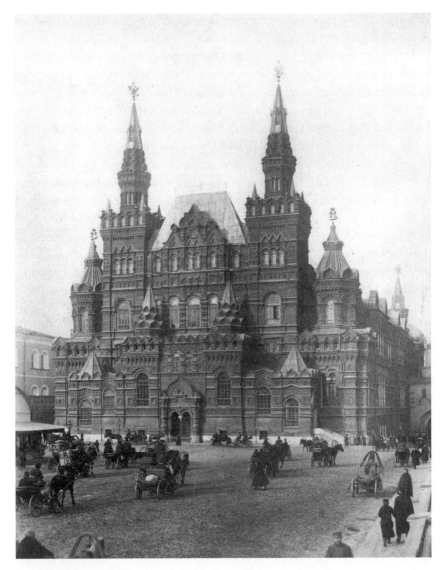

15. The Historical Museum in Moscow, architect V. O. Shervud (1875–83)

of the popular daily *The Voice* to stop aping the achievements of Western civilization, to focus on their own history, and to begin taking pride in their culture. The metaphors that contemporaries used to describe the new museum speak eloquently of its symbolic value in society: "a living chronicle of a thousand-year-old Russia"; "a living monument to the millennium of

Russia's existence"; "an all-Russian monument that testifies to the Russian people's love for their fatherland"; "a monument to all of Russia, the history and heritage (*dostoianie*) of our whole fatherland"; "a material expression and representation of the thousand-year history of the Russian people in all its varieties and everyday situations."[122] Echoes of the millennial sentiments voiced ten years earlier in Novgorod and reiterated in the Rumiantsev Museum now proudly resounded in the monumental rhetoric of the new National Museum.

Years before it actually opened its doors to the public in 1883, the Historical Museum was declared a major culture-building institution.[123] One feuilletonist put it in fairly simple terms: "the museum will tell us loudly, clearly, and truthfully: who we were, who we are, and what is our worth, and thus what our place is in the family of civilized states." The museum's main role would be to serve as a "catechism of national consciousness" (*katekhizis samosoznaniia*).[124] Society expressed its "unanimous support" (*edinodushnoe soglasie*) for this initiative.[125] All elements of the museum—the objects on display, the building's architecture, its interior design—were enlisted in this creative endeavor. Thus, Buslaev and Solovyov were tasked with a careful selection of subjects from the Russian national past to be reproduced in the interior decorations.[126] But it was the museum's building that caused the most discussion. One reason, as a correspondent for *The Voice* perceptively observed, was that no special architectural form for public museums had previously existed in Russia.

To be national in both content and form was the main social mission of museums according to nationally conscious contemporaries like Stasov, Zabelin, and Shervud.[127] A particular design in the Russian style for a museum building was first successfully executed in the construction of the Polytechnical Museum in 1874–77.[128] Shervud's design for the Historical Museum, titled "Fatherland," was submitted in 1875; this winning model, described after Pushkin as "smelling of Russian antiquity," met with near universal acclaim.[129] The architect Shervud admitted in private correspondence with the historian Zabelin that he aspired to accomplish in architecture what the composer Glinka had done in Russian music. Shervud believed that genuine art is inherently national: "Art is created by the people, and this art also creates the people" (*Iskusstvo sozdaetsia narodom, no ono v to zhe vremia sozdaet narod*).[130]

Just as there was no precedent for such a building, there was also no agreement on what would compose its exhibits. Contemporaries did not

seem to know what a national museum was supposed to be. As journalists tried to explain this new phenomenon to their readership by comparing it with existing European institutions, individual authors offered disparate museums as possible role models: the Royal Museum of Berlin, the Museum of Munich, the British Museum.[131] There is still no consensus among professionals and scholars as to what precisely constitutes a national museum. The curator of the Pitt Rivers Museum in Oxford, for instance, defined a national museum in 1904 as essentially a folk museum.[132] According to a more recent opinion, national museums are to be viewed as "institutions funded by the national government."[133] One reason for such a difference of opinion is the fluidity of the concept itself: depending on their cultural needs, different countries at different time periods invest the idea of "national museum" with their own unique meanings.

This variety of definitions notwithstanding, the founding of the national museum was an important milestone in the Russian culture-building project. During the entire decade between the museum's conception in 1872 and its opening eleven years later, the press incessantly wrote about the institution and its significance for the country, broadcasting the museum's every failure and every success and encouraging the public to deliberate on this important project. The plurality of opinions and voices that we find in the contemporary press do not add up; rather, we encounter a fascinating work in progress and an accumulation of discourse on culture. One author, for instance, argued that the establishment of a national museum should be a matter of pride for any country: a museum means that the state has already evolved to assume its final form, "that it is what it should be," and that it could now look back on its own progress and observe it in peace.[134] The organizers specifically emphasized that the National Museum would be an all-embracing institution representing a comprehensive picture of Russia:

> *All* artifacts related to the famous episodes in the history of the Russian state will be gathered in the Museum. Arranged in chronological order, these artifacts will represent, as much as possible, a *complete picture* of every epoch, including all landmarks of religion, law, science and literature, art, items pertaining to trade and Russian everyday life in general, as well as the military and the navy.[135]

The museum's primary task—to visually represent the millennial history of the Russian state and its sweeping content—qualified the Historical Museum

as indeed a *national* institution.[136] The museum was "national" in another sense, too, as it became a part of public culture and the talk of the nation.

Unlike the popular discourse built around the Historical Museum, the institution itself did not fare well. If discursively the Historical Museum had served as a bastion of identity for over a decade, factually the partially completed museum finally opened its doors to the public only in 1883, in conjunction with Alexander III's coronation. The first eleven rooms were finished at this time; in the following 34 years, another five would be added, ending the exposition at the sixteenth century. Eighteen rooms allocated to the history of the Romanovs were never realized. The construction of the building, originally meant to be completed in 1877, met with enough organizational and financial setbacks that the architect Shervud had to publicly defend the very idea of the museum in the press. Society, too, began expressing doubts as to whether the museum was even necessary at all.[137] Already in 1885, Zabelin, who took charge of the museum that year, compared it to a "paralyzed invalid and insolvent debtor."[138]

After its lackluster opening, the Historical Museum faded from the pages of the press. The first brief guidebook of the exposition was released only in 1914. It seems that society virtually forgot about the museum, which had been on everybody's mind only a few years earlier. Russia's "main" museum was apparently "invisible" enough that *another* proposal for a "Special National Museum" was suggested in the 1910s in association with the Romanov dynasty's tercentenary.

The creation of a national museum had, yet again, turned out to be an impossible project. The impracticality of such a collective dream is apparent in retrospect. But at the time, in anticipation of a public museum for the display of the entire country, the contemporary Russian press greeted each new candidate wishfully as a genuine national institution. Although the Historical Museum itself proved to be disappointing, the associated public discourse became an integral part of the culture-building practice. In the process of all these false starts, Russian audiences joined together to imagine what should constitute such a national institution, and these imaginings were far more important than the eventual museum could ever be.[139]

NATIONAL REVIVAL WRIT LARGE

From a Cult of Antiquity to a Souvenir Identity

Toward the end of the nineteenth century, the Russian national revival manifested itself in large architectural forms as well as small-scale designs, including the handicrafts and souvenirs produced in large quantity in artists' colonies and kustar workshops. This miniature version of a national culture was fashioned by creative artists in Abramtsevo, Talashkino, and similar centers and became part of public culture via theatrical performances, handicraft exhibitions and sales, world's fairs, and the concurrent critical commentary in the press. Not only individual objects, but entire sites of culture came to represent this invented tradition, which I will call "our Berendeevka"—the name that the playwright Ostrovsky used to designate the domain of his mythic tsar Berendey and that Russian journalists subsequently applied to describe the Russian Kustar Pavilion at the International Fair in Paris in 1900.

The fairy-tale village Berendeevka is the setting for Ostrovsky's play in verse *The Snow Maiden: A Spring Fairy Tale* (*Snegurochka: Vesenniaia skazka*), published in 1873.[1] A literary construct at its origin, the new word soon acquired a life of its own. Berendeevka and its derivatives—the adjectives *berendeevskii* and *berendeev*, the abstract noun *berendeevshchina*—came to designate a variety of fantastic creations, uniquely Russian in appearance and spirit, that survive to this day. Among them we find the artist Maliutin's wooden edifices, the Russian pavilions at international fairs, and products of Princess Tenisheva's handicraft workshops. A fruitful construct, Berendeevka continued to evolve over time. In the Soviet period, it came to stand for expressly Russian, primordial sites of nature. For instance, in a direct allusion to nineteenth-century fiction, Mikhail Prishvin imagines himself as the tsar Berendey, when

he recounts his explorations of pristine lakes and woods in the vicinity of the old Russian city Pereslavl'-Zalessky in his collection of sketches *Berendeyan Springs* (*Rodniki Berendeia*, 1926). The "Berendeev forest" in Yuri Nagibin's story of the same title is a mysterious location where characters get lost to ultimately rediscover their identity.[2] In post-Soviet era, echoes of the late-nineteenth-century obsession with the imagined Berendeevka can be found in the factual Pereslavl'-Zalessky museum, The House of Berendey (*Dom Berendeia*), the city park in Kostroma called Berendeevka, cafes and restaurants, the construction of the elite cottage village Berendeevka outside of Moscow, and most prosaically, the brands of mayonnaise and mineral water also called "Berendeevka," with the apparent connotation of something genuine and traditional.

But around the turn of the century, when the Kustar Pavilion in Paris made headlines in Russia and abroad, Berendeevka mainly referred to a quaint, fairy-tale variety of the Russian style in architecture and the applied arts. The word's emotive coloration ranged from the celebratory to the sarcastic, never remaining neutral. Art critic and publisher Sergei Makovsky described one of the most representative examples of the trend, a signature little hut (*teremok*) by the Talashkino resident artist Sergei Maliutin, with the following words: "Some details astound you with their suddenness, their picturesque simplicity, their brave originality in composition. One senses in them this peculiar, Berendeyan beauty, something extremely Eastern Slavic, barbarian, and cozy."[3]

Berendeevka is the invented tradition par excellence in that a late-nineteenth-century literary figment came to stand for the historical origins of Russian cultural identity. The constructedness of Berendeevka is apparent: part of the national revival that was taking place all over Europe, Russian antiquity was reinvented during the nineteenth century to serve the distinctly modern needs of nation-building via art. What distinguished the Russian scenario was that, in negotiating tradition and modernity, Russia was not only looking over its shoulder to the pre-Petrine period, but it was also casting a sideward glance toward the mirror of Western opinion. The opposition between two capital cities and the two sides of modernity associated with them also informed much of the national revival discourse, as we discussed in Chapter 6.

Owing to modern means of production and dissemination, the folk arts, aestheticized by professional artists and revived as luxury kustar goods, became available for consumers at large. No longer the exclusive property of

exhibition facilities and literary texts, the Berendeevka conceit was repeated in every media form—on stage, on canvas, in music, in architecture, and in handicrafts. Its public appeal was undeniable, but the blurring of the distinction between high and low that the middle-brow aesthetics entailed also meant the loss of an aura of authenticity; thus the ersatz effect of the national tradition turned into a souvenir industry that contemporaries noticed.

Representation of Russian culture as Berendeevka—a quaint village with wooden architecture, peasant crafts, and mythical inhabitants, dressed in folk costumes and engaged in folk songs and dances—enjoyed considerable popularity. Why did this particular version of culture resonate so meaningfully in Russia and abroad?

The image of Russia as Tsar Berendey's fairy-tale kingdom, a humble yet ornate outpost on the periphery of Europe, was part of romantic modernity à la Russe. As a national ideal, Berendeevka is a utopian site of culture with a distinctly nostalgic orientation, a Russian version of "looking backward." Yet in very real terms, Russia *qua* Berendeevka achieved international visibility and distinction at the World's Fair in Paris, and style Russe became a fashion statement and an object of imitation, reversing the familiar pattern of borrowing from Europe, when Russia imitated "everyone and everything" (*vse i vsekh*), as Stasov once famously declared.

The changed status of folk art played a critical role in this scenario. The proliferation of what contemporaries referred to as Russian antiquity in the form of handicrafts and souvenirs was a major part of the national revival. On the one hand, everyday peasant utensils became museum items; on the other, artists and peasants produced replicas of those original objects for sale in kustar shops around the country. This marketable version of culture was further advanced by Princess Tenisheva's exhibitions of Russian antiquity in Europe and Diaghilev's campaign for the export of national culture that culminated in the international triumph of the Russian Seasons. Berendeevka ultimately provided not only a highly satisfactory answer to the quest for a national form in the arts, but also a basis for what I call a *souvenir identity*—a largely imagined memory of the past, vivid and marketable, presented in the style of the reinvented tradition and closely associated with folk performances, exhibitions, and gift stores. The popular trope "our Berendeevka" may also help explain the durability of Russian souvenir culture, which remained part of the usable past in Soviet times even when the imperial heritage was rejected wholesale, and which continues to enjoy broad appeal in the post-Soviet era as well.

In the discussion that follows, I first consider the Russian fascination with national antiquity by looking at the history of the term and its application in a variety of printed editions. In the following section I analyze the creative processes at work in Abramtsevo, Talashkino, and the Museum of Folk Art in Moscow. Next, this chapter explores fictional representations of the Berendeevka ideal as exemplified by *The Snow Maiden* and *Lefty*. The concluding remarks address the spectacular effect that "our Berendeevka," as Russian journalists dubbed the Kustar Pavilion in Paris, produced in 1900; this effect was fashioned in the press as much as it was manufactured on site.

The Russian Cult of Antiquity

Writing about traditional crafts and artifacts reached the headlines of mass-circulation editions in the last third of the nineteenth century. It was part of the "patriotic fever" (*patrioticheskaia goriachka*) of the 1870s, as one author described the period when people sought out antiquities and archaeological rarities everywhere; the cult of antiquity was especially conspicuous following the much longer period of a rejection of native everyday life and indigenous traditions.[4]

The Russian word for antiquity, *starina*, in the general sense of ancient times and relics of culture, had been in circulation since the late eighteenth century. Karamzin used the title *Russian Antiquity* (*Russkaia starina*) for a collection of anecdotes by foreign authors about old Moscow, which he prefaced with the lamentation: "Alas, we so poorly know Russian antiquity, which is dear to the hearts of patriots!"[5] In the pages of *The Messenger of Europe*, Karamzin encouraged his readers to study and love the national past: "One wants to know antiquity, whatever it may be, even a foreign one, although our own is so much dearer to us."[6] Pushkin applied the term in his famous lines from *Ruslan and Liudmila*, "a tale of the times of old" (*predaniia stariny glubokoi*), an ironic reference to the leitmotif that runs through Macpherson's famous literary hoax *Poems of Ossian*.[7] The antiquity of *Ruslan and Liudmila* was as much imagined as that of *Ossian*.[8]

The Russian cult of antiquity began at midcentury. At its origin was neither a museum nor an exhibition of rare artifacts, but a printed edition. Fedor Solntsev was among the first to publicize art objects from Russia's past in a multivolume collection called *Antiquities of the Russian State* (*Drevnosti rossiiskogo gosudarstva*), commissioned and funded by Nicholas I. Between

1846 and 1853, the Archaeological Commission under the direction of Sergei Stroganov published Solntsev's drawings of Russian weapons, religious utensils, church decorations, armor, and collectible items from the Kremlin Armory. Six hundred copies were printed.[9] The stated purpose of this grand project was to make artifacts from the sixth to the eighteenth centuries available, "to make known, in all their detail and idiosyncratic aspect, our ancient Russian mores, customs, rites, ecclesiastical, military, civilian, and peasant dress, dwellings and buildings, the degree of knowledge or enlightenment, technology, arts, trades, and various objects in our society."[10]

It was this printed edition that initially represented objects of Russian antiquity, including icons, as works of *art*. The kind of compilation that Solntsev accomplished was important because it allowed artifacts scattered in the vestries of monasteries and churches to be brought together. Taking the general state of the dispersal of culture into consideration, Solntsev's volumes were like a portable museum, revealing a magnificent collection of decorative objects and armor, beautifully reproduced in colored lithography.

Originally, *Antiquities of the Russian State* was part of a state-sponsored effort to preserve national culture during the era of Nicholas I.[11] The influence of Solntsev's original edition was enormous. Stasov was quick to recognize the artist's contribution as a lesson in patriotism, designating Solntsev as "one of the best and the few who taught us all to cherish and love the real, native (*korennaia*) Russia."[12] It is worth emphasizing that it was Solntsev's edition that creative artists working in the Russian style used as the *original* upon which to model their creations. Sazikov, for instance, used precisely Solntsev's drawings to create his award-winning silver centerpiece with Dmitry Donskoy, which attracted much international attention in the Crystal Palace in 1851. The Ovchinnikov jewelry firm likewise utilized ornamentation patterns influenced by Solntsev's illustrations in their many enamel works, including caskets, liturgy sets, gospel and icon mountings, as well as objects of everyday use. Later in the century, Fabergé derived some of the old Russian motifs for his decorative jewelry from Solntsev's edition as well.[13]

Next to Solntsev's *Antiquities of the Russian State*, several similar editions appeared around midcentury.[14] The director of the Stroganov School, Viktor Butovsky, compiled examples from medieval manuscript illuminations into one volume, published as *The History of the Russian Ornament from the X to XVI Century according to Ancient Manuscripts* (*Istoriia russkogo ornamenta s X do XVI stoletiia po drevnim rukopisiam*). In 1872, Stasov published his illustrated study *Russian Folk Ornament* (*Russkii narodnyi ornament*).[15] To-

gether, all these publications provided what Anne Odom has called "a grammar of Russian ornament"—a collective textbook of images and decorative details that contemporary designers of furniture, textiles, and silver could draw upon to produce works of art and industry in the old Russian style.[16] At the same time, the many textbooks of Russian antiquity, coupled with the plurality of connotations of the term itself, meant that eclecticism and stylization also became part of this reinvented tradition. In this scenario, elements of modern peasant embroidery combined easily with pre-Petrine manuscripts and enamels.

As the nineteenth century progressed, the range of specific meanings associated with the concept *starina* diversified: antiquity referred to old times, traditional customs, and collectible objects of material culture, as well as folk songs and *byliny*. Closer to the century's end, *starina* figured prominently in a variety of printed editions, including historical journals, art journals, ethnographic studies, travel accounts, catalogues, and works of fiction, not to mention versatile writings in the daily periodical press. The sheer volume of publications devoted to this broadly defined topic evidences an obsession with Russian antiquity. Writing also recorded fluctuations in the meaning of antiquity, as different interpretive communities engaged with this subject.

A number of general interest books, for example, used *starina* in their titles to connect feelings of national pride to a long-standing tradition. Vasily Sipovsky's *Native Antiquity: A History of the Fatherland in Stories and Pictures* (*Rodnaia starina: otechestvennaia istoriia v rasskazakh i kartinakh*, 1885–1888) profiled remote history from the time period between the ninth and the seventeenth centuries.[17] Among works of fiction, Saltykov-Shchedrin's *Old Days in Poshekhonie* (*Poshekhonskaia starina*), which first appeared in installments in *The Messenger of Europe* in 1887–89, addressed the subject of local history under the rubric of *starina*. Dmitry Averkiev's play *Old Days in Kashira* (*Kashirskaia starina*) enjoyed popularity in print after its success at Moscow's Malyi Theater in 1871; contemporaries referred to this play as a classic and even a cliché, due to the audiences' familiarity with it.[18] Grigory Danilevsky's *The Family's Old History* (*Semeinaia starina*) was reissued in 1887 as part of Suvorin's "thrift editions" series, which speaks about its popularity.[19]

Several historically oriented journals added to the growing collection of texts and images from the national past, including the monthly *Russian Antiquity* (1870–1918). On average, 5000 copies of *Russian Antiquity* were printed annually, with the number of subscribers ranging between 3500 and

6000. The journal's main focus was the fairly recent history of the imperial period, but its overall style helped connect the genealogy of the Russian empire with the national sentiments prevalent in contemporary society. The distant past was incorporated into the style of the journal designed by Solntsev, who for thirty years collaborated with the editor Mikhail Semevsky and contributed to the journal's recognizable aura of antiquity. Historical documents profiled by *Russian Antiquity* helped popularize ideas and images from the Russian past among the public.[20]

In 1875, another periodical devoted to Russian history was founded, the illustrated monthly *Ancient and New Russia* (*Drevniaia i novaia Rossiia*). Among others, well-known historians Zabelin, Bestuzhev-Riumin, Kostomarov, and Dmitry Ilovaisky published articles in this forum.[21] The journal's millennial rhetoric underscored the continuity of Russian cultural tradition, represented on the title page as the meeting place of antiquity and modernity (in the face of Peter the Great) against the background of the Millennium Monument. The new journal aimed to provide the general public with accessible and accurate information on Russian history, geography, and ethnography. The journal's cover was executed in the Russian style; engravings of various antique objects, such as the ancient helmet of Prince Iaroslav, copied from Solntsev's *Antiquities* and reproduced in the first volume, could be found in its pages.[22] Illustrations placed alongside articles written in a "simple and clear language understandable for all" reinforced the idea that old Russian monuments, buildings, and objects of art could serve as an effective means to promote patriotic sentiments.[23]

Several other editions, both of specialized and general interest, published materials on topics related to Russian antiquity. The journal *Living Antiquity* (*Zhivaia starina*, 1890–1916) advanced the study of folklore and ethnic cultures and languages of indigenous people on the territory of the Russian empire.[24] *Russian Archive* (*Russkii arkhiv*, 1863–1917) published diaries, official documents, letters, and memoirs with a focus on the history of the eighteenth and nineteenth centuries. The journal *Architect* (*Zodchii*, 1872–1917) and the design magazine *Motifs of Russian Architecture* (*Motivy russkoi arkhitektury*) profiled new projects for wooden dwellings and Russian-style interiors and furniture.[25] Many more buildings appeared in the pages of these publications than were realized in material form.

All these journals had the explicit purpose of popularizing Russian history, including old monuments of art and architecture. Elegant publications printed on expensive paper with high-quality illustrations produced a wel-

come effect, although their print runs, which usually oscillated between 1000 and 3000 copies, could never compete with the mass-circulation press. Daily editions, in their turn, contributed sundry writing to the public discourse on Russian culture and tradition, reinforcing the impression that antiquity, previously held in material form only in select museums and handicrafts workshops, was available to all. By the end of the century, Russian antiquity was everywhere. The difference in specific narrow meanings was often eclipsed by the overarching sentiment that Russia possessed old, uninterrupted, original culture.

Reinventing Tradition in Abramtsevo, Talashkino, and Beyond

> National consciousness—this firmament of the people's spirit—
> is strengthened by the contemplation and examination of mon-
> uments of a bygone life, and we are happy that our fatherland
> can still gather and store in a safe haven many objects that have
> great importance in the worldwide appreciation of the arts.
> —*Maria Tenisheva*[26]

Print editions accomplished the important task of publicizing Russian antiquity among a general readership. But there were other, quite real locations for the propagation and restoration of Russian antiquity, including various collections, exhibitions, and publications. Among other forums, the artists' colonies Abramtsevo and Talashkino, where revival activities were concentrated, stand out. It was in these art circles, led by the famous Maecenas, entrepreneur Savva Mamontov, and Princess Maria Tenisheva that the Berendeevka tradition was nurtured and subsequently displayed at domestic and international exhibitions, performed in theaters, popularized in the specialized and mass press, and offered for sale and export. In the controlled environment of artists' colonies, any peasant item stood a fair chance of becoming a collectible object to be preserved, studied, and reproduced. Following handicrafts, other categories of everyday peasant life, including icons, lubki, wooden huts (izbas), and traditional costumes, taken for granted for ages, were revived as objects of *art* as well. All of a sudden, a rich, beautiful, and original tradition was discovered. This is precisely what the invented tradition "Berendeevka" was all about: this *sudden discovery* of an old, genuine, national idiom in the arts.

What we perceive today as Russian folk art expressive of an innate national spirit is the product of social theories of the Romantic period and late nineteenth-century creative workshops. Notably, neither the matreshka nor the balalaika nor Vasnetsov's fairy-tale Hut on Chicken Legs in Abramtsevo, for that matter, belonged to the traditional peasant environment. The popularity of Russian antiquity was not limited to any particular segment of society: efforts of artists and patrons coincided with the taste of the general public, as well as interests supported by government programs.[27] According to Hilton, "Historians, social reformers, and official policymakers as well as artists believed that restoring the forms of historical and folk culture could help to restore the traditional values threatened by modern conditions.... This conservative attitude was also part of the reason for Alexander III's official nationalism in the arts at the end of the nineteenth century."[28] Why did peasant culture draw so much attention? The peasantry and the rural way of life were idealized by populists during the "going to the people" (*khozhdenie v narod*) period in the 1870s. Moreover, as Wendy Salmond explains:

> The future of peasant crafts had a particular resonance in nineteenth-century Russia, a nation whose overwhelmingly peasant population made the pangs of modernization particularly acute and whose sense of national identity was complicated by its geographical position between Europe and Asia and by the historical extremism of the Petrine reforms. As a symbol of benighted resistance to western ideas of progress, peasant culture had been the object of upper-class contempt in Russia since the early 18th century; but the discovery of spiritual and aesthetic value in peasant life began to manifest itself as early as the mid-nineteenth century, in response to the international rise of patriotic sentiment and, more specifically, to the new sympathy for Russia's peasantry that emerged from the Emancipation of the Serfs in 1861.[29]

At the same time, it was not until the folk arts and crafts were on the verge of extinction that serious revival efforts began across society. Until then, educated Russians had considered kustar items with distaste or indifference.[30] The situation changed when some 35 kustar workshops began operating more or less successfully, timed with a changed attitude toward Russian handicrafts in Europe. "A growing interest abroad in the carefully promoted and packaged kustar arts and crafts encouraged educated Russians to rethink their automatic rejection of homegrown goods and to take

pride in the fact that *le koustar russe* was now perceived as one of Europe's last genuine primitives."[31]

When everyday peasant objects turned into museum treasures, a peculiar confusion of categories occurred, as Hilton suggests, leading folk art to be commonly identified and conflated with specifically *Russian* art and much of the pre-Petrine tradition as well.[32] This restored Russian antiquity offered a means of securing continuity with the past and representing the ruptured national tradition as long and uninterrupted. Moreover, the category of peasant everyday life was aestheticized and nostalgically idealized, often to excess, adding a bright veneer to the paltry picture of peasant experience that the Itinerants had exposed only recently.

The idea of the national changed clothes again in the last decades of the nineteenth century: if the national element was rendered primarily via content in the realist art of the Itinerants, form and ornamentation were at a premium in the age of the folk revival. Whereas the Itinerants aimed to imitate life as closely as possible, in all its ugly and vulgar details, the neonational aesthetics of revived Russian antiquity was defined by the opposite scenario, life copying art. From stage, book, and canvas, the motifs of Russian antiquity entered the Russian public sphere as highly desirable and indeed often fashionable commodities. But the peasant bric-a-brac reproduced by the kustar home industry was not folk art in the true sense; the new aesthetic was less a way of life than an exotic accessory for the urban wealthy, the ideal consumers of kustar goods. Not to mention the real problem "that the heirs to all these museum artifacts—the peasants of modern-day Russia—seemed perfectly ready to relinquish their patrimony, and showed little inclination to continue the unprofitable, passé ways of their forefathers."[33]

The dress-up components and stage effects of the Berendeevka invented tradition were hard to miss. The mixed categories of art and *byt* also threatened to reduce art to endless reproductions, which was indeed the case with many popular souvenirs. In painting, too, artists in the 1880s took up stories from pre-Petrine Russia and depicted models in elaborate historical costumes, as can be seen in Konstantin Makovsky's opulent *A Boyar's Wedding Feast in the Seventeenth Century* (*Boiarskii svadebnyi pir v XVII veke*, 1883), Vasily Surikov's dramatic *Boyarina Morozova* (1887), and Konstantin Korovin's lyrical *Northern Idyll* (*Severnaia idilliia*, 1886). The aura of original Russianness was achieved via costumes, historical references, and the evocative background consisting of old izbas, terems, fortresses, and native landscape.[34]

Folk culture came to serve as a bridge connecting tradition and modernity in the last two decades of the nineteenth century; it also offered a glimpse of a hopeful future. Ivan Bilibin reconstructed the spirit of national revival as follows:

> Only very recently, like an America, have we discovered the ancient Rus' of art, maimed by vandals, covered with dust and mold. But even under the dust she was beautiful, so beautiful that one can easily understand the first sudden rush that seized the discoverers: Come back, come back!... So now nationalist artists are faced with a task of colossal difficulty: using this rich and ancient heritage, they must create something new and serious that logically follows from what has survived.... We will await this and, losing no time, we will collect and collect everything that still remains of old in our peasants' huts, and we will study it and study it. We shall try to let nothing slip from our attention. And perhaps, under the influence of this passion for bygone beauty, there may even be created, at last, a new, completely individual Russian style with nothing of tawdriness about it.[35]

Natalia Polenova, the artist Vasily Polenov's wife, too, emphasized this urgency for revival efforts: "Our goal is to capture the still-living art of the people, and give it the opportunity to develop. What turns up in publications is mostly dead and forgotten.... The thread is broken and it is terribly difficult to retie it artificially.... And that is why we look for inspiration and models mainly by going around the izbas and examining things that are part of the environment, trying, of course, to exclude foreign novelties."[36]

National revival in the Berendeevka style, as cultivated in Abramtsevo and made available for exhibition and sale both domestically and internationally, was a welcome answer to the contemporary appeals to rescue folk art. But then it was precisely this concerted effort on the part of the creative intelligentsia to teach people how to create national art and produce objects of everyday use for the museum display or the market that raised suspicion of some judges of taste, like Benois: "What a nightmare, what nonsense is this idea of the folk attempting to create in the folk spirit." The critic continues: "Various efforts to return to the people produce ... the sourest impression. All this is, perhaps, honorable, but at the same time contentious, intangible (*otvlechenno*), 'museumized,' preposterous."[37] What Benois and other contemporaries contested was the very theatricality of the Berendeevka tradition, its *effect* of appearing national. Between the awe of

self-discovery and the reasonable concern with artifice and imitation, the Russian national revival was subject to many debates. The brief commercial success of the handicrafts produced in Abramtsevo between 1885 and 1890 placed the Russian art industry and the controversies surrounding it in the foreground of public life.

Abramtsevo

From a private enterprise of an individual industrialist to a pivotal event in public culture that significantly shaped the way we imagine Russian national tradition, the story of Abramtsevo is key to understanding the dynamics of culture-making in late imperial Russia.

The history of Abramtsevo as an artists' colony dates back to the 1870s, when Savva Mamontov, a rich entrepreneur and a competent artist of many talents, settled in the former estate of the Aksakovs and soon invited many gifted young people to visit. Among the artists, Repin, Vasnetsov, Serov, Nesterov, Levitan, Ostroukhov, Polenov, and Vrubel created many famous works during their sojourns at Mamontov's estate. Shaliapin and Stanislavsky began their careers there as well.

All these famous names speak positively for Abramtsevo and its crucial role in the history of the Russian arts. But Abramtsevo was more than an art circle: it was an entire way of life that implied harmony between beauty and utility and a temporary reconciliation of the controversy on aesthetics that had raged in Russian society since the 1860s.[38] Stage design, architecture, opera, handicrafts—all these arts flourished in Abramtsevo.[39] The enthusiastic reception of Mamontov's Private Russian Opera in Moscow and the triumph of the Russian Kustar Department at the 1900 International Exhibition in Paris secured the reputation of Abramtsevo as the "cradle of the whole movement for the revival of the national spirit in Russian art" and a laboratory of the neo-Russian style.[40] "Cradle" and "laboratory" are two metaphors used conventionally to describe Abramtsevo's place in the national revival movement.[41] In the discussion that follows, I pursue a different metaphor and consider the famous artists' colony as an "island of antiquity."

Buildings, their content, performances, daily activities, even clothing—everything was an integral part of this island of culture styled in the "traditional" Russian idiom. The fanciful bathhouse was designed by Ropet in the fashion of the fairy-tale teremok; Vasnetsov's re-creation of Baba-Yaga's

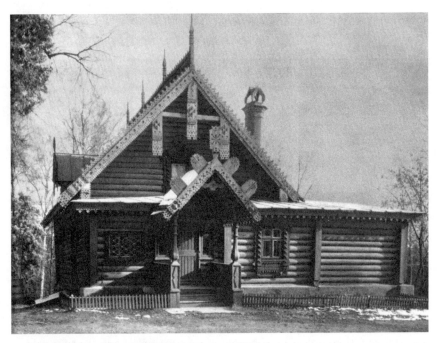

16. Abramtsevo workshop, design by V. Gartman (1872)

hut on chicken legs looked as if it had walked straight out of the folktale. In 1873, Gartman built his Abramtsevo workshop, richly decorated with ornament borrowed from folk embroidery (*image 16*). The joinery that promoted carpentry skills was established at Abramtsevo in 1876 and soon gained popularity under the leadership of Elena Polenova, who became the kustar workshop's artistic director in 1885. The home theater where the first production of *The Snow Maiden* took place in 1882 prepared the success of Mamontov's Russian Private Opera, which enchanted urban audiences. There was also a museum of folk arts in Abramtsevo, established in 1885 by Elizaveta Mamontova and Polevona; it contained samples of peasant crafts-manship collected during their rounds in nearby villages. In a sense, the whole estate became a museum in the open air. The controlled climate in this restored complex preserved the smell of the "Russian spirit." What is more, one could live in this museum complex, surrounded by handicrafts and dwellings fit for the exhibition display.

The atmosphere of creativity helped unite artists belonging to different gen-erations and schools into a community, as did the compelling figure of Ma-

montov, who maintained that "art in its every manifestation must be national above all" and who encouraged artists to pursue distinctly Russian themes and forms.[42] Gray emphasizes the shared pursuit of national themes in art: "Apart from this common recourse to Russian history, myth, fairy-tale and folklore, the paintings and drawings produced at Abramtsevo share few defining features, which could be seen to explode any notion of group identity."[43] The building of the Abramtsevo church in 1882 is just one telling example of how the proverbial Russian spirit manifested itself in daily activities on the estate. Polenova recounts that every artist partook with his or her own soul, not just their hands, in this inspired project. "Everybody lived by the interests of this construction; everybody was united by this common project, which became dear to every participant." And later she notes again: "So much love, interest, and personal character of the project's every participant went into the Abramtsevo church that it forever remained a dear link that connected everybody."[44]

In short, Abramtsevo was an ideal site of culture where the spirit of Russian antiquity was restored and preserved with care. But this island of antiquity existed separately from the mainland of industrializing Russia. So much more intriguing are the ways in which this isolated local phenomenon translated into a ubiquitous presence in the Russian public sphere. How did the Abramtsevo experiment become part of public culture and come to greatly influence the image of Russia abroad as well? What were the mechanisms for making and marketing Russian antiquity?

The face of Abramtsevo that was visible to society at large was the one connected, first of all, with art exhibitions, opera performances, sales of kustar items, and the written commentary, both in the popular press and later in new art journals, such as the *World of Art*. Among the communication channels that linked the island with the mainland, the performances of the Russian Private Opera in Moscow and the exhibitions of handicrafts and furniture produced in the workshops attracted significant attention. Abramtsevo also drew the attention of the public as a reputable center for the applied arts after the kustar goods produced in its workshop won gold medals at the 1893 World's Columbian Exposition in Chicago, the 1900 Paris Exposition Universelle, and the First All-Russian Kustar Exhibition in 1902. But it was ample commentary in the press and, more often than not, controversy, that helped maintain the public's interest between performances and exhibitions and turned Abramtsevo into the talk of the nation.

Several exhibitions dating to Abramtsevo's most productive period generated a huge volume of commentary. In 1896, an exhibition in Nizhnii

Novgorod caused a big stir in society, in the course of which the names of Mamontov and Mikhail Vrubel became part of the discourse on art and identity. The conservative jury rejected two stylistically daring panels commissioned to a then little-known Vrubel for the exhibition's Northern Pavilion. In response, Mamontov, who was in charge of the installation, defiantly showcased them in a specially constructed pavilion just outside the exhibition grounds.[45] This provocation scandalized society, and Abramtsevo and its owner were soon entangled in the web of vigorous polemics.

Among the many other voices that participated in the debate was that of the young Maxim Gorky, who engaged in an extended polemic in the pages of *The Nizhnii Novgorod Sheet* (*Nizhegorodskii listok*) with several authors and newspapers, arguing strongly against Vrubel's "new art" (*novoe iskusstvo*). In reference to *Princess Dream* (*Printsessa Greza*) in particular, Gorky wrote: "After all, what does all this ugliness mean? Destitution of spirit and poverty of imagination? Impoverishment (*oskudenie*) of realism and the decline (*upadok*) of taste? Or is it simply an attempt at originality (*original'nichanie*) of the person who knows that he does not have enough talent to be famous and thus resorts to scandals in art in order to gain fame?"[46] Gorky's narrator in these feuilletons styles himself as a representative of the public and as an ignoramus (*profan*). Responding to the artist Andrei Karelin's critique of his opinion of the "new art," Gorky's speaker voices a position reminiscent of the amateur art criticism of the 1860s–70s that informed the "nationality and realism" discourse: "Either art should be understandable and edifying or it is not needed for life and for the people. It has been proven that Vrubel's art is understandable only to specialists. What is its vital (*zhiznennyi*) meaning? What is the meaning of his paintings without the accompanying commentary, which is required in order to understand their plots and technique?"[47] In short, Gorky categorically declares that Vrubel's paintings are nothing else but "a chaos of art," which even explanations by specialists like Karelin cannot improve.[48] Such exchanges on Vrubel in particular and the new directions in art in general kept Abramtsevo present in the public sphere.

Mamontov's Russian Private Opera, which performed many Russian operas in the late 1890s, including *The Snow Maiden, Sadko, The Tsar's Bride, A May Night,* and *The Maid of Pskov,* was regularly covered in the press. Chaliapin's participation, as well as the costumes and sets by Korovin, Maliavin, Vasnetsov, and Vrubel, brought tremendous success to the theater, especially when the company toured St. Petersburg during the 1897–98 season. Grover points out that "for the most part the reviews of the Private Opera

were virtually rapturous." He credits Stasov specifically for this triumph.[49] Stasov praised not only *The Snow Maiden* and Vasnetsov; he also authored the most enthusiastic review of *The Maid of Pskov*, which was published in *News and the Stock-Exchange Gazette* (*Novosti i birzhevaia gazeta*).[50]

All these reviews helped promote Abramtsevo and the multifarious productions associated with it. But Abramtsevo also was implicated in the fierce debates that unfolded around the *World of Art* journal. In the first two volumes of the *World of Art* in 1899, jointly subsidized by Mamontov and Tenisheva, one finds views of the Abramtsevo church and its interior; examples of furniture produced in its joinery workshop; paintings by Vasnetsov; ornamental designs and embroidery patterns; book illustrations by Elena Polenova; Natalia Davydova's sketches for carpets and linens; Korovin's decorative panels for exhibitions in Nizhnii Novgorod (1896) and his design for the "Berendeevka" Kustar Pavilion at the 1900 World's Fair in Paris. Diaghilev also authored a separate article about Vasnetsov's exhibition. Diaghilev writes, praising Vasnetsov for his "virginal nationality" (*devstvennaia natsional'nost'*): "Never before had national consciousness in the Russian arts been expressed so strongly." Along with Surikov and Repin, Vasnetsov was a harbinger of the revival "in the national Russian spirit"; from Surikov's intransigent *Morozova* to the sweet *Snow Maiden* by Vasnetsov, distinctly national images were created by artists who "were not afraid to be themselves."[51]

In itself, the coverage of Abramtsevo in the journal was not at all subversive; after all Abramtsevo's owner was also the journal's sponsor. Yet the high-quality illustrations related to Abramtsevo appeared in the same issues of the *World of Art* that contained Diaghilev's provocative editorial, which scandalized society. It is not that the new art journal itself was read widely, but journalists wrote about it frequently in mass-circulation dailies; nor were these writings well-tempered. Scandalous publicity promoted the *World of Art* no less than its attractive reproductions, as we have seen with the example of the inflammatory exchange between Diaghilev and Repin on account of the Russian Museum's reputation. The *World of Art* certainly put activities at Abramtsevo in the spotlight.

The Museum of Folk Art

The Moscow Kustar Museum, or The Museum of Folk Art, was founded by the Moscow zemstvo in 1885, with the bulk of its collection deriving

from the 1882 All-Russian Exhibition of Arts and Industries. Over the course of the nineteenth century, museums devoted to folk crafts, applied art, and national traditions appeared in many European countries and enjoyed great popularity with the general public.[52] Among the first such institutions was the Victoria and Albert Museum in South Kensington, which opened in 1852 and accommodated a plethora of materials from the 1851 Great Exhibition. As Wendy Salmond characterizes the trend, "In an industrializing age, when national distinctiveness was at a premium, each nation could maintain a clear cultural identity by preserving ethnic traditions in a carefully husbanded and marketable form."[53] The Museum of Folk Art in Moscow was the first Russian museum for the display of such handicrafts. Following Moscow's example, other important collections of folk arts and antiquities emerged in the 1880s and 1890s in St. Petersburg, Nizhnii Novgorod, Kostroma, and Viatka. The proliferation of both scholarly research and new art schools like the Stieglitz likewise supported the new development in Russia.[54]

The Museum of Folk Art was not a regular museum in that the sale of kustar goods formed one of its main functions, especially in the first years of the museum's existence. Far from being a temple of muses, the Museum of Folk Art was more of a middleman in the extended system of the production and consumption of folk arts. The very existence of this particular institution points to a change of taste in Russia: after the critical realism of the Itinerants, the ornamental designs inspired by folk handicrafts drew the attention of artists, critics, and consumers.

The Museum facilitated the revival movement in many ways, collecting kustar works for educational purposes, providing models, and assisting with sales. The museum's activities supported trades such as embroidery, weaving, woodcarving, lace-making, and toy-making that ranged in quality "from mass-produced souvenirs and bric-a-brac to one-of-a-kind furniture commissions indistinguishable from the work of professional urban workshops."[55] The landmark First All-Russian Kustar Exhibition held in 1902 in St. Petersburg highlighted the tangible achievements of the Russian revival and the general popularity of the kustar products. Among other popular editions, *The Cornfield* covered this event and supplied ample illustrations.[56] Following the success at the first All-Russian Industrial Arts Exhibition in 1882, the kustar industry turned into a "fashionable issue," as Vladimir Bezobrazov phrased it in his report. Importantly, the economist credited the periodical press for this achievement.[57] Several other big kustar exhibitions

took place in Russia between 1882 and 1913; kustar sections at Russian pavilions never failed to impress at world's fairs either.

Some "traditional" Russian souvenirs came into being as part of the kustar movement, most prominently the nested doll, matreshka. Wendy Salmond has demonstrated persuasively how souvenirs of the invented traditions originated and proliferated in imperial Russia. The traditional Russian matreshka is actually one of the youngest emblems of cultural identity, albeit arguably the most durable one, as it continues enjoying popularity to this day, having prospered during the Soviet and post-Soviet periods as well. The first such "traditional" doll was designed by a professional artist and produced at Sergiev Posad. "Contrary to popular belief today, the matreshka was not an ancient folk-symbol or even a traditional kustar toy, but was designed in 1891 by the young artist Maliutin for Maria Mamontova's Children's Education toy shop on Leontievskii Lane."[58]

The Museum of Folk Art was a successful commercial operation, but it is precisely this utilitarian aspect of the collection that disturbed the pioneers of the kustar movement, Mamontova and Polenova. Polenova recalls that the most common items of everyday use, like stockings, scarves, knives, and trays were available for sale, and that the museum did not pursue any artistic goals.[59] After the Kustar Museum on several occasions showed reluctance to accept the products of Abramtsevo workshops, the Abramtsevo owners opened their own storeroom (sklad) in Moscow in December 1886. This new enterprise enjoyed immediate success: "The public eagerly began visiting this new kind of shop that offered artistic kustar works of purely Russian folk production, which had long been forgotten and pushed out by factory-made items."[60] In several years, the storeroom expanded, and in 1890, a new shop with a more central location opened in Moscow. Mamontova commissioned Vrubel, who would soon scandalize society in Nizhnii Novgorod, to design the interior and paint the sign for the shop, now called "The Shop of Russian Works" (Magazin russkikh rabot).[61]

Exhibitions and sales were important encounters of kustar art and the public in their own right. Contemporary debates brought even more publicity, as readers considered the potential of the kustar industry. One source summarized the essence of these discussions that carried on throughout the late nineteenth to early twentieth century as follows: "It's true that kustar goods are not *folk art* in the sense that it's the wealthy urban population and not the people that use them, but in the artistic sense they must without a doubt be acknowledged as a renaissance of original Russian creativity."[62] As late as

1913, for example, reviews of the Second All-Russian Kustar Exhibition in St. Petersburg, which accommodated about 6000 exhibitors and was attended by nearly 200,000 visitors, showed that after many years of exhibitions and discussions, there still was no consensus as to whether the Berendeevka tradition was another version of the Potemkin village, a nationalist provocation, or a genuine expression of national character.[63] On the one hand, the workshops, the museum, and the store succeeded in keeping interest in the decorative arts alive in the age of Russia's belated industrial revolution. On the other, this tradition, revived just as it was about to disappear, continued to live on not as part of its makers' environment, but as a popular souvenir industry.

Talashkino

Talashkino operated as an artists' colony and one of the major centers of the national art revival between 1893 and 1914. It was founded by an extraordinary woman, Princess Maria Klavdievna Tenisheva (née Piatkovskaia, 1858–1928), a patron of the arts and an artist herself, who lived mostly in Talashkino prior to her emigration to Paris in 1916.[64] Tenisheva was involved in several key art events around the turn of the century, including the *World of Art* journal and the Russian Kustar Pavilion at the 1900 International Exhibition in Paris. The artists' colony at Tenisheva's estate Talashkino was part of her artistic heritage, too.

Talashkino initially attracted international attention in 1900, when twelve balalaikas, decorated by Tenisheva, Vrubel, Maliutin, Davydova, and Golovin, received much publicity at the World's Fair in Paris. After this initial success, Tenisheva exhibited objects from her Russian Antiquity Museum in the French capital and then put products from her workshops on sale in Paris and Prague. She also displayed some of her enamel works in London.[65] Between 1905 and 1908, the Russian folk arts enjoyed unprecedented success in Europe, where Tenisheva received the acclaim she longed for. She also claimed, not without reason, to have influenced French vogue: "Both of my Parisian exhibitions greatly affected style and accessories in ladies' fashion. A year later I noticed in ladies' fashion an obvious influence of our embroidery, our Russian dresses, *sarafans*, shirts, headdresses, homespun coats, even the name "blouse Russe" appeared, etc. In jewelry, too, our Russian craftsmanship found reflection, which only delighted me and justified all my efforts and expenses."[66]

In Russia, however, the success of Talashkino exhibitions and workshops was met either with indifference or ridicule during the imperial period and was disregarded entirely during the Soviet times. "In the long run," as Wendy Salmond concludes, "the cultural oasis on which Tenisheva had lavished so much love and money appears to have made little lasting impression on the surrounding area."[67] The many reasons behind society's obvious blindness to the national treasure that was Talashkino included timing, taste, gender stereotypes, and contemporary collecting practices. Talashkino also owed its strange fate to the whims of the contemporary press, which fashioned its image in the public sphere more than any other factor.

Tenisheva's artists' colony was clearly modeled on Mamontov's Abramtsevo, which opened more than two decades earlier, and similarly included a school for peasant children, a church, kustar workshops, a theater, a collection of folk arts and antiquities, a balalaika orchestra, and a shop in Moscow called The Wellspring (*Rodnik*) for the sale of peasant handicrafts. It was, as the princess herself described Talashkino, a unique and separate site of culture: "a whole little world of its own, where at every step life bubbled, every nerve throbbed, something was being created; link by link, an intricate chain was being forged and connected."[68]

Talashkino derived its special appearance from several landmarks that drew heavily on motifs from fairy tales and folk ornament: the famous Teremok in the nearby hamlet (*khutor*) Flenovo, built by the artist-in-residence Maliutin, the artist's studio and house in Talashkino, the entrance gates to the estate, and the chapel in Flenovo, with its grandiose mosaics by Roerich, in the creation of which Tenisheva herself participated (*image 17*). Maliutin also designed the Russian Antiquity Museum in Smolensk, with the participation of Vasnetsov and Tenisheva in 1904–5. In aggregate, all these structures served as a physical implementation of the creative principles that guided Princess Tenisheva's domain. Talashkino was an entire museum in the open air, a prototype of modern heritage and frontier type museums, with an underlying double temporality.

In imperial Russia, Talashkino was a special location of culture, indeed a "fairy-tale kingdom," as Breshko-Breshkovsky called it.[69] This metaphor is particularly well suited to describe what was essentially an island of Russian antiquity in the midst of a rapidly industrializing nation, with all its connotations of nostalgia, beauty, fantasy, and longing—something highly desirable yet fundamentally unreal. This fairy-tale island of culture existed in striking contrast to the impoverished and underdeveloped mainland of provincial

17. Teremok in Flenovo near Talashkino, design by S. Maliutin (1900s). Sergei Makovskii, *Talachkino: L'art décoratif des ateliers de la princesse Ténichef* (St. Pétersbourg: Édition "Sodrougestvo," 1906)

Russia, and the princess admitted as much: "One feels somehow guilty to live in our cultured Talashkino in finery and prosperity and to endure indifferently the dirt and ignorance and impenetrable darkness everywhere around.... To find this soul, to wash off what has grown onto it from lack of culture, and any sort of seed could be grown in this desolate but good soil."[70]

As much as Tenisheva explicitly intended to revive the genuine national culture of the peasantry, statements like the one above implicitly equate the peasantry with backwardness. The *narod* in her account is the opposite of the "cultured layer of society" (*kul'turnyi sloi obshchestva*): the bearers of the precious vernacular tradition that she worked so hard to emulate in Talashkino are still the dirty and uncultured masses. The contradiction in this statement helps explain the main paradox of Talashkino: on the one hand, it existed to preserve tradition; on the other, that tradition first needed to be created and cleaned. This reminds us of the predicament of national culture, as nineteenth-century Russian thinkers posed it: the fundamental incompatibility of learned culture and illiterate people. Talashkino then was a center of a *refined* peasant culture, a museum version of a tradition that, in

its everyday guise, was interpreted as actually lacking the very culture that was being rescued from oblivion. If the whole imperative of the national revival was to bring traditional handicrafts back into daily use, the form in which they returned—purposefully crude, uncomfortable, and impracticable for use in the everyday environment—was fit only for museum display.

Tenisheva also referred to Talashkino as "an oasis of culture" (*kul'turnyi ochag*).[71] An "oasis of culture," a "fairy-tale kingdom," an island of antiquity—all these metaphors point to Talashkino's special but separate status, its essential disconnect from the rest of society, which the estate maintained even at a time when workshops were operating successfully. Somehow any bridges with the mainland that Tenisheva attempted to put up did not hold. Several contemporaries perceptively noticed the infeasibility of Tenisheva's undertaking in Talashkino fairly early. Alexandre Benois, whom Tenisheva employed as curator of her growing collection and as a consultant in the mid-1890s, was frankly skeptical of Tenisheva's determination to refine the national style in Talashkino:

> The princess herself at that time turned entirely to a new idea: the creation of an art center in her estate that would help create the notorious (*preslovutyi*) national *style*. Much like all other similar amateur undertakings this one was also destined to fail. *Style*, and especially one meant to express the very soul of the people, does not depend on the good intentions of separate persons, but forms on its own following only some mysterious organic laws.[72]

In his introduction to the Talashkino catalogue, commissioned by Tenisheva in 1905, Makovsky, too, underscored the lack of viability in a modern age of fancy objects in the antiquated style, pointing to the fact that they could only remain curious collectible toys.[73]

The public response to Tenisheva's undertakings was lukewarm at best; her beloved "oasis of culture" was largely invisible in much of Russia. In December 1901, for instance, Tenisheva organized an exhibition of kustar goods from her Talashkino workshops in the regional center, Smolensk. She put on display the best of her students' works: embroidery, benches, pipes, balalaikas, frames, towels, and sleds decorated with fancy carvings and painting. Despite the minimal price of admission (10 kopeks), not more than fifty visitors attended the exhibition in the course of an entire month. In her memoirs, Tenisheva openly admits to this public failure: "Overall our objects did not cause exaltation but only silent surprise, which we were unsure how

to interpret: as a sign of recognition or denial of this sort of production, an indication of sympathy or reproach."[74]

In Europe, by contrast, Talashkino's wares were in high demand and several exhibitions and sales that Tenisheva organized enjoyed unprecedented success. Talashkino gained a reputation as one of the best-known national revival centers abroad. During Tenisheva's first extended stay in Paris (1905–8), she put on display some of the treasures from her Museum of Russian Antiquities in the Musée des Arts Décoratifs at the Louvre in 1907, where the exhibition attracted 78,000 visitors during the five months of its operation.[75] Summarizing the unequivocally favorable reception of her collections and her art abroad, Tenisheva noted that a whole guestbook could be compiled of the positive reviews that the French, the English, and the Czechs had authored. The overall effect that we glean from foreign reviews can be summed up as the poetic charm of Russian barbarity. Shortly thereafter, Diaghilev's Ballets Russes rose to fame and fortune on this same wave of appreciation for Russian exotica.[76] The princess reflected on her success in Europe: "I'm happy and proud that it fell to my lot to introduce our antiquity, our art to the West, to show that we had a touching and magnificent past."[77] But she never tired of emphasizing that her ultimate ambition was to be of service to Russia, making the indifference with which her many efforts to propagate national antiquity met in Russia so much more painful. In one letter to Roerich, for instance, Tenisheva lamented what she called the "criminal disregard for everything national" among Russian "supposedly cultured" society, the members of which loved everything Western but were absolutely clueless about their national heritage.[78]

The one capacity in which Talashkino was present in the Russian public sphere was as an object of controversy. Not that the princess herself provoked scandal; but one way or another, she was implicated in several conspicuous public events around the turn of the century. Her ill-famed association with the World of Art group, to take one example, was ruthlessly mocked in the scandalous caricatures that appeared in the St. Petersburg journal *The Jester* (*Shut*).

Tenisheva subsidized the new art journal the *World of Art* in its first year jointly with Mamontov, whose artists' colony, Abramtsevo, the journal promoted in several of its early issues. It was on this account that Princess Tenisheva acquired a reputation as "the mother of decadence" (*mat' dekadentstva*). Two caricatures contributed to her public disgrace. In one, published in the satirical monthly *The Jester*, Pavel Shcherbov represented the

18. Pavel Shcherbov, *The Idyll. Shut*, no. 13 (1899)

princess as a cow milked by Diaghilev (*image 18*). This caricature, called *The Idyll* and featuring, aside from Tenisheva and Diaghilev, key players in the World of Art group, became instantly famous. Contemporaries could easily decipher the story depicted in this piece of graphic art: Tenisheva (the cow) and Diaghilev (the milkmaid) are surrounded by Diaghilev's associates: his onetime close collaborator Filosofov, artist Mikhail Nesterov with embroidery, and graphic artist and designer Leon Bakst (represented as a cockerel), as well as the veteran artist Repin (who initially collaborated with the World of Art), here depicted hurrying to deliver the laurel wreath to the cow. The company is positioned against a background stylized in the likeness of the journal *World of Art*'s cover. In the background is a mammoth (an allusion to Mamontov) and two Finns drinking beer (an allusion to Diaghilev's debut, the exhibition of Russian and Finnish artists). Stasov, for one, was positively ecstatic about this masterpiece of graphic art. In a letter to Shcherbov in March 1899 he wrote: "Such a caricature is one hundred times more important than any articles against the decadents. This is a real hydrocyanic acid (*sinil'naia kislota*), which kills like a burst of thunder!"[79]

In another caricature titled *Salzburg*, Shcherbov represented Tenisheva as dressed in scruffy peasant clothes, bargaining with Diaghilev over an old rag (*image 19*). This drawing alluded to the 1898 exhibition of Russian and Finnish artists organized by Diaghilev, which took place in a part of St. Petersburg known as the "salt city" (*solianoi gorodok* or, in German, *Salzburg*). The numbered items among the scattered debris correspond to the artworks from the exhibition listed in the catalogue. The rag that the dirty *baba* (Tenisheva) considers is Vrubel's panel *The Morning*. If any ambiguity remained as to how this drawing should be read, Stasov dispelled it by explaining that the "junk" for sale in the caricature stood for "paintings in the style of manure and decadence" (*kartiny navoznogo i dekadentskogo stilia*).[80] Art represented as rubbish compromised the aesthetic judgment of the buyer as much as it questioned the seller's talent. This is how Talashkino was present in the Russian public sphere: as a bundle of scandalous representations of its owner and her many benevolent undertakings.

Tenisheva herself clearly blamed Russian society and its inability to take a woman-patron and collector seriously.

> My God, how hard it is for a woman to do anything on her own. She is blamed for everything, her every step is misinterpreted; anyone can judge her, accuse her, and insult her without punishment. And especially if this woman ventures to create something of her own. No matter how noble her goals might be, no matter what the results of her activity—even the lazy one considers it his duty to throw stones at her....[81]

Indeed, the Russian general public was not particularly receptive to innovation and originality, as Makovsky, who in 1905 compiled a deluxe catalogue to publicize the Talashkino workshops, observed. "In Russia, one needs to have extraordinary power to deliver one's talent to the treasury (*sokrovishchnitsa*) of native culture. That's why it is buried in the ground so often. The best efforts at creativity are marked by malicious laughter here. And so was ridiculed the 'Russian decadence' of Talashkino, too." Makovsky concluded that Talashkino remained on the margins of culture because the Russian "middle," or the general public, could not stand anything exceptional and instinctively shied away from it.[82]

Both Tenisheva and Makovsky are right in their estimate of the general public's failure to accept exceptional art and people. But one factor that influenced the fate of Talashkino most was the contemporary press. Tenisheva's

19. Pavel Shcherbov, *Salzburg*. *Shut*, no. 6 (1898)

gender combined with her ambition and visibility made her an easy target for attacks in the periodical editions of the day. Much as Princess Tenisheva succeeded in creating the oasis of Russian antiquity in Talashkino, she could not control the discourse in the fickle popular press, which cast a shadow of doubt on many of her noble undertakings. The double life of Talashkino during the imperial period reveals the power of what passed for public opinion to influence the fate of cultural monuments.

Tales of a National Revival: *The Snow Maiden* and *Lefty*

The idea of the invented tradition that we called Berendeevka originated in 1873 in a work of fiction. The village by this name served as the setting for Alexander Ostrovsky's spring tale *The Snow Maiden*. The plot centers on the title character, the daughter of Spring and Frost, who comes to live among people. She is drawn to the people by their songs, especially those of the shepherd Lel'. Her beauty attracts everybody, and she breaks more than one engagement unwittingly, including that of the visiting merchant Mizgir'. But her cold heart does not know love, and she pleads with her mother for

it. Spring warns her daughter that the passion of love will doom her, but ultimately grants her wish. The Snow Maiden indeed melts away in the arms of her suitor Mizgir', as the Berendeyans celebrate the end of winter and the return of the Sun.

Berendeevka is an idyllic domain of the benevolent Tsar Berendey and his happy, lazy subjects called the Berendeyans. Making merry is what the Berendeyans excel in:

> These people of great soul
> Are great at everything. They don't confuse with leisure
> Their affairs. If one's to work, then work;
> If sing and dance, then 'til you drop and to your heart's content.
> To rationally look at you one'd say
> That you are kind and honest people since
> Only the honest and the kind
> Can sing so loudly and so bravely dance.[83]

The action takes place in prehistoric times when people venerated the sun Yarilo as their main deity, who is disaffected with the Berendeyans in the tale for their neglect of love and beauty. Ostrovsky's Berendeyans are part fact, part fiction. Dal's *Dictionary* mentions the settlement (*selo*) Berendeevo, where carved figurines called *berendeiki* were produced, with the verb *berendeit'* literally referring to the craft of dressing wooden toys (*strogat'*) and metaphorically to being busy with trifles (*zanimat'sia pustiakami*).[84]

Legends about the ancient Berendeyan tribe were available in several contemporary sources.[85] Ostrovsky apparently consulted with specialists in Russian antiquity during his work on the "spring tale." For instance, his representation of the rhythm of the Russian gusli, a traditional string instrument, derives from *The Tale of Igor's Campaign*. The folk tsar Berendey, however, is a more recent invention popularized by the Romantic poet Vasily Zhukovsky in his eponymous literary fairy tale of 1831.[86] The Snow Maiden, whom we take today to be a stock figure of Russian fairy tales, likewise became a recognizable part of the folk tradition only after she had been represented in the arts by Ostrovsky, Vasnetsov, Rimsky-Korsakov, and other artists.

The Snow Maiden draws on several folk motifs and tales in which a snow doll comes to life. Scholars identified Ivan Khudiakov's *Great-Russian Fairy Tales* (*Velikorusskie skazki*, published in 1862) as one possible source for *The Snow Maiden* plot. Versions of the Snow Maiden tale were likewise available

in Afanas'ev's *Russian Fairy Tales* (*Narodnye russkie skazki,* published in 1855–64), as well as his *The Poetic Views of the Slavs Toward Nature* (*Poeticheskie vozzreniia slavian na prirodu*), three volumes of which came out between 1865 and 1869. Afanas'ev also published many articles on folklore, both in popular newspapers, like *Moskovskie vedomosti,* and thick journals. Along with works by Fedor Buslaev, Alexander Pypin, and Pavel Rybnikov, Afanas'ev's publications contributed greatly to a growing volume of folklore materials that became broadly available in the Russian public sphere by midcentury.

Snegurka (Snegurochka, Snezhevinochka) is born out of snow, as her name suggests. Several versions of the Snow Maiden tale coexisted. In one tale, an old man brings a handful of snow and puts it on the stove; the snow melts, and the beautiful girl appears out of the mist. Another rendition depicts a childless couple who make a doll out of snow, which then turns into a beautiful and clever girl. But with the first signs of spring the Snow Maiden grows sad and then evaporates after jumping over a fire at the example of other girls.[87] Still another variant tells the story of a little girl, Snezhevinochka, rescued from a forest by a kind fox.

Aside from his heroine's birth from snow, however, Ostrovsky took little from any of these folk versions, and the playwright's rendition of the familiar tale puzzled contemporary critics. Not only was the fantastic plot, coming from the realist author famous for denouncing the "kingdom of darkness," confusing, critics also dwelled on the seemingly unmotivated resolution of the complicated love triangles in the play. Moreover, the carefree Berendeyans do not mourn the sacrifice of Snegurochka and her newly found love, Mizgir'; a play that features a tragic end for the protagonist concludes in a cheerful celebration of spring and the return of Yarilo. As the tsar Berendey rationalizes, the Snow Maiden's departure should not be a reason for sadness, for, with the removal of the stranger, the Berendeyans can rejoice at regaining the unity of their decorative community.

The Snow Maiden has a rich history of productions. The premiere of the dramatic version, with Tchaikovsky's incidental music, took place in May 1873 in Moscow's Bolshoi Theater. After nine performances, the last of which took place in August 1874, this production was no longer staged. Shortly after the Moscow premiere, the play was published in *The Messenger of Europe* in September 1873. In 1880, Rimsky-Korsakov wrote the opera *The Snow Maiden* based on Ostrovsky's tale; it premiered in the Mariinsky Theater of St. Petersburg in January 1882, where it received a lukewarm reception. The following winter, an amateur production of a dramatic version

of *The Snow Maiden* took place in Abramtsevo. For this performance, in which Vasnetsov, Repin, and Mamontov played the roles of Father Frost, the boyar Bermiata, and Tsar Berendey, respectively, Vasnetsov prepared his original sets, which soon made a sensation.[88]

In 1885, Rimsky-Korsakov's version premiered in Mamontov's Private Opera in Moscow. This production, with the stage design prepared by Vasnetsov, Levitan, and Korovin, made a better impression on the audiences, with several newspapers even recommending that the opera be included in the repertoire of the Bolshoi Theater.[89] Despite the strong impression that it produced on connoisseurs, *The Snow Maiden* stood apart as a Russian opera in a repertoire dominated by traditional European offerings, and the majority of contemporary critics thought that Rimsky-Korsakov's unfamiliar Russian music was a fiasco.[90] *The Snow Maiden* was staged again in Mamontov's renewed theater, which resumed work in 1896 after several years of interruption. The reception of the unlucky opera by critics was again lukewarm.[91]

Many more productions followed in Russia and abroad. When a French producer considered staging *The Snow Maiden* at the Paris Opéra Comique in 1907, Mamontov applauded Snegurochka "as an opera that represented the best of Russia, that is, 'the refined and poetic spirit of the Russian people,' rather than the coarse, drunken peasants that Western audiences expected."[92] This Parisian staging was a definite success. The costumes especially produced an indelible impression. Princess Tenisheva took charge of it and personally made the crown for Tsar Berendey.[93] In her memoirs, Tenisheva emphasizes how every detail of the traditional Russian attire was painstakingly and deliberately reproduced, writing: "I was given unlimited credit. Since it was impossible to get the right fabrics for the costumes, I made all the sarafans embroidered from top to bottom, and that, naturally, was not cheap. The *kokoshniki* [women's headdresses], necklaces, *shugai*, and men's costumes—all passed through my hands, and I made the crown of Tsar Berendey personally in my studio, since the one made by the theater's jeweler was unsatisfactory."[94] The end result was a lavish production that enjoyed great success with foreign audiences.

At home, however, the press remained largely unimpressed. In 1873–74, the public's response to *The Snow Maiden* as a printed text and the Moscow dramatic production, with music by Tchaikovsky, was uniformly negative. But although reviewers found little to praise in Ostrovsky's new play, they talked about it constantly. Among plenteous contributions to the anti-*Snow Maiden* discourse, one finds a range of interpretations, including one that

takes the sun Yarilo to be the Snow Maiden's ardent lover whose burning desire causes her to melt. This reading, along with other more or less plausible explanations of the strange play, circulated widely in society.[95]

In this first round of reviews, the Berendeyans were represented as fantastic, idle, silly, fake people. For instance, Viktor Burenin, who in the mid-1870s was the most widely read and universally loathed feuilletonist, wrote: "The Berendeyans deserve to be called fools rather than people. They stand just a few steps above the gorilla. They are guided by mostly instinctive, animalistic feelings, and express them in meaningless songs about the wet-tailed Shrovetide" (*maslenitsa-mokrokhvostka*). Burenin likewise dismissed Tsar Berendey's supposed artistic talents (Ostrovsky depicted him decorating a pillar in his palace) by calling him a simple house painter (*maliar*). "The silliest among the Berendeyans is their ruler (*vlastelin*), Berendey."[96] Incidentally, Burenin wrote this review without having seen the production and derived his categorical judgment from other printed reviews. This practice was far from unusual at the time. Another reviewer also singled out excessive foolishness as a predominant trait of the Berendeyans, "the people more foolish than fools themselves whose highest psychic attainment is revealed in sounds, 'He-he-he! ho-ho-ho!'"[97] Minaev subjected *The Snow Maiden* to further ridicule in the pages of *The Spark* (*Iskra*), comparing the emptiness of Ostrovsky's spring tale to the lamentable state of Russian literature as a whole.[98] Contemporaries considered the play, whether as a printed text or a stage production, as meaningless buffoonery (*balagan*), a preposterous vaudeville, a "poetic hodgepodge (*vinegret*)," or "some sort of fantastic caprice."[99]

Critics did appreciate that Ostrovsky situated the play "in the very midst of Russian fairy-tale antiquity," but they thought that on stage it came across as either a Wagnerian production or a poor imitation of Shakespeare. A gothic castle representing the palace of Tsar Berendey in the first theatrical performance, as well as Berendey's outfit, reminiscent of the Venetian doge (*venetsianskii dozh*) costume, added to the falsity and oddity of the Berendeyans.[100] Overall, the predominant impression was that of a strange, foreign, and useless fake: "Ostrovsky's entire tale is not a traditional national product but a foreign and contemporary work, masquerading in antique Russian dress.... There is some joviality in the tale, but even this joviality is somehow not Russian."[101] What is striking is that reviewers repeatedly underscored the *lack* of national character in this first round of critical responses.

Goncharov's favorable, albeit unpublished, reaction stands apart amidst contemporary reviews. In his essay, Goncharov does not contradict public opinion, according to which Ostrovsky's recent plays, dating to the early 1870s, received a lukewarm reception both on stage and in print. He also interprets *The Snow Maiden* as a foundation of Ostrovsky's oeuvre, comparing it to the Millennium Monument:

> He always paints just one, one and the same picture: the viewer begins getting weary. The painting is huge, and there is nothing else to paint: he has to continue working on this one and only painting. Ostrovsky cannot represent anything else. This painting is "The Millennium Monument of Russia." With its one side it pushes against the prehistoric times (The Snow Maiden); with the other, comes to an end at the first railway station, with petty tyrants.[102]

This sculptural analogy helpfully elucidates Ostrovsky's oeuvre and accommodates the plurality of his national characters; it also evidences that the decade-long public discourse on the Russian Millennium took root in society and remained topical long after the actual monument in Novgorod was unveiled.

Considering the discouragingly negative reaction of contemporaries, how did the silly and lazy Berendeyans, a pagan tribe worshipping the sun, come to be identified with distinctly Russian national traditions? We owe this identification largely to the artist Vasnetsov and the art critic Stasov.

The shift began in 1882, the year when Vasnetsov created the original sets and costumes for the amateur production of *The Snow Maiden* in Abramtsevo. For the 1885 premiere at Mamontov's Russian Private Opera, Vasnetsov included the famous "Berendey's Palace" set for Act III (*image 20*). In his letter to Stasov, Repin raved about Vasnetsov's costumes and recommended them for the production of Rimsky-Korsakov's opera in St. Petersburg, where it was indeed staged later. In 1898, Stasov attended the opera in St. Petersburg. In an article devoted to the artist he praised him for capturing the Russian essence of Tsar Berendey.[103]

Along with others, Stasov applauded Vasnetsov's masterful translation of Ostrovsky's pithy stage directions into a full-scale representation of Russian folk tradition. Ostrovsky describes Berendeevka as follows: "palaces, houses, izbas—all made of wood, with fancy, multicolored carving [*rez'ba*]." Tsar Berendey's palace is outlined in similarly minimalistic terms, with added details of blind gusli players and two jesters who entertain the tsar while he decorates a palace pillar.[104]

20. Viktor Vasnetsov, *Tsar Berendey's Palace*. Set design for Rimsky-Korsakov's opera *Snow Maiden* (1885)

But Vasnetsov did much more than visualize Ostrovsky's stage directions; he created multicolored ornamental compositions that made peasant huts as well as palaces look like undeniable works of art. The artist defamiliarized the common peasant hut, rendering the massive logs of the walls picturesque and elegant. Arches, pillars, and columns in Tsar Berendey's palace seemed to derive from motifs found in pre-Petrine books and traditional woodcuts; they also reminded one of the interior of a typical peasant household. Vasnetsov created something that was simultaneously new and recognizable: not a representation of peasant everyday life, but an allusion to its mythic quality.[105] The artist demonstrated how the Russian national idea could be successfully dressed in antiquity. This work won Vasnetsov recognition as a master of a genuinely antique Russian style even by such irreconcilable opponents as Diaghilev and Stasov, both of whom published reproductions of many of his works in the first issues of the journals the *World of Art* and *Art et industrie*, respectively.[106]

In 1873, the public responded with little enthusiasm to Ostrovsky's spring tale. In the 1880s, Vasnetsov's décor likewise confused the audiences initially. Polenova summarizes society's reaction to the later production as follows:

The staging of the *Snow Maiden* was something entirely new in the realm of theater and created a total revolution in Russian decorative art. The public, used to conventions of state (*kazennyi*) theaters, to elaborate types of sets and costumes, did not understand the new direction right away. But the artistic world appreciated it and welcomed the new era in the theaters' life beginning with the first performances.[107]

Following the initially ambiguous reviews, the popular press, too, began broadcasting the positive association between Berendeevka and genuine Russian antiquity. Stasov played no small role in delivering this message to the broader public.

Throughout his long career, Stasov promoted national ideals as he saw them realized now in Gartman and Ropet, now in Repin, now in Vasnetsov, whom he represents as no less than a national hero in his exuberant review.[108] But Stasov's authoritative judgment was based on several misconceptions that the critic himself failed to notice. First, the genuine traditional Russian antiquity that Vasnetsov intuited was in fact learned from monumental editions, like Solntsev's *Antiquities of the Russian State*, which contained "entire museums of everything old-Russian, genuinely national, artistic and creative."[109] Second, Stasov directly identifies the Berendeyans with ancient Russians. Initially, the critic admits that the Berendeyans of Ostrovsky's tale are pure fantasy. He also points out that the historical Berendeyans were Turkic nomads known for their cruelty and belligerent spirit. But neither of these issues prevents him from emphasizing the genuine Russianness of Vasnetsov and his "*Russian, genuinely Russian pictures.*"[110] According to Stasov, "Vasnetsov painted a whole fifty sketches of Slavic types, physiognomies, and costumes for these *fake (fal'shivye)* Berendeyans ..., and this amazing *gallery of truth*, nationality, and talent is among Vasnetsov's main claims to great importance in the history of our art."[111] This is how the "fake Berendeyans" came to represent genuine Russian national culture.

Stasov quotes Ostrovsky's minimalist description of the stage and dwells on Vasnetsov's masterful ability to render wooden architecture adorned with carvings and paint. Where some journalists ridiculed the tsar-house-painter's work, Stasov sees Berendey as an organic part of his kingdom. The critic compares Berendey's chambers to other forms of folk art: an old embroidered shirt, old sleds adorned with bright colors, or a carved spindle. Everything is "full of poetry, life, truth, Russian spirit, fantasy, and beauty."[112] Marvelous forms, marvelous colors—this rhetoric of wonder is in accord

with the fairy-tale genre, and indeed, Stasov's re-creation of Russian antiqui-
ty based on Vasnetsov's art is also a fairy tale, as beautiful as it is fantastic.[113]

Stasov's opinion weighed a lot by itself, but it did not exist in isolation.
In his evaluation of Vasnetsov, Stasov provides numerous examples from
the press demonstrating that his contemporaries failed to appreciate Vas-
netsov's rendition of historical and fantastic folk themes. He cites in this
context *The New Time*, *The Rumor*, and *The St. Petersburg News*.[114] As more
critics and amateurs joined in the conversation, now supporting the vener-
able Stasov, now opposing him, the public discourse ceased to be about *The
Snow Maiden* as an opera or a play. Rather, attention shifted to the image of
Berendeevka, especially after it was very successfully applied to the Russian
department's design at the Paris International Exhibition in 1900 and the
whole high-end kustar industry, as practiced by the masters at Abramtsevo
and Talashkino.

The character of the Snow Maiden, in the meantime, acquired a fame of
its own, as Vasnetsov, Vrubel, Roerich, Stelletsky, and others painted their
versions of this young woman born of snow. With time, the Snow Maiden
became recognized as a unique Russian national symbol that accompanies
Father Frost on his New Year's rounds. It is worth emphasizing that the ver-
sion that became a permanent fixture of Russian national identity was not
the one derived from traditional folktales, but the one initially authored by
Ostrovsky and refined by artists in Abramtsevo: a beautiful woman in a bro-
cade coat trimmed with white fur, as Vasnetsov represented her, or Vrubel's
diva in a fancy crown of ice, reminiscent of a *kokoshnik* (*image 21*). Despite
the obvious fact that Ostrovsky invented his Berendeevka and Vasnetsov in-
vented the style of representing it, Berendeevka was now readily associated
with a genuine Russian antiquity and recognized for its rich ornamentation,
original character, and overall harmony.

The rhetoric of national revival brought to the foreground the maker
of that tradition—the collective talent of the Russian people. The image
of a "natural" artist of common origins, unencumbered by formal train-
ing in the Academy, was a familiar presence in public culture during the
post-emancipation decades. The talent of such artists of common origin
is not a refined skill cultivated in the Academy's hothouse, but an or-
ganic outgrowth of the Russian soil. The reception of Nikolai Leskov's
Lefty shows how facts and fictions of Russian antiquity circulated in late-
nineteenth-century society and how eagerly contemporaries responded

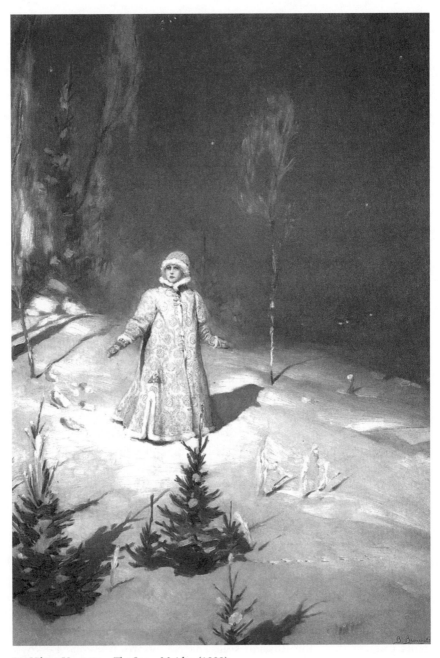

21. Viktor Vasnetsov, *The Snow Maiden* (1899)

to them, taking even literary characters as proof of the longevity of Russian national culture.

The full title of Leskov's original publication is *A Skaz about Cross-eyed Lefty from Tula and a Steel Flea (A Workshop Legend)*. In 1881 Leskov initially published this stylized tale narrated in a folksy voice in three installments in I. Aksakov's Slavophile biweekly *Rus'*, with a separate edition following shortly thereafter.[115] Since then, Lefty has been consistently regarded as a traditional Russian hero, "a national favorite (*liubimets*) and national symbol," most recently in the post-Soviet era.[116] Leskov situates the story between the Napoleonic and Crimean wars. After the Council of Vienna, the victorious Russian emperor Alexander I travels to Britain to "marvel" at the country's museums, collections, rarities, novelties, and other sorts of "wonders" (*chudes posmotret'*). At the culminating point of his tour, the English present him with a unique artifact: a dancing mechanical flea made of steel. The tsar hastens to declare that "nobody can equal the English in their craftsmanship." Years after this initial encounter, the emperor Nicholas I, who inherits the dancing flea, sends it to the famed Tula craftsmen, well known for their ingenuity. They are instructed to "ponder" the English curiosity and to "do something about it." Having "pondered" the flea at great length, the Tula craftsmen—"a talented people upon whom the hopes of the nation now rested"—accomplish the impossible. Without a microscope or any other technological assistance, they manage to shoe the dancing flea. At that, on each shoe they carve the name of the Russian craftsman who made it. Only cross-eyed Lefty's name is nowhere to be found, for he made the tiniest parts—the nails used to hammer on the shoes. The emperor sends the shod flea back to England, making it now the turn of the English to marvel at Russian craftsmanship. In the age of the world's fairs, in which Russia had participated since 1851, it was not uncommon to judge national talent by the results of an international competition, a miniature version of which Leskov reenacts in his tale.

Lefty's reversal of the familiar "Russia meets the West" scenario stemmed not from Russia's technological advancement during the previous decades, as the story makes clear, but from the timeless, ingenious talent of the Russian people. Thus, in answer to his English hosts' question about his aptitude in mathematics, Lefty responds with disarming honesty: "our learning is simple: we read the Book of Psalms and the Book of Half-Dreams but we don't learn any arithmetic at all."[117] During his interview in England, Lefty voices several sentiments expressive of national pride: the Orthodox faith is

the most "correct" one (*pravil'naia*), and traditional Russian lace is far more attractive than British fashion.[118] His patriotism also finds expression in his eagerness to deliver a message to the tsar upon his return home on how the British keep their rifles in good condition. But the tsar forgets about Lefty, only recently celebrated for his talent as a hero in Russia and abroad, and the craftsman dies before he can pass on the information that he gleaned in Britain to the tsar. Had the government heard Lefty's observations and heeded his advice, the narrator suggests, the outcome of the Crimean War might have been different.

Lefty's stylized speech, full of colloquialisms and incorrect usage of foreign words, underscores his connection to an old Russian tradition unadulterated by Western influence. It is Lefty's common sense and astute vision that win Russia a symbolic victory; as Leskov suggests, Russian strength lies neither in education nor in technology but in the native talents that survive among the common Russian people. In the final chapter, Leskov's storyteller spells out Lefty's affiliation with the old tradition by invoking "tales of the times of old" (*predaniia stariny*). Lefty comes to represent organic folk craftsmanship, which needs no assistance from Western mechanical devices or scholarly learning to flourish.

> All this is now "a matter of days long past," "a tale of the times of old," but the days aren't so very old, either, so we need not be in a hurry to forget the legend, despite the air of fable it has about it and the epic character of the hero.... The workers, of course, can appreciate the advantages they gain from devices put at their disposal by science but they remember the days of old with pride and affection. This is their epic and one with a very "human soul."[119]

The rhetoric of "legend" and "fable" implies mythic qualities rather than historical evidence. But the discourse of rediscovered antiquities was so topical in the last third of the nineteenth century that, immediately upon publication, Lefty was also rendered by the contemporary press as some sort of pre-Petrine artifact that had escaped modern reforms. It is hardly random that the action of the story begins in the British chamber of curiosities, which the tsar Alexander I and the ataman of the Don Cossack army Platov visit as part of their tour after the Russian victory over Napoleon. Lefty, too, belongs in a cabinet of wonders, but of a different kind, populated by imagined literary heroes who made a very real difference to a national culture.

Lefty's craftsmanship is useless, however. Despite the Tula masters' phenomenal skill and ingenuity, they basically ruin the mechanical flea; it can no longer dance after having been shod by the Russians. Taking this fact into consideration, A. M. Panchenko deconstructs the national hero, Lefty, reclassifying him as a "national problem": the tale about the left-handed craftsman from Tula, as he puts it, is a "skaz about Russian national demise (*padenie*)." Lefty's useless victory and misapplied talent invalidate him as a hero. "We may have surprised the world and defeated the English, but we have spoiled a good product, a very entertaining trifle." If Lefty stands for the Russian people—and both the author and his critics agreed that he does—then he represents a tragic, and not heroic fate.[120]

What is the appeal of this left-handed, uneducated protagonist, who, despite his best intentions, spoils a clever foreign toy? Contemporaries attempted to discern the authorial intent in several reviews that followed the initial publication of Leskov's *Skaz about Cross-eyed Lefty*. Whether the author intended to applaud the ingenuity of Russian craftsmen or to criticize their ineptitude became the subject of an extended controversy that unfolded in the contemporary press upon the tale's publication. The cause of the debates was the preface, removed from subsequent editions, in which the author claimed to have simply recorded a legend narrated by an old believer who used to live in Tula. Reviewers took Leskov's literary device at face value, arguing that the author presented a tale that had long been known (*legenda staraia i obshcheizvestnaia*).[121] The irony of the story was obviously lost on commentators. *The Voice*, for instance, praised the Russian craftsmen for their victory over educated Europe. In less categorical and more critical terms, a reviewer in *Notes of the Fatherland* saw the ideology of the Slavophile movement behind the plot (*Lefty* was, after all, originally published in Aksakov's *Rus'*). *The New Time*, on the other hand, lashed out at the author for degrading the talented Russian people who, while being celebrated abroad, were left to perish in their own motherland.[122]

Responding to his critics in June 1882, Leskov published a brief article in *The New Time* called "About the Russian Lefty."

> Everything that is purely *national* in the "skaz about lefty from Tula and a steel flea" is included in the following joke or witticism (*pribautka*): "the English made a flea out of steel, and our Tula natives shod it and sent it back to them." Nothing else is known about "the flea," and regarding "the lefty," as the hero of this whole story and a representative of Russian people, there are no folk

skazes about him, and I consider it impossible that anybody should have "heard about him a long time ago" because—I have to confess—I *invented* this entire story in the month of May last year, and *Lefty* is a personage *invented by me.* As to the English flea that was shod by Tula people, this is not a legend at all, but a short joke or witticism, similar to "the German monkey," which "the German had invented," but it couldn't sit still (kept jumping), until a Moscow furrier (*mekhovshchik*) "*sewed* a tail onto it—and then it sat still." There is one and the same idea behind this monkey and the flea, and it is expressed in the same tone, in which there is perhaps much less praise than gentle irony on account of one's ability to improve any sort of foreign novelty.[123]

Despite Leskov's open admission, the stylized craftsman Lefty came to serve as evidence of the Russian tradition's longevity and a vivid embodiment of all those nameless peasants who worked in art colonies in Abramtsevo, Talashkino, and beyond. In the age of the national revival, folk arts and peasant artists became the new heroes of culture, a status shared by the craftsman Lefty, the wooden toy matreshka, Vasnetsov's legendary *Bogatyri*, the tsar Berendey and his jolly Berendeyans, the Snow Maiden, and the mythic Firebird. Paradoxically, the controversy that the initial entry of *Lefty* into the public sphere occasioned did not detract but, on the contrary, increased the public's attention to the tale and made its protagonist a readily identifiable point of reference that many beyond the museums and artists' colonies could share.

The Triumph of Berendeevka: The Making of Russian Souvenir Identity, Paris 1900

The 1900 Paris Exposition Universelle was called "the crowning event of the Century"; it was also the culminating event in the half a century of world's fairs, the history of which began in 1851 in London.[124] The context of international exhibitions, which by their very nature bring the prominent cultural attributes of every country into high profile, helps highlight uniquely national elements in items on display. In comparison with Russia's modest performance at preceding international contests, the unquestionable success that Russia enjoyed at the 1900 World's Fair in Paris was spectacular. Commentators unanimously praised the taste and distinction of the Russian department. But the unique image that it projected was achieved at a cost: Russian cultural identity rested on one category, which contemporaries

called "motifs of Russian antiquity."[125] Of course, aside from arts and crafts, a great variety of objects from many branches of industry were put on display in Paris, but emphasis on "Russianness" as the defining category produced a peculiar effect. David Fisher explains: "The effort by Russia's exhibition organizers to make Russia known in the West actually served to make Russia appear less industrialized and modernized and more strange and exotic than it could have been portrayed. While Russian exhibits failed to embrace the dominant theme of technological progress at the exhibitions, they succeeded in presenting a readily defined, idiosyncratic national style."[126]

In the context of the international fair, Russian antiquity appeared as an attractive and, later, fashionable curiosity, as well as an effective marketing tool. Sergei Makovsky described the peculiarity of the Russian scenario as follows:

> For many reasons, Russia preserved its national distinctiveness (*obosoblennost'*) better than other countries. Despite the yawning abyss separating our cultured classes from the people, in its innermost impetus, Russian art is closer to folk arts than the creative work of West Europe. For them, it is all in the past. For us, perhaps precisely because we, carried away by Western art, could not appreciate our national beauty for such a long time, our new art returned back to national motifs as it strove to achieve independence. And at the end of the nineteenth century, our art industry turned toward the style of the pre-Petrine days, to samples of peasant kustar production, to the poetry of the remote, fairy-tale, dear antiquity.[127]

The Berendeevka village pavilion was key to Russian success. Russian souvenir identity, invented not so long ago in the workshops of Mamontov and Tenisheva, was well received in 1900. The international exhibition helped qualify Berendeevka and all its attributes as expressions of national distinctiveness that were traditional, recognizable, and antique.

The 1900 World's Fair in Paris was neither the first nor the last one where Russians represented their cultural identity in the form of quaint wooden structures richly embellished with ornamental details and "smelling" of a distinct Russian spirit. In 1867, at the Fourth International Exhibition, the Russian department displayed traditionalist wooden structures for the first time, including a decorative façade in the Russian style. Russian huts and stables also aroused curiosity at that time, as the commissar for the Russian department reported: "civilized France was amazed at the fact that the

barbarians had a style and, moreover, a style which proved to be original, so the public was constantly lingering in front of the Russian huts situated in the park of the Russian department."[128] Nor was Russia alone in resorting to revivalist techniques to attain unique self-representation. Other countries likewise used eclectic buildings in their national styles to house their pavilions, which differed from each other mainly in decorative details.

The Russian Berendeevka of 1900 produced a striking impression by taking modern stylization to excess: the exaggeratedly ornamental décor of the wooden structures was in harmony with the fairy-tale treatment of the interiors and objects inside. This carefully packaged souvenir proved long-lasting. The international exhibitions that followed capitalized on the successful design for the Parisian World's Fair: the Berendeevka idiom continued to rule the day in the Russian departments at the international exhibitions in Glasgow (1901), Milan (1906), and Bordeaux (1907).[129] Locally, a charming wooden village was built in Yaroslavl' in conjunction with the tercentenary celebrations of the Romanovs in 1913.[130]

The Berendeevka village in Paris looked as if it was borrowed from *The Snow Maiden* sets. One correspondent described: "Both little houses and the church are lined up so as to all together form a kind of a street in the Russian village. One can only regret that this street here is very narrow."[131] The handicrafts pavilion comprised four buildings connected by a gallery: a peasant home, a boyar's home, a church, and a section for modern kustar objects (*images 22, 23*).[132] As if to further amplify the impression that all these structures were genuinely Russian, the committee chose to transport to Paris entire logs and a team of peasants to construct the pavilion on site. In March 1900, the journal *L'Illustration* published a photograph showing Russian *moujicks* working on their Kustar Pavilion, which enhanced the authenticity of the installation as well as its exotic appeal.[133] The Borderlands Pavilion, where the majority of Russian exhibits were situated, was likewise designed in the Russian manner as a grandiose reproduction of the Moscow Kremlin.

The Moscow Kustar Museum had undertaken the commission to build the Berendeevka Pavilion, also known as the "Russian Village," designed by Korovin. The journal *Art et industrie* publicized Korovin's design, drawing readers' attention to the Kustar Pavilion executed in the "fairy-tale Russian style" with a multicolored roof and ornamental details inside and outside and the church structure modeled on the 17th-century edifice from Arkhangel'sk gubernia.[134] Alexander Golovin designed the interior of the

22. The Kustar Pavilion at the Exposition Universelle in Paris, design by K. Korovin and A. Golovin (1900). *Mir iskusstva*, no. 21/22 (1900)

Berendeevka complex. Images of these fabulous buildings were reprinted in contemporary editions; the *World of Art*, for one, included several high-quality illustrations from the World's Fair. As Korovin himself noted in a different context, the Russian revival style produced a distinctly joyful impression: "The Russian heart is delighted to see precisely the beautiful, purely Russian creation, creative work that is not overshadowed by the foreign. We arrive at the conclusion that Russia, thank God, is not poor in talents and can take pride in them in front of the entire civilized old world."[135]

The arrangement of some 6000 objects inside the Russian Berendeevka village produced an equally satisfying impression. Laces, shawls, fabrics, toys, furniture, icons, and religious items—these are just some of the ob-

23. The interior of the Kustar Pavilion at the Exposition Universelle in Paris (1900), detail.
Mir iskusstva, no. 21/22 (1900)

jects that were displayed in the Berendeevka complex. Designs by artists
Vrubel, Elena Polenova, Maria Iakunchikova-Veber, Davydova, and Golovin
produced the strongest impression. Overall, Russian antiquity was painted,
decorated, exhibited, written, and celebrated in Paris in every possible
way. Russian handicrafts of various kinds received 119 awards and brought
18,500 rubles of revenue.[136]

Critics especially praised splendid balalaikas produced in Talashkino,
which attracted additional attention due to Vasily Andreev's orchestra of
folk instruments, one of the hits in Paris during the exhibition.[137] Balalaikas,
which first appeared in Russia around the early eighteenth century, were
nearly entirely forgotten by the middle of the nineteenth, only to be reinvent-
ed as part of an old folk tradition in the course of the national revival move-
ment. Reviews in the West supported the invented tradition of the balalaika's

antiquity. Describing balalaikas decorated by Tenisheva herself and artists that resided at her Talashkino, including Maliutin, Davydova, and Vrubel, one reporter wrote: "The balalaikas illustrated are the property of Princess Ténicheff—a fervent adherent of the new movement—for whom they were decorated by the different artists. The balalaika—the Russian peasant's guitar—is of very ancient Slavic origin, its peculiar triangular shape showing its primitive character, and lends itself admirably to decoration."[138]

The tone of foreign accounts of the Russian exhibition reflected the aura of awe that the Russian department occasioned. Against a beneficial political background, of which the Alexander III Memorial Bridge in Paris was a conspicuous reminder, the leitmotif of distinction went through much of the commentary in which Russia comes across as picturesque, somewhat exotic, and distinctly national. This kind of response had been much desired since the first international exhibition half a century before in London, but had to remain a wishful dream (Vera Pavlovna's among others) for decades.

The epithets chosen to describe the kustar exhibition are telling. Journalists found the Russian display "most amusing," "picturesque," and possessing "local color." To give just two examples, among many others:

> Under the walls of the Kremlin all the little national home industries peculiar to Russia are carried on under the eyes of the visitors. Peasants in native dress make embroidery, ornaments in bone and shell and little images. This part of the exhibit was organized by the Duchess Elizabeth, sister of the Empress. It includes the "isbas" of an improvised village, where many of the most amusing of all the national industries are grouped together.[139]

Another source emphasized the realistic representation of local life: "The entire exhibit is intended to show not only Russian industry, civilization and commerce, but Russian life; and it is these picturesque glimpses of local color which give to the exposition a cosmopolitan interest."[140]

Reviewers especially emphasized the authenticity of the Russian exhibit:

> Here, 'all the Russias' were on display.... But the image of Russia that the public was likely to take away was not this. It was of 'picturesque, decorative, colourful, lively' Old Russia, represented by the crenellated palace—a veritable Kremlin—which stood alongside the pavilions of the French colonies and other 'exotic nations' in Trocadero grounds. Here, it was possible to wander into the Caucasian gallery framed by male and female Circassian figures, the

Central Asian gallery containing treasures of the Emir of Bokhara, and 'La Russie boreale'. And here, in this old Russian citadel, behind the white walls, standing 'in opposition to the city, neither vulgar nor fantastic, but authentic in every detail', was the kustar exhibit, or, as it was more popularly known, the Russian Village.[141]

Reviews in the European press admired the charm of Russian antiquity brought to life. The journal *Dekorative Kunst*, for example, emphasized the "complete harmony" of the Russian exhibition, where objects on display resonated with the interior and exterior designs. This harmony was possible because both artists and craftsmen "drew their inspiration from old folk samples, studied the flora of their country, came into contact with the charm of its legends and tales."[142] Still another review praised Korovin as a talented decorator who devoted his talent "to the most noble of goals—the preservation and revival of old Russian national art, the awakening of national feeling."[143]

Russian responses to the Berendeevka success in Paris varied. On the one hand, contemporaries recognized in the Russian display the proverbial "Russian spirit." One private impression, for instance, captured the overall sentiment of tenderness (*umilenie*) and enchantment that the Berendeevka village invited:

> I received a strong impression; a whiff of something genuinely Russian, epic (*bylinnyi*) was in the air—the artist Korovin managed to convey this character to our department. The Kustar department, built according to his drawings, comprises an entire fairy-tale little town with wooden palaces (*terema*), multicolored carvings, little porches and connecting passages (*perekhody*). All this is done not in the banal Russian style, but in the one that is being developed by the Vasnetsovs, Korovin, and others.[144]

Newspapers and journals wrote regularly about the kustar village Berendeevka, first describing the progress of its construction, and later detailing its interior and all the exhibits within.[145]

But praise was not the only response to Korovin's designs; critics were just as enthusiastic classifying them as "mediocre" and "decadent." The newspaper *Moscow News* was particularly critical of the "decadent" turn that Chaliapin, Korovin, and Golovin gave to Moscow theater.[146] One outraged reporter, in the tradition of amateur art criticism, dismissed Russian paint-

ings, among which several won major prizes, as "that artistic rubbish which supposedly represents Russian art."[147] Still others saw in the Berendeevka village simply an updated version of the Potemkin village. One contributor expressed it as follows:

> This is an attempt to bring life into the dried-up forms of what in wooden structures is called the *Russian style*. Needless to say, this is not a village at all, and can only confuse a foreigner who wished to find out what a Russian village is about. This is not an ethnographically accurate reproduction of Russian village structures, but a fantastic variation on the themes of Russian national architectures. The intent here is laudable, but the result is still very weak: the constructed buildings are heavy, gaudy, and do not produce a complete impression.[148]

This dissonance between image and meaning, so obvious to a native observer, escaped foreign commentators who praised precisely the harmony of the fantastic souvenir that was the Berendeevka complex. Benois also commented on this important difference in the public reception of Berendeevka in Russia and abroad: Russians, according to him, were exceedingly critical of the Kustar Pavilion in part because the so-called "Russian village" had very little in common with buildings actually found in Russian villages.[149]

Amidst plentiful commentary devoted to the Berendeevka village in Paris was the voice of Benois, who reviewed the Russian department in Paris in the recently founded *World of Art* journal. The journal published numerous images of the Russian department's exterior and interior, showcasing the handiworks and Korovin's architectural designs as works of art.[150] In the pages of this printed edition, one could take a closer look at embroidery, fabrics, carpets, furniture, and all kinds of small figurines that were part of the Russian exhibition in Paris and appreciate the fairy-tale naïveté that Benois identified so perceptively.

Benois's "Letters from the International Exhibition," which appeared in *The World of Art* in 1900, offer a nuanced interpretation of Russia's self-representation in Paris. The critic admits that the Russian department both succeeded and failed in representing the country "honorably" (*dostoino*), depending on whether Turkey or France should be accepted as the benchmark. Benois points to the paradox that Russia was not represented in its totality as a nation and a state at all, for several separate Russian pavilions correspond to only separate parts of the whole: the Kremlin Pavilion—a

"toy," "a parody, if you wish," represented Siberia, although it produced a certain "muscovite" impression, especially on foreigners; the Russian Village was more like a "miniature annex" than an official pavilion; and the Military department, while being "typical of Russia," did not reflect "our national culture" either.

Benois considers the Berendeevka pavilion to be Russia's "most interesting and most artistic exhibit" (*eksponat*). Although far from being a real "Russian village," the pavilion is "a purely Russian structure, a poetic re-creation of those wooden intricate and fancy towns (*zateilivykh i prichudlivykh gorodov*) ... that used to be scattered all over pre-Petrine Russia." But even as he rejoices at the variety of peasant handicrafts, Benois also laments their near extinction: the more peasant handicrafts become overly academic and characterless, the more they lose in their naïve beauty, and the sooner they become "rarities and antiquities." The critic praises Abramtsevo artists for learning from peasants and hence producing admirable samples, the only drawback of which is the intentional crudeness and fussiness (*delannaia, umyshlennaia ikh grubost' i aliapovatost'*). "I think that all this 'Berendeevka' would lose none of its naïveté and maybe at the same time even add to its fancy (*fantastichnost'*) if artists who worked on it, without resorting at all to either Ropet's or the academic devices of the 'fine arts' (*iziashchnost'*), nevertheless paid more attention to workmanship (*otdelka*) and put in more effort."[151] Still, the overall impression produced by the Russian exhibition at the Parisian World's Fair was positive, as Benois recalls: "We Russians were quite up to the mark."[152]

The invented tradition of Berendeevka strongly influenced both the Russian and foreign imagination, and continues to serve as an expedient reference point to Russian national culture today. If other parts of the revived Russian antiquity were part history, part fiction, the Berendeevka figment was a pure literary invention. Yet its many versions—on stage and at world's fairs, in exhibition halls and museums, in journals, newspapers, and books—caught the imagination of Russians eager to find an image that would render Russian distinction in positive terms.

What is remarkable is that as Russian antiquity continued to be rediscovered by new artists, authors, and public figures, its point of origin constantly shifted. This is why there are so many different interpretations of what precisely the national style and Russian antiquity were supposed to mean. Written commentary fully shares in the responsibility of creating a national

idiom in the arts in all its multiple manifestations. In 1902, Grabar outlined the chaotic process of fashioning the national idiom in the arts in the pages of the *World of Art*:

> Beginning with Thon we started to create "in the Russian spirit" with all our heart (*usilenno*).... What is most amusing is that no sooner had we created something than we hurried to announce to the entire world that Rus' had been found. Thon found it, and everybody believed that it was indeed Rus'. Then Shervud found it. And again everybody believed. The Ropet episode is the most curious one. Even a person with such exquisite taste as Mamontov believed him. And everybody believed Ropet's cockerels. Then appeared the Rus' of Stasov, and it then seemed that it was the very real one ... but still there is no Rus', as there has never been (*a Rusi net, kak net*).[153]

In turn, Grabar proposes his own starting point in the national tradition: Vasnetsov's and Surikov's paintings, followed by the Russian applied arts. Grabar's brief history of the Russian quest for a cultural identity in the arts highlights the continuous shifts in what society perceives as genuinely traditional. Soon Grabar's own candidates for true carriers of nationality, Vasnetsov and Russian handicrafts, would also come under suspicion by the following generation. Without naming it, Grabar actually demonstrates in his article the very impossibility of creating national culture to order. What he recommends to artists is to stop "the entirely abnormal chase after this phantom, this enigmatic, elusive Rus'" and to allow artistic freedom to do its work, for one cannot create nationality by force.[154]

EPILOGUE

The World of Art *in the News:*
Culture Wars at the Turn of the Century

The epitome of the nineteenth-century culture wars was a dazzling journal with the most outrageous reputation, the *World of Art*. Beginning with its very first issue, the journal instantly became a major public event. Against the background of a precipitous but haphazard growth of illustrated periodicals in the last two decades of the nineteenth century, the *World of Art* impressed as a masterpiece of artistic production.[1] This St. Petersburg edition inaugurated a new trend in art journals, as represented by the slew of publications that followed and overlapped with their pioneer: the lavishly illustrated monthly *Artistic Treasures of Russia* (*Khudozhestvennye sokrovishcha Rossii*, 1901–7), *Past Years* (*Starye gody*, 1907–16), *Apollon* (1909–17), and *The Golden Fleece* (*Zolotoe runo*, 1906–9), which carried on the work of the *World of Art* in Moscow. The journal itself, however, was never very popular, as researchers point out, with the number of subscribers rarely exceeding one thousand.[2] What made it a public event of consequence was the journal's penchant for scandal.

More than anything else, the *World of Art* journal distinguished itself as an endless source of controversy. Art in Russia had undeniably become news by the end of the century, as this periodical demonstrated. The first five issues of the *World of Art* actually sold quickly and a new edition became necessary.[3] The journal was entangled in debates with critics, artists, societies, and publications of every ilk; the general public that did not subscribe to the *World of Art* engaged in controversies fanned by the journal in the pages of the less radical, albeit hardly less opinionated, daily editions.

The World of Art group entailed the printed periodical of exquisite quality, a "club," and two cycles of exhibitions; it positioned itself at the crossroads of versatile conversations on art and identity that proliferated in late imperial Russia. As John Bowlt cautions, "It is essential to remember that the primary importance of the World of Art lay not in its artistic output, but rather in its diverse activities as a propagator of Russian culture and transmitter of esthetic ideas and ideals from past ages and from its own, Silver Age."[4] The World of Art group provided a missing link between the Gold and Silver Ages, between Russia and the West, between text and image.

The *World of Art* journal also served as a battlefield of opinions. This publication did not exist outside controversy: it was calculated to provoke and outrage. The group's members mused, for instance, whether they should "shock the bourgeois" (*oshelomit' burzhuia*) right away or initiate the philistines gradually and treat them kindly (*oblaskat'*) by offering them Vasnetsov's epic heroes, the *Bogatyri*.[5] But even the inclusion of Vasnetsov's excessive stylizations, which enjoyed nearly universal acceptance among Russian audiences, who were still learning how to appreciate beauty, only added to the controversy that the new publication sparked.

Sergei Diaghilev, the group's commander in chief on the culture front, visibly thrived on conflict. A recognized dilettante in the arts, he nevertheless spoke authoritatively and never hesitated to challenge other authorities, especially Stasov. Diaghilev excelled as a self-taught critic. According to estimates by Soviet scholars, he delivered 120 articles and interviews, only a third of which appeared in the *World of Art*.[6] He was a clever feuilletonist of sorts, especially in his earlier bombastic contributions to discourse surrounding the arts. But first and foremost, he was a provocateur: an aura of scandal surrounded his public statements, inviting responses in a variety of forms, from articles and letters to the editor, to satirical illustrations that appeared in periodicals such as the weekly art journal with caricatures *The Jester*.

Diaghilev was a considerable public presence in fin-de-siècle Russia. For example, *The New Time*'s "art critic" Burenin, known for his ruthlessness and even malice among peers, allowed himself a tone of impudent familiarity in characterizing the *World of Art*'s editor as "a very healthy and perhaps even fattened up, like a bull, Mr. Diaghilev." He concludes his review of the *World of Art* with a gibing address, which could well match some of Diaghilev's own pronouncements: "Ah, Mr. Diaghilev, Mr. Diaghilev; a joker you are, it seems, and not at all the 'director' of an art journal."[7] Burenin launches a personal attack here, an attempt at character assassination, commenting

on the journal between bursts of offensive sarcasm. Civility was not part of
the etiquette in these battles, which resembled now a slapstick comedy, now
a fistfight.

Perhaps the most vivid image of these culture wars can be found in Pavel
Shcherbov's caricatures in *The Jester*. *Vavila Barabanov and Nikola Kritichenko
Having an Intimate Conversation about Aesthetics* (1898), for instance, rep-
resents a fistfight in the middle of a circus arena involving Stasov, Diaghilev,
and artist and journalist Nikolai Kravchenko (*image 24*). The public in the
background is shown reading newspaper pages closely. Shcherbov's carica-
ture literally translates fighting words on the page into a visual image of a
violent fistfight between the authors of art columns. Diaghilev was certainly
Stasov's nemesis; he began baiting the esteemed critic in the pages of *News
and the Stock-Exchange Gazette* in 1896–97 with columns signed "S. D." Sta-
sov responded with a review of the first exhibition organized by the World of
Art group, which he published under the venomous title, "A Nest of Lepers."[8]
This aggressive exchange only intensified as the years went on. With all this
negative publicity, Stasov probably did more to promote the new art group
than anybody else. What is more, as Richard Taruskin concludes, "thanks
largely to Stasov's rabid attacks, *Mir iskusstva* is surrounded in history by an
aura of maximalist radicalism it hardly deserves."[9] It is precisely the categor-
ical judgment of the culture wars' participants, and not their critical insights
or proclamations of "truth," that contributed to the tradition of animated
debates in imperial Russia and made the visual arts the talk of the nation.

Diaghilev's editorial in the first issue of the *World of Art*, confidently ti-
tled "Complicated Questions" (*Slozhnye voprosy*), is a masterpiece of the art
of provocation. Leaving out many of the burning issues of the day, which
Diaghilev did not hesitate to tackle, let us consider just two questions that
had resonated in society for decades: "What is art?" and "What is national
culture?" At the turn of the century, the role of art in society was as topi-
cal as ever. Tolstoy's treatise *What Is Art?* (*Chto takoe iskusstvo?*) revived
society's interest in the predicament of culture when it appeared in *Issues of
Philosophy and Psychology* (*Voprosy filosofii i psikhologii*), shortly before the
inaugural issue of the *World of Art*. In his editorial, Diaghilev considered
"the challenge delivered to art by its ungrateful servant Lev Tolstoi, who has
rejected the art of every era and has reduced its very status to the level of one
of the Christian virtues." Diaghilev rebuffed Tolstoy's attack on modern cul-
ture and asserted the superiority of beauty and freedom in art. In the same
gesture, he categorically rejected the heritage of Stasov, Chernyshevsky, the

24. Pavel Shcherbov, *Vavila Barabanov and Nikola Kritichenko Having an Intimate Conversation about Aesthetics. Shut,* no. 10 (1898)

Itinerants, and other proponents of "useful" aesthetics. The great impresario was particularly merciless toward Chernyshevsky: "This pernicious figure has not yet been digested, and deep down our artistic judges still cherish the barbaric image of him touching art with his dirty fingers, intent upon destroying or at least befouling it."[10] Diaghilev's conclusion is a hymn to beauty, which he elevates both above Tolstoyan morality and Chernyshevsky's social usefulness: "Above all, we are a generation that craves beauty. And we find it everywhere, in both good and evil."

The *World of Art* journal likewise attempted to redefine the notion of "national culture." National character remained a priority in many debates on art, and Tolstoy's treatise offered critics another reason to revisit unresolved issues. Art historian Gnedich, for instance, contributed to debates a feuilleton titled "About Beauty," which was published in *The New Time* near the end of 1898. Art cannot be universal, argued Gnedich, for what is dear and distinct to one nation—be it a costume, an ornament, or a landscape—may appear ugly to another. For Gnedich, "the people [*narod*] cannot have any

other beauty except for their national character—and this is where all of their art derives from."[11]

"National" was at once a desired and a contested attribute. Striking as it may appear, both the ultranationalist Stasov and the cosmopolitan Diaghilev insisted on the importance of national qualities in art, albeit in ways that could not be more different. Stasov's curses in the direction of antinational decadents are well known. Other critics, too, reinforced the notion that the World of Art group was decisively lacking in patriotic sentiments. For example, poet and publicist Petr Pertsov, who stood behind the Symbolist movement, authored an article titled "Decadents and Nationalism," in which he contended that the World of Art's position on cultural identity was the one of an "extreme deviation from the national type towards Europe."[12]

Contrary to preconceived notions, the World of Art group did not object to national tradition per se; it objected to what Benois called "false nationalism":

> In Russia much that was characteristically Russian annoyed us by its coarseness, triviality and unattractive barbarism. It was this coarseness that we longed to fight and to uproot. But the problem had to be solved with the greatest care so as not to harm or break what was really precious; for the good and the bad often lay close together. It was indispensable to save all that was being threatened by the leveling spirit of time, or by false nationalism.[13]

The works of the Itinerants represented just such a false nationalism, "the result of the many years of propaganda of the Itinerants' lubok-style pictures with the inevitable columns of related explanatory text by V. V. Stasov." It was in the writings of Stasov and other "unenlightened" critics that a "moralistic anecdote" had become a defining trait of the Russian people's creative output.[14]

The World of Art group nominated their own selection of artworks as representatively national, and offered their version of Russian culture to the public in the form of exhibitions at home and the Russian Seasons abroad. Several issues of the *World of Art* profiled artists who engaged with neonational imagery and themes, such as Vasnetsov, Polenova, Nesterov, and Yakunchikova; separate issues were devoted to the artists' colonies Abramtsevo and Talashkino as well.[15] The idea of national culture as it was fashioned by the *World of Art* journal and displayed throughout Europe prioritized beautiful decorative designs that rendered the presumed spirit of Russian identity rather than replicating local reality. For example, for his 1906 exhibition of Russian art

in Paris, Diaghilev excluded the works of realists, but included icons, viewed conventionally as religious and historical objects, and showcased them as works of art and masterpieces of the Russian tradition.[16]

The graphic artist and theater designer Mstislav Dobujinsky, himself a World of Art member, outlined the national question in the following terms:

> In proclaiming these ideas, which went counter to those generally accepted, *The World of Art* showed a much deeper understanding of the very essence of "national" art than that which prevailed among its opponents. It held that the "Russian" in art does not depend only on folk motifs or folk subjects. The "Russian spirit" manifests itself spontaneously, and in the most unexpected forms, and truly national art cannot be created artificially, "to order." The so-called Russian style in church architecture and ornamental art of the nineteenth century was but a soulless compilation of ready made "Russian motifs" and was therefore false and quasi-Russian.[17]

Diaghilev, too, emphasized precisely the national distinctiveness of his productions as the key to the Ballets Russes' success. As he claimed in an interview to *The New York Times*: "By looking first within, and being unflinchingly ourselves, I believe we have succeeded in producing a distinctively Russian art hitherto unknown to the world. We have done this, first of all, by going straight to the nation's treasures of music and folk-lore, and employing all the arts of the theatre save the art of speech to present their complete and harmonious symbols on the stage."[18]

But Diaghilev's was not the last word on the issue of nationality in art, nor could there be a conclusive definition, for as long as a national tradition remains alive it evolves continuously. The intensified debates near the century's end further underscored the very artificiality of the noble construct called "national culture."[19] Competing versions of the national met even in the pages of a single periodical, as was the case with the *World of Art*, where the idea of the national changed more than once during the journal's brief existence.

Diaghilev's statement on national art, which was part of his "Complicated Questions," is worth quoting at length as a good example of the many conflicting versions of cultural identity in circulation near the end of the century:

> Nationalism is still a sore issue in modern art, especially Russian art. Many people see in it our entire salvation, and they attempt to preserve it in us artificially. But what could be more destructive than the wish to *become* a

national artist. The only possible nationalism is unconscious nationalism that is in the blood. This is a rare and most valuable treasure. The very nature of such an artist must be national; it must involuntarily (perhaps even *against* the artist's will) be a constant reflection of indigenous nationality. Such an artist must bear within him the characteristics of the nation; he must be, so to speak, its natural offspring, with its pure, ancient blood. In such cases nationalism has value, an immeasurable value. But nationalism that is held as a principle is a mask and a sign of lack of respect for the nation. All the crudity of our art in particular flows from this false search: as if, just by wishing it, you could capture the Russian spirit and convey its essence! So these seekers come along and seize what, in their superficial understanding, appears to be the most typical feature of our national character but which is actually the thing that most discredits it. This is a fatal error, and until we see in Russian art an elegant, grandiose harmony, a majestic simplicity and rare beauty of colour, we will have no real art. Take a look at our real pride: the icons of ancient Novgorod and Rostov—what could be nobler and more harmonious? Remember our great composers, Glinka and Tchaikovsky: how subtly and elegantly and yet on what a gigantic scale do they express the whole of Russia, everything that is purely Russian. Of course, our art cannot avoid severity, a Tatar quality, and if it comes out in an artist because he is incapable of thinking any other way, because he is imbued with this spirit, as with Surikov or Borodin for example, then clearly all the charm of such an artist lies in his sincerity and simple candour. But as for the false Berendei, the Stenka Razins of our art, they are our scourge, they are the truly *un*Russian people.[20]

Not a decade had passed since Berendeevka had been celebrated as the national ideal before Diaghilev dismissed it as a downright fake. According to the discourse advanced by the new art journals, like *Artistic Treasures of Russia*, the *World of Art*, and *Past Years*, another representational shift was underway at the turn of the century: the center of national culture shifted again, away from Moscow. The cosmopolitan St. Petersburg was now undergoing a "renaissance," while Stasov, Repin, and the whole "Russian school" that they stood for, as well as the ostentatious exhibition pavilions in the Russian style, became subjects of ridicule in the press by the young generation of "decadents" grouped around the *World of Art*.[21] The classic Moscow vs. St. Petersburg opposition was a productive rivalry in the end, promoting dialogue, along with controversy. As Dobujinsky, who created many memorable images of the city, reflected in retrospect: "St. Petersburg was the opposite of Moscow in every way. They represented opposite poles of Russian

culture, this dualism being an exceptional feature of Russian history.... One might say that both these worlds—Moscow and St. Petersburg—supplemented each other, and in this continual opposition, combined with a mutual attraction, Russian artistic life continued to develop."[22]

To what extent was the version of Russian culture that Diaghilev took abroad more "genuine" than the "false Berendeyans"? Researchers have demonstrated that the "export campaign of Russian art" that the World of Art group launched after the journal had been discontinued relied on an invented tradition of sorts as well. The glamorous version of Russian culture that sold so well in Europe was manufactured specifically for a foreign audience. The ballet *Firebird*, for instance, which was received abroad as quintessentially Russian, would never have been created for the Russian public. The music historian Richard Taruskin aptly describes the irony of the *Firebird*'s situation: "This very deliberately, in fact self-consciously 'Russian' work had no antecedent in Russian art and was expressly created for a non-Russian audience."[23] Thus it was in early-twentieth-century Paris that the traditional identification of Russia with the "land of the firebird" was formed. To add to this paradoxical scenario, during the two decades that the Ballets Russes dazzled audiences in Europe and America, the company never performed in Russia.[24]

Nor would the Russian public have been aware of their culture's major triumph in Europe had it not been for Benois's regular updates on the Russian Seasons published as the column "The Artistic Letters" (*Khudozhestvennye pis'ma*) in the general interest newspaper *Speech* (*Rech'*). It was in the pages of this edition that the critic announced the victory of the "entire Russian culture, the very distinctiveness (*osobennost'*) of Russian art."[25] And this is also how the Ballets Russes informed the prevailing sense of Russian cultural identity: although Diaghilev's company never performed in Russia, Russians at home could share in national pride generated by it in Europe via publications in the popular press. That Russians experienced the triumph of Diaghilev's Ballets Russes as the success of their national culture evidences the extent to which the press fashioned the outlines of cultural identity. It was not the performance, inaccessible to the Russian general public, but the resonance that it caused in society that brought home a cultural triumph.

Near the turn of the century, a plethora of temporary exhibitions, new public museums, and the ever more volatile debates that accompanied them all contributed to a noticeable accumulation of culture. The many layers called "national" now included not only realist paintings and Russian-style

architecture, folk arts and folk themes, but lubki and old icons as well, which
had only recently been rediscovered as works of traditional Russian *art*. Two
exhibitions of icons were held in Moscow in 1913: one was part of the Ro-
manovs' tercentenary celebrations; the other, the Exhibition of Original Icons
and Lubki (*Vystavka original'nykh ikon i lubkov*), was organized by Mikhail
Larionov and presented over one hundred cleaned and restored masterpieces
from the fourteenth century on. Still another version of the national relocated
abroad, as did Diaghilev's Ballets Russes, and returned to Russia in the form
of celebratory reviews and mementos of the souvenir industry. The spectrum
of the national ran the gamut from peasant crafts to Carl Fabergé's exqui-
site jewelry and Easter eggs, which drew international attention at the Paris
World's Fair in 1900. On another level, the triumph of national culture re-
vealed itself in public celebrations of all kinds and the jubilee mania near the
century's end. The culture wars of the late nineteenth–early twentieth century
attained unprecedented notoriety and visibility as well.

Versatile exhibitions proliferated more than ever, but this previously
coveted plenitude vexed more than it delighted. Kravchenko, for instance,
commented on the phenomenon as follows: "An exhibition here, exhibi-
tion there, exhibitions everywhere—all over exhibitions, exhibitions, exhi-
bitions."[26] Gnedich, writing under the pseudonym Old John, also pointed
to the extraordinary number of these public events: "Where, where haven't
they opened—the harvest is unbelievable, stunning."[27] If journalists previ-
ously wrote about the shortages of art installations, now there was variety
and excess, compounded by the chaos of conflicting opinions in the press.
Art as news became a familiar presence in the Russian public sphere.

Shcherbov's remarkable caricature, *The Bazaar of the 20th Century* (*Bazar
XX veka*), provides a helpful illustration of Russian culture's plentitude and
chaos (*image 25*). The representation of artistic life at the turn of the century
as a bazaar emphasizes not only the plurality of offerings but their diversity
and volatility as well. The caricature itself made news when it was displayed
at an early 1908 exhibition of watercolors in St. Petersburg. Among others,
Benois commented on this masterpiece of graphic arts in a lengthy article that
appeared shortly after the exhibition. Shcherbov represented over 90 partici-
pants in this bazaar, including individual artists (Roerich, for instance), groups
(the World of Art), institutions (such as the Academy of Fine Arts), patrons
(Mamontov, Tenisheva), journalists (Breshko-Breshkovsky), critics (Stasov),
and voluntary associations (The Ladies' Art Circle). Among the many colorful
characters, one recognizes the academicians Repin, Prakhov, and Chistiakov;
sculptors Beklemishev and Trubetskoy; artists Makovsky, Miasoedov, So-

25. Pavel Shcherbov, *The Bazaar of the 20th Century* (1908). The State Tretiakov Gallery, Moscow

mov, Vasnetsov (on horseback), Nesterov (holding onto the tail of Vasnetsov's horse), and Kravchenko (playing an accordion); art historians Benois (with gusli) and Grabar (holding a magnifying glass); and collector Sergei Shcherbatov, with the salon "Contemporary Art" represented as a yoke around his neck.

This group caricature of the many makers of public culture is a unique portrait, bringing together antagonists in a fashion possible only in the museum or in the pages of the press. Shcherbov relied on discrete symbolic details to identify his characters—such as Tenisheva with Vrubel's balalaika under her arm, Vasnetsov on horseback holding a fancy shield, as if impersonating his own *bogatyri*, Mamontov with his ceramics, and Diaghilev as a nanny wheeling about the mischievous toddler Maliavin in a baby carriage—which suggests that these elements were recognizable to contemporaries. Enough had been written about the many different aspects of art to make iconic representations of its key players recognizable.

We can see similar group "portraits" of other fields of culture, too. Soon after Shcherbov's *Bazaar*, a large composition by the artist Nikolai Remizov (signed with the pseudonym Re-mi) appeared called *Salon of Her Highness Russian Literature*, featuring 37 portraits of Russian authors.[28] Shcherbov himself drew a group portrait of art critics writing for St. Petersburg periodicals. The caricature, called *A Spring Concert of Lovers of the St. Petersburg Kritikverein* [Critics' Club] (*Vesennii kontsert liubitelei Sankt-Peterburgskogo kritikfereina, 1900*), included representations of *The New Time's* contributors Kravchenko and Kosorotov, the latter with a gramophone used to articulate "common sense"; the *Art et industrie* editor Nikolai Sobko, with a parakeet, which hints at his nickname Popka; Stasov with his trombone; artist and critic Mechislav Dal'kevich, actress Lidia Iavorskaia, and Diaghilev at the piano; theater critic Isai Rozenberg; and battle-scene painter Ivan Vladimirov with a concertina in his hands.[29]

The front cover of the popular journal *The Cornfield* displayed an image of Russian culture in the broader sense, including the sciences, the arts, and letters (*image 26*). Many attributes of the arts are grouped in this illustration around a central female figure representing Russia: musical instruments, fancy silverware in the Russian style, a monument to Pushkin, scribbling cherubs, as well as the flying pages from the journal *The Cornfield* that reported on all these cultural happenings. The unpretentious message of this cluttered composition is that of a rich harvest of cultural production and its nationwide dissemination by the journal. The stylized letters of the title as well as the ornamental details of the silver vessels add a clear national coloration to this composite image. *The Cornfield* was by far the most widely read illustrated weekly devoted to literature, politics, and contemporary life. Its print run reached 55,000 in 1880, and 235,000 copies were in circulation by 1900. As the journal's front cover suggests, *The Cornfield* both gathered a variety of cultural offerings together and broadly disseminated them. It published reproductions of paintings, including those by the Russian artists Shishkin, Vasnetsov, Vereshchagin, and Repin, as well as works of literature, Tolstoy's novel *Resurrection* among them. A collection of 2131 biographical sketches of important makers of Russian culture, like Belinsky, Granovsky, Krylov, Pushkin, Lermontov, etc., presented yet another contribution that this thin "journal for family reading" made to Russian public culture.[30]

In the course of public celebrations during the last decade of the nineteenth century, many of the key makers of culture in imperial society were granted the status of heroes. The conspicuous increase in celebrations of

26. Cover page for *The Cornfield* journal (1898)

every kind, including those related to culture in the narrow sense, was yet another effort to strengthen the state and unite citizens around a shared idea, as scholars have observed. This is how Konstantin Tsimbaev categorized the phenomenon of jubilee mania that swept Russian society near the end of the imperial period.[31] The expression "jubilee mania" (*iubileemaniia*) itself peppered the pages of the contemporary press, much as "museum mania" had several decades earlier.

While the majority of occasions chosen for celebration clearly belonged to the realm of military and state glory, not to mention religious holidays, a great number of cultural figures also occupied the center of public attention during those years. The official and formal character of most state-sponsored events precluded the kind of universal public response that would encourage a sense of community, however. The many celebrations of culture, by contrast, seemed to invite participation, albeit often in the form of controversy.

Dostoevsky's famous 1881 Pushkin address was among the earlier utterances in the ongoing discourse on the celebration and canonization of literary classics. Pushkin became an institution of national culture when, at the century's end, a massive centennial of the poet's birthday was commemorated in 1899 on the initiative of the tsar. Marcus Levitt usefully framed the 1899 literary celebration as a major public event that stood out against the background of the "crisis of Russian culture" and the previous attacks on the national poet from left and right. The centrality of Pushkin in the pantheon of Russian cultural heroes was well established by then, and this had profound implications for the Russian state that co-opted him. But other groups of the population claimed Pushkin for themselves as well, including the intelligentsia, the general public, and later the émigré community abroad. Levitt writes: "The public image of Pushkin had become quite confused and contradictory, owing to the now quite complex and disunified Russian reading public, the unsettled state of Pushkin scholarship, and to the many contradictory notions about Pushkin then in circulation."[32]

The Pushkin jubilee was far from an isolated occasion. At the turn of the century, Russian society celebrated the jubilees of Gogol and Chekhov, and the 80th birthday of the "living classic" Leo Tolstoy, among many others.[33] The 40th anniversary of the literary career of another living classic, the editor and publisher of *The Library for Reading* Boborykin, was celebrated in the same spirit in October 1900. Little as he might be remembered today, at that time Boborykin loomed large in the Russian public sphere, with scores of

books and articles to his credit.[34] The appearance of several museums dedicated to Russian authors permanently secured their place in public culture: following the first such institution, Pushkin's museum at the Lyceum, which opened in 1879, museums memorializing Lermontov, Tolstoy, and Chekhov were soon established.[35] Next to these literary celebrities, the founding figures of Russian music and painting were feted as well. In celebrating creative artists as heroes, Russians celebrated the achievements of their national culture, the existence of which had been in doubt only several decades earlier. This effort to canonize the founding fathers helped overcome the perceived crisis of culture, but it also achieved the opposite in the process by amplifying the discourse and intensifying the controversy.

In music, the fiftieth anniversaries of Glinka's famous operas, *Life for the Tsar* and *Ruslan and Liudmila*, were celebrated in 1886 and 1892, respectively. A monument to Glinka in Smolensk, funded by an all-Russian subscription, was unveiled in 1886. Glinka's temporary museum was opened in the Mariinsky Theater in 1892. In 1896, a permanent museum was established in the St. Petersburg conservatory, which included photographs of the composer's portraits from the Tretiakov Gallery.[36] Commemorations of the great Russian composer continued with the installation of a bronze monument by the sculptor Robert Bach, unveiled in 1906 in St. Petersburg's Theater Square to celebrate Glinka's centennial. Contrasted with all the celebratory accounts that accompanied these occasions, Sergei Makovsky wrote about the ugliness of "poor" Glinka's statue, admitting at the same time that only a few in Russia could distinguish between "a street sign and a painting, between a bronze scarecrow and a statue." The public sculpture in his account is not a cause for celebration, but a reason for concern about the state of culture and aesthetic taste in Russian society.[37]

Makovsky's outcry over Glinka's statue, however, pales in comparison with a major controversy occasioned by Karl Briullov's jubilee. Briullov's centennial was celebrated on December 12, 1899, at the Academy of Fine Arts and received extensive coverage in the periodical press.[38] Among the special tributes, the Moscow Conservatory Orchestra performed a cantata written by Mikhail Ippolitov-Ivanov for the occasion, with lyrics from the 1836 composition, originally used to greet Briullov's renowned painting when it arrived in Russia: "And may *The Last Day of Pompeii* be for the Russian paintbrush its first day."[39] Collector Pavel Delarov gave a talk on Briullov's significance in the history of the visual arts, later reproduced in the press. It was during this public celebration that Briullov was posthumously appointed the head of the

Russian school of art. But it was a different and what some thought impromptu speech by Ilya Repin that sparked the controversy. The response by contemporaries to Repin's tribute, excerpts of which quickly appeared in newspapers, was initially euphoric, until the appearance of one publication in the *World of Art*. This article, "The Bruillov Jubilation," started a veritable scandal by calling Repin's celebratory speech an embarrassment (*nedorazumenie*) and claiming that it lacked the most important thing, thought (*mysl'*).[40]

The *World of Art* was not the first periodical to challenge Repin or question Briullov's contribution to the history of Russian art. Turgenev was known to have referred to Briullov as a "plump nonentity" (*pukhlaia nichtozhnost'*), a sentiment that many shared in the 1860s and 1870s.[41] But the iconoclastic art journal took the controversy to a whole new level in several publications that followed during the next year. Benois returned to Repin's speech, mocking the latter's pronouncement that Briullov was "the best painter after Raphael, the greatest artist in the past 300 years." Benois concedes in his article that Briullov's influence was enormous and only increased after his death. From the point of view of the Academy, Briullov was indeed an excellent draftsman; even Stasov, despite his loud voice, was unable to knock over this "idol." Yet Benois's overview of Briullov's oeuvre and career only proves that "Briullov was neither a genius nor even a very clever person, but simply a brilliant salon conversationalist." Everything that Briullov had created either stemmed from lies or the desire to astound and please.[42] Professor G. Pavlutsky's broad overview of Briullov's career in the following issue of the *World of Art* looked back at publications that appeared between the 1850s and 1899, the year of the centennial. He reminded the reader that *The Last Day of Pompeii* awakened the public's interest in art, which had grown considerably ever since. Still, Pavlutsky's concluding remarks deny Briullov any originality. His verdict reads: "Thus Briullov's works do not contain any new elements that are not to be found in the works of other nations.... Briullov could not make an epoch in Russian art."[43] Even as the artist was canonized as the founding—albeit unoriginal—father, Briullov remained a contested figure. The process of institutionalization itself took the form of an ongoing dialogue between discourse and counter-discourse.

The World of Art group opened a new chapter in the story of Russian culture, a story that was written largely outside of Russia in the early twentieth century. Revolutions and the world war created further divisions be-

tween versions of culture at home and abroad, imperial and Soviet. These new manifestations of cultural identity, now running parallel to each other, now intersecting, are a topic for another book. What the 1900 world's fair in Paris prepared, what Tenisheva's and Diaghilev's exhibitions reinforced, and what the Ballets Russes ultimately crowned was a version of Russian culture for export.[44] Yet, in a final paradox, this Russian culture fashioned for export helped articulate the national tradition at home, too.

1900 is an arbitrary end point to this story, more of a convention than a conclusion. Controversies surrounding the making and the disseminating of culture continue to this day. New museums and new invented traditions emerged during the prerevolutionary years in Russia. Between Diaghilev's culture for export that the Ballets Russes presented to Europe and Tolstoy's deeply personal, anticultural sentiments, versions of culture continued to multiply in the late imperial period. Nor did the triumph of Russian culture around the turn of the century provide a lasting answer to the conundrum of national identity. There are many reasons for that, and this monograph dwells on only one possibility among many.

The concept "national" in the singular remains a problem. Any attempt to capture a national essence from a living culture results either in the creation of monumental myths or token souvenirs of identity, such as the wall calendars, porcelain figurines, and wooden dolls that came to symbolize Russia in nineteenth-century Paris and modern Moscow alike. Unlike these symbolic images, national culture as a lived experience is fractured and incomplete. What precisely constitutes the national spirit always remains open to debate depending on when and who is speaking. This edginess and incompleteness of the cultural tradition is what gives it its essential vitality; it also stands behind its propensity toward myth-making as a way to heal the rift.

National culture always hovers between an impossible ideal and endless reproductions of the souvenir industry. While time preserved many of the institutions that the Russian cultural renaissance created—nominal bastions of history and tradition—the public debates surrounding these collections and monuments of the visual arts continue to fluctuate as new generations of artists, critics, and consumers appear. And this is why, unlike a museum, cultural identity can never be written in stone. What endures is the ongoing dialogue about culture, a national tradition no less distinct than the Firebird.

NOTES

Introduction

1. Maksim Gor'kii, *Revoliutsiia i kul'tura: Stat'i za 1917 g.* (Berlin: Izd. t-va I. P. Ladyzhnikova, 1918), 49.

2. Letter to D. A. Lutokhin, 3 May 1922, in Boris Pil'niak, *Mne gor'kaia vypala slava... Pis'ma 1915–1937* (Moscow: AGRAF, 2002), 166.

3. Among recent titles, see James Cracraft and Daniel Rowland, eds., *Architectures of Russian Identity: 1500 to the Present* (Ithaca: Cornell University Press, 2003); Christopher Ely, *This Meager Nature: Landscape and National Identity in Imperial Russia* (DeKalb: Northern Illinois University Press, 2002); Rosalind P. Gray, *Russian Genre Painting in the Nineteenth Century* (Oxford: Oxford University Press, 2000); Andrew L. Jenks, *Russia in a Box: Art and Identity in an Age of Revolution* (DeKalb: Northern Illinois University Press, 2005); Richard Stites, *Serfdom, Society, and the Arts in Imperial Russia: The Pleasure and the Power* (New Haven: Yale University Press, 2005).

4. Aleksandr Solzhenitsyn, *The First Circle,* trans. Thomas P. Whitney (New York: Harper & Row, 1968), 358; Vladimir Tolstoi, "Muzei v Rossii—bol'she, chem muzei," *Mir i muzei* 1 (1998).

5. The visual arts conventionally include painting, sculpture, and architecture, also known as the traditional "trinity of high art." I use the concept in this classical sense. An interpretation in a broader sense includes cinema, puppetry, etc. See "The Idea of 'The Visual Arts,'" in *The Philosophy of the Visual Arts*, ed. Philip Alperson (New York: Oxford University Press, 1992), 1–6.

6. For details, see W. Bruce Lincoln, *The Great Reforms: Autocracy, Bureaucracy, and the Politics of Change in Imperial Russia* (DeKalb: Northern Illinois University Press, 1990).

7. V. G. Belinskii, "Obshchee znachenie slova literatura," *Polnoe sobranie sochinenii*, vol. 5 (Moscow: Izd-vo Akademii nauk SSSR, 1954), 653. More recently, Geoffrey Hosking observed: "Russia's 'imagined community' was fashioned by literature more than by any other factor...." See his *Russia: People and Empire, 1552–1917* (Cambridge: Harvard University Press, 1997), 293. See also Benedict Anderson's influential study *Imagined Communities: Reflections on the Origin and Spread of Nationalism*, rev. ed. (London: Verso, 1991).

8. N. Kurochkin, "Predislovie," in Pierre-Joseph Proudhon, *Iskusstvo: Ego osnovaniia i obshchestvennoe naznachenie* (St. Petersburg, 1865), iii.

9. [K. N. Bestuzhev-Riumin], "Sankt-Peterburg. 30-go ianvaria 1873," *Golos*, no. 31, 31 January 1873.

10. Benedict Anderson, "Nationalism, Identity, and the World-in-Motion: On the Logics of Seriality," in *Cosmopolitics*, ed. Pheng Cheah and Bruce Robbins (Minneapolis: University of Minnesota Press, 1998), 117–33.

11. S., "Tipy sovremennykh gazet. II. Golos," *Slovo*, no. 9 (September 1879): 182. See also "Tipy sovremennykh gazet. I. 'Novoe Vremia,'" *Slovo*, no. 8 (August 1879): 242.

12. See, for instance, Peter H. Hoffenberg, *An Empire on Display: English, Indian, and Australian Exhibitions from the Crystal Palace to the Great War* (Berkeley: University of California Press, 2001); *Imagining Modern German Culture, 1889–1910*, ed. Françoise Forster-Hahn (Washington: National Gallery of Art, 1996); *Nationalism and French Visual Culture, 1870–1914*, ed. June Hargrove and Neil McWilliam (Washington: National Gallery of Art, 2005); Brandon Taylor, *Art for the Nation: Exhibitions and the London Public, 1747–2001* (Manchester: Manchester University Press, 1999); Robin Simon, *Hogarth, France and British Art: The Rise of the Arts in 18th-Century Britain* (London: Hogarth Arts, 2007). See also Brian Wallis, "Selling Nations: International Exhibitions and Cultural Diplomacy," in *Museum Culture: Histories, Discourses, Spectacles,* ed. Daniel J. Sherman and Irit Rogoff (Minneapolis: University of Minnesota Press, 1994), 265–81; "the nation as a work of art" is his expression.

13. B. F. Egorov, *Bor'ba esteticheskikh idei v Rossii 1860-kh godov* (Leningrad: Iskusstvo, 1991), 17.

1: National Culture

1. John Godfrey Herder [Johann Gottfried Herder], *Outlines of a Philosophy of the History of Man*, trans. T. Churchill, 2nd ed., vol. 1 (London: Luke Hansard, 1800), vi.

2. James Bradburne, "The Poverty of Nations: Should Museums Create Identity?" in *Heritage and Museums: Shaping National Identity*, ed. J. M. Fladmark (Shaftesbury: Donhead Publishing Ltd, 2000), 379–80.

3. William H. Sewell, Jr., "The Concept(s) of Culture," in *Beyond the Cultural Turn: New Directions in the Study of Society and Culture*, ed. Victoria E. Bonnel and Lynn Hunt (Berkeley: University of California Press, 1999), 35–36.

4. James Clifford, *The Predicament of Culture: Twentieth-Century Ethnography, Literature, and Art* (Cambridge: Harvard University Press, 1988), 10.

5. Laura Engelstein, "Culture, Culture Everywhere: Interpretations of Modern Russia, across the 1991 Divide," *Kritika: Explorations in Russian and Eurasian History* 2, no. 2 (Spring 2001): 363–93.

6. A. Belyi, "Krizis kul'tury," *Simvolizm kak miroponimanie* (Moscow: Izd-vo "Respublika," 1994), 260–96. As Kobena Mercer observes in a different context, "identity only becomes an issue when it is in crisis, when something assumed to be fixed, coherent and stable is displaced by the experience of doubt and uncertainty." Kobena Mercer, "Welcome to the Jungle: Identity and Diversity in Postmodern Politics," in *Identity: Community, Culture, Difference*, ed. Jonathan Rutherford (London: Lawrence & Wishart, 1990), 43. Culture is hardly a uniquely Russian preoccupation, as evidenced by scholarly and popular volumes, such as Wolf Lepenies, *The Seduction of Culture in German History* (Princeton: Princeton University Press, 2006) and *Français! Notre histoire, nos passions*, ed. Carl Aderhold and Renaud Thomazo (Paris: Larousse, 2003).

7. Nicolas Berdyaev, *The Russian Idea* (New York: The Macmillan Company, 1948), 252, 130.

8. Culture as the "most complex whole" is the classic definition by E. B. Tylor; see Clifford Geertz, "Thick Description: Toward an Interpretive Theory of Culture," *The Interpretation of Cultures: Selected Essays* (New York: Basic Books, 1973), 4. James H. Billington, *The Icon and the Axe: An Interpretive History of Russian Culture* (New York: Vintage Books edition, 1970), viii.

9. Fragments of this narrative have been written by different researchers over the years. In 2000, a monograph-length study on the topic was published for the first time in Russia. Iu. Asoian and A. Malafeev, *Otkrytie idei kul'tury: Opyt russkoi kul'turologii serediny XIX–nachala XX vekov* (Moscow: OGI, 2000).

10. Cf. Catriona Kelly's essay "Popular Culture," in *The Cambridge Companion to Modern Russian Culture*, ed. Nicholas Rzhevsky (New York: Cambridge University Press, 1998). For more on commercialized leisure, such as tourism, sports, theater, nightlife, and cinema, see Louise McReynolds, *Russia at Play: Leisure Activities at the End of the Tsarist Era* (Ithaca: Cornell University Press, 2003). This present volume is explicitly not concerned with mass culture or popular entertainment, be it lubki or *narodnye gulianiia*. My emphasis remains on the literate middle, the core of the Russian public.

11. Richard Stites, *Serfdom, Society, and the Arts in Imperial Russia: The Pleasure and the Power* (New Haven: Yale University Press, 2005), 4.

12. Several recent studies have explored the connection between the visual arts and national identity in the Russian context. Among them are Stephen M. Norris, *A War of Images: Russian Popular Prints, Wartime Culture, and National Identity, 1812–1945* (DeKalb: Northern Illinois University Press, 2006) and *Picturing Russia: Explorations in Visual Culture*, ed. Valerie A. Kivelson and Joan Neuberger (New Haven: Yale University Press, 2008).

13. Jeffrey Brooks, "Russian Nationalism and Russian Literature: The Canonization of the Classics," in *Nation and Ideology: Essays in Honor of Wayne S. Vucinich*, ed. Ivo Banac et al. (New York: Columbia University Press, 1981), 315. See also Brooks's seminal study, which changed the way we think about Russian culture today: *When Russia Learned to Read: Literacy and Popular Literature, 1861–1917* (Princeton: Princeton University Press, 1985).

14. Nicolas Berdyaev, *The Russian Idea*, 129. Berdyaev writes: "There was among the Russians none of that veneration of culture which is so characteristic of Western people" (128).

15. Orlando Figes, *Natasha's Dance: A Cultural History of Russia* (New York: Picador, 2002), xxxii. For more on the history of Russian culture, see Nicholas Rzhevsky, "Russian Cultural History: Introduction," in *The Cambridge Companion to Modern Russian Culture*, 1. On the "Russian soul" construct, see Robert C. Williams, "The Russian Soul: A Study in European Thought and Non-European Nationalism," *Journal of the History of Ideas* 31, no. 4 (October–December 1970): 573–88.

16. As Caryl Emerson observed in oral remarks at the AAASS 2007 Convention (New Orleans), the idea of a national culture has been plagued by two paradoxes: the false binary opposition between Russia and the West and the artificial obfuscation of differences between classes and groups.

17. Stuart Hall, "Cultural Identity and Diaspora," in *Colonial Discourse and Post-Colonial Theory: A Reader*, ed. Patrick Williams and Laura Chrisman (New York: Columbia University Press, 1994), 392.

18. Leo Tolstoy, *What Is Art?* trans. Aylmer Maude (Bridgewater: Replica Books, 2000), 1.

19. L. N. Tolstoi, *Voina i mir*, Epilog II, *Sobranie sochinenii v 22 tomakh*, vol. 7 (Moscow: Khudozhestvennaia literatura, 1981), 316, 325; L. N. Tolstoi, *Chto takoe iskusstvo? Sobranie sochinenii v 22 tomakh*, vol. 15 (Moscow: Khudozhestvennaia literatura, 1983), esp. 85–99.

20. Benedict Anderson, *Imagined Communities: Reflections on the Origin and Spread of Nationalism*, rev. ed. (London: Verso, 1991); *The Invention of Tradition*, ed. Eric Hobsbawm and Terence Ranger (Cambridge: Cambridge University Press, 1983); Jürgen Habermas, *The Structural Transformation of the Public Sphere: An Inquiry into a Category of Bourgeois Society*, trans. Thomas Burger with the assistance of Frederick Lawrence (Cambridge: The MIT Press, 1989); Pierre Bourdieu, *The Field of Cultural Production: Essays on Art and Literature*, ed. Randal Johnson (New York: Columbia University Press, 1993); Yuri M. Lotman, *Universe of the Mind: A Semiotic Theory of Culture*, trans. Ann Shukman (Bloomington: Indiana University Press, 1990); Clifford Geertz, *The Interpretation of Cultures: Selected Essays* (New York: Basic Books, 1973); G. Iu. Sternin, *Khudozhestvennaia zhizn' Rossii seridiny XIX veka* (Moscow: Iskusstvo, 1991); William Mills Todd III, *Fiction and Society in the Age of Pushkin: Ideology, Institutions, and Narrative* (Cambridge: Harvard University Press, 1986); *Literature and Society in Imperial Russia, 1800–1914*, ed. William Mills Todd III (Stanford: Stanford University Press, 1978); M. M. Bakhtin, *The Dialogic Imagination: Four Essays* (Austin: The University of Texas Press, 1981); *Practicing New Historicism*, eds. Catherine Gallagher and Stephen Greenblatt (Chicago: University of Chicago Press, 2000); D. S. Likhachev, *Reflections on Russia* (Boulder: Westview Press, 1991).

21. Eric Hobsbawm, "Introduction: Inventing Traditions," in *The Invention of Tradition*, 2, 7–8.

22. Eric Hobsbawm, "Mass-Producing Traditions: Europe, 1870–1914," in *The Invention of Tradition*, 303–4.

23. Jeffrey Brooks, "Russian Nationalism and Russian Literature," 315.

24. Yuri M. Lotman, "Semiotic Space," *Universe of the Mind: A Semiotic Theory of Culture*, 126–27.

25. Lotman also points to the artificiality of this model of a unified culture. Yu. M. Lotman and B. A. Uspensky, "On the Semiotic Mechanism of Culture," *New Literary History* 9, no. 2 (Winter 1978): 227.

26. Pierre Bourdieu, "Outline of a Sociological Theory of Art Perception," *The Field of Cultural Production*, 234.

27. Stuart Hall, "Cultural Identity and Diaspora," 394. For Geertz, too, "Cultural analysis is intrinsically incomplete," and museums and folklore can only offer a temporary escape from this cultural predicament. Geertz, "Thick Description: Toward an Interpretive Theory of Culture," 29. See also Lotman and Uspensky, "On the Semiotic Mechanism of Culture," 222; Iu. M. Lotman, "Vvedenie: Byt i kul'tura," *Besedy o russkoi kul'ture: Byt i traditsii russkogo dvorianstva (XVIII–nachalo XIX veka)* (St. Petersburg: "Iskusstvo-SPB," 1994), 9.

28. Figes, xxviii–xxx.

29. M. M. Bakhtin, "Toward a Methodology for the Human Sciences," *Speech Genres and Other Late Essays*, ed. Caryl Emerson and Michael Holquist, trans. Vern W. McGee (Austin: University of Texas Press, 1986), 170.

30. Schönle and Shine recently called this approach "constructivist." Andreas Schönle and Jeremy Shine, "Introduction," in *Lotman and Cultural Studies: Encounters and Extensions*, ed. Andreas Schönle (Madison: The University of Wisconsin Press, 2006), 8–9.

I take a discursive construct to be a socially configured way of thinking and talking about phenomena, governed by a given society's conventions and codes.

31. Paperny compares the "conversation" between Culture 1 and Culture 2 to the absurd dialogue in Beckett's *Waiting for Godot*. For instance, one and the same architectural project—the design of the Palace of the Soviets—caused radically different reactions from representatives of two polar cultures, as if they spoke different languages. Vladimir Paperny, *Kul'tura "Dva"* (Ann Arbor: Ardis, 1985).

32. M. M. Bakhtin, "Otvet na vopros redaktsii 'Novogo mira,'" *Literaturno-kriticheskie stat'i* (Moscow: "Khudozhestvennaia literatura," 1986), 507–8. For more on multiple layers of culture see also Iu. M. Lotman, "Vvedenie: Byt i kul'tura," *Besedy o russkoi kul'ture*, 15. Cf. Daniel Brower, "Whose Cultures?" *Kritika: Explorations in Russian and Eurasian History* 3, no. 1 (Winter 2002): 81.

33. Geertz, "Thick Description: Toward an Interpretive Theory of Culture," 12. Cf. Lotman and Uspensky's pronouncement: "culture is, by definition, a social phenomenon." Lotman and Uspensky, "On the Semiotic Mechanism of Culture," 213.

34. Cf. Jürgen Habermas, *The Structural Transformation of the Public Sphere: An Inquiry into a Category of Bourgeois Society*, trans. Thomas Burger with the assistance of Frederick Lawrence (Cambridge: The MIT Press, 1989), xviii.

35. Richard S. Wortman, *Scenarios of Power: Myth and Ceremony in Russian Monarchy*, Studies of the Harriman Institute, vol. 2 (Princeton: Princeton University Press, 2000).

36. Arjun Appadurai and Carol A. Breckenridge, "Museums Are Good to Think: Heritage on View in India," in *Museums and Communities: The Politics of Public Culture*, ed. Ivan Karp, Christine Mullen Kreamer, and Steven D. Lavine (Washington: Smithsonian Institution Press, 1992), 38.

37. Nicolas Berdyaev, *The Russian Idea*, 221.

38. Figes, "Natasha's Dance," xxx–xxxi.

39. For more on the history of the term see A. L. Kroeber and Clyde Kluckhohn, *Culture: A Critical Review of Concepts and Definitions* (New York: Vintage Books, 1952).

40. Ivan Re..f..ts [Renofants], *Karmannaia knizhka dlia liubitelei chteniia russkikh knig, gazet i zhurnalov, ili, Kratkoe istolkovanie vstrechaiushchikhsia v nikh slov voennykh, morskikh, politicheskikh, kommercheskikh i raznykh drugikh iz inostrannykh iazykov zaimstvovannykh, koikh znacheniia ne kazhdomu izvestny: knizhka podruchnaia dlia kazhdogo sosloviia, pola i vozrasta* (St. Petersburg, 1837). This lexicon recorded two main meanings for the word, the cultivation of the land and education. For a useful brief history of the word in English, see Catriona Kelly, Hilary Pilkington, David Shepherd, Vadim Volkov, "Introduction: Why Cultural Studies?" in *Russian Cultural Studies: An Introduction*, ed. Catriona Kelly and David Shepherd (Oxford: Oxford University Press, 1998), 7–12. The following reference sources proved particularly useful in tracing the history of the word and its application: *Etimologicheskii slovar' russkogo iazyka*, ed. N. M. Shanskii, vol. II (Moscow: Izd-vo Moskovskogo universiteta, 1982); Iu. S. Sorokin, *Razvitie slovarnogo sostava russkogo literaturnogo iazyka (30–90-e gody)* (Moscow: Nauka, 1965), 94–95; R. A. Budagov, *Istoriia slov v istorii obshchestva* (Moscow: Prosveshchenie, 1971), 128–29.

41. I. Pokrovskii, "Pamiatnyi listok oshibok v russkom iazyke," as cited in Asoian, 68.

42. This aspect of cultural history is covered comprehensively in Asoian. See also *Entsiklopedicheskii slovar'*, published by Brokgauz and Efron, vol. 38 (St. Petersburg: I. A. Efron, 1890–1904), 144–51.

43. Raymond Williams, *Culture and Society: 1780–1950* (New York: Columbia University Press, 1983), xvi–xviii. More recently, Larry Shiner likewise argued that the idea of art, along with such categories as the aesthetics and the artist, was invented in the eighteenth century. Larry Shiner, *The Invention of Art: A Cultural History* (Chicago: University of Chicago Press, 2001).

44. M. E. Saltykov-Shchedrin, *Ubezhishche Monrepo, Sobranie sochinenii*, vol. 8 (Moscow: Izdatel'stvo "Pravda," 1951), 124.

45. D. V. Venevitinov, "Neskol'ko myslei v plan zhurnala," *Polnoe sobranie sochinenii* (Moscow: Academia, 1934), 216–17.

46. The original printed version of the letter, as it was published in *The Telescope*, is reproduced in P. Ia. Chaadaev, *Polnoe sobranie sochinenii i izbrannye pis'ma*, vol. 1 (Moscow: Nauka, 1991), 641–76; see esp. 652, 658. For a modern translation, see the same edition, vol. 1, 320–39. For the French original, see vol. 1, 86–106. In the original publication, the idea of culture was rendered by the contemporary synonyms *obrazovannost'* and *prosveshchenie* (modern translations use *kul'tura* instead).

47. I. V. Kireevskii, "Otryvki," *Izbrannye stat'i* (Moscow: "Sovremennik," 1984), 277; Janko Lavrin, "Kireevsky and the Problem of Culture," *Russian Review* 20, no. 2 (April 1961): 120.

48. Susanna Rabow-Edling, "The Role of 'Europe' in Russian Nationalism: Reinterpreting the Relationship between Russia and the West in Slavophile Thought," in *Russia in the European Context 1789–1914: A Member of the Family*, ed. Susan P. McCaffray and Michael Melancon (New York: Palgrave Macmillan, 2005), 100.

49. I. V. Kireevskii, "Deviatnadtsatyi vek," *Izbrannye stat'i*, 78.

50. A. S. Khomiakov, "Mnenie russkikh ob inostrantsakh," *Polnoe sobranie sochinenii*, vol. 1 (Moscow: Univ. tip., 1900), 65–67.

51. Vasilii Grigorievich Avseenko (1842–1913) was a critic and a writer of fiction, including a novel *The Milky Way* (*Mlechnyi put'*), which appeared in installments in *Russkii vestnik* in 1875–76 and received a largely negative response in the contemporary press. His article "Opiat' o narodnosti i o kul'turnykh tipakh" was published in *Russkii vestnik* 3 (1876).

52. F. M. Dostoevskii, *Dnevnik pisatelia*, April 1876, *Polnoe sobranie sochinenii v 30 tomakh* (thereafter *PSS*), vol. 22 (Leningrad: Nauka, 1981), 109–10.

53. For more on this exchange, see F. M. Dostoevskii, *Dnevnik pisatelia*, April 1876, 103–19; see also pertinent commentary in this volume, 370–81.

54. Where it was possible to identify historical authors who published under given pseudonyms, such information is provided in footnotes. In 1875–78, poet and critic Vasilii Markov wrote under the pseudonym V. M. for *The St. Petersburg News*. I. F. Masanov, *Slovar' psevdonimov russkikh pisatelei, uchenykh i obshchestvennykh deiatelei*, vol. 1 (Moscow: Izdatel'stvo vsesoiuznoi knizhnoi palaty, 1956), 197.

55. M. E. Saltykov-Shchedrin, "Kul'turnye liudi," *Polnoe sobranie sochinenii*, vol. 11 (Leningrad: Gos. izd-vo khudozh. lit-ry, 1934), 510, 497.

56. See, for instance, K. N. Bestuzhev-Riumin, "Teoriia kul'turno-istoricheskikh tipov," in N. Ia. Danilevskii, *Rossiia i Evropa: Vzgliad na kul'turnye i politicheskie otnosheniia slavianskogo mira k germano-romanskomu*, 6th ed. (St. Petersburg: Izd-vo "Glagol," 1995), 432–35.

57. Danilevskii, *Rossiia i Evropa*, 429.

58. Ibid., 424, 429. Bestuzhev-Riumin, too, fully endorsed the Slavs' ability in the

arts, as he echoed Danilevsky's opinion: "For a long time our art has lived by imitation and only now comes out onto the straight path." K. N. Bestuzhev-Riumin, "Teoriia kul'turno-istoricheskikh tipov," 452, 443.

59. Danilevskii, *Rossiia i Evropa*, 426.

60. Ibid., 421, 232. Cf. Berdyaev, *The Russian Idea*, 221.

61. V. S. Solov'ev, *Natsional'nyi vopros v Rossii, Sobranie sochinenii Vladimira Sergeevicha Solov'eva: S 3-mia portretami i avtografom*, 2nd ed., vol. 5 (St. Petersburg: Knigoizdatel'skoe Tovarishchestvo "Prosveshchenie," 1911–1914), 109, 100–102.

62. Ibid., 29–35, 144, 103.

63. N. N. Strakhov, "Nasha kul'tura i vsemirnoe edinstvo," *Russkii vestnik*, no. 6 (June 1888): 200–56; Solov'ev, *Natsional'nyi vopros v Rossii*, 304, 310.

64. *****, "Mysli ne-literatora (Pis'mo v redaktsiiu). I. Russkaia samobytnost' i g. Vl. Solov'ev," *Novoe vremia*, no. 4529, 7 October 1888.

65. Asoian, 173.

66. Andrei Belyi, "Filosofiia kul'tury," *Simvolizm kak miroponimanie*, 326.

67. N. A. Berdyaev, "O kul'ture," *Filosofiia tvorchestva, kul'tury i iskusstva*, vol. 1 (Moscow: Izd-vo "Iskusstvo," 1994), 524–25. In Berdyaev's analysis, civilization moves in the opposite direction to culture, from the bottom up.

68. V. I. Lenin, "Kriticheskie zametki po natsional'nomu voprosu," *Polnoe sobranie sochinenii*, 5th ed., vol. 24 (Moscow: Gosudarstvennoe izdatel'stvo politicheskoi literatury, 1961), 120–21. Originally published in 1913, in the journal *Prosveshchenie* (issues no. 10, 11, 12); italics in the original.

69. A. Belyi, "Krizis kul'tury," as cited in Asoian, 142. See also Andrei Belyi, "Filosofiia kul'tury," *Simvolizm kak miroponimanie*, 326; Andrei Belyi, "Puti kul'tury," *Simvolizm kak miroponimanie*, 308. Cf. Theodor W. Adorno, "Valéry Proust Museum," *Prisms*, trans. Samuel and Shierry Weber (London: Neville Spearman, 1967), 175–78.

70. As cited in Asoian, 183.

71. N. F. Fedorov, "Muzei, ego smysl i naznachenie," *Sochineniia* (Moscow: Mysl', 1982), 575–604.

72. Pavel Florenskii, "Khristianstvo i kul'tura," *Zhurnal moskovskoi patriarkhii* 4 (1983): 53–54. This article was written in 1924 and originally published in England the same year.

73. See also N. A. Berdiaev, "O kul'ture," *Filosofiia tvorchestva, kul'tury i iskusstva*, vol. 1, 525.

74. N. K. Roerich, "Kul'tura—pochitanie sveta," *Kul'tura i tsivilizatsiia* (Moscow: Mezhdunar. tsentr Rerikhov, 1994), 41. Roerich, who conceptualized culture as literally worship, defined it as the "Cult of Light" (*pochitanie sveta*), with a double meaning of enlightenment, as in the European tradition, and the cult of Eastern mysticism.

75. See, for instance, I. V. Stalin, *Marksizm i natsional'no-kolonial'nyi vopros* (Moscow: Partiinoe izd-vo, 1934).

2: Launching the Discourse

1. Thomas Richards, *The Commodity Culture of Victorian England: Advertising and Spectacle, 1851–1914* (Stanford: Stanford University Press, 1990), 17. Other researchers suggest slightly different numbers.

2. Jeffrey A. Auerbach, *The Great Exhibition of 1851: A Nation on Display* (New Haven: Yale University Press, 1999), 138, 185; see also James Buzard, *The Beaten Track: European Tourism, Literature, and the Ways to Culture, 1800–1918* (Oxford: Oxford University Press, 1993). Although three times as many foreigners traveled to Britain in 1851 in comparison with previous years, their number was nevertheless significantly lower than expected. Aside from exhibitors and individual travelers, some Russian officials from the Ministries of Finance and State Domains came to visit the Crystal Palace in order to observe foreign departments and purchase equipment. David C. Fisher, "Russia and the Crystal Palace in 1851," in *Britain, the Empire, and the World at the Great Exhibition of 1851*, ed. Jeffrey A. Auerbach and Peter H. Hoffenberg (Hampshire: Ashgate Publishing Company, 2008), 123–46. For more on Russia's participation in international exhibitions, see David C. Fisher, "Exhibiting Russia at the World's Fairs, 1851–1900" (PhD diss., Indiana University, 2003). See also the recently published article by Anthony Swift, "Russia and the Great Exhibition of 1851: Representation, Perceptions, and a Missed Opportunity," *Jahrbücher für Geschichte Osteuropas* 55 (2007): 242–63.

3. The bibliography on the Crystal Palace is vast and growing. Auerbach's *The Great Exhibition of 1851: A Nation on Display* is a good starting point, as well as *The Great Exhibition*, by John R. Davis (Stroud: Sutton Publishing Ltd., 1999) and Jan Piggott's *Palace of the People: The Crystal Palace at Sydenham, 1854–1936* (Madison: University of Wisconsin Press, 2004).

4. See, for instance, the anthology *The Art of All Nations, 1850–73: The Emerging Role of Exhibitions and Critics*, ed. Elizabeth Gilmore Holt (Princeton: Princeton University Press, 1982).

5. For more on coronation albums, see Edward Kasinec and Richard Wortman, "The Mythology of Empire: Imperial Russian Coronation Albums," *Biblion: The Bulletin of the New York Public Library* 1, no. 1 (Fall 1992): 77–100.

6. Marshall Berman, *All That Is Solid Melts into Air: The Experience of Modernity* (New York: Penguin, 1988), 236.

7. Charles Dickens, "The Great Exhibition and the Little One," *Household Words* 3, no. 67 (1851): 356–60.

8. Cited in Andrew H. Miller, *Novels Behind Glass: Commodity, Culture, and Victorian Narrative* (Cambridge: Cambridge University Press, 1995), 53.

9. Walter Benjamin, "Paris, Capital of the Nineteenth Century," *Reflections: Essays, Aphorisms, Autobiographical Writings*, trans. Edmund Jephcott, ed. Peter Demetz (New York: Schocken Books, 1986), 151–53.

10. John Ruskin, *Proserpina; Ariadne Florentina; The Opening of the Crystal Palace* (Boston: Colonial Press Company, 1890), 412.

11. Patrick Beaver, *The Crystal Palace: A Portrait of Victorian Enterprise* (Chichester: Phillimore, 1986), 57.

12. John Stoughton, *The Palace of Glass and the Gathering of the People: A Book for the Exhibition* (London: Religious Tract Society, 1851). The "poet" in question is apparently Chaucer.

13. A. Sturdza, "Dukhovnaia zhizn' i dukhovnaia slovesnost' na Vostoke," *Moskvitianin*, no. 16, kn. 2 (August 1851): 370.

14. F. B., "Pchelka. Zhurnal'naia vsiakaia vsiachina," *Severnaia pchela*, no. 100, 5 May 1851. Almost half a century later, Leo Tolstoy described the 1893 international exhibition in Chicago in similarly categorical terms: "The Chicago exhibition, like all exhibitions, is

a striking example of imprudence and hypocrisy: everything is done for profit and amusement—from boredom—but noble aims of love of the people are ascribed to it. Orgies are better." *Tolstoy's Diaries*, ed. R. F. Christian, vol. 1 (London: The Athlone Press, 1985), 323.

15. Auerbach, 5.

16. Richards, 25. See also Phillip T. Smith, "London 1851: The Great Exhibition of the Works of Industry of all Nations," in *Historical Dictionary of World's Fairs and Expositions, 1851–1988*, ed. John E. Findling (New York: Greenwood Press, 1990), 3–9. The layout of the Exhibition followed a nationalist agenda as well. George Stocking observes that initially "Prince Albert had proposed that grouping be without reference to national origin; however, the actual arrangement was national and geographical...." See George W. Stocking, Jr., *Victorian Anthropology* (New York: The Free Press, 1987), 2. For more on the representation of things and nations at world exhibitions, see Timothy Mitchell, "The World as Exhibition," *Comparative Studies in Society and History* 31, no. 2 (April 1989): 217–36.

17. F. B., "Pchelka. Zhurnal'naia vsiakaia vsiachina," *Severnaia pchela*, no. 100, 5 May 1851. While the Great Exhibition continued in London, where Russia so obviously was not measuring up to the competition, newspapers also wrote with much enthusiasm about the local fair in Uriupinsk. N. K., "Uriupinskaia iarmarka. Iz putevykh zametok," *Severnaia pchela*, no. 142, 27 June 1851; G. V., "Uriupinskaia iarmarka," *Moskovskie vedomosti*, no. 109, 11 September 1851.

18. *The Art-Journal Illustrated Catalogue of the International Exhibition, 1862* (London: J. S. Virtue, 1862), xii.

19. Thomas Prasch, "International Exhibition of 1862," in *Historical Dictionary of World's Fairs and Expositions, 1851–1988*, ed. John E. Findling (New York: Greenwood Press, 1990), 25.

20. *The Quarterly Review* 112 (July 1862): 186–87.

21. *Severnaia pchela*, no. 117, 2 May 1862; *Severnaia pchela*, no. 136, 22 May 1862.

22. *Russkii khudozhestvennyi listok*, no. 12, 20 April 1862.

23. Among many other similar responses, see "Angliia," *Severnaia pchela*, no. 131, 16 May 1862.

24. V. Stasov, "Posle vsemirnoi vystavki," *Sovremennik* 95 (April 1863): 234.

25. V. V. Stasov, "Nasha khudozhestvennaia proviziia dlia Londonskoi vystavki (1862)," *Sobranie sochinenii V. V. Stasova, 1847–1886*, vol. 1 (St. Petersburg: Tipografiia M. M. Stasiulevicha, 1894), 69. This article was published in *Sovremennaia letopis'*, no. 11 (1862).

26. Despite his looming presence in the nineteenth-century public sphere, monograph-length studies on Stasov are not abundant. Among titles in Russian, the one by O. D. Golubeva, *V. V. Stasov* (St. Petersburg: Rossiiskaia natsional'naia biblioteka, 1995), focuses on Stasov's career in the Russian National Library in St. Petersburg (former Publichnaia). Several other books date to the 1980s and 1970s, for instance, Yuri Olkhovsky, *Vladimir Stasov and Russian National Culture* (Ann Arbor: UMI Research Press, 1983). See also a useful recent article by Alexey Makhrov, "Defining Art Criticism in Nineteenth-Century Russia: Vladimir Stasov as Independent Critic," in *Critical Exchange: Art Criticism of the Eighteenth and Nineteenth Centuries in Russia and Western Europe*, ed. Carol Adlam and Juliet Simpson (Oxford: Peter Lang, 2009), 207–26.

27. As cited in Richard Stites, *Serfdom, Society, and the Arts in Imperial Russia: The Pleasure and the Power* (New Haven: Yale University Press, 2005), 394.

28. D. V. Filosofov, *Slova i zhizn': Literaturnye spory noveishego vremeni* (St. Petersburg: Tipografiia Akts. obshch. tip. dela, 1909), 319–20.

29. B. I. Esin, *Russkaia dorevoliutsionnaia gazeta, 1702–1917 gg.: Kratkii ocherk* (Moscow: Izdat. Moskovskogo un-ta, 1971), 38.

30. As cited in V. K. Mezenin, *Parad vsemirnykh vystavok* (Moscow: "Znanie," 1990), 8. The writing of the British authors devoted to the Crystal Palace was plentiful. There are a number of critical interpretations of Crystal Palace "fictions" available; among the recent ones is Andrew H. Miller's *Novels Behind Glass* (1995); see also Philip Landon, "Great Exhibitions: Representations of the Crystal Palace in Mayhew, Dickens, and Dostoevsky," *Nineteenth-Century Contexts* 20 (1997): 27–59.

31. "Vsemirnaia vystavka v Londone. Pis'ma iz Londona," *Moskovskie vedomosti*, no. 72, 16 June 1851. Baron Fel'kerzam's publication was based on the letters of his London friends. When the last installment was published, Fel'kerzam expressed hope that his efforts had been of service to the Russian public. "Vsemirnaia vystavka v Londone. Pis'ma iz Londona," *Moskovskie vedomosti*, no. 85, 17 July 1851.

32. Georg Min, "Pis'ma iz Anglii," *Moskovskie vedomosti*, no. 98, 16 August 1851; no. 112, 18 September 1851. The fairy-tale frame for the Crystal Palace narratives seems to have been fairly common; see, for example, Charles Dickens, "Three May-Days in London," *Household Words* 3, no. 58 (1851): 121–24.

33. A. I. Koshelev, *Poezdka russkogo zemledel'tsa v London na Vsemirnuiu vystavku* (Moscow, 1852), 16, 93, 99.

34. *The Northern Bee* likewise described Paxton's masterpiece as a "contemporary wonder" (*sovremennoe divo*). "Londonskaia vsemirnaia vystavka," *Severnaia pchela*, no. 112, 21 May 1851. Russian reactions to the British modern wonder were by no means unique. German commentators, too, picked up on the Crystal Palace's magic. Julius Lessing, whom Benjamin quotes at length in his *Arcades Project*, recalls "how the news of the Crystal Palace reached us in Germany, and how pictures of it were hung in the middle-class parlors of distant provincial towns. It seemed then that the world we knew from old fairy tales—of the princess in the glass coffin, of queens and elves dwelling in crystal houses— had come to life …, and these impressions have persisted through the decades." Julius Lessing, as quoted in Walter Benjamin, *The Arcades Project*, trans. Howard Eiland and Kevin McLaughlin (Cambridge: Belknap Press of Harvard University Press, 1999), 184.

35. Khomiakov, A. S., "Aristotel' i vsemirnaia vystavka," *Polnoe sobranie sochinenii Alekseia Stepanovicha Khomiakova*, vol. 1 (Moscow, 1900), 185–86, 192.

36. Koshelev, 16, 93, 99.

37. F. B., "Pchelka. Zhurnal'naia vsiakaia vsiachina," *Severnaia pchela*, no. 117, 26 May 1851.

38. N. Sazonov, "Mesto Rossii na vsemirnoi vystavke," *Poliarnaia zvezda*, vol. 2 (1856), 225.

39. Apparently, Chernyshevsky was in London on June 26–30, 1859. See Iu. M. Steklov, *N. G. Chernyshevskii: Ego zhizn' i deiatel'nost'*, vol. 2 (Moscow, 1928), 48.

40. N. G. Chernyshevskii, "Novosti literatury, iskusstv, nauk i promyshlennosti," *Polnoe sobranie sochinenii*, ed. V. Ia. Kirpotin, vol. 16 (Moscow: Gos. izd-vo khudozh. lit-ry, 1953), 89–127. Originally published in *Otechestvennye zapiski* 8 (1854).

41. "Peterburgskaia letopis'," *Sankt-Peterburgskie vedomosti*, no. 63, 20 March 1860; E. A. Borisova, *Russkaia arkhitektura vtoroi poloviny XIX veka* (Moscow: Nauka, 1979), 68–70.

42. The novel was published in *The Contemporary*, nos. 3, 4, and 5 (1863) and was

reviewed in virtually every periodical. As a book, it was illegally issued in Geneva in the late 1860s and only in 1905 published in Russia. N. A. Alekseev, "Kommentarii k zhurnal'noi redaktsii 'Chto delat'?'" in N. G. Chernyshevskii, *Polnoe sobranie sochinenii*, ed. V. Ia. Kirpotin, vol. 11 (Moscow: Gos. izd-vo khudozh. lit-ry, 1939): 702–11; B. I. Esin, "Rasprostranenie zhurnal'nogo teksta romana N. G. Chernyshevskogo 'Chto delat'?'" in *Zhurnalistika i literatura*, ed. E. A. Lazarevich (Moscow: Izd-vo Moskovskogo universiteta, 1972), 275–76. On the novel's enormous popularity, see also Irina Paperno, *Chernyshevsky and the Age of Realism: Study in the Semiotics of Behavior* (Stanford: Stanford University Press, 1988), 26–38.

43. N. G. Chernyshevsky, "Vera Pavlovna's Fourth Dream," in Fyodor Dostoevsky, *Notes from Underground*, trans. Michael R. Katz (New York: Norton, 1989), 99–117.

44. Berman, 237. This dream is also a classic expression of the "woman question," which preoccupied Russian educated society in the 1860s.

45. Lev Paniutin, "Novyi god," *Rasskazy Nila Admirari*, vol. 2 (St. Petersburg, 1872), 21–42, esp. 28, 38, 41–42.

46. For contemporary reportage on what the Crystal Palace in Sydenham had to offer during the 1862 exhibition, see, for instance, M. R., "Listok. Putevye zametki," *Syn Otechestva*, no. 188, 7 August 1862; no. 190, 9 August 1862.

47. N. Vagner, "'Malen'kii narod' Londona v 'Khrustal'nom dvortse' Sidengema (Etiud iz pedagogicheskoi khroniki Anglii)," *Slovo*, no. 11 (November 1879), 1–19. Other Russian commentators, too, found the successful application of a public culture of display for the purposes of general education in Britain inspirational. A. Khodnev, for one, put forward a strong argument for the establishment of a useful, accessible museum of applied arts and sciences in Russia similar to the one that had opened in London's South Kensington. A. Khodnev, *Ob ustroistve muzeumov, s tsel'iu narodnogo obrazovaniia i prakticheskoi pol'zy* (St. Petersburg, 1862).

48. V. V. Stasov, "Stolitsy Evropy i ikh arkhitektura," *Sobranie sochinenii V. V. Stasova, 1847–1886*, vol. 1 (St. Petersburg: Tipografiia M. M. Stasiulevicha, 1894), 398.

49. N. F. Bel'chikov, "Chernyshevskii i Dostoevskii (iz istorii parodii)," *Pechat' i revoliutsiia* 5 (July-August 1928): 35–53; B. P. Koz'min, "'Raskol v nigilistakh' (Epizod iz istorii russkoi obshchestvennoi mysli 60-kh godov)," *Iz istorii revoliutsionnoi mysli v Rossii: Izbrannye trudy* (Moscow: Izd-vo Akademii nauk SSSR, 1961), 20–67; V. A. Tunimanov, *Tvorchestvo Dostoevskogo, 1854–1862* (Leningrad: Nauka, 1980), 246–93; Joseph Frank, *Dostoevsky: The Stir of Liberation, 1860–1865* (Princeton: Princeton University Press, 1986), 310–47; Efraim Sicher, "By Underground to Crystal Palace: The Dystopian Eden," *Comparative Literature Studies* 22, no. 3 (Fall 1985): 377–93; Marshall Berman, "Afterword: The Crystal Palace, Fact and Symbol," in *All That Is Solid Melts into Air*, 235–48. Most recently, Michael Katz published an article that brings together many of the different versions of the Crystal Palace imagined in nineteenth-century Russia. Katz claims, without documentation, that "Dostoevsky made a side trip to Sydenham to see the transformed and reconstructed Crystal Palace." Michael R. Katz, "But This Building—What on Earth Is It?" *New England Review* 23, no. 1 (Winter 2002): 65–76. See also his "The Russian Response to Modernity: Crystal Palace, Eiffel Tower, Brooklyn Bridge," *Southwest Review* 93 (2008): 44–57.

50. Berman, 243, 245.

51. Sicher characterizes Buckle's *History of Civilization in England* (1857–61) as something that "threatens to formulate the laws of nature into a logarithm table, leaving nothing to chance and excluding the possibility of individual action." Sicher, 383.

52. *Vremia*, no. 2 (February 1863): 132–99.

53. Vladimir Nabokov, "Memoirs from a Mousehole," *Lectures on Russian Literature*, ed. Fredson Bowers (San Diego: Harcourt Brace & Company, 1981), 118.

54. Auerbach, 206; Berman, 237.

55. Fyodor Dostoevsky, "From *Winter Notes on Summer Impressions*," *Notes from Underground*, 97.

56. F. M. Dostoevskii, "Zimnie zametki o letnikh vpechatleniiakh," *PSS*, vol. 5 (Leningrad: Nauka, 1973), 69.

57. "Angliia," *Syn otechestva*, no. 104, 1 May 1862.

58. V. Stasov, "Posle vsemirnoi vystavki," *Sovremennik* 96 (May 1863): 58.

59. Dostoevskii, "Zimnie zametki," 68–69.

60. M. I. Brusovani and R. G. Gal'perina, "Zagranichnye puteshestviia F. M. Dostoevskogo 1862 i 1863 gg.," in *Dostoevskii: Materialy i issledovaniia*, vol. 8 (Leningrad: Nauka, 1988), 281. This is the most precise account of Dostoevsky's itinerary abroad, which the authors reconstructed based on Dostoevsky's foreign passport, letters, and his "Winter Notes." We do not know for certain whether Dostoevsky saw the Crystal Palace or not. It should be taken into account that during the time when Europe and Russia delighted in the first Crystal Palace in 1851, Dostoevsky was far from urban centers where discussions of the new wonder actively circulated. Nor do we know for sure whether Chernyshevsky, who spent only four days in London in 1859 while on an explicit mission to meet and talk with Herzen, actually visited the Crystal Palace either. For more on Dostoevsky's and Herzen's meeting in London, see Elena Druzhakov, "Dostoevskii i Gertsen. Londonskoe svidanie 1862 goda," *Canadian-American Slavic Studies* 17, no. 3 (Fall 1983): 325–48.

61. Feodor Dostoevsky, *Crime and Punishment*, ed. George Gibian, 3rd ed. (New York: W. W. Norton & Company, 1989), 135.

62. Dostoevsky, *Notes*, 25.

63. Dostoevskii, "Zimnie zametki," 70–71.

64. Berman, 237.

65. Prasch, 25.

66. V. Poletika, "Poezdka na Londonskuiu vystavku. II.," *Severnaia pchela*, no. 160, 16 June 1862.

67. Brusovani and Gal'perina, 281.

68. Dostoevskii, "Zimnie zametki," 49.

69. Auerbach, 67–69.

70. "The Great Exhibition," *The Times*, 9 June 1851, p. 8.

71. *The Crystal Palace Exhibition: Illustrated Catalogue, London 1851* (New York: Dover Publications, 1970), 266.

72. "Russia," *The Illustrated Exhibitor*, no. 8 (26 July 1851): 125–26. The reporters obviously judged not only the material goods on display in the Crystal Palace, but the system that produced them as well. Appropriately, the pamphlet *The Productions of All Nations About to Appear at the Great Exhibition of 1851*, published a well-known caricature of Nicholas I with a barrel labeled "elbow grease from 30,000,000 serfs." This caricature is mentioned in Auerbach, 168.

73. "Russia," *The Illustrated Exhibitor*, no. 8 (26 July 1851): 128.

74. John Tallis, *Tallis's History and Description of the Crystal Palace, and the Exhibition of the World's Industry in 1851*, vol. 3 (London: J. Tallis and Co., 1852), 159.

75. "The Great Exhibition," *The Times*, 9 June 1851, p. 8.

76. "The Russian Court," *The Illustrated London News*, 21 June 1851, p. 597.

77. Koshelev, 19.

78. Phillip T. Smith, 7. The Sazikov firm first gained recognition near the end of the eighteenth century and flourished in Russia until the end of the nineteenth. Vyacheslav Mukhin, "The St. Petersburg Branch of the Sazikov Firm and Russian Silverware of the 19th and Early 20th Centuries," in *The Fabulous Epoch of Fabergé. St. Petersburg—Paris—Moscow: Exhibition at the Catherine Palace in Tsarskoye Selo*, ed. V. Mukhin (Moscow: Nord, 1992), 43.

79. *Reports by the Juries on the Subjects in the Thirty Classes into Which the Exhibition Was Divided* (London: Printed for the Royal Commission by William Clowes & Sons, 1852), 515.

80. Tallis, 33.

81. Ibid., 33; "Russia," *The Illustrated Exhibitor*, no. 8 (26 July 1851): 129.

82. *The Crystal Palace Exhibition: Illustrated Catalogue*, 267.

83. *The Broadsheet of Russian Art*, no. 21 (1851), as cited in Mukhin, "The St. Petersburg Branch of the Sazikov Firm and Russian Silverware of the 19th and Early 20th Centuries," 46.

84. Anne Odom, "Fabergé: The Moscow Workshops," in *Fabergé: Imperial Jeweler*, ed. Géza von Habsburg and Marina Lopato (New York: Harry N. Abrams, 1994), 109–10.

85. David C. Fisher, "Russia and the Crystal Palace in 1851," 123–46.

86. [L. M. Samoilov and A. A. Sherer], "Fel'eton. Vzgliad na russkoe otdelenie vsemirnoi vystavki 1851 goda. (Soobshcheno)," *Sankt-Peterburgskie vedomosti*, no. 165, 26 July 1851.

87. G. Min, "Pis'ma iz Anglii. V.," *Moskovskie vedomosti*, no. 131, 1 November 1851.

88. "Fel'eton. Zametki," *Sankt-Peterburgskie vedomosti*, no. 87, 21 April 1851.

89. V. P., "Fel'eton. Vystavka malakhitovykh veshchei, otpravliaemykh na londonskuiu vystavku fabrikoi gg. Demidovykh," *Sankt-Peterburgskie vedomosti*, no. 91, 26 April 1851.

90. "Fel'eton. Smes'," *Sankt-Peterburgskie vedomosti*, no. 36, 14 February 1851.

91. F. B., "Pchelka. Zhurnal'naia vsiakaia vsiachina," *Severnaia pchela*, no. 106, 12 May 1851.

92. Koshelev, 18.

93. Russia did not participate in the 1855 International Exhibition in Paris, which took place during the Crimean War.

94. L. de-R., "Russkoe otdelenie vsemirnoi vystavki," *Sovremennaia letopis'*, no. 35 (August 1862): 26.

95. Such is the estimate of "the second London correspondent" for *The Northern Bee*. "Russkoe otdelenie na vsemirnoi vystavke," *Severnaia pchela*, no. 113, 28 April 1862.

96. Fisher argues that the national turn in the Russian display was actually a British idea. According to him, Sir Roderick Murchison, a famous British geologist and a Russophile of a kind, suggested that "everything of truly, nationally, Russian make ... will attract much greater attention than ... French, German, or English gravy boats." David C. Fisher, "Especially, Peculiarly Russian: The English Roots of the 'Russian Idea' at the 1862 London International Exhibition," unpublished paper given at the Mid-America Conference on History (Lawrence, Kansas; September 22, 2000).

97. "Zamechaniia na stat'iu 'Russkoe otdelenie na vsemirnoi vystavke,'" *Sankt-Peterburgskie vedomosti*, no. 117, 2 June 1862.

98. "Khronika russkogo otdeleniia," *Severnaia pchela*, no. 128, 13 May 1862. Of course, there were other opinions available. M. R., the author of travel notes serialized in *Son of the Fatherland*, thought that Russia had maintained a high profile at the exhibition

and even moved ahead of other countries precisely because of the unique character of its products, such as the ornamental vases, candelabra, and bronzes already familiar from 1851. M. R., "Listok. Putevye zametki. V.," *Syn otechestva*, no. 179, 27 July 1862.

99. "Khronika russkogo otdeleniia," *Severnaia pchela*, no. 123, 8 May 1862.

100. "Russkoe otdelenie na vsemirnoi vystavke," *Severnaia pchela*, no. 113, 28 April 1862.

101. V. Poletika, "Poezdka na Londonskuiu vystavku. II.," *Severnaia pchela*, no. 160, 16 June 1862.

102. V. Stasov, "Posle vsemirnoi vystavki," *Sovremennik* 95 (April 1863): 232–35. Retrospectively, V. K. Mezenin selects P. M. Obukhov's cannon as an emblem of the 1862 Russian department; contemporary reporters, however, barely noticed it. V. K. Mezenin, *Parad vsemirnykh vystavok* (Moscow: "Znanie," 1990), 28.

103. Francis Turner Palgrave, *Handbook to the Fine Art Collections in the International Exhibition of 1862* (London: Macmillan and Co., 1862), 8.

104. Stasov, "Nasha khudozhestvennaia proviziia," 69–70.

105. Paul Greenhalgh, *Ephemeral Vistas: The Expositions Universelles, Great Exhibitions, and World's Fairs, 1851–1939* (Manchester: Manchester University Press, 1988), 198–208.

106. Prasch, 28. Zaretskaia believes that the expression "Russian school of art" was articulated for the first time precisely at the international exhibitions. D. M. Zaretskaia, "Rossiia na vsemirnoi vystavke 1851 goda," *Voprosy istorii*, no. 7 (July 1986): 184.

107. V. Stasov, "Posle vsemirnoi vystavki," *Sovremennik* 95 (April 1863): 230. For a comparative perspective on the question of identity in art, see Rosalind P. Blakesley, "Slavs, Brits and the Question of National Identity in Art: Russian Responses to British Painting in the Mid-Nineteenth Century," in *English Accents: Interactions with British Art c. 1776–1855*, ed. Christiana Payne and William Vaughan (Aldershot: Ashgate, 2004), 203–24.

108. F. Buslaev, "Kartiny russkoi shkoly zhivopisi, nakhodivshiesia na londonskoi vsemirnoi vystavke," *Sovremennaia letopis'*, no. 5 (February 1863): 6.

109. A. A-v, "Po povodu kartin russkoi zhivopisi, byvshikh na londonskoi vystavke," *Nashe vremia*, no.18, 23 January 1863.

110. K. V., "Khudozhestvennye zametki," *Russkii khudozhestvennyi listok*, no. 18, 20 June 1862, p. 69.

111. Buslaev, "Kartiny russkoi shkoly zhivopisi," 6.

112. Stasov, "Nasha khudozhestvennaia proviziia," 75.

113. Ibid., 70.

114. P. Petrov, "Khudozhestvennaia zhivopis' za sto let," *Severnoe siianie* 1 (1862): 391–404.

115. D. Grigorovich, "Kartiny angliiskikh zhivopistsev na vystavkakh 1862 goda v Londone," *Russkii vestnik* 44, no. 3 (March 1863): 90.

116. Consider one of the more articulate statements of this discourse, Aleksandr Benua, "Iskusstvo," in *Rossiia v kontse XIX veka*, ed. V. I. Kovalevskii (St. Petersburg, 1900), 889–98.

117. "Otzyv v *Times* o russkom otdelenii khudozhestvennoi vystavki," *Sovremennaia letopis'*, no. 44 (November 1862): 21–22.

118. J. Beavington Atkinson, "Russian School," *The Art-Journal* (1862): 197–98.

119. "Otzyv v *Times* o russkom otdelenii khudozhestvennoi vystavki," 21–22. One of the British guidebooks thought that Russian art merited notice for "the insight given into

Russian life, [rather] than for artistic qualities." *A Plain Guide to the International Exhibition. The Wonders of the Exhibition Showing How They May Be Seen at One Visit* (London: Sampson Low, Son, and Co., 1862), 63.

120. A. A-v, "Po povodu kartin russkoi zhivopisi, byvshikh na londonskoi vystavke," *Nashe vremia*, no.18, 23 January 1863.

121. Grigorovich, "Kartiny angliiskikh zhivopistsev," 818.

122. Buslaev, "Kartiny russkoi shkoly," 7–10.

123. "Russkoe otdelenie na vsemirnoi vystavke," *Severnaia pchela*, no. 113, 28 April 1862.

124. "Zamechaniia na stat'iu 'Russkoe otdelenie na vsemirnoi vystavke,'" *Sankt-Peterburgskie vedomosti*, no. 117, 2 June 1862. Another reader explained to Russia's Second London Correspondent the difference between painting and engraving, thereby correcting the journalist's unfair judgment of Russian art displayed at the exhibition. "Ne artist," "O russkikh graviurakh na londonskoi obshchenarodnoi vystavke," *Severnaia pchela*, no. 132, 18 May 1862.

125. V. Stasov, "Posle vsemirnoi vystavki," *Sovremennik* 96 (May 1863): 26–27, 44–45, 35; *Sovremennik* 95 (April 1863): 226, 232.

126. Buslaev, "Kartiny russkoi shkoly," 7–8.

127. V. V. Stasov, "Dvadtsat' piat' let russkogo iskusstva. Nasha zhivopis'," *Sobranie sochinenii V. V. Stasova, 1847–1886*, vol. 1 (St. Petersburg: Tipografiia M. M. Stasiulevicha, 1894), 494.

128. Ibid., 521.

3: Art and Society

1. V. S. Solov'ev, *Natsional'nyi vopros v Rossii, Sobranie sochinenii Vladimira Sergeevicha Solov'eva: S 3-mia portretami i avtografom*, 2nd ed., vol. 5 (St. Petersburg: Knigoizdatel'skoe Tovarishchestvo "Prosveshchenie," 1911–1914), 3.

2. Ivan Beliaev, "Tysiacheletie russkoi zemli," *Den'*, no. 12, 1 January 1862. This article is prefaced by K. Aksakov's pronouncement: "The wheel of Russian history turns around every 150 years"; Beliaev breaks Russian history into seven segments, the last of which, defined by the turn to nationality, began in 1762.

3. *Mirskoe slovo*, 1863. Cited in V. S., "Popytki narodnoi zhurnalistiki," *Sovremennik* 95 (March 1863): 143.

4. See *Severnaia pchela*, no. 168 (1860). Kostomarov's "Kto byli variagi-rus', t.e. chto my takoe?" in *Severnaia pchela* is a response to D. Shcheglov's article in *Notes of the Fatherland*, which in turn provoked Shcheglov's retort in the pages of yet another publication, *The St. Petersburg News*, no. 193, 6 September 1860. Kostomarov wrote another piece devoted to the millennium as well, "Tysiacheletie," which was published in *The St. Petersburg News* in early 1862 (no. 5).

5. Geoff Eley and Ronald Grigor Suny, "Introduction: From the Moment of Social History to the Work of Cultural Representation," in *Becoming National: A Reader*, ed. Geoff Eley and Ronald Grigor Suny (New York: Oxford University Press, 1996), 6, 21.

6. Ronald Grigor Suny, "History," in *Encyclopedia of Nationalism*, ed. Alexander J. Motyl, vol. 1 (San Diego: Academic Press, 2001), 335.

7. Geoffrey A. Hosking, "Empire and Nation-Building in Late Imperial Russia," in

Russian Nationalism, Past and Present, ed. Geoffrey Hosking and Robert Service (New York: St. Martin's Press, 1998), 19–20. See also W. Bruce Lincoln, *The Great Reforms: Autocracy, Bureaucracy, and the Politics of Change in Imperial Russia* (DeKalb: Northern Illinois University Press, 1990), 36–37.

 8. Geoffrey A. Hosking, *Russia: People and Empire, 1552–1917* (Cambridge: Harvard University Press, 1997), xix. See also Andreas Kappeler, *Rossiia—mnogonatsional'naia imperiia: Vozniknovenie, istoriia, raspad* (Moscow: Izdatel'stvo "Progress-Traditsiia," 1997), 177. On the crucial distinction between *Rus'* and *Rossiia, russkii* and *rossiiskii*, see Hosking, xix; Ladis K. D. Kristof, "The Russian Image of Russia: An Applied Study in Geopolitical Methodology," in *Essays in Political Geography*, ed. Charles A. Fisher (London: Methuen & Co, 1968), 349.

 9. Kristof, 347.

 10. Among others, see Theodore R. Weeks, *Nation and State in Late Imperial Russia: Nationalism and Russification on the Western Frontier, 1863–1914* (DeKalb: Northern Illinois University Press, 1996); Kappeler, *Rossiia—mnogonatsional'naia imperiia*; Hosking, *Russia: People and Empire, 1552–1917*; D. C. B. Lieven, *Empire: The Russian Empire and Its Rivals* (London: John Murray, 2000); Vera Tolz, *Russia* (New York: Oxford University Press, 2001).

 11. Nicholas V. Riasanovsky, *Nicholas I and Official Nationality in Russia, 1825–1855* (Berkeley: University of California Press, 1967), 73–76.

 12. Kappeler, 177–79; Roman Szporluk, *Communism and Nationalism: Karl Marx versus Friedrich List* (New York: Oxford University Press, 1988), 160. For the most part, I follow Kappeler in this brief outline of the history of the Russian national movement.

 13. V. G. Belinskii, "Rossiia do Petra Velikogo," *Polnoe sobranie sochinenii*, vol. 5 (Moscow: Izd-vo Akademii nauk SSSR, 1954), 121, 124. See also Andrzej Walicki, *A History of Russian Thought from the Enlightenment to Marxism*, trans. Hilda Andrews-Rusiecka (Stanford: Stanford University Press, 1979), 136; Andrea Rutherford, "Vissarion Belinskii and the Ukrainian National Question," *The Russian Review* 54 (October 1995): 500–515. Decades later, P. N. Miliukov likewise placed the origins of Russian cultural tradition in the era of Peter the Great. P. N. Miliukov, *Natsional'nyi vopros (Proiskhozhdenie natsional'nosti i natsional'nye voprosy v Rossii)* (Prague: Swobodnaja Rossija, 1925), 124. For a historical discussion of *narodnost'*, see Nathaniel Knight, "Ethnicity, Nationality, and the Masses: *Narodnost'* and Modernity in Imperial Russia," in *Russian Modernity: Politics, Knowledge, Practices*, ed. David L. Hoffman and Yanni Kotsonis (Houndsmills: St. Martin's, 2000), 41–64.

 14. Hans Rogger, *National Consciousness in Eighteenth-Century Russia* (Cambridge: Harvard University Press, 1960), 276–77. For more on Russia's relation to Europe see also *Nationalism: A Report by a Study Group of Members of the Royal Institute of International Affairs* (London: Oxford University Press, 1939), 66, 71.

 15. Sir Lewis Namier, "Nationality and Liberty," in *Vanished Supremacies: Essays on European History, 1812–1918* (New York: Harper Torchbooks, 1963), 31, 38, 50; Szporluk, *Communism and Nationalism*, 152–53, 160. Namier dates the active rise of modern nationalism to the French Revolution (36).

 16. In his evaluation of Russian policies in Poland, Hosking points to the problematic "high cost of trying to Russify a people with a well-developed national identity and sense of culture, religion and citizenship quite different from those of Russia." Hosking, *Russia: People and Empire*, 378. The Polish "wound" disrupted not only the politics of Russification

but Russian Pan-Slavism as well. For more on this see Riasanovsky, *Nicholas I and Official Nationality in Russia,* 153. For more on the Polish Uprising of 1863, see, for instance, Vladimir Debogorii-Mokrievich, *Vospominaniia* (St. Petersburg: "Svobodnyi trud," 1906), 11ff. As Weeks observes, the nationality issue "tended to flare up only in reaction to external events, such as the Polish insurrection of 1863, the Ukrainian pogroms of 1881, or the Kishinev pogrom in 1903." Weeks, 20.

17. M. K. Lemke, *Ocherki po istorii russkoi tsenzury i zhurnalistiki XIX stoletiia* (St. Petersburg: Kn-vo M. V. Pirozhkova, 1904), 134; Kappeler, 156.

18. Suny, "History," 347.

19. Miliukov, 138. Cf. Miliukov's discussion on the widening sphere of cultural communication between the 1860s and 1890s. He positions language as the most sensitive barometer of the new Russian national cultural tradition. Miliukov, *Natsional'nyi vopros,* esp. 149–50. Reflecting this major social change, the term "intelligentsia" came into use early in the 1860s. Edward C. Thaden, *Russia since 1801: The Making of a New Society* (New York: Wiley-Interscience, 1971), 220.

20. N. V. Shelgunov, *Sochineniia,* 2nd ed., vol. 1 (St. Petersburg: Tip. I. N. Skorokhodova, 1895), 484; V. A. Sollogub, *Povesti. Vospominaniia* (Leningrad: "Khudozh. lit-ra," Leningradskoe otd-nie, 1988), 588; Dostoevskii, *PSS,* vol. 10, 32. The censor Nikitenko similarly emphasized that only following the emancipation of serfs did the Russian nation's progress, in slow motion since the time of Peter the Great, acquire a "conscious and definite" character and become a "screaming necessity" (*vopiiushchaia potrebnost'*). A. V. Nikitenko, *Zapiski i dnevnik,* vol. 2 (St. Petersburg: A. S. Suvorin, 1893), 269. See also Edward C. Thaden, *Conservative Nationalism in Nineteenth-Century Russia* (Seattle, University of Washington Press, 1964), 6.

21. Martin E. Malia, *Russia under Western Eyes: From the Bronze Horseman to the Lenin Mausoleum* (Cambridge: The Belknap Press of Harvard University Press, 1999), 170.

22. On different versions of nationalism in Russia see, for instance, Thaden, *Conservative Nationalism,* and Nathaniel Knight, "Ethnicity, Nationality, and the Masses: *Narodnost'* and Modernity in Imperial Russia." For more on the middle, culturally oriented phase B of nation-building during which educated members of society (journalists, teachers, social activists) disseminated the idea of nationalism through the press and the school, see Miroslav Hroch, *Social Preconditions of National Revival in Europe: A Comparative Analysis of the Social Composition of Patriotic Groups among the Smaller European Nations,* trans. Ben Fowkes (New York: Columbia University Press, 2000), 23–24.

23. I adopt here the terms that Brubaker uses in his analysis of national dynamics in post-Soviet Russia. Rogers Brubaker, *Nationalism Reframed: Nationhood and the National Question in the New Europe* (New York: Cambridge University Press, 1996), 48–49.

24. Kristof, 354.

25. "Sankt-Peterburg. 30-go ianvaria 1873," *Golos,* no. 31, 31 January 1873. The article is unsigned; on its attribution to K. N. Bestuzhev-Riumin, the professor of history at St. Petersburg University, see A. M. Razgon, "Rossiiskii Istoricheskii muzei: Istoriia ego osnovaniia i deiatel'nosti (1872–1917 gg.)," in *Ocherki istorii muzeinogo dela v Rossii,* vyp. 2 (Moscow: Sovetskaia Rossiia, 1960), 239n.

26. The classic account of museum history is Germain Bazin, *The Museum Age,* trans. Jane van Nuis Cahill (New York: Universe Books, 1967). More recently, museum studies have attracted the attention of scholars from a variety of disciplines to which the vast current bibliography is a fair testimony. A comprehensive history of Russian museums

remains to be written, although several recent articles, mentioned in endnotes below, indicate an increasing interest in the field among Slavists as well.

27. Brandon Taylor, *Art for the Nation: Exhibitions and the London Public, 1747–2001* (Manchester: Manchester University Press, 1999), 29; Linda Colley, *Britons: Forging the Nation, 1707–1837* (New Haven: Yale University Press, 1992), 174; Bazin, *The Museum Age*, 214, 221–22.

28. Carol Duncan, "Art Museums and the Ritual of Citizenship," in *Exhibiting Cultures: The Poetics and Politics of Museum Display*, ed. Ivan Karp and Steven D. Lavine (Washington: Smithsonian Institution Press, 1991), 88. For more on the symbolic power of the museum, see Chantal Georgel, "The Museum as Metaphor in Nineteenth-Century France," in *Museum Culture: Histories, Discourses, Spectacles,* ed. Daniel J. Sherman and Irit Rogoff (Minneapolis: University of Minnesota Press, 1994), 113.

29. E. P. Karpeev, T. K. Shafranovskaia, *Kunstkamera* (St. Petersburg: OOO "Almaz," 1996), 128.

30. P. Pekarskii, *Nauka i literatura v Rossii pri Petre Velikom* (St. Petersburg: "Obshchestvennaia pol'za," 1862), 57. See also A. M. Panchenko, "*Dva etapa russkogo barokko*," *Tekstologiia i poetika russkoi literatury XI—XVII vekov* (Leningrad: Nauka, 1977), 106.

31. For more on Peter the Great's Kunstkamera, see Anthony Anemone, "The Monsters of Peter the Great: The Culture of the St. Petersburg Kunstkamera in the Eighteenth Century," *The Slavic and East European Journal* 44, no. 4 (Winter 2000), 583–602.

32. S. A. Kasparinskaia, "Muzei Rossii i vliianie gosudarstvennoi politiki na ikh razvitie (XVIII–nach. XX v.)," in *Muzei i vlast': Gosudarstvennaia politika v oblasti muzeinogo dela (XVIII–XX vv.). Sbornik nauchnykh trudov* (Moscow: Nauchno-issledovatel'skii institut kul'tury, 1991), 16. Scholars differ on the exact size of Catherine's collection, with numbers ranging from 2,600 to 4,000 paintings.

33. Johann Gottlieb Georgi, *Opisanie rossiisko-imperatorskogo stolichnogo goroda Sankt-Peterburga i dostopamiatnostei v okrestnostiakh onogo, s planom* (St. Petersburg: Liga, 1996), 343.

34. Kasparinskaia, "Muzei Rossii," 32. "The museum boom" (*muzeinyi bum*) is B. F. Egorov's term; according to him, both the newspaper boom and the museum boom resulted from the social movements of the 1860s. See B. F. Egorov, *Bor'ba esteticheskikh idei v Rossii 1860-kh godov* (Leningrad: Iskusstvo, 1991), 17. In his reminiscences, Boborykin noticed that it was not until the 1860s that the Russian public began frequenting the exhibitions. P. D. Boborykin, *Vospominaniia*, vol. 1 (Moscow: Khudozhestvennaia literatura, 1965), 311.

35. On the history of private and public collections in Russia see Rosalind P. Gray, *Russian Genre Painting in the Nineteenth Century* (Oxford: Oxford University Press, 2000). For private collections, see O. Ya. Neverov, *Great Private Collections of Imperial Russia* (New York: The Vendome Press, 2004).

36. "Peterburgskaia letopis," *Sankt-Peterburgskie vedomosti*, no. 150, 10 July 1860.

37. "Kabinet redkostei v S. Peterburge," *Sankt-Peterburgskie vedomosti*, no. 281, 16 December 1849.

38. Similar calls for more institutions of public culture punctuated the reform-era press. Among many others, in 1863, *The Northern Bee* reported a new initiative by the Ministry of Public Education to make museums more accessible to the public by extending their working hours, abolishing entrance tickets, and introducing clear labels and guidebooks. *Severnaia pchela*, no. 78, 22 March 1863.

39. Kasparinskaia, "Muzei Rossii," 53; E. I. Kirichenko, "Istorizm myshleniia i tip muzeinogo zdaniia v russkoi arkhitekture serediny i vtoroi poloviny XIX v.," in *Vzaimosviaz' iskusstv v khudozhestvennom razvitii Rossii vtoroi poloviny XIX veka: Ideinye printsipy, strukturnye osobennosti* (Moscow: Izd-vo "Nauka," 1982), 119; E. I. Kirichenko, "K voprosu o poreformennykh vystavkakh Rossii kak vyrazhenii istoricheskogo svoeobraziia arkhitektury vtoroi poloviny XIX v.," in *Khudozhestvennye protsessy v russkoi kul'ture vtoroi poloviny XIX veka*, ed. G. Iu. Sternin (Moscow: Izd-vo "Nauka," 1984), 96. It is instructive to compare the museum boom in Russia with an analogous phenomenon in Britain. See Kevin Walsh, *The Representation of the Past: Museums and Heritage in the Post-Modern World* (New York: Routledge, 1992), 31.

40. A. S. Khomiakov, "Pis'ma v Peterburg o vystavke," in *Polnoe sobranie sochinenii Alekseia Stepanovicha Khomiakova*, vol. 3 (Moscow: Univ. tip., 1900): 90. Cf. M. K-ii, "Moskovskii Golitsynskii muzei," *Vestnik Moskovskoi Politekhnicheskoi vystavki*, no. 38, 7 June 1872.

41. Ts-a, "Vnutrennie izvestiia. Sushchestvuiushchie i predpolagaemye muzei v Moskve," *Sankt-Peterburgskie vedomosti*, no. 21, 21 January 1870.

42. On exhibitions in the provinces, see, for instance, S. Povsemestnyi, "Gubernskie vystavki v 1862 godu," *Illiustratsiia*, no. 250, 20 December 1862; also Iu. I. Zvereva, Kh. M. Tur'inskaia, "Iz istorii muzeinogo dela v Rossii (konets XIX–nachalo XX v.), *Vestnik Moskovskogo universiteta*, seriia 8. Istoriia, no. 4 (2007), 40–62. Another reason for such wide publicity was the paucity of daily publications in Moscow; as one contemporary Muscovite opined, there was "almost one" (*pochti odna*) newspaper in the old capital in the mid-1860s. Moskvich, "Raznye izvestiia i zametki. Muzei kniazia S. M. Golitsyna v Moskve," *Sankt-Peterburgskie vedomosti*, no. 135, 20 May 1866.

43. See Joseph Bradley, *Voluntary Associations in Tsarist Russia: Science, Patriotism, and Civil Society* (Cambridge: Harvard University Press, 2009).

44. S. A. Kasparinskaia-Ovsiannikova, "Vystavki izobrazitel'nogo iskusstva v Peterburge i Moskve v poreformennyi period (vtoraia polovina XIX v.)," *Ocherki istorii muzeinogo dela v SSSR*, vyp. 7 (Moscow: Sovetskaia Rossiia, 1971), 368–69; D. A. Ravikovich, "Muzeinye deiateli i kollektsionery v Rossii (XVIII–nach. XX v.)," in *Muzeevedenie: Kontseptual'nye problemy muzeinoi entsiklopedii* (Moscow: Nauchno-issl. in-t kul'tury, 1990), 20–23. In 1846, the Kushelev-Bezborodko collection was the only one open to the public, and only for two hours once a week to persons in proper attire (i.e., no commoners were allowed).

45. The American Association of Museums offers several working definitions on its web site, <www.aam-us.org>; the one standard that diverse museums share is their "unique contribution to the public by collecting, preserving, and interpreting the things of this world."

46. Lewis Mumford, *The Culture of Cities* (San Diego: Harcourt Brace & Company, 1996), 446.

47. Benedict Anderson, *Imagined Communities: Reflections on the Origin and Spread of Nationalism*, rev. ed. (London; Verso, 1991), 163; Ivan Karp, "Culture and Representation," in *Exhibiting Cultures: The Poetics and Politics of Museum Display*, ed. Ivan Karp and Steven D. Lavine (Washington: Smithsonian Institution Press, 1991), 14; Tony Bennett, *The Birth of the Museum: History, Theory, Politics* (New York: Routledge, 1995), 37.

48. Anderson, *Imagined Communities*, 178. See also Homi K. Bhabha, "Beyond the Pale: Art in the Age of Multicultural Translation," in *1993 Biennial Exhibition* (New York: Whitney Museum of American Art, 1993), 63. The subject of "empowerment," with all

ideological repercussions, is beyond the boundaries of this project; for analysis of power dynamics in the museum see Tony Bennett, *The Birth of the Museum: History, Theory, Politics* (New York: Routledge, 1995).

49. Philip Fisher, *Making and Effacing Art: Modern American Art in a Culture of Museums* (New York: Oxford University Press, 1991), 8. The art and identity correlation has been productively explored in several recent studies. See, for instance, *Nationalism and French Visual Culture, 1870–1914*, ed. June Hargrove and Neil McWilliam (Washington: National Gallery of Art, 2005); Richard Thomson, *The Troubled Republic: Visual Culture and Social Debate in France, 1889–1900* (New Haven: Yale University Press, 2004); James J. Sheehan, *Museums in the German Art World from the End of the Old Regime to the Rise of Modernism* (New York: Oxford University Press, 2000); *Imagining Modern German Culture, 1889–1910*, ed. Françoise Forster-Hahn (Washington: National Gallery of Art, 1996); David Crowley, *National Style and Nation-State: Design in Poland from the Vernacular Revival to the International Style* (Manchester: Manchester University Press, 1992); Daniel J. Sherman, *Worthy Monuments: Art Museums and the Politics of Culture in Nineteenth-Century France* (Cambridge: Harvard University Press, 1989); Peter Paret, *Art as History: Episodes in the Culture and Politics of Nineteenth-Century Germany* (Princeton: Princeton University Press, 1988); and John Boulton Smith, *The Golden Age of Finnish Art: Art Nouveau and the National Spirit* (Helsinki: Otava Pub. Co., 1985).

50. "Museums," in *Encyclopedia of Aesthetics*, ed. Michael Kelly, 4 vols. (New York: Oxford University Press, 1998).

51. For a detailed analysis of the connection between art and state, specifically the Louvre, see Carol Duncan and Alan Wallach, "The Universal Survey Museum," *Art History* 3, no. 4 (December 1980): 448–69.

52. Sharon J. Macdonald, "Museums, Nationals, Postnational and Transcultural identitites," *Museums and Society* 1, no. 1 (2003), 1–2.

53. Douglas Crimp, "On the Museum's Ruins," in *The Anti-Aesthetic: Essays on Post-modern Culture*, ed. Hal Foster (Seattle: Bay Press, 1983), 49–50; Jim McGuigan, *Culture and the Public Sphere* (New York: Routledge, 1996), 131; Eugenio Donato, "The Museum's Furnace: Notes toward a Contextual Reading of *Bouvard and Pécuchet*," in *Textual Strategies: Perspectives in Post-Structural Criticism*, ed. Josué V. Harari (Ithaca: Cornell University Press, 1979), 224.

54. Walter Benjamin, "Eduard Fuchs: Collector and Historian," *New German Critique* 5 (Spring 1975): 55–56.

55. Theodor W. Adorno, "Valéry Proust Museum," *Prisms*, trans. Samuel and Shierry Weber (London: Neville Spearman, 1967), 175–78.

56. James Clifford, "Introduction: Partial Truths," in *Writing Culture: The Poetics and Politics of Ethnography*, ed. James Clifford and George E. Marcus (Berkeley: University of California Press, 1986), 4–7.

57. James Clifford, "On Collecting Art and Culture," *The Predicament of Culture: Twentieth-Century Ethnography, Literature, and Art* (Cambridge: Harvard University Press, 1988), 220. Pitkin defines the term as follows: "representation, taken generally, means the making present *in some sense* of something which is nevertheless *not* present literally or in fact." Hanna Fenichel Pitkin, *The Concept of Representation* (Berkeley: University of California Press, 1967), 8–9.

58. Clifford, "Introduction: Partial Truths," 26.

59. Stuart Hall, "Introduction: Who Needs 'Identity'?" in *Questions of Cultural Iden-*

tity, ed. Stuart Hall and Paul du Gay (London: SAGE Publications, 1996), 4.

60. George Brown Goode, "The Museums of the Future" (1889), as cited in Barbara Kirshenblatt-Gimblett, "Objects of Ethnography," in *Exhibiting Cultures: The Poetics and Politics of Museum Display*, ed. Ivan Karp and Steven D. Lavine (Washington: Smithsonian Institution Press, 1991), 395. G. B. Goode was director of the U. S. National Museum.

61. Mieke Bal, "The Discourse of the Museum," in *Thinking about Exhibitions*, ed. Reesa Greenberg, Bruce W. Ferguson, and Sandy Nairne (New York: Routledge, 1996), 214. Along similar lines, Crane observes that prior to the nineteenth-century museum age, the concept "museum" "denoted equally a study space, a space of discussion, and a space of display." Susan A. Crane, *Collecting and Historical Consciousness in Early Nineteenth-Century Germany* (Ithaca: Cornell University Press, 2000), 107.

62. In contrast to Brooks, von Geldern, and McReynolds, I am not addressing mass culture and popular entertainment. In my usage, which is consistent with the nineteenth-century practice, "public" always implies the literate public. For an excellent treatment of popular culture and the popular press, see Jeffrey Brooks, *When Russia Learned to Read: Literacy and Popular Literature, 1861–1917* (Princeton: Princeton University Press, 1985) and *Entertaining Tsarist Russia: Tales, Songs, Plays, Movies, Jokes, Ads, and Images from Russian Urban Life, 1779–1917*, ed. James von Geldern and Louise McReynolds (Bloomington: Indiana University Press, 1998).

63. Duncan and Wallach, 456–57.

64. "Neskol'ko slov o vystavke 1861 goda," *Russkii invalid*, no. 192, 3 September 1861.

65. "Vazhnost' i pol'za vystavok," *Syn otechestva*, no. 158, 3 July 1862.

66. Govorun, "Peterburgskaia letopis," *Svetoch* 6 (1861): 50.

67. One of the earliest systematic scholarly interpretations of folklore was V. F. Miller's *Ocherki russkoi narodnoi slovesnosti* (Moscow: T-vo I. D. Sytina, 1897–1924). Cf. V. V. Stasov, "Proiskhozhdenie russkikh bylin," *Sobranie sochinenii V. V. Stasova, 1847–1886*, vol. 3 (St. Petersburg: Tipografiia M. M. Stasiulevicha, 1894), 948–1260, originally published in *Vestnik Evropy*, no. 1–4, 6, 7 (1868).

68. As one example among many, see P. V. Shein, *Velikoruss v svoikh pesniakh, obriadakh, obychaiakh, verovaniiakh, skazkakh, legendakh i t. p.* (St. Petersburg: Izd. Imp. Akademii nauk, 1898-). For more on Russian folklore, see, for instance, Y. M. Sokolov, *Russian Folklore*, trans. Catherine Ruth Smith (Hatboro: Folklore Associates, 1966); *The Study of Russian Folklore*, ed. and transl. Felix J. Oinas and Stephen Soudakoff (The Hague: Mouton, 1975); Felix J. Oinas, *Essays on Russian Folklore and Mythology* (Columbus: Slavica Publishers, Inc., 1984).

69. Prominent examples of this new national trend include Balakirev's *Second Overture on Russian Themes* (1864); Mussorgsky's *Boris Godunov* (1868–1869), *Pictures at an Exhibition* (1874), and *Khovanshchina* (1872–1880); Rimsky-Korsakov's *Snow Maiden* (1882), *The Tsar's Bride* (1898), and *Sadko* (1898); and Borodin's *Prince Igor* (1890). For more examples and further details, see, for instance, The New Grove's *Russian Masters 1* and *Russian Masters 2* (New York: W. W. Norton & Company, 1980). In 1884, Balakirev's *Second Overture on Russian Themes* was renamed *Rus'*, a concept central to Slavophile thought. Along with the title, the message of this musical composition changed as well, the final version being, in the words of the composer himself, the representation of "how Peter the Great killed our native Russian life." Francis Maes, *A History of Russian Music: From Kamarinskaya to Babi Yar*, trans. Arnold J. Pomerans and Erica Pomerans (Berkeley:

University of California Press, 2002), 7.

70. For a sample of contemporary critical discourse on Russian music, see Stuart Campbell, *Russians on Russian Music, 1880–1917: An Anthology* (New York: Cambridge University Press, 2003). Many more reviews appeared in daily newspapers.

71. See V. Serova, "Russkaia muzyka," *Severnyi vestnik* 4, part II (December 1885), 1.

72. Bibliography on the history of Russian music is considerable. See, for instance, Caryl Emerson, *Boris Godunov: Transpositions of a Russian Theme* (Bloomington: Indiana University Press, 1986); Richard Taruskin, *Defining Russia Musically: Historical and Hermeneutical Essays* (Princeton: Princeton University Press, 1997); Marina Frolova-Walker, *Russian Music and Nationalism: From Glinka to Stalin* (New Haven: Yale University Press, 2007); Richard Taruskin, *On Russian Music* (Berkeley: University of California Press, 2009). In several of his studies, Taruskin usefully illuminates the connection between music and criticism. See also his *Opera and Drama in Russia as Preached and Practiced in the 1860s* (Ann Arbor: UMI Research Press, 1981). For more on musical nationalism, see Maes, 2–3. Maes demonstrates that musical nationalism was grounded in a specific ideological context. It also displayed a proclivity for myth-making, as illustrated by Natasha Rostova's impromptu folk dance in *War and Peace* and the unadulterated Russianness of the Mighty Five circle of composers. The introductory chapter, called "Natasha's Dance, or Musical Nationalism," opens with the same famous scene from Tolstoy's *War and Peace* that furnished the title for Figes's recent study. Both critics go on to demonstrate that Tolstoy "has conjured up something highly improbable" in that scene, for the sentiment that "folk music springs straight from nature and that Russian music 'can be breathed in with the Russian air' is a nineteenth-century idea."

73. I. A. Goncharov, *Sobranie sochinenii v 8-mi tomakh*, vol. 8 (Moscow, 1955), 491–92, as cited in *Russkaia drama epokhi A. N. Ostrovskogo*, ed. A. I. Zhuravleva (Moscow: Izd-vo Moskovskogo univ-ta, 1984), 6.

74. A. N. Ostrovskii, *Polnoe sobranie sochinenii*, vol. 10 (Moscow: "Iskusstvo," 1978), 137–38, as cited in *Russkaia drama epokhi A. N. Ostrovskogo*, 9–10.

75. Several recent studies on theater in particular highlighted the importance of popular forms of culture in imperial Russia. Catriona Kelly, *Petrushka: The Russian Carnival Puppet Theater* (Cambridge: Cambridge University Press, 1990); E. Anthony Swift, *Popular Theater and Society in Tsarist Russia* (Berkeley: University of California Press, 2002); Gary Thurston, *The Popular Theater Movement in Russia, 1862–1919* (Evanston: Northwestern University Press, 1998).

76. Jeffrey Brooks, "Russian Nationalism and Russian Literature: The Canonization of the Classics," in *Nation and Ideology: Essays in Honor of Wayne S. Vucinich*, ed. Ivo Banac et al. (New York: Columbia University Press, 1981), 316. All these expressions of Russian cultural nationalism were sufficiently persuasive to outlast the political nationalism of the old regime and endure well into the Soviet era.

77. Shervud, much praised for the Russianness of his design, aspired to accomplish in architecture what the composer Glinka had done in Russian music, as he admitted in private correspondence with the historian Zabelin. V. G. Lisovskii, *"Natsional'nyi stil'" v arkhitekture Rossii* (Moscow: Sovpadenie, 2000), 140–42.

78. Cf. James Buzard, "Culture for Export: Tourism and Autoethnography in Postwar Britain," in *Being Elsewhere: Tourism, Consumer Culture, and Identity in Modern Europe and North America*, ed. Shelley Baranowski and Ellen Furlough (Ann Arbor: University of Michigan Press, 2001), 299–319.

79. Aleksandr Benua, "Iskusstvo," in *Rossiia v kontse XIX veka*, ed. V. I. Kovalevskii

(St. Petersburg: Tipografiia Akts. Obshch. Brokgauz-Effron, 1900), 889. For the original edition in French, see *La Russie à la fin du 19e siècle*, ed. V. I. Kovalevskii (Paris: P. Dupont, 1900). Cf. N. Shtrup, "Muzyka," in *Rossiia v kontse XIX veka*, 882. The national trend in music, according to Shtrup, first manifested itself in the works of Glinka, the founder of the Russian school, and was followed by the "mighty five" group of composers, "Glinka's disciples and fighters for the national character of our music." Another edition, representing the nineteenth century as the age of national culture in Russia, appeared in 1901. A popular compilation aimed at a general readership, *XIX vek: Illiustrirovannyi obzor minuvshego stoletiia*, was published as a supplement to the "thin" journal *Niva* and included four major essays by Stasov devoted to architecture, sculpture, painting, and music. Stasov used this publication in the illustrated weekly as an opportunity to popularize the fine arts in general and to highlight the national distinction of the Russian arts in particular.

80. The constantly changing rubrics in contemporary indexes offer tangible evidence of culture's volatile state. For instance, in V. O. Mikhnevich's index, *Piatnadtsatiletie gazety Golos, 1863–1877*, there is no category "culture" per se, and a modest number of cultural offerings is intermixed with obituaries and miscellany under the broader rubric "Public life and literature." By contrast, the index to the journal *Istoricheskii vestnik* (*Historical News*) that came out 30 years later listed hundreds of entries on museums, archives, libraries, and monuments, next to the traditional leader in the category of culture, Russian literature. V. O. Mikhnevich, *Piatnadtsatiletie gazety "Golos,"* (St. Petersburg: A. A. Kraevskii, 1878); B. M. Gorodetskii, *Sistematicheskii ukazatel' soderzhaniia "Istoricheskogo vestnika" za 25 let (za 1880–1904 gg.)* (St. Petersburg, 1908). Cf. V. I. Mezhov, *Russkaia istoricheskaia bibliografiia za 1865–1876 vkliuchitel'no*, 8 vols. (St. Petersburg: Tip. Imp. akademii nauk, 1882–1890). In Mezhov's bibliography, literature, theater, and the arts belong to separate sections. If there was one rubric under which various forms of cultural expression could be found assembled together, it was "Public life and literature" (Obshchestvennaia zhizn' i literatura).

81. William Mills Todd III, *Fiction and Society in the Age of Pushkin: Ideology, Institutions, and Narrative* (Cambridge: Harvard University Press, 1986).

82. There were 79 Russian-language titles in 1870. Brooks, *When Russia Learned to Read*, 112. There is a surprising diversity in the data provided by different researchers. The ambiguity of the term "gazeta" in its early use might be one reason for the confusion; another, as William Mills Todd suggests, stems from the fact that not all researchers count newspapers that had a very brief life span. Cf., for instance, V. G. Berezina, "Gazety 1860-kh godov," in *Ocherki po istorii russkoi zhurnalistiki i kritiki*, vol. 2 (Leningrad: Izd-vo LGU, 1965), 31; B. I. Esin, *Russkaia dorevoliutsionnaia gazeta, 1702–1917 gg.: Kratkii ocherk* (Moscow: Izdat. Moskovskogo un-ta, 1971), 28; N. M. Lisovskii, *Periodicheskaia pechat' v Rossii, 1703–1903: Statistiko-bibliograficheskii obzor russkoi periodicheskoi pechati* (St. Petersburg: A. E. Vineke, 1903), 22; Effie Ambler, *Russian Journalism and Politics, 1861–1881: The Career of Aleksei S. Suvorin* (Detroit: Wayne State University Press, 1972), 34.

83. Berezina, 30–31.

84. Lemke, 18. *Obshchestvennost'*, alternately translated as civic-mindedness, public opinion, or educated public, refers to socially-active, civic-minded people in society. At midcentury, *obshchestvennost'* must have still been a fairly novel phenomenon: the word is not recorded either in the *Dictionary of Pushkin's Language* (*Slovar' iazyka Pushkina*) or in Dal's (*Tolkovyi slovar' zhivogo velikorusskogo iazyka*). According to Kelly and Volkov, although the word was coined at end of the eighteenth century, it

"disappeared" from language until the 1840s and 1850s, when it was revived by radicals (Belinsky, Herzen) to connote social solidarity. See Catriona Kelly and Vadim Volkov, "*Obshchestvennost', Sobornost'*: Collective Identities," in *Constructing Russian Culture in the Age of Revolution: 1881–1940*, ed. Catriona Kelly and David Shepherd (New York: Oxford University Press, 1998), 26–27. For more on thick journals, see *Literary Journals in Imperial Russia*, ed. Deborah A. Martinsen (New York: Cambridge University Press, 1997).

85. Berezina, 31–32. Cf. the explosion of the daily press in Britain after the tax on newspapers was repealed in 1855. For instance, the circulation of three popular papers, the *Family Herald*, the *London Journal*, and *Cassell's Family Paper*, totaled 895,000 in 1858. Circulation figures for Russian newspapers during the same period are much more modest in comparison, with *The Voice* reaching the highest mark of 10,000 in the 1860s. In the late 1850s, as some of the British periodicals were selling in the thousands, Alexandre Dumas, for instance, thought that Russian journalism was still in its infancy. Richard D. Altick, *The English Common Reader: A Social History of the Mass Reading Public, 1800–1900*, 2nd ed. (Columbus: Ohio State University Press, 1998), 348–64, esp. 357. Cf. "Circulation of St. Petersburg Newspapers," table 6, in Louise McReynolds, *The News under Russia's Old Regime: The Development of a Mass-Circulation Press* (Princeton: Princeton University Press, 1991); Aleksandr Diuma (otets), "Vpechatleniia ot poezdki v Rossiiu," in D. V. Grigorovich, *Literaturnye vospominaniia; s prilozheniem polnogo teksta vospominanii P. M. Kovalevskogo* (Leningrad: "Academia," 1928), 472.

86. In 1895, N. A. Rubakin argued that the readership was a mirror image of Russian social life. Rubakin prioritized the role of the reader in the literary process long before reader-response criticism appeared. N. A. Rubakin, *Etiudy o russkoi chitaiushchei publike: Fakty, tsifry i nabliudeniia* (St. Petersburg, 1895), esp. 1.

87. "Tipy sovremennykh gazet I. 'Novoe Vremia,'" *Slovo*, no. 8 (August 1879): 230.

88. N. V. Shelgunov, *Vospominaniia*, vol. 1 (Moscow: "Khudozhestvennaia literatura," 1967), 92. Freedom—in every meaning of the word—encapsulated the spirit of the 1860s, Shelgunov believed. He also pointed out the unique "humanism" (*gumannost'*) of the era, which, among other noteworthy phenomena, saw a fivefold increase in the student body at St. Petersburg University (see esp. 131–35). For more on his evaluation of newspapers in particular, see N. V. Shelgunov, *Ocherki russkoi zhizni* (St. Petersburg: Izd. O. N. Popovoi, 1895), 534–38. Boborykin also described the mid-1850s as a thaw on the eve of the resurrection of public life and culture in Russia. Boborykin, 133.

89. As cited in Lemke, 17–18.

90. As Todd notes, no comprehensive statistics on literacy were compiled prior to the 1897 census; based on available evidence, an estimated 95 percent of Russians were illiterate in the first half of the nineteenth century. See Todd, *Fiction and Society in the Age of Pushkin*, 20, 100.

91. Anderson, *Imagined Communities*, 25.

92. "Listok," *Syn Otechestva*, no. 1, 1 January 1862. Boborykin recalls that the period between 1860 and 1863 was especially very bright and lively. Boborykin, 400.

93. For literacy rates in St. Petersburg and Moscow in the 1860s see Hosking, *Russia: People and Empire*, 333. Jeffrey Brooks estimates literacy in rural areas at 6 percent in the 1860s. According to the first census of the Russian empire, conducted in 1897, around 21 percent of the population was literate. Brooks, *When Russia Learned to Read*, 4. The difference between the capital cities and the provinces was striking. Uspensky, for instance,

described the time he spent in the village as life "without newspapers." See Gleb Uspenskii, *Iz derevenskogo dnevnika, Polnoe sobranie sochinenii*, vol. 4 (St. Petersburg: A. F. Marks, 1908), 46–47.

94. The Russian word *publika* (meaning the public or educated society) and its derivatives first appeared in the Russian language in the first quarter of the eighteenth century. Douglas Smith, *Working the Rough Stone: Freemasonry and Society in Eighteenth-Century Russia* (DeKalb: Northern Illinois University Press, 1999), 54–55.

95. Lisovskii, *Periodicheskaia pechat' v Rossii*, 3–13, 21; *Russkaia periodicheskaia pechat' (1702–1894): Spravochnik*, ed. A. G. Dement'ev, A. V. Zapadov, and M. S. Cherepakhov (Moscow: Gos. izd-vo polit. lit-ry, 1959), 14, 131.

96. McReynolds, 9.

97. Another argued that only a daily paper could possibly be of benefit to modern Russia when the weekly *Son of the Fatherland* metamorphosed into a daily edition in 1862. K. R'ianov, "Fel'eton. Ideal peterburgskoi gazety," *Russkii invalid*, no. 190, 1 September 1861; "Listok," *Syn Otechestva*, no. 1, 1 January 1862.

98. Esin, *Russkaia dorevoliutsionnaia gazeta*, 21–35; McReynolds, 47–48.

99. L. A. Plotkin, "Obshchestvennoe i literaturnoe dvizhenie 1860-kh godov. Tsenzurnaia politika pravitel'stva," in *Ocherki po istorii russkoi zhurnalistiki i kritiki*, vol. 2 (Leningrad: Izd-vo Leningradskogo gos. universiteta, 1965), 13–14.

100. Ambler, 27.

101. Esin, *Russkaia dorevoliutsionnaia gazeta*, 34. Annual subscription had been the conventional way of distributing the periodical press.

102. McReynolds, 24.

103. Ambler, 22. On Bulgarin's peculiar mode of advertising, such as placing recommendations for certain wares within *The Northern Bee*'s feuilletons, see *Istoriia russkoi zhurnalistiki XVIII–XIX vekov*, ed. A. V. Zapadov, et al. (Moscow: Vysshaia shkola, 1973), 159. In his fictional story "The Portrait," Gogol has the newspaper owner (Bulgarin, presumably) place a similar advertisement for the artist Chartkov.

104. On circulation data, see McReynolds, 20.

105. Lisovskii, *Periodicheskaia pechat' v Rossii*, 16.

106. Esin, *Russkaia dorevoliutsionnaia gazeta*, 19–22.

107. Ambler defines the period from 1870 to 1914 in Europe as "the golden age of the newspaper press." Ambler, 27. McReynolds summarizes the effect that the war had on Russian journalism: "The Russo-Turkish War had the dubious benefit of making it possible for Russian journalism to catch up with Western journalism." McReynolds, 87.

108. Lisovskii, *Periodicheskaia pechat' v Rossii*, 28. During the war with Turkey in 1877, the daily practice of writing and reading the news amounted to no less than "a revolution in newspaper reading," as James von Geldern and Louise McReynolds qualify it. *Entertaining Tsarist Russia*, 117. As the century drew to a close, workers increasingly became regular readers of popular newspapers as well. See, for instance, "S. I. Kanatchikov Recounts His Adventures as a Peasant-Worker-Activist, 1879–1896," in *Major Problems in the History of Imperial Russia*, ed. James Cracraft (Lexington: D. C. Heath and Company, 1994), 536.

109. Esin, *Russkaia dorevoliutsionnaia gazeta*, 26–32.

110. K. R'ianov, "Fel'eton. Ideal peterburgskoi gazety," *Russkii invalid*, no. 190, 1 September 1861.

111. D. N., "Peterburgskie ezhednevnye gazety," *Peterburgskii listok*, no. 27, 23

February 1865. For a more ironic take on the daily press, see, for instance, "Vnutrennee obozrenie," *Sovremennik* 98 (1863): 359–78.

112. McReynolds, 7.

113. Berezina, 54–59.

114. F. Bulgakov, "Literaturnye zametki. O chtenii," *Novoe vremia*, no. 8909, 14 December 1900.

115. Richard Wortman, *Scenarios of Power: Myth and Ceremony in Russian Monarchy*, vol. 2 (Princeton: Princeton University Press, 2000), 134–35.

116. Weeks, 21.

117. D. N., "Peterburgskie ezhednevnye gazety," *Peterburgskii listok*, no. 27, 23 February 1865.

118. S., "Tipy sovremennykh gazet. II. Golos," *Slovo*, no. 9 (September 1879): 168. On the ambiguity of "public opinion" in the Russian context see, for instance, Marcus C. Levitt, *Russian Literary Politics and the Pushkin Celebration of 1880* (Ithaca: Cornell University Press, 1989), 12.

119. Berezina, 47.

120. Mikhnevich, *Piatnadtsatiletie gazety "Golos,"* i–ii.

121. Esin, *Russkaia dorevoliutsionnaia gazeta*, 39.

122. "Commercial soul" is Turgenev's expression, as cited in McReynolds, 33. F. M. Dostoevskii, "Kalambury v zhizni i v literature," *PSS*, vol. 20, 137; originally published in Dostoevsky's journal *Epoch* in 1864. See also Dostoevsky's parody of Kraevsky in the epilogue to *Unizhennye i oskorblennye*.

123. For more on the "invisible" Russian middle class, see Alfred J. Rieber, "The Fragmented 'Middle Ranks,'" in *Major Problems in the History of Imperial Russia*, 494–504; McReynolds, 6–7. See also M. I. Pyliaev, *Staryi Peterburg* (Moscow: SP "IKPA," 1990), 228; Gleb Uspenskii, "Burzhui," *Polnoe sobranie sochinenii*, vol. 5, 569–89.

124. In 1826, Bulgarin reasoned that the middle estate (*srednee sostoianie*) was the most numerous among the Russian readership; it comprised the so-called Russian public proper (i.e., the public that read for the most part in Russian). N. D., "K istorii russkoi literatury. F. V. Bulgarin i N. I. Grech (Kak izdateli zhurnalov)," *Russkaia starina* 9 (September 1900): 581. In "Nevsky Prospect," Gogol provides ironic commentary on *The Northern Bee's* commercialism and its middling readership. See also Stephen Moeller-Sally, "0000; or, The Sign of the Subject in Gogol's Petersburg," in *Russian Subjects: Empire, Nation, and the Culture of the Golden Age*, ed. Monika Greenleaf and Stephen Moeller-Sally (Evanston: Northwestern University Press, 1998), 325–46.

125. S., "Tipy sovremennykh gazet. II. Golos," *Slovo*, no. 9 (September 1879): 182.

126. "Listok," *Syn Otechestva*, no. 1, 1 January 1862. According to Berezina, in 1862, *Syn Otechestva* had a circulation of 20,000, out of which 13,000 were sold in the provinces. See Berezina, 48.

127. K. R'ianov, "Fel'eton. Ideal peterburgskoi gazety," *Russkii invalid*, no. 190, 1 September 1861.

128. As cited in Esin, *Russkaia dorevoliutsionnaia gazeta*, 29.

129. "Introduction," in *Entertaining Tsarist Russia*, xviii.

130. For more on newspapers for the people, see Berezina, 40. For more on stylization, see B. I. Esin, *Istoriia russkoi zhurnalistiki XIX v.* (Moscow: "Vysshaia shkola," 1989), 117. On literature for the people in general, see Brooks, *When Russia Learned to Read*.

131. A. A. Kraevskii, "Novaia gazeta na 1863 god. Golos, gazeta ezhednevnaia,

politicheskaia i literaturnaia, izdavaemaia A. A. Kraevskim," *Sankt-Peterburgskie vedomosti*, no. 177, 15 August 1862; McReynolds, 30–31. The early-nineteenth-century British periodical press presents an interesting comparison as far as techniques of audience-making go. Jon P. Klancher writes: "Periodical texts and their myriad writers give us a new way to see how 'making audiences' meant evolving readers' interpretive frameworks and shaping their ideological awareness." Jon P. Klancher, *The Making of English Reading Audiences, 1790–1832* (Madison: The University of Wisconsin Press, 1987), 4. I am grateful to Anne Lounsbery for bringing this source to my attention.

132. S., "Tipy sovremennykh gazet. II. Golos," *Slovo*, no. 9 (September 1879): 169–71.

133. S., "Tipy sovremennykh gazet. III. Moskovskie vedomosti," *Slovo*, no. 10 (October 1879): 200. According to this series of sketches in *Slovo*, there were only three newspapers in the 1870s expressive of the public opinion: *The New Times, The Voice,* and *Moscow News*.

134. As Habermas defines it, the public sphere is "a sphere which mediates between society and state, in which the public organizes itself as the bearer of public opinion." Habermas's model is built specifically upon the dominant bourgeois public sphere, which emerged in early capitalism. Jürgen Habermas, "The Public Sphere: An Encyclopedia Article," trans. Sara Lennox and Frank Lennox, *New German Critique* 5 (Fall 1974): 50. Cf. Geoff Eley's argument that "nineteenth-century Russia provides an excellent counterexample for the growth of the public sphere." Geoff Eley, "Nations, Publics, and Political Cultures: Placing Habermas in the Nineteenth Century," in *Culture/Power/History: A Reader in Contemporary Social Theory*, ed. Nicholas B. Dirks, Geoff Eley, and Sherry B. Ortner (Princeton: Princeton University Press, 1994), 323.

135. Lincoln, *The Great Reforms*, 40.

136. Kraevskii, "Novaia gazeta na 1863 god."

137. McReynolds, 38–39.

138. V. Korsh, "S.-Peterburgskie vedomosti s 1863 goda," *Sankt-Peterburgskie vedomosti*, no. 200, 14 September 1862.

139. "Russkaia literatura polozhila u nas osnovanie publichnosti i obshchestvennogo mneniia." V. G. Belinskii, "Obshchee znachenie slova literatura," *Polnoe sobranie sochinenii*, vol. 5 (Moscow: Izd-vo Akademii nauk SSSR, 1954), 653.

140. Kraevskii, "Novaia gazeta na 1863 god."

141. "Listok," *Syn Otechestva*, no. 1, 1 January 1862.

142. Esin, *Russkaia dorevoliutsionnaia gazeta*, 31.

143. Todd, *Fiction and Society*, 99–103.

144. K. Aksakov, "Publika—narod," as cited in *Istoriia russkoi zhurnalistiki XVIII–XIX vekov*, 321–22. First published in the newspaper *Molva* (no. 36, 1857). The newspaper *The Voice* also discussed the distinction between the public and narod; see "Vsednevnaia zhizn'," *Golos*, no. 211, 2 August 1864.

145. Vladimir Dal', *Tolkovyi slovar' zhivogo velikorusskogo iazyka*, 3rd ed., vol. 3 (St. Petersburg: Izdanie t-va M. O. Vol'f, 1907), 1403.

146. On the centrality of cultural publics in the process of nation-building, see Eley and Suny, 23.

147. Jürgen Habermas, *The Structural Transformation of the Public Sphere: An Inquiry into a Category of Bourgeois Society*, trans. Thomas Burger with Frederick Lawrence (Cambridge: The MIT Press, 1989), 182, 244.

148. N. D., "K istorii russkoi literatury. F. V. Bulgarin i N. I. Grech (Kak izdateli

zhurnalov)," 579–81.

149. N. Ia. Danilevskii, *Rossiia i Evropa: Vzgliad na kul'turnye i politicheskie otnosheniia slavianskogo mira k germano-romanskomu*, 6th ed. (St. Petersburg: Izd-vo "Glagol," 1995), 239–40.

150. S., "Tipy sovremennykh gazet. II. Golos," *Slovo*, no. 9 (September 1879): 168. It is interesting that this commentator chose a male government clerk to personify public opinion. Earlier in the century, the publisher of the popular journal *Library for Reading* O. I. Senkovsky compared Russian society's taste to "the whim of the pregnant woman." Cited in Todd, *Fiction and Society*, 98.

151. For more on the formation of different reading audiences, see McReynolds, 26; Berezina, 38–39.

152. "Listok," *Syn Otechestva*, no. 1, 1 January 1862.

153. Staryi Dzhon, "Ob iskusstve," *Novoe vremia*, no. 8619, 26 March 1900. Cf. Michael Warner, "The Mass Public and the Mass Subject," *The Phantom Public Sphere*, ed. Bruce Robbins (Minneapolis: University of Minnesota Press, 1993), 238. See also Thomas E. Crow, *Painters and Public Life in Eighteenth-Century Paris* (New Haven: Yale University Press, 1985).

154. A. V. Druzhinin, *Pis'ma inogorodnego podpischika, Sobranie sochinenii A. V. Druzhinina*, ed. N. V. Gerbelia, vol. 6 (St. Petersburg: Tip. Imp. Akademii nauk, 1865–67), 223–25.

155. K. P., "Zametki," *Sankt-Peterburgskie vedomosti*, no. 230, 1848. Quoted in E. I. Zhurbina, *Povest' s dvumia siuzhetami: O publitsisticheskoi proze*, 2nd ed. (Moscow: Sov. pisatel', 1979), 91–92. All feuilletonists mentioned in this chapter were men, thus the consistent application of the pronoun "he." Of course, in the Russian originals the authors referred to the feuilletonist as "he" as well. Among the few women who wrote for newspapers at the time was Evgenia Tur, the author of Parisian reviews in the *Voice*.

156. *Otechestvennye Zapiski* 26 (1843): 41. Quoted in E. I. Zhurbina, *Teoriia i praktika khudozhestvenno-publitsisticheskikh zhanrov* (Moscow: "Mysl'," 1969), 252. Cf. a peculiar literary project in which Lisa engaged in Dostoevsky's *Demons*: in one volume, she intends to gather precisely the kind of ephemeral "facts" that belonged to newspaper feuilletons (fires, benefits, curiosities, etc.). See F. Dostoevsky, *Demons*, trans. Richard Pevear and Larissa Volokhonsky (New York: Vintage Books, 1994), part I, chapter 4 (II).

157. B. Tomashevskii, "U istokov fel'etona," in *Fel'eton: Sbornik statei*, ed. Iu. N. Tynianov and B. V. Kazanskii (Leningrad: Academia, 1927), 59.

158. Iu. G. Oksman, "Ot redaktora," in *Fel'etony sorokovykh godov: Zhurnal'naia i gazetnaia proza I. A. Goncharova, F. M. Dostoevskogo, I. S. Turgeneva* (Moscow: Academia, 1930), 5–6.

159. Zhurbina, *Teoriia i praktika khudozhestvenno-publitsisticheskikh zhanrov*, 219–20.

160. H. J. Hunt, *Le Socialisme et le romantisme en France: Etude de la presse socialiste de 1830 à 1848*, as cited in Walter Benjamin, *The Arcades Project*, trans. Howard Eiland and Kevin McLaughlin (Cambridge: Belknap Press of Harvard University Press, 1999), 777. The Russian provincial press took the unprincipled character of the feuilleton to the next level of banality. See, for instance, N. V. Shelgunov, *Ocherki russkoi zhizni* (St. Petersburg: Izd. O. N. Popovoi, 1895), 536–38.

161. Walter Benjamin, "Paris, Capital of the Nineteenth Century," *Reflections: Essays, Aphorisms, Autobiographical Writings*, ed. Peter Demetz, trans. Edmund Jephcott (New

York: Schocken Books, 1986), 161.

162. "S.-Peterburgskie vedomosti s 1863 goda," *Sankt-Peterburgskie vedomosti*, no. 200, 14 September 1862.

163. As Viktor Shklovsky pointed out, the notion "feuilleton" implies both the "little feuilleton," the size of an article, and the large novel-feuilleton. Shklovskii, *Gamburgskii schet* (Leningrad: Izd-vo pisatelei v Leningrade, 1928), 63. For more on different national varieties of the feuilleton, see Karen L. Ryan-Hayes, *Russian Publicistic Satire Under Glasnost: The Journalistic Feuilleton* (Lewiston: The Edwin Mellen Press, 1993), 1–3. On the serialized novel-feuilleton, as practiced both in France and Russia in the nineteenth century (Eugene Sue, Dostoevsky), see, for instance, G. M. Fridlender, *Realizm Dostoevskogo* (Moscow: "Nauka," 1964), 126ff. For more on the nineteenth-century feuilleton in particular, see Melissa Frazier "Turgenev and a Proliferating French Press: The Feuilleton and Feuilletonistic in *A Nest of the Gentry*," *Slavic Review* 69, no. 4 (Winter 2010): 925–43; Konstantine Klioutchkine, "The Rise of *Crime and Punishment* from the Air of the Media," *Slavic Review* 61, no. 1 (Spring 2002): 405–22.

164. Il'ia Gruzdev, "Tekhnika gazetnogo fel'etona," in *Fel'eton: Sbornik statei*, 13.

165. Joseph Frank, *Dostoevsky: The Seeds of Revolt, 1821–1849* (Princeton: Princeton University Press, 1976), 226.

166. V. O. Mikhnevich, *Piatnadtsatiletie gazety "Golos."*

167. Donald Fanger, *Dostoevsky and Romantic Realism: A Study of Dostoevsky in Relation to Balzac, Dickens, and Gogol* (Cambridge: Harvard University Press, 1965), 136.

168. There are a number of important studies by Russian Formalists and Soviet critics that address this subject. See, for instance, *Fel'eton: Sbornik statei*; Shklovskii, *Gamburgskii schet*; *Fel'etony sorokovykh godov*; *Russkii fel'eton. V pomoshch' rabotnikam pechati*, ed. A. V. Zapadov (Moscow: Gos. izd-vo polit. lit-ry, 1958); and two monographs by Zhurbina, *Teoriia i praktika khudozhestvenno-publitsisticheskikh zhanrov* and *Povest' s dvumia siuzhetami: O publitsisticheskoi proze.*

169. Zhurbina, *Povest' s dvumia siuzhetami*, 104–8, 96. See also A. I. Stan'ko, "Satiricheskaia bibliograficheskaia zametka i fel'eton v literaturnykh gazetakh 1830–1840-kh godov," in *Russkaia zhurnalistika XVIII–XIX vv. (iz istorii zhanrov)* (Leningrad: Izd-vo Leningradskogo universiteta, 1969), 25–41.

170. Iu. Tynianov and B. Kazanskii, "Ot redaktsii," in *Fel'eton: Sbornik statei*, 7; Vladimir B. Shklovskii, "Fel'eton i esse," in *Fel'eton: Sbornik statei*, 78.

171. B. Tomashevskii, "U istokov fel'etona," in *Fel'eton: Sbornik statei*, 70.

172. Zhurbina, *Povest' s dvumia siuzhetami*, 91, 100; Berezina, 56. Dostoevsky's "Petersburg Chronicle" was printed in *The St. Petersburg News* in 1847 in four installments. For more on Dostoevsky's feuilletons see Fanger, *Dostoevsky and Romantic Realism*, 134–51; Frank, 217–38; Gary Saul Morson, *The Boundaries of Genre: Dostoevsky's Diary of a Writer and the Traditions of Literary Utopia* (Austin: University of Texas Press, 1981), 17–22.

173. F. M. Dostoevskii, *PSS*, vol. 19, 68.

174. V. G. Belinsky described the feuilletonist as a stylized persona, "a chatterer, apparently good-natured and sincere, but in truth often malicious and evil-tongued, someone who knows everything, sees everything, keeps quiet about a good deal but definitely manages to express everything, stings with epigrams and insinuations, and amuses with a lively and clever word as well as a childish joke." Quoted in Frank, 219. On the role of the feuilletonist as a social critic, see McReynolds, 66–67.

175. In 1868, Boborykin wrote biweekly feuilletons, "From an Italian Boulevard" (*S*

Ital'ianskogo bul'vara) for Korsh's *St. Petersburg News*. Boborykin, 398, 445.

176. Storonnii, "Zametki o khudozhestve," *Novoe vremia*, no. 8865, 31 October 1900.

177. Morson, 16. See also Fanger, *Dostoevsky and Romantic Realism*, 135–36; Frank, 219.

178. McReynolds, 66.

179. A. V. Druzhinin, "Dramaticheskii fel'eton o fel'etone i o fel'etonistakh," in *Russkii fel'eton. V pomoshch' rabotnikam pechati*, 122–28. First published in *The St. Petersburg News* in 1855 in the feuilleton rubric "Zametki peterburgskogo turista." Even the art journal *Northern Lights* (*Severnoe siianie*, 1862–65) felt that the presence of the feuilleton was necessary. "Khudozhestvennyi fel'eton," *Severnoe siianie* 1 (1862): 253–56.

180. V. G. Belinskii, *Polnoe sobranie sochinenii*, vol. 9 (Moscow: Izd-vo AN SSSR, 1953–59), 220–21. Quoted in *Fiziologiia Peterburga*, ed. V. A. Nedzvetskii (Moscow: "Sov. Rossiia," 1984), 301.

181. Under the title "Russkii fel'etonist (Zoologicheskii ocherk)," Panaev's sketch was first published in 1841 in *Notes of the Fatherland*. It was scheduled to be reprinted as part of A. P. Bashutskii's *Nashi, spisannye s natury russkimi*; however, the new edition of the work, under the present title, appeared only in Nekrasov's *Fiziologiia Peterburga* in 1845. See I. I. Panaev, "Peterburgskii fel'etonist," in *Fiziologiia Peterburga*, 251–69. The physiological sketch and the feuilleton are related forms; as Joseph Frank observes, "It is difficult to distinguish the feuilleton from the physiological sketch in any clear-cut fashion" (Frank, 219). The feuilletonists were conscious of their readers' expectations (real and imagined). See, for instance, *Syn otechestva*, no. 47, 20 November 1860.

182. Panaev, "Peterburgskii fel'etonist," 300–301.

183. I. I. Panaev, "Peterburgskii literaturnyi promyshlennik," in *Russkii fel'eton. V pomoshch' rabotnikam pechati*, 130–39. First published in December issue of *The Contemporary* (1857), in the feuilleton rubric "Peterburgskaia zhizn'. Zametki Novogo poeta."

184. V. L. Komarovich, "Peterburgskie fel'etony Dostoevskogo," in *Fel'etony sorokovykh godov*, 93. Zhurbina argues that specificity (*konkretnost'*) is the defining feature of the feuilleton. See Zhurbina, *Teoriia i praktika*, 222.

185. Storonnii, "Zametki o khudozhestve," *Novoe vremia*, no. 8865, 31 October 1900.

186. Il'ia Gruzdev, "Tekhnika gazetnogo fel'etona," in *Fel'eton: Sbornik statei*, 13. *Podval* as a newspaper section first appeared in Bulgarin's *The Northern Bee* in the 1830s. See Esin, *Russkaia dorevoliutsionnaia gazeta*, 20.

187. See Gruzdev, 13, 29; Tynianov and Kazanskii, 7.

188. Zhurbina, a recognized authority on the subject, insists on separating the two meanings of the term "feuilleton," a newspaper rubric and a literary genre. According to her interpretation, it is wrong to talk about the early feuilletons in *The Northern Bee* as such; rather, the newspaper feuilleton should be regarded as merely an outgrowth of the "Smes'" rubric. Thus she dismisses Iu. G. Oksman's supposition that the Russian feuilleton was born in the pages of Bulgarin's *The Northern Bee* as a legend. Instead, she traces the origins of the genre to the works by Marlinsky, Ryleev, and Pushkin. Iu. G. Oksman and B. I. Esin, on the other hand, emphasize the fact that in the nineteenth century the feuilleton was closely associated with its specific location at the bottom of the newspaper page. See Zhurbina, *Teoriia i praktika*, 212, 214–15; Zhurbina, *Povest' s dvumia siuzhetami*, 104; Oksman, 5; Esin, *Russkaia dorevoliutsionnaia gazeta*, 38. In the early twentieth century, the feuilleton evolves into a story-feuilleton (*fel'eton-rasskaz*); see I. L. Orsher, *Literaturnyi put' dorevoliutsionnogo zhurnalista* (Moscow: Gos. izd-vo, 1930): 96–100.

189. Tynianov and Kazanskii, 7. For more on critical interpretations of the feuil-

leton, see S. K. Simkina, "Zhanry russkoi periodiki i masterstvo kritikov, publitsistov i ocherkistov XIX veka v sovetskoi kriticheskoi literature (Materialy k bibliografii)," in *Russkaia zhurnalistika XVIII–XIX vv.*, 139–42.

190. V. Shklovskii, *Tekhnika pisatel'skogo remesla* (Moscow: Molodaia gvardiia, 1930), 27–28. E. I. Zhurbina similarly emphasizes the borderline nature of the feuilleton. Zhurbina, *Teoriia i praktika*, 6, 249–50.

191. Morson, 15–16, 21.

192. Tynianov and Kazanskii, 6–7.

193. V. P., "Fel'eton. Zametki," *Sankt-Peterburgskie vedomosti*, no. 22, 28 January 1851.

194. Druzhinin, *Pis'ma inogorodnego podpischika*, 224–25.

195. V. Mikhnevich, *Nashi znakomye: Fel'etonnyi slovar' sovremennikov*, 2 vols. (St. Petersburg, 1884).

196. V. Dalmatov gives a very personal, moving account of the bearded woman's fate in his psychological sketch "Iuliia Pastrana. Psikhologicheskii ocherk," *Po tu storonu kulis: Teatral'nye ocherki*, vol. 1 (St. Petersburg: Tip. A. S. Suvorina, 1908), 22–64. Noted here are the attractions most frequently mentioned in the newspapers of the period. For a more detailed account of popular culture in St. Petersburg see Iurii Alianskii, *Uveselitel'nye zavedeniia starogo Peterburga* (St. Petersburg: AOZT "PF," 1996). For more on newspaper feuilletons, see Katia Dianina, "The Feuilleton: An Everyday Guide to Public Culture in the Age of the Great Reforms," *SEEJ* 47, no. 2 (2003): 186–208.

197. Feodor Dostoevsky, *Crime and Punishment*, ed. George Gibian, 3rd edition (New York: W. W. Norton & Company, 1989), 135–36. I. I. Izler was considered a founder of popular entertainment (*narodnye uveseleniia*) in St. Petersburg. See, for instance, *Golos*, no. 172, 24 June 1864. In summer 1864, Izler engaged two celebrities, "the rubber man" and "the human fly" (*chelovek-mukha*), who performed in Mineral'nye vody with great success, drawing some 4,000 spectators. See *Golos*, no. 158, 10 June 1864. On popular entertainment in general, see *Entertaining Tsarist Russia*.

198. *Illustrated Weekly News*, 12 October 1862, as cited in Peter H. Hoffenberg, *An Empire on Display: English, Indian, and Australian Exhibitions from the Crystal Palace to the Great War* (Berkeley: University of California Press, 2001), xiii.

199. For more on this, see Katia Dianina, "Passage to Europe: Dostoevskii in the St. Petersburg Arcade," *Slavic Review* 62, no. 2 (Summer 2003): 237–57.

200. *Golos*, no. 277, 20 October 1863.

201. Nikolai Shelgunov, "Dvoedushie esteticheskogo konservatizma," *Delo*, no. 10 (October 1870): 54–55, as cited in Charles A. Moser, *Esthetics as Nightmare: Russian Literary Theory, 1855–1870* (Princeton: Princeton University Press, 1989), 29.

202. A. Somov, "Vystavka imperatorskoi akademii khudozhestv," *Sankt-Peterburgskie vedomosti*, no. 213, 25 September 1863.

203. "Iz peterburgskoi zhizni," *Severnaia pochta*, no. 211, 26 September 1863. N. A., "Zamechatel'naia kartina," *Sankt-Peterburgskie vedomosti*, no. 188, 23 August 1863; A. A., "Kartina Ge," *Sankt-Peterburgskie vedomosti*, no. 205, 14 September 1863; P. P., "Fel'eton. Pis'ma peterburgskogo pustynnika," *Sovremennyi listok*, no. 40 (6 October 1863): 453. Reviews of this painting were numerous; see, for example, "Tainaia vecheria, kartina g-na Ge," *Golos*, no. 244, 17 September 1863; "Vsednevnaia zhizn," *Golos*, no. 249, 22 September 1863. Under the pseudonym N. A. published writer and literary critic Nikolai Akhsharumov. I. F. Masanov, *Slovar' psevdonimov russkikh pisatelei, uchenykh i obshchestvennykh deiatelei*,

vol. 2 (Moscow: Izdatel'stvo vsesoiuznoi knizhnoi palaty, 1957), 209.

204. Dostoevskii, "Po povodu vystavki," *PSS*, vol. 21, 76-77. Jackson believes that the writer rejected Ge's interpretation chiefly "because the painter's idea of Christ did not correspond to Dostoevsky's notion of the ideal of Christ." Robert Louis Jackson, *Dostoevsky's Quest for Form: A Study of His Philosophy of Art* (New Haven: Yale University Press, 1966), 220; see also 122-23. Dostoevsky ironically invokes Ge's painting in his *Notes from Underground* as well (*PSS*, vol. 5, 109).

205. Stasov, "Dvadtsat' piat' let russkogo iskusstva," *Sobranie sochinenii V. V. Stasova, 1847-1886*, vol. 1 (St. Petersburg: Tipografiia M. M. Stasiulevicha, 1894), 562.

206. N. G., "Zametka po povodu khudozhestvennoi vystavki," *Sovremennaia letopis'*, no. 38 (November 1863): 14-15.

207. Nikitenko, vol. 2, 405, 408.

208. [Saltykov-Shchedrin], "Nasha obshchestvennaia zhizn'," *Sovremennik* 99 (November 1863): 139, 144. For more opinions on Ge's painting, see commentary in Dostoevskii, *PSS*, vol. 21, 429-30.

209. Stasov, "Dvadtsat' piat' let russkogo iskusstva," 570-71.

210. A. Somov, "Vystavka imperatorskoi akademii khudozhestv," *Sankt-Peterburgskie vedomosti*, no. 213, 25 September 1863; I., "Vystavka v akademii khudozhestv," *Russkii invalid*, no. 215, 1 October 1863; N. Dmitriev, "Godichnaia vystavka v S.-Peterburgskoi akademii khudozhestv," *Sovremennaia letopis'*, no. 36 (October 1863): 14.

211. Mikhail Fedorov, "Iz peterburgskoi zhizni. Vystavka v akademii khudozhestv," *Narodnoe bogatstvo*, no. 231, 25 October 1863.

212. "O kartinnoi vystavke v akademii khudozhestv," *Vest'*, no. 8, 29 September 1863.

213. I. E. Repin, *Dalekoe blizkoe*, 179, as cited in Kasparinskaia-Ovsiannikova, "Vystavki," 370.

214. Thus the Russian art department in 1862 was organized by the Academy's Professor Iordan. Formally, the Academy continued to support the later international fairs as well, but now its choices reflected public taste. Significantly, the Academy published its "call for artworks" in the newspapers; for instance, *Sankt-Peterburgskie vedomosti*, no. 284, 29 October 1865. See *Imperatorskaia Sankt-Peterburgskaia Akademiia Khudozhestv:1964-1914*, ed. S. N. Kondakov (St. Petersburg: R. Golike, 1914), 46; N. Moleva and E. Beliutin, *Russkaia khudozhestvennaia shkola vtoroi poloviny XIX-nachala XX veka* (Moscow: Iskusstvo, 1967), 41. Grigorovich was in charge of the Fine Arts department at the 1867 international exhibition in Paris. For more on Russia's improved self-representation in 1867, see the memoirs of Boborykin, who covered the event. Boborykin, *Vospominaniia*, vol. 1, 440-43.

215. Cf. Valkenier's argument that Russian art of the 1860s and 1870s was *not* defined by nationalism and the "distinctive, peculiarly Russian style," which came to be associated with the Itinerant movement in later decades. Elizabeth Kridl Valkenier, *Russian Realist Art: The State and Society: The Peredvizhniki and Their Tradition* (New York: Columbia University Press, 1989), 52.

216. M., "Peterburgskaia khronika," *Russkii invalid*, no. 331, 25 December 1866.

217. V. S., "Vystavka v akademii khudozhestv," *Sankt-Peterburgskie vedomosti*, no. 10, 10 January 1867; no. 12, 12 January 1867.

218. V. S., "Khudozhestvennye zametki o vystavke," *Sankt-Peterburgskie vedomosti*, no. 138, 21 May 1870; no. 143, 26 May 1870; V. S., "Khudozhestvennye zametki o Venskoi vystavke. (Okonchanie)," *Sankt-Peterburgskie vedomosti*, no. 314, 14 November 1873.

219. V. S., "Russkaia zhivopis' i skul'ptura na londonskoi vystavke," *Sankt-Peterburg-*

skie vedomosti, no. 201, 25 July 1872. Stasov claimed that the British press also appreciated Russian art: *Athenaeum, The Times, The Standard,* and *The Daily-Telegraph* all praised the Russian school of art, at least according to the compilation of foreign reviews that Stasov put together for his article in *The St. Petersburg News.*

220. P. Kovalevskii, "Godichnaia vystavka v akademii khudozhestv," *Vestnik Evropy* 11 (November 1870): 360. Cf. Stasov's description of Russian art's life cycle: "young Russian art, this fresh, wonderful, little adolescent (*podrostochek*), begins evolving into an independent, original entity, it gains strength and rises into the full beauty of a young healthy power, it finally brings us flowers and fruit, unknown to previous times, and begins developing with its mighty hand new forms and new motifs that are borrowed from no one." V. S., "Mamki i nian'ki ne vpopad," *Sankt-Peterburgskie vedomosti,* no. 12, 12 January 1866.

221. V. Stasov, "Nashi khudozhestvennye dela. Stat'ia chetvertaia i posledniaia," *Sankt-Peterburgskie vedomosti,* no. 43, 12 February 1869.

222. N. Arnol'di, "Neskol'ko slov o russkom iskusstve i ego kritikakh," *Moskovskii vestnik,* no. 45, 7 November 1860.

223. For an earlier history of art criticism in Russia, see Alexey Makhrov, "The Pioneers of Russian Art Criticism: Between State and Public Opinion, 1804–1855," *Slavonic and East European Review* 81, no. 4 (October 2003): 614–33.

224. K. N. Batiushkov, "Progulka v akademiiu khudozhestv," *Sochineniia,* vol. 2 (St. Petersburg, 1885), 92–117, esp. 108. For more on this first review of an art exhibition in Russia see R. S. Kaufman, *Ocherki istorii russkoi khudozhestvennoi kritiki XIX veka* (Moscow: "Iskusstvo," 1985), 18–36.

225. Frederick S. Starr, "Russian Art and Society, 1800–1850," in *Art and Culture in Nineteenth-Century Russia,* ed. Theofanis George Stavrou (Bloomington: Indiana University Press, 1983), 95–96. Specialized periodical editions of this earlier period also included Kukol'nik's *The Gazette of Fine Arts* (*Khudozhestvennaia gazeta,* 1836–41); for more on *Khudozhestvennaia gazeta,* see Kaufman, 37–51. Cf. Mokritsky's appeal to the critics in the 1830s to do more toward encouraging young talented artists. *Dnevnik khudozhnika A. N. Mokritskogo* (Moscow: Izobrazit. iskusstvo, 1975), 58.

226. *Kartiny russkoi zhivopisi,* ed. N. V. Kukol'nik (St. Petersburg: V tip. III Otdel. Sobstv. E. I. V. kantseliarii, 1846), 80–82.

227. N. Kh., "Vystavka v akademii khudozhestv," *Illiustratsiia,* no. 16, 24 April 1858; N. Kh., "Eshche neskol'ko slov o vystavke akademii khudozhestv," *Illiustratsiia,* no. 24, 19 June 1858; see also "Vystavka v akademii khudozhestv," *Illiustratsiia,* no. 73, 11 June 1859.

228. Nikolai Ramazanov, *Materialy dlia istorii khudozhestv v Rossii* (Moscow: V Gubernskoi tip., 1863). This compilation consists of Ramazanov's biographical sketches of the artists and his reminiscences. For one of the numerous descriptions of the feuilletonists as dilettantes see the article signed *Liubitel' zhivopisi,* "Po povodu statei o khudozhestvennoi vystavke pomeshchennykh v gazete 'Sovremennoe slovo,'" *Sankt-Peterburgskie vedomosti,* no. 234, 27 October 1862.

229. E. Viollet-le-Duc, *Russkoe iskusstvo: Ego istochniki, ego sostavnye elementy, ego vysshee razvitie, ego budushchnost'* (Moscow: Tip. A. Gattsyka, 1879).

230. Aleksandr Benua, *Istoriia zhivopisi v XIX veke. Russkaia zhivopis'* (St. Petersburg: Izd. t-va "Znanie," 1901).

231. "Peterburgskaia letopis'," *Sankt-Peterburgskie vedomosti,* no. 204, 17 September 1861.

232. M-k-n, "Mysli i zametki po sluchaiu obozreniia vystavki akademii khudozhestv," *Semeinyi krug,* no. 46 (17 November 1860): 158.

233. G. G. Miasoedov, "Vstupitel'naia stat'ia k al'bomu 'Dvadtsatipiatiletiia Tova-rishchestva peredvizhnykh khudozhestvennykh vystavok,'" in *Tovarishchestvo peredvizhnykh khudozhestvennykh vystavok, 1869–1899: Pis'ma, dokumenty* (Moscow: Iskusstvo, 1987), 536.

234. V. S., "Po povodu vystavki v akademii khudozhestv," *Sankt-Peterburgskie vedomosti*, no. 322, 21 November 1867.

235. V. Stasov, "Nashi khudozhestvennye dela," *Sankt-Peterburgskie vedomosti*, no. 36, 5 February 1869. In his defense of the emerging profession, Stasov even came up with a derogatory term to designate such amateur critical writing, "*fel'etonnaia kritika.*"

236. V. Stasov, "G-nu advokatu Akademii khudozhestv," *Izbrannye sochineniia v trekh tomakh*, ed. E. D. Stasova et al., vol. 1 (Moscow: Iskusstvo, 1952), 49–50, as cited in Makhrov, "Defining Art Criticism in Nineteenth-Century Russia," 214–15.

237. D. I. Pisarev, "Razrushenie estetiki," *Sochineniia D. I. Pisareva: Polnoe sobranie v shesti tomakh, s portretom avtora i stat'ei Evgeniia Solov'eva*, vol. 4 (St. Petersburg: Tip. A. Porokhovshchikova, 1897), 515–16.

238. N. Nabokov, "Po povodu beglogo obzora akademicheskoi vystavki g. fel'etonista Severnoi pchely," *Sovremennaia letopis'*, no. 40 (October 1862): 14.

239. Gleb Uspenskii, "Po povodu odnoi kartinki," *Polnoe sobranie sochinenii Gleba Uspenskogo*, vol. 5 (St. Petersburg: A. F. Marks, 1908), 229–36.

240. As quoted in *The Wanderers: Masters of 19th-Century Russian Painting: An Exhibition from the Soviet Union*, ed. Elizabeth Kridl Valkenier (Dallas: Dallas Museum of Art, 1990), 191.

241. As quoted in Ibid., 196. Grigorovich, in fact, attended the Academy of Fine Arts, a passable experience that he describes in his *Neudavshaiasia zhizn'* (1850). D. V. Grigorovich, *Literaturnye vospominaniia* (Leningrad: "Academia," 1928), 69ff.

242. V. G. Korolenko, "Dve kartiny. Razmyshleniia literatora," *Sobranie sochinenii v desiati tomakh*, vol. 8 (Moscow: Gos. izd-vo khudozh. lit-ry, 1955), 293–304; V. M. Garshin, "Zametki o khudozhestvennykh vystavkakh," *Polnoe sobranie sochinenii V. M. Garshina* (St. Petersburg: Izdanie T-va A. F. Marks, 1910), 428–40.

243. As quoted in *The Wanderers*, 196.

244. [Saltykov-Shchedrin], "Nasha obshchestvennaia zhizn'," *Sovremennik* 99 (November 1863): 140.

245. A. Matushinskii, "Polednie khudozhestvennye vystavki v Peterburge," *Russkii vestnik* 99, no. 6 (June 1872): 769–70.

246. This is not to deny the existence of professional art criticism prior to the last quarter of the nineteenth century; such earlier editions as *The Journal of Fine Arts* and *The Gazette of Fine Arts*, however, were short-lived, did not carry much debate, and were not aimed at the broad public. For more on art criticism in the early nineteenth century, see Gray, *Russian Genre Painting in the Nineteenth Century*, esp. Ch. 2, "The Intelligentsia and the Press," and the online database, "Russian Visual Arts: Art Criticism in Context, 1814–1909" (Sheffield: HRIOnline, 2005; <http://hri.shef.ac.uk/rva/>).

247. Habermas, *The Structural Transformation of the Public Sphere*, 40–41.

248. As an example of such a bibliography see, for instance, the bibliographical section "Literatura" in Benua, *Istoriia zhivopisi v XIX veke. Russkaia zhivopis'*, 275–85.

249. Sergei Makovskii, *Stranitsy khudozhestvennoi kritiki*, vol. 2 (St. Petersburg: "Panteon," 1909), 5, 23.

250. Ibid, 8, 26–29.

4: Institutions and Debates

1. K. G. Sokol, *Monumenty imperii: Opisanie dvukhsot naibolee interesnykh pamiatnikov imperatorskoi Rossii* (Moscow: Izd-vo GEOS, 1999), 19–23. That "the millennium of Russia" refers to both the event and the memorial further underscores the monument's central role in the festivities. Its symbolic value became especially obvious during World War II: during the occupation, German troops disassembled the monument for the purposes of transporting it to Germany; already in 1944, the Soviets had it restored. For more on the monument's history, see Ol'ga Maiorova, "Bessmertnyi Riurik: Prazdnovanie Tysiacheletiia Rossii v 1862 g.," *Novoe literaturnoe obozrenie*, no. 43 (2000): 137–65.

2. See, for instance, Andreas Huyssen, *Twilight Memories: Marking Time in a Culture of Amnesia* (New York: Routledge, 1995), 249–50; Mikhail Yampolsky, "In the Shadow of Monuments: Notes on Iconoclasm and Time," in *Soviet Hieroglyphics: Visual Culture in Late Twentieth-Century Russia*, ed. Nancy Condee (Bloomington: Indiana University Press, 1995), 104. Cf. Jakobson on the peculiar temporality of statues: Roman Jakobson, "The Statue in Puškin's Poetic Mythology," *Language and Literature*, ed. Krystyna Pomorska and Stephen Rudy (Cambridge: The Belknap Press of Harvard University Press, 1987), 353.

3. "Pis'mo nashego pervogo korrespondenta," *Syn otechestva*, no. 218, 11 September 1862.

4. On millennial celebrations in St. Petersburg see *Syn otechestva*, no. 217, 10 September 1862; "Peterburgskoe obozrenie," *Severnaia pchela*, no. 244, 11 September 1862, and *Illiustratsiia*, no. 236, 13 September 1862; for celebrations in Kishinev, see *Syn otechestva*, no. 230, 25 September 1862.

5. Maiorova, "Bessmertnyi Riurik," 137–65.

6. Richard S. Wortman, *Scenarios of Power: Myth and Ceremony in Russian Monarchy*, vol. 2 (Princeton: Princeton University Press, 2000), 80.

7. M. K. Lemke, *Ocherki po istorii russkoi tsenzury i zhurnalistiki XIX stoletiia* (St. Petersburg: Kn-vo M. V. Pirozhkova, 1904), 19.

8. For a detailed description of the monument, see V. G. Smirnov, *Rossiia v bronze: Pamiatnik Tysiacheletiiu Rossii i ego geroi* (Novgorod: Russkaia provintsiia, 1993).

9. "Rossiia," *Sankt-Peterburgskie vedomosti*, no. 178, 17 August 1862. As Richard Wortman observes, editorials on the Millennium celebration in *Severnaia pochta* were written by minister of the interior Petr Valuev. The newspaper was launched by the Ministry of the Interior in early 1862 to influence public opinion in the wake of the Great Reforms. See Wortman, *Scenarios of Power*, vol. 2, 78, 71.

10. "Neskol'ko slov o pamiatnike tysiacheletiiu Rossii," *Severnaia pchela*, no. 204, 30 July 1862. Other newspaper accounts liberally added details to this basic description of the monument without challenging the official line. See, for instance, "Pis'mo nashego vtorogo korrespondenta," *Syn otechestva*, no. 219, 12 September 1862.

11. Sokol, 19. In their ability to contain and control an immense volume of information, the monument and the novel could both function as vehicles for imagining the Russian nation; both invited reading and interpretation.

12. V. V. Stasov, *Sobranie sochinenii V. V. Stasova, 1847–1886*, vol. 1 (St. Petersburg: Tipografiia M. M. Stasiulevicha, 1894), 43–50.

13. M. Mikeshin, "I. Pis'ma v redaktsiiu 'Sanktpeterburgskikh vedomostei,'" *Sankt-Peterburgskie vedomosti*, no. 28, 5 February 1860. Forced to explain himself, Stasov pursued this principled if irascible dialogue with a retort in *Russkii vestnik* (*The Russian Herald*).

14. V. V. Stasov, "Eshche dva slova o proekte pamiatnika tysiacheletiiu Rossii," *Sochineniia V. V. Stasova: 1847–1886*, vol. 1, 51–56. Both of Stasov's pieces appeared in *Russkii vestnik* (vol. 23, 1859, and vol. 25, 1860).

15. Huyssen argues that public discourse animating the monument tends to be at its most intense at the planning stages. Huyssen, 258.

16. E. N. Maslova, *Pamiatnik "Tysiacheletie Rossii,"* comp. S. N. Semanov (Moscow: "Sovetskaia Rossiia," 1985), 21–23.

17. See N. Otto and I. Kupriianov, *Biograficheskie ocherki lits, izobrazhennykh na pamiatnike tysiacheletiia Rossii, vozdvignutom v g. Novgorode 1862 g.* (Novgorod, 1862).

18. Olga Maiorova offers a detailed analysis of the imperial narrative fashioned for the Millennium as a "rejuvenated model of autocracy." Cf. the discussion of discursive inclusion and exclusion in William Mills Todd III, *Fiction and Society in the Age of Pushkin: Ideology, Institutions, and Narrative* (Cambridge: Harvard University Press, 1986), 18–25.

19. Shevchenko's works were regularly published in the Ukrainian-language journal *Osnova* (*The Foundation*, 1861–62). His fellow "brother" N. I. Kostomarov was a frequent contributor to this publication as well. Shevchenko's funeral in 1861 was attended by scores of artists, writers, students, journalists. For more on Shevchenko's last years in St. Petersburg see, for instance, Pavlo Zaitsev, *Taras Shevchenko: A Life*, trans. George S. N. Luckyj (Toronto: University of Toronto Press, 1988), 221–68. See also Volodymyr Miiakovsky, "Shevchenko in the Brotherhood of Saints Cyril and Methodius," in *Shevchenko and the Critics, 1861–1980*, ed. George S. N. Luckyj (Toronto: University of Toronto Press, 1980), 355–85; Edward C. Thaden, *Russia's Western Borderlands, 1710–1870* (Princeton: Princeton University Press, 1984), 140–41.

20. In 1863, minister of internal affairs, Petr Valuev, secretly banned all Ukrainian-language publishing, except belles-lettres. He declared that the Ukrainian language had never existed. A more explicit ban came in 1876, the so-called *Ems Ukaz*, which prohibited all use of Ukrainian. See Orest Subtelny, *Ukraine: A History* (Toronto: University of Toronto Press, 1988), esp. 282–83. Benedict Anderson used a brilliant visceral metaphor to describe a similar phenomenon of "stretching the short, tight, skin of the nation over the gigantic body of the empire." Benedict Anderson, *Imagined Communities: Reflections on the Origin and Spread of Nationalism*, rev. ed. (London: Verso, 1991), 86.

21. "Listok," *Syn otechestva*, no. 159, 4 July 1862.

22. "Pis'mo nashego vtorogo korrespondenta," *Syn otechestva*, no. 219, 12 September 1862.

23. F. Buslaev, "Pamiatnik tysiacheletiiu Rossii," *Nashe vremia*, no. 9, 13 January 1862.

24. "Neskol'ko slov o pamiatnike tysiacheletiiu Rossii," *Severnaia pchela*, no. 204, 30 July 1862. The addition of Derzhavin's figure was only one among a number of corrections to the original design; the same article, for instance, announced that Emperor Nicholas I would be represented on the monument as well. For more on the modification of the canon, see Maslova, 23–24.

25. *Pamiatnik tysiacheletiia Rossii, otkrytyi v Novgorode 8 sentiabria 1862 goda* (St. Petersburg, 1862); for discussion on who should represent Russian culture, see especially 34–38.

26. Khudozhnik [F. F. L'vov], "Vospominaniia ob Akademii khudozhestv, 1859–1864," *Russkaia starina*, no. 10 (October 1880): 399.

27. V. V. Stasov, "Odin iz proektov pamiatnika tysiacheletiiu Rossii," *Sobranie sochinenii V. V. Stasova, 1847–1886*, vol. 1, 43–50.

28. Cf. Marina Warner, *Monuments and Maidens: The Allegory of the Female Form* (New York: Atheneum, 1985). Warner approaches the traditional female form in national monuments as an "expression of desiderata and virtues" and points to a radical difference between the "symbolic order" (women as allegorical figures signifying liberty, justice, freedom, etc.) and the "actual order" (women's fundamental lack of freedom in the nineteenth century to practice the virtuous concepts that they represent). See xix–xx. For more on contemporary responses to the allegory of Russia in Mikeshin's monument, see Maiorova, "Bessmertnyi Riurik," 148.

29. V. V. Stasov, "Dvadtsat' piat' let russkogo iskusstva," *Izbrannye sochineniia v trekh tomakh*, vol. 2 (Moscow: Iskusstvo, 1952), 483–84. Buslaev compared the monument to Delaroche's *Hémicycle*. F. I. Buslaev, "Pamiatnik Tysiacheletiiu Rossii," *Moi dosugi: Sobrannye iz periodicheskikh izdanii melkie sochineniia*, part II (Moscow: V Sinodal'noi tipografii, 1886), 191–95, as cited in Maiorova, "Bessmertnyi Riurik."

30. F. Buslaev, "Pamiatnik tysiacheletiiu Rossii," *Nashe vremia*, no. 9, 13 January 1862.

31. V. Ch., "Pis'mo nashego vtorogo korrespondenta," *Syn otechestva*, no. 219, 12 September 1862. Writer and journalist Vladimir Cherevanskii, who wrote for *Son of the Fatherland* in the 1870s, used the pseudonym V. Ch. I. F. Masanov, *Slovar' psevdonimov russkikh pisatelei, uchenykh i obshchestvennykh deiatelei*, vol. 1 (Moscow: Izdatel'stvo vsesoiuznoi knizhnoi palaty, 1956), 207.

32. See also Maiorova's discussion of "primiritel'nyi pafos." Maiorova, "Bessmertnyi Riurik," 153–58.

33. In 1857, the Committee of Ministers designated the monument as "a national (*narodnyi*) monument to the MILLENNIUM of the Russian state." Wortman, *Scenarios of Power*, vol. 2, 80.

34. "Zametki novogo poeta," *Sovremennik* 79 (February 1860): 375.

35. O., "Eshche dva slova o proekte pamiatnika tysiacheletiiu Rossii," *Russkii vestnik* 25 (February 1860): 158–59.

36. On Aksakov's reaction to the Millennium, see Wortman, *Scenarios of Power*, vol. 2, 87–88.

37. F. Buslaev, "Pamiatnik tysiacheletiiu Rossii," *Nashe vremia*, no. 9, 13 January 1862. Buslaev's article also appeared in *Moi dosugi*, part II, 187–208. For a detailed interpretation of this aspect of Buslaev's criticism, see Wortman, *Scenarios of Power*, vol. 2, 84.

38. Stasov, "Dvadtsat' piat' let russkogo iskusstva," 484.

39. *Syn otechestva*, no. 216, 8 September 1862, as cited in Maiorova, "Bessmertnyi Riurik," 163.

40. Ar. Eval'd, "Prazdnik tysiacheletiia Rossii (Ot nashego korrespondenta)," *Sankt-Peterburgskie vedomosti*, no. 196, 8 September 1862.

41. "Prazdnik tysiacheletiia Rossii," *Sankt-Peterburgskie vedomosti*, no. 212, 29 September 1862.

42. Maiorova argues that the need for national consolidation was one of the overarching ideas of the Millennium celebration. Maiorova, "Bessmertnyi Riurik," 163.

43. As one journalist put it wishfully, the "Millennium of Russia" was a monument of "national importance" in that it productively affected the imagination of the masses (*massy*). "Pamiatnik tysiacheletiiu Rossii," *Syn otechestva*, no. 250, 18 October 1862. On broad accessibility of the monument, see also "Listok," *Syn otechestva*, no. 159, 4 July 1862.

44. "Listok," *Syn otechestva*, no. 183, 1 August 1862.

45. See "862–1862," *Sankt-Peterburgskie vedomosti*, no. 1, 3 January 1862.

46. "Pis'mo nashego pervogo korrespondenta," *Syn otechestva*, no. 218, 11 September 1862.

47. Wortman, *Scenarios of Power*, vol. 2, 88, 85. For more on Wortman's interpretation of the Millennium celebrations as an official narrative of power, see 74–91.

48. V. Ch., "Pis'mo nashego vtorogo korrespondenta," *Syn otechestva*, no. 217, 10 September 1862.

49. Maiorova, "Bessmertnyi Riurik," 142.

50. [V. Z. Eliseev], "862–1862, ili Tysiacheletie Rossii," in *Svistok: Sobranie literaturnykh, zhurnal'nykh i drugikh zametok. Satiricheskoe prilozhenie k zhurnalu* "Sovremennik," *1859–1863*, ed. M. A. Alekseev et al. (Moscow: Izd-vo "Nauka," 1981), 232–54.

51. Platon Pavlov, *Tysiacheletie Rossii. Kratkii ocherk otechestvennoi istorii* (St. Petersburg: I. Paul'son, 1863), 1. Holquist underscores Russians' urgent interest in history during the reign of Nicholas I, when the national past became the center of controversy. Billington discusses the strong influence that Hegel's philosophy of history had on Russian romantics in the "remarkable decade" of 1838–48. Wachtel writes more broadly that "at some point in their careers practically all of Russia's most famous writers took it upon themselves to write the nation's history." See Michael Holquist, *Dostoevsky and the Novel* (Princeton: Princeton University Press, 1977), esp. 6–10; James H. Billington, *The Icon and the Axe: An Interpretive History of Russian Culture* (New York: Vintage Books, 1966), 314–28; Andrew Baruch Wachtel, *An Obsession with History: Russian Writers Confront the Past* (Stanford: Stanford University Press, 1994), 1–18.

52. V. Ch., "Pis'mo nashego vtorogo korrespondenta," *Syn otechestva*, no. 217, 10 September 1862. Cf. "Prazdnik tysiacheletiia Rossii (Ot nashego korrespondenta)," *Sankt-Peterburgskie vedomosti*, no. 212, 29 September 1862.

53. Nikolai Barsukov, *Zhizn' i trudy M. P. Pogodina*, vol. 17 (St. Petersburg: Tip. M. M. Stasiulevicha, 1903), 278–79; Thomas M. Prymak, *Mykola Kostomarov: A Biography* (Toronto: University of Toronto Press, 1996), 94–98. Shortly prior to this public debate, Kostomarov published a major article, "The Two Russian Nationalities," in the Ukrainian journal *The Foundation*, in which he argued for the fundamental equality of the Great Russian and the Ukrainian people, a position with which many of his contemporaries found it difficult to reconcile. N. I. Kostomarov, *Dve russkie narodnosti* (Kiev: Maiden, 1991). I'm grateful to George G. Grabowicz for drawing my attention to this source. Kostomarov was a prominent thinker of the Ukrainian revival; characteristic of his position was the prioritization of the people over the state. See also Grabowicz's "Insight and Blindness in the Reception of Ševchenko: The Case of Kostomarov," *Harvard Ukrainian Studies* 17, no. 3/ 4 (December 1993): 279–340.

54. For a complete text of the debate, see "Publichnyi disput 19 marta 1860 goda o nachale Rusi mezhdu gg. Pogodinym i Kostomarovym," *Sovremennik* 80 (1860): 257–92.

55. "The subject of the debate was very dry ... and the public attended, of course, only out of its love and respect for Kostomarov," wrote Chernyshevsky to his family. Letter of 22 March 1860, N. G. Chernyshevskii, *Polnoe sobranie sochinenii*, vol. 14 (Moscow: Gos. izd-vo khudozh. lit-ry, 1949), 289, as cited in Prymak, 221. P. Shpilevskii, "Disput akademika Pogodina i profesora [sic] Kostomarova," *Illiustratsiia*, no. 113, 31 March 1860.

56. A. V. Nikitenko, *Zapiski i dnevnik*, vol. 2 (St. Petersburg: A. S. Suvorin, 1893), 180. Among many others, Dostoevsky also intended to write an article covering this event, but then assigned it to another regular contributor to *Epoch*, Averkiev. V. S. Nechaeva, *Zhurnal M. M. i F. M. Dostoevskikh "Epokha." 1864–1865* (Moscow: Nauka, 1975), 109–12. For more on the reception of this public debate see also F. M. Dostoevskii, *PSS*, vol. 18, 263.

57. This was Pogodin's response to Lamanskii's notorious phrase "my ne dozreli do publichnykh prenii," voiced in the Petersburg Passage. Another voice that joined the debate was that of D. Shcheglov. See his "G. Kostomarovu," *Sankt-Peterburgskie vedomosti*, no. 193, 6 September 1860. Two years after Pogodin and Kostomarov initiated the tradition of public debate, two other scholars, Golovin and Dukhinskii, entered into a public polemic on the origins of Russia. See N. Golovin, "Otkuda prishli russy?" *Sankt-Peterburgskie vedomosti*, no. 126, 13 June 1862, and "Uchenyi turnir v Parizhe," *Severnaia pchela*, no. 195, 21 July 1862. Petr Khavskii responded to this exchange in his "Tysiacheletie Rossii"; see *Severnaia pchela*, no. 239, 5 September 1862. Further evidence of the event's broad publicity is a caricature of the debate, which appeared in *The Spark* (*Iskra*). See its reproduction in Lemke, 116. For a detailed discussion of the debate, see V. A. D'iakov, "Uchenaia duel' M. P. Pogodina c N. I. Kostomarovym (O publichnom dispute po normannskomu voprosu 19 marta 1860 g.)," in *Istoriografiia i istochnikovedenie stran Tsentral'noi i Iugo-Vostochnoi Evropy* (Moscow: Nauka, 1986), 40–56.

58. [K. N. Lebedev], "Publichnyi disput 19 marta 1860 goda o nachale Rusi mezhdu gg. Pogodinym i Kostomarovym," *Sovremennik* 80 (1860): 292. In 1862, another public dispute between these two historians flared up over the Battle of Kulikovo field. See, for instance, M. Pogodin, "Dva slova o state 'Kulikovskaia bitva', pomeshchennoi v kalendare," *Den'*, no. 4, 25 January 1864; also M. Pogodin, "N. I. Kostomarovu," *Den'*, no. 7, 15 February 1864.

59. The historian Platon Pavlov devoted to Russia's Millennium a public lecture, a new forum for disseminating information that became popular in the 1860s. L. F. Panteleev, *Vospominaniia* (Moscow: Gos. izd-vo khudozh. lit-ry, 1958), 227–28.

60. Advertisements for these two editions were published, respectively, in *Severnaia pchela*, no. 236, 2 September 1862, and *Severnaia pchela*, no. 262, 29 September 1862.

61. In the words of F. Buslaev: "At last, based on the depiction appended to the *Calendar for 1862*, all of Russia, whether literate or not, can in general familiarize itself with the monument, which is being erected in memory of its millennial existence." F. Buslaev, "Pamiatnik tysiacheletiiu Rossii," *Nashe vremia*, no. 9, 13 January 1862.

62. For an announcement to this effect, see "Prazdnovanie tysiacheletiia Rossii," *Russkii listok*, no. 32 / 33, 26 August 1862.

63. "Peterburgskoe obozrenie," *Severnaia pchela*, no. 264, 1 October 1862. For more on lubki issued to commemorate the Millennium, see Wortman, *Scenarios of Power*, vol. 2, 88–89.

64. "Listok," *Syn Otechestva*, no. 183, 1 August 1862.

65. Stasov, "Dvadtsat' piat' let russkogo iskusstva," 483.

66. D. V. Grigorovich, *Progulka po Ermitazhu* (St. Petersburg, 1865), 134–35.

67. Jennifer Cahn, "Nikolai Punin and Russian Avant-Garde Museology, 1917–1932" (PhD diss., University of Southern California, 1999), 38.

68. J. G. Kohl, *Russia and the Russians in 1842*, vol. 1 (Ann Arbor: University Microfilms International, 1980), 282. Although only few Russians had access to the Hermitage treasures, most upper-class foreign visitors to St. Petersburg had an opportunity to delight in its collections. Even such an unsentimental critic as J. Beavington Atkinson extolled the museum: "The Imperial Hermitage alone repays a journey to St. Petersburg." See his *An Art Tour to Northern Capitals of Europe* (New York: Macmillan and Co., 1873), 174ff.

69. Frederick S. Starr, "Russian Art and Society, 1800–1850," in *Art and Culture in Nineteenth-Century Russia*, 96.

70. For details, see G. K. Leont'eva, *Karl Briullov* (Leningrad: Iskusstvo, 1976), 115–16.

71. Anatolii Polovtsov, "Briullovskaia iubileinaia vystavka (Pis'mo iz Peterburga)," *Moskovskie vedomosti*, no. 348, 18 December 1899.

72. Germain Bazin, *The Museum Age*, trans. Jane van Nuis Cahill (New York: Universe Books, 1967), 215.

73. *Muzei Imperatorskogo Ermitazha. Opisanie razlichnykh sobranii sostavliaiushchikh muzei s istoricheskim vvedeniem ob Ermitazhe Imperatritsy Ekateriny II i ob obrazovanii muzeia novogo Ermitazha* (St. Petersburg, 1861), xxvii, italics added.

74. N. N. Vrangel', *Iskusstvo i gosudar' Nikolai Pavlovich* (Petrograd, 1915), 8, 5.

75. S. A. Ovsiannikova, "Khudozhestvennye muzei Peterburga i Moskvy II-i pol. XIX–nach. XX veka (Ermitazh, Tret'iakovskaia galereia, Russkii muzei)," in *Trudy Nauchno-issledovatel'skogo instituta muzeevedeniia*, vol. 7 (Moscow, 1962), 12–16.

76. "Preobrazovaniia v imperatorskom Ermitazhe," *Golos*, no. 66, 6 March 1864.

77. Geraldine Norman, *The Hermitage: The Biography of a Great Museum* (New York: Fromm International, 1998), 86–92.

78. V. F. Levinson-Lessing, *Istoriia kartinnoi galerei Ermitazha (1764–1917)* (Leningrad: Iskusstvo, 1985), 203, 244. According to Ovsiannikova, visitors to the Hermitage numbered 50,000 in 1892 and 89,000 in 1895. See Ovsiannikova, "Khudozhestvennye muzei Peterburga i Moskvy," 23.

79. K. V., "Pis'ma iz Moskvy. I.," *Russkii khudozhestvennyi listok*, no. 24, 20 August 1862; D., "Neskol'ko slov o khudozhestvennykh muzeiakh," *Birzhevye vedomosti*, no. 321, 2 December 1864.

80. Stasov, "Dvadtsat' piat' let russkogo iskusstva," 507; Levinson-Lessing, 227.

81. Aleksandr Benua, *Moi vospominaniia*, vol. 1 (Moscow: Nauka, 1990), 697.

82. M. V. Alpatov, "Znachenie Ermitazha v russkoi i mirovoi kul'ture," *Etiudy po vseobshchei istorii iskusstv: Izbrannye iskusstvovedcheskie raboty* (Moscow: Sov. khudozhnik, 1979), 187.

83. Pierre Bourdieu and Alain Darbel, with Dominique Schnapper, *The Love of Art: European Art Museums and Their Public*, trans. Caroline Beattie and Nick Merriman (Stanford: Stanford University Press, 1990), 109, 112. See also Pierre Bourdieu, *The Field of Cultural Production: Essays on Art and Literature*, ed. Randal Johnson (New York: Columbia University Press, 1993).

84. A. Somov, *Kartiny Imperatorskogo Ermitazha: Dlia posetitelei etoi galerei* (St. Petersburg: V tip. A. Iakobsona, 1859); F. Zhil', *Muzei Imperatorskogo Ermitazha* (St. Petersburg: V tip. Imperatorskoii Akademii nauk, 1861); *Katalog kartin: Imperatorskii Ermitazh* (St. Petersburg: V tip. Eksped. zagotovl. gos. bumag, 1863); D. V. Grigorovich, *Progulka po Ermitazhu* (St. Petersburg, 1865). The Hermitage's most distinguished guidebook, Alexandre Benois's *Putevoditel' po kartinnoi galeree Imperatorskogo Ermitazha*, came out only in 1910.

85. Grigorovich, 152, 4.

86. Levinson-Lessing, 204–28.

87. O. V. Mikats, *Kopirovanie v Ermitazhe kak shkola masterstva russkikh khudozhnikov XVIII–XIX vekov* (St. Petersburg: Gos. Ermitazh, 1996), 65.

88. V. V. Stasov, "Publichnaia biblioteka i Ermitazh pri Aleksandre I," *Sobranie sochinenii V. V. Stasova, 1847–1886*, vol. 1 (St. Petersburg, 1894), 453.

89. Aleksandr Benua, *Putevoditel' po kartinnoi galeree Imperatorskogo Ermitazha* (St. Petersburg: Izd. Obshchiny sv. Evgenii, [n.d.]), 1.

90. S. K. Isakov et al., *Kratkii istoricheskii ocherk: Imperatorskaia akademiia khudozhestv, 1764–1914* (St. Petersburg, 1914), 1. Among other things, the Statutes stipulated the

right of the Academy's graduates to work as artists independent of military or state service. Valkenier, *Russian Realist Art*, 3. On the history of the Academy in general, see I. I. Bekker, I. A. Brodskii, S. K. Isakov, *Akademiia khudozhestv: Istoricheskii ocherk* (Leningrad: "Iskusstvo," 1940); V. G. Lisovskii, *Akademiia khudozhestv* (St. Petersburg: OOO "Almaz," 1997).

91. The building for the Academy was for the most part finished by 1872; however, it took another half a century to complete all the details of the décor. *Imperatorskaia Sankt-Peterburgskaia Akademiia Khudozhestv: 1964–1914*, ed. S. N. Kondakov (St. Petersburg: R. Golike, 1914), 8–11.

92. *Imperatorskaia Sankt-Peterburgskaia Akademiia Khudozhestv: 1964–1914*, 38–40; 42. See also N. Moleva and E. Beliutin, *Russkaia khudozhestvennaia shkola vtoroi poloviny XIX–nachala XX veka* (Moscow: Iskusstvo, 1967), 11.

93. Valkenier, *Russian Realist Art*, 3–7.

94. "The only school that achieved any strong independent identity," writes Frederick Starr, "was the Moscow School of Painting, Sculpture, and Architecture, founded in 1843." Frederick S. Starr, "Russian Art and Society, 1800–1850," in *Art and Culture in Nineteenth-Century Russia*, 102.

95. Richard Stites wrote extensively on the history of the Academy. See his *Serfdom, Society, and the Arts in Imperial Russia: The Pleasure and the Power* (New Haven: Yale University Press, 2005), esp. Part IV, Pictures at an Exhibition, 283–379. See also Rosalind P. Blakesley, "Pride and the Politics of Nationality in Russia's Imperial Academy of Fine Arts, 1757–1807," *Art History* 33, no. 5 (December 2010): 800–835. Another intermediary between art and the public was the St. Petersburg Society for the Encouragement of Artists, founded in the late 1820s. G. Komelova, "Peterburgskoe obshchestvo pooshchreniia khudozhestv i ego deiatel'nost' v 20–40kh gg. XIX v.," *Soobshcheniia Gosudarstvennogo Ermitazha* 13 (1958): 34.

96. The exhibition was open for only two weeks, one of which was reserved for ticket-holders, the other for the general public. "Pravila, kotorye imeiut byt' nabliudaemy pri otkrytii Imperatorskoi Akademii Khudozhestv dlia publiki," *Sankt-Peterburgskie vedomosti*, no. 216, 22 September 1839. On triennial exhibitions see also M-k-n, "Mysli i zametki po sluchaiu obozreniia vystavki akademii khudozhestv," *Semeinyi krug*, no. 46 (17 November 1860): 156–57. Georgi notes that every year in the 1790s, "for a whole week," the Academy exhibited the most recent works by its students and professors. See Johann Gottlieb Georgi, *Opisanie rossiisko-imperatorskogo stolichnogo goroda Sankt-Peterburga i dostopamiatnostei v okrestnostiakh onogo, s planom* (St. Petersburg: Liga, 1996), 274, 396–97. Cf. Bennett's argument on the self-regulating public in the museum. Tony Bennett, *The Birth of the Museum: History, Theory, Politics* (London: Routledge, 1995).

97. M-k-n, "Mysli i zametki po sluchaiu obozreniia vystavki akademii khudozhestv," 158.

98. "Neskol'ko slov ob akademicheskoi khudozhestvennoi vystavke v 1862 godu," *Sovremennoe slovo*, no. 104, 9 October 1862. For more of similarly negative ("dirty," "stuffy," etc.) descriptions of the Academy, see Bekker, Brodskii, Isakov, 96–101.

99. A. Somov, "Khudozhestvennye zametki," *Illiustratsiia*, no. 251, 3 January 1863.

100. L. M. Zhemchuzhnikov, *Moi vospominaniia iz proshlogo*, ed. A. G. Vereshchagina (Leningrad: "Iskusstvo," 1971), 102, 128.

101. "Fel'eton," *Sovremennoe slovo*, no. 70, 30 March 1863. The sentiment that contemporaries shared was that early in the century, "the Academy of Arts was a closed institution divorced from the public, unlinked to the life of the great capital. The artists were inside; the public were outside." Stites, 317–18. On the history of Academic exhibitions

in general, see S. A. Kasparinskaia-Ovsiannikova, "Vystavki izobraziteľnogo iskusstva v Peterburge i Moskve v poreformennyi period (vtoraia polovina XIX v.)," in *Ocherki istorii muzeinogo dela v SSSR*, vyp. 7 (Moscow: Sovetskaia Rossiia, 1971), 366–99.

102. Lev Zhemchuzhnikov, "Neskoľko zamechanii po povodu poslednei vystavki v S. Peterburgskoi akademii khudozhestv," *Osnova*, no. 2 (February 1861): 137, 154. This article, authored by an artist, was apparently influential in artistic circles. Hundreds of offprints were distributed among the Academy's students. See Zhemchuzhnikov, *Moi vospominaniia iz proshlogo*, 353.

103. Ibid., 101.

104. P. P. Svin'in, *Dostopamiatnosti Sankt-Peterburga i ego okrestnostei* (St. Petersburg: "Liga Plius," 1997), 87. For more on Svin'in's contributions to pictorial and literary patriotism, see Christopher Ely, "The Picturesque and the Holy: Visions of Touristic Space in Russia, 1820–1850," in *Architectures of Russian Identity: 1500 to the Present*, ed. by James Cracraft and Daniel Rowland (Ithaca: Cornell University Press, 2003), 80–90.

105. G. S. Churak, "Private Art Collecting in 19th-Century Russia," in *The Wanderers: Masters of 19th-Century Russian Painting: An Exhibition from the Soviet Union*, ed. Elizabeth Kridl Valkenier (Dallas: Dallas Museum of Art, 1990), 63–64. In 1824, the St. Petersburg Society for the Encouragement of Artists called for an art gallery dedicated exclusively to Russian art: "The glory of Russia demands that a Russian museum or a gallery of the Russian school of art should be established." Komelova, 35. For the prehistory of the Russian Museum, see Kevin Tyner Thomas, "Collecting the Fatherland: Early-Nineteenth-Century Proposals for a Russian National Museum," in *Imperial Russia: New Histories for the Empire*, ed. Jane Burbank and David L. Ransel (Bloomington: Indiana University Press, 1998), 91–107. On earlier attempts to found public museums of art in Russia, such as the Aesthetic Museum in Moscow (proposed in 1831), see also S. A. Ovsiannikova, "Khudozhestvennye muzei Peterburga i Moskvy II-i pol. XIX–nach. XX veka (Ermitazh, Tret'iakovskaia galereia, Russkii muzei)," in *Trudy Nauchno-issledovateľskogo instituta muzeevedeniia*, vol. 7 (Moscow, 1962), 7–11.

106. A. S. Khomiakov, "Pis'ma v Peterburg o vystavke" (1843) and "Pis'mo v Peterburg po povodu zheleznoi dorogi" (1845), *Polnoe sobranie sochinenii Alekseia Stepanovicha Khomiakova*, vol. 3 (Moscow: Univ. tip., 1900), 96, 114.

107. V. Stasov, "Nashi khudozhestvennye dela. Stat'ia vtoraia," *Sankt-Peterburgskie vedomosti*, no. 36, 5 February 1869. Later, Mikhailov also interpreted the 1860s as an aesthetic turning point that marked the beginning of bourgeois art in Russia. See A. I. Mikhailov, "Zametki o razvitii burzhuaznoi zhivopisi v Rossii (60–70 gg. XIX v.)," in *Russkaia zhivopis' XIX veka: Sbornik statei*, ed. V. M. Friche (Moscow: RANION, 1929), 113.

108. V. M. Friche, *Ocherki sotsiaľnoi istorii iskusstva* (Moscow: Novaia Moskva, 1923), 78.

109. "Neskoľko slov ob akademicheskoi khudozhestvennoi vystavke v 1862 godu," *Sovremennoe slovo*, no. 104, 9 October 1862.

110. I., "Vystavka v akademii khudozhestv," *Russkii invalid*, no. 215, 1 October 1863.

111. A. Somov, "Khudozhestvennye zametki," *Illiustratsiia*, no. 251, 3 January 1863.

112. Khudozhnik [F. F. L'vov], "Vospominaniia ob Akademii khudozhestv, 1859–1864," *Russkaia starina*, no.10 (October 1880): 392, 404, 408. From 1859 to 1865, Fedor Lvov was the Conference Secretary of the Academy. The artist N. N. Ge likewise reminisced that neither the library nor the museum was easily accessible to the Academy's students in the 1840s and 1850s. See I. V. Ginzburg, "K istorii Akademii khudozhestv vo

vtoroi polovine XIX veka," in *Voprosy khudozhestvennogo obrazovaniia*, vyp. 9 (Leningrad: Akademiia khudozhestv SSSR, 1974), 6.

113. V. V. Stasov, "Nasha khudozhestvennaia proviziia dlia Londonskoi vystavki (1862)," *Sobranie sochinenii V. V. Stasova, 1847–1886*, vol. 1 (St. Petersburg: Tipografiia M. M. Stasiulevicha, 1894), 74.

114. Critics favored genre painting and landscape during this era as truthful representations of reality. A. V. Prakhov wrote in 1878: "there is just one word on everyone's lips, and, fortunately, on most everyone's mind—truth." As cited in *The Wanderers*, 189.

115. Christopher Ely, *This Meager Nature: Landscape and National Identity in Imperial Russia* (DeKalb: Northern Illinois University Press, 2002), 223.

116. M. I., "Fel'eton. Godichnaia vystavka v Imperatorskoi akademii khudozhestv. III.," *Sankt-Peterburgskie vedomosti*, no. 242, 26 October 1850.

117. "Peterburgskaia letopis," *Sankt-Peterburgskie vedomosti*, no. 204, 17 September 1861.

118. I. E. Repin, *Dalekoe blizkoe*, (Moscow: Iskusstvo, 1944), 158–59, as cited in Kasparinskaia-Ovsiannikova, "Vystavki," 370.

119. "Peterburgskaia letopis," *Sankt-Peterburgskie vedomosti*, no. 202, 18 September 1860. See also K. V., "Fel'eton. Zametka nespetsialista po povodu vystavki v akademii khudozhestv. Beglyi vzgliad na proshloe," *Russkii invalid*, no. 205, 24 September 1860.

120. Moleva and Beliutin, *Russkaia khudozhestvennaia shkola*, 9. In comparison with the overall approval of this new orientation in art, critical voices were few and far between. For an example of a "disappointed" review of the genre see "Vystavka v Akademii khudozhestv," *Illiustratsiia*, no. 73, 11 June 1859.

121. Mikhailov, 91.

122. [S. Diaghilev], "Peredvizhnaia vystavka," *Sergei Diagilev i russkoe iskusstvo: Stat'i, otkrytye pis'ma, interv'iu. Sovremenniki o Diagileve*, ed. I. S. Zil'bershtein and V. A. Samkov, vol. 1 (Moscow: "Izobrazitel'noe iskusstvo," 1982), 68. Originally published in *Novosti i birzhevaia gazeta*, no. 63 and 67 (5 March and 9 March 1897).

123. Pierre Bourdieu, "Outline of a Sociological Theory of Art Perception," *The Field of Cultural Production: Essays on Art and Literature*, ed. Randal Johnson (New York: Columbia University Press, 1993), 217.

124. Ia. D. Minchenkov, *Vospominaniia o peredvizhnikakh*, 6th ed. (Leningrad: "Khudozhnik RSFSR," 1980), 146. I'm grateful to Lev Loseff for bringing this source to my attention.

125. Among many memorable such artists we can name Chartkov from Gogol's story "The Portrait" (1835), the unfortunate Piskarev from "Nevsky Avenue" (*Nevskii prospekt*, 1834), the dilettante Raisky, the protagonist of Goncharov's novel *The Precipice* (*Obryv*, 1869), the title character from Taras Shevchenko's partly autobiographical novella *The Artist* (*Khudozhnik*, 1856), the heroine of Nadezhda Khvoshchinskaia's narrative *The Boarding-School Girl* (*Pansionerka*, 1861), who ends up working as a copyist in the Hermitage museum, and the artist from Chekhov's "The House with the Mezzanine (An Artist's Tale)" (*Dom s mezoninom (rasskaz khudozhnika)*, 1896).

126. K. A. Barsht, "O tipologicheskikh vzaimosviaziakh literatury i zhivopisi (na materiale russkogo iskusstva XIX veka)," in *Russkaia literatura i izobrazitel'noe iskusstvo XVIII–nachala XX veka: Sbornik nauchnykh trudov* ("Nauka": Leningrad, 1988), 5–34, esp. 5, 8. Cf. Aronson and S. Reiser, *Literaturnye kruzhki i salony* (Moscow: "Agraf," 2001), 28.

127. Stasov, "Dvadtsat' piat' let russkogo iskusstva," 496; Rosalind P. Gray, *Russian Genre Painting in the Nineteenth Century* (Oxford: Oxford University Press, 2000),

150–51. Overall, for detailed analysis of Fedotov's paintings, see Gray, *Russian Genre Painting*, 133–51.

128. As cited in Gray, *Russian Genre Painting*, 137.

129. Friche, 101.

130. The text of the poem, "Popravka obstoiatel'stv, ili zhenit'ba maiora (Predislovie k kartine)," appears in *Pavel Andreevich Fedotov: Khudozhnik i poet*, ed. by Ia. D. Leshchinskii (Leningrad: "Iskusstvo," 1946), 146–57. For more on Fedotov's reading see Zhemchuzhnikov, *Moi vospominaniia iz proshlogo*, 109–10.

131. Gray, *Russian Genre Painting*, 143–44. Gray suggests that the major brings in "promising financial prospects" into the impoverished merchant's household; Fedotov's poem seems to imply the opposite scenario.

132. A. Maikov, "Vystavka v Imperatorskoi Akademii Khudozhestv," in *Pavel Andreevich Fedotov: Khudozhnik i poet*, 227. Originally published in *Sovremennik*, December 1849.

133. Stasov, "Dvadtsat' piat' let russkogo iskusstva," 498.

134. G. I. Uspenskii, "Skandal. Obyknovennaia istoriia," *Polnoe sobranie sochinenii*, vol. 1 (Moscow: Izdatel'stvo Akademii nauk SSSR, 1952), 438–55.

135. For more on the artists' social backgrounds, see Valkenier, *Russian Realist Art*, 10–17.

136. See, for instance, "Peterburgskaia letopis'," *Sankt-Peterburgskie vedomosti*, no. 204, 17 September 1861; V. S., "Vystavka v akademii khudozhestv," *Sankt-Peterburgskie vedomosti*, no. 291, 22 October 1870.

137. V. S., "Khudozhestvennye novosti," *Sankt-Peterburgskie vedomosti*, no. 283, 14 October 1871.

138. Kasparinskaia-Ovsiannikova, "Vystavki," 369n.

139. Evgeny Steiner, "Pursuing Independence: Kramskoi and the Peredvizhniki vs. the Academy of Arts," *The Russian Review* 70 (April 2011): 252–71.

5: The Russian Art World in the News

1. As cited in Theophile Gautier, *Russia*, trans. Florence MacIntyre Tyson, vol. 2 (Philadelphia: The John Winston Company, 1905), 249.

2. V. V. Stasov, "Dvadtsat' piat' let russkogo iskusstva," *Sobranie sochinenii V. V. Stasova, 1847–1886*, vol. 1 (St. Petersburg: Tipografiia M. M. Stasiulevicha, 1894), 502–21, 478, 628.

3. K. N. Batiushkov, "Progulka v akademiiu khudozhestv," *Sochineniia*, vol. 2 (St. Petersburg, 1885), 92–117, esp. 108.

4. A. S. Khomiakov, "O vozmozhnosti Russkoi khudozhestvennoi shkoly," *Polnoe sobranie sochinenii Alekseia Stepanovicha Khomiakova*, vol. 1 (Moscow, 1900), 75, 99.

5. Khomiakov's conclusion is that national culture (dukhovnaia lichnost' naroda) can reveal itself only through its own forms. A. S. Khomiakov, "Pis'mo v Peterburg po povodu zheleznoi dorogi," *Polnoe sobranie sochinenii*, vol. 3 (Moscow, 1900); originally published in *Moskvitianin* in 1845.

6. P. V. Delarov, "Karl Briullov i ego znachenie v istorii zhivopisi," *Iskusstvo i khudozhestvennaia promyshlennost'* 2 (1899–1900), 133.

7. Cited in I. V. Ginzburg, "K istorii Akademii khudozhestv vo vtoroi polovine XIX veka," in *Voprosy khudozhestvennogo obrazovaniia*, vyp. 9 (Leningrad, 1974), 4.

8. P. D. Boborykin, *Vospominaniia*, vol. 1 (Moscow: Khudozhestvennaia literatura, 1965), 309.

9. A. I. Mikhailov, "Zametki o razvitii burzhuaznoi zhivopisi v Rossii (60–70 gg. XIX v.)," in *Russkaia zhivopis' XIX veka: Sbornik statei*, ed. Friche, 91.

10. N. Moleva and E. Beliutin, *Russkaia khudozhestvennaia shkola vtoroi poloviny XIX–nachala XX veka* (Moscow: Iskusstvo, 1967), 24.

11. Stasov, "Dvadtsat' piat' let russkogo iskusstva," 540; V. Stasov, "Nashi khudozhestvennye dela. Stat'ia pervaia," *Sankt-Peterburgskie vedomosti*, no. 29, 29 January 1869. Cf. N. Kukol'nik, "Russkaia zhivopisnaia shkola," in *Kartiny russkoi zhivopisi*, ed. N. V. Kukol'nik (St. Petersburg, 1846), 12–14.

12. *The Wanderers: Masters of 19th-Century Russian Painting: An Exhibition from the Soviet Union*, ed. Elizabeth Kridl Valkenier (Dallas: Dallas Museum of Art, 1990), 186.

13. Gautier, vol. 2, 272, 265–67.

14. Stasov, "Dvadtsat' piat' let russkogo iskusstva," 524–26, 634, 624. Alexandre Benois ironically described the "new Russian style" of Thon as an ancient tradition invented "in one sitting" (*v odin priest*). See Aleksandr Benua, "Iskusstvo," in *Rossiia v kontse XIX veka*, ed. V. I. Kovalevskii (St. Petersburg, 1900), 898.

15. Charles A. Moser, *Esthetics as Nightmare: Russian Literary Theory, 1855–1870* (Princeton: Princeton University Press, 1989), xiii. For more on the aesthetic debates of the 1860s see B. F. Egorov, *Bor'ba esteticheskikh idei v Rossii 1860-kh godov* (Leningrad: Iskusstvo, 1991), esp. 34–56.

16. Theodor W. Adorno, *Aesthetic Theory*, trans. and ed. by Robert Hullot-Kentor (Minneapolis: University of Minnesota Press, 1997), 45–61. See also Peter Uwe Hohendahl, "Aesthetic Violence: The Concept of the Ugly in Adorno's *Aesthetic Theory*," *Cultural Critique*, no. 60 (Spring 2005): 170–96.

17. John E. Bowlt, "Russian Painting in the Nineteenth Century," in *Art and Culture in Nineteenth-Century Russia*, ed. Theofanis George Stavrou (Bloomington: Indiana University Press, 1983), 129.

18. V. M. Friche, *Ocherki sotsial'noi istorii iskusstva* (Moscow: Novaia Moskva, 1923), 130. Cf. Bazarov's comments on painting in Turgenev's *Fathers and Sons*.

19. For more on political criticism of art see Elizabeth Kridl Valkenier, *Russian Realist Art: The State and Society:The Peredvizhniki and Their Tradition*, Studies of the Harriman Institute, Columbia University (New York: Columbia University Press, 1989), 19–23.

20. For a discussion of different interfaces between artists and their critics during the age of realism, see Carol Adlam, "Realist Aesthetics in Nineteenth-Century Russian Art Writing," *Slavonic and East European Review* 83, no. 4 (October 2005): 639–63. See also *Russian Visual Arts: Art Criticism in Context, 1814–1909*, eds. Carol Adlam, Alexey Makhrov, and Robert Russell (Sheffield: HRIOnline, 2005. <http://hri.shef.ac.uk/rva/>).

21. Khudozhnik, "Na otvet g-na O. Khudozhniku," *Sovremennaia letopis'*, no. 49 (December 1862): 28.

22. Khudozhnik, "Po povodu zametok o vystavke akademii khudozhestv," *Sovremennaia letopis'*, no. 44 (November 1862): 27.

23. Kaufman, by contrast, emphasizes precisely professional art criticism, the origins of which he traces back to Batiushkov's review of the exhibition at the Academy of Fine Arts in 1814. R. S. Kaufman, *Ocherki istorii russkoi khudozhestvennoi kritiki XIX veka* (Moscow: "Iskusstvo," 1985).

24. N. Dmitriev, "Godichnaia vystavka v S.-Peterburgskoi akademii khudozhestv," *Sovremennaia letopis'*, no. 36 (October 1863): 15.

25. See, for instance, Moser, *Esthetics as Nightmare*; Egorov, *Bor'ba esteticheskikh idei v Rossii 1860-kh godov*; B. F. Egorov, *Izbrannoe: Esteticheskie idei v Rossii XIX veka* (St. Petersburg: Letnii sad, 2009).

26. Stasov, "Dvadtsat' piat' let russkogo iskusstva," 536. Boborykin came up with an interesting term to describe Stasov's ideology that evolved under the strong influence of Chernyshevsky: "nihilism with national undertones" (*nigilizm na natsional'noi podkladke*). Boborykin, *Vospominaniia*, vol. 1, 310.

27. N. G. Chernyshevsky, "The Aesthetic Relation of Art to Reality" (A Dissertation), *Selected Philosophical Essays* (Moscow, 1953), 373–81, 320. For more on Chernyshevsky's aesthetics see, for instance, William F. Woehrlin, *Chernyshevsky: The Man and the Journalist* (Cambridge: Harvard University Press, 1971), 144–86.

28. V. G. Belinskii, Letter to V. P. Botkin, 2–6 December 1847, *Sobranie sochinenii v deviati tomakh*, vol. 9 (Moscow: "Khudozhestvennaia literatura," 1982), 693–94; B. M. Eikhenbaum, *Lev Tolstoi*, part 1 (München: Wilhelm Fink Verlag, 1968), 224ff. I am grateful to Donald Fanger for drawing my attention to these sources.

29. As cited in Bowlt, "Russian Painting in the Nineteenth Century," 128.

30. See Pisarev's review, "Razrushenie estetiki," *Sochineniia D. I. Pisareva: Polnoe sobranie v shesti tomakh, s portretom avtora i stat'ei Evgeniia Solov'eva*, vol. 4 (St. Petersburg: Tip. A. Porokhovshchikova, 1897), 497–516, esp. 502. See also Dmitry Pisarev, "The Realists," in *Russian Philosophy*, ed. James M. Edie, James P. Scanlan, Mary-Barbara Zeldin, vol. 2 (Knoxville: The University of Tennessee Press, 1976), 86.

31. Fedor Dostoevsky, "Mr. –bov and the Question of Art," *Dostoevsky's Occasional Writings*, trans. David Magarshack (Evanston: Northwestern University Press, 1997), 124–25.

32. Robert Louis Jackson, *Dostoevsky's Quest for Form: A Study of His Philosophy of Art* (New Haven: Yale University Press, 1966), 146–48.

33. Dostoevsky wrote in *A Writer's Diary*: "Ia uzhasno liubliu realizm v iskusstve, no u inykh sovremennykh realistov nashikh *net nravstvennogo tsentra* v ikh kartinakh...." F. M. Dostoevskii, *Dnevnik pisatelia za 1877 g.*, *PSS*, vol. 25, 90.

34. F. M. Dostoevskii, "Vystavka v Akademii khudozhestv za 1860–1861 god," *PSS*, vol. 19, 151–68. For more on Dostoevsky's aesthetics see G. M. Fridlender, "Estetika Dostoevskogo," in *Dostoevskii—khudozhnik i myslitel': Sbornik statei* (Moscow: "Khudozhestvennaia literatura," 1972), esp. 145–64. On Iakobi's painting in particular, see Jackson, *Dostoevsky's Quest for Form*, 72–75.

35. Friche, *Ocherki sotsial'noi istorii iskusstva*, 165.

36. V. V. Stasov, "Khudozhestvennaia vystavka za 25 let," *Sobranie sochinenii V. V. Stasova, 1847–1886*, vol. 1 (St. Petersburg: Tipografiia M. M. Stasiulevicha, 1894), 479.

37. Ibid., 479. For more on the evolution of Stasov's aesthetics see G. A. Obraztsov, *Estetika V. V. Stasova i razvitie russkogo natsional'no-realisticheskogo iskusstva* (Leningrad: Izd-vo Leningradskogo universiteta, 1975).

38. Valkenier, *Russian Realist Art*, 19.

39. Moser, 69.

40. Stasov described the Itinerants as follows: "The latest generation of artists has been brought up on Gogol, Ostrovsky and Nekrasov, Belinsky, Dobrolyubov and Pisarev; literary and social themes have been replaced by such issues as 'Who Is At Fault?' and

'What Is To Be Done?' and the majority of compositions of the major European thinkers who were then available in Russian translation. Consequently, since their school days they have felt stifled and uncomfortable within the old school framework of the Academy, with its artificial limitations and guidelines for artistic creation, with its classical trimmings, based on antique statues, paintings by the old masters and assigned, musty subjects..." As cited in *The Wanderers*, 191.

41. Evgeny Steiner, "Pursuing Independence: Kramskoi and the Peredvizhniki vs. the Academy of Arts," *The Russian Review* 70 (April 2011): 253. See also his "A Battle for the 'People's Cause' or for the Market Case: Kramskoi and the Itinerants," *Cahiers du Monde russe*, 50/4 (Octobre-décembre 2009):1-20.

42. For an extensive analysis of these artistic groups, see Steiner, "Pursuing Independence" and Steiner, "A Battle for the 'People's Cause.'"

43. I. E. Repin, *Dalekoe blizkoe* (Leningrad, 1982), 169, as cited in Steiner, "Pursuing Independence," 253.

44. Mikhailov, 93; F. S. Roginskaia, *Tovarishchestvo peredvizhnykh khudozhestvennykh vystavok: Istoricheskie ocherki* (Moscow: "Iskusstvo," 1989), 21. For more on the organization of the Itinerants society, see Valkenier, *Russian Realist Art*, 39.

45. Mikhailov, 93. Financial considerations of The Association of Traveling Art Exhibitions, including exhibitions and sales, were reflected in its foundational Statutes. Valkenier, *Russian Realist Art*, 39.

46. K. V., "Fel'eton. Zametka nespetsialista po povodu vystavki v akademii khudozhestv. Beglyi vzgliad na proshloe," *Russkii invalid*, no. 205, 24 September 1860. Another feuilletonist agreed that the age of traditional patronage had passed and that "the best and the most generous patron was the public." "Iz peterburgskoi zhizni," *Severnaia pochta*, no. 211, 26 September 1863.

47. Christopher Ely, *This Meager Nature: Landscape and National Identity in Imperial Russia* (DeKalb: Northern Illinois University Press, 2002), 196. See also Khudozhnik [F. F. L'vov], "Vospominaniia ob Akademii khudozhestv, 1859-1864," *Russkaia starina*, no.10 (October 1880): 405; V. S., "Eshche o nyneshnei vystavke," *Sankt-Peterburgskie vedomosti*, no. 290, 4 November 1865; V. S., "Vystavka v akademii khudozhestv," *Sankt-Peterburgskie vedomosti*, no. 291, 22 October 1870.

48. Elizabeth Kridl Valkenier, "The Intelligentsia and Art," in *Art and Culture in Nineteenth-Century Russia*, 161.

49. Stasov, "Dvadtsat' piat' let russkogo iskusstva," 543.

50. For an extensive analysis of Perov's artistic career, see Rosalind P. Gray, *Russian Genre Painting in the Nineteenth Century* (Oxford: Oxford University Press, 2000), 155-77.

51. We may also add I. M. Prianishnikov's *Shutniki. Gostinyi dvor v Moskve* (1865), A. M. Volkov's *Obzhornyi riad v Peterburge* (1858), V. E. Makovsky's *Anticipation* (1875), and a plethora of other such topical representations of contemporary Russian reality.

52. Stasov, "Dvadtsat' piat' let russkogo iskusstva," 549. D. V. Grigorovich recalls that Briullov had a "fanatic" following at the Academy after his return from abroad to St. Petersburg in 1836. See D. V. Grigorovich, *Literaturnye vospominaniia* (Leningrad: "Academia," 1928), 71.

53. Dostoevskii, "Po povodu vystavki," *PSS*, vol. 21, 69-70.

54. Ibid., 76. See also Jackson 219-21 for analysis of Dostoevsky's article.

55. Stasov, "Dvadtsat' piat' let russkogo iskusstva," 548.

56. O., "Po povodu vystavki v akademii khudozhestv," *Russkii khudozhestvennyi*

listok, no. 25 (1 September 1860): 93.

57. V. M. Garshin, "Khudozhniki," *Rasskazy* (Moscow, 1976), 106–9.

58. K. A. Barsht, "O tipologicheskikh vzaimosviaziakh literatury i zhivopisi (na materiale russkogo iskusstva XIX veka)," in *Russkaia literatura i izobrazitel'noe iskusstvo XVIII–nachala XX veka: Sbornik nauchnykh trudov* (Leningrad: "Nauka," 1988), 11.

59. Garshin, "Khudozhniki," 106.

60. Gray, *Russian Genre Painting*, 138–41; Valkenier, *Russian Realist Art*, 59–61.

61. There is an inconsistency among scholars as to the precise number of paintings that were displayed: Valkenier provides the number 46; Kasparinskaia-Ovsiannikova, 82.

62. S. A. Kasparinskaia-Ovsiannikova, "Vystavki izobrazitel'nogo iskusstva v Peterburge i Moskve v poreformennyi period (vtoraia polovina XIX v.)," in *Ocherki istorii muzeinogo dela v SSSR*, vyp. 7 (Moscow: Sovetskaia Rossiia, 1971), 377.

63. Valkenier, *Russian Realist Art*, 40.

64. Roginskaia, 18.

65. Friche, *Ocherki sotsial'noi istorii iskusstva*, 112. See also Valkenier, *Russian Realist Art*, 36.

66. Roginskaia, 24.

67. V. S., "Peredvizhnaia vystavka. Stat'ia pervaia," *Sankt-Peterburgskie vedomosti*, no. 333, 3 December 1871.

68. Roginskaia, 26.

69. Valkenier, *Russian Realist Art*, 47.

70. Ibid., 45.

71. As cited in Mikhailov, 105.

72. Gray, *Russian Genre Painting*, 36–37.

73. "Kokorevskaia kartinnaia galereia," *Kartinnye galerei Evropy* 2 (1863): 45–46. Another reporter also believed that the Kokorev Gallery succeeded in being accessible to the public, something that he thought was the primary function of a museum. K. V., "Pis'ma iz Moskvy. (Okonchanie)," *Russkii khudozhestvennyi listok*, no. 29 (10 October 1862): 115–17.

74. Stasov, "Khudozhestvennaia vystavka za 25 let," 483. One reason behind this cultural gravitation toward Moscow was demographic: "In Moscow by 1830 the merchants slightly outnumbered the gentry, but in St. Petersburg there were 42,900 nobles and only 6,800 merchants, many of them of modest means. The rest of the population was made up of a large group of petit bourgeois, a still larger group of recently urbanized peasants, and some 13,000 foreigners (2.9 percent of the population)." Frederick S. Starr, "Russian Art and Society, 1800–1850," in *Art and Culture in Nineteenth-Century Russia*, 98.

75. Richard Stites, *Serfdom, Society, and the Arts in Imperial Russia: The Pleasure and the Power* (New Haven: Yale University Press, 2005), 388.

76. Valkenier has written about Tretiakov at length. See Valkenier, *Russian Realist Art*, esp. 64–65. On Tretiakov's purchases at the first Itinerant exhibition, see Roginskaia, 27. For more on Tretiakov's art patronage and on the developing art market in Moscow in general, see John O. Norman, "Pavel Tretiakov and Merchant Art Patronage, 1850–1900" and John E. Bowlt, "The Moscow Art Market," in *Between Tsar and People: Educated Society and the Quest for Public Identity in Late Imperial Russia*, ed. Edith W. Clowes, Samuel D. Kassow, and James L. West (Princeton: Princeton University Press, 1991), 93–107, 108–28.

77. For more on individual works that were exhibited at the Itinerant exhibitions, as well as Tretiakov's acquisition patterns, see Kasparinskaia-Ovsiannikova, "Vystavki

izobrazitel'nogo iskusstva v Peterburge i Moskve," 366-99.

78. V. S., "Peredvizhnaia vystavka. Stat'ia pervaia," *Sankt-Peterburgskie vedomosti*, no. 333, 3 December 1871.

79. S. A. Ovsiannikova, "Khudozhestvennye muzei Peterburga i Moskvy II-i pol. XIX—nach. XX veka (Ermitazh, Tret'iakovskaia galereia, Russkii muzei)," in *Trudy Nauchno-issledovatel'skogo instituta muzeevedeniia*, vol. 7 (Moscow, 1962), 33-35, 39.

80. A sketch for Vasnetsov's façade repeatedly appeared in the press; the design was implemented in 1902-4. Lisovskii, *"Natsional'nyi stil',"* 262-63. For more on art and identity, see Ely, *This Meager Nature*.

81. *Pavel i Sergei Tret'iakovy: Zhizn'. Kollektsiia. Muzei*, ed. N. N. Mamontova, T. A. Lykova, T. V. Iudenkova (Moskva: Makhaon, 2006), 345-50, 359.

82. *Vasilii Grigor'evich Perov: Ego zhizn' i proizvedeniia: 60 fototipii s ego kartin bez retushi*, ed. N. P. Sobko, D. A. Rovinskii (St. Petersburg, 1892).

83. *Slovar' russkikh khudozhnikov, vaiatelei, zhivopistsev, zodchikh, risoval'shchikov, graverov, litografov...*, ed. N. P. Sobko, 3 vols. (St. Petersburg: Tip. M. M. Stasiulevicha, 1893-99).

84. *Pavel i Sergei Tret'iakovy*, 252. Stasov published his article "Kramskoi po ego pis'mam i stat'iam" in *Vestnik Evropy* (November–December 1887).

85. *Pavel i Sergei Tret'iakovy*, 284, 304.

86. The amount of contemporary writing devoted to his collecting activity and the Itinerant exhibitions, where he made most of his purchases, is so massive as to occupy an entire volume of bibliography. *Tovarishchestvo peredvizhnykh khudozhestvennykh vystavok*, ed. G. Burova, O. Gaponova, V. Rumiantseva, vol. 2 (Obzory vystavok v periodicheskoi pechati) (Moscow: Iskusstvo, 1959). Bibliography on the Tretiakov Gallery in general is extensive. Among earlier catalogues and guides, we find both general-interest editions, such as A. M. Mironov, *Putevoditel' po Moskovskoi gorodskoi khudozhestvennoi galeree P. i S. Tret'iakovykh* (Moscow: Mamontov, 1902), and more specialized volumes, such as one which has younger museumgoers in mind, O. P. Orlova, *Dva poseshcheniia s det'mi Tret'iakovskoi galerei* (Moscow: Mamontov, 1898). Among Soviet publications, A. P. Botkina's *Pavel Mikhailovich Tret'iakov v zhizni i iskusstve* went through five editions (5th ed., Moscow: Iskusstvo, 1995). The most recent volume, *Pavel i Sergei Tret'iakovy*, provides a detailed history and chronology of the collection, as well as excellent illustrations.

87. Storonnii Zritel', "Kartiny V. G. Perova. Khudozhestvennye novosti," *Khudozhestvennyi zhurnal* 3 (St. Petersburg, 1882), 145-50. For Tretiakov's letter, see *Pavel i Sergei Tret'iakovy*, 211.

88. On Stasov's career as an art critic, see Alexey Makhrov, "Defining Art Criticism in Nineteenth-Century Russia: Vladimir Stasov as Independent Critic," in *Critical Exchange: Art Criticism of the Eighteenth and Nineteenth Centuries in Russia and Western Europe*, ed. Carol Adlam and Juliet Simpson (Oxford: Peter Lang, 2009), 207-26.

89. V. V. Stasov, "Pavel Mikhailovich Tret'iakov i ego kartinnaia galereia," *Stat'i i zametki, publikovavshiesia v gazetakh i ne voshedshie v knizhnye izdaniia*, vol. 2 (Moscow: Iskusstvo, 1954), 376-416, esp. 375-88.

90. Stasov's article, "P. M. Tret'iakov i ego kartinnaia galereia," was published in *Russkaia starina* 80 (December 1893). Tretiakov's response appeared in *Moskovskie vedomosti*, no. 342 (1893). "Pis'mo P. M. Tret'iakova V. V. Stasovu ot 11 dekabria 1893," *Stat'i i zametki, publikovavshiesia v gazetakh i ne voshedshie v knizhnye izdaniia*, vol. 2 (Moscow: Iskusstvo, 1954), 432-34.

91. G. G. Miasoedov, "Vstupitel'naia stat'ia k al'bomu 'Dvadtsatipiatiletiia Tovarishchestva peredvizhnykh khudozhestvennykh vystavok,'" in *Tovarishchestvo peredvizhnykh khudozhestvennykh vystavok, 1869–1899: Pis'ma, dokumenty* (Moscow: Iskusstvo, 1987), 533–38.

92. *Tovarishchestvo peredvizhnykh khudozhestvennykh vystavok,* ed. G. Burova, O. Gaponova, V. Rumiantseva, vol. 1 (Perechen' proizvedenii i bibliografiia) (Moscow: Iskusstvo, 1952). The original catalogue, compiled by P. Tretiakov himself, is reproduced in its entirety in *Pavel i Sergei Tret'iakovy.*

93. V. Mikheev, "Russkii peizazh v gorodskoi galeree P. i S. Tret'iakovykh," *Artist* 35 (March 1894):142.

94. I. O., "Pavel Mikhailovich Tret'iakov," *Mir iskusstva* 1 (1899), part II, 45–46. See also P. Polevoi, "Pamiati P. M. Tret'iakova," *Istoricheskii vestnik* 3 (1899): 945–50.

95. D. Mikhailov, "Russkaia etnografiia v muzee imperatora Aleksandra III," *Moskovskie vedomosti,* no. 66, 7 March 1900.

96. Stasov, "Dvadtsat' piat' let russkogo iskusstva," 494. For more on the Russian Museum's history, see *Iz istorii muzeia: Sbornik statei i publikatsii,* ed. I. N. Karasik and E. N. Petrova (St. Petersburg: Gosudarstvennyi Russkii muzei, 1995). See also Jennifer Cahn, "Nikolai Punin and Russian Avant-Garde Museology, 1917–1932" (PhD diss., University of Southern California, 1999).

97. V. V. Stasov, "A. M. Gornostaev," *Vestnik iziashchnykh iskusstv* 6 (1888), 445–50.

98. Ovsiannikova, "Khudozhestvennye muzei Peterburga i Moskvy," 49–50. On the origins of the Russian Museum collection and its various precursors, see G. N. Goldovskii, "Osnovnye etapy formirovaniia kollektsii zhivopisi," in *Iz istorii muzeia: Sbornik statei i publikatsii,* 137; V. A. Gusev, "Vstuplenie," in *Iz istorii muzeia: Sbornik statei i publikatsii,* 6; E. V. Basner, "Nachalo," in *Iz istorii muzeia: Sbornik statei i publikatsii,* 23.

99. Benois referred to it specifically as a "museum of national art" (*muzei natsional'nogo iskusstva*). Aleksandr Benua, *Moi vospominaniia,* 2nd ed., vol. 2 (Moscow: Nauka, 1990), 51. Among other epithets used to describe the museum were *publichnyi, obshchedostupnyi, vsenarodnyi, natsional'nyi;* some authors used "national" and "Russian" interchangeably when referring to the Russian Museum.

100. See, for instance, V. Prokof'ev, "Russkii muzei Imperatora Aleksandra III," *Novoe vremia,* no. 7911, 7 March 1898. See also "Otkrytie Russkogo muzeia Imperatora Aleksandra III," *Sankt-Peterburgskie vedomosti,* no. 65, 8 March 1898; "Smes'. Russkii muzei Imperatora Aleksandra III," *Istoricheskii vestnik* 72 (May 1898): 678–83.

101. Benua, *Moi vospominaniia,* vol. 2, 200–201.

102. A. V. Polovtsov, *Progulka po Russkomu muzeiu Imperatora Aleksandra III v S.-Peterburge* (Moscow, 1900), 14, 16.

103. N. N. Breshko-Breshkovskii, *Russkii muzei Imperatora Aleksandra III* (St. Petersburg, 1904).

104. Polovtsov, 16–17.

105. N. Vrangel', *Russkii muzei Imperatora Aleksandra III* (St. Petersburg, 1904), lx. Ovsiannikova argues that the Russian Museum was very popular among the people; some visitors wrote to the museum's administration requesting that accessible guides to the museum's collection should be published to aid the general public in appreciating Russian art. Ovsiannikova, "Khudozhestvennye muzei Peterburga i Moskvy," 55.

106. Ol'ga Kulibina, *Russkii muzei Imperatora Aleksandra III: Ob"iasnenie k kartinam sostavlennoe dlia naroda Ol'goiu Kulibinoi,* 2nd ed. (St. Petersburg, 1910). See also P. I. Nera-

dovskii, *Iz zhizni khudozhnika* (Leningrad: "Khudozhnik RSFSR," 1965), 9. Neradovskii describes a touching picture of a peasant, caught marveling at Mikhailovskii Palace; having visited the museum several years before, this peasant now brought his grandson to see *The Last Day of Pompeii*. Neradovskii, 107.

107. Polovtsov, 2. According to Ovsiannikova, over 130,000 people visited the museum in 1900; by 1917, the museum received 200,000 visitors a year. See Ovsiannikova, "Khudozhestvennye muzei Peterburga i Moskvy," 54–56. See also G. E. Lebedev, *Gosudarstvennyi Russkii muzei, 1895–1945* (Leningrad: "Iskusstvo," 1946), 67. Cf. data for the Tretiakov gallery: in 1903, the number of visitors reached the "record" number of 130,548 visitors. *Gosudarstvennaia Tret'iakovskaia Galereia: Ocherki istorii, 1856–1917*, ed. Ia. V. Bruk, (Leningrad: "Khudozhnik RSFSR," 1981), 193.

108. On free admission see, for instance, A. S. Suvorin, *Russkii kalendar' na 1904 g.* (St. Petersburg: A. S. Suvorin, 1904); Karl Baedeker, *Russia: A Handbook for Travellers* (Leipzig, New York: 1914). The museum's staff in the 1890s was minimal: only two curators, along with a photographer, a salesperson for publications, doorman, and janitor worked in the museum. V. A. Gusev, "Vstuplenie," in *Iz istorii muzeia: Sbornik statei i publikatsii*, 8. On inexpensive, large-scale reproductions of paintings (*avtotipii*) "for dissemination among the poor classes of the population," see *Mir iskusstva* 1 (1899): 84.

109. Sergei Diaghilev, "O russkikh muzeiakh," *Mir iskusstva*, vol. 6 (1901): 163.

110. Eduard Stark, *Nashi khudozhestvennye sokrovishcha (Russkii muzei Imperatora Aleksandra III)* (St. Petersburg: P. P. Soikin, 1913), 6–7.

111. "Russkii muzei imperatora Aleksandra III," *Novoe vremia*, no. 6877, 23 April 1895. In this article, we find one of the earliest instances when the term "Russkaia kul'tura" was used.

112. Polovtsov, 14–15.

113. Vrangel was particularly scrupulous to observe the absence of some important figures in the collection and the presence of some inferior artists as well. N. Vrangel', *Russkii muzei Imperatora Aleksandra III* (St. Petersburg, 1904), lviii–lix.

114. Breshko-Breshkovskii, iii. Curiously, Neradovskii reminisces that the arrangement of paintings in the Tretiakov Gallery was far from advantageous; rows of paintings covered entire walls from floor to ceiling, and the space was so tight that the numerous visitors could hardly move around. P. I. Neradovskii, *Iz zhizni khudozhnika* (Leningrad: "Khudozhnik RSFSR," 1965), 23.

115. Specifically, E. V. Basner argues that Russian *obshchestvennost'* did not welcome the Russian Museum precisely because of the museum's affinity with the official nationality formula, "Orthodoxy, autocracy, and nationality." E. V. Basner, "Nachalo," in *Iz istorii muzeia: Sbornik statei i publikatsii*, 24.

116. As quoted in I. N. Shuvalova, "Predystoriia," in *Iz istorii muzeia: Sbornik statei i publikatsii*, 22. Tretiakov's gifting of his collection to Moscow was a major catalyst for the formation of the Russian Museum in St. Petersburg. E. V. Basner, "Nachalo," in *Iz istorii muzeia: Sbornik statei i publikatsii*, 23.

117. I. Arsen'ev, "Russkii muzei Imperatora Aleksandra III-go," *Iskusstvo i khudozhestvennaia promyshlennost'* 3, no. 2 (1900–1901): 51.

118. K. Sluchevskii, *Voznikaiushchaia sokrovishchnitsa: Russkii muzei Imperatora Aleksandra III* (St. Petersburg: Tip. M-va vn. del, 1898), 5.

119. This document is reproduced in an album devoted to the museum's centenary, Galina Polikarpova, *100 let Russkogo muzeia v fotografiiakh, 1898–1998* (St. Petersburg: Gosudarstvennyi Russkii muzei, 1998), n.p.

120. K. Voenskii, *Russkii muzei Imperatora Aleksandra III* (St. Petersburg, 1897), 3–5, 18.

121. Polovtsov, 1, 16; see also Kulibina, Stark, Vrangel'.

122. "Russkii muzei Imperatora Aleksandra III," *Niva* 12 (1898): 239–40. Other common epithets used to describe the museum included a "material" (*veshchestvennyi*) monument to Alexander III's peaceful rule and an "edifying monument of national art" (*pouchitel'nyi pamiatnik natsional'nogo iskusstva*). I. Arsen'ev, "Russkii muzei Imperatora Aleksandra III-go," *Iskusstvo i khudozhestvennaia promyshlennost'* 3, no. 2 (1900–1901): 51.

123. Polovtsov, 119, 124.

124. As quoted in I. N. Shuvalova, "Predystoriia," in *Iz istorii muzeia: Sbornik statei i publikatsii*, 21–22.

125. Curiously, the Mikhailovskii Palace was a conspicuous center of artistic life in Russia *before* the museum took up residence inside. Grand Duchess Elena Pavlovna, the patroness of Russian music and the arts, opened her famous salon there soon after the death of her husband, who had held dazzling fetes in the palace (*"blestiashchie prazdniki"*); later on, her daughter, Ekaterina Mikhailovna, continued the tradition. Much like Catherine the Great's Hermitage assemblies, these semiformal gatherings in imperial quarters soon acquired a mythic quality. In the same way as Catherine's Hermitage, this salon was a peculiar island of public culture "by invitation" within the imperial domain, where state patronage advanced Russian arts and society. It also foreshadowed the ambiguous place that the Russian Museum of Alexander III came to occupy in society in the following decades. Grand Duchess Elena Pavlovna was what art historian Vrangel describes as "the soul of that movement which in the 1850s–1860s seized the whole of St. Petersburg." Not only did her salon welcome well-known artists and musicians, among them Anton Rubinstein, but, according to another retrospective account, "in the whole of Russia there was not a single prominent figure (*deiatel'*) in the fields of politics, public life, science, literature, or the arts, who did not have free access to the salon of the great duchess Elena Pavnovna." N. Vrangel', *Russkii muzei Imperatora Aleksandra III: Zhivopis' i skul'ptura* (St. Petersburg: Izd. Russkogo Muzeia Imperatora Aleksandra III, 1904), lii–lvi; Stark, 6; G. E. Lebedev, *Gosudarstvennyi Russkii muzei, 1895–1945* (Leningrad: "Iskusstvo," 1946), 6–7.

126. Voenskii, 19–20; see also Stark, 4.

127. Breshko-Breshkovskii, ii.

128. For more on the formation of the initial exposition, see G. N. Goldovskii, "Osnovnye etapy formirovaniia kollektsii zhivopisi," in *Iz istorii muzeia: Sbornik statei i publikatsii*, 137–53.

129. For more on this collection, which contained 96 items (about one fifth of the total number of paintings at the time of museum's opening), see B. A. Kosolapov, "'Galereia' kniazia A. B. Lobanova-Rostovskogo," in *Iz istorii muzeia: Sbornik statei i publikatsii*, 154–58.

130. Ovsiannikova, "Khudozhestvennye muzei Peterburga i Moskvy," 51–53.

131. Aleksandr Benua, *Moi vospominaniia*, vol. 2, 199.

132. P. I. Neradovskii, *Iz zhizni khudozhnika* (Leningrad: "Khudozhnik RSFSR," 1965), 166.

133. A. Benua, *Russkii muzei Imperatora Aleksandra III* (Moscow, 1906), 3, as cited in E. V. Basner, "Nachalo," in *Iz istorii muzeia: Sbornik statei i publikatsii*, 32.

134. A. Savinov, introduction to P. I. Neradovskii, *Iz zhizni khudozhnika*, 6–7. Neradovskii describes the chaos that ruled the museum in the first decade of its existence in some colorful detail. See especially the chapters "Poriadki muzeia" and "Pervye khraniteli,"

Iz zhizni khudozhnika, 113–22.

135. A. Rostislavov, "A. V. Polovtsov, *Progulka po Russkomu muzeiu Imperatora Aleksandra III v S.-Peterburge*," review, *Mir iskusstva* 5 (1901): 179–80.

136. Benois recalls that Repin enjoyed undisputed prestige in their company. Benua, *Moi vospominaniia*, vol. 2, 49–50.

137. "Zametki," *Mir iskusstva* 1 (1899): 83–84.

138. I. Repin, "Po adresu 'Mira iskusstva,'" *Mir iskusstva* 1 (1899): 1–4.

139. Sergei Diaghilev, "Pis'mo po adresu I. Repina," *Mir iskusstva* 1 (1899): 4–8.

140. Sergei Diaghilev, "O russkikh muzeiakh," *Mir iskusstva* 6 (1901): 168.

6: Built out of Words

1. Anthony D. Smith, *The Ethnic Origins of Nations* (Oxford: Blackwell, 1986), 148.

2. As cited in A. M. Razgon, "Rossiiskii Istoricheskii muzei: Istoriia ego osnovaniia i deiatel'nosti (1872–1917 gg.)," in *Ocherki istorii muzeinogo dela v Rossii*, vyp. 2 (Moscow: Sovetskaia Rossiia, 1960), 232–33.

3. [K. N. Bestuzhev-Riumin], "Sankt-Peterburg. 30-go ianvaria 1873," *Golos*, 31 January 1873, no. 31. "Muzei dolzhen byt' istoricheskim," wrote Bestuzhev-Riumin in the next installment. See "Sankt-Peterburg. 9-go fevralia 1873," *Golos*, no. 41, 10 February 1873.

4. Evgenia Kirichenko, *Russian Design and the Fine Arts, 1750–1917*, comp. Mikhail Anikst (New York: Abrams, 1991), 11. For more on the Russian national style and its several varieties, see also V. G. Lisovskii, *"Natsional'nyi stil'" v arkhitekture Rossii* (Moscow: Sovpadenie, 2000); Wendy R. Salmond, *Arts and Crafts in Late Imperial Russia: Reviving the Kustar Art Industries, 1870–1917* (New York: Cambridge University Press, 1996); Alison Hilton, *Russian Folk Art* (Bloomington: Indiana University Press, 1995); Andrew L. Jenks, *Russia in a Box: Art and Identity in an Age of Revolution* (DeKalb: Northern Illinois University Press, 2005).

5. Kirichenko, *Russian Design and the Fine Arts*, 118.

6. Iv. Zabelin, "Cherty samobytnosti v drevne-russkom zodchestve," *Drevniaia i novaia Rossiia*, no. 4 (April 1878), 185, 189. Zabelin also proposed that genuine Russian style in architecture did not disappear in the eighteenth century but receded to the periphery. See also Lisovskii, *"Natsional'nyi stil',"* 128.

7. Zabelin, "Cherty samobytnosti," 295; Lisovskii, *"Natsional'nyi stil',"* 154.

8. Sergei Makovskii, "Natsional'nyi vopros," *Stranitsy khudozhestvennoi kritiki*, vol. 2 (St. Petersburg: "Panteon," 1909), 30–31.

9. E. I. Kirichenko, E. G. Shcheboleva, *Russkaia provintsiia* (Moscow: "Nash dom—L'Age d'Homme," 1997), 157.

10. For more on Gartman's style in particular and his "iarmorochnaia fantastika," see V. A. Vasina-Grossman, "Musorgskii i Viktor Gartman," in *Khudozhestvennye protsessy v russkoi kul'ture vtoroi poloviny XIX veka*, ed. G. Iu. Sternin (Moscow: Izd-vo "Nauka," 1984), 37–51.

11. V. V. Stasov, "Dvadtsat' piat' let russkogo iskusstva," *Sobranie sochinenii V. V. Stasova, 1847–1886*, vol. 1 (St. Petersburg: Tipografiia M. M. Stasiulevicha, 1894), 643. The first international exhibition to use wooden architecture in the traditional Russian style was the 1867 world's fair in Paris. For more on exhibition pavilions in the Russian style see Iu. A. Nikitin, "Arkhitektura russkikh vystavochnykh pavil'onov na vsemirnykh i mezh-

dunarodnykh vystavkakh," in *Problemy sinteza iskusstv i arkhitektury*, vyp. 7 (Leningrad: Akademiia khudozhestv SSSR, 1977), 68-77.

12. For more on the architecture of the Russian department in Paris see Lisovskii, *"Natsional'nyi stil'*," 234-36.

13. For more on the proliferation of Russian-style architecture in the Russian empire, see Richard Wortman, "The 'Russian Style' in Church Architecture as Imperial Symbol after 1881," in *Architectures of Russian Identity: 1500 to the Present*, ed. James Cracraft and Daniel Rowland (Ithaca: Cornell University Press, 2003), 101-16. On cultural Russification, see *Russification in the Baltic Provinces and Finland, 1855-1914*, ed. Edward C. Thaden (Princeton: Princeton University Press, 1981); Theodore R. Weeks, *Nation and State in Late Imperial Russia: Nationalism and Russification on the Western Frontier, 1863-1914* (DeKalb: Northern Illinois University Press, 1996); *Orientalism and Empire in Russia*, ed. Michael David-Fox, Peter Holquist, Alexander Martin (Bloomington: Slavica, 2006).

14. Quoted in Lisovskii, *"Natsional'nyi stil'*," 165.

15. V. G. Lisovskii, "Peterburgskaia Akademiia khudozhestv i problema 'natsional'nogo stilia,'" in *Problemy razvitiia russkogo iskusstva*, vyp. 8 (Leningrad: Akademiia khudozhestv SSSR, 1976), 26-35.

16. Church architecture of the 1880s (of which the "Savior-on-the-blood" is one flamboyant example) is a typical expression of this later stage of official Russian style, which Wortman discusses in some detail. Richard S. Wortman, *Scenarios of Power: Myth and Ceremony in Russian Monarchy*, vol. 2 (Princeton: Princeton University Press, 2000), 244-49.

17. Sazikov's silversmith workshop, which had produced the prizewinning center-piece for the Russian department at the Great Exhibition in 1851, now specialized in more practical objects that were popular among Russian consumers, such as women's jewelry and tableware. As an indication of the style's omnipresence, Kirichenko also mentions Chekhov's story "The Grasshopper," in which the heroine sets up her dining room in the Russian style. Kirichenko, *Russian Design and the Fine Arts*, 125, 145-53. Among those who designed functional items in the Russian style were V. Gartman, M. Vrubel (ceramics), S. Maliutin (furniture, utensils), and E. Polenova (embroidery, furniture).

18. N. V. Polenova, *Abramtsevo: Vospominaniia* (Moscow: Izd. M. i S. Sabashnikovykh, 1922), 26.

19. All as cited in Rosalind Polly Gray, "Questions of Identity at Abramtsevo," in *Artistic Brotherhoods in the Nineteenth Century*, ed. Laura Morowitz and William Vaughan (Aldershot: Ashgate, 2000), 109.

20. Khodnev, for instance, argued for the establishment of public museums supported by voluntary associations, such as the Free Economic Society (*Vol'noe Ekonomicheskoe obshchestvo*). A. Khodnev, *Ob ustroistve muzeumov, s tsel'iu narodnogo obrazovaniia i prakticheskoi pol'zy* (St. Petersburg, 1862), 10-11. Stasov likewise emphasized the importance of private initiative, independent of government. V. V. Stasov, "Nasha etnograficheskaia vystavka i ee kritiki (1867)," *Sobranie sochinenii V. V. Stasova, 1847-1886*, vol. 3 (St. Petersburg: Tipografiia M. M. Stasiulevicha, 1894), 936; originally, this article appeared in *Sankt-Peterburgskie vedomosti*, no. 179 and no. 182, 1867, under the pseudonym "Ivan Kaverin." On exhibitions in the first half of the nineteenth century, see, for instance, A. I. Mikhailovskaia, "Iz istorii promyshlennykh vystavok v Rossii pervoi poloviny XIX v.: Pervye vserossiiskie promyshlennye vystavki," in *Ocherki istorii muzeinogo dela v Rossii*, vyp. 3 (Moscow, 1961). D. A. Ravikovich, "Muzeinye deiateli i kollektsionery

v Rossii XVIII–nach. XX v.," in *Kontseptual'nye problemy muzeinoi entsiklopedii* (Moscow: Nauchno-issl. in-t kul'tury, 1990), 21–23, 29.

21. The exhibition "Rumiantsevskii muzei v kul'turnoi zhizni Rossii" was on view at A. S. Pushkin Museum on Prechistenka in 2003.

22. For more on the museum's early history see *Putevoditel'*, issued by Moskovskii publichnyi i Rumiantsovskii muzei, vol. 1 (Moscow: Izd-vo L. D. Frenkel', 1923), 9–17; Rosalind P. Gray, *Russian Genre Painting in the Nineteenth Century* (Oxford: Oxford University Press, 2000), 39–40.

23. *Putevoditel'*, 23–24. Later, the Rumiantsev library would form the core of Moscow's former Lenin Library collection, now the Russian State Library. Stasov praised Rumiantsev's collection specifically for its old manuscripts. The year of Rumiantsev's death, 1826, was also the year when Pogodin began amassing his famous library of old manuscripts (*Drevle-khranilishche*). V. V. Stasov, "Rumiantsovskii muzei. Istoriia ego perevoda iz Peterburga v Moskvu v 1860–1861 godakh," *Sobranie sochinenii V. V. Stasova, 1847–1886*, vol. 3 (St. Petersburg: Tipografiia M. M. Stasiulevicha, 1894), 1689–90; see also "Vnutrennee obozrenie," *Sovremennik* 98 (1863): 383ff.

24. *Putevoditel'*, 27.

25. J. G. Kohl, *Russia and the Russians in 1842*, vol. 1 (Ann Arbor: University Microfilms International, 1980), 297.

26. *Piatidesiatiletie Rumiantsovskogo muzeia v Moskve, 1862–1912: Istoricheskii ocherk* (Moscow: T-vo skoropechatni A. A. Levenson, 1913), 95.

27. Ibid., 18, 9.

28. Ibid., 10. The Pashkov House, named after its original owner, the Moscow nobleman Pashkov, was built in Moscow in 1787. *Illiustrirovannyi putevoditel' po etnograficheskomu muzeiu*, rev. ed. (Moscow: Tip. K. L. Men'shova, 1916), 9. On the museum's complex composition see also N. Dmitriev, "Moskovskii publichnyi muzei," *Nashe vremia*, no. 171, 9 August 1862.

29. "Katalog Kartinnogo otdeleniia Moskovskogo Publichnogo Muzeia," *Kartinnye galerei Evropy* 2 (1863): 139–44.

30. A. A-v, "Prianishnikovskaia kartinnaia galereia," *Kartinnye galerei Evropy* 1 (1862): 183; see also I. Anichkov, "Opisanie kartinnoi galerei F. I. Prianishnikova," *Russkii*, no. 14, 26 February 1868; no. 26, 3 June 1868.

31. "Pis'mo iz Moskvy," *Russkii invalid*, no. 112, 22 May 1862.

32. "Otkrytie publichnoi biblioteki i muzeia v Moskve," *Nashe vremia*, no. 100, 12 May 1862.

33. "Obshchestvennye dela. Moskva. Publichnyi muzei," *Syn otechestva*, no. 120, 19 May 1862. This article first appeared in *Moskovskie vedomosti*, 12 May 1862, under M. Longinov's signature.

34. See, for instance, "Iz Moskvy, o zhizni i literature," *Sankt-Peterburgskie vedomosti*, no. 141, 1 July 1862. *The Northern Post* reported 16,000 visitors in the first twenty days of the museum's operations, from May 6 to May 25, with the number reaching 2,300 on the single day of May 25. "Moskovskie pis'ma. IX," *Severnaia pochta*, no. 124, 9 June 1862.

35. *Piatidesiatiletie Rumiantsovskogo muzeia*, 21–22.

36. Stasov, "Rumiantsovskii muzei," 1691–92.

37. Nathaniel Knight and Olga Maiorova have written extensively about this exhibition and its impact on the Russian question; I am omitting many of the insightful details that their studies have uncovered. Ol'ga Maiorova, "Slavianskii s"ezd 1867 goda: Metaforika

torzhestva," *Novoe literaturnoe obozrenie* 51 (2001): 89–110; Nataniel Nait [Nathaniel Knight], "Imperiia napokaz: Vserossiiskaia etnograficheskaia vystavka 1867 goda," *Novoe literaturnoe obozrenie* 51 (2001): 111–31. Razgon also provides a comprehensive survey of ethnographic museums in Russia. A. M. Razgon, "Etnograficheskie muzei v Rossii (1861–1917)," in *Ocherki istorii muzeinogo dela v Rossii*, vyp. 3 (Moscow: Sovetskaia Rossiia, 1961), 230–68. For more on ethnography in Russia see also Knight, "Science, Empire, and Nationality: Ethnography in the Russian Geographical Society, 1845–1855," in *Imperial Russia: New Histories for the Empire*, ed. Jane Burbank and David L. Ransel (Bloomington: Indiana University Press, 1998), 108–41.

38. *Piatidesiatiletie Imperatorskogo obshchestva liubitelei estestvoznaniia, antropologii i etnografii, 1863–1913*, comp. V. V. Bogdanov (Moscow, 1914), 11; Nait, "Imperiia napokaz," 124.

39. The museum's full name was *Dashkovskii Etnograficheskii Muzei, ustroennyi pri sodeistvii Obshchestva Liubitelei Estestvoznaniia pri Moskovskom Universitete*. V. F. Miller, *Sistematicheskoe opisanie kollektsii Dashkovskogo etnograficheskogo muzeia* (Moscow: Tip. E.G. Potapova, 1887), ix. Later on, Dashkov was appointed the director of the Rumiantsev Museum. *Illiustrirovannyi putevoditel' po etnograficheskomu muzeiu*, 11.

40. Maiorova, "Slavianskii s"ezd 1867 goda," 94.

41. A. N. Pypin, *Istoriia russkoi etnografii*, vol. 1 (St. Petersburg: M. M. Stasiulevich, 1890), 15. The exhibition introduced a unifying, ethnic model of self-identification based on ethnicity that was prevalent all over Europe at the time. Maiorova, "Slavianskii s"ezd 1867 goda," 95, 108.

42. Ibid., 111–12.

43. Nait, "Imperiia napokaz," 111–12, 123.

44. Michael Boro Petrovich, *The Emergence of Russian Panslavism, 1856–1870* (Westport: Greenwood Press, 1985), 201–9, 224, 239; *Piatidesiatiletie Imperatorskogo obshchestva liubitelei estestvoznaniia*, 11. For more on the Slav Congress and related matters, see S. A. Nikitin, *Slavianskie komitety v Rossii v 1858–1876 godakh* (Moscow: Izd-vo Moskovskogo universiteta, 1960). See also F. I. Buslaev, *Moi vospominaniia* (Moscow, 1897), 365–66; A. V. Nikitenko, *Zapiski i dnevnik*, vol. 1 (St. Petersburg: A. S. Suvorin, 1893), 150–51, 190.

45. Petrovich, 240.

46. "Moskva, 18-go iiulia," *Moskva*, no. 86, 18 July 1867. Pogodin, too, wrote about the Russian language becoming a "common literary language of all Slavs." M. Pogodin, "Rech' proiznesennaia pered obedom v vospominanie o Slavianskom s"ezde v Moskve, 1867 goda, Maia 16 dnia," *Russkii*, no. 25, 27 May 1868, p. 392. See also Maiorova, "Slavianskii s"ezd 1867 goda," 104–5.

47. Pogodin, "Rech'," 393; see also Maiorova, "Slavianskii s"ezd 1867 goda," 109.

48. "Moskva, 1-go iiulia," *Moskva*, no. 72, 1 July 1867; Pogodin, "Rech'," 387.

49. *Etnograficheskaia vystavka 1867 goda* (Moscow: Tipografiia M. N. Lavrova i ko, 1878), 3; see also Petrovich, 201, for more details.

50. For a detailed discussion of OLEAE, see Joseph Bradley, "Subjects into Citizens: Societies, Civil Society, and Autocracy in Tsarist Russia," *The American Historical Review* 107, no. 4 (October 2002): 1094–123. In broader terms, Bradley discusses the importance of voluntary associations for fostering civil society in nineteenth-century Russia.

51. *Piatidesiatiletie Imperatorskogo obshchestva liubitelei estestvoznaniia*, 5–6, 24.

52. For more on voluntary associations in Russia, see Joseph Bradley, *Voluntary Associations in Tsarist Russia: Science, Patriotism, and Civil Society* (Cambridge: Harvard

University Press, 2009).

53. Ravikovich, "Muzeinye deiateli," 162–63.

54. For a detailed overview of these opinions, see Petrovich, 234 ff.; *Etnograficheskaia vystavka 1867 goda*, 29–36. Both the daily newspapers and more "permanent" publications responded to the exhibition. Aside from other sources quoted in this chapter, the following accounts were available, for instance: N. Ch., "Russkaia etnograficheskaia vystavka v Moskve (pis'ma v redaktsiiu 'SPb. Vedomostei')," *Sankt-Peterburgskie vedomosti*, no. 141, 24 May 1867, as well as the preceding and following issues; "Obshchee obozrenie," *Sankt-Peterburgskie vedomosti*, no. 287, 17 October 1867. Newspapers also advertised the book devoted to the exhibition and the Slav Congress, *Vserossiiskaia etnograficheskaia vystavka i Slavianskii s'ezd v mae 1867 goda* (Moscow: V Univ. tip., 1867); it was announced, for instance, in *Russkii*, no. 5, 15 January 1868, p. 6. In 1862, newspapers publicized an earlier edition on Russian ethnography, issued to coincide with the Millennium: T. de Pauly, *Description ethnographique des peuples de la Russie* (St. Petersburg: F. Bellizard, 1862), which was advertised in "Etnograficheskoe opisanie narodov, obitaiushchikh v Rossii," *Sankt-Peterburgskie vedomosti*, no. 236, 30 October 1862. For more on the Slav Congress see also "Moskva, 21-go marta," *Moskva*, no. 64, 21 March 1867; "Moskva, 10-go noiabria," *Moskva*, no. 176, 10 November 1867, etc.

55. *Etnograficheskaia vystavka 1867 goda*, 32–33.

56. "Obshchee obozrenie," *Sankt-Peterburgskie vedomosti*, no. 285, 15 October 1867.

57. Stasov, "Nasha etnograficheskaia vystavka i ee kritiki (1867)," 939; see also Nait, "Imperiia napokaz," 123–24.

58. "Moskva, 3-go noiabria," *Moskva*, no. 170, 3 November 1867.

59. Stasov, "Nasha etnograficheskaia vystavka i ee kritiki (1867)," 935–48.

60. *Piatidesiatiletie Rumiantsovskogo muzeia*, 179; [S. Maksimov,] "Etnograficheskaia vystavka v Moskve. II," *Golos*, no. 122, 4 May 1867.

61. *Etnograficheskaia vystavka 1867 goda*, 12–15. Regardless of the exhibition's multiethnic component, the organizers and the press rhetorically drew the public's attention away from the Slavic question toward the Russian one (some sources even claimed that the two were basically interchangeable). Above all, the Ethnographic Exhibition in Moscow gave Russians the opportunity to learn about themselves.

62. As cited in Maiorova, "Slavianskii s'ezd 1867 goda," 103.

63. I. S. Aksakov's Pan-Slavist publication received several warnings from the censor and was eventually closed in 1868.

64. Pogodin, "Rech'," 388.

65. *Piatidesiatiletie Rumiantsovskogo muzeia*, 23–24.

66. "Khronika," *Sankt-Peterburgskie vedomosti*, no. 133, 16 May 1872.

67. S. Maksimov, "Etnograficheskaia vystavka v Moskve. I," *Golos*, no. 117, 29 April 1867. Maiorova observes that Moscow served as a "metonymy for all Russia—the patron and the gatherer of the Slavs." Maiorova, "Slavianskii s'ezd 1867 goda," 103.

68. "Kokorevskaia kartinnaia galereia v Moskve," *Russkii listok*, no. 4, 28 January 1862, p. 32–33; K. V., "Khudozhestvennye zametki. II," *Russkii khudozhestvennyi listok*, no. 5, 10 February 1862, p. 21–22. The Gallery survived for less than ten years only, but its impact on Moscow society was strong. Gray, *Russian Genre Painting*, 38.

69. "Moskovskie kartinnye galerei (chastnykh liubitelei)," *Kartinnye galerei Evropy* 2 (1863): 221–28; "Kartinnaia galereia K. T. Soldatenkova," *Kartinnye galerei Evropy* 1 (1862): 210–14.

70. "Vnutrennie izvestiia. Golitsynskii muzeum v Moskve," *Russkii invalid*, no. 283,

20 December 1864; see also "Golitsynskaia kartinnaia galereia," *Kartinnye galerei Evropy* 2 (1863): 117–20.

71. *Piatidesiatiletie Rumiantsovskogo muzeia*, 163. For more on the importance of the systematic organization of art in Russian museums, see Gray, *Russian Genre Painting*, 38.

72. A. Somov, "Kartinnaia galereia grafa Kusheleva," *Illiustratsiia*, no. 249, 13 December 1862; no. 250, 20 December 1862. See also Geraldine Norman, *The Hermitage: The Biography of a Great Museum* (New York: Fromm International, 1998), 106–7; "Spisok kartin prinesennykh v dar S.-Peterburgskoi Akademii Khudozhestv pokoinym grafom N. A. Kushelevym-Bezborodko," *Kartinnye galerei Evropy* 2 (1863): 163–79. See also I. V. Ginzburg, "K istorii Akademii khudozhestv vo vtoroi polovine XIX veka," in *Voprosy khudozhestvennogo obrazovaniia*, vyp. 9 (Leningrad: Akademiia khudozhestv SSSR, 1974), 9.

73. This collection was started by A. S. Stroganov during the age of Catherine the Great. According to the 1793 catalogue, Stroganov's museum contained 87 paintings by 55 masters, including works by Poussin, Ruisdael, Greuze, Van Dyck. Even then, contemporaries recognized the collection as noteworthy: by the early nineteenth century, it was a popular destination for both local and foreign visitors. See O. B. Artamonova, "K voprosy o kollektsionirovanii zapadnoevropeiskoi zhivopisi grafom A. S. Stroganovym," in *Kollektsionery i metsenaty v Sankt-Peterburge, 1703–1917: Tezisy dokladov konferentsii* (St. Petersburg: Gosudarstvennyi Ermitazh, 1995), 6–8; A. A-v, "Galereia grafa S. G. Stroganova (v S. Peterburge)," *Kartinnye galerei Evropy* 2 (1863): 245–50.

74. "Leikhtenbergskaia galereia v S.-Peterburge," *Kartinnye galerei Evropy* 1 (1862): 231ff.

75. L. F. Panteleev, *Vospominaniia*, edited by S. A. Reiser (Moscow: Gos. izd-vo khudozh. lit-ry, 1958), 226. Newspapers, too, supported this discussion on capital cities. See, for instance, "Nechto po povodu stolits," *Golos*, no. 100, 26 April 1863.

76. On the Moscow Kremlin as a center of enlightenment and the arts see, for instance, Moskovskii publichnyi i Rumiantsovskii muzei, *Torzhestvennoe zasedanie v pamiat' grafa N. P. Rumiantsova, 3 aprelia 1897 g.* (Moscow: V. V. Chicherin, 1897), 6–7.

77. For more on Moscow's symbolism as the center of national culture, see Gray, *Russian Genre Painting*, 38–39; Camilla Gray, *The Russian Experiment in Art, 1863–1922*, ed. Marian Burleigh-Motley, rev. and enl. ed. (New York: Thames and Hudson, 1986), 10; Wortman, *Scenarios of Power*, vol. 2, 207.

78. Lisovskii, "*Natsional'nyi stil'*," 165, 196–97; Kirichenko, *Russian Design and the Fine Arts*, 113.

79. "Iz Moskvy, o zhizni i literature," *Sankt-Peterburgskie vedomosti*, no. 141, 1 July 1862.

80. "Moskovskie pis'ma. IX," *Severnaia pochta*, no. 124, 9 June 1862.

81. K. V., "Pis'ma iz Moskvy. I.," *Russkii khudozhestvennyi listok*, no. 24, 20 August 1862, p. 91.

82. D., "Neskol'ko slov o khudozhestvennykh muzeiakh," *Birzhevye vedomosti*, no. 321, 2 December 1864.

83. "Khudozhestvennaia deiatel'nost' v Moskve," *Sankt-Peterburgskie vedomosti*, no. 44, 28 February 1862.

84. The exhibition was referred to as "a festival of public activity" in "Otkrytie Politekhnicheskoi vystavki," *Vestnik Moskovskoi Politekhnicheskoi vystavki*, no. 31, 31 May 1872. I. L. Zhuravskaia, "K istorii Politekhnicheskoi vystavki v Moskve," in *Istoricheskii muzei: Entsiklopediia otechestvennoi istorii i kul'tury*, ed. V. L. Egorov (Moscow: Gosudarstvennyi

istoricheskii muzei, 1995), 10–21. For the number of visitors on individual days, see, for instance, Obmokni, "Vystavochnyi fel'eton. Prolog," *Vestnik Moskovskoi Politekhnicheskoi vystavki*, no. 82, 21 July 1872.

85. Joseph Bradley, "Pictures at an Exhibition: Science, Patriotism, and Civil Society in Imperial Russia," *Slavic Review* 67, no. 4 (Winter 2008): 965. See also his "Voluntary Associations, Civic Culture, and *Obshchestvennost'* in Moscow," in *Between Tsar and People: Educated Society and the Quest for Public Identity in Late Imperial Russia*, ed. Edith W. Clowes, Samuel D. Kassow, and James L. West (Princeton: Princeton University Press, 1991), 131–48. The contemporary press was keen on emphasizing that the exhibition was the "first major enterprise" organized by the private sector (*chastnaia initsiativa*). See, for instance, Obmokni, "Vystavochnyi fel'eton. Glava shestaia i posledniaia," *Vestnik Moskovskoi Politekhnicheskoi vystavki*, no. 127, 4 September 1872.

86. N. M., "Po povodu vystavki, ustroennoi v Moskve v pamiat' dvukhsotletnego iubileia Petra Velikogo," *Gramotei*, no. 9 (1872): 47–67. Among many others, the term "restaurant" was also included.

87. "Moskva, 1-go maia," *Vestnik Moskovskoi Politekhnicheskoi vystavki*, no. 1, 1 May 1872.

88. The first exhibition of manufacture took place in Russia in 1829; between then and 1861, eleven such exhibitions were organized. E. I. Kirichenko, "K voprosu o pore-formennykh vystavkakh Rossii kak vyrazhenii istoricheskogo svoeobraziia arkhitektury vtoroi poloviny XIX v.," in *Khudozhestvennye protsessy v russkoi kul'ture vtoroi poloviny XIX veka*, ed. G. Iu. Sternin (Moscow: Izd-vo "Nauka," 1984), 91. The competition between the two cities and their respective exhibitions was so obvious that even foreign observers noticed it. "Anglichane o vystavke. Korrespondentsiia v 'Daily Telegraph,'" *Vestnik Moskovskoi Politekhnicheskoi vystavki*, no. 73, 12 July 1872.

89. "Vnutrennie izvestiia. Neskol'ko slov o vystavke 1861 goda," *Russkii invalid*, no. 192, 3 September 1861.

90. K. V., "Voprosy, vozbuzhdennye poslednei vystavkoi manufakturnykh proizve-denii," *Russkii khudozhestvennyi listok*, no. 27, 20 September 1861.

91. K. Skal'kovskii, "Vserossiiskaia Manufakturnaia vystavka v promyshlennom otnoshenii," *Sankt-Peterburgskie vedomosti*, no. 186, 9 July 1870; no. 145, 28 May 1870. See also other installments of the same article: *Sankt-Peterburgskie vedomosti*, no. 150, 3 June 1870; no. 156, 9 June 1870; no. 160, 13 June 1870. An extensive catalogue was published on this occasion as well: *Ukazatel' Vserossiiskoi Manufakturnoi vystavki 1870 goda v S.-Peter-burge* (St. Petersburg, 1870). Nikitenko thought that the overall appearance of the exhibition was "majestic and elegant" (*Obshchii vid velichestven i iziashchen*). Nikitenko, vol. 1, 237.

92. N. N., "Nedel'nye ocherki i kartinki," *Sankt-Peterburgskie vedomosti*, no. 141, 24 May 1870.

93. For more on the foundation of the museum see Razgon, "Rossiiskii Istoricheskii muzei," 235–39.

94. O. M. Lebedinskaia, "Istoricheskii muzei v kul'turnoi zhizni Rossii (1872–1917 gg.). Istochniki i istoriografiia problemy," in *Istoricheskii muzei: Entsiklopediia otechestven-noi istorii i kul'tury*, 26.

95. One guidebook elaborated on the intricate connection between the exhibits from different eras in the Sevastopol pavilion: "In their entirety, the various collections of this department narrate with great feeling the valorous heroic deeds, which mark the contemporary history of the same very Rus' that nine hundred years earlier, in the vicinity

of the very same Sevastopol, in ancient Chersonesus, won itself glory not only through military action, but what is most important, through the acceptance of the Christian faith from the Greeks." *Imperatorskii rossiiskii istoricheskii muzei: ukazatel' pamiatnikov*, 2nd ed. (Moscow: Tip. A. I. Mamontova, 1893), iii. The city was originally called Korsun'; the Greeks called it Chersonesus; later, the Slavs called it Kherson.

96. "Peterburg, 29-go maia," *Sankt-Peterburgskie vedomosti*, no. 147, 30 May 1872.

97. N. S. Stromilov, "Petrovskii muzei. Istoricheskii otdel Politekhnicheskoi Vystavki," *Vestnik Moskovskoi Politekhnicheskoi vystavki*, no. 124, 1 September 1872.

98. V. Kachenovskii, "Istoricheskii otdel," *Vestnik Moskovskoi Politekhnicheskoi vystavki*, no. 107, 15 August 1872.

99. N. S. Stromilov, "Pamiatniki Petru Velikomu v Rossii," *Vestnik Moskovskoi Politekhnicheskoi vystavki*, no. 107, 15 August 1872; S. Liubetskii, "Otkrytie pamiatnika Petru I Ekaterinoiu II," *Vestnik Moskovskoi Politekhnicheskoi vystavki*, no. 6, 6 May 1872; L. Lupakov, "Obshchestvennye uveseleniia pri Petre I," *Vestnik Moskovskoi Politekhnicheskoi vystavki*, no. 74, 13 July 1872; "Iz zhizni i deianii Petra Velikogo," *Peterburgskaia gazeta*, no. 73, 16 May 1872; "Peterburg pri Petre Velikom," *Peterburgskii listok*, no. 95, 16 May 1872; no. 96, 17 May 1872. For discussion of Peter's bicentennial, see also Wortman, *Scenarios of Power*, vol. 2, 120–23.

100. "Otkrytie Politekhnicheskoi vystavki," *Vestnik Moskovskoi Politekhnicheskoi vystavki*, no. 31, 31 May 1872.

101. "Iubilei Petra I (itogi)," *Peterburgskii listok*, no. 117, 17 June 1872.

102. Kirichenko considers 1872 to be the beginning of a new tradition in the architecture of exhibitions. See Kirichenko, "K voprosu o poreformennykh vystavkakh," 119.

103. Cf. Walter Benjamin, *The Arcades Project*, trans. Howard Eiland and Kevin McLaughlin (Cambridge: Belknap Press, 1999).

104. Zhuravskaia, 11; Lisovskii, "*Natsional'nyi stil'*," 135; Marietta Shaginian, *Pervaia Vserossiiskaia. Roman-khronika* (Moscow: Molodaia gvardiia, 1965), 82; V. Kachenovskii, "Istoricheskii otdel," *Vestnik Moskovskoi Politekhnicheskoi vystavki*, no. 107, 15 August 1872.

105. "Anglichane o vystavke. Korrespondentsiia v 'Daily Telegraph,'" *Vestnik Moskovskoi Politekhnicheskoi vystavki*, no. 73, 12 July 1872.

106. As Wortman argues, Russianness became a matter of official taste during the reign of Alexander III.

107. "Moskva, 1-go Maia," *Vestnik Moskovskoi Politekhnicheskoi vystavki*, no. 1, 1 May 1872. See also *Vestnik Moskovskoi Politekhnicheskoi vystavki*, no. 18, 18 May 1872; no. 29, 29 May 1872; no. 67, 6 July 1872. By all counts, the Department of Turkestan was one of the most popular ones; see, for instance, Obmokni's account of it in the issue no. 91, dated 30 July 1872. Amidst other sundry details, the newspaper reported that one litterateur—Turgenev—attended the exhibition. Many other newspapers and journals wrote about the exhibition as well. See, for example, "Vnutrennee obozrenie," *Niva* 3, no. 20 (1872): 317–18.

108. "Obmokni" is possibly a playful allusion to Gogol's fragment "The Lawsuit" (*Tiazhba*), where one character puts this word in place of her signature, which leads to a comic confusion after her death. Subsequently, "Obmokni" has come to allude ironically to any illegible scribbling.

109. Igor' Sviatoslavich, "Moskva v 1882 g. (Iz zapisok puteshestvennika)," *Vestnik Moskovskoi Politekhnicheskoi vystavki*, no. 114, 22 August 1872. Cf. another fictional narrative by Marietta Shaginian, *The First All-Russian Exhibition, A Novel-Chronicle* (*Pervaia*

Vserossiiskaia. Roman-khronika, 1965).

110. As cited in Kevin Tyner Thomas, "Collecting the Fatherland: Early-Nineteenth-Century Proposals for a Russian National Museum," in *Imperial Russia: New Histories for the Empire*, ed. Jane Burbank and David L. Ransel (Bloomington: Indiana University Press, 1998), 92–93. See also E. N. Mastenitsa, "Muzei v formirovanii mentaliteta," in *Psikhologiia Peterburga i peterburzhtsev za tri stoletiia: Materialy Rossiiskoi nauchnoi konferentsii 25 maia 1999 g.* (St. Petersburg: Nestor, 1999), 17–21.

111. As cited in I. A. Shalina, "Kollektsiia ikon M. P. Pogodina," in *Iz istorii muzeia: Sbornik statei i publikatsii*, ed. I. N. Karasik and E. N. Petrova (St. Petersburg: Gosudarstvennyi Russkii muzei, 1995), 22.

112. In 1864, an interesting museum project circulated in the press: the so-called "Central" (*tsentral'nyi*) museum, which was envisioned to embrace all existing museums of the Academy of Sciences in St. Petersburg. See "Tsentral'nyi muzeum v S. Peterburge," *Severnaia pchela*, no. 220, 30 August 1864.

113. Moskovskii publichnyi i Rumiantsevskii muzei, *Putevoditel'*, 30, 39. By the 1920s, its collections were disbanded and divided between various museums, whereas its depository of books and manuscripts formed the foundation for Moscow's Lenin Library in 1925. N. M. Polunina, A. I. Frolov, *Osnovateli: Rossiiskie prosvetiteli* (Moscow: Sovetskaia Rossiia, 1990), 131. For more on the history of the Rumiantsev Museum in general see K. I. Kestner, *Materialy dlia istoricheskogo opisaniia Rumiantsovskogo muzeuma* (Moscow: Rumiantsevskii muzeum, 1882).

114. K. N. Bestuzhev-Riumin, "Sankt-Peterburg. 30-go ianvaria 1873," *Golos*, no. 31, 31 January 1873. To judge by recorded numbers, the plenitude of museums that Bestuzhev-Riumin alludes to is an exaggeration.

115. Stasov, "Dvadtsat' piat' let russkogo iskusstva," 494.

116. The history of the museum's name offers an insightful commentary on two conflicting narratives in Russian history, the national and the imperial. Initially, Colonel Chepelevsky referred to the museum as *Russkii natsional'nyi muzei* in his report to the heir; officially, however, the museum became known as *Imperatorskii Rossiiskii Istoricheskii Muzei*. Later in the century, contemporaries again referred to it as "national": *natsional'nyi muzei Imperatora Aleksandra III*. At earlier stages of the museum's history, the two adjectives, "russkii" and "rossiiskii," seemed to be largely interchangeable. Adelung's 1817 proposal was titled "Predlozhenie ob uchrezhdenii russkogo natsional'nogo muzeia," whereas several years later, Wichmann proposed a similar institution called "Rossiiskii otechestvennyi muzei." Razgon, "Rossiiskii Istoricheskii muzei," 226–28, 236; Thomas, "Collecting the Fatherland," 91–107; *Imperatorskii rossiiskii istoricheskii muzei: Ukazatel' pamiatnikov*, iv; *Nedelia stroitelia*, no. 44 (1896): 213.

117. Lebedinskaia, 26. For more on the foundation of the museum, see Razgon, "Rossiiskii Istoricheskii muzei," 235–39. A detailed chronology of the museum can be found in *Otchet Imperatorskogo Rossiiskogo Istoricheskogo Muzeia imeni Imperatora Aleksandra III v Moskve za 1883–1908 gody* (Moscow: Sinodal'naia tip., 1916).

118. "Muzei imeni Gosudaria Naslednika Tsesarevicha v Moskve," *Russkaia starina* 11 (November 1874): 595; Razgon, "Rossiiskii Istoricheskii muzei," 242.

119. "Kokorevskaia kartinnaia galereia," *Kartinnye galerei Evropy* 2 (1863): 46. See also "Moskovskie zametki," *Golos*, no. 235, 26 August 1875.

120. "Sankt-Peterburg. 30-go ianvaria 1873," *Golos*, no. 31, 31 January 1873. The press also designated the Historical Museum as the "main" museum in the country. "Moskovskie zametki," *Golos*, no. 235, 26 August 1875; "Muzei imeni Gosudaria Nasled-

nika Tsesarevicha v Moskve," *Russkaia starina* 11 (November 1874): 597. See also V. I. Sizov, "Istoricheskii muzei v Moskve," *Iskusstvo i khudozhestvennaia promyshlennost'*, no. 8 (May 1899): 638.

121. "Moskovskie zametki," *Golos*, no. 235, 26 August 1875. On the Rumiantsev Museum's role in energizing society's interest in Russian history, see *Sbornik materialov dlia istorii Rumiantsevskogo muzeia*, vyp. 1 (Moscow: Izd. Moskovskogo publichnogo i Rumiantsevskogo muzeev, 1882), 2.

122. "Muzei imeni Gosudaria Naslednika Tsesarevicha v Moskve," *Russkaia starina* 11 (November 1874): 591, 596; D. Kasitsyn, "Iz dorozhnykh nabliudenii. Berlinskii Korolevskii Muzei," *Moskovskie vedomosti*, no. 19, 21 January 1876; I. E. Zabelin, as cited in Razgon, "Rossiiskii Istoricheskii muzei," 271.

123. On the museum's library, composed of a number of distinguished collections (for instance, the Golitsyn and the Chertkov libraries, which specialized in Russian history), see *Otchet Imperatorskogo Rossiiskogo Istoricheskogo Muzeia*. For a description of the museum's auditorium, planned to seat 500 people, see "Moskovskii istoricheskii muzei po proektu gg. Semenova i Sherbuta," *Russkii mir*, no. 174, 27 September 1875.

124. "Moskovskie zametki," *Golos*, no. 235, 26 August 1875.

125. "Muzei imeni Gosudaria Naslednika Tsesarevicha v Moskve," *Russkaia starina* 11 (November 1874): 596.

126. E. I. Kirichenko, "Istorizm myshleniia i tip muzeinogo zdaniia v russkoi arkhitekture serediny i vtoroi poloviny XIX v.," in *Vzaimosviaz' iskusstv v khudozhestvennom razvitii Rossii vtoroi poloviny XIX veka: Ideinye printsipy, strukturnye osobennosti*, ed. G. Iu. Sternin (Moscow: Izd-vo "Nauka," 1982), 138. See also "Vnutrennee ubranstvo budushchego istoricheskogo muzeia v Moskve," *Istoricheskii vestnik* 3 (1880): 211–13.

127. Kirichenko, "Istorizm myshleniia," 131.

128. Lisovskii, *"Natsional'nyi stil',"* 127–39.

129. "Moskovskie zametki," *Golos*, no. 235, 26 August 1875.

130. As cited in Kirichenko, "Istorizm myshleniia," 137.

131. D. Kasitsyn, "Iz dorozhnykh nabliudenii. Berlinskii Korolevskii Muzei," *Moskovskie vedomosti*, no. 19, 21 January 1876; "Iz Moskvy, 18-go avgusta," *Golos*, no. 229, 20 August 1875. Cf. "Moskovskie zametki," *Golos*, no. 235, 26 August 1875.

132. Annie E. Coombes, "Museums and the Formation of National and Cultural Identities," *The Oxford Art Journal* 11, no. 2 (1988): 65. The Soviet scholar A. M. Razgon used a different set of prototypes for a national museum, including the National Archaeological Museum in Copenhagen (1807), the Versailles (1848), and the National Museum in Nuremberg (1855). The Museum in Nuremberg, similar to the projected Russian National Museum, was at its origin mostly a collection of historical artifacts. Razgon, "Rossiiskii Istoricheskii muzei," 227. For more on the German National Museum in Nuremberg see Detlef Hoffmann, "The German Art Museum and the History of the Nation," in *Museum Culture: Histories, Discourses, Spectacles*, ed. Daniel J. Sherman and Irit Rogoff (Minneapolis: University of Minnesota Press, 1994), 3–21, esp. 6–8.

133. "Museums," in *The New Encyclopedia Britannica*, 15th ed., vol. 24 (Chicago: Encyclopedia Britannica, 1994), 485.

134. "Moskovskie zametki," *Golos*, no. 235, 26 August 1875.

135. "Muzei imeni Gosudaria Naslednika Tsesarevicha v Moskve," *Russkaia starina* 11 (November 1874): 592, emphasis added.

136. *Svedeniia ob ustroistve muzeia imeni Gosudaria Naslednika Tsesarevicha*

(Moscow, 1874), 8.

137. *Novoe vremia*, 20 October 1881, 7 November 1881; *Sovremennye izvestiia*, 22 October 1881; *Golos*, 7 May 1882.

138. As cited in Lebedinskaia, 25, 29n. See also N. A. Mal'tseva, "Rossiiskii Istoricheskii muzei i vopros ob uchrezhdenii natsional'nogo muzeia im. 300-letiia Doma Romanovykh," in *Istoricheskii muzei: Entsiklopediia otechestvennoi istorii i kul'tury*, 30–41.

139. When, after decades of inactivity, the museum reopened in 2002, it reentered the public sphere via commentary in the press as much as via exhibitions and catalogues.

7: National Revival Writ Large

1. Ostrovsky's play was originally published in the journal *Vestnik Evropy*, no. 9 (1873).

2. M. M. Prishvin, *Rodniki Berendeia, Sobranie sochinenii*, vol. 3 (Moscow: Gosudarstvennoe izdatel'stvo, 1927–1930). Significantly, local historians (*kraevedy*) criticized Prishvin precisely for mistakes in details that resulted from the author's liberal mixing of fact and fiction. See, for instance, N. P. Antsiferov, "Belletristy-kraevedy: Vopros o sviazi kraevedeniia s khudozhestvennoi literaturoi," *Kraevedenie*, no. 1 (1927): 31–46. Iu. M. Nagibin, *Berendeev les: Rasskazy, ocherki* (Moscow: Sovetskii pisatel', 1978).

3. S. K. Makovskii, *Talashkino: Izdeliia masterskikh kn. M. Kl. Tenishevoi* (St. Petersburg: Izdanie "Sodruzhestva," 1905), 44.

4. Sverkhshtatnyi arkheolog, "Neskol'ko slov o polozhenii nashikh arkheologicheskikh pamiatnikov," *Drevniaia i novaia Rossiia*, no. 11 (1875): 275–79. Among other essays on old Russian architecture and art, the following ones also appeared in the journal *Drevniaia i novaia Rossiia*: P. Chaev, "O russkom starinnom tserkovnom zodchestve," no. 6 (1875): 141–53; E. Barsov, "Severnye narodnye skazaniia o drevne-russkikh kniaz'iakh i tsariakh," no. 9 (1879): 400–413; I. Zabelin, "Cherty samobytnosti v drevne-russkom zodchestve," no. 3 (1878): 185–203 and no. 4 (1878): 281–303.

5. N. M. Karamzin, "Russkaia starina," *Vestnik Evropy*, no. 20 (1802): 251. Earlier, the short-lived journal *Starina i novizna*, which compiled poetry, translations, and materials drawn from history and geography, was published in St. Petersburg by V. G. Ruban in 1772.

6. N. M. Karamzin, "Istoricheskie vospominaniia i zamechaniia na puti k Troitse," *Vestnik Evropy*, no. 15 (1802): 207–26.

7. A. S. Pushkin, *Ruslan i Liudmila, Polnoe sobranie sochinenii v desiati tomakh*, vol. 4 (Moscow: Izd-vo Akademii nauk SSSR, 1963), 13. Cf. the "original": "A tale of the times of old! The deeds of the days of other years!" *The Works of Ossian, the Son of Fingal*, trans. from the Gaelic language by James Macpherson, 3rd. ed., 2 vols. (London, 1765). By 1820, when Pushkin's poem was published, doubt about Ossian's authenticity and the whole controversy that followed Macpherson's publication in Britain from the very beginning had reached Russia, and the poet's irony could not be missed.

8. For more on the presence of Ossian in Russian culture, see Iu. D. Levin, *Ossian v russkoi literature: konets XVIII-pervaia tret' XIX veka* (Leningrad: Nauka, 1980). The first Russian translation by A. I. Dmitriev appeared in 1788. During the last two decades of the eighteenth and the first three of the nineteenth century, 188 various translations, adaptations, variations, critical articles and reminiscences dealing with Ossian appeared in Russia. V. I. Maslov, *Ossian v Rossii (Bibliografiia)* (Leningrad: Izd. Otd-niia gumanitarnykh nauk

Akademii nauk SSSR, 1928).

9. F. G. Solntsev, *Drevnosti Rossiiskogo gosudarstva*, 6 vols. (Moscow: V tip. Aleksandra Semena, 1849–1865). Solntsev made over 3000 drawings of Russian weapons, religious utensils, church decorations, armor, and collectible items from the Kremlin Armory. About 500 of them were published. Mary Stuart, *Aristocrat-Librarian in Service to the Tsar: Aleksei Nikolaevich Olenin and the Imperial Public Library* (New York: Columbia University Press, 1986), 109. I'm grateful to Richard Wortman for bringing this source to my attention. On Solntsev, see *Visualizing Russia: Fedor Solntsev and Crafting a National Past*, ed. Cynthia Hyla Whittaker (Leiden: Brill, 2010). See also Anne Odom, "Fedor Solntsev, the Kremlin Service, and the Origins of the Russian Style," *Hillwood Studies*, no. 1 (Fall 1991): 3; Anne Odom, "Fabergé: The Moscow Workshops," in *Fabergé: Imperial Jeweler*, ed. Géza von Habsburg and Marina Lopato (New York: Harry N. Abrams, 1993), 106–7.

10. Unpublished proposal, as quoted in Stuart, *Aristocrat-Librarian in Service to the Tsar*, 108.

11. Solntsev's magnificent volume was recently reissued as part of the ongoing restoration of the pre-Soviet version of national culture, with many rare printed sources from the imperial period returning to circulation in the form of glamorous reprints. See, for instance, *Drevnosti Rossiiskogo gosudarstva*, ed. E. S. Davydova (Moscow: Belyi gorod, 2007).

12. The once forgotten Solntsev, too, returns today as a national hero, with a new museum devoted to him that opened in 2004 and several commemorative editions reissued in 2007. Thus, as the latest edition of *Antiquities* claims, not only individual books, albums, and names, but entire layers of national culture have been usefully reclaimed by post-Soviet Russia. V. I. Shevchenko, "Sokrovishche istorii i khudozhestva," in *Drevnosti Rossiiskogo gosudarstva* (Moscow: Belyi gorod, 2007), 27–29.

13. Galina Smorodinova, "Pavel Ovchinnikov and Russian Gold- and Silversmithery," in *The Fabulous Epoch of Fabergé. St. Petersburg—Paris—Moscow: Exhibition at the Catherine Palace in Tsarskoye Selo* (Moscow: Nord, 1992), 58; Anne Odom, "Fabergé: The Moscow Workshops," in *Fabergé: Imperial Jeweler*, ed. Géza von Habsburg and Marina Lopato (New York: Harry N. Abrams, 1993), 109–15.

14. Among these editions were *Russkaia starina v pamiatnikakh tserkovnogo i grazhdanskogo zodchestva*, complied by I. M. Snegirev and A. A. Martynov (1848), and 6 volumes of Snegirev's *Pamiatniki drevnego khudozhestva v Rossii* (1850–54). See Karen Kettering, "Decoration and Disconnection: The *Russkii stil'* and Russian Decorative Arts at Nineteenth-Century American World's Fairs," in *Russian Art and the West: A Century of Dialogue in Painting, Architecture, and the Decorative Arts*, ed. Rosalind P. Blakesley and Susan E. Reid (DeKalb: Northern Illinois University Press, 2007), 62–63.

15. V. V. Stasov, *Russkii narodnyi ornament* (St. Petersburg: Tip. T-va Obshchestvennoi pol'zy, 1872). Thirty plates from Stasov's volume were published in English in 1976. See V. Stasov, *Russian Peasant Design Motifs for Needleworkers and Craftsmen* (New York: Dover Publications, Inc., 1976).

16. Odom, "Fabergé: The Moscow Workshops," 106–7.

17. Among many other volumes that used *starina* prominently in their titles were I. Ia. Krasnitskii's *Tverskaia starina: Ocherki istorii, drevnostei i etnografii* (1876), A. Sapunov's *Vitebskaia starina* (1883), A. A. Titov's *Rostovskaia starina* (1883), E. N. Opochinin's *Teatral'naia starina: Istoricheskie stat'i, ocherki po dokumentam, melochi i kur'ezy* (1902). *Starina, pamiatniki, predaniia i legendy prikamskogo kraia* compiled by V. F. Kudriavtsev

was originally published as part of Viatka gubernia calendar for 1897. A book of memoirs by V. P. Karpov, *Khar'kovskaia starina: Iz vospominanii starozhila 1830-1860 gg.*, came out in 1900. Another such volume was authored by Ivan Poboinin, *Toropetskaia starina: Istoricheskie ocherki goroda Toroptsa s drevneishikh vremen do kontsa XVII veka*, issued by the Imperial Society for History and Antiquities of Russia at Moscow University (*Imperatorskoe obshchestvo istorii i drevnostei rossiiskikh pri Moskovskom Universitete*) in 1902.

18. The "old days" (*starina*) of the title refers, in this case, to the 17th century, the golden pre-Petrine age of Russian history when the tsar Aleksei Mikhailovich ruled. D. V. Averkiev, *Kashirskaia starina*, in *Russkaia drama epokhi A. N. Ostrovskogo*, ed. A. I. Zhuravleva (Moscow: Izd-vo Moskovskogo univ-ta, 1984), 283-354. Biographical and autobiographical works likewise deployed the *starina* appellation to frame personal narratives. Among others, the Slavophile Nadezhda Sokhanskaia authored a novella titled "The Days of Old: The Family's Memory" (1861) that chronicles the history of the narrator's family. N. S. Sokhanskaia, *Starina: Semeinaia pamiat'*, in *Povesti Kokhanovskoi*, vol. 1 (Moscow: V tipografii Bakhmeteva, 1863), 181-267.

19. G. P. Danilevskii, *Semeinaia starina* (St. Petersburg: Izd. A. S. Suvorina, 1887). Among other thematically related narratives is an unfinished fragment "Days of Old" ("Starina") by Mel'nikov-Pecherskii, documenting the life of one noble lady. P. I. Mel'nikov, "Starina," *Polnoe sobranie sochinenii P. I. Mel'nikova (Andreia Pecherskogo)*, vol. 6 (Petrograd, 1915), 169-85. Several poetic compilations contributed to the cult of antiquity as well, including a volume devoted to archaic imagery in poetry, *Russkaia starina v rodnoi poezii: Illiustrirovannyi sbornik stikhotvornykh obraztsov s primechaniiami i slovarem*, issued by P. P. Romanovich in 1890, and *Sedaia starina: Desiat' byval'shchin*, published by A. Korinfskii in 1912, which contained ten poetic adaptations of well-known *byliny*.

20. During the 49 years that it was in circulation, *Russkaia starina* definitely made a public statement on Russian history and culture, which remains relevant to this day, to judge by the 2008 reprint of the journal's entire 175 volumes. *Russkaia starina: Ezhemesiachnoe istoricheskoe izdanie*, reprint edition of 1870-1918, 175 vols. (St. Petersburg: Al'faret, 2008). Other periodical publications included the monthly *The Olden Days of Kiev* (*Kievskaia starina*, 1882-1906), dealing with the history, archaeology, ethnography, and literature of Ukraine; *The Olden and Modern Times: A Historical Compilation* (*Starina i novizna: Istoricheskii sbornik, 1897-1917*); *The Olden Days of Smolensk* (*Smolenskaia starina*, 1909-1916); and *The Musical Past* (*Muzykal'naia starina*, 1903-1911), containing materials for the history of music in Russia.

21. Index of all materials that appeared in the journal can be found in *Sistematicheskii ukazatel' statei istoricheskogo zhurnala "Drevniaia i novaia Rossiia," 1875-1881* (St. Petersburg: Izdanie A. S. Suvorina, 1893). See, for instance, K. Bestuzhev-Riumin, "Chemu uchit russkaia istoriia," *Drevniaia i novaia Rossiia*, no. 1 (1877): 5-25; Iv. Zabelin, "Cherty samobytnosti v drevne-russkom zodchestve," *Drevniaia i novaia Rossiia*, no. 4 (April 1878).

22. *Drevniaia i novaia Rossiia* 1 (1875): 108. Also included in this volume are the illustrations of old vases and crosses, along with portraits of historical figures.

23. "Ob izdanii sbornika 'Drevniaia i novaia Rossiia' v 1875 g.," *Drevniaia i novaia Rossiia* 1 (1875): n.p.

24. For more, see Kh. M. Tur'inskaia, "Etnomuzeevedcheskaia mysl' v zhurnale 'Zhivaia starina' (1890-1916)," *Gumanitarnaia kul'tura i etnoidentifikatsiia* 2 (2005): 270-79.

25. Popular journals, such as *The Cornfield*, likewise publicized designs in the Russian

style. Among many other things, *The Cornfield* published drawings of traditional wooden churches in its pages. "Pamiatniki drevnego russkogo zodchestva," *Niva* (1898): 715–16.

26. As cited in L. Zhuravleva, *Kniaginia Mariia Tenisheva* (Smolensk: "Poligramma," 1994), 256.

27. Alison Hilton, *Russian Folk Art* (Bloomington: Indiana University Press, 1994), 4, 216, 223.

28. Ibid., 220.

29. Wendy Salmond, "A Matter of Give and Take: Peasant Crafts and Their Revival in Late Imperial Russia," *Design Issues* 13, no. 1 (Spring 1997): 6.

30. Wendy R. Salmond, *Arts and Crafts in Late Imperial Russia: Reviving the Kustar Art Industries, 1870–1917* (New York: Cambridge University Press, 1996), 15.

31. Ibid., 144.

32. Hilton, *Russian Folk Art*, 227–29.

33. Salmond, "A Matter of Give and Take," 7.

34. Hilton, *Russian Folk Art*, 217–18.

35. As cited in Richard Taruskin, *Stravinsky and the Russian Traditions: A Biography of the Works Through Mavra*, vol. 1 (Oxford: Oxford University Press, 1996), 516.

36. As cited in Hilton, *Russian Folk Art*, 233.

37. Aleksandr Benua, "Kustarnaia vystavka," *Mir iskusstva*, no. 3 (1902): 48, as cited in N. Lapshina, "Mir iskusstva": Ocherki istorii i tvorcheskoi praktiki (Moscow: Iskusstvo, 1977), 68.

38. See G. Iu. Sternin, "Abramtsevo—'tip zhizni' i tip iskusstva," in *Abramtsevo: Khudozhestvennyi kruzhok. Zhivopis', grafika, skul'ptura, teatr, masterskie* (Leningrad: "Khudozhnik RSFSR," 1988), 7–23.

39. For more, see V. S. Mamontov, *Vospominaniia o russkikh khudozhnikakh (Abramtsevskii khudozhestvennyi kruzhok)* (Moscow: Izd-vo Akademii khudozhestv SSSR, 1950), 4. These memoirs are authored by Mamontov's son; although often impressionistic, they help re-create the overall atmosphere of Abramtsevo.

40. N. V. Polenova, *Abramtsevo: Vospominaniia* (Moscow: Izd. M. i S. Sabash-nikovykh, 1922), 5.

41. Prominent Soviet art historian Sternin underscored the double temporality of this "nest of culture," as he calls Abramtsevo, pointing to several contexts of Russian contemporaneity in which it simultaneously existed. G. Iu. Sternin, *Russkaia khudozhest-vennaia kul'tura vtoroi poloviny XIX–nachala XX veka* (Moscow: Sovetskii khudozhnik, 1984), 187.

42. As cited in Rosalind Polly Gray, "Questions of Identity at Abramtsevo," in *Artistic Brotherhoods in the Nineteenth Century*, ed. Laura Morowitz and William Vaughan (Alder-shot: Ashgate, 2000), 113.

43. Ibid., 117.

44. Polenova, 40–42.

45. Aleksandr Benua, *Moi vospominaniia v piati knigakh*, vol. 2 (Moscow: Nauka, 1990), 210–11.

46. Nekto X [M. Gor'kii], "M. Vrubel' i 'Printsessa Greza' Rostana," *Nizhegorodskii listok*, no. 202, 24 July 1896. In 1896, Gorky wrote for *Nizhegorodskii listok* a series of feuilletons devoted to the all-Russian exhibition in Nizhnii Novgorod, titled "Beglye zametki." The exchange continued in the newspapers *Volgar'*, *Nedelia*, and *Nizhegorodskaia pochta*.

47. Nekto X [M. Gor'kii], "Beglye zametki," *Nizhegorodskii listok*, no. 209, 31 July 1896.

48. Nekto X [M. Gor'kii], "Beglye zametki," *Nizhegorodskii listok*, no. 229, 20 August 1896. For more on Nizhnii Novgorod fair, see *Nizhegorodskaia iarmarka v vospominaniiakh sovremennikov*, ed. N. A. Bogoroditskaia (Nizhnii Novgorod: [s.n.], 2000); Anne Lincoln Fitzpatrick, *The Great Russian Fair: Nizhnii Novgorod, 1840–1890* (New York: St. Martin's Press, 1990).

49. Stuart R. Grover, "Savva Mamontov and the Mamontov Circle, 1870–1905: Artistic Patronage and the Rise of Nationalism in Russian Art" (PhD diss., University of Wisconsin, 1971), 314.

50. The article "Infinite Joy" was published on March 9, 1898. Grover, "Savva Mamontov and the Mamontov Circle," 314.

51. Sergei Diaghilev, "K vystavke V. M. Vasnetsova," *Mir iskusstva* 1 (1898): 66–67. See also in the same volume "Zametki," *Mir iskusstva* 1 (1898): 82.

52. Several case studies of the national revival in architecture and applied art, including discussion of vernacular styles in Russia, Poland, Hungary, Finland, England, Japan, and Ireland, are collected in *Art and the National Dream: The Search for Vernacular Expression in Turn-of-the-Century Design*, ed. Nicola Gordon Bowe (Dublin: Irish Academic Press, 1993). What all these national traditions had in common, as Bowe points out in the "Introduction," was the vernacular idiom of national Romanticism. See also Albert Streen, "Tradition and Revival: The Past in Norway's National Consciousness," in *Norwegian Folk Art: The Migration of a Tradition* (New York: Abbeville Press, 1995), 249–56; Bratislav Pantelić, "Nationalism and Architecture: The Creation of a National Style in Serbian Architecture and Its Political Implications," *The Journal of the Society of Architectural Historians* 56, no. 1 (March 1997): 16–41; on the medievalizing spirit in German nineteenth-century architecture, see Barbara Miller Lane, "National Romanticism in Modern German Architecture," in *Nationalism in the Visual Arts*, ed. Richard A. Etlin (Washington: National Gallery of Art, 1991), 111–44.

53. Salmond, "A Matter of Give and Take," 6.

54. Hilton, *Russian Folk Art*, 223–25.

55. Salmond, *Arts and Crafts*, 93.

56. *Niva*, no. 11 (1902).

57. V. P. Bezobrazov, *Otchet o Vserossiiskoi khudozhestvenno-promyshlennoi vystavke 1882 goda v Moskve*, as quoted in Lewis H. Siegelbaum, "Exhibiting *Kustar'* Industry in Late Imperial Russia/Exhibiting Late Imperial Russia in *Kustar'* Industry," in *Transforming Peasants: Society, State and the Peasantry, 1861–1930*, ed. Judith Pallot (New York: St. Martin's Press, 1998), 38–39.

58. Salmond, *Arts and Crafts*, 85–86.

59. Polenova, *Abramtsevo*, 59.

60. Ibid., 67–68.

61. Salmond, *Arts and Crafts*, 37–38; Polenova, *Abramtsevo*, 88, 96.

62. *Moscow Past and Present*, as cited in Salmond, *Arts and Crafts*, 144.

63. See *Rech'*, 20 March 1913; *Den'*, 12 March 1903; S. Liubosh', "V kustarnom tsarstve," *Rech'*, 11 March 1913, as cited in Siegelbaum, "Exhibiting *Kustar'* Industry," 55.

64. The story of Tenisheva's life is still being reconstructed, complicated as it is by missing or destroyed archival materials. This discussion is not a part of a biography. On the contrary, it draws upon the often anecdotal information that represented Tenisheva and her many projects in the contemporary press. The point here is to look at the slice of public culture as it was being made in a dialogue between a variety of sources and persons. L.

Zhuravleva published extensively on different aspects of Tenisheva's life and art. Her publications include *Teremok* (Moscow, 1974), *"Pridite i vladeite mudrye—"* (Smolensk, 1990), *Talashkino: Ocherk-putevoditel'* (Moscow, 1989), *Kniaginia Mariia Tenisheva* (Smolensk, 1992), *Tenishevskii muzei "Russkaia starina"* (Smolensk, 1998). See also A. I. Frolov, "Mariia Tenisheva," ch. in *Osnovateli rossiiskikh muzeev* (Moscow, 1991), 62–79. A. A. Aronov, "Mariia Klavdievna Tenisheva (1867–1928), ch. in *Zolotoi vek russkogo metsenatstva* (Moscow: Izd-vo Moskovskogo gos. universiteta kul'tury, 1995), 56–77. In 2008, the 150th anniversary of Tenisheva's birth was celebrated in cultural centers across the country. See exhibition catalogues, *Sobranie kniagini M. K. Tenishevoi: K 110-letiiu Russkogo muzeia* (St. Petersburg: Palace Editions, 2008) and *Kniaginia Mariia Tenisheva v zerkale Serebrianogo veka* (Moscow: GIM, 2008).

65. Mariia Tenisheva, *Vpechatleniia moei zhizni* (Moscow: Molodaia gvardiia, 2006), 362; Dzhesko Ozer, *Mir emalei kniagini Marii Tenishevoi* [*Princess Maria Tenisheva and Her World of Enamels*] (Moscow: Ozer Dzh., 2004), 34.

66. Tenisheva, *Vpechatleniia*, 362.

67. Salmond, *Arts and Crafts*, 142.

68. Tenisheva, *Vpechatleniia*, 226.

69. N. Breshko-Breshkovskii, "V skazochnom tsarstve," *Novyi mir* 23 (1905).

70. Tenisheva, *Vpechatleniia*, 214.

71. Ibid., 344–45.

72. Benua, *Moi vospominaniia v piati knigakh*, vol. 2, 197.

73. Makovskii, *Talashkino*, 54.

74. Tenisheva, *Vpechatleniia*, 234.

75. The exhibition "Objets d'art russes anciens faisant partie des collections de la Princesse Marie Tenichév exposés au muse des arts décoratifs" was on display between May 10 and October 10, 1907. Ozer, 33.

76. See, for instance, C. De Danilovicz, "Talashkino: Princess Tenishef's School of Russian Applied Art," *The International Studio* 32, no. 126 (August 1907): 135; K. R. Cain, "Talachino [sic]: A Home for Russian Folk Art," *The Craftsman* 27, no. 1 (October 1914): 92–96.

77. Tenisheva, *Vpechatleniia*, 366.

78. As cited in Zhuravleva, *Kniaginia Mariia Tenisheva*, 243.

79. As cited in A. N. Savinov, *Pavel Egorovich Shcherbov* (Leningrad: Khudozhnik RSFSR, 1969), 72.

80. As cited in Savinov, 58.

81. Tenisheva, *Vpechatleniia*, 291.

82. Makovskii, *Talashkino*, 64–65.

83. A. N. Ostrovskii, *Snegurochka: Vesenniaia skazka v chetyrekh deistviiakh s prologom*, *Polnoe sobranie sochinenii v dvenadtsati tomakh*, vol. 7 (Moscow: "Iskusstvo," 1977), 432.

84. Vladimir Dal', *Tolkovyi slovar' zhivogo velikorusskogo iazyka*, vol. 1 (Moscow: "Terra," 2000; reprint of 1903–9 edition), 204. For more on the origin of Berendeevka, see L. A. Rozanova, "Berendei i ikh tsar' kak nositeli russkogo natsional'nogo kharaktera," in *Natsional'nyi kharakter i russkaia kul'turnaia traditsiia v tvorchestve A. N. Ostrovskogo*. Materialy nauchno-prakticheskoi konferentsii 27–28 marta 1998 goda, part II (Kostroma: "Evrika-M," 1998), 23.

85. L. Lotman, "Primechaniia," in Ostrovskii, *Snegurochka*, 588–89.

86. V. A. Zhukovskii, "Skazka o tsare Berendee, o syne ego Ivane-tsareviche, o

khitrostiakh Koshcheia bessmertnogo i o premudrosti Mar'i-tsarevny, Koshcheevoi docheri," *Sobranie sochinenii v 4 tomakh*, vol. 3 (Moscow: Gos. izd-vo khudozhestvennoi lit-ry, 1960), 157–69. Gogol considered Zhukovsky's folktale to be "purely Russian." Ibid., 537. See also S. V. Berezkina, "Pushkinskaia fol'klornaia zapis' i 'Skazka o tsare Berendee' V. A. Zhukovskogo," in *Pushkin: Issledovaniia i materialy*, vol. 13 (Leningrad: Nauka, 1989), 267–78.

87. Aleksandr Afanas'ev, *Mify, pover'ia i sueveriia slavian: Poeticheskie vozzreniia slavian na prirodu*, vol. 2 (Moscow: EKSMO, 2002), 604–6. Cf. other versions where Snezhevinochka turns into a pink flower or a reed. Ibid., 472–73.

88. For more on Vasnetsov's sets, see V. V. Stasov, "Viktor Mikhailovich Vasnetsov i ego raboty," *Stat'i i zametki, publikovavshiesia v gazetakh i ne voshedshie v knizhnye izdaniia*, vol. 2 (Moscow: Izd-vo Akademii khudozhestv SSSR, 1954), 207; V. V. Stasov, "Tsar' Berendei i ego palata," *Iskusstvo i khudozhestvennaia promyshlennost'*," no. 1 and 2 (1898): 97–98.

89. E. Khmelevskaia, "Primechaniia," in A. N. Ostrovskii, *Snegurochka*, 594.

90. For a detailed history of Mamontov's opera see Chapter IV in Grover, "Savva Mamontov and the Mamontov Circle," 293ff. See also Taruskin, *Stravinsky and the Russian Traditions*, vol. 1, 492–95.

91. For more on Ostrovsky's play and its reception, see T. Shakh-Azizova, "Real'nost' i fantaziia ('Snegurochka' A. N. Ostrovskogo i ee sud'ba v russkom iskusstve poslednei treti XIX i nachala XX v.)," in *Vzaimosviaz' iskusstv v khudozhestvennom razvitii Rossii vtoroi poloviny XIX veka: Ideinye printsipy, strukturnye osobennosti*, ed. G. Iu. Sternin (Moscow: Izd-vo "Nauka," 1982), 219–63. In the 1900–1901 season, another three premieres of *Snegurochka* took place. After the play, now accompanied with music by A. T. Grechaninov, failed at MKhT, Meyerhold opined that *The Snow Maiden* must have outlived its time. Shakh-Azizova concludes that overall, there were no successful productions of *Snegurochka*.

92. S. I. Mamontov's letter to Albert Carré, 15 December 1907, as cited in Janet Kennedy, "Pride and Prejudice: Serge Diaghilev, the Ballet Russes, and the French Public," in *Art, Culture, and National Identity in Fin-de-siècle Europe*, ed. Michelle Facos and Sharon L. Hirsh (New York: Cambridge University Press, 2003), 104.

93. Tenisheva, *Vpechatleniia*, 363–66.

94. Alexandre Vassiliev, *Beauty in Exile: The Artists, Models, and Nobility Who Fled the Russian Revolution and Influenced the World of Fashion*, trans. Antonina W. Bouis and Anya Kucharev (New York: Harry N. Abrams, 2000), 12–13.

95. X., "Pis'mo v redaktsiiu SPb. Vedomostei. O 'Snegurochke,'" *Sankt-Peterburgskie vedomosti*, no. 140, 1873, in *Kriticheskie kommentarii k sochineniiam A. N. Ostrovskogo: Khronologicheskii sbornik kritiko-bibliograficheskikh statei*, ed. by V. Zelinskii, part IV (Moscow: Tip. Vil'de, 1914), 151–57. For other unfavorable responses to Ostrovsky's new play, see Khmelevskaia, "Primechaniia," in Ostrovskii, *Snegurochka*, 590–95.

96. Z. [V. Burenin], "Zhurnalistika," *Sankt-Peterburgskie vedomosti*, no. 250 (1873), in *Kriticheskie kommentarii k sochineniiam A. N. Ostrovskogo*, part IV, 167–68. For more on V. P. Burenin's contribution to contemporary public culture, see B. B. Glinskii, *Sredi literatorov i uchenykh: Biografii, nekrologi, kharakteristiki, vospominaniia, vstrechi* (St. Petersburg, 1914); idem., "*Novoe vremia" (1876–1916): Istoricheskii ocherk* (Petrograd: Tip. T-va A. S. Suvorina "Novoe vremia," 1916), 28–34. As Glinskii points out, although Burenin was loathed in liberal circles for his scathing style of criticism, especially during his tenure at Suvorin's *The New Time*, everybody continued to read his feuilletons on the sly.

97. S. G. V. [S. T. Gertso-Vinogradskii], "Ocherki sovremennoi zhurnalistiki," *Odesskii vestnik*, no. 212 (1873), in *Kriticheskie kommentarii k sochineniiam A. N. Ostrovskogo*, part IV, 175.

98. Minaev, "Vesennie zametki 'Iskry' (vchera, segodnia i zavtra)," *Iskra*, no. 30 (27 May 1873): 7.

99. "Russkaia literatura," *Syn otechestva*, no. 212 (1873), in *Kriticheskie kommentarii k sochineniiam A. N. Ostrovskogo*, part IV, 157–61; Z. [V. Burenin], "Zhurnalistika," 161–73; S. G. V. [S. T. Gertso-Vinogradskii], "Ocherki sovremennoi zhurnalistiki," 173–80.

100. X., "Pis'mo v redaktsiiu Spb. Vedomostei. O 'Snegurochke,'" *Sankt-Peterburgskie vedomosti*, no. 140 (1873), in *Kriticheskie kommentarii k sochineniiam A. N. Ostrovskogo*, part IV, 151–57.

101. S. G. V. [S. T. Gertso-Vinogradskii], "Ocherki sovremennoi zhurnalistiki," 193.

102. I. A. Goncharov, "Materialy, zagotovliaemye dlia kriticheskoi stat'i ob Ostrovskom," in *Pamiati A. N. Ostrovskogo: Sbornik statei ob Ostrovskom i neizdannye trudy ego*, ed. E. P. Karpov (Petrograd: Put' k znaniiu, 1923), 18, 10.

103. Stasov, "Viktor Mikhailovich Vasnetsov i ego raboty," 207–9.

104. Ostrovskii, *Snegurochka*, 365, 408–9.

105. For further details on Vasnetsov's design, see Evgenia Kirichenko, *Russian Design and the Fine Arts, 1750–1917*, comp. Mikhail Anikst (New York: Abrams, 1991), 152–53.

106. *Art et industrie* was published by N. P. Sobko in St. Petersburg in 1898–1902.

107. Polenova, *Abramtsevo*, 84.

108. Stasov, "Tsar' Berendei i ego palata," 97–98.

109. Stasov, "Viktor Mikhailovich Vasnetsov i ego raboty," 186. Stasov's article was initially published in *Iskusstvo i khudozhestvennaia promyshlennost'*, nos. 1 and 2 (1898).

110. Emphasis in the original. V. V. Stasov, "Moi adres publike," *Izbrannye sochineniia v trekh tomakh*, vol. 3 (Moscow: Iskusstvo, 1952), 266. This article, written in 1899, was first published in *Novosti i birzhevaia gazeta*, no. 43, 12 February 1899.

111. Emphasis added. Stasov, "Viktor Mikhailovich Vasnetsov i ego raboty," 212.

112. Stasov, "Moi adres publike," 267.

113. For more examples of the rhetoric of miracles in Stasov's writing on Vasnetsov, see Stasov, "Tsar' Berendei i ego palata," 97–98.

114. Stasov, "Viktor Mikhailovich Vasnetsov i ego raboty," 189. See also T. Shakh-Azizova, 219–63.

115. N. Leskov, *Skaz o tul'skom Levshe i o stal'noi blokhe (Tsekhovaia legenda)*(St. Petersburg: Tip. Suvorina, 1882).

116. A. M. Panchenko, "Leskovskii Levsha kak natsional'naia problema," *Russkaia istoriia i kul'tura: Raboty raznykh let* (St. Petersburg: Iuna, 1999), 448.

117. Nikolai Leskov, "Lefty, Being the Tale of Cross-Eyed Lefty of Tula and the Steel Flea," *The Enchanted Wanderer and Other Stories*, trans. George H. Hanna (Moscow: Progress, 1974), 286.

118. N. S. Leskov, "Levsha (skaz o tul'skom kosom levshe i o stal'noi blokhe)," *Sobranie sochinenii*, vol. 7 (Moscow: Gos. izd-vo khudozhestvennoi literatury, 1958), 50–52.

119. Leskov, "Lefty," 298–99; slightly modified translation. For the original, see Leskov, "Levsha (skaz o tul'skom kosom levshe i o stal'noi blokhe)," 58–59.

120. Panchenko, "Leskovskii Levsha kak natsional'naia problema," 451–52.

121. N. S. Leskov, "O russkom levshe (literaturnoe ob"iasnenie)," *Sobranie sochinenii*, vol. 11 (Moscow: Gos. izd-vo khudozhestvennoi literatury, 1958), 219.

122. See, for instance, *Golos*, no. 152, 8 June 1882; *Novoe vremia*, no. 2224, 30 May 1882; *Otechestvennye zapiski*, no. 6, part II (1882): 257. Also *Vestnik Evropy*, no. 7 (1882), journal cover, n.p.

123. Italics and quotation marks in the original. Leskov, "O russkom levshe," 219–20. Originally published in *Novoe vremia*, no. 2256, 11 June 1882. Leskov responded directly to the unsigned "Malen'kii fel'eton" in *Novoe vremia*, no. 2244, 30 May 1882. See B. Ia. Bukhshtab, "Primechaniia," in N. S. Leskov, *Sobranie sochinenii*, vol. 7 (Moscow: Gos. izd-vo khudozhestvennoi literatury, 1958), 498–504.

124. James B. Campbell, *Campbell's Illustrated History of The Paris International Exposition Universelle of 1900* (Chicago: Chicago & Omaha Publishing Co., 1900), n.p.

125. M., "Vsemirnaia vystavka v Parizhe 1900-go goda. Pis'mo vrotoe," *Vestnik Evropy* 5 (May 1900): 320–321. For other installments by the same author see M., "Vsemirnaia vystavka v Parizhe 1900-go goda. Pis'mo pervoe," *Vestnik Evropy* 4 (April 1900): 781–91; M., "Vsemirnaia vystavka v Parizhe 1900-go goda. Pis'mo tret'e," *Vestnik Evropy* 7 (July 1900): 309–40.

126. David C. Fisher, "Exhibiting Russia at the World's Fairs, 1851–1900" (PhD diss., Indiana University, 2003), 125–26. For more on the 1900 International Exhibition in general, see Richard D. Mandell, *Paris 1900: The Great World's Fair* (Toronto: University of Toronto Press, 1967).

127. Makovskii, *Talashkino*, 37.

128. Maria V. Nashchokina, "Russia at the International Exhibitions of the Late 19th and early 20th Centuries (architectural and artistic aspects), *Art Nouveau/Jugendstil Architecture: International Joint Cultural Study and Action Project to Preserve and Restore World Art Nouveau/Jugendstil Architectural Heritage* (Helsinki: University Press, 1991), 105.

129. Ibid., 107–8.

130. George Heard Hamilton, *The Art and Architecture of Russia* (Baltimore: Penguin Books, 1954), 265.

131. M., "Vsemirnaia vystavka v Parizhe 1900-go goda. Pis'mo vrotoe," *Vestnik Evropy* 5 (May 1900): 324.

132. Salmond, *Arts and Crafts*, 90.

133. The photograph is reproduced in Musée d'Orsay, *L'Art russe dans la seconde moitié du XIXe siècle: en quête d'identité* (Paris: Musée d'Orsay, 2005), 315.

134. *Iskusstvo i khudozhestvennaia promyshlennost'* (1898–1899): 1044–45, as cited in *Konstantin Korovin: Zhizn' i tvorchestvo. Pis'ma, dokumenty, vospominaniia*, ed. N. M. Moleva (Moscow: Izd-vo Akademii khudozhestv SSSR, 1963), 283–84.

135. "K. A. Korovin o moskovskom teatral'nom sezone 1913 goda," as cited in *Konstantin Korovin: Zhizn' i tvorchestvo*, 394.

136. Kristen M. Harkness, "Putting Russian Folk Art on the World Stage: Policies, Politics, and the 1900 Exposition Universelle," unpublished paper presented at the AAASS National Convention in 2007. For more on the reception of Russian handicrafts in France, see Campbell, 85.

137. "Parizhskaia vsemirnaia vystavka 1900 g. (Ot nashego korrespondenta)," *Niva*, no. 36 (1900): 718.

138. Netta Peacock, "The New Movement in Russian Decorative Art," *The Studio* 13 (May 1901): 276.

139. Campbell, 82.

140. Ibid., 82.

141. Maurice Normand, 'La Russie à l'Exposition', *L'Illustration*, 5 May 1900, p. 281–87, as cited in Siegelbaum, 47.

142. *Dekorative Kunst*, no. 12 (September 1900): 480–88, as cited in *Konstantin Korovin: Zhizn' i tvorchestvo*, 287.

143. *Revue encyclopédique*, no. 371 (13 October 1900): 801–10, as cited in *Konstantin Korovin: Zhizn' i tvorchestvo*, 287–88.

144. "B. N. Matveev—M. N. Matveevoi [Parizh. 1900]," as cited in *Konstantin Korovin: Zhizn' i tvorchestvo*, 285.

145. See, for instance, a series of articles in *The New Time*. P. Vozhin, "Na vystavke," *Novoe vremia*, no. 8648, 25 March 1900; P. Vozhin, "Ofitsial'noe otkrytie vystavki," *Novoe vremia*, no. 8660, 6 April 1900; P. Vozhin, "G. Lube v Sibirskom pavil'one," *Novoe vremia*, no. 8664, 12 April 1900.

146. "Iz vospominanii V. A. Teliakovskogo," as cited in *Konstantin Korovin: Zhizn' i tvorchestvo*, 291.

147. Aleksei Pletnev, "S vystavki. Parizh, 9 maia," *Sankt-Peterburgskie vedomosti*, no. 121, 5 May 1900.

148. P. Ge, "Vsemirnaia vystavka 1900 goda. Khudozhestvennyi otdel," *Zhizn'* 10 (October 1900): 200.

149. Aleksandr Benua, "Pis'ma so vsemirnoi vystavki," *Mir iskusstva* 4 (1900): 107–10.

150. *Mir iskusstva* 4 (1900).

151. Benua, "Pis'ma so vsemirnoi vystavki," 107–10.

152. Alexandre Benois, *Memoirs*, trans. Moura Budberg (London: Chatto & Windus, 1960), 193.

153. Igor' Grabar', "Neskol'ko myslei o sovremennom prikladnom iskusstve v Rossii," *Mir iskusstva* 7 (1902): 51–52.

154. Ibid., 55.

Epilogue

1. M. V. Dobujinsky, "The St. Petersburg Renaissance," *Russian Review* 2, no. 1 (Autumn, 1942): 51. For more on art journals, see John E. Bowlt, *The Silver Age: Russian Art of the Early Twentieth Century and the "World of Art" Group* (Newtonville: Oriental Research Partners, 1982), 56–57. On the World of Art group in general, see N. Lapshina, *"Mir iskusstva": Ocherki istorii i tvorcheskoi praktiki* (Moscow: Iskusstvo, 1977).

2. John E. Bowlt, "The World of Art," *Russian Literature Triquarterly* 4 (Fall 1972): 188–89. See also M. G. Etkind, *Aleksandr Nikolaevich Benua: 1870–1960* (Leningrad: Iskusstvo, 1965), 55.

3. "Zametki," *Mir iskusstva* 1 (1898): 82.

4. Bowlt, *The Silver Age*, 271. See also Stuart R. Grover, "The World of Art Movement in Russia," *Russian Review* 32, no. 1 (January 1973): 28–42.

5. Aleksandr Benua, *Moi vospominaniia v piati knigakh*, vol. 2 (Moscow: Nauka, 1990), 230.

6. I. S. Zil'bershtein and V. A. Samkov, "Slovo o Sergee Diagileve," in *Sergei Diagilev i russkoe iskusstvo: Stat'i, otkrytye pis'ma, interv'iu. Sovremenniki o Diagileve*, ed. I. S. Zil'bershtein and V. A. Samkov, vol. 1 (Moscow: "Izobrazitel'noe iskusstvo," 1982), 40–41.

7. V. Burenin, "Kriticheskie ocherki. Novye khudozhestvennye zhurnaly. II," *Novoe vremia*, no. 8173, 27 November 1898.

8. For more on Diaghilev and his altercations with Stasov, see I. S. Zil'bershtein and V. A. Samkov, "Slovo o Sergee Diagileve," 13.

9. Richard Taruskin, *Stravinsky and the Russian Traditions: A Biography of the Works through Mavra*, vol. 1 (Oxford: Oxford University Press, 1996), 436.

10. S. Diaghilev, "Complicated Questions: Eternal Conflict," trans. Carol Adlam, in *Russian Visual Arts: Art Criticism in Context, 1814-1909* (Sheffield: HRIOnline, 2005; <http://hri.shef.ac.uk/rva/>).

11. P. Gnedich, "O krasote," *Novoe vremia*, no. 8190, 14 December 1898.

12. P. Pertsov, "Dekadenty i natsionalizm," *Novoe vremia*, no. 8910, 15 December 1900.

13. Benois, *Reminiscences of the Russian Ballet*, as cited in Janet Kennedy, *The "Mir iskusstva" Group and Russian Art, 1898-1912* (New York: Garland Pub., 1977), 120. Dobujinsky likewise argued that, contrary to popular belief, the cosmopolitan World of Art group prized authentic Russian art highly, objecting only to stylized, quasi-Russian folk motifs and subjects of the "gingerbread" variety. See Dobujinsky, "The St. Petersburg Renaissance," 54-55.

14. St. Iaremich, "Peredvizhnicheskoe nachalo v russkom iskusstve," *Mir iskusstva* 7 (1902): 24-25.

15. For example, the journal published reproductions of works by E. D. Polenova (1899, no. 1-4), M. V. Nesterov (1900, no. 1-2), M. V. Yakunchikova (1904, no. 3), and art produced at Talashkino workshops (1903, no. 4). See Bowlt, "The World of Art," 192.

16. Kennedy, *The "Mir iskusstva" Group and Russian Art*, 120-21.

17. Dobujinsky, "The St. Petersburg Renaissance," 49.

18. Olin Downes, "The Revolutionary Mr. Diaghileff," *New York Times*, 23 January 1916, X6.

19. Cf. Kennedy's analysis of the mutability of the Russian style. Janet Kennedy, "Pride and Prejudice: Serge Diaghilev, the Ballet Russes, and the French Public," in *Art, Culture, and National Identity in Fin-de-siècle Europe*, ed. Michelle Facos and Sharon L. Hirsh (New York: Cambridge University Press, 2003), 115.

20. Diaghilev, "Complicated Questions."

21. For more on the St. Petersburg of the era, see Emily D. Johnson, *How St. Petersburg Learned to Study Itself: The Russian Idea of Kraevedenie* (University Park: Pennsylvania State University Press, 2006); Katerina Clark, *Petersburg, Crucible of Cultural Revolution* (Cambridge: Harvard University Press, 1995).

22. Dobujinsky, "The St. Petersburg Renaissance," 54-55.

23. Taruskin, *Stravinsky and the Russian Traditions*, vol. 1, 647; Sally Banes, "*Firebird* and the Idea of Russianness," in *The Ballets Russes and Its World*, ed. Lynn Garafola and Nancy Van Norman Baer (New Haven: Yale University Press, 1999), 121.

24. See also Lynn Garafola, *Diaghilev's Ballets Russes* (New York: Da Capo Press, 1998); Ulle V. Holt, "Style, Fashion, Politics, and Identity: The Ballets Russes in Paris from 1909 to 1914" (PhD diss., Brown University, 2000).

25. A. Benua, "Russkie spektakli v Parizhe," *Rech'*, 19 June 1909, as cited in Etkind, *Aleksandr Nikolaevich Benua*, 98.

26. N. K. [Nikolai Kravchenko], "Vystavki," *Novoe vremia*, no. 8552, 17 December 1899. The artist Nikolai Kravchenko wrote under the pseudonym N. K. for *The New Time*. I. F. Masanov, *Slovar' psevdonimov russkikh pisatelei, uchenykh i obshchestvennykh deiatelei*,

vol. 2 (Moscow: Izdatel'stvo vsesoiuznoi knizhnoi palaty, 1957), 220. In 1904 he published a compilation of his travel notes previously serialized in *The New Time* under the title *V Kitai! Putevye zametki khudozhnika*; this edition was illustrated with his own sketches (St. Petersburg: T-vo R. Golike i A. Vil'borg, 1904).

27. Staryi Dzhon, "Khudozhniki i tseniteli," *Novoe vremia*, no. 8642, 19 March 1900.

28. A. N. Savinov, *Pavel Egorovich Shcherbov* (Leningrad: "Khudozhnik RSFSR," 1969), 93–96. See also G. Sternin, *Ocherki russkoi satiricheskoi grafiki* (Moscow: Iskusstvo, 1964).

29. Savinov, 81.

30. For more details, see A. G. Dement'ev, A. V. Zapadov and M. S. Cherepakhov, eds., *Russkaia periodicheskaia pechat' (1702–1894): Spravochnik* (Moscow: Gos. izd-vo polit. lit-ry, 1959), 530–31.

31. K. N. Tsimbaev, "Fenomen iubileemanii v Rossiiskoi obshchestvennoi zhizni kontsa XIX-nachala XX veka," *Voprosy istorii*, no. 11 (2005): 98–108.

32. Marcus C. Levitt, *Russian Literary Politics and the Pushkin Celebration of 1880* (Ithaca: Cornell University Press, 1989), 158–59.

33. For more on Gogol's status as a Russian classical figure, see Stephen Moeller-Sally, *Gogol's Afterlife: The Evolution of a Classic in Imperial and Soviet Russia* (Evanston: Northwestern University Press, 2002).

34. As an example of contemporary tributes to Boborykin, see D. V. Filosofov, "P. D. Boborykin," in *Zagadki russkoi kul'tury* (Moscow: NPK "INTELVAK," 2004), 596–610.

35. S. A. Kasparinskaia, "Muzei Rossii i vliianie gosudarstvennoi politiki na ikh razvitie (XVIII-nach. XX v.)," in *Muzei i vlast': Gosudarstvennaia politika v oblasti muzeinogo dela (XVIII–XX vv.). Sbornik nauchnykh trudov* (Moscow: Nauchno-issledovatel'skii institut kul'tury, 1991), 65–66.

36. *Pavel i Sergei Tret'iakovy: Zhizn'. Kollektsiia. Muzei*, ed. N. N. Mamontova, T. A. Lykova and T. V. Iudenkova (Moscow: Makhaon, 2006), 385, 379.

37. S. Makovskii, "Pamiatnik M. I. Glinke," *Zolotoe runo*, no. 4 (1906): 92–94.

38. P. V. Delarov, "Karl Briullov i ego znachenie v istorii zhivopisi," *Iskusstvo i khudozhestvennaia promyshlennost'* 2 (1899–1900): 121–40; Anatolii Polovtsov, "Reformator russkogo iskusstva. K stoletiiu rozhdeniia K. P. Briullova (1799–12 dekabria–1899)," *Moskovskie vedomosti*, no. 342, 12 December 1899; N. K., "Khudozhestvennye novosti," *Novoe vremia*, no. 8547, 12 December 1899; N. Selivanov (Starover), "Karl Pavlovich Briullov," *Sankt-Peterburgskie vedomosti*, no. 340, 12 December 1899; Anatolii Polovtsov, "Briullovskii iubilei (ot nashego korrespondenta)," *Moskovskie vedomosti*, no. 345, 15 December 1899; Anatolii Polovtsov, "Briullovskaia iubileinaia vystavka (Pis'mo iz Peterburga)," *Moskovskie vedomosti*, no. 348, 18 December 1899; Anatolii Polovtsov, "Novye dannye o 'Poslednem dne Pompei' K. P. Briullova," *Moskovskie vedomosti*, no. 351, 21 December 1899; L. M., "Dve iubileinye vystavki v pamiat' K. P. Briullova v Moskve," *Sankt-Peterburgskie vedomosti*, no. 353, 25 December 1899; Anatolii Polovtsov, "Dve naprasliny na K. P. Briullova," *Moskovskie vedomosti*, no. 360, 31 December 1899.

39. "Chestvovanie pamiati K. P. Briullova," *Moskovskie vedomosti*, no. 343, 13 December 1899.

40. "Briullovskoe torzhestvo," *Mir iskusstva* 2 (1899): 95–96. For more on Repin's speech specifically, see Izabella Ginzburg, "Nasledie Briullova v otsenke Repina," in *Repin*, ed. I. E. Grabar' and I. S. Zil'bershtein, vol. 1 (Moscow: Izdatel'stvo akademii nauk SSSR, 1948), 525–43.

41. Staryi Dzhon, "Iubilei tragika-simvolista," *Novoe vremia*, no. 8554, 19 December 1899; P. V. Delarov, "Karl Briullov i ego znachenie v istorii zhivopisi," *Iskusstvo i khudozhestvennaia promyshlennost'* 2 (1899–1900): 121.

42. A. Benua, "K. P. Briullov," *Mir iskusstva* 3 (1900): 7–18.

43. G. Pavlutskii, "Po povodu iubileia Briullova," *Mir iskusstva* 4 (1900): 1–11, 28–47.

44. Cf. the discussion of the British export of cultural self-representation in James Buzard, "Culture for Export: Tourism and Autoethnography in Postwar Britain," in *Being Elsewhere: Tourism, Consumer Culture, and Identity in Modern Europe and North America*, ed. Shelley Baranowski and Ellen Furlough (Ann Arbor: University of Michigan Press, 2001), 299–319.

SELECTED BIBLIOGRAPHY

Periodicals

Apollon
Artist
Biblioteka dlia chteniia
Birzhevye vedomosti
Budil'nik
Delo
Den'
Drevniaia i novaia Rossiia
Golos
Gramotei
Illiustratsiia
Iskra
Iskusstvo i khudozhestvennaia promyshlennost'
Istoricheskii vestnik
Kartinnye galerei Evropy
Khudozhestvennaia gazeta
Khudozhestvennye sokrovishcha Rossii
Khudozhestvennyi zhurnal
Kievskaia starina
Literaturnaia gazeta
Mir iskusstva
Mirskoe slovo
Molva
Moskovskie vedomosti
Moskovskii vestnik
Moskva
Moskvitianin
Muzykal'naia starina
Narodnoe bogatstvo
Nashe vremia
Nedelia stroitelia

Niva
Nizhegorodskii listok
Novoe vremia
Novosti i birzhevaia gazeta
Novyi mir
Osnova
Otechestvennye zapiski
Pchela
Peterburgskaia gazeta
Peterburgskii listok
Poliarnaia zvezda
Rech'
Russkaia starina
Russkie vedomosti
Russkii
Russkii arkhiv
Russkii invalid
Russkii khudozhestvennyi listok
Russkii listok
Russkii mir
Russkii vestnik
Sankt-Peterburgskie vedomosti
Semeinyi krug
Severnaia pchela
Severnaia pochta
Severnoe siianie
Severnyi vestnik
Shut
Slovo
Smolenskaia starina
Sovremennaia letopis'
Sovremennik
Sovremennoe slovo
Sovremennye izvestiia
Sovremennyi listok
Starina i novizna
Starye gody
Svetoch
Svetopis'
Svistok
Syn otechestva
Teleskop
Vedomosti
Vestnik Evropy
Vestnik iziashchnykh iskusstv

Vestnik Moskovskoi Politekhnicheskoi vystavki
Vest'
Vremia
Zaria
Zhivaia starina
Zhizn'
Zhurnal iziashchnykh iskusstv
Zodchii
Zolotoe runo

Books, Articles, and Other Sources

XIX vek: Illiustrirovannyi obzor minuvshego stoletiia. St. Petersburg: Izd. A. F. Marksa, 1901.

Aderhold, Carl. *Français! Notre histoire, nos passions.* Paris: Larousse, 2003.

Adlam, Carol. "Realist Aesthetics in Nineteenth-Century Russian Art Writing." *Slavonic and East European Review* 83, no. 4 (October 2005): 639–63.

Adlam, Carol, Alexey Makhrov, and Robert Russell, eds. *Russian Visual Arts: Art Criticism in Context, 1814–1909.* Sheffield: HRIOnline, 2005. <http://hri.shef.ac.uk/rva/>.

Adorno, Theodor W. *Aesthetic Theory.* Edited and translated by Robert Hullot-Kentor. Minneapolis: University of Minnesota Press, 1997.

———. *Prisms.* Translated by Samuel and Shierry Weber. London: Neville Spearman, 1967.

Afanas'ev, A. N. *Mify, pover'ia i sueveriia slavian: Poeticheskie vozzreniia slavian na prirodu.* 3 vols. Moscow: EKSMO, 2002.

Alekseev, M. A. et al., eds. *Svistok: Sobranie literaturnykh, zhurnal'nykh i drugikh zametok. Satiricheskoe prilozhenie k zhurnalu "Sovremennik," 1859–1863.* Moscow: Izd-vo "Nauka," 1981.

Alianskii, Iurii. *Uveselitel'nye zavedeniia starogo Peterburga.* St. Petersburg: AOZT "PF," 1996.

Alpatov, M. V. *Etiudy po vseobshchei istorii iskusstv: Izbrannye iskusstvovedcheskie raboty.* Moscow: Sov. khudozhnik, 1979.

Alperson, Phillip, ed. *The Philosophy of the Visual Arts.* New York: Oxford University Press, 1992.

Altick, Richard D. *The English Common Reader: A Social History of the Mass Reading Public, 1800–1900.* 2nd ed. Columbus: Ohio State University Press, 1998.

Ambler, Effie. *Russian Journalism and Politics, 1861–1881: The Career of Aleksei S. Suvorin.* Detroit: Wayne State University Press, 1972.

The American Association of Museums. Web. <www.aam-us.org>

Anderson, Benedict. *Imagined Communities: Reflections on the Origin and Spread of Nationalism.* Rev. ed. London: Verso, 1991.

———. "Nationalism, Identity, and the World-in-Motion: On the Logics of Seriality." In *Cosmopolitics,* edited by Pheng Cheah and Bruce Robbins, 117–33. Minneapolis: University of Minnesota Press, 1998.

Andreeva, V. V., and S. N. Gol'dshtein, eds. *Tovarishchestvo peredvizhnykh khudozhestvennykh*

vystavok, 1869–1899: Pis'ma, dokumenty. 2 vols. Moscow: "Iskusstvo," 1987.

Anemone, Anthony. "The Monsters of Peter the Great: The Culture of the St. Petersburg Kunstkamera in the Eighteenth Century." *The Slavic and East European Journal* 44, no. 4 (Winter 2000): 583–602.

Antsiferov, N. P. "Belletristy-kraevedy: Vopros o sviazi kraevedeniia s khudozhestvennoi literaturoi." *Kraevedenie*, no. 1 (1927): 31–46.

Appadurai, Arjun, and Carol A. Breckenridge. "Museums Are Good to Think: Heritage on View in India." In *Museums and Communities: The Politics of Public Culture*, edited by Ivan Karp, Christine Mullen Kreamer, and Steven D. Lavine, 34–55. Washington: Smithsonian Institution Press, 1992.

Aronov, A. A. *Zolotoi vek russkogo metsenatstva.* Moscow: Izd-vo Moskovskogo gos. universiteta kul'tury, 1995.

Aronson, M., and S. Reiser. *Literaturnye kruzhki i salony.* Edited by B. M. Eikhenbaum. Moscow: "Agraf," 2001.

The Art Journal Illustrated Catalogue of the International Exhibition, 1862. London: J. S. Virtue, 1862.

L'Art russe dans la seconde moitié du XIXe siècle: en quête d'identité. Paris: Société française de promotion artistique, 2005.

Artamonova, O. B. "K voprosu o kollektsionirovanii zapadnoevropeiskoi zhivopisi grafom A. S. Stroganovym." In *Kollektsionery i metsenaty v Sankt-Peterburge, 1703–1917: Tezisy dokladov konferentsii*, 6–8. St. Petersburg: Gosudarstvennyi Ermitazh, 1995.

Asoian, Iu., and A. Malafeev. *Otkrytie idei kul'tury: Opyt russkoi kul'turologii serediny XIX–nachala XX vekov.* Moscow: OGI, 2000.

Atkinson, J. Beavington. *An Art Tour to Northern Capitals of Europe.* New York: Macmillan and Co., 1873.

Auerbach, Jeffrey A. *The Great Exhibition of 1851: A Nation on Display.* New Haven: Yale University Press, 1999.

Baedeker, Karl. *Russia, with Teheran, Port Arthur, and Peking: Handbook for Travellers.* Leipzig: K. Baedeker, 1914.

Bakhtin, M. M. *The Dialogic Imagination: Four Essays.* Edited by Michael Holquist, translated by Caryl Emerson and Michael Holquist. Austin: The University of Texas Press, 1981.

———. *Literaturno-kriticheskie stat'i.* Moscow: "Khudozhestvennaia literatura," 1986.

———. *Speech Genres and Other Late Essays.* Edited by Caryl Emerson and Michael Holquist, translated by Vern W. McGee. Austin: University of Texas Press, 1986.

Bal, Mieke. "The Discourse of the Museum." In *Thinking about Exhibitions*, edited by Reesa Greenberg, Bruce W. Ferguson, and Sandy Nairne, 201–18. New York: Routledge, 1996.

Banes, Sally. "*Firebird* and the Idea of Russianness." In *The Ballets Russes and Its World*, edited by Lynn Garafola and Nancy Van Norman Baer, 117–34. New Haven: Yale University Press, 1999.

Barsht, K. A. "O tipologicheskikh vzaimosviaziakh literatury i zhivopisi (na materiale russkogo iskusstva XIX veka)." In *Russkaia literatura i izobrazitel'noe iskusstvo XVIII–nachala XX veka: Sbornik nauchnykh trudov*, 5–34. Leningrad: "Nauka," 1988.

Barsukov, N. P. *Zhizn' i trudy M. P. Pogodina.* Vol. 17. St. Peterburg: Tip. M. M. Stasiulevicha, 1903.

Batiushkov, K. N. "Progulka v akademiiu khudozhestv." *Sochineniia*. Vol. 2, 92–117. St. Petersburg, 1885.

Bazin, Germain. *The Museum Age*. Translated by Jane van Nuis Cahill. New York: Universe Books, 1967.

Beaver, Patrick. *The Crystal Palace: A Portrait of Victorian Enterprise*. Chichester: Phillimore, 1986.

Bekker, I. I., I. A. Brodsky, and S. K. Isakov. *Akademiia khudozhestv: Istoricheskii ocherk*. Leningrad: "Iskusstvo," 1940.

Bel'chikov, N. F. "Chernyshevskii i Dostoevskii (iz istorii parodii)." *Pechat' i revoliutsiia* 5 (July-August 1928): 35–53.

Belinskii, V. G. "Obshchee znachenie slova literatura." *Polnoe sobranie sochinenii*. Vol. 5, 620–53. Moscow: Izd-vo Akademii nauk SSSR, 1954.

———. "Rossiia do Petra Velikogo." *Polnoe sobranie sochinenii*. Vol. 5, 91–152. Moscow: Izd-vo Akademii nauk SSSR, 1954.

Belyi, Andrei. *Simvolizm kak miroponimanie*. Moscow: Izd-vo "Respublika," 1994.

Benjamin, Walter. *The Arcades Project*. Translated by Howard Eiland and Kevin McLaughlin. Cambridge: Belknap Press of Harvard University Press, 1999.

———. "Eduard Fuchs: Collector and Historian." *New German Critique* 5 (Spring 1975): 27–58.

———. "Paris, Capital of the Nineteenth Century." *Reflections: Essays, Aphorisms, Autobiographical Writings*, edited by Peter Demetz and translated by Edmund Jephcott, 146–62. New York: Schocken Books, 1986.

Bennett, Tony. *The Birth of the Museum: History, Theory, Politics*. New York: Routledge, 1995.

Benua, Aleksandr. *Istoriia zhivopisi v XIX veke. Russkaia zhivopis'*. St. Petersburg: Izd. t-va "Znanie," 1901.

——— [Benois, Alexandre]. *Memoirs*. Translated by Moura Budberg. London: Chatto & Windus, 1960.

———. *Moi vospominaniia v piati knigakh*. 2nd ed. Moscow: Nauka, 1990.

———. *Putevoditel' po kartinnoi galeree Imperatorskogo Ermitazha*. St. Petersburg: Izd. Obshchiny sv. Evgenii, [n.d.].

——— [Benois, Alexandre]. *Reminiscences of the Russian Ballet*. Translated by Mary Britnieva. London: Putnam, 1941.

———. *Russkii muzei Imperatora Aleksandra III*. Moscow: Izd. I. N. Knebel', 1906.

Berdiaev, N. A. *Filosofiia tvorchestva, kul'tury i iskusstva*. 2 vols. Moscow: Izd-vo "Iskusstvo," 1994.

——— [Berdyaev, Nicolas]. *The Russian Idea*. Translated by R. M. French. New York: The Macmillan Company, 1948.

Berezina, V. G. "Gazety 1860-kh godov." In *Ocherki po istorii russkoi zhurnalistiki i kritiki*. Vol. 2, 30–59. Leningrad: Izd-vo LGU, 1965.

Berezkina, S. V. "Pushkinskaia fol'klornaia zapis' i 'Skazka o tsare Berendee' V. A. Zhukovskogo." In *Pushkin: Issledovaniia i materialy*. Vol. 13, 267–78. Leningrad: Nauka, 1989.

Berman, Marshall. *All That Is Solid Melts into Air: The Experience of Modernity*. New York: Penguin, 1988.

Bezobrazov, V. P. *Otchet o Vserossiiskoi khudozhestvenno-promyshlennoi vystavke 1882 goda v Moskve*. St. Petersburg: V Tip. V. Bezobrazova, 1883–1884.

Bhabha, Homi K. "Beyond the Pale: Art in the Age of Multicultural Translation." In *1993 Biennial Exhibition*, 62–73. New York: Whitney Museum of American Art, 1993.

Billington, James H. *The Icon and the Axe: An Interpretive History of Russian Culture*. New York: Vintage Books, 1970.

Blakesley, Rosalind P. "Pride and the Politics of Nationality in Russia's Imperial Academy of Fine Arts, 1757–1807." *Art History* 33, no. 5 (December 2010): 800–835.

——. "Slavs, Brits and the Question of National Identity in Art: Russian Responses to British Painting in the Mid-Nineteenth Century." In *English Accents: Interactions with British Art c. 1776–1855*, edited by Christiana Payne and William Vaughan, 203–24. Aldershot: Ashgate, 2004.

Boborykin, P. D. *Vospominaniia. Seriia literaturnykh memuarov*. Vol. 1. Moscow: Khudozhestvennaia literatura, 1965.

Bogoroditskaia, N. A., ed. *Nizhegorodskaia iarmarka v vospominaniiakh sovremennikov*. Nizhnii Novgorod: [s.n.], 2000.

Borisova, E. A. *Russkaia arkhitektura vtoroi poloviny XIX veka*. Moscow: Nauka, 1979.

Botkina, A. P. *Pavel Mikhailovich Tret'iakov v zhizni i iskusstve*. 5th ed. Moscow: Iskusstvo, 1995.

Bourdieu, Pierre. *The Field of Cultural Production: Essays on Art and Literature*. Edited by Randal Johnson. New York: Columbia University Press, 1993.

Bourdieu, Pierre, and Alain Darbel, with Dominique Schnapper. *The Love of Art: European Art Museums and Their Public*. Translated by Caroline Beattie and Nick Merriman. Stanford: Stanford University Press, 1990.

Bowe, Nicola Gordon, ed. *Art and the National Dream: The Search for Vernacular Expression in Turn-of-the-Century Design*. Dublin: Irish Academic Press, 1993.

Bowlt, John E. "The Moscow Art Market." In *Between Tsar and People: Educated Society and the Quest for Public Identity in Late Imperial Russia*, edited by Edith W. Clowes, Samuel D. Kassow, and James L. West, 108–28. Princeton: Princeton University Press, 1991.

——. "Russian Painting in the Nineteenth Century." In *Art and Culture in Nineteenth-Century Russia*, edited by Theofanis George Stavrou, 113–39. Bloomington: Indiana University Press, 1983.

——. *The Silver Age: Russian Art of the Early Twentieth Century and the "World of Art" Group*. Newtonville: Oriental Research Partners, 1982.

——. "The World of Art." *Russian Literature Triquarterly* 4 (Fall 1972): 184–218.

Bradburne, James. "The Poverty of Nations: Should Museums Create Identity?" In *Heritage and Museums: Shaping National Identity*, edited by J. M. Fladmark, 379–93. Shaftesbury: Donhead Publishing Ltd., 2000.

Bradley, Joseph. "Pictures at an Exhibition: Science, Patriotism, and Civil Society in Imperial Russia." *Slavic Review* 67, no. 4 (Winter 2008): 934–66.

——. "Subjects into Citizens: Societies, Civil Society, and Autocracy in Tsarist Russia." *The American Historical Review* 107, no. 4 (October 2002): 1094–123.

——. "Voluntary Associations, Civic Culture, and *Obshchestvennost'* in Moscow." In *Between Tsar and People: Educated Society and the Quest for Public Identity in Late*

Imperial Russia, edited by Edith W. Clowes, Samuel D. Kassow, and James L. West, 131–48. Princeton: Princeton University Press, 1991.

———. *Voluntary Associations in Tsarist Russia: Science, Patriotism, and Civil Society*. Cambridge: Harvard University Press, 2009.

Breshko-Breshkovskii, N. N. *Russkii muzei Imperatora Aleksandra III*. St. Petersburg: Tovarishchestvo M. O. Vol'f, 1903.

Brooks, Jeffrey. "Russian Nationalism and Russian Literature: The Canonization of the Classics." In *Nation and Ideology: Essays in Honor of Wayne S. Vucinich*, edited by Ivo Banac et al., 315–34. New York: Columbia University Press, 1981.

———. *When Russia Learned to Read: Literacy and Popular Literature, 1861–1917*. Princeton: Princeton University Press, 1985.

Brower, Daniel. "Whose Cultures?" *Kritika* 3, no. 1 (Winter 2002): 81–88.

Brubaker, Rogers. *Nationalism Reframed: Nationhood and the National Question in the New Europe*. New York: Cambridge University Press, 1996.

Bruk, Ia. V., ed. *Gosudarstvennaia Tret'iakovskaia galereia: Ocherki istorii, 1856–1917. K 125-letiiu osnovaniia Tret'iakovskoi galerei*. Leningrad: "Khudozhnik RSFSR," 1981.

Brusovani, M. I., and R. G. Gal'perina. "Zagranichnye puteshestviia F. M. Dostoevskogo 1862 i 1863 gg." In *Dostoevskii: Materialy i issledovaniia*. Vol. 8, 272–92. Leningrad: Nauka, 1988.

Buckle, Henry Thomas. *History of Civilization in England*. 2nd ed. London: J.W. Parker, 1858.

Budagov, R. A. *Istoriia slov v istorii obshchestva*. Moscow: Prosveshchenie, 1971.

Burova, G., O. Gaponova, and V. Rumiantseva, eds. *Tovarishchestvo peredvizhnykh khudozhestvennykh vystavok*. 2 vols. Moscow: Iskusstvo, 1959.

Buslaev, F. I. *Moi dosugi: Sobrannye iz periodicheskikh izdanii melkie sochineniia Fedora Buslaeva*. 2 vols. Moscow: V Sinodal'noi tipografii, 1886.

———. *Moi vospominaniia*. Moscow, 1897.

Buzard, James. *The Beaten Track: European Tourism, Literature, and the Ways to Culture, 1800–1918*. Oxford: Oxford University Press, 1993.

———. "Culture for Export: Tourism and Autoethnography in Postwar Britain." In *Being Elsewhere: Tourism, Consumer Culture, and Identity in Modern Europe and North America*, edited by Shelley Baranowski and Ellen Furlough, 299–319. Ann Arbor: University of Michigan Press, 2001.

Cahn, Jennifer. "Nikolai Punin and Russian Avant-Garde Museology, 1917–1932." PhD diss., University of Southern California, 1999.

Cain, K. R. "Talachino [sic]: A Home for Russian Folk Art." *The Craftsman* 27, no. 1 (October 1914): 92–96.

Campbell, James B. *Campbell's Illustrated History of The Paris International Exposition Universelle of 1900*. Chicago: Chicago & Omaha Publishing Co., 1900.

Campbell, Stuart. *Russians on Russian Music, 1880–1917: An Anthology*. New York: Cambridge University Press, 2003.

Chaadaev, P. Ia. "Filosoficheskie pis'ma (1829–1830)." *Polnoe sobranie sochinenii i izbrannye pis'ma*. Vol. 1. Moscow: Nauka, 1991.

Chaev, P. "O russkom starinnom tserkovnom zodchestve." *Drevniaia i novaia Rossiia* 3, no. 6 (1875): 141–53.

Charles, Barbara Fahs. "Exhibition as (Art) Form." In *Past Meets Present: Essays about Historic Interpretation and Public Audiences*, edited by Jo Blatti, 97–104. Washington: Smithsonian Institution Press, 1987.

Chekalevskii, P. P. *Rassuzhdeniia o svobodnykh khudozhestvakh, s opisaniem nekotorykh proizvedenii rossiiskikh khudozhnikov*. St. Petersburg, 1793.

Chernyshevsky, N. G. "The Aesthetic Relation of Art to Reality (A Dissertation)." *Selected Philosophical Essays*, 281–381. Moscow: Foreign Languages Pub. House, 1953.

—— [Chernyshevskii, N. G]. "Novosti literatury, iskusstv, nauk i promyshlennosti." *Polnoe sobranie sochinenii*, edited by V. Ia. Kirpotin. Vol. 16, 89–127. Moscow: Gos. izd-vo khudozh. lit-ry, 1953.

Clark, Katerina. *Petersburg, Crucible of Cultural Revolution*. Cambridge: Harvard University Press, 1995.

Clifford, James. "Introduction: Partial Truths." In *Writing Culture: The Poetics and Politics of Ethnography*, edited by James Clifford and George E. Marcus, 1–26. Berkeley: University of California Press, 1986.

——. *The Predicament of Culture: Twentieth-Century Ethnography, Literature, and Art*. Cambridge: Harvard University Press, 1988.

Colley, Linda. *Britons: Forging the Nation, 1707–1837*. New Haven: Yale University Press, 1992.

Coombes, Annie E. "Museums and the Formation of National and Cultural Identities." *The Oxford Art Journal* 11, no. 2 (1988): 57–68.

Cracraft, James, and Daniel Rowland, eds. *Architectures of Russian Identity: 1500 to the Present*. Ithaca: Cornell University Press, 2003.

Crimp, Douglas. "On the Museum's Ruins." In *The Anti-Aesthetic: Essays on Postmodern Culture*, edited by Hal Foster, 43–56. Seattle: Bay Press, 1983.

Crow, Thomas E. *Painters and Public Life in Eighteenth-Century Paris*. New Haven: Yale University Press, 1985.

The Crystal Palace Exhibition: Illustrated Catalogue, London 1851. New York: Dover Publications, 1970.

Dal', Vladimir. *Tolkovyi slovar' zhivogo velikorusskogo iazyka*. Edited by Baudouin de Courtenay. 4 vols. St. Petersburg: Izdanie t-va M. O. Vol'fa, 1903–9.

Dalmatov, V. P. "Iuliia Pastrana. Psikhologicheskii ocherk." *Po tu storonu kulis: Teatral'nye ocherki*, 22–64. St. Petersburg: Tip. A. S. Suvorina, 1908.

Danilevskii, G. P. *Semeinaia starina*. St. Petersburg: Izd. A. S. Suvorina, 1887.

Danilevskii, N. Ia. *Rossiia i Evropa: Vzgliad na kul'turnye i politicheskie otnosheniia slavianskogo mira k germano-romanskomu*. 6th ed. St. Petersburg: Izd-vo "Glagol," 1995.

David-Fox, Michael, Peter Holquist, and Alexander Martin, eds. *Orientalism and Empire in Russia*. Bloomington: Slavica, 2006.

Davis, John R. *The Great Exhibition*. Stroud: Sutton Publishing Ltd., 1999.

Debogorii-Mokrievich, Vladimir. *Vospominaniia*. St. Petersburg: "Svobodnyi trud," 1906.

De Danilovicz, C. "Talashkino: Princess Tenishef's School of Russian Applied Art." *The International Studio* 32, no. 126 (August 1907): 135–40.

Dement'ev, A. G., A. V. Zapadov, and M. S. Cherepakhov, eds. *Russkaia periodicheskaia pechat' (1702–1894): Spravochnik*. Moscow: Gos. izd-vo polit. lit-ry, 1959.

Diaghilev, Sergei. "Complicated Questions: Eternal Conflict." In *Russian Visual Arts: Art Criticism in Context, 1814–1909*. Trans. Carol Adlam. Sheffield: HRIOnline, 2005. <http://hri.shef.ac.uk/rva/>.

———— [Diagilev, Sergei]. "O russkikh muzeiakh." *Mir iskusstva* 6 (1901): 163–74.

————. "Pis'mo po adresu I. Repina." *Mir iskusstva* 1 (1899): 4–8.

————. *Sergei Diagilev i russkoe iskusstvo: Stat'i, otkrytye pis'ma, interv'iu. Sovremenniki o Diagileve.* Edited by I. S. Zil'bershtein and V. A. Samkov. 2 vols. Moscow: "Izobrazitel'noe iskusstvo," 1982.

D'iakov, V. A. "Uchenaia duel' M. P. Pogodina c N. I. Kostomarovym (O publichnom dispute po normannskomu voprosu 19 marta 1860 g.)." *Istoriografiia i istochnikovedenie stran Tsentral'noi i Iugo-Vostochnoi Evropy,* 40–56. Moscow: Nauka, 1986.

Dianina, Katia. "The Feuilleton: An Everyday Guide to Public Culture in the Age of the Great Reforms." *SEEJ* 47, no. 2 (2003): 186–208.

————. "Passage to Europe: Dostoevskii in the St. Petersburg Arcade." *Slavic Review* 62, no. 2 (Summer 2003): 237–57.

Dickens, Charles. "The Great Exhibition and the Little One." *Household Words* 3, no. 67 (1851): 356–360.

————. "Three May-Days in London." *Household Words* 3, no. 58 (1851): 121–24.

Dobujinsky, M. V. "The St. Petersburg Renaissance." *Russian Review* 2, no. 1 (Autumn 1942): 46–59.

Donato, Eugenio. "The Museum's Furnace: Notes toward a Contextual Reading of *Bouvard and Pécuchet*." In *Textual Strategies: Perspectives in Post-Structural Criticism,* edited by Josué V. Harari, 213–38. Ithaca: Cornell University Press, 1979.

Dostoevskii, F. M. *Dnevnik pisatelia za 1876 g. (ianvar'—aprel'). Polnoe sobranie sochinenii v tridtsati tomakh.* Vol. 22. Leningrad: Nauka, 1981.

————. *Dnevnik pisatelia za 1877 g. (ianvar'—avgust). Polnoe sobranie sochinenii v tridtsati tomakh.* Vol. 25. Leningrad: Nauka, 1983.

————. "Kalambury v zhizni i v literature." *Polnoe sobranie sochinenii v tridtsati tomakh.* Vol. 20, 137–47. Leningrad: Nauka, 1980.

————. "Po povodu vystavki." *Polnoe sobranie sochinenii v tridtsati tomakh.* Vol. 21, 68–77. Leningrad: Nauka, 1980.

————. "Vystavka v Akademii khudozhestv za 1860–1861 god." *Polnoe sobranie sochinenii v tridtsati tomakh.* Vol. 19, 151–68. Leningrad: Nauka, 1979.

————. "Zimnie zametki o letnikh vpechatleniiakh." *Polnoe sobranie sochinenii v tridtsati tomakh.* Vol. 5, 46–98. Leningrad: Nauka, 1973.

———— [Dostoevsky, Fyodor]. *Crime and Punishment.* 3rd ed. Edited by George Gibian. New York: W. W. Norton & Company, 1989.

————. *Demons.* Translated by Richard Pevear and Larissa Volokhonsky. New York: Vintage books, 1994.

————. "Mr.–bov and the Question of Art." *Dostoevsky's Occasional Writings,* translated by David Magarshack, 86–137. Evanston: Northwestern University Press, 1997.

————. *Notes from Underground.* Translated by Michael R. Katz. New York: Norton, 1989.

Druzhakov, Elena. "Dostoevskii i Gertsen. Londonskoe svidanie 1862 goda." *Canadian-American Slavic Studies* 17, no. 3 (Fall 1983): 325–48.

Druzhinin, A. V. "Dramaticheskii fel'eton o fel'etone i o fel'etonistakh." In *Russkii fel'eton. V pomoshch' rabotnikam pechati,* edited by A. V. Zapadov, 122–28. Moscow: Gos. izd-vo polit. lit-ry, 1958.

Duncan, Carol. "Art Museums and the Ritual of Citizenship." In *Exhibiting Cultures: The Poetics and Politics of Museum Display,* edited by Ivan Karp and Steven D. Lavine,

88–103. Washington: Smithsonian Institution Press, 1991.

Duncan, Carol, and Alan Wallach, "The Universal Survey Museum." *Art History* 3, no. 4 (December 1980): 448–69.

Egorov, B. F. *Bor'ba esteticheskikh idei v Rossii 1860-kh godov*. Leningrad: Iskusstvo, 1991.

———. *Izbrannoe: Esteticheskie idei v Rossii XIX veka*. St. Petersburg: Letnii sad, 2009.

Egorov, V. L., ed. *Istoricheskii muzei: Entsiklopediia otechestvennoi istorii i kul'tury*. Moscow: Gos. istoricheskii muzei, 1995.

Eikhenbaum, B. M. *Lev Tolstoi*, part 1. München: Wilhelm Fink Verlag, 1968.

Eley, Geoff. "Nations, Publics, and Political Cultures: Placing Habermas in the Nineteenth Century." In *Culture/Power/History: A Reader in Contemporary Social Theory*, edited by Nicholas B. Dirks, Geoff Eley, and Sherry B. Ortner, 297–335. Princeton: Princeton University Press, 1994.

Eley, Geoff, and Ronald Grigor Suny. "Introduction: From the Moment of Social History to the Work of Cultural Representation." In *Becoming National: A Reader*, edited by Geoff Eley and Ronald Grigor Suny, 3–38. New York: Oxford University Press, 1996.

Ely, Christopher. *This Meager Nature: Landscape and National Identity in Imperial Russia*. DeKalb: Northern Illinois University Press, 2002.

———. "The Picturesque and the Holy: Visions of Touristic Space in Russia, 1820–1850." *Architectures of Russian Identity: 1500 to the Present*, edited by James Cracraft and Daniel Rowland, 80–90. Ithaca: Cornell University Press, 2003.

Emel'ianov, N. P., ed. *Russkaia zhurnalistika XVIII–XIX vv. (iz istorii zhanrov)*. Leningrad: Izd-vo Leningradskogo universiteta, 1969.

Emerson, Caryl. *Boris Godunov: Transpositions of a Russian Theme*. Bloomington: Indiana University Press, 1986.

Engelstein, Laura, "Culture, Culture Everywhere: Interpretations of Modern Russia, across the 1991 Divide." *Kritika: Explorations in Russian and Eurasian History* 2, no. 2 (Spring 2001): 363–93.

Esin, B. I. *Istoriia russkoi zhurnalistiki XIX v.* Moscow: "Vysshaia shkola," 1989.

———. *Russkaia dorevoliutsionnaia gazeta, 1702–1917 gg.: Kratkii ocherk*. Moscow: Izdat. Moskovskogo un-ta, 1971.

Etkind, M. G. *Aleksandr Nikolaevich Benua: 1870–1960*. Leningrad: Iskusstvo, 1965.

Etnograficheskaia vystavka 1867 goda. Moscow: Tipografiia M. N. Lavrova i ko, 1878. Fanger, Donald. *Dostoevsky and Romantic Realism: A Study of Dostoevsky in Relation to Balzac, Dickens, and Gogol*. Cambridge: Harvard University Press, 1965.

Fedorov, N. F. "Muzei, ego smysl i naznachenie." *Sochineniia*, 575–604. Moscow: Mysl', 1982.

———. *Sobranie sochinenii v 4-kh tomakh*. 4 vols. Moscow: Traditsiia, 1997.

Figes, Orlando. *Natasha's Dance: A Cultural History of Russia*. New York: Picador, 2002.

Filosofov, D. V. *Slova i zhizn': Literaturnye spory noveishego vremeni*. St. Petersburg: Tipo-grafiia Akts. obshch. tip. dela, 1909.

Findling, John E., ed. *Historical Dictionary of World's Fairs and Expositions, 1851–1988*. New York: Greenwood Press, 1990.

Fisher, David C. "Exhibiting Russia at the World's Fairs, 1851–1900." PhD diss., Indiana University, 2003.

———. "Russia and the Crystal Palace in 1851." In *Britain, the Empire, and the World at the Great Exhibition of 1851*, edited by Jeffrey A. Auerbach and Peter H. Hoffenberg, 123–46. Hampshire: Ashgate Publishing Company, 2008.

Fisher, Philip. *Making and Effacing Art: Modern American Art in a Culture of Museums* New York: Oxford University Press, 1991.

Fitzpatrick, Anne Lincoln. *The Great Russian Fair: Nizhnii Novgorod, 1840–1890.* New York: St. Martin's Press, 1990.

Florenskii, Pavel. "Khristianstvo i kul'tura." *Zhurnal moskovskoi patriarkhii* 4 (1983): 53–57.

Forster-Hahn, Françoise, ed. *Imagining Modern German Culture, 1889–1910.* Washington: National Gallery of Art, 1996.

Frank, Joseph. *Dostoevsky: The Seeds of Revolt, 1821–1849.* Princeton: Princeton University Press, 1976.

———. *Dostoevsky: The Stir of Liberation, 1860–1865.* Princeton: Princeton University Press, 1986.

Frazier, Melissa. "Turgenev and a Proliferating French Press: The Feuilleton and Feuilleton-istic in *A Nest of the Gentry,*" *Slavic Review* 69, no. 4 (Winter 2010): 925–43.

Friche, V. M. *Ocherki sotsial'noi istorii iskusstva.* Moscow: Novaia Moskva, 1923.

———, ed. *Russkaia zhivopis' XIX veka: Sbornik statei.* Moscow: RANION, 1929.

Fridlender, G. M. "Estetika Dostoevskogo." In *Dostoevskii—khudozhnik i myslitel': Sbornik statei,* 97–164. Moscow: "Khudozhestvennaia literatura," 1972.

———. *Realizm Dostoevskogo.* Moscow: "Nauka," 1964.

Frolov, A. I. *Osnovateli rossiiskikh muzeev.* Moscow: RGGU, 1991.

Frolova-Walker, Marina. *Russian Music and Nationalism: From Glinka to Stalin.* New Haven: Yale University Press, 2007.

Gallagher, Catherine, and Stephen Greenblatt, eds. *Practicing New Historicism.* Chicago: University of Chicago Press, 2000.

Garafola, Lynn. *Diaghilev's Ballets Russes.* New York: Da Capo Press, 1998.

Garshin, V. M. "Khudozhniki." *Rasskazy,* 98–115. Moscow: Sovetskaia Rossiia, 1976.

———. "Zametki o khudozhestvennykh vystavkakh." *Polnoe sobranie sochinenii V. M. Garshina,* 428–40. St. Petersburg: Izdanie T-va A. F. Marks, 1910.

Gautier, Theophile. *Russia.* Translated by Florence MacIntyre Tyson. 2 vols. Philadelphia: The John Winston Company, 1905.

Geertz, Clifford. *The Interpretation of Cultures: Selected Essays.* New York: Basic Books, 1973.

Georgi, I. G. [Johann Gottlieb]. *Opisanie rossiisko-imperatorskogo stolichnogo goroda Sankt-Peterburga i dostopamiatnostei v okrestnostiakh onogo, s planom.* St. Petersburg: Liga, 1996.

Ginzburg, I. V. "K istorii Akademii khudozhestv vo vtoroi polovine XIX veka." In *Voprosy khudozhestvennogo obrazovaniia.* Vyp. 9, 3–16. Leningrad: Akademiia khudozhestv SSSR, In-t zhivopisi, skul'ptury i arkhitektury, 1974.

Glinskii, B. B. *"Novoe vremia": Istoricheskii ocherk (1876–1916).* Petrograd: Tip. T-va A. S. Suvorina "Novoe vremia," 1916.

———. *Sredi literatorov i uchenykh: Biografii, nekrologi, kharakteristiki, vospominaniia, vstrechi.* St. Petersburg, 1914.

Gnedich, P. P. *Istoriia iskusstv: Zodchestvo, zhivopis', vaianie.* St. Petersburg: Izdanie A. F. Marksa, 1897.

Gogol, Nikolai. *The Complete Tales of Nikolai Gogol.* Translated by Constance Garnett. Chicago: The University of Chicago Press, 1985.

———. *The Arabesques.* Edited by Carl R. Proffer, translated by A. Tulloch. Ann Harbor: Ardis Publishing, 1982.

Golubeva, O. D. *V. V. Stasov*. St. Petersburg: Rossiiskaia natsional'naia biblioteka, 1995.

Goode, George Brown. *The Museums of the Future*. Washington: The Smithsonian National Institute, 1889.

Gor'kii, Maksim. *Revoliutsiia i kul'tura: Stat'i za 1917 g*. Berlin: Izd. t-va I. P. Ladyzhnikova, 1918.

Gorodetskii, B. M. *Sistematicheskii ukazatel' soderzhaniia "Istoricheskogo vestnika" za 25 let (za 1880–1904 gg.)*. St. Petersburg, 1908.

Grabar', I. E. *Istoriia russkogo iskusstva*. 6 vols. Moscow: I. Knebel', 1909–1913.

Grabar', I. E., and I. S. Zil'bershtein, eds. *Repin. Khudozhestvennoe nasledstvo*. 2 vols. Moscow: Izdatel'stvo akademii nauk SSSR, 1948–1949.

Grabowicz, George. "Insight and Blindness in the Reception of Ševchenko: The Case of Kostomarov," *Harvard Ukrainian Studies* 17, no. 3 (December 1993): 279–340.

Gray, Camilla. *The Russian Experiment in Art, 1863–1922*. Revised and updated by Marian Burleigh-Motley. New York: Thames and Hudson, 1986.

Gray, Rosalind P. *Russian Genre Painting in the Nineteenth Century*. Oxford: Oxford University Press, 2000.

———. "Questions of Identity at Abramtsevo." In *Artistic Brotherhoods in the Nineteenth Century*, edited by Laura Morowitz and William Vaughan, 105–21. Aldershot: Ashgate, 2000.

Greenhalgh, Paul. *Ephemeral Vistas: The Expositions Universelles, Great Exhibitions, and World's Fairs, 1851–1939*. Manchester: Manchester University Press, 1988.

Grigorovich, D. V. *Literaturnye vospominaniia; s prilozheniem polnogo teksta vospominanii P. M. Kovalevskogo*. Pamiatniki literaturnogo byta. Leningrad: "Academia," 1928.

———. *Progulka po Ermitazhu*. St. Petersburg, 1865.

Grover, Stuart R. "Savva Mamontov and the Mamontov Circle, 1870–1905: Artistic Patronage and the Rise of Nationalism in Russian Art." PhD diss., University of Wisconsin, 1971.

———. "The World of Art Movement in Russia." *Russian Review* 32, no. 1 (January 1973): 28–42.

Habermas, Jürgen. "The Public Sphere: An Encyclopedia Article." Translated by Sara Lennox and Frank Lennox. *New German Critique* 5 (Fall 1974): 49–55.

———. *The Structural Transformation of the Public Sphere: An Inquiry into a Category of Bourgeois Society*. Translated by Thomas Burger with the assistance of Frederick Lawrence. Cambridge: The MIT Press, 1989.

Hall, Stuart. "Introduction: Who Needs 'Identity'?" In *Questions of Cultural Identity*, edited by Stuart Hall and Paul du Gay, 3–17. London: SAGE Publications, 1996.

———. "Cultural Identity and Diaspora." In *Colonial Discourse and Post-Colonial Theory: A Reader*, edited by Patrick Williams and Laura Chrisman, 392–403. New York: Columbia University Press, 1994.

Hamilton, George Heard. *The Art and Architecture of Russia*. Baltimore: Penguin Books, 1954.

Hargrove, June, and Neil McWilliam, eds. *Nationalism and French Visual Culture, 1870–1914*. Washington: National Gallery of Art, 2005.

Herder, Johann Gottfried [John Godfrey Herder]. *Outlines of a Philosophy of the History of Man*. Translated by T. O. Churchill. 2nd ed. London: Luke Hansard, 1800.

Hilton, Alison. *Russian Folk Art*. Bloomington: Indiana University Press, 1995.

Hobsbawm, Eric, and Terence Ranger, eds. *The Invention of Tradition*. Cambridge: Cambridge University Press, 1983.

Hoffenberg, Peter H. *An Empire on Display: English, Indian, and Australian Exhibitions from the Crystal Palace to the Great War*. Berkeley: University of California Press, 2001.

Hohendahl, Peter Uwe. "Aesthetic Violence: The Concept of the Ugly in Adorno's *Aesthetic Theory*." *Cultural Critique* 60 (Spring 2005): 170–96.

Holquist, Michael. *Dostoevsky and the Novel*. Princeton: Princeton University Press, 1977.

Holt, Elizabeth Gilmore, ed. *The Art of All Nations, 1850–73: The Emerging Role of Exhibitions and Critics*. Princeton: Princeton University Press, 1982.

Holt, Ulle V. "Style, Fashion, Politics, and Identity: The Ballets Russes in Paris from 1909 to 1914." PhD diss., Brown University, 2000.

Hosking, Geoffrey A. "Empire and Nation-Building in Late Imperial Russia." In *Russian Nationalism, Past and Present*, edited by Geoffrey Hosking and Robert Service, 12–20. New York: St. Martin's Press, 1998.

———. *Russia: People and Empire, 1552–1917*. Cambridge: Harvard University Press, 1997.

Hroch, Miroslav. *Social Preconditions of National Revival in Europe: A Comparative Analysis of the Social Composition of Patriotic Groups among the Smaller European Nations*. Translated by Ben Fowkes. New York: Columbia University Press, 2000.

Huyssen, Andreas. *Twilight Memories: Marking Time in a Culture of Amnesia*. New York: Routledge, 1995.

Illiustrirovannyi putevoditel' po etnograficheskomu muzeiu. Rev. ed. Moscow: Tip. K. L. Men'shova, 1916.

Imperatorskii rossiiskii istoricheskii muzei: Ukazatel' pamiatnikov. 2nd ed. Moscow: Tip. A. I. Mamontova, 1893.

Isakov, S. K. et al. *Kratkii istoricheskii ocherk: Imperatorskaia akademiia khudozhestv, 1764–1914*. St. Petersburg, 1914.

Jackson, Robert Louis. *Dostoevsky's Quest for Form: A Study of His Philosophy of Art*. New Haven: Yale University Press, 1966.

Jakobson, Roman. "The Statue in Puškin's Poetic Mythology." In *Language and Literature*, edited by Krystyna Pomorska and Stephen Rudy, 318–67. Cambridge: The Belknap Press of Harvard University Press, 1987.

Jenks, Andrew L. *Russia in a Box: Art and Identity in an Age of Revolution*. DeKalb: Northern Illinois University Press, 2005.

Johnson, Emily D. *How St. Petersburg Learned to Study Itself: The Russian Idea of Kraevedenie*. University Park: Pennsylvania State University Press, 2006.

Kanatchikov, S. I. "S. I. Kanatchikov Recounts His Adventures as a Peasant-Worker-Activist, 1879–1896." In *Major Problems in the History of Imperial Russia*, edited by James Cracraft, 528–51. Lexington: D. C. Heath and Company, 1994.

Kappeler, A. *Rossiia—mnogonatsional'naia imperiia: Vozniknovenie, istoriia, raspad*. Moscow: Izdatel'stvo "Progress-Traditsiia," 1997.

Karamzin, N. M. "Istoricheskie vospominaniia i zamechaniia na puti k Troitse." *Vestnik Evropy*, no. 15 (1802): 207–26, no. 16 (1802): 287–304, no. 17 (1802): 30–47.

———. "Russkaia starina." *Vestnik Evropy*, no. 20 (1803): 251–71, no. 21 (1803): 94–103.

Karasik, I. N., and E. N. Petrova, eds. *Iz istorii muzeia: Sbornik statei i publikatsii*. St. Petersburg: Gosudarstvennyi Russkii muzei, 1995.

Karp, Ivan. "Culture and Representation." In *Exhibiting Cultures: The Poetics and Politics of Museum Display*, edited by Ivan Karp and Steven D. Lavine, 11–24. Washington: Smithsonian Institution Press, 1991.

———. "Introduction: Museums and Communities: The Politics of Public Culture." In *Museums and Communities: The Politics of Public Culture*, edited by Ivan Karp, Christine Mullen Kreamer, and Steven D. Lavine, 1–17. Washington: Smithsonian Institution Press, 1992.

Karpeev, E. P., and T. K. Shafranovskaia. *Kunstkamera*. St. Petersburg: OOO "Almaz," 1996.

Karpov, E. P., ed. *Pamiati A. N. Ostrovskogo: Sbornik statei ob Ostrovskom i neizdannye trudy ego*. Petrograd: Put' k znaniiu, 1923.

Karpov, V. P. *Khar'kovskaia starina: Iz vospominanii starozhila, 1830–1860 gg*. Khar'kov: Tip. "Iuzhnogo kraia," 1900.

Kasinec, Edward, and Richard Wortman. "The Mythology of Empire: Imperial Russian Coronation Albums." *Biblion: The Bulletin of the New York Public Library* 1. no. 1 (Fall 1992): 77–100.

Kasparinskaia, S. A. "Muzei Rossii i vliianie gosudarstvennoi politiki na ikh razvitie (XVIII–nach. XX v.)." In *Muzei i vlast': Gosudarstvennaia politika v oblasti muzeinogo dela (XVIII–XX vv.). Sbornik nauchnykh trudov*, 8–95. Moscow: Nauchno-issledovatel'skii institut kul'tury, 1991.

Kasparinskaia-Ovsiannikova, S. A. "Vystavki izobrazitel'nogo iskusstva v Peterburge i Moskve v poreformennyi period (vtoraia polovina XIX v.)." In *Ocherki istorii muzeinogo dela v SSSR*. Vyp. 7, 366–99. Moscow: Sovetskaia Rossiia, 1971.

Katalog kartin: Imperatorskii Ermitazh. St. Petersburg: V tip. Eksped. zagotovl. gos. bumag, 1863.

Katz, Michael R. "But This Building—What on Earth Is It?" *New England Review* 23, no.1 (Winter 2002): 65–76.

———. "The Russian Response to Modernity: Crystal Palace, Eiffel Tower, Brooklyn Bridge." *Southwest Review* 93 (2008): 44–57.

Kaufman, R. S. *Ocherki istorii russkoi khudozhestvennoi kritiki XIX veka*. Moscow: "Iskusstvo," 1985.

Kelly, Catriona, Hilary Pilkington, David Shepherd, and Vadim Volkov, "Introduction: Why Cultural Studies?" In *Russian Cultural Studies: An Introduction*, edited by Catriona Kelly and David Shepherd, 1–20. Oxford: Oxford University Press, 1998.

Kelly, Catriona. *Petrushka: The Russian Carnival Puppet Theater*. Cambridge: Cambridge University Press, 1990.

———. "Popular culture." In *The Cambridge Companion to Modern Russian Culture*, edited by Nicholas Rzhevsky, 125–55. New York: Cambridge University Press, 1998.

Kelly, Catriona, and Vadim Volkov. "*Obshchestvennost'*, *Sobornost'*: Collective Identities." In *Constructing Russian Culture in the Age of Revolution: 1881–1940*, edited by Catriona Kelly and David Shepherd, 26–27. New York: Oxford University Press, 1998.

Kennedy, Janet. *The "Mir iskusstva" Group and Russian Art, 1898–1912*. New York: Garland Pub., 1977.

———. "Pride and Prejudice: Serge Diaghilev, the Ballet Russes, and the French Public." In *Art, Culture, and National Identity in Fin-de-siècle Europe*, edited by Michelle Facos

and Sharon L. Hirsh, 90–118. New York: Cambridge University Press, 2003.

Kestner, K. I. *Materialy dlia istoricheskogo opisaniia Rumiantsevskogo muzeuma.* Moscow: Rumiantsevskii muzeum, 1882.

Kettering, Karen. "Decoration and Disconnection: The *Russkii stil'* and Russian Decorative Arts at Nineteenth-Century American World's Fairs." In *Russian Art and the West: A Century of Dialogue in Painting, Architecture, and the Decorative Arts*, edited by Rosalind P. Blakesley and Susan E. Reid, 61–85. DeKalb: Northern Illinois University Press, 2007.

Khodnev, A. *Ob ustroistve muzeumov, s tsel'iu narodnogo obrazovaniia i prakticheskoi pol'zy.* St. Petersburg: 1862.

Khomiakov, A. S. "Aristotel' i vsemirnaia vystavka." *Polnoe sobranie sochinenii Alekseia Stepanovicha Khomiakova.* Vol. 1, 177–97. Moscow: Univ. tip., 1900.

———. "Mnenie russkikh ob inostrantsakh." *Polnoe sobranie sochinenii Alekseia Stepanovicha Khomiakova.* Vol. 1, 31–72. Moscow: Univ. tip., 1900.

———. "O vozmozhnosti Russkoi khudozhestvennoi shkoly." *Polnoe sobranie sochinenii Alekseia Stepanovicha Khomiakova.* Vol. 1, 73–105. Moscow: Univ. tip., 1900.

———. "Pis'ma v Peterburg o vystavke." *Polnoe sobranie sochinenii Alekseia Stepanovicha Khomiakova.* Vol. 3, 86–98. Moscow: Univ. tip., 1900.

———. "Pis'mo v Peterburg po povodu zheleznoi dorogi." *Polnoe sobranie sochinenii Alekseia Stepanovicha Khomiakova.* Vol. 3, 104–19. Moscow: Univ. tip., 1900.

Kireevskii, I. V. *Izbrannye stat'i.* Moscow: "Sovremennik," 1984.

Kirichenko, E. I. "Istorizm myshleniia i tip muzeinogo zdaniia v russkoi arkhitekture serediny i vtoroi poloviny XIX v." In *Vzaimosviaz' iskusstv v khudozhestvennom razvitii Rossii vtoroi poloviny XIX veka: Ideinye printsipy, strukturnye osobennosti*, edited by G. Iu. Sternin, 109–62. Moscow: Izd-vo "Nauka," 1982.

———. "K voprosu o poreformennykh vystavkakh Rossii kak vyrazhenii istoricheskogo svoeobraziia arkhitektury vtoroi poloviny XIX v." In *Khudozhestvennye protsessy v russkoi kul'ture vtoroi poloviny XIX veka*, edited by G. Iu. Sternin, 83–136. Moscow: Izd-vo "Nauka," 1984.

———. *Russian Design and the Fine Arts, 1750–1917.* Compiled by Mikhail Anikst. New York: Abrams, 1991.

Kirichenko, E. I., and E. G. Shcheboleva. *Russkaia provintsiia.* Moscow: "Nash dom—L'Age d'Homme," 1997.

Kirshenblatt-Gimblett, Barbara. "Objects of Ethnography." In *Exhibiting Cultures: The Poetics and Politics of Museum Display*, edited by Ivan Karp and Steven D. Lavine, 386–443. Washington: Smithsonian Institution Press, 1991.

Kivelson, Valerie A., and Joan Neuberger, eds. *Picturing Russia: Explorations in Visual Culture.* New Haven: Yale University Press, 2008.

Klancher, Jon P. *The Making of English Reading Audiences, 1790–1832.* Madison: The University of Wisconsin Press, 1987. Klioutchkine, Konstantine. "The Rise of *Crime and Punishment* from the Air of the Media." *Slavic Review* 61, no. 1 (Spring 2002): 405–22.

Kniaginia Mariia Tenisheva v zerkale Serebrianogo veka. Moscow: GIM, 2008.

Knight, Nathaniel. "Ethnicity, Nationality, and the Masses: *Narodnost'* and Modernity in Imperial Russia." In *Russian Modernity: Politics, Knowledge, Practices*, edited by

David L. Hoffmann and Yanni Kotsonis, 41–64. Houndmills: St. Martin's, 2000.

——— [Nait, Nataniel']. "Imperiia napokaz: Vserossiiskaia etnograficheskaia vystavka 1867 goda." *Novoe literaturnoe obozrenie* 51 (2001): 111–31.

———. "Science, Empire, and Nationality: Ethnography in the Russian Geographical Society, 1845–1855." In *Imperial Russia: New Histories for the Empire*, edited by Jane Burbank and David L. Ransel, 108–41. Bloomington: Indiana University Press, 1998.

Kohl, J. G. *Russia and the Russians in 1842*. Ann Arbor: University Microfilms International, 1980.

Komelova, G. "Peterburgskoe obshchestvo pooshchreniia khudozhestv i ego deiatel'nost' v 20–40kh gg. XIX v." In *Soobshcheniia Gosudarstvennogo Ermitazha*. Vol. 13, 34–36. Leningrad: Iskusstvo, 1958.

Kondakov, S. N., ed. *Imperatorskaia Sankt-Peterburgskaia Akademiia Khudozhestv: 1964–1914*. 2 vols. St. Petersburg: R. Golike, 1914.

Korinfskii, Apollon. *Sedaia starina: Desiat' byval'shchin*. Moscow: A. D. Stupin, 1912.

Korolenko, V. G. "Dve kartiny. Razmyshleniia literatora." *Sobranie sochinenii v desiati tomakh*. Vol. 8, 293–304. Moscow: Gos. izd-vo khudozh. lit-ry, 1955.

Koshelev, A. I. *Poezdka russkogo zemledel'tsa v London na Vsemirnuiu vystavku*. Moscow, 1852.

Kostomarov, N. I. *Dve russkie narodnosti*. Kiev: Maiden, 1991.

Kovalevskii, V. I., ed. *Rossiia v kontse XIX veka*. St. Petersburg: Tipografiia Akts. Obshch. Brokgauz-Effron, 1900.

Koz'min, B. P. "'Raskol v nigilistakh' (Epizod iz istorii russkoi obshchestvennoi mysli 60-kh godov)." *Iz istorii revoliutsionnoi mysli v Rossii: Izbrannye trudy*, 20–67. Moscow: Izd-vo Akademii nauk SSSR, 1961.

Krasnitskii, I. Ia. *Tverskaia starina: Ocherki istorii, drevnostei i etnografii*. St. Petersburg: Voen. Tip., 1876.

Kristof, Ladis K. D. "The Russian Image of Russia: An Applied Study in Geopolitical Methodology." In *Essays in Political Geography*, edited by Charles A. Fisher, 345–87. London: Methuen & Co., 1968.

Kroeber, A. L., and Clyde Kluckhohn. *Culture: A Critical Review of Concepts and Definitions*. New York: Vintage Books, 1952.

Kudriavtsev, V. F. *Starina, pamiatniki, predaniia i legendy Prikamskogo kraia: Ocherk*. Viatka: Gubernskaia tipografiia, 1897.

Kukol'nik, N. *Kartiny russkoi zhivopisi*. St. Petersburg: V tip. III Otdel. Sobstv. E. I. V. kantseliarii, 1846.

Kulibina, Ol'ga. *Russkii muzei Imperatora Aleksandra III: Ob"iasnenie k kartinam sostavlennoe dlia naroda Ol'goiu Kulibinoi*. 2nd ed. St. Petersburg: Montvida, 1905.

Landon, Philip. "Great Exhibitions: Representations of the Crystal Palace in Mayhew, Dickens, and Dostoevsky." *Nineteenth-Century Contexts* 20 (1997): 27–59.

Lane, Barbara Miller. "National Romanticism in Modern German Architecture." In *Nationalism in the Visual Arts*, Studies in the History of Art, 29, edited by Richard A. Etlin, 111–44. Washington: National Gallery of Art, 1991.

Lapshina, N. *"Mir iskusstva": Ocherki istorii i tvorcheskoi praktiki*. Moscow: Iskusstvo, 1977.

Lavrin, Janko. "Kireevsky and the Problem of Culture." *Russian Review* 20, no. 2 (April 1961): 110–20.

Lazarevich, E. A., ed. *Zhurnalistika i literatura*. Moscow: Izd-vo Moskovskogo universiteta, 1972.

Lebedev, G. E. *Gosudarstvennyi Russkii muzei, 1895–1945*. Leningrad: "Iskusstvo," 1946.

Lemke, M. K. *Ocherki po istorii russkoi tsenzury i zhurnalistiki XIX stoletiia*. St. Petersburg: Kn-vo M. V. Pirozhkova, 1904.

Lenin, V. I. "Kriticheskie zametki po natsional'nomu voprosu." *Polnoe sobranie sochinenii*. 5th ed. Vol. 24, 113–50. Moscow: Gosudarstvennoe izdatel'stvo politicheskoi literatury, 1961.

Leont'eva, G. K. *Karl Briullov*. Leningrad: Iskusstvo, 1976.

Lepenies, Wolf. *The Seduction of Culture in German History*. Princeton: Princeton University Press, 2006.

Leshchinskii, Ia. D., ed. *Pavel Andreevich Fedotov: Khudozhnik i poet*. Leningrad: "Iskusstvo," 1946.

Leskov, N. S. *The Enchanted Wanderer and Other Stories*. Translated by George H. Hanna. Moscow: Progress, 1974.

———. "Levsha (skaz o tul'skom kosom levshe i o stal'noi blokhe)." *Sobranie sochinenii*. Vol. 7, 26–59. Moscow: Gos. izd-vo khudozhestvennoi literatury, 1958.

———. "O russkom levshe (literaturnoe ob"iasnenie)." *Sobranie sochinenii*. Vol. 11, 219–20. Moscow: Gos. izd-vo khudozhestvennoi literatury, 1958.

———. *Skaz o tul'skom Levshe i o stal'noi blokhe (Tsekhovaia legenda)*. St. Petersburg: Tip. Suvorina, 1882.

Levin, Iu. D. *Ossian v russkoi literature: Konets XVIII–pervaia tret' XIX veka*. Leningrad: Nauka, 1980.

Levinson-Lessing, V. F. *Istoriia kartinnoi galerei Ermitazha (1764–1917)*. Leningrad: Iskusstvo, 1985.

Levitt, Marcus C. *Russian Literary Politics and the Pushkin Celebration of 1880*. Ithaca: Cornell University Press, 1989.

Lieven, D. C. B. *Empire: The Russian Empire and Its Rivals*. London: John Murray, 2000.

Likhachev, D. S. *Reflections on Russia*. Boulder: Westview Press, 1991.

Lincoln, W. Bruce. *The Great Reforms: Autocracy, Bureaucracy, and the Politics of Change in Imperial Russia*. DeKalb: Northern Illinois University Press, 1990.

Lisovskii, N. M. *Periodicheskaia pechat' v Rossii, 1703–1903: Statistiko-bibliograficheskii obzor russkoi periodicheskoi pechati*. St. Petersburg: A. E. Vineke, 1903.

Lisovskii, V. G. *Akademiia khudozhestv*. St. Petersburg: OOO "Almaz," 1997.

———. "*Natsional'nyi stil'*" v arkhitekture Rossii. Moscow: Sovpadenie, 2000.

———. "Peterburgskaia Akademiia khudozhestv i problema 'natsional'nogo stilia.'" In *Problemy razvitiia russkogo iskusstva*, vyp. 8, 26–35. Leningrad: Akademiia khudozhestv SSSR, In-t zhivopisi, skul'ptury i arkhitektury, 1976.

Lotman, Iu. M. *Besedy o russkoi kul'ture: Byt i traditsii russkogo dvorianstva (XVIII–nachalo XIX veka)*. St. Petersburg: "Iskusstvo-SPB," 1994.

———. *Universe of the Mind: A Semiotic Theory of Culture*. Translated by Ann Shukman. Bloomington: Indiana University Press, 1990.

Lotman, Yu. M., and B. A. Uspensky. "On the Semiotic Mechanism of Culture." *New Literary History* 9, no. 2 (Winter 1978): 211–32.

Macdonald, Sharon J. "Museums, Nationals, Postnational and Transcultural Identities." *Museums and Society* 1, no. 1 (2003): 1–16.

Maes, Francis. *A History of Russian Music: From Kamarinskaya to Babi Yar*. Translated by Arnold J. Pomerans and Erica Pomerans. Berkeley: University of California Press, 2002.

Maiorova, Ol'ga. "Bessmertnyi Riurik: Prazdnovanie Tysiacheletiia Rossii v 1862 g." *Novoe literaturnoe obozrenie* 43 (2000): 137–65.

———. "Slavianskii s"ezd 1867 goda: Metaforika torzhestva." *Novoe literaturnoe obozrenie* 51 (2001): 89–110.

Malia, Martin E. *Russia under Western Eyes: From the Bronze Horseman to the Lenin Mausoleum.* Cambridge: The Belknap Press of Harvard University Press, 1999.

Makhrov, Alexey. "Defining Art Criticism in Nineteenth-Century Russia: Vladimir Stasov as Independent Critic." In *Critical Exchange: Art Criticism of the Eighteenth and Nineteenth Centuries in Russia and Western Europe,* edited by Carol Adlam and Juliet Simpson, 207–26. Oxford: Peter Lang, 2009.

———. "The Pioneers of Russian Art Criticism: Between State and Public Opinion, 1804–1855." *Slavonic and East European Review,* 81, no. 4 (October 2003): 614–33.

Makovskii, S. K. *Talashkino: Izdeliia masterskikh kn. M. Kl. Tenishevoi.* St. Petersburg: Izdanie "Sodruzhestvo," 1905.

———. *L'art décoratif des ateliers de la princesse Ténichef.* St. Pétersbourg: Édition "Sodrougestvo," 1906.

———. *Stranitsy khudozhestvennoi kritiki.* 3 vols. St. Petersburg: Knigoizd. "Panteon," 1909–13.

Mal'tseva, N. A. "Rossiiskii Istoricheskii muzei i vopros ob uchrezhdenii natsional'nogo muzeia im. 300-letiia Doma Romanovykh." In *Istoricheskii muzei: Entsiklopediia otechestvennoi istorii i kul'tury,* 30–41. Moscow: Gosudarstvennyi istoricheskii muzei, 1995.

Mamontov, V. S. *Vospominaniia o russkikh khudozhnikakh (Abramtsevskii khudozhestvennyi kruzhok).* Moscow: Izd-vo Akademii khudozhestv SSSR, 1950.

Mamontova, N. N., T. A. Lykova, and T. V. Iudenkova, eds. *Pavel i Sergei Tret'iakovy: Zhizn'. Kollektsiia. Muzei.* Moscow: Makhaon, 2006.

Mandell, Richard D. *Paris 1900: The Great World's Fair.* Toronto: University of Toronto Press, 1967.

Martinsen, Deborah A., ed. *Literary Journals in Imperial Russia.* New York: Cambridge University Press, 1997.

Masanov, I. F. *Slovar' psevdonimov russkikh pisatelei, uchenykh i obshchestvennykh deiatelei.* 4 vols. Moscow: Izdatel'stvo vsesoiuznoi knizhnoi palaty, 1956–1960.

Maslov, V. I. *Ossian v Rossii (Bibliografiia).* Leningrad: Izd. Otd-niia gumanitarnykh nauk Akademii nauk SSSR, 1928.

Maslova, E. N. *Pamiatnik "Tysiacheletie Rossii."* Comp. S. N. Semanov. Moscow: "Sovetskaia Rossiia," 1985.

Mastenitsa, E. N. "Muzei v formirovanii mentaliteta." In *Psikhologiia Peterburga i peterburzhtsev za tri stoletiia: Materialy Rossiiskoi nauchnoi konferentsii 25 maia 1999 g,* 17–21. St. Petersburg: Nestor, 1999.

McGuigan, Jim. *Culture and the Public Sphere.* New York: Routledge, 1996.

McReynolds, Louise. *The News under Russia's Old Regime: The Development of a Mass-Circulation Press.* Princeton: Princeton University Press, 1991.

———. *Russia at Play: Leisure Activities at the End of the Tsarist Era.* Ithaca: Cornell University Press, 2003.

Mel'nikov, P. I. "Starina." *Polnoe sobranie sochinenii P. I. Mel'nikova (Andreia Pecherskogo).* Vol. 6, 169–85. Petrograd, 1915.

Mercer, Kobena. "Welcome to the Jungle: Identity and Diversity in Postmodern Politics." In *Identity: Community, Culture, Difference*, edited by Jonathan Rutherford, 43–71. London: Lawrence & Wishart, 1990.

Mezenin, V. K. *Parad vsemirnykh vystavok*. Moscow: "Znanie," 1990.

Mezhov, V. I. *Russkaia istoricheskaia bibliografiia za 1865–1876 vkliuchitel'no*. 8 vols. St. Petersburg: Tip. Imp. akademii nauk, 1882–1890.

Miiakovsky, Volodymyr. "Shevchenko in the Brotherhood of Saints Cyril and Methodius." In *Shevchenko and the Critics, 1861–1980*, edited by George S. N. Luckyj, 355–85. Toronto: University of Toronto Press, 1980.

Mikats, O. V. *Kopirovanie v Ermitazhe kak shkola masterstva russkikh khudozhnikov XVIII–XIX vekov*. St. Petersburg: Gos. Ermitazh, 1996.

Mikhailov, A. I. "Zametki o razvitii burzhuaznoi zhivopisi v Rossii (60–70 gg. XIX v.)." In *Russkaia zhivopis' XIX veka: Sbornik statei*, edited by V. M. Friche, 84–114. Moscow: RANION, 1929.

Mikhailovskaia, A. I. "Iz istorii promyshlennykh vystavok v Rossii pervoi poloviny XIX v. (pervye vserossiiskie promyshlennye vystavki)." In *Ocherki istorii muzeinogo dela v Rossii*, vyp. 3, 79–154. Moscow: Sovetskaia Rossiia, 1961.

Mikhnevich, V. O. *Nashi znakomye: Fel'etonnyi slovar' sovremennikov*. 2 vols. St. Petersburg: Tip. E. Goppe, 1884.

———. *Piatnadtsatiletie gazety "Golos."* St. Petersburg: A. A. Kraevskii, 1878.

Miliukov, P. N. *Natsional'nyi vopros (Proiskhozhdenie natsional'nosti i natsional'nye voprosy v Rossii)*. Prague: Swobodnaja Rossija, 1925.

Miller, Andrew H. *Novels Behind Glass: Commodity, Culture, and Victorian Narrative*. Cambridge: Cambridge University Press, 1995.

Miller, V. F. *Ocherki russkoi narodnoi slovesnosti*. Moscow: T-vo I. D. Sytina, 1897–1924.

———. *Sistematicheskoe opisanie kollektsii Dashkovskogo etnograficheskogo muzeia*. Moscow: Tip. E. G. Potapova, 1887.

Minchenkov, Ia. D. *Vospominaniia o peredvizhnikakh*. 6th ed. Leningrad: "Khudozhnik RSFSR," 1980.

Mironov, A. M. *Putevoditel' po Moskovskoi gorodskoi khudozhestvennoi galeree P. i S. Tret'iakovykh*. Moscow: Mamontov, 1902.

Mitchell, Timothy. "The World as Exhibition." *Comparative Studies in Society and History* 31, no. 2 (April 1989): 217–36.

Moeller-Sally, Stephen. "0000; or, The Sign of the Subject in Gogol's Petersburg." In *Russian Subjects: Empire, Nation, and the Culture of the Golden Age*, edited by Monika Greenleaf and Stephen Moeller-Sally, 325–46. Evanston: Northwestern University Press, 1998.

———. *Gogol's Afterlife: The Evolution of a Classic in Imperial and Soviet Russia*. Evanston: Northwestern University Press, 2002.

Mokritskii, A. N. *Dnevnik khudozhnika A. N. Mokritskogo*. Edited by N. L. Priimak. Moscow: Izobrazit. iskusstvo, 1975.

Moleva, N. M., ed. *Konstantin Korovin: Zhizn' i tvorchestvo. Pis'ma, dokumenty, vospominaniia*. Moscow: Izd-vo Akademii khudozhestv SSSR, 1963.

Moleva, N., and E. Beliutin. *Russkaia khudozhestvennaia shkola vtoroi poloviny XIX–nachala XX veka*. Moscow: Iskusstvo, 1967.

Morson, Gary Saul. *The Boundaries of Genre: Dostoevsky's Diary of a Writer and the Traditions of Literary Utopia*. Austin: University of Texas Press, 1981.

Moskovskii publichnyi i Rumiantsevskii muzei. *Putevoditel'*. Moscow: Izd-vo L. D. Frenkel', 1923.

———. *Torzhestvennoe zasedanie v pamiat' grafa N. P. Rumiantseva, 3 aprelia 1897 g.* Moscow: V. V. Chicherin, 1897.

Moser, Charles A. *Esthetics as Nightmare: Russian Literary Theory, 1855–1870*. Princeton: Princeton University Press, 1989.

Motyl, Alexander J., ed. *Encyclopedia of Nationalism*. 2 vols. San Diego: Academic Press, 2001.

Mukhin, Vyacheslav, ed. *The Fabulous Epoch of Fabergé. St. Petersburg—Paris—Moscow: Exhibition at the Catherine Palace in Tsarskoye Selo*. Moscow: Nord, 1992.

Mumford, Lewis. *The Culture of Cities*. New York: Harcourt Brace, 1996.

Nabokov, Vladimir. "Memoirs from a Mousehole." *Lectures on Russian Literature*, edited by Fredson Bowers, 115–25. San Diego: Harcourt Brace & Company, 1981.

Nagibin, Iu. M. *Berendeev les: Rasskazy, ocherki*. Moscow: Sovetskii pisatel', 1978.

Namier, Sir Lewis. *Vanished Supremacies: Essays on European History, 1812–1918*. New York: Harper Torchbooks, 1963.

Nashchokina, Maria V. "Russia at the International Exhibitions of the Late 19th and Early 20th Centuries (architectural and artistic aspects)." In *Art Nouveau/Jugendstil Architecture: International Joint Cultural Study and Action Project to Preserve and Restore World Art Nouveau/Jugendstil Architectural Heritage*, edited by Margaretha Ehrström, Ritva Wäre, and Adelaide Lönnberg, 104–13. Helsinki: University Press, 1991.

Nationalism: A Report by a Study Group of Members of the Royal Institute of International Affairs. London: Oxford University Press, 1939.

Nechaeva, V. S. *Zhurnal M. M. i F. M. Dostoevskikh "Epokha," 1864–1865*. Moscow: Nauka, 1975.

Nekrasov, N., ed. *Fiziologiia Peterburga*. Biblioteka russkoi khudozhestvennoi publitsistiki, edited by V. A. Nedzvetskii. Moscow: "Sov. Rossiia," 1984.

Nenarokomova, I. S. *Pavel Tret'iakov i ego galereia*. Moscow: Galart, 1994.

Neradovskii, P. I. *Iz zhizni khudozhnika*. Leningrad: "Khudozhnik RSFSR," 1965.

Neverov, O. Ya. *Great Private Collections of Imperial Russia*. New York: The Vendome Press, 2004.

Nikitenko, A.V. *Zapiski i dnevnik*. 3 vols. St. Petersburg: A. S. Suvorin, 1893.

Nikitin, Iu. A. "Arkhitektura russkikh vystavochnykh pavil'onov na vsemirnykh i mezhdunarodnykh vystavkakh." In *Problemy sinteza iskusstv i arkhitektury*, vyp. 7, 68–77. Leningrad: Akademiia khudozhestv SSSR, In-t zhivopisi, skul'ptury i arkhitektury, 1977.

Nikitin, S. A. *Slavianskie komitety v Rossii v 1858–1876 godakh*. Moscow: Izd-vo Moskovskogo universiteta, 1960.

Norman, Geraldine. *The Hermitage: The Biography of a Great Museum*. New York: Fromm International, 1998.

Norman, John O. "Pavel Tretiakov and Merchant Art Patronage, 1850–1900." In *Between Tsar and People: Educated Society and the Quest for Public Identity in Late Imperial Russia*, edited by Edith W. Clowes, Samuel D. Kassow, and James L. West, 93–107. Princeton: Princeton University Press, 1991.

Normand, Maurice. "La Russie à l'Exposition." *L'Illustration*, 5 May 1900, 281–87.

Norris, Stephen M. *A War of Images: Russian Popular Prints, Wartime Culture, and National Identity, 1812–1945*. DeKalb: Northern Illinois University Press, 2006.

Novitskii, A. P. *Istoriia russkogo iskusstva s drevneishikh vremen*. Moscow: V. N. Lind, 1903.

Obraztsov, G. A. *Estetika V. V. Stasova i razvitie russkogo natsional'no-realisticheskogo iskusstva*. Leningrad: Izd-vo Leningradskogo universiteta, 1975.

Ocherki po istorii russkoi zhurnalistiki i kritiki. 2 vols. Leningrad: Izd-vo Leningradskogo gos. universiteta, 1965.

Odom, Anne. "Fabergé: The Moscow Workshops." In *Fabergé: Imperial Jeweler*, edited by Géza von Habsburg and Marina Lopato, 104–15. New York: Harry N. Abrams, 1994.

———. "Fedor Solntsev, the Kremlin Service, and the Origins of the Russian Style." *Hillwood Studies* 1 (Fall 1991): 1–4.

Oinas, Felix J. *Essays on Russian Folklore and Mythology*. Columbus: Slavica Publishers, Inc., 1984.

Oksman, Iu. G. *Fel'etony sorokovykh godov: Zhurnal'naia i gazetnaia proza I.A. Goncharova, F.M. Dostoevskogo, I.S. Turgeneva*. Moscow: Academia, 1930.

Olkhovsky, Yuri. *Vladimir Stasov and Russian National Culture*. Ann Arbor: UMI Research Press, 1983.

Opochinin, E. N. *Teatral'naia starina: Istoricheskie stat'i, ocherki po dokumentam, melochi i kur'ezy*. Moscow: T-vo tip. A. I. Mamontova, 1902.

Orlova, O. P. *Dva poseshcheniia s det'mi Tret'iakovskoi galerei*. Moscow: Mamontov, 1898.

Orsher, I. L. *Literaturnyi put' dorevoliutsionnogo zhurnalista*. Moscow: Gos. izd-vo, 1930.

Ostrovskii, A. N. *Snegurochka: Vesenniaia skazka v chetyrekh deistviiakh s prologom. Polnoe sobranie sochinenii v dvenadtsati tomakh*. Vol. 7. Moscow: "Iskusstvo," 1977.

Otchet Imperatorskogo Rossiiskogo Istoricheskogo Muzeia imeni Imperatora Aleksandra III v Moskve za 1883–1908 gody. Moscow: Sinodal'naia tip., 1916.

Otto, N., and I. Kupriianov. *Biograficheskie ocherki lits, izobrazhennykh na pamiatnike tysiacheletiia Rossii, vozdvignutom v g. Novgorode 1862 g*. Novgorod: 1862.

Ovsiannikova, S. A. "Khudozhestvennye muzei Peterburga i Moskvy II-i pol. XIX–nach. XX veka (Ermitazh, Tret'iakovskaia galereia, Russkii muzei)." In *Trudy Nauchno-issledovatel'skogo instituta muzeevedeniia*. Vol. 7, 7–62. Moscow, 1962.

Ozer, Dzhesko. *Mir emalei kniagini Marii Tenishevoi [Princess Maria Tenisheva and Her World of Enamels]*. Moscow: Ozer Dzh., 2004.

Palgrave, Francis Turner. *Handbook to the Fine Art Collections in the International Exhibition of 1862*. London: Macmillan and Co., 1862.

Pamiatnik tysiacheletiia Rossii, otkrytyi v Novgorode 8 sentiabria 1862 goda. St. Petersburg: V Tip. V. Spiridonova, 1862.

Panaev, I. I. "Peterburgskii fel'etonist." In *Fiziologiia Peterburga*, Biblioteka russkoi khudozhestvennoi publtsistiki, edited by V. A. Nedzvetskii, 251–301. Moscow: "Sov. Rossiia," 1984.

———. "Peterburgskii literaturnyi promyshlennik." In *Russkii fel'eton. V pomoshch' rabotnikam pechati*, edited by A. V. Zapadov, 130–39. Moscow: Gos. izd-vo polit. lit-ry, 1958.

Panchenko, A. M. "Dva etapa russkogo barokko." In *Tekstologiia i poetika russkoi literatury XI–XVII vekov*, edited by D. S. Likhachev, 100–106. Leningrad: Nauka, 1977.

———. "Leskovskii Levsha kak natsional'naia problema." *Russkaia istoriia i kul'tura: Raboty raznykh let.* 448–52. St. Petersburg: Iuna, 1999.

Paniutin, Lev. "Novyi God." In *Rasskazy Nila Admirari.* Vol. 2, 21–42. St. Petersburg, 1872.

Panteleev, L. F. *Vospominaniia.* Edited by S. A. Reiser. Moscow: Gos. izd-vo khudozh. lit-ry, 1958.

Pantelić, Bratislav. "Nationalism and Architecture: The Creation of a National Style in Serbian Architecture and Its Political Implications." *The Journal of the Society of Architectural Historians* 56, no. 1 (March 1997): 16–41.

Paperno, Irina. *Chernyshevsky and the Age of Realism: Study in the Semiotics of Behavior.* Stanford: Stanford University Press, 1988.

Paperny, Vladimir. *Kul'tura "Dva."* Ann Arbor: Ardis, 1985.

Paret, Peter. *Art as History: Episodes in the Culture and Politics of Nineteenth-Century Germany.* Princeton: Princeton University Press, 1988.

Pauly, T. de. *Description ethnographique des peuples de la Russie.* St. Petersburg: F. Bellizard, 1862.

Pavlov, Platon. *Tysiacheletie Rossii: Kratkii ocherk otechestvennoi istorii.* St. Petersburg: I. Paul'son, 1863.

Pekarskii, P. *Nauka i literatura v Rossii pri Petre Velikom.* St. Petersburg: "Obshchestvennaia pol'za," 1862.

Piatidesiatiletie Imperatorskogo obshchestva liubitelei estestvoznaniia, antropologii i etnografii, 1863–1913. Compiled by V. V. Bogdanov. Moscow, 1914.

Piatidesiatiletie Rumiantsovskogo muzeia v Moskve, 1862–1912: Istoricheskii ocherk. Moscow: T-vo skoropechatni A. A. Levenson, 1913.

Piggott, Jan. *Palace of the People: The Crystal Palace at Sydenham, 1854–1936.* Madison: University of Wisconsin Press, 2004.

Petrovich, Michael Boro. *The Emergence of Russian Panslavism, 1856–1870.* Westport: Greenwood Press, 1985.

Pil'niak, Boris. *Mne gor'kaia vypala slava…: Pis'ma 1915–1937.* Moscow: AGRAF, 2002.

Pisarev, D. I. "Razrushenie estetiki." *Sochineniia D. I. Pisareva: Polnoe sobranie v shesti tomakh, s portretom avtora i stat'ei Evgeniia Solov'eva.* Vol. 4, 497–516. St. Petersburg: Tip. A. Porokhovshchikova, 1897.

———. "The Realists." In *Russian Philosophy*, edited by James M. Edie, James P. Scanlan, and Mary-Barbara Zeldin. Vol. 2, 79–96. Chicago: Quadrangle Books, 1965.

Pitkin, Hanna Fenichel. *The Concept of Representation.* Berkeley: University of California Press, 1967.

A Plain Guide to the International Exhibition: The Wonders of the Exhibition Showing How They May Be Seen at One Visit. London: Sampson Low, Son, and Co., 1862.

Poboinin, Ivan. *Toropetskaia starina: Istoricheskie ocherki goroda Toroptsa s drevneishikh vremen do kontsa XVII veka.* Moscow: Universitetskaia tipografiia, 1902.

Polenova, N.V. *Abramtsevo: Vospominaniia.* Moscow: Izd. M. i S. Sabashnikovykh, 1922.

Polikarpova, Galina. *100 let Russkogo muzeia v fotografiiakh, 1898–1998.* St. Petersburg: Gosudarstvennyi Russkii muzei, 1998.

Polovtsov, A.V. *Progulka po Russkomu muzeiu Imperatora Aleksandra III v S.-Peterburge.* Moscow, 1900.

Polunina, N. M., and A. I. Frolov. *Osnovateli: Rossiiskie prosvetiteli.* Moscow: Sovetskaia Rossiia, 1990.

Prasch, Thomas. "International Exhibition of 1862." In *Historical Dictionary of World's Fairs and Expositions, 1851–1988*, edited by John E. Findling, 23–30. New York: Greenwood Press, 1990.

Prishvin, M. M. *Rodniki Berendeia. Sobranie sochinenii.* Vol. 3. Moscow: Gosudarstvennoe izdatel'stvo, 1927–1930.

Proudhon, Pierre-Joseph. *Iskusstvo: Ego osnovaniia i obshchestvennoe naznachenie.* Translated by N. Kurochkin. St. Petersburg: Izd. Perevodchikov, 1865.

Prymak, Thomas M. *Mykola Kostomarov: A Biography.* Toronto: University of Toronto Press, 1996.

Pushkin, A. S. *Ruslan i Liudmila. Polnoe sobranie sochinenii v desiati tomakh.* Vol. 4. Moscow: Izd-vo Akademii nauk SSSR, 1963.

Pyliaev, M. I. *Staryi Peterburg.* Moscow: SP "IKPA," 1990.

Pypin, A.N. *Istoriia russkoi etnografii.* Vol. 1. St. Petersburg: M. M. Stasiulevich, 1890.

Rabow-Edling, Susanna. "The Role of 'Europe' in Russian Nationalism: Reinterpreting the Relationship between Russia and the West in Slavophile Thought." In *Russia in the European Context 1789–1914: A Member of the Family*, edited by Susan P. McCaffray and Michael Melancon, 97–112. New York: Palgrave Macmillan, 2005.

Ramazanov, Nikolai. *Materialy dlia istorii khudozhestv v Rossii.* Moscow: V Gubernskoi tip., 1863.

Ravikovich, D. A. "Muzeinye deiateli i kollektsionery v Rossii XVIII–nach. XX v." In *Kontseptual'nye problemy muzeinoi entsiklopedii.* Moscow: Nauchno-issl. in-t kul'tury, 1990.

Razgon, A. M. "Etnograficheskie muzei v Rossii (1861–1917)." In *Ocherki istorii muzeinogo dela v Rossii.* Vyp. 3. Moscow: Sovetskaia Rossiia, 1961.

———. "Rossiiskii Istoricheskii muzei: Istoriia ego osnovaniia i deiatel'nosti (1872–1917 gg.)." In *Ocherki istorii muzeinogo dela v Rossii.* Vyp. 2, 224–99. Moscow: Sovetskaia Rossiia, 1960.

Re..f..ts, Ivan [Renofants, I. M.]. *Karmannaia knizhka dlia liubitelei chteniia russkikh knig, gazet i zhurnalov, ili, Kratkoe istolkovanie vstrechaiushchikhsia v nikh slov voennykh, morskikh, politicheskikh, kommercheskikh i raznykh drugikh iz inostrannykh iazykov zaimstvovannykh, koikh znacheniia ne kazhdomu izvestny: Knizhka podruchnaia dlia kazhdogo sosloviia, pola i vozrasta.* St. Petersburg, 1837.

Repin, I. E. *Dalekoe blizkoe.* Edited by Kornei Chukovskii. Moscow: Iskusstvo, 1944.

Riasanovsky, Nicholas V. *Nicholas I and Official Nationality in Russia, 1825–1855.* Berkeley: University of California Press, 1967.

Richards, Thomas. *The Commodity Culture of Victorian England: Advertising and Spectacle, 1851–1914.* Stanford: Stanford University Press, 1990.

Rieber, Alfred J. "The Fragmented 'Middle Ranks.'" In *Major Problems in the History of Imperial Russia*, edited by James Cracraft, 494–504. Lexington: D. C. Heath and Company, 1994.

Roerich, N. K. *Kul'tura i tsivilizatsiia.* Moscow: Mezhdunar. tsentr Rerikhov, 1994.

Rogger, Hans. *National Consciousness in Eighteenth-Century Russia.* Russian Research Center Studies. Cambridge: Harvard University Press, 1960.

Roginskaia, F. S. *Tovarishchestvo peredvizhnykh khudozhestvennykh vystavok: Istoricheskie ocherki.* Moscow: "Iskusstvo," 1989.

Romanovich, P. P., ed. *Russkaia starina v rodnoi poezii: Illiustrirovannyi sbornik stikhotvornykh obraztsov s primechaniiami i slovarem*. Novgorod: Tipo-lit. Gub. pravleniia, 1890.

Rozanova, L. A. "Berendei i ikh tsar' kak nositeli russkogo natsional'nogo kharaktera." In *Natsional'nyi kharakter i russkaia kul'turnaia traditsiia v tvorchestve A. N. Ostrovskogo*. Materialy nauchno-prakticheskoi konferentsii 27–28 marta 1998 goda, part II, 18–30. Kostroma: "Evrika-M," 1998.

Rubakin, N. A. *Etiudy o russkoi chitaiushchei publike: Fakty, tsifry i nabliudeniia*. St. Petersburg, 1895.

Ruskin, John. *Proserpina; Ariadne Florentina; The Opening of the Crystal Palace*. Boston: Colonial Press Company, 1890.

Russkaia starina: Ezhemesiachnoe istoricheskoe izdanie. Reprint ed. St. Petersburg: Al'faret, 2008.

Rutherford, Andrea. "Vissarion Belinskii and the Ukrainian National Question." *The Russian Review* 54 (October 1995): 500–515.

Ryan-Hayes, Karen L. *Russian Publicistic Satire under Glasnost: The Journalistic Feuilleton*. Lewiston: The Edwin Mellen Press, 1993.

Rzhevsky, Nicholas. "Russian Cultural History: Introduction." In *The Cambridge Companion to Modern Russian Culture*, edited by Nicholas Rzhevsky, 1–18. New York: Cambridge University Press, 1998.

Salmond, Wendy R. *Arts and Crafts in Late Imperial Russia: Reviving the Kustar Art Industries, 1870–1917*. New York: Cambridge University Press, 1996.

———. "A Matter of Give and Take: Peasant Crafts and Their Revival in Late Imperial Russia." *Design Issues* 13, no. 1 (Spring 1997): 5–14.

Saltykov-Shchedrin, M. E. "Kul'turnye liudi." *Polnoe sobranie sochinenii*. Vol. 11, 497–532. Leningrad: Gos. izd-vo khudozh. lit-ry, 1934.

———. *Ubezhishche Monrepo. Sobranie sochinenii*. Vol. 8. Moscow: Izdatel'stvo "Pravda," 1951.

Sapunov, A. *Vitebskaia starina*. Vitebsk: Tipo-lit. G. A. Malkina, 1883.

Savinov, A. N. *Pavel Egorovich Shcherbov*. Leningrad: Khudozhnik RSFSR, 1969.

Sbornik materialov dlia istorii Rumiantsevskogo muzeia. 2 vols. Moscow: Izd. Moskovskogo publichnogo i Rumiantsevskogo muzeev, 1882–86.

Schönle, Andreas, ed. *Lotman and Cultural Studies: Encounters and Extensions*. Madison: The University of Wisconsin Press, 2006.

Sewell, William H., Jr. "The Concept(s) of Culture." In *Beyond the Cultural Turn: New Directions in the Study of Society and Culture*, edited by Victoria E. Bonnel and Lynn Hunt, 35–61. Berkeley: University of California Press, 1999.

Shaginian, Marietta. *Pervaia Vserossiiskaia. Roman-khronika*. Moscow: Molodaia gvardiia, 1965.

Shakh-Azizova, T. "Real'nost' i fantaziia ('Snegurochka' A. N. Ostrovskogo i ee sud'ba v russkom iskusstve poslednei treti XIX i nachala XX v.)." In *Vzaimosviaz' iskusstv v khudozhestvennom razvitii Rossii vtoroi poloviny XIX veka: Ideinye printsipy, strukturnye osobennosti*, edited by G. Iu. Sternin, 219–63. Moscow: Izd-vo "Nauka," 1982.

Sheehan, James J. *Museums in the German Art World from the End of the Old Regime to the Rise of Modernism*. New York: Oxford University Press, 2000.

Shein, P. V. *Velikoruss v svoikh pesniakh, obriadakh, obychaiakh, verovaniiakh, skazkakh, legendakh i t. p.* St. Petersburg: Izd. Imp. Akademii nauk, 1898–.

Shelgunov, N. V. *Ocherki russkoi zhizni*. St. Petersburg: Izd. O. N. Popovoi, 1895.

———. *Sochineniia N. V. Shelgunova*. 2nd ed. St. Petersburg: Tip. I. N. Skorokhodova, 1895.

———. *Vospominaniia*. Seriia literaturnykh memuarov. Moscow: "Khudozhestvennaia literatura," 1967.

Sherman, Daniel J. *Worthy Monuments: Art Museums and the Politics of Culture in Nineteenth-Century France*. Cambridge: Harvard University Press, 1989.

Sherman, Daniel J., and Irit Rogoff, eds. *Museum Culture: Histories, Discourses, Spectacles*. Minneapolis: University of Minnesota Press, 1994.

Shiner, Larry. *The Invention of Art: A Cultural History*. Chicago: The University of Chicago Press, 2001.

Shklovskii, Viktor. *Gamburgskii schet*. Leningrad: Izd-vo pisatelei v Leningrade, 1928.

———. *Tekhnika pisatel'skogo remesla*. Moscow: Molodaia gvardiia, 1930.

Sicher, Efraim. "By Underground to Crystal Palace: The Dystopian Eden." *Comparative Literature Studies* 22, no. 3 (Fall 1985): 377–93.

Siegelbaum, Lewis H. "Exhibiting *Kustar'* Industry in Late Imperial Russia / Exhibiting Late Imperial Russia in *Kustar'* Industry." In *Transforming Peasants: Society, State and the Peasantry, 1861–1930*, edited by Judith Pallot, 37–63. New York: St. Martin's Press, 1998.

Simon, Robin. *Hogarth, France and British Art: The Rise of the Arts in 18th-Century Britain*. London: Hogarth Arts, 2007.

Sistematicheskii ukazatel' statei istoricheskogo zhurnala "Drevniaia i novaia Rossiia," 1875–1881. St. Petersburg: Izdanie A. S. Suvorina, 1893.

Sluchevskii, K. *Vozzikaiushchaia sokrovishchnitsa: Russkii muzei Imperatora Aleksandra III*. St. Petersburg: Tip. M-va vn. del, 1898.

Smirnov, V. G. *Rossiia v bronze: Pamiatnik Tysiacheletiiu Rossii i ego geroi*. Novgorod: Russkaia provintsiia, 1993.

Smith, Anthony D. *The Ethnic Origins of Nations*. Oxford: Blackwell, 1986.

Smith, Douglas. *Working the Rough Stone: Freemasonry and Society in Eighteenth-Century Russia*. DeKalb: Northern Illinois University Press, 1999.

Smith, John Boulton. *The Golden Age of Finnish Art: Art Nouveau and the National Spirit*. Helsinki: Otava Pub. Co., 1985.

Snegirev, Ivan, and A. A. Martynov, eds. *Russkaia starina v pamiatnikakh tserkovnogo i grazhdanskogo zodchestva*. Moscow: V Politseiskoi tip., 1848.

Snegirev, Ivan, ed. *Pamiatniki drevnego khudozhestva v Rossii: Sobranie risunkov s tserkovnykh i domashnikh utvarei, sv. krestov, predmetov, ikonopisi ikonostasov, detal'nye izobrazheniia otdel'nykh chastei zdanii, ukrasheniia, obraztsy mebeli i drugikh prinadlezhnostei starinnogo russkogo byta*. 6 vols. Moscow: Izd. A. A. Martynova, 1850–54.

Sobko, N. P., ed. *Slovar' russkikh khudozhnikov, vaiatelei, zhivopistsev, zodchikh, risoval'shchikov, graverov, litografov, medal'erov, mozaichistov, ikonopistsev, liteishchikov, chekanshchikov, skanshchikov i proch. s drevneishikh vremen do nashikh dnei (XI–XIX vv.)*. 3 vols. St. Petersburg: Tip. M. M. Stasiulevicha, 1893–99.

Sobko, N. P., and D. A. Rovinskii, eds. *Vasilii Grigor'evich Perov: Ego zhizn' i proizvedeniia: 60 fototipii s ego kartin bez retushi*. St. Petersburg, 1892.

Sobranie kniagini M. K. Tenishevoi: K 110-letiiu Russkogo muzeia. St. Petersburg: Palace Editions, 2008.

Sokhanskaia, N. S. *Starina: Semeinaia pamiat'*. In *Povesti Kokhanovskoi*. Vol. 1, 181–267. Moscow: V tipografii Bakhmeteva, 1863.

Sokol, K. G. *Monumenty imperii: Opisanie dvukhsot naibolee interesnykh pamiatnikov imperatorskoi Rossii*. Moscow: Izd-vo GEOS, 1999.

Sokolov, Y. M. *Russian Folklore*. Translated by Catherine Ruth Smith. Hatboro: Folklore Associates, 1966.

Sollogub, V. A. *Povesti. Vospominaniia*. Leningrad: "Khudozh. lit-ra," Leningradskoe otdnie, 1988.

Solntsev, F. G. *Drevnosti Rossiiskogo gosudarstva*. 6 vols. Moscow: V tip. Aleksandra Semena, 1849–65.

———. *Drevnosti Rossiiskogo gosudarstva*. Edited by E. S. Davydova. Moscow: Belyi gorod, 2007.

Solov'ev, V. S. *Natsional'nyi vopros v Rossii. Sobranie sochinenii Vladimira Sergeevicha Solov'eva: S 3-mia portretami i avtografom*. 2nd ed. Vol. 5. St. Petersburg: Knigoizdatel'skoe Tovarishchestvo "Prosveshchenie," 1911–14.

Solzhenitsyn, Aleksandr. *The First Circle*. Translated by Thomas P. Whitney. New York: Harper & Row, 1968.

Somov, A. *Kartiny Imperatorskogo Ermitazha: Dlia posetitelei etoi galerei*. St. Petersburg: V tip. A. Iakobsona, 1859.

Sorokin, Iu. S. *Razvitie slovarnogo sostava russkogo literaturnogo iazyka (30–90-e gody)*. Moscow: Nauka, 1965.

Stalin, I. V. *Marksizm i natsional'no-kolonial'nyi vopros*. Moscow: Partiinoe izd-vo, 1934.

Stark, Eduard. *Nashi khudozhestvennye sokrovishcha: Russkii muzei Imperatora Aleksandra III*. St. Petersburg: P. P. Soikin, 1913.

Starr, Frederick S. "Russian Art and Society, 1800–1850." In *Art and Culture in Nineteenth-Century Russia*, edited by Theofanis George Stavrou, 87–112. Bloomington: Indiana University Press, 1983.

Stasov, V. V. "Dvadtsat' piat' let russkogo iskusstva." *Sobranie sochinenii V. V. Stasova, 1847–1886*. Vol. 1, 493–698. St. Petersburg: Tipografiia M. M. Stasiulevicha, 1894.

———. "Eshche dva slova o proekte pamiatnika tysiacheletiiu Rossii." *Sochineniia V. V. Stasova: 1847–1886*. Vol. 1, 51–56. St. Petersburg: Tipografiia M. M. Stasiulevicha, 1894.

———. *Izbrannye sochineniia v trekh tomakh*. 3 vols. Moscow: Iskusstvo, 1952.

———. "Khudozhestvennaia vystavka za 25 let." *Sobranie sochinenii V. V. Stasova, 1847–1886*. Vol. 1, 469–87. St. Petersburg: Tipografiia M. M. Stasiulevicha, 1894.

———. "Moi adres publike." *Izbrannye sochineniia v trekh tomakh*. Vol. 3, 264–67. Moscow: Iskusstvo, 1952.

———. "Nasha etnograficheskaia vystavka i ee kritiki (1867)." *Sobranie sochinenii V. V. Stasova, 1847–1886*. Vol. 3, 935–48. St. Petersburg: Tipografiia M. M. Stasiulevicha, 1894.

———. "Nasha khudozhennaia proviziia dlia Londonskoi vystavki (1862)." *Sobranie sochinenii V. V. Stasova, 1847–1886*. Vol. 1, 69–88. St. Petersburg: Tipografiia M. M. Stasiulevicha, 1894.

———. "Odin iz proektov pamiatnika tysiacheletiiu Rossii." *Sobranie sochinenii V. V. Stasova, 1847–1886*. Vol. 1, 43–51. St. Petersburg: Tipografiia M. M. Stasiulevicha, 1894.

———. "Proiskhozhdenie russkikh bylin." *Sobranie sochinenii V. V. Stasova, 1847–1886*.

Vol. 3, 948–1260. St. Petersburg: Tipografiia M. M. Stasiulevicha, 1894.

———. "Publichnaia biblioteka i Ermitazh pri Aleksandre I." *Sobranie sochinenii V. V. Stasova, 1847–1886.* Vol. 1, 451–58. St. Petersburg: Tipografiia M. M. Stasiulevicha, 1894.

———. "Rumiantsovskii muzei. Istoriia ego perevoda iz Peterburga v Moskvu v 1860–1861 godakh." *Sobranie sochinenii V. V. Stasova, 1847–1886.* Vol. 3, 1687–712. St. Petersburg: Tipografiia M. M. Stasiulevicha, 1894.

———. *Russian Peasant Design Motifs for Needleworkers and Craftsmen.* New York: Dover Publications, Inc., 1976.

———. *Russkii narodnyi ornament. Vypusk pervyi: Shit'e, tkani, kruzheva.* Izdanie Obshchestva Pooshchreniia Khudozhnikov. S ob"iasnitel'nym tekstom V. Stasova. St. Petersburg: Tip. T-va Obshchestvennoi pol'zy, 1872.

———. *Sobranie sochinenii V. V. Stasova, 1847–1886.* 3 vols. St. Petersburg: Tipografiia M. M. Stasiulevicha, 1894.

———. *Stat'i i zametki, publikovavshiesia v gazetakh i ne voshedshie v knizhnye izdaniia.* Edited by V. M. Lobanov. 2 vols. Moscow: Izd-vo Akademii khudozhestv SSSR, 1952–54.

———. "Stolitsy Evropy i ikh arkhitektura." *Sobranie sochinenii V. V. Stasova, 1847–1886.* Vol. 1, 387–442. St. Petersburg: Tipografiia M. M. Stasiulevicha, 1894.

———. "Tsar' Berendei i ego palata." *Iskusstvo i khudozhestvennaia promyshlennost'* 1 and 2 (1898).

Stavrou, Theofanis George, ed. *Art and Culture in Nineteenth-Century Russia.* Bloomington: Indiana University Press, 1983.

Steiner, Evgeny. "A Battle for the 'People's Cause' or for the Market Case: Kramskoi and the Itinerants." *Cahiers du Monde russe* 50, no. 4 (Octobre-Décembre 2009): 1–20.

———. "Pursuing Independence: Kramskoi and the Peredvizhniki vs. the Academy of Arts." *The Russian Review* 70 (April 2011): 252–71.

Steklov, Iu. M. *N. G. Chernyshevskii: Ego zhizn' i deiatel'nost'.* Moscow: Gos. izd-vo, 1928.

Sternin, G. Iu. "Abramtsevo—'tip zhizni' i tip iskusstva." In *Abramtsevo: Khudozhestvennyi kruzhok. Zhivopis', grafika, skul'ptura, teatr, masterskie,* 7–23. Leningrad: "Khudozhnik RSFSR," 1988.

———. *Khudozhestvennaia zhizn' Rossii sered14 XIX veka.* Moscow: Iskusstvo, 1991.

———. *Ocherki russkoi satiricheskoi grafiki.* Moscow: Iskusstvo, 1964.

———. *Russkaia khudozhestvennaia kul'tura vtoroi poloviny XIX–nachala XX veka.* Moscow: Sovetskii khudozhnik, 1984.

Stites, Richard. *Serfdom, Society, and the Arts in Imperial Russia: The Pleasure and the Power.* New Haven: Yale University Press, 2005.

Stocking, George W., Jr. *Victorian Anthropology.* New York: The Free Press, 1987.

Stoughton, John. *The Palace of Glass and the Gathering of the People: A Book for the Exhibition.* London: Religious Tract Society, 1851.

Strakhov, N. N. "Nasha kul'tura i vsemirnoe edinstvo." *Russkii vestnik* 6 (June 1888): 200–56.

Streen, Albert. "Tradition and Revival: The Past in Norway's National Consciousness." In *Norwegian Folk Art: The Migration of a Tradition,* edited by Marion Nelson, 249–56. New York: Abbeville Press, 1995.

Stuart, Mary. *Aristocrat-Librarian in Service to the Tsar: Aleksei Nikolaevich Olenin and the*

Imperial Public Library. New York: Columbia University Press, 1986.

The Study of Russian Folklore. Edited and translated by Felix J. Oinas and Stephen Souda-koff. The Hague: Mouton, 1975.

Subtelny, Orest. *Ukraine: A History*. Toronto: University of Toronto Press, 1988.

Suvorin, A. S. *Russkii kalendar' na 1904 g.* St. Petersburg: A. S. Suvorin, 1904.

Svedeniia ob ustroistve muzeia imeni Gosudaria Naslednika Tsesarevicha. Moscow, 1874.

Svin'in, P. P. *Dostopamiatnosti Sankt-Peterburga i ego okrestnostei*. St. Petersburg: "Liga Plius," 1997.

Swift, E. Anthony. *Popular Theater and Society in Tsarist Russia*. Berkeley: University of California Press, 2002.

Swift, Anthony. "Russia and the Great Exhibition of 1851: Representation, Perceptions, and a Missed Opportunity." *Jahrbücher für Geschichte Osteuropas* 55 (2007): 242–63.

Szporluk, Roman. *Communism and Nationalism: Karl Marx versus Friedrich List*. New York: Oxford University Press, 1988.

Tallis, John. *Tallis's History and Description of the Crystal Palace, and the Exhibition of the World's Industry in 1851*. London: J. Tallis and Co., 1852.

Taruskin, Richard. *Defining Russia Musically: Historical and Hermeneutical Essays*. Princeton: Princeton University Press, 1997.

———. *On Russian Music*. Berkeley: University of California Press, 2009.

———. *Opera and Drama in Russia as Preached and Practiced in the 1860s*. Ann Arbor: UMI Research Press, 1981.

———. *Stravinsky and the Russian Traditions: A Biography of the Works through Mavra*. Oxford: Oxford University Press, 1996.

Taylor, Brandon. *Art for the Nation: Exhibitions and the London Public, 1747–2001*. The Barber Institute's Critical Perspectives in Art History. Manchester: Manchester University Press, 1999.

Thaden, Edward C. *Conservative Nationalism in Nineteenth-Century Russia*. Seattle, University of Washington Press, 1964.

———. *Russia since 1801: The Making of a New Society*. New York: Wiley-Interscience, 1971.

———. *Russia's Western Borderlands, 1710–1870*. Princeton: Princeton University Press, 1984.

———, ed. *Russification in the Baltic Provinces and Finland, 1855–1914*. Princeton: Princeton University Press, 1981.

Tenisheva, Mariia. *Vpechatleniia moei zhizni*. Moscow: Molodaia gvardiia, 2006.

Thomas, Kevin Tyner Thomas. "Collecting the Fatherland: Early-Nineteenth-Century Proposals for a Russian National Museum." In *Imperial Russia: New Histories for the Empire*, edited by Jane Burbank and David L. Ransel, 91–107. Bloomington: Indiana University Press, 1998.

Thomson, Richard. *The Troubled Republic: Visual Culture and Social Debate in France, 1889–1900*. New Haven: Yale University Press, 2004.

Thurston, Gary. *The Popular Theater Movement in Russia, 1862–1919*. Evanston: Northwestern University Press, 1998.

Titov, A. A. *Rostovskaia starina*. Rostov: Tip. Sorokina, 1883.

Todd, William Mills III. *Fiction and Society in the Age of Pushkin: Ideology, Institutions, and Narrative*. Cambridge: Harvard University Press, 1986.

———, ed. *Literature and Society in Imperial Russia, 1800–1914.* Stanford: Stanford University Press, 1978.

Tolstoi, Vladimir. "Muzei v Rossii—bol'she, chem muzei." *Mir i muzei* 1 (Autumn 1998).

Tolstoi, L. N. *Chto takoe iskusstvo? Sobranie sochinenii v 22 tomakh.* Vol. 15. Moscow: Khudozhestvennaia literatura, 1983.

———. [Tolstoy, Leo]. *Tolstoy's Diaries.* Edited and translated by R. F. Christian. London: The Athlone Press, 1985.

———. *What Is Art?* Translated by Aylmer Maude. Bridgewater: Replica Books, 2000.

Tolz, Vera. *Russia.* New York: Oxford University Press, 2001.

Tsimbaev, K. N. "Fenomen iubileemanii v Rossiiskoi obshchestvennoi zhizni kontsa XIX–nachala XX veka." *Voprosy istorii*, no. 11 (2005): 98–108.

Tunimanov, V. A. *Tvorchestvo Dostoevskogo, 1854–1862.* Leningrad: Nauka, 1980.

Tur'inskaia, Kh. M. "Etnomuzeevedcheskaia mysl' v zhurnale 'Zhivaia starina' (1890–1916)." *Gumanitarnaia kul'tura i etnoidentifikatsiia* 2 (2005): 270–79.

Tylor, Edward B. *Primitive Culture: Researches into the Development of Mythology, Philosophy, Religion, Art, and Custom.* London: J. Murray, 1871.

Tynianov, Iu. N., and B. V. Kazanskii, eds. *Fel'eton: Sbornik statei.* Voprosy sovremennoi literatury. Leningrad: Academia, 1927.

Ukazatel' Vserossiiskoi Manufakturnoi vystavki 1870 goda v S.-Peterburge. St. Petersburg, 1870.

Uspenskii, A. I. *Ocherki po istorii russkogo iskusstva.* Moscow: Izd. V. R. Uspenskoi, 1910–.

Uspenskii, Gleb. "Burzhui." *Polnoe sobranie sochinenii Gleba Uspenskogo.* Vol. 5, 569–89. St. Petersburg: A. F. Marks, 1908.

———. *Iz derevenskogo dnevnika. Polnoe sobranie sochinenii Gleba Uspenskogo.* Vol. 4, 3–238. St. Petersburg: A. F. Marks, 1908.

———. "Po povodu odnoi kartinki." *Polnoe sobranie sochinenii Gleba Uspenskogo.* Vol. 5, 229–36. St. Petersburg: A. F. Marks, 1908.

———. "Skandal: Obyknovennaia istoriia." *Polnoe sobranie sochinenii.* Vol. 1, 438–55. Moscow: Izdatel'stvo Akademii nauk SSSR, 1952.

Valkenier, Elizabeth Kridl. *Russian Realist Art: The State and Society: The Peredvizhniki and Their Tradition.* New York: Columbia University Press, 1989.

———, ed. *The Wanderers: Masters of 19th-Century Russian Painting: An Exhibition from the Soviet Union.* Dallas: Dallas Museum of Art, 1990.

Vasil'ev, Aleksandr. *Beauty in Exile: The Artists, Models, and Nobility Who Fled the Russian Revolution and Influenced the World of Fashion.* Translated by Antonina W. Bouis and Anya Kucharev. New York: Harry N. Abrams, 2000.

Vasina-Grossman, V. A. "Musorgskii i Viktor Gartman." In *Khudozhestvennye protsessy v russkoi kul'ture vtoroi poloviny XIX veka*, edited by G. Iu. Sternin, 37–51. Moscow: Izd-vo "Nauka," 1984.

Venevitinov, D. V. "Neskol'ko myslei v plan zhurnala." *Polnoe sobranie sochinenii*, edited by B. V. Smirenskii, 215–20. Moscow: Academia, 1934.

Viollet-le-Duc, Eugène-Emmanuel. *Russkoe iskusstvo: Ego istochniki, ego sostavnye elementy, ego vysshee razvitie, ego budushchnost'.* Moscow: Tip. A. Gattsyka, 1879.

von Geldern, James, and Louise McReynolds, eds. *Entertaining Tsarist Russia: Tales, Songs, Plays, Movies, Jokes, Ads, and Images from Russian Urban Life, 1779–1917.* Indiana-Michigan Series in Russian and East European Studies. Bloomington: Indiana

University Press, 1998.

Vrangel', N. N. *Iskusstvo i gosudar' Nikolai Pavlovich*. Petrograd, 1915.

———. *Russkii muzei Imperatora Aleksandra III: Zhivopis' i skul'ptura*. 2 vols. St. Petersburg: Izd. Russkogo Muzeia Imperatora Aleksandra III, 1904.

Vserossiiskaia etnograficheskaia vystavka i Slavianskii s'ezd v mae 1867 goda. Moscow: V Univ. tip., 1867.

Walicki, Andrzej. *A History of Russian Thought from the Enlightenment to Marxism*. Translated by Hilda Andrews-Rusiecka. Stanford: Stanford University Press, 1979.

Wallis, Brian. "Selling Nations: International Exhibitions and 'Cultural Diplomacy.'" In *Museum Culture: Histories, Discourses, Spectacles*, edited by Daniel J. Sherman and Irit Rogoff, 265–81. Minneapolis: University of Minnesota Press, 1994.

Walsh, Kevin. *The Representation of the Past: Museums and Heritage in the Post-Modern World*. The Heritage: Care—Preservation—Management. New York: Routledge, 1992.

Warner, Marina. *Monuments and Maidens: The Allegory of the Female Form*. New York: Atheneum, 1985.

Warner, Michael. "The Mass Public and the Mass Subject." In *The Phantom Public Sphere*, edited by Bruce Robbins, 234–55. Minneapolis: University of Minnesota Press, 1993.

Wachtel, Andrew Baruch. *An Obsession with History: Russian Writers Confront the Past*. Stanford: Stanford University Press, 1994.

Weeks, Theodore R. *Nation and State in Late Imperial Russia: Nationalism and Russification on the Western Frontier, 1863–1914*. DeKalb: Northern Illinois University Press, 1996.

Williams, Raymond. *Culture and Society: 1780–1950*. New York: Columbia University Press, 1983.

Williams, Robert C. "The Russian Soul: A Study in European Thought and Non-European Nationalism." *Journal of the History of Ideas* 31, no.4 (October-December 1970): 573–88.

Whittaker, Cynthia Hyla, ed. *Visualizing Russia: Fedor Solntsev and Crafting a National Past*. Leiden and Boston: Brill, 2010.

Woehrlin, William, F. *Chernyshevsky: The Man and the Journalist*. Cambridge: Harvard University Press, 1971.

The Works of Ossian, the Son of Fingal. 3rd ed. 2 vols. Translated by James Macpherson. London, 1765.

Wortman, Richard S. "The 'Russian Style' in Church Architecture as Imperial Symbol after 1881." In *Architectures of Russian Identity: 1500 to the Present*, edited by James Cracraft and Daniel Rowland, 101–16. Ithaca: Cornell University Press, 2003.

———. *Scenarios of Power: Myth and Ceremony in Russian Monarchy*. Studies of the Harriman Institute. 2 vols. Princeton: Princeton University Press, 2000.

Yampolsky, Mikhail. "In the Shadow of Monuments: Notes on Iconoclasm and Time." In *Soviet Hieroglyphics: Visual Culture in Late Twentieth-Century Russia*, edited by Nancy Condee, 93–112. Bloomington: Indiana University Press, 1995.

Zabelin, I. "Cherty samobytnosti v drevne-russkom zodchestve." *Drevniaia i novaia Rossiia*, no. 3 (1878): 185–203 and no. 4 (1878): 281–303.

Zaitsev, Pavlo. *Taras Shevchenko: A Life*. Translated by George S. N. Luckyj. Toronto: University of Toronto Press, 1988.

Zapadov, A. V. et al., eds. *Istoriia russkoi zhurnalistiki XVIII–XIX vekov*. Moscow: Vysshaia

shkola, 1973.

Zapadov, A. V., ed. *Russkii fel'eton. V pomoshch' rabotnikam pechati.* Moscow: Gos. izd-vo polit. lit-ry, 1958.

Zaretskaia, D. M. "Rossiia na vsemirnoi vystavke 1851 goda." *Voprosy istorii* 7 (July 1986): 180–85.

Zelinskii, V., ed. *Kriticheskie kommentarii k sochineniiam A. N. Ostrovskogo: Khronologicheskii sbornik kritiko-bibliograficheskikh statei.* 4th ed. Moscow: Tip. Vil'de, 1915–.

Zhemchuzhnikov, L. M. *Moi vospominaniia iz proshlogo.* Edited by A. G. Vereshchagina. Leningrad: "Iskusstvo," 1971.

Zhil', F. *Muzei Imperatorskogo Ermitazha: Opisanie razlichnykh sobranii sostavliaiushchikh muzei s istoricheskim vvedeniem ob Ermitazhe Imperatritsy Ekateriny II i o obrazovanii muzeia novogo Ermitazha.* St. Petersburg: V tip. Imperatorskoii Akademii nauk, 1861.

Zhukovskii, V. A. "Skazka o tsare Berendee, o syne ego Ivane-tsareviche, o khitrostiakh Koshcheia bessmertnogo i o premudrosti Mar'i-tsarevny, Koshcheevoi docheri." *Sobranie sochinenii v 4 tomakh.* Vol. 3, 157–69. Leningrad: Gos. izd-vo khudozhestvennoi lit-ry, 1960.

Zhuravleva, A. I., ed. *Russkaia drama epokhi A. N. Ostrovskogo.* Moscow: Izd-vo Moskovskogo univ-ta, 1984.

Zhuravleva, L. *Kniaginia Mariia Tenisheva.* Smolensk: Smolenskii gos. pedagog. in-t im. K. Marksa, 1992.

——. *Kniaginia Mariia Tenisheva.* Smolensk: "Poligramma," 1994.

——. *"Pridite i vladeite mudrye—"* Smolensk: Moskovskii rabochii, 1990.

——. *Talashkino: Ocherk-putevoditel'.* Moscow: Izobrazitel'noe iskusstvo, 1989.

——. *Tenishevskii muzei "Russkaia starina."* Ann Arbor: Distributed by ATC Books International, Inc., 1998.

——. *Teremok.* Moscow: Moskovskii rabochii, 1974.

Zhurbina, E. I. *Povest' s dvumia siuzhetami: O publitsisticheskoi proze.* 2nd ed. Moscow: Sov. pisatel', 1979.

——. *Teoriia i praktika khudozhestvenno-publitsisticheskikh zhanrov.* Moscow: "Mysl'," 1969.

INDEX